HISTORY OF THE UNITED STATES

CAPITOL

A chronicle of design,
construction, and politics

HISTORY OF THE UNITED STATES

CAPITOL

A chronicle of design,
construction, and politics

Prepared Under the

Direction of the

Architect of the Capitol

by

William C. Allen
Architectural Historian

U. S. GOVERNMENT PRINTING OFFICE WASHINGTON 2001

106th Congress, 2d Session
Senate Document 106–29
Printed pursuant to H. Con. Res. 221

Library of Congress Cataloging-in-Publication Data

Allen, William C. (William Charles), 1950–
 History of the United States Capitol : a chronicle of design, construction, and politics /
prepared under the direction of the Architect of the Capitol by William C. Allen
 p. cm.
 Includes bibliographical references and index.
 1. United States Capitol (Washington, D.C.)—History. 2. Washington
(D.C.)—Buildings, structures, etc. 3. Political culture—United States—History. 4.
Architecture and state—Washington (D.C.)—History. I. United States. Architect of the
Capitol. II. Title.

F204.C2 A458 2001
975.3'042—dc21

 2001023757

TABLE OF CONTENTS

ILLUSTRATIONS

Unless otherwise indicated, illustrations are from the records or collections of the Architect of the Capitol.

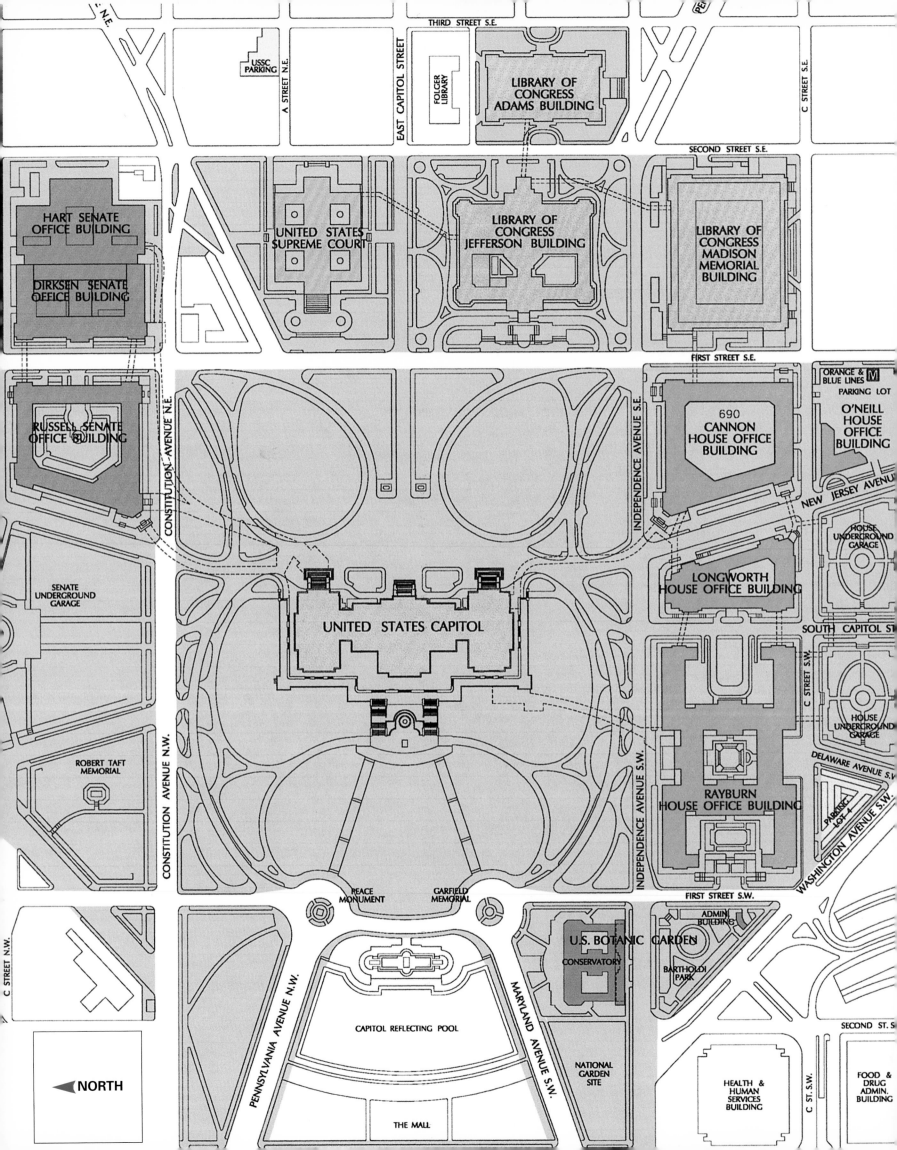

FOREWORD

When I was appointed Architect of the Capitol in 1997, a ten-year celebration was under way that marked the bicentennial of the Capitol's initial construction. Four years prior to my arrival, the nation marked the 200th anniversary of the Capitol's cornerstone laying. In the year 2000 Congress celebrated two centuries of residence in what had become the nation's most venerated building. During this bicentennial period, numerous projects and programs were undertaken to give the American people a better understanding of this great building and the ideals that it stands for. Soon after taking office I learned that one of the projects was the preparation of a comprehensive history of the Capitol's design and construction. I have been pleased to lend my support to this very important work.

Within the general story of the Capitol's development lies the history of the office I am honored to hold. The office of Architect of the Capitol in effect began to function in 1791 when President George Washington appointed a three-man commission to oversee work in the new capital city. This included supervision of all construction activities on Capitol Hill—a significant aspect of what my office does today. In 1867 the commission's responsibilities were handed over to Edward Clark, an architect who was then finishing a large expansion project that also involved putting a new dome on top of the Capitol. With the two offices blended, the modern-day Architect of the Capitol became the officer in charge of all aspects of construction and maintenance for government buildings on Capitol Hill.

In reading about the history of the Capitol I am struck by the fact that for more than 200 years it has been a work in progress. Construction of the building that George Washington had approved was begun in 1793 but was soon altered by an architectural metamorphosis dictated by changing circumstance, fashion, and fortune. Furthermore, as the nation grew so did the Congress and the Capitol. Change and growth seem to be threads that bind the Capitol's history together. At the end of the present volume, mention is made of congressional approval of a Capitol Visitor Center. It has been my privilege to oversee the design of this large underground facility, the construction of which will begin in 2002. It will add greatly to the comfort and security of the millions of visitors who come to the Capitol to see Congress in session and to learn about the great building in which it meets. It also exemplifies the fact that the Capitol is a vital, evolving building.

The office of Architect of the Capitol has diverse responsibilities that include the preservation of the building's historic fabric and many of its works of art. Through publications such as this my office also engages in educational efforts to enhance the public's understanding of the building's complex and fascinating history. With such an understanding often comes a new appreciation for our country's own unique journey over the last two centuries. It also engenders a sense of gratitude for the many men and women who have contributed their special talents to make the Capitol one of the world's greatest buildings. The human aspect of the Capitol's story is a reminder that much of history is biography, and that the nation's autobiography may clearly be seen through the magnificent building known simply as "The Capitol."

Alan M. Hantman, FAIA
Architect of the Capitol

PREFACE

On February 22, 1827, members of the House of Representatives spent the afternoon debating the merits of legislation aimed at the gradual improvement of the navy. Two days later, the subject of discussion was licensing ships engaged in mackerel fishing. On both occasions the galleries were full of sightseers who had come to the Capitol to have a look around and see Congress in action. Visitors watched from galleries located behind the chamber's magnificent Corinthian colonnade. Tall shafts of variegated stone and Italian marble capitals gave an impression of grandeur and monumentality that was exceedingly rare in American architecture of the period. Gold fringe dangled from crimson drapery that was festooned between the columns. Sunlight filtered through a large round aperture in the wooden ceiling, which was painted and gilded to imitate a coffered dome. On the carpeted floor below, 212 representatives sat in armchairs covered with horsehair upholstery, their hats stowed on small shelves held between the chair legs. Some congressmen followed the proceedings, but others read newspapers or wrote letters home. Bad acoustics made it difficult to pay attention in any event. Small clusters of congressmen congregated behind the rail to smoke cigars and discuss politics or the evening's entertainment. Presiding over the spirited scene was the Speaker of the House, who was seated on a raised dais with a sil-ver inkwell and candelabra on the desk before him. At his right was the ceremonial mace, symbol of the authority of the House. Overhead, swags of fringed drapery hung from a mahogany sounding board.

Between the naval and mackerel debates, the House took up the topic of funding the public buildings in the capital city of Washington. Legislation before the House included an appropriation for the continuation of the Capitol's construction. A congressman from Kentucky named Charles Wickliffe rose from his seat to ask why the Capitol was still under construction after thirty-four years of work. He knew old men in his home district who had spent their youths working on the building and who were now utterly astonished to learn that the Capitol was still not finished. He did not understand how the United States, with all its wealth and resources, could not complete a building in the span of more than three decades. He would not support the appropriation because he could foresee that there would be no end to these funding requests.

In 1870, forty-three years after Wickliffe's remarks, the House was meeting in a new chamber designed for improved hearing and speaking. Gone were the echoes that plagued the old hall, but the new chamber was so cavernous that hearing was still difficult for those seated far from the orator. The new hall was covered by a flat iron

ceiling with a stained-glass skylight framed by gold-leafed moldings, stars, and pendants. Galleries surrounded the chamber on four sides without columns or draperies to block views or muffle voices. In this new chamber, during a debate about relocating a pair of bronze doors, Fernando Wood of New York City rose from his leather-tufted chair to complain that every year something was done to change the Capitol purely for the sake of change. He regretted to say that this desire for change—particularly in reference to the Capitol—was an unstable and unflattering aspect of the American character.

In 1903 Joseph Cannon of Illinois sponsored legislation to "complete" the Capitol with an addition to its east front. To document the need for a larger Capitol, Cannon cited the growth of the nation, the increasing number of congressmen and senators, and the expanding number of committees that reflected the overall growth of public business. The time was right, Cannon claimed, to complete the Capitol with a new east front. Seventy-five years later, other legislators claimed they wanted to finish the building with a new west front extension. Despite outward appearances, it had become clear that the Capitol's completion was in the eye of the beholder.

Like so many aspects of American life, the Capitol is often viewed as a work in progress—an architectural evolution reflecting the country's own political, economic, and social development. It was not the vision of a single person nor the product of a single age; rather, it was—and continues to be—the accumulation of thousands of ideas worked by thousands of people over a two-hundred-year period. Honorable and gifted political leaders, architects, and builders appear at critical moments in the Capitol's history, but the story is also tangled and enlivened by dozens of unscrupulous and obstreperous characters who complicate matters along the way.

How the Capitol has evolved makes for an unusually intricate tale, but it is one worth telling. Most early histories were written by architects who saw the building's story mainly through biographies of its designers. Robert Mills published accounts of the design and construction of the Capitol in guide books that he sold to visitors to the federal city in the 1840s and 1850s. In 1877

The American Architect and Building News carried an essay entitled "Architecture and Architects at the Capitol of the United States From its Foundation Until 1875" written by Adolf Cluss, a Washington architect. The most prolific writer on the subject at the end of the nineteenth century was Glenn Brown, an architect who served as secretary of the American Institute of Architects from 1899 to 1913. He began writing about the capital city and its major buildings in 1894 when *Architectural Review* published his article "The Selection of Sites for Federal Buildings." Two years later he wrote a monograph on William Thornton, one of the Capitol's more enigmatic figures. Brown's series of articles for the *American Architect and Building News* appearing in 1896 and 1897 covered the early history of the Capitol and formed the basis for the first half of his most famous work, the two-volume *History of the United States Capitol* (1900, 1902). Throughout much of the twentieth century, Brown was the top authority on the Capitol's history.

Three years before Brown's first volume appeared, Washington lawyer and novelist George C. Hazelton published *The National Capitol: Its Architecture and History*. It was a popular history and guide to the building, which was reprinted in 1902 and 1914. Many of the myths surrounding the Capitol's construction were cheerfully retold by Hazelton, who divulged in the preface that the most delightful "truths" in history lie in "romance and tradition." In 1940 art historian Ihna T. Frary published *They Built the Capitol*, a breezy work based largely on Brown. In 1963 the United States Capitol Historical Society began publishing *We, the People*, a handsome and reliable guidebook currently in its fourteenth edition and available in several foreign languages. Twenty-seven years later, Congress issued a short overview of the building's construction in *The United States Capitol: A Brief Architectural History* prepared by the Architect of the Capitol. Many of the visual delights of the Capitol's architecture were captured by Fred Maroon, a gifted photographer who published a collection of spectacular pictures in his book *The United States Capitol* (1993). Works of recent scholarship include Pamela Scott's *Temple of Liberty* (1995), an important catalogue accompanying a bicenten-

nial exhibit held at the Library of Congress covering the Capitol's early history. Annual symposia on the Capitol's art and architecture sponsored by the United States Capitol Historical Society encourage fresh inquiries by some of America's most respected scholars. *A Republic for the Ages: The United States Capitol and the Political Culture of the Early Republic* was published in 1999 as a compilation of papers from the 1993 bicentennial conference. Papers presented at the Society's 1994 and 1995 symposia were published in *The United States Capitol: Designing and Decorating a National Icon.* The Society promises to continue holding conferences that will no doubt stimulate further inquiries into various aspects of the Capitol's history.

In preparation for the 1993 bicentennial of the Capitol's first cornerstone, steps were taken by the Architect of the Capitol to compile a comprehensive chronicle of its design and construction history. The bicentennial seemed a good time to provide a fresh look at these intriguing subjects. There was a need for an in-depth examination of the Capitol's development set within a broader political and social context. Some of the ground to be covered was not new, yet much needed a fresh reexamination, while long-ignored or recent aspects of the Capitol's history needed to be folded into the story. Illustrations from familiar sources would be augmented from the lesser-known photographic records held by the Architect of the Capitol. Preparation of the bicentennial history of the Capitol was supported by the Capitol Preservation Commission, a bicameral congressional entity that funds projects related to the Capitol's history and preservation.

The text of the present volume draws heavily on primary source material, such as the edited and published papers of William Thornton and B. Henry Latrobe. Unpublished primary sources, particularly papers and manuscripts only recently made available, were valuable resources as well; important examples were the papers of Thomas U. Walter, acquired by the Athenaeum of Philadelphia in 1983, and the journals of Montgomery C. Meigs, long available at the Library of Congress but only recently transcribed from their original Pitman shorthand. The records of the Architect of the Capitol and the debates of Congress were two

valuable resources that were generally underutilized in previous histories. Not found in the bibliography are the personal observations made by the author over an eighteen-year period. A daily examination of the Capitol's intricate structure and architecture offered unique opportunities to learn lessons about the building that no document or book could provide. Bringing these documents, observations, and illustrations together in a comprehensive history was one way the Architect of the Capitol sought to make a permanent contribution to the understanding of one of America's most intriguing buildings.

With gratitude, the author would like to thank his professional colleagues who helped in this effort. First and foremost, Ann Kenny's assistance was indispensable. She performed innumerable scholarly and dreary tasks with equal aplomb, doing research, collecting illustrations, and keeping track of paper work. Her compilation of the most extensive chronology of the Capitol's history brought mounds of diverse research materials into sharp focus. John Hackett and Sarah Turner, archivists in the office of the Architect of the Capitol, helped sort through 150 years' worth of material generated by an agency that rarely discarded anything. Pamela Violante McConnell, the agency's registrar, gambled her eyesight and sanity transcribing correspondence of Montgomery Meigs and Frederick Law Olmsted. Benjamin Myers, James Corbus, Michelle Gatlin, and R. Edward Ashby of the Architect's records center were always helpful with the historic drawings and records under their care. The Architect's photo lab, headed by Wayne Firth, holds a priceless and growing collection of images dating from 1855. Michael Dunn, Steve Payne, and Chuck Badal contributed their considerable talents to the photographic illustrations, as did their predecessors, Harry Burnett and Mark Blair. Special drawings were prepared in the Architecture Division by staff architects Edward Fogle and Juliana Luke and by an especially able intern, Eric Keune.

Three repositories outside the office of the Architect of the Capitol hold key drawings significant to the history of the Capitol. At the Library of Congress, C. Ford Peatross, curator of architecture, design, and engineering collections, generously shared his time and knowledge regarding

the extensive holdings in the Prints and Photographs Division. Bruce Laverty, archivist of the Athenaeum of Philadelphia's architectural collections, and Elizabeth Gordon, registrar at the Maryland Historical Society, provided similar access to their collections.

I am grateful to many helpful people who made it possible to include illustrations from their collections: Jenna Loossemore of the American Antiquarian Society; Sherry C. Birk of the American Architectural Foundation; Sarah Turner of the American Institute of Architects Archives; Angela Giral and Janet Parks of the Avery Architectural and Fine Arts Library; Pamela Greiff of the Boston Athenaeum; Elizabeth Lunchsinger of the Corcoran Gallery of Art; Jacklyn Burns of the J. Paul Getty Museum; Lucinda P. Janke of the Kiplinger Washington Collection; David Prencipe of the Maryland Historical Society; William M. Fowler, Jr. and Jennifer Tolpa of the Massachusetts Historical Society; Annie Brose of the National Museum of American Art; Ann M. Shumard of the National Portrait Gallery; Radames Suarez and Wayne Furman of the New York Public Library; Mary Doherty of the Metropolitan Museum of Art; Rodney A. Ross of the National Archives and Records Administration; Nancy Stanfield and Barbara Goldstein Wood of the National Gallery of Art; Joyce Connolly of the Frederick Law Olmsted National Historic Site; Thomas G. Sudbrink of the U. S. Department of State; Arthur Lawrence and Duncan Burns of the Union League Club; Gail R. Redmann of the Historical Society of Washington, D. C.; and Betty Monkman and Lydia S. Tederick of the White House.

Scholars in specialized fields helped review the manuscript and invariably offered useful advice. Herbert M. Franklin, administrative assistant to the Architect of the Capitol, made helpful suggestions on the early draft. The Architect's curator, Barbara Wolanin, prevented errors from creeping into matters relating to the Capitol's artwork. The Capitol's landscape architect, Matthew Evans, offered valuable insights regarding the Olmsted landscape.

Authorities in congressional history, Richard Baker and Donald A. Ritchie of the U. S. Senate Historical Office, Donald Kennon, chief historian for the Capitol Historical Society, and Cynthia Pease Miller, former archivist and historian in the office of the clerk of the House of Representatives, shared their unique perspectives and knowledge. Diane Skvarla, curator of the Senate, and her predecessor, James Ketchum, provided information regarding the restoration of the old Senate and Supreme Court chambers. Professor Charles E. Brownell of Virginia Commonwealth University generously reviewed the chapters dealing with the work of B. Henry Latrobe and provided valuable guidance. I am indebted to Professor Michael Fazio of Mississippi State University for drawing my attention to the only known sketch of the Capitol made while the center building was under construction. I am also grateful to Pamela Scott, Don Hawkins, Jhennifer A. Amundson, Susan Brizzolara Wojcik, and James M. Goode, all of whom took time to review parts of the text. Cynthia Ware and David C. Lund suggested ways to make the manuscript more accessible, consistent, and clear. Wendy Wolff, editor in the Senate Historical Office, provided valuable direction regarding the book's index. Special thanks goes to Architect of the Capitol staff editor Eric Paff, who worked wonders with the manuscript. I am grateful to Lyle Green, Janice Sterling, Bill Rawley and John Sapp at the Government Printing Office for making the long road to publication so smooth. Particular thanks go to the patient and talented designers of this book, Erika Echols and DiAnn Baum.

A final word of appreciation is due to the men and women who take care of the Capitol and its surrounding campus. Many have made time to share their insights and their gratifying affection for the buildings under their care. It takes many people to keep the Capitol going—carpenters, painters, electricians, plumbers, sheet metal workers, laborers, gardeners, architects, and engineers. Each of them is part of a long and worthy tradition of knowledge, hard work, and perseverance.

HISTORY OF THE UNITED STATES

CAPITOL

"We have built no national temples but the Capitol; we consult no common oracle but the Constitution."

Representative Rufus Choate, 1833

GRANDEUR

ON THE POTOMAC

From a two-hundred-year perspective, it is not easy to grasp the difficulties surrounding the location, design, and construction of the United States Capitol. When work began in the 1790s, the enterprise had more enemies than friends. Citizens of New York, Philadelphia, and Baltimore did not want the nation's capital sited on the Potomac River. The Capitol's beginnings were stymied by its size, scale, and lack of precedent. In the beginning Congress did not provide funds to build it. Regional jealousy, political intrigue, and a general lack of architectural sophistication retarded the work. The resources of the remote neighborhood were not particularly favorable, offering little in the way of manpower or raw materials to help build this ambitious structure, and doubters were everywhere, questioning the wisdom of putting such a building in such a place. Yet, despite the obstacles, the Capitol slowly evolved into a monument of classical grandeur that commands admiration and respect. Today it is one of the most famous structures in the world, not only one of America's great architectural achievements but also an international symbol of democracy and self-government.

View of the Potomac and the City of Washington (Detail)

Engraving of a painting by George Beck, ca. 1796

Kiplinger Washington Collection

Long before the first stone was set, the story of the Capitol was intertwined with the effort to establish the seat of federal government. The Revolution that won the right of self- government for thirteen independent states started a controversy over the location of the new nation's capital, a fight some historians consider the last battle of the war.[1] At the close of military hostilities with Great Britain in 1781, the United States was a nation loosely bound under the Articles of Confederation, a weak form of government with no executive, no judiciary, and a virtually powerless Congress. Although the subject of the country's permanent capital was discussed during this period, legislators could not agree on an issue so taut with regional tension. In 1783 Thomas Jefferson, then a representative in Congress, wrote the governor of Virginia about possible locations for a new capital and noted that sites on the Hudson, Delaware, and Potomac rivers were being considered. The Hudson location had little support, while the Delaware River site had seven votes. Southern states liked the idea of two capitals, one on the Potomac at Georgetown, Maryland, and one farther north. Without nine states agreeing, however, the location of the nation's capital remained unsettled.[2]

In 1787 a convention was called to devise ways to improve the Articles of Confederation, but delegates soon realized that a totally new constitution was needed to bind the states into "a more perfect union." During four months in Philadelphia, they

View of the Federal Edifice in New York

by Amos Doolittle, 1789

Library of Congress

Citizens of New York raised money to transform their old city hall into the nation's capitol, hoping Congress would extend its stay in the city indefinitely. Pierre L'Enfant designed the alterations, including a Doric portico with thirteen stars in the entablature and an eagle in the pediment. Plaques carved with laurel wreaths and thirteen arrows were placed above the upper windows. Inside he created an American order with stars and the rays of the sun illuminating the national monogram that was integrated into column capitals.

Despite New York's hospitality, Congress spent only two sessions in Federal Hall. After the Residence Act passed in 1790, the federal government left for Philadelphia, awaiting a new capital city being prepared on the Potomac.

devised a framework of federal government that has endured to this day. They dealt quickly with the issue of a capital city: in article one, section eight, the Framers granted Congress the right to accept a donation of land "not exceeding ten Miles square" over which it would "exercise exclusive Legislation in all cases whatsoever." Congress was given the

authority to supply the district with "needful" (i.e., necessary) buildings in which to conduct business. Thus, the capital city of Washington and the Capitol of the United States were authorized in the country's Constitution. The delegates, however, had left the details to be ironed out in the future, and deciding where to establish the seat of government and what to build as a capitol proved to be far more difficult and quarrelsome tasks.

The first session of the first Congress began in New York City on March 4, 1789, but a quorum in the House of Representatives and Senate was not present until a month later. Once there were enough members present to conduct business, Congress began to set the machinery of government into motion, establishing the first cabinet departments, creating the first judicial system, prescribing oaths of office, and proposing the first amendments to the Constitution, which became the Bill of Rights. Amid this important work the issue of creating a seat of government was discussed, but nothing conclusive happened. A movement by northern interests to locate the capital on the Susquehanna River was thwarted by Virginia Congressman James Madison, and the subject was deferred until the second session. As time passed, however, interest in a capital city grew as people realized the riches and prestige that were at stake. Such a place would have vast commercial possibilities, and real estate values would surely soar. Also, as today, state pride and local loyalties were potent forces and figured into the contest. Unlike legislation that applied to the country evenly, selecting the site of the nation's capital would result in one big winner and at least a couple sore losers.

One of the best records of the discussion regarding the seat of government is found in the diary of William Maclay, a senator from Pennsylvania who spiced his observations with humor and skepticism. Maclay wrote of the rancor surrounding the dual question of establishing both a permanent federal capital and a temporary capital where Congress would meet while the permanent one was under construction. On June 8, 1790, Maclay described the reaction of two South Carolina senators, Ralph Izard and Pierce Butler, when Philadelphia was being considered as a location for the nation's permanent capital:

> How shall I describe this day of confusion In the Senate? Mr. Lee laid on the table a Report

of some additional Rules, relative to the intercourse between the Two houses, after this he moved that the bill for the permanent Residence of Congress should be postponed to take up Resolution of the Representatives for adjourning to Philada. now it was Izard flamed and Butler bounced & both seemed to rage with madness.[3]

To defeat Philadelphia, Izard and Butler went to the lodgings of Samuel Johnston, a sickly senator from North Carolina, and brought him into the chamber in a sedan chair. (He was still wearing a night cap.) A sickbed was set up in an adjoining committee room. A second ailing senator, William Few of Georgia, came to the chamber unassisted. With these reinforcements, Izard and Butler defeated Philadelphia by two votes while the Senate roared with so much noise that Maclay thought it sounded like a fish market.

Maclay's diary is full of similar accounts, of more speeches, of maneuvering by northern and southern factions, and of coalitions that were formed and dissolved almost daily. No site below the Potomac nor above New York was considered, but many in between were. President George Washington pushed steadily for the Potomac. During the Revolution he conceived the idea of locating the country's capital along the Potomac and as president he used his influence to promote the river's commercial and political future. Southerners pointed to one of its more obvious advantages: a capital on the Potomac would be near the geographic center of the country. Philadelphia, then America's largest city, had the powerful Pennsylvania delegation behind it but was regarded with suspicion by members from southern, slave-holding states. New York City was the natural favorite of New England states. Opposition from both the Philadelphia and Potomac interests to New York as even the temporary capital was strong because, the argument ran, if Congress stayed in New York much longer, it would never leave. Representatives from Maryland were divided between the Potomac and Baltimore locations, two sites also favored by the Carolina interests.

By the end of June 1790, there seemed to be only halfhearted efforts to challenge the president's push for a permanent capital on the Potomac. Unable to match Washington's clout, Maclay lamented:

The President of the U. S. has (in my Opinion) had Great Influence in this Business. The Game Was played by him and his Adherents of Virginia & Maryland between New York & Philada. to Give One of those places the Temporary Residence. But the permanent Residence on the Potowmack.[4]

The Senate returned to the temporary capital issue in another long day of debate on June 29. Again, the excitable Senator Izard showed "visible perturbation" and bounced "at a strange rate."[5] Maryland Senator Charles Carroll proposed a temporary residence of ten years in Philadelphia, to which New York Senators Philip Schuyler and Rufus King countered with an offer to divide it between Philadelphia and New York, five years in each city. After some discussion the measure failed on the tie breaking vote of Vice President John Adams. The same provision failed again the following day.

It may well have seemed to some members of the fledgling Congress that the deadlock would persist ad infinitum. Some, too, may have wondered that Alexander Hamilton, the secretary of the treasury and a close adviser to the president, had not participated in the administration's push for the Potomac capital. Maclay, for instance, knew that if Hamilton were to join in, his forceful personality would be overwhelming: "If Hamilton has his hand in the Residence now," Maclay wrote, "he will have his Foot in it before the end of the Session."[6] But the secretary was otherwise occupied with his funding proposal, a scheme in which the federal government would absorb debts incurred by states in waging the Revolutionary War. Thus, both the nation's debt and its credit would be held by the central government, consolidating its authority and fostering a greater sense of nationalism. Hamilton's plan was popular in northern states, where public debt was greater than in the south. There were fears that New England would leave the Union if its war debts were not taken over by the central government—some people predicted that the nation would dissolve into bickering confederations over this issue.

Thomas Jefferson, now secretary of state, understood that Hamilton needed southern votes to pass his plan for "assumption," as the scheme was known. He also knew that the Potomac capital would fail without some support from northern interests. A chance encounter with the secretary of the treasury led Jefferson to suggest an informal dinner in his rooms at which interested parties could discuss a

mutual accommodation. Guests included three Virginia congressmen: James Madison, the leading administration supporter in the House of Representatives, Alexander White, and Richard Bland Lee. Both White and Lee represented districts bordering the Potomac, and both were opposed to Hamilton's assumption plan. In recalling the evening, Jefferson wrote: "So two of the Potomac members (White & Lee, but White with a revulsion of stomach almost

convulsive) agreed to change their vote, & Hamilton undertook to carry the other point."[7] The compromise, or vote swap, paved the way for passage on July 16, 1790 of legislation that would become known as the Residence Act. The Act stipulated that Philadelphia would serve as the temporary capital for ten years while a new city was laid out and a few government buildings were erected on the northern bank of the Potomac River near Georgetown. Like many others, Jefferson was relieved by the decision. He said the question "was always a heating one," and was glad that it would be "put to sleep for ten years."[8]

The bill that emerged from Congress indicated the legislature did not want any further part in founding the nation's capital. Its work done, Congress left the matter in the president's hands, giving him the authority to select the exact site along

Robert Morris Moving the Capitol to Philadelphia

Unidentified Artist, 1790

American Antiquarian Society

In a cartoon mocking the government's move from New York, Pennsylvania Senator Robert Morris is shown with Federal Hall on his shoulders headed for Philadelphia, where a devil and prostitutes await his arrival.

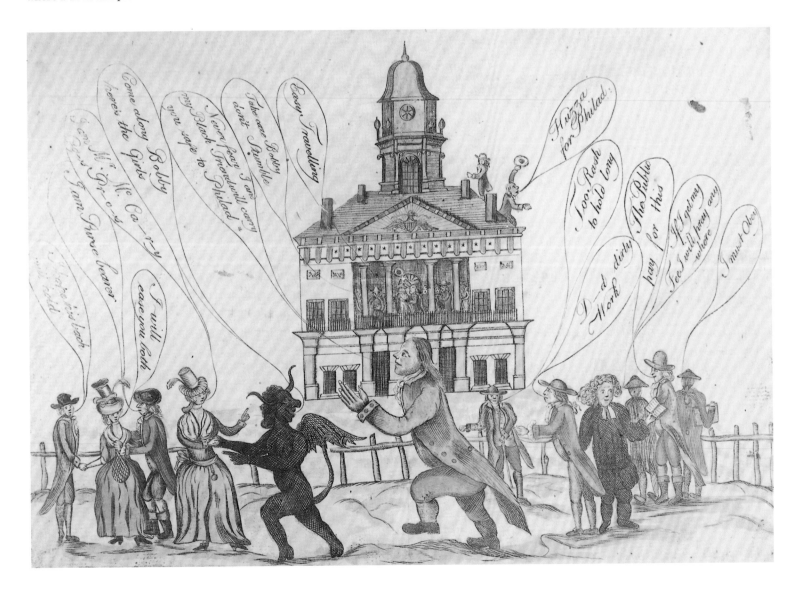

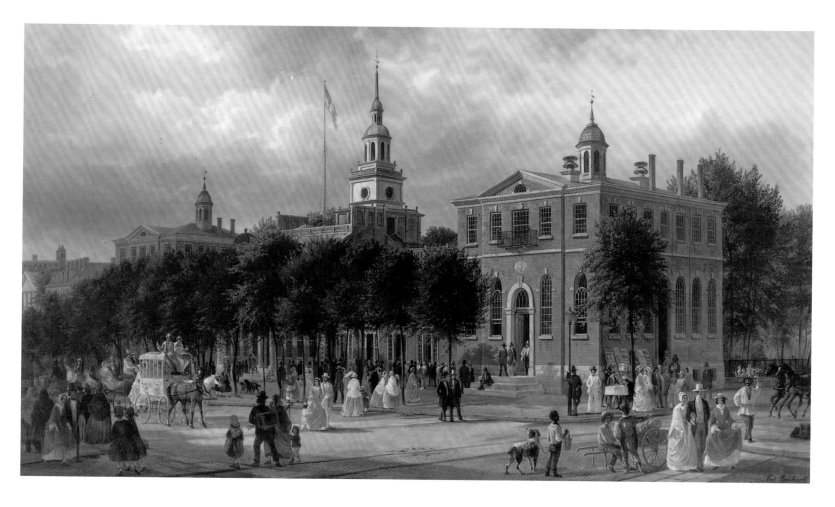

Philadelphia in 1858
by Ferdinand Richardt, 1858
The White House Collection

*T*he Philadelphia County Court House was occupied by Congress from 1790 until 1800. The tower of Independence Hall, its celebrated neighbor on Chestnut Street, can be seen behind the trees.

the Potomac and to appoint a three-man commission to act as his personal representative in putting the law into effect. Congress did not then, nor would it for many years afterwards, appropriate funds for the enterprise. It set December 1800 as the time it would meet in its permanent home and directed that two buildings, a house for the president and a legislative hall, be ready by then. It would pack up and leave New York and reconvene in Philadelphia by the start of the third session, which was scheduled to begin on December 6, 1790. Once there, some still hoped that Congress would stay and that the idea of a Potomac capital would fade into oblivion.

THE FIRST BOARD AND L'ENFANT

*I*n January 1791 President Washington named three men to the board of commissioners that would manage the affairs of the new city on the Potomac. While each had a personal stake in the venture's success, none were experienced in city planning, construction, or architecture. The first appointee was Daniel Carroll of Rock Creek, a member of one of the aristocratic families of Maryland, who had been voted out of Congress due to his support of Hamilton's assumption plan. Carroll's family roots ran deep in the neighborhood selected for the capital, and he shared Washington's interest in improving the navigation of the Potomac River through a system of locks and bypasses all the way to the Ohio River. The "Potowmack Company," as the venture was known, sought to open a navigable route to the west through which goods and settlers would pass, thus

earning handsome profits for the investors. The second appointee, also from Maryland, was Thomas Johnson, a member of the first and second Continental Congresses, the first governor of Maryland, and, after Washington, the second president of the Potowmack Company. In 1775 Johnson had nominated Washington to be commander-in-chief of the American armies at the beginning of the Revolution. To fill the third seat on the board, Washington appointed a member of his own family and inner circle, David Stuart of Virginia. He was married to the widow of Martha Washington's son, John Parke Custis. Stuart enjoyed Washington's friendship and shared his enthusiasm for locating the capital on the Potomac. Like the rest of the board, he was also an investor in the Potowmack Company.

The board's duties were broad and vague: every known and unknown aspect of the federal city came within its jurisdiction. Before a city could be laid out there had to be a plan, surveyors had to be employed to lay out streets and lots, and workmen had to be hired to clear the land. Washington arranged for the new federal territory to include his hometown of Alexandria on the Virginia side of the Potomac, and he selected a site just upriver for the capital. It would be established between the shallow waters of Rock Creek and the wide, deep Eastern Branch, later known as the Anacostia River, on the Maryland side. Beyond Rock Creek lay the port of Georgetown and, above it, the falls of the Potomac at the head of navigation.

On Washington's orders, the French-American engineer Pierre Charles L'Enfant was commissioned to design the city and the public buildings. He had asked the president for the job on September 11, 1789, ten months before the Residence Act became law:

> The late determination of Congress to lay the foundation of a city which is to become the Capital of this vast Empire, offer so great an occasion of acquiring reputation . . . that Your Excellency will not be surprised that my ambition and the desire I have of becoming a useful citizen should lead me to wish to share in the undertaking . . . No nation perhaps had ever before the opportunity offered them of deliberately deciding on the spot where their Capital city should be fixed . . . I am fully sensible of the extent of the undertaking and under the hope of the continuation of the indulgence you have hitherto honored me with I now presume to solicit the favor of being Employed in this Business.[9]

Informing the commissioners of the president's decision to employ L'Enfant, Jefferson said that he was considered particularly qualified to draw the city's plan.[10] A month later Secretary of State Jefferson asked L'Enfant to go to the site and meet with Andrew Ellicott, who had been employed to survey the ten-mile square federal district.[11] L'Enfant was to go over the ground, make drawings, and determine the locations of the President's House and the Capitol. By June, L'Enfant's ideas had sufficiently jelled to enable him to describe the principal features of the city plan. It had a grid street pattern over which broad diagonal avenues would be laid. Most of these grand avenues would radiate from the two principal buildings and give the city variety, direct routes between major points, and impressive vistas. The Capitol would be on Jenkins Hill, an elevated site that was like "a pedestal waiting for a monument."[12] The waters of a nearby spring could be diverted to cascade down the hill, giving the Capitol a sprightly podium. At the foot of Jenkins Hill, the principal public garden, or Mall, would begin its path westward to the Potomac more than a mile away. Along the edge of this green swath were places of "general resort . . . such sort of places as may be attractive to the learned and afford diversion to the idle."[13] The Mall was also an ideal location for the equestrian statue of Washington voted by Congress in 1783. The President's House would be located on a line north of the statue, with a commanding view down the Potomac to Alexandria in the distance.

The President's House and Capitol would be linked by the grandest avenue of the city. It would

Pierre L'Enfant

Silhouette by Sarah DeHart, ca. 1785

U.S. Department of State

*T*rained at the Royal Academy of Painting and Sculpture in Paris, L'Enfant (1754–1825) came to America in 1776, serving with distinction in the Continental Army. He was promoted to captain of engineers in 1778 and to brevet major in 1783. Following the Revolution, he was asked to design the insignia for the Society of the Cincinnati, a prestigious fraternity of army officers serving under George Washington during the war.

L'Enfant was given the unprecedented opportunity of designing the new federal city, the President's House, and the Capitol. His failure to produce plans for the two principal buildings was a factor leading to his dismissal in 1792.

be named for the State of Pennsylvania, a tactical move meant to appease the enemies of the federal city who were working in Philadelphia to keep the capital there. (Washington was not pleased when he learned that the Pennsylvania legislature intended to build a capitol and a presidential mansion in Philadelphia as enticements. If the Potomac capital were not ready in time, Philadelphia would happily remain the seat of government indefinitely.)

L'Enfant's city plan included sites for fountains; a national church; squares for states to improve with statues, columns, or obelisks; and unassigned squares that might later be used for colleges and academies. Washington was pleased

PLAN of the CITY of Washington (Detail)

by Pierre L'Enfant, 1791

Engraved by James Thackara and John Vallance

Library of Congress

L'Enfant's plan placed the Capitol and President's House far apart in separate sectors of the new federal city. While the separation expressed the constitutional division of power, the two principal buildings acted like magnets, attracting real estate development to those neighborhoods. On Jenkins Hill, along the Mall, and elsewhere on the map, the indication of monumental public buildings was a graphic device meant to convey a sense of grandeur and importance to the plan.

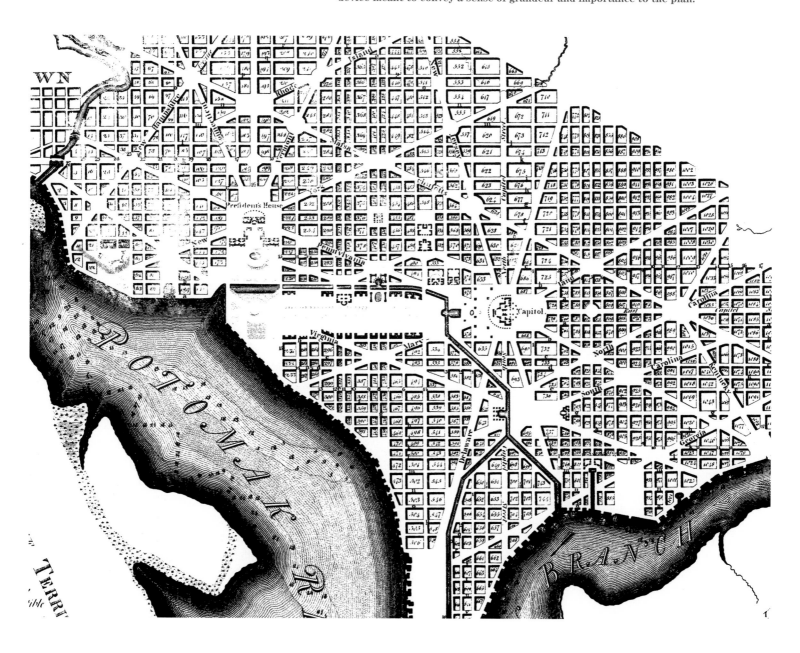

with the plan because it fulfilled his hopes for the city's enduring and useful future. Covering about eleven square miles, the city on paper was three square miles larger than London and ten square miles larger than Philadelphia.[14] It aimed at being a truly national metropolis, a great federal capital that would help bind far-flung states into a united country.

Washington wanted the plan published as soon as possible, but before that could be arranged, the names of the federal district and the new capital had to be settled upon. On September 8, 1791, the commissioners met in Georgetown with Jefferson and Madison. There it was decided to name the city "Washington" and the territory "Columbia."

Prior to its publication Jefferson carefully scrutinized the city map and made editorial changes to the notes that explained its features. He clarified some of L'Enfant's clumsy English, added the names of the city and territory, and crossed out every reference to "Congress house" and wrote the word "Capitol" in its place. This seemingly minor clarification was significant, for it spoke volumes of the administration's aspirations for the Capitol and the nation it would serve. Instead of a mere house for Congress, the nation would have a capitol, a place of national purposes, a place with symbolic roots in the Roman Republic and steeped in its virtues of citizenship and ancient examples of self-government. The word was derived from the Latin *capitolium,* literally a city on a hill, but more particularly associated with the great Roman temple dedicated to Jupiter Optimus Maximus on the Capitoline Hill. When Jefferson substituted "Capitol" for "Congress House," he also followed the appellative precedent set by the Virginia House of Burgesses in 1699, when it authorized building a new "Capitoll" in Williamsburg.[15] Most colonial legislatures met in a "statehouse."

Once the map was published, the world would see the intended scope of the federal city and understand the administration's high ambitions for it. On a more practical note, it was also necessary to have an accurate plan available when the first building lots were put up for sale in October. While in Philadelphia in September, L'Enfant provided an incomplete version of the plan to an obscure engraver named Narcisse Pigalle, who failed to publish the plan because he could not find a suitable sheet of copper. For the October sale L'Enfant could have displayed his personal copy of the city plan but refused for fear that speculators would buy only the most desirable parcels. In disbelief, the commissioners pointed out the difficulty of selling lots without buyers knowing where they were located. Further, with the proceeds earmarked to finance construction of the President's House and Capitol, L'Enfant's refusal to hand over the city plan caused fears that nothing would get built at all. When the first public sale of lots was held on October 17, 1791 only thirty-five parcels were purchased, netting just $2,000 in cash.[16] Washington blamed L'Enfant for the disappointing results, sympathizing with investors who refused to buy a "pig in a poke."[17]

The second sale of lots was scheduled for the spring of 1792. Determined that there would be no excuse for this one proceeding under the same handicap that hampered the first, Washington ordered L'Enfant to ready the plan for publication. The final version was completed and delivered to the president on February 20, 1792. Andrew Ellicott finished the plan after making some alterations of his own. Having found L'Enfant to be completely ignoring the task at hand, Ellicott finished the plan and "engaged two good artists (both Americans) to execute the engraving."[18] James Thackara and John Vallance of Philadelphia quickly produced a small version of the map that was published in *The Universal Asylum and Columbia Magazine* in March 1792. This gave Americans their first glimpse of their future capital city. While the partners worked on the large official version, Washington decided that another engraver should also be given the map in case Thackara and Vallance took too long. (They were, after all, from Philadelphia.) Samuel Hill of Boston was engaged to fill this second order as a backup.

The second sale of lots, like the first, proceeded without a published city plan. Hill's engraving, printed in Philadelphia by Robert Scott in October 1792, did not entirely please the president, but the version by Thackara and Vallance did. Both showed the same plan and used the same wording to explain its features, but the second plan was a more beautiful engraving, with two winged figures representing Freedom and Fame flanking a shield with the Washington family crest. Important, too, were the notations of the depths of the Potomac and Anacostia rivers that were missing from Hill's map.

Washington felt this information was vital in promoting the city's future commercial development. Both versions included what appeared to be grand buildings, a variety of vast structures with interesting features such as forecourts, domes, and porticoes. The suggestion of buildings added visual interest to the plan but did not represent real structures or designs. Rather, the images showed where buildings would be located and graphically promoted the idea of a monumental city.

L'Enfant's involvement in the creation of the nation's capital was a mixed blessing. He did, indeed, provide the visionary plan that is often cited as one of the finest conceptions of urban design, but his spirited personality and hot temper were his undoing. He never understood the role of the commissioners, considering Washington his sole patron and caring to please only him. By law, however, the commissioners were L'Enfant's employers, and for them he had only contempt. Despite the short time in which he planned the city (about five months), he seemingly was unable to follow through on other assignments. As 1791 slipped away, the commissioners worried about designs for the President's House and the Capitol. L'Enfant hinted that he had prepared plans for the principal buildings but was not ready to show them. Jefferson thought that the designs were carried in L'Enfant's head. Washington heard that John Trumbull (an artist and his former aide-de-camp) had been shown a design for the Capitol by L'Enfant, and Trumbull confirmed the story years later. It is certain, however, that none of the commissioners saw any architectural drawings and they complained that L'Enfant's workmen were digging on Jenkins Hill prior to the "adoption of unprepared plans."[19] Laborers should, in their opinion, be digging clay for brick rather than digging foundations for buildings that no one knew anything about, much less had approved. They tried to redirect the men, but nobody would follow their orders. Early in 1792 Jefferson wrote diplomatically to L'Enfant that "the advance of the season begins to require that the plans for the buildings and other public works at the Federal city should be in readiness,"[20] but the engineer responded with a glib declaration that the work was great and he needed time to prepare great plans:

> To change a wilderness into a city, to erect and beautify buildings etc, to that degree of

perfection necessary to receive the seat of government of a vast empire the short period of time that remains to effect these objects is an undertaking vast as it is novel.[21]

Such a statement did nothing to further the progress of the city, the President's House, or the Capitol—it was only buying time.

The final straw was L'Enfant's conspicuous lack of good sense when it came to the matter of the house being built for Daniel Carroll of Duddington (not to be confused with his distant relative, Commissioner Daniel Carroll of Rock Creek).[22] Carroll inherited much of the area that would become Capitol Hill, and after the federal city was established he began construction of a large brick residence on his property in August 1791. Unaware that it encroached seven feet into what would become New Jersey Avenue, Carroll was understandably enraged when L'Enfant sent a crew to tear the building down. The site had been owned by the Carroll family for generations, while the street was nothing more than a line of ink on a piece of paper. Had L'Enfant been more prudent, an accommodation could have been reached. Instead, he acted as if everyone should submit to the plan and its author. Learning of L'Enfant's folly, Washington said that his actions "astonish me beyond measure."[23] His patience and faith gone, Washington agreed to let L'Enfant go. The task of firing L'Enfant fell to Jefferson, who wrote the engineer on February 27, 1792, that his "services must be at an end."[24] His "extravagant plans," his "mad zeal," and his "great confidence" could not compensate for insubordination and bad judgment.[25]

THE COMPETITION OF 1792

*U*sually spring marks the beginning of the building season, but the spring of 1792 saw nothing done at the Capitol or the President's House due to the lack of plans. The top of Jenkins Hill was virtually untouched except for some unspecified site work undertaken by L'Enfant's workmen. Instead of echoing with the noise of hammers and saws Jenkins Hill was quiet, nearly deserted; the commotion typically stirred up by a large construction project was conspicuously

Brick Market, Newport, Rhode Island

by Peter Harrison, 1761–1772

Library of Congress

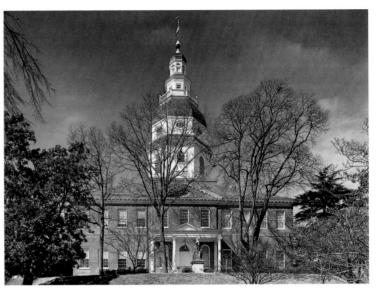

Maryland Statehouse, Annapolis

by Joseph Anderson, 1772–1779. Tower by Joseph Clark, 1787

Library of Congress

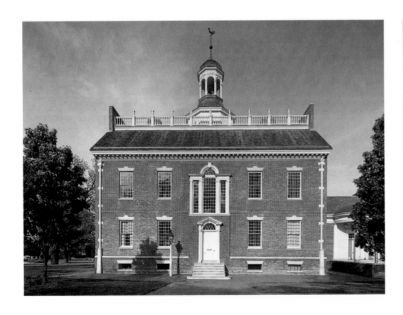

Delaware Statehouse, Dover

by Alexander Givan, 1788–1792

Library of Congress

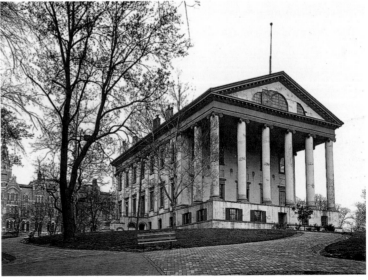

Virginia State Capitol, Richmond

by Thomas Jefferson and Charles-Louis Clérisseau, 1785–1798

Library of Congress

*M*ost American public buildings in the late eighteenth century were based on domestic forms and details. A cupola was often the only feature that distinguished a public building from a private residence. A fine example is the Maryland Statehouse. While residential in form and spirit, its eye-catching tower proclaimed the building's public purpose. A smaller and more typical example is the Delaware Statehouse, completed the same year the Capitol competition was held.

Less frequently, public buildings were derived from nonresidential sources. An example is the Brick Market in Newport, a fairly sophisticated design adapted from a public building in London (the New Gallery of Somerset House) with a one-story arcade supporting the main floors articulated by two-story pilasters and a full entablature. Principal story windows were topped by alternating curved and triangular pediments.

The revolutionary Virginia Capitol was a clean break from the Georgian tradition in public architecture. It was adapted directly from the Maison Carrée in Nimes, France, which Thomas Jefferson believed to be "the most precious morsel of architecture left to us by antiquity." The capitol's design was the earliest expression of neoclassicism in American architecture, helping launch the country's builders and architects on a half-century love affair with the antiquities of Greece and Rome.

Initially, President Washington did not articulate what he wanted the federal Capitol to be and had virtually no precedent to follow. Yet he believed the Capitol should overshadow statehouses of the Delaware and Maryland sort. The Virginia capitol offered a more monumental model, but its restrictive temple form could not be enlarged to accommodate Congress without incurring enormous expense. Eventually, a synthesis of Georgian architecture and neoclassicism would emerge from the protracted process of inventing and designing the United States Capitol.

absent. Five months had been lost in waiting for L'Enfant to produce a design for the Capitol, and still more time would be needed to obtain a design from someone else. Jefferson wrote the commissioners to suggest they advertise for the plans. The suggestion was democratic and idealistic in its presumption that there was talent enough in the country to produce numerous designs from which to choose. Commissioner Thomas Johnson wrote a draft advertisement and sent it to the president for approval, and on March 6, 1792, Jefferson returned the draft with alterations. In the same letter he advised the commissioners to begin the cellars of both buildings and, anticipating a local shortage of skilled builders, suggested they look into importing

Germans and Highlanders. He also said that Daniel Carroll's house should be rebuilt, a regrettable but unavoidable expense.[26]

The advertisement written by Commissioner Johnson was the first enumeration of the number and size of rooms needed for the Capitol. This and another prepared for the President's House were the first specifications ever written for federal buildings. The Capitol advertisement called for a brick building with a chamber for the House of Representatives and a conference room, each capable of seating 300 persons. The Senate would need a chamber covering 1,200 square feet, about the size of a room thirty-five feet square. These three principal rooms were to be two stories high, as were the lobbies at the entrances to the legislative chambers. Finally, twelve one-story rooms were needed to accommodate committees and clerks. Each of these was to be 600 square feet, or about twenty-five feet square.

Whether it was a matter of economy or insufficient foresight, the advertisement called for a relatively modest structure with fifteen rooms and two lobbies. Yet compared with Congress Hall in Philadelphia, the Capitol would have been spacious. That building had only four committee rooms, no conference rooms, no lobbies, and narrow corridors.[27] Federal Hall in New York, on the other hand, housed two legislative chambers, ten committee rooms, three offices, a two-story vestibule, a caretaker's apartment, a machinery room, an audience room, and a room for the New York Society library.[28] In terms of the internal accommodations, the administration probably had Federal Hall in mind when the Capitol advertisement was written; certainly it wanted something larger than Congress Hall. The only new feature was the large conference room, where the president would preside over joint sessions of Congress and deliver his annual message on the state of the union.

There was no mention in the advertisement of architecture or style; no mention of domes, porticoes, or columns. In a letter to L'Enfant more than a year previously, Jefferson had expressed his personal desire for a capitol designed after "one of the models of antiquity, which have had the approbation of thousands of years."[29] American taste could only improve, Jefferson thought, by exposure to copies of classical Roman architecture adapted to the practical needs of the new republic. Such buildings

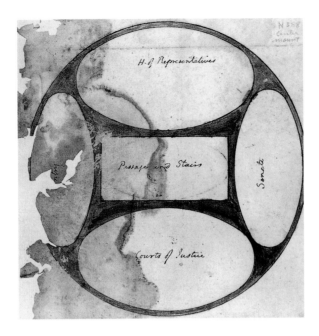

Plan for the Capitol

by Thomas Jefferson, ca. 1792

Massachusetts Historical Society

*J*efferson wanted Congress housed in a replica of an ancient Roman temple, in a manner similar to the Virginia legislature's accommodation in a version of the Maison Carrée. Since the capitol in Richmond was an example of Roman "cubic" architecture, he thought the federal Capitol should be modeled after a "spherical" temple. This plan illustrates Jefferson's adaptation of the Pantheon in Rome for Congress and the "Courts of Justice."

It is not known if the drawing was an intellectual exercise or a serious proposal, but the plan was more theoretical than practical. Jefferson later resurrected the plan for the Rotunda at the University of Virginia, where it proved more feasible for classrooms and a library.

would educate Americans at home and help America's reputation abroad. In 1785 Jefferson remarked: "I am an enthusiast on the subject of the arts . . . as its object is to improve the taste of my countrymen, to increase their reputation, to reconcile to them the respect of the world and procure them its praise."[30] His sensitivity to world opinion was partly national pride and partly a reaction to European theories regarding American inferiority, which he wished to prove false at every opportunity. The celebrated French naturalist George-Louis Buffon, for instance, hypothesized that the New World could not produce or sustain animal or human populations equal to those in Europe and presented the theory as an example of America's inherent inferiority. To counter this ill-informed assumption, Jefferson presented Buffon with the bones of a huge American elk, the size of which forced him to retract his theory.[31] In matters of American architecture, it would be more difficult to defend the national honor unless every opportunity was taken to cultivate taste in the fine arts. Jefferson thought the public buildings in the new federal city were a good place to put American architecture on the right footing and he hoped ancient Roman architecture would light the way. These antiquities offered the truth, taste, and timelessness that American architecture needed.

Jefferson's thoughts about architecture were absent from the commissioner's newspaper advertisement soliciting a Capitol design. They offered $500 and a lot in the federal city as prizes for the best plan, while the runner-up would receive $250. Entrants were expected to provide an elevation of each front of the building, sections, and floor plans. Estimates of brickwork necessary for the walls were also expected. This seemingly modest set of requirements actually included more drawings than were usually made for a building during this period, and the contestants were given little time to develop their designs. Dated March 15, 1792, the advertisement was sent to newspapers in Boston, Baltimore, Charleston, Richmond, Philadelphia, and New York; the commissioners expected the designs to be in their hands by July 15, 1792.

It is not certain exactly how many designs were submitted in the Capitol competition. Thirteen men are known to have entered and several others are mentioned as possible additions. Thirty-six drawings preserved by the Maryland Historical Society and one in the Library of Congress are the only ones known to survive today. These collections represent eighteen designs by ten men. The drawings form a remarkable body of evidence regarding the state of architectural draftsmanship and design ability in America at the close of the eighteenth century. Indeed, they are often used to illustrate the nonexistence of an architectural profession in this period, a time when most design services were provided by carpenters or master masons. When they were first published in 1896, architect and historian Glenn Brown wrote that the drawings "were made by amateurs or contractors

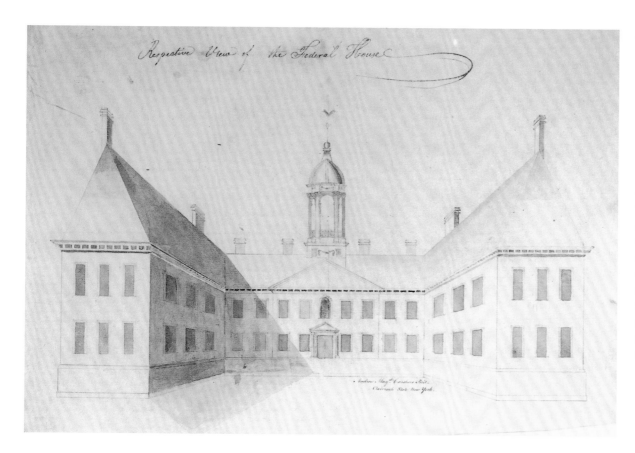

Respective View of
the Federal House

by Andrew Mayfield
Carshore, 1792

Maryland Historical Society,
Baltimore, Maryland

*C*arshore's design met
all the requirements for
the Capitol enumerated
by the board of commis-
sioners, yet the result
was no more imposing
than a county courthouse.
Carshore's attempt at per-
spective was adventurous
but clumsy, two things
that might be said of most
entries in the competition
of 1792.

Proposed Design for the Capitol

by Samuel Dobie, 1792

Maryland Historical Society, Baltimore, Maryland

A square mass, a portico for each elevation, and a
central dome indicate that Dobie had the Villa Rotunda
in mind in this proposal. Jefferson also admired Palla-
dio's mid-sixteenth-century masterpiece located near
Vicenza, Italy: he anonymously submitted a design for
the President's House based on it.

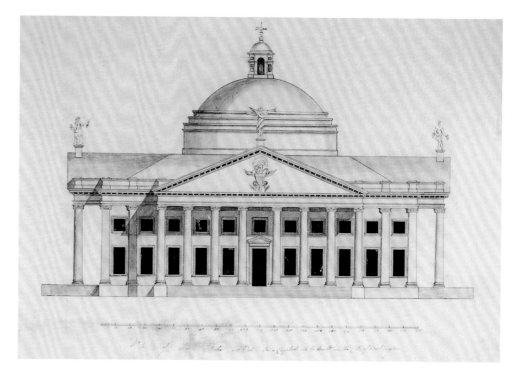

who did not have the first idea as to what consti-
tuted either good draftsmanship or design or what
were the necessary requisites of a Congressional
Hall."[32] Taken as a group, the drawings were fairly
crude, but were also characteristic of the general
draftsmanship skills of the period.

Brown's criticism was based partly on what he
considered a general failure to understand the
requirements of a "Congressional Hall." The fault
really was that most entries followed the utilitar-
ian nature of the published specifications virtually
to the letter. The advertisement called for twelve

committee rooms, and only two entries failed to
provide exactly that number. Each entry had a
conference room and a chamber for the House of

An Elevation for a Capitol

by James Diamond, 1792

Maryland Historical Society, Baltimore, Maryland

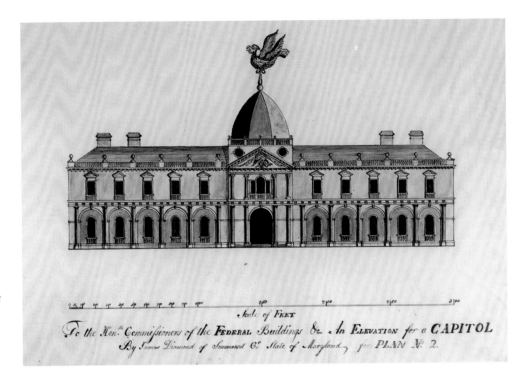

Although ridiculed for the ungainly bird atop its dome, Diamond's drawing nonetheless incorporated a number of sophisticated design elements, including window frames capped with pediments and engaged Doric columns. Its plan was based on the Italian palazzo form with a square courtyard and interior arcade for sheltered circulation. More than anything else, Diamond's lack of artistic skill doomed his competition entry.

Proposed Design for the Capitol

by Charles Wintersmith, 1792

Maryland Historical Society, Baltimore, Maryland

When Wintersmith learned his design had not been approved, he wrote the secretary of state asking if it was too large. The remarkably unsophisticated floor plan failed to provide adequate horizontal or vertical circulation. The message conveyed by the Spartan exterior was more suited to an army barrack than to the seat of an aspiring republic.

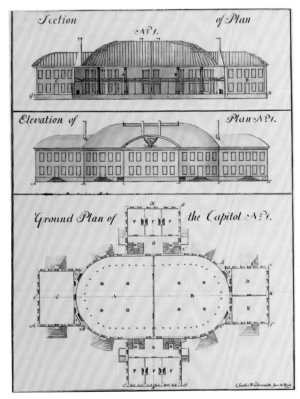

Representatives of the same size as specified. Deviations from the published specifications appear to have been chiefly limited to the size of the Senate chamber: only Andrew Mayfield Carshore's design provided exactly 1,200 square feet as requested. Other competitors felt at liberty to give the Senate a larger room than called for. Samuel Dobie's Palladian design, for example, contained a Senate chamber 53 feet square, over double the size desired. The largest chamber, given in James Diamond's "Plan No. 4," was 44 feet wide by 96 feet long, with an area of 4,224 square feet, or about three and a half times the space wanted.

The men who submitted designs for the Capitol were as varied as the country itself. Two were veterans of General Burgoyne's army, one was a school teacher from upstate New York, one was a prominent builder and furniture maker from New England, one would later become mayor of Baltimore, another was a builder and politician, two were carpenters, three were master builders, one was a territorial judge, and one was a businessman. Only one was a professional architect in the modern meaning of the word. They were from Ireland, France, England, and Germany as well as native born. Despite their diverse backgrounds and training, each would have called himself an architect. To some of their contemporaries, being

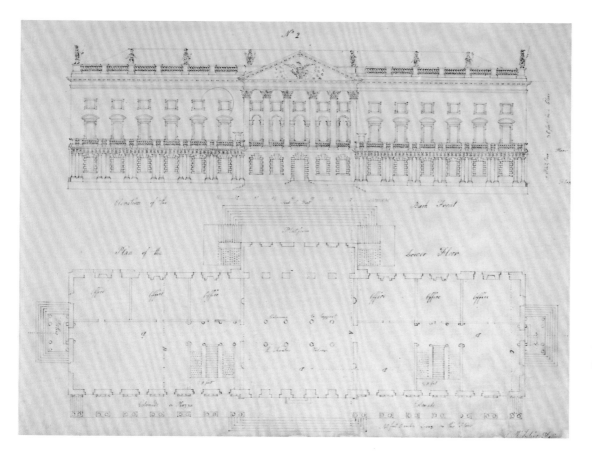

**Proposed Design
for the Capitol**

by Samuel McIntire, 1792

Maryland Historical Society,
Baltimore, Maryland

*M*cIntire's design was one
of the better proposals submitted
to the commissioners. Its three-
story height and imposing length
gave it the dimensions necessary
to impart a feeling of importance,
while its Corinthian portico gave
a hint of Roman grandeur. Eagles,
stars, and allegorical figures
above the balustrade provided
the building with its decorative
iconography. The absence of a
dome and certain problems with
the floor plan were, however,
fatal shortcomings.

an architect was a learned hobby or skill—like writ-
ing poetry or playing music. To others, an architect
was synonymous with being a master builder.

Few among the competitors are well-remem-
bered today. Only Samuel McIntire left a mark on
American culture beyond his footnote in the his-
tory of the United States Capitol. The houses he
designed and built for the wealthy merchants in
Salem, Massachusetts, and the furniture he made
or carved were celebrated accomplishments that
have long made him famous. For McIntire, unlike
other competitors, participation in this contest was
only a minor disappointment in an otherwise
notable career.

The only professional architect in the competi-
tion of 1792 was Etienne (Stephen) Sulpice Hallet,
a native of Paris who came to the United States
around 1790. He first settled in Philadelphia and
worked a while for L'Enfant as a draftsman. In 1791,
Hallet drew a plan and elevation of a capitol that
he showed to Secretary of State Jefferson and a
few others. This design, later dubbed the "fancy
piece," was prophetic. It had a domed center build-
ing flanked by wings expressing the bicameral

nature of the legislative branch. However, it was
considered unrealistic, and perhaps too French for
American tastes, and the design was shelved for
the time being. Hallet's entry in the 1792 competi-
tion reflected Jefferson's ideas about a temple-
form building, a so-called "model of antiquity." The
plan met all the requirements stated in the adver-
tisement, but it was a tight fit. At the request of
the commissioners, Hallet later refined his ideas
for the Capitol, drawing upon his ideas from his
"fancy piece," and eventually made a substantial
contribution to the approved design.

As they received the drawings that came to
Philadelphia, Washington and Jefferson may have
realized that the competition was not such a good
idea after all. Washington was clearly disappointed
with what he saw. To the commissioners he pre-
dicted that "if none more elegant than these should
appear . . . the exhibition of architecture will be a
very dull one indeed."[33]

Although not truly satisfied with any of the
designs, Washington liked certain things about cer-
tain ones. Judge George Turner's design (now lost)
included a dome that struck the president favorably.

He thought a dome would give the Capitol "beauty and grandeur" and might be a useful place to mount a clock or hang a bell.[34] The biggest problem with Turner's design, however, was the lack of an executive apartment. A room for the president and a dome soon became indispensable features for the Capitol in Washington's mind, although neither had been mentioned in the advertisement. It is uncertain why Washington came to think of an executive apartment and a dome as necessary, but it is clear that his thoughts regarding the Capitol continued to evolve as he looked over the designs. A presidential apartment, although of little architectural significance, would be a practical convenience for the chief executive when visiting the Capitol. A dome, on the other hand, would set the Capitol apart from any other building in America, where domes were unknown. Several statehouses were crowned by towers or lanterns, but a classical dome carried on a drum would be something new and grand. It would help give the Capitol prestige and would be a welcome addition to the city's skyline.

The Capitol was not off to a good start. First L'Enfant disappointed the president and significantly delayed the work by his failure to design the building. Then the competition had brought in a bewildering hodgepodge of designs more suited for county courthouses than for the nation's Capitol. Fortunately, the competition for the President's House fared better when a design by James Hoban, an Irish born architect from Charleston, was selected. The Capitol competition closed in the summer of 1792 without a winning design. Another building season was lost.

THE CONFERENCE PLAN: AN UNEASY COMPROMISE

At the end of August 1792, President Washington went to Georgetown to attend a commissioners' meeting. Judge George Turner and Stephen Hallet were asked to attend as well, and a now-lost design by Samuel Blodget, a young businessman from Boston, was to be reviewed. During the meeting Judge Turner bowed out of the contest and Blod-

get's design was evidently rejected. Before the end of the meeting all hopes were squarely with Hallet. This winnowing of the field could not have been entirely surprising: he was, after all, the only trained architect in the competition, and he had given the Capitol more thought than anyone except, perhaps, Jefferson.[35]

Hallet had brought to the meeting an enlarged version of his temple form design, a variation of his failed competition entry. Jefferson probably encouraged him, still hoping to shoehorn Congress into a "model of antiquity." While more ample, Hallet's second temple scheme was rejected as impractical and too expensive. Washington and the commissioners now asked him to rethink the "fancy piece." It had not been entered into the competition but was now viewed with high hopes. Hallet was asked to polish it into a more economical version with a more practical floor plan accommodating a conference room, a presidential apartment, and more committee rooms. Frills were to be kept to a minimum.

Hallet's pre-competition plan consisted of five parts: a domed center section with a rotunda; two flanking square courtyards; and two wings, each with a large legislative chamber and four committee rooms. As historian Pamela Scott has pointed out, Hallet modeled the dome after the chapel of the Collège des Quatre Nations in Paris.[36] He finished the first of two variations of the "fancy piece" by the time of the October sale of lots, thus allowing Washington to show potential buyers what the administration might build on Jenkins Hill in order to stimulate investment in that neighborhood. This new design greatly elongated the central section but preserved the rotunda and added a chamber for the Senate behind it. The legislative chambers were better scaled for the membership of the House and Senate, and twenty rooms were provided for offices and committees on the first floor alone. The second variation, finished in January 1793, had a central Ionic portico, flanking wings with Palladian windows, sculpted panels, and allegorical statuary. Hallet's second variation was the best of the lot, yet there remained the matter of high cost and a nagging suspicion that the design was still too French, not quite American in feeling.

In July 1792, the commissioners received a letter from Dr. William Thornton, who wrote from his plantation on the island of Tortola in the West

Elevation of the "Fancy Piece"

by Stephen Hallet, 1791

Library of Congress

*H*allet's pre-competition design was the earliest documented attempt at a plan for America's Capitol. It was unlike anything ever seen in the United States. It was grand and monumental—just as Washington wanted—but it was also too foreign and promised to be too expensive. Yet with its central dome and flanking wings, the "Fancy Piece" was a prophetic composition.

Indies. He had heard about the competitions for the President's House and the Capitol and, although the deadlines had passed, wanted to know if he could still submit designs. The commissioners told Thornton that a design had been selected for the President's House but they would welcome a plan for the Capitol. Thus encouraged, Thornton labored furiously on his island home to produce a design for the Capitol; much later he would claim that he worked "day and night." [37] He took his design to Philadelphia in the last days of 1792 and was told to give it to Jefferson for the president's consideration. Before sending it along, however, he had a talk with his friend Judge George Turner, and he soon learned about the failed entries and the administration's evolving thoughts about the Capitol. Prudently, Thornton put aside his "Tortola scheme" and at once began a new design, one that would be "more suited to the situation." [38]

In January 1793, Thornton was ready with his new design. The president was immediately taken with it, lavishing high praise for its "Grandeur, Simplicity, and Beauty." [39] Jefferson, too, was impressed. He wrote Commissioner Johnson:

> Dr. Thornton's plan of a capitol has been produced and has so captivated the eyes and judgement of all as to leave no doubt you will prefer it when it shall be exhibited to you . . . It is simple, noble, beautiful, excellently distributed, and moderate in size . . . and among it admirers

no one is more delighted than him [President Washington] whose decision is most important. [40]

Thornton's design was partly an essay in the emerging neoclassical style and partly an orthodox, high-style Georgian building. Its centerpiece was a domed rotunda fronted by a Corinthian portico. The portico, with twelve Corinthian columns standing on a one-story arcade, provided a sheltered carriage way and a balcony similar to those at Federal Hall in New York but larger and grander. The dome and portico were both reminiscent of the great Roman temple known as the Pantheon built in the second century A.D. by the emperor Hadrian. Thornton's adaptation of the Pantheon for his United States Capitol linked the new republic to the classical world and to its ideas of civic virtue and self-government. (It did not matter that the Pantheon was built during the Roman Empire rather than during the Republic.) Two wings flanking the central section were designed

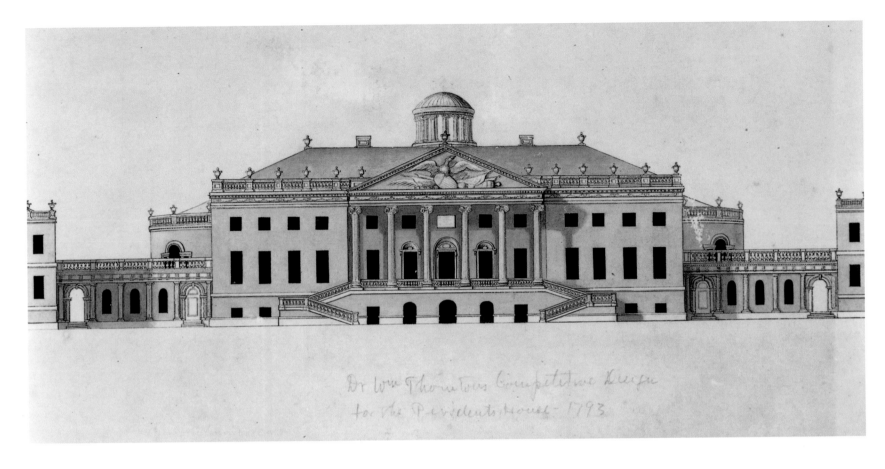

Dr. Wm Thornton's Competitive Design
for the Presidents House – 1793

Tortola Scheme
by Dr. William Thornton, 1792

Prints & Drawing Collection, The Octagon Museum, Washington, D. C.

Thornton's initial idea for the Capitol was essentially a large house with wings. The interior of the center building contained the legislative chambers, a conference room, and two committee rooms. Since there were no staircases, all rooms were two stories high. Wings contained more committee rooms.

in a conventional Georgian manner with a rusticated ground story supporting Corinthian pilasters and a full entablature. Curving pediments top the principal floor windows. Considering its scale, the elaborateness of the Corinthian order, the rich window treatment, and its dome, no standing structure in America could compare with Thornton's proposed Capitol.

Like other gentleman architects of the time, Thornton studied classical architecture in publications by such authors as Andrea Palladio and Sir William Chambers. In other published sources he studied the great buildings of Europe (especially Great Britain) to learn about the principles of composition. He was familiar with Colin Campbell's

Vitruvius Britannicus (first volume 1715), a collection of engravings showing the great houses of Britain. Indeed, Thornton's first design for the Capitol—the one that he brought to Philadelphia but did not show—so resembled a residence that for years it was misidentified as an entry in the President's House competition. Although separated by only a few weeks, the "Tortola scheme" and the winning design for the Capitol are so different in quality that it is difficult to believe that they are by the same man. Some light may be shed on this contrast by John Trumbull's later (and wonderfully tantalizing) recollection that while in Philadelphia Thornton was "assisted by a Russian Officer of Engineers;"[41] this description probably refers to Thornton's friend John Jacob Ulrich Rivardi, a Swiss engineer who had served in the Russian army.[42] While uncertain, Rivardi's role in the design process may account for the sudden and dramatic improvement in Thornton's architectural and drafting skills.

A few days after being notified by the commissioners that Dr. Thornton's design had been approved, Hallet responded with yet another

design for the Capitol, the only one encompassing his ideas alone and not another variation of the "fancy piece." This new design retained the idea of two wings flanking a center building, but now the center building was deeply recessed between the wings. The earlier high baroque dome was replaced by a low, neoclassical dome over a conference room. Its semicircular projection from the main body of the Capitol was the dominant feature of the garden front, which would face the Mall to the west. Its similarity to Thornton's west elevation and, indeed, its similarity to the Capitol footprint shown on L'Enfant's city plan, has been speculated upon by a number of historians.[43] The coincidence, however, has never been adequately explained.

On February 7, 1793, the commissioners wrote the secretary of state regarding Thornton's win-ning design and its effects on Hallet, who had invested considerable time and effort developing variations on the "fancy piece" and was hard at work on yet another design. They told Jefferson: "Tho' the Plan of a Capitol [is] so highly satisfactory to the President, and all who have seen it, we feel sensibly for poor Hallet, and shall do everything in our power to sooth him." For his part, Hallet asked that a final decision on the matter be postponed until his drawings were finished. On April 5, 1793, however, Dr. Thornton's design for the Capitol was awarded the prize of $500 and a building lot in the city of Washington. To compensate "poor Hallet," the commissioners gave him £100, which was worth nearly the same as $500 and a city lot. But they also asked him to study Thornton's design and report on the feasibility of

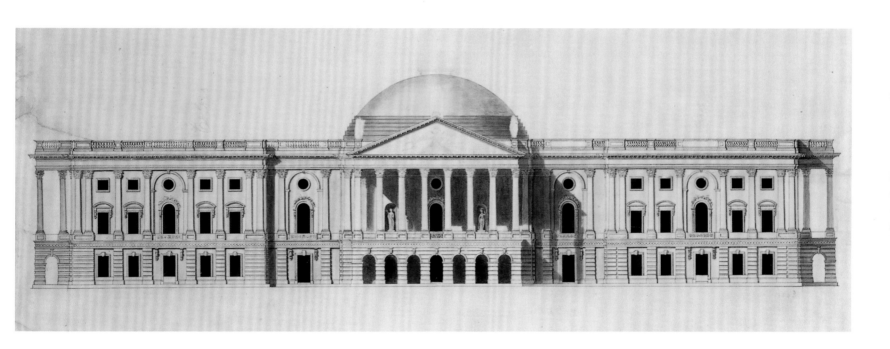

Design for the Capitol, East Elevation

by Dr. William Thornton, ca. 1793–1797

Library of Congress

*T*he central dome and portico, derived from the Roman Pantheon, were two elements of Thornton's design looking forward to the emerging neoclassical taste in art and architecture. Other elements, such as the Corinthian pilasters, the rusticated ground story, and the ornamental window frames, were more conventional features similar to those at the Brick Market in Newport. In this drawing, Thornton (possibly assisted by John Rivardi, an obscure Swiss engineer) struck the right balance between the rising neoclassicism that accorded with Jefferson's taste and the familiar but fading Georgian style with which Washington was more comfortable.

Final Capitol Design

by Stephen Hallet, 1793

Library of Congress

*H*allet's last attempt at a Capitol design was his first not to follow the suggestions of others. His efforts were too late, however, as a newcomer's design had already won Washington's approval. This elevation shows Hallet's proposed west front with a semicircular conference room topped by a low neoclassical dome based on the ancient Pantheon in Rome.

its construction, placing him effectively in the position of a consulting architect expected to evaluate his rival's work. In making this request, the commissioners showed an astonishingly poor understanding of human nature and ethics.

Hallet issued his report at the end of June 1793; naturally, he tried to devastate Thornton's design. It would take thirty years to build, he predicted, and the cost would be staggering. He said that the columns of the portico were too far apart, the upper windows of the Senate chamber were blocked by a coved ceiling, the president's apartment had no windows at all, the ground story was badly lighted and poorly laid out, and there was a "want of unity between the ornaments and the order." A serious problem was found in the conference room, which was bisected by a screen of columns that would block views and render the room awkward to use. The dome over the rotunda was carried on columns placed too far apart. Staircases did not have enough headroom. (See Plan A, page 39.)

Thornton was given an opportunity to respond to Hallet's report. This was the first of many times he defended himself against critics, using wit and sarcasm to compensate for his lack of training or experience. He countered Hallet's allegations by stating that they gave too much attention to "trifling inaccuracies in the plan." The expensive, ornamental parts could be delayed, he argued, so their immediate expense was not really a problem. The expected growth of the nation demanded a large Capitol, and his was not too large. Any problems in the construction could be overcome, he asserted, by employing people who knew how to build. He pointed to several larger structures in Europe that had overcome greater difficulties and had been built in less time than the seven and a half years remaining before it would be occupied by Congress. Noting that his reply was limited to only a few observations answering "voluminous objections," he implied that more could be said if "Mr. Hallet's report had been written in a more legible hand."[44]

Despite Thornton's assurances, the problems in his plan alarmed the commissioners and caused considerable chagrin for the president, who had merely assumed the plans were workable. Although he realized that it was "unlucky that this investigation of Doctor Thornton's plan, and estimate of the cost had not preceded the adoption of it,"[45] he still thought the exterior was beautiful, and he would tolerate no more delay. While professing to know nothing of architecture himself, Washington hoped knowledgeable people could correct the errors

and he asked Jefferson to host a conference to iron out the problems. His instruction on the matter was unambiguous: "The case is important. A Plan must be adopted; and good, or bad, it must be entered upon."[46] Clearly, there was to be no turning back now.

In his Philadelphia office, the secretary of state gathered together all parties concerned with the Capitol problem. The two adversaries, Hallet and Thornton, were there. Hoban, the architect of the President's House, traveled from the federal city to attend, and two Philadelphia builders, William Williams and Thomas Carstairs, were brought in as impartial advisors. Even the president himself attended part of the meeting. On July 17, 1793, Jefferson wrote to inform Washington of the agreement that had been reached at the end of the conference.[47] He told of a floor plan brought by Hallet that could be fitted into Thornton's design for the outside. (See Plan B, page 39.)Everyone at the conference considered the new floor plan a great improvement, especially as it concerned the two wings. Admittedly, it had one serious defect; the central section and portico were recessed between the wings and therefore would be virtually hidden except when seen head-on. Hallet was instructed to study how his plan could restore the portico to the line of the wings as shown in Thornton's elevation. However, the design and plan of the wings were things all could agree on, and, most important, construction of those parts could begin soon. Good or bad, what would become known as the "conference plan" was adopted, and the Capitol's architectural honors would be shared (in theory, at least) by Stephen Hallet, author of the floor plan, and William Thornton, author of the exterior elevation.

The outcome of Jefferson's conference had one particularly odd (although not long- lasting) consequence. According to the building's hierarchy shown in Thornton's elevation, the principal rooms were intended to occupy the second level—the *piano nobile*. These rooms would reside above a rusticated ground story containing less important rooms. Yet in the conference plan, the House and Senate chambers were put on the ground level, which resulted in an architectural "disagreement" between the inside arrangement and the outside elevation. For architectural and sentimental reasons, Jefferson wanted the House chamber to be contained within a three-story volume so it could have a dome

like the one over the Paris grain market, which he adored. While serving as the American Minister to France, he had often visited the famous Halle au Bled in the company of his intimate friend Maria Cosway. Together they admired the sparkling ribbons of glass alternating between wooden ribs, and Jefferson became so enamored with its architectural effect that he later determined to have it replicated over the House chamber.[48] He suggested lowering the floor of the chamber to the ground level so that the dome would be hidden from outside views. Thus, the wings would match, but the House chamber would have a dazzling and unexpected interior dome unlike anything previously attempted in American architecture. Any trick to accommodate this dome was acceptable to Jefferson, whose obsession with it was neither characteristic nor particularly admirable. The resulting violation of a basic architectural rule was troublesome to future architects and was only resolved with great effort and expense—ironically enough, during Jefferson's presidency a decade later.

THE FIRST CORNERSTONE

*S*oon after the "conference plan" was adopted, surveyors were sent to Jenkins Hill to stake out the location of the Capitol's wings. Meanwhile, the commissioners hired Stephen Hallet to oversee construction, partly as compensation for his past efforts and partly because he designed the floor plan of the wings. Supervising Hallet was James Hoban, the architect of the President's House, who after a year's employment in the federal city had proven entirely satisfactory. As the city's "surveyor of public buildings," he supervised construction of all four federal buildings undertaken in the 1790s.[49] He was expected to concentrate his efforts on the President's House, coming to the Capitol only when Hallet needed the benefit of a more experienced builder. Hoban's command of the English language was also better than Hallet's, and this was probably considered an advantage when dealing with contractors and workmen.

Following the lines staked out by the city's surveying department, laborers began digging the

Capitol's foundations during the last days of July 1793. Masons who finished the foundations at the President's House on August 7 began laying stone for the Capitol's foundations the next day. Around this time Commissioner David Stuart wrote other members of the board about a ceremony to mark the beginnings of the Capitol. His letter reminded his colleagues of the cornerstone ceremony at the President's House held the previous year and asked if the Capitol should not be begun under similarly formal circumstances. Although the subject had been overlooked at their last meeting, it was not too late to assemble the board and lay a "foundation stone."[50]

At their September 2 meeting, the commissioners decided to host a much more elaborate ceremony than the one held at the President's House. Now at least a year behind schedule, the whole project had gotten off to such a discouraging start that a grand display of pomp was highly desirable to help restore confidence. The cornerstone would be laid on Wednesday, September 18, 1793, during the first large public event staged in the federal city—an event that was a guaranteed success because the president was scheduled to attend. The public ceremony may have been Washington's idea: he, as much as anyone, understood the importance of ceremony and ritual. As the first president, he skillfully managed protocol and the role of ceremony for the office. He also was a Mason, and, like the ceremony at the President's House a year earlier, the Capitol's cornerstone would be laid with Masonic rites. The newspaper invitation announcing the cornerstone ceremony was directed to the Masonic fraternity:

> The Capitol is in progression – the southeast is yet kept vacant that [the] corner stone is to be laid with the assistance of the brotherhood [on] the 18th Inst. Those of the craft however dispersed are requested to join the work. The solemnity is expected to equal the occasion.[51]

Contemporary Masonic practice included the laying of an inscribed metal plate along with a cornerstone. The brass plate used at the President's House in 1792 had been made by Caleb Bentley, a Quaker clockmaker and silversmith who lived in Georgetown not far from Suter's Fountain Inn, where the commissioners held their meetings. The commissioners returned to Bentley in the summer of 1793 for another plate, this one made of silver, for the Capitol ceremony.[52]

Considering the short notice, the cornerstone ceremony was well attended. The proceedings were reported in an article in *The Columbia Mirror and Alexandria Gazette,* which remains the only known eyewitness account of the event. Activities began at 10:00 a.m. with the appearance of President Washington and his entourage on the south bank of the Potomac River. Crossing the river with the president was a company of volunteer artillery from Alexandria. The procession joined Masonic lodges from Maryland and Virginia, and all marched to the President's Square, where they met the new lodge from the federal city. Together they marched two abreast, "with music playing, drums beating, colors flying, and spectators rejoicing," to the site of the Capitol about a mile and a half away. There the procession reformed and Washington, flanked by Joseph Clark (the Grand Master) and Dr. E. C. Dick (the master of the Virginia lodge), stood to the east of a "huge stone" while the others formed a circle west of it. Soon, the engraved plate was delivered and the inscription read:

> This South East corner stone, of the Capitol of the United States of America in the City of Washington, was laid on the 18th day of September, in the thirteenth year of American Independence, in the first year of the second term of the Presidency of George Washington, whose virtues in the civil administration of his country have been as conspicuous and beneficial, as his Military valor and prudence have been useful in establishing her liberties, and in the year of Masonry 5793, by the Grand Lodge of Maryland, several lodges under its jurisdiction, and Lodge 22, from Alexandria, Virginia.

> Thomas Johnson
> David Stuart Commissioners
> Daniel Carroll
> Joseph Clark R. W. G. M.—P. T.
> James Hoban Architects
> Stephen Hallate
> Collen Williamson M. Mason

The plate was handed to Washington, who stepped down into the foundation trench, laid the plate on the ground, and lowered the cornerstone onto it. With the president were Joseph Clark and three "worshipful masters" bearing the corn, wine, and oil used to consecrate the stone. Chanting accompanied Washington's ascent from the trench. Clark gave a hastily prepared speech punctuated by numerous volleys from the artillery. Following

the formal exercises, a 500 pound ox was barbecued and those in attendance "generally partook, with every abundance of other recreation." By dark the festivities had ended.[53]

Five days after the cornerstone was laid, the commissioners formally approved Washington's suggestion to face the President's House and Capitol with freestone. Brick, of course, had been specified in the newspaper advertisement and was the material most often used for buildings of the best sort in the region. The expense of stone and the general lack of stone workers limited its use to the trim for brick buildings. While dressed stone buildings were not unheard of, they were exceedingly rare. The idea of using stone for the Capitol, however, had been under discussion at least since March 1792, when Jefferson recalled a conversation between the president and a Mr. Stewart of Baltimore regarding an idea of facing the public buildings with different colored stones.[54] The President's House and Capitol were to be huge buildings by American standards, and facing them in stone would only heighten the sense of permanence and grandeur.

The sandstone (also called freestone) quarries around Aquia Creek, Virginia, had been the source of most local stone since the seventeenth century and would supply the federal city as well. They produced a fine-grained brownish stone that did not contain bedding layers and could therefore be worked "freely" in any direction (hence the term *freestone*). Even before plans of the public buildings were in hand, it was obvious that a great new city would require a reliable supply of stone. In 1791, L'Enfant had negotiated the purchase of a quarry from the Brent family on Wiggington's Island at the mouth of Aquia Creek where it entered the Potomac River, about forty miles downstream from Washington. The proximity of the quarry to water transportation was as important a factor to its selection as any other consideration. Sturdy, flat-bottomed boats called scows were used to bring the stone to the federal city, where a wharf was built at the foot of New Jersey Avenue to receive the cargo destined for the Capitol. A wharf at Goose Creek (sometimes called Tiber Creek) served the President's House.

Finding workmen to quarry, cut, and carve stone was a problem the commissioners and their successors faced for years. There were virtually no local craftsmen to hire, and what few there were fashioned little things like tombstones and steps. Europe was the best source of masons to work in the federal city. Collen Williamson, Scottish stone mason recently arrived in America and a relative of innkeeper John Suter, was the first to be invited to work on the federal buildings. He took charge of the stone department in 1792 and oversaw the laying of the foundations at the President's House and the Capitol. He also ran the quarrying operations at Aquia, using a great deal of slave labor. In July 1792, a stonecutter from England named George Blagden was recommended to the commissioners by Adam Traquair, a Philadelphia stone merchant. Blagden's employment in Washington began in 1794 and continued for thirty-two years. At the commissioners' request, George Walker, a Philadelphia merchant and large investor in Washington real estate, called on stone workers during a visit to London, but had more luck in Scotland where he recruited masons from Lodge No. 8 in Edinburgh. The commissioners agreed to pay the travel expenses to America incurred by these workmen, whose employment at home suffered during the Napoleonic Wars. Among them was Robert Brown, who would spend a long career helping to build the city of Washington.

In the spring of 1794, the commissioners put the foundation work at the Capitol under two contracts and asked Collen Williamson to provide general superintendence. A local mason named Cornelius McDermott Roe was hired to lay the foundations of one wing (probably the south wing), and James and John Maitland, Robert Brown, and John Delahanty, direct from Europe, were employed on the other wing. Roe's contract stipulated that stone was to be brought to the site at the public's expense and that the commissioners would allow him to use some of the laborers on their payroll. He could not find enough hands on his own and would repay their wages from his fee. He was to be paid six shillings ($0.80) per perch for laying stone in straight walls and seven shillings, six pence ($1.00) per perch for curving walls. (A perch usually equals about twenty-five cubic feet of stone.) The masons working on the other wing, however, were paid four shillings, six pence ($0.60) per perch, and this difference soon led to unrest. The team of Brown, Delahanty, and James and John Maitland petitioned the commissioners to speed

stone delivery or at least give them preference to Roe when stone was brought to the Capitol. They pointed out that since Roe was being paid more, he "could better afford to be idle."[55]

While the workmen were having problems at the Capitol, the commissioners began to have problems with Hallet. At their June 1794 meeting, they asked him for designs and details for several parts of the Capitol.[56] These were to show how he planned to treat the center section, how he planned to restore the portico to the line of the wings, and how much progress had been made on the details. Like L'Enfant before him, though, Hallet refused to cooperate. The commissioners were understandably concerned that workmen were already digging the foundation trenches for the building's center section before any plan had been presented—much less approved—especially since they could see that the foundations did not provide for the great round vestibule, or rotunda, that was Washington's favorite part of the design. Dr. Thornton (who was prone to exaggerate) recalled the president's reaction to Hallet's omission of the rotunda, saying that he "expressed his disapprobation in a stile of such warmth as his dignity and self-command seldom permitted."[57] The commissioners warned Hallet that he had no authority to proceed on the center building until they and the president had approved it.

Another matter of some concern was that Hallet's direct orders to the masons and laborers undermined Williamson's authority as head of the stone department. The commissioners wrote Hallet saying they wished the foundation work to be directed by Williamson, who was the only one authorized to oversee masons. The commissioners cautioned Hallet that they could not "intrust the same piece of business to the direction of two heads capable of pursuing different wills."[58] Hallet, however, was uninterested in the chain of command. He also found the commissioners' request for drawings annoying. He was the author of the plan, was confident that he had been hired to build it, and apparently thought further approvals unnecessary. When the commissioners reprimanded him for building foundations that clearly deviated from Dr. Thornton's plan, Hallet angrily asserted that Thornton had nothing to do with the building's plan:

> I misunderstood your mind as to the Plan. So far that I thought to be indebted for the adoption of mine to its total difference with the other . . . I

never thought of introducing in it anything belonging to Dr. Thornton's exhibition. So I claim the genuine invention of the plan now executing and beg leave to say hereafter before you and the President the proofs of my right to it.[59]

It is difficult to understand why Hallet refused to show the commissioners his new plans. He had devised a variation of the "conference plan" that included a courtyard between the conference room and the east portico, which was advanced beyond the east face of the wings.[60] (See Plan C, page 39.) Thus, the portico was restored to the position shown in Dr. Thornton's elevation and became a portal through which the central courtyard was reached. The courtyard replaced the grand vestibule as the central feature, avoiding the strange juxtaposition of a domed conference room behind a domed rotunda. It was a reasonable solution but resulted in an exterior that did not exactly match Dr. Thornton's elevation. Perhaps Hallet thought the commissioners would not approve such a departure and hoped to push construction far enough that they would be obliged to accept it as a fait accompli. If this was the case, he was sadly mistaken. On June 28, 1794, the same day on which he wrote to "claim the genuine invention of the plan," Hallet was dismissed for refusing to show his plans to the commissioners, for proceeding with construction without approval, and for refusing to submit to Hoban's supervision. Thus, another high-handed employee fell to the charge of insubordination.

"SCENES OF VILLAINY"

After Hallet's dismissal nothing more was done in the Capitol's center section. The foundation trenches remained empty of stone, and no more work would be done there for a quarter-century. Workmen continued to lay the foundations of the wings, which had been under way for a year without much to show for it. The south wing contractor used a shortcut method known as the "continental trench," which meant unloading stone and mortar into the trench without laying the stones regularly or to bond them uniformly with mortar. Masons on the north wing worked more professionally but neglected to provide air holes for ventilation. Such

openings were necessary to prevent trapping moisture that would destroy wooden framing and floor boards, which would be installed later. The commissioners were relying on Williamson and Hoban to guarantee the work, but neither seemed to notice the shoddy workmanship.

Even though he was spared these details, President Washington was unhappy with the state of affairs in the federal city. Construction was not progressing rapidly enough in the face of a relentless deadline, and the city's enemies were convinced that Congress would never move to the Potomac to live in tents and govern from huts. The president determined that the board should be replenished with men willing to devote their full energies to the city. Henceforth, they would be required to live there and would receive an annual salary of $1,600 as compensation for full-time employment. Two of the original commissioners, Thomas Johnson and David Stuart, were happy to quit. Johnson was in poor health, and Stuart's attendance became unpredictable. Daniel Carroll agreed to stay on until his replacement was named.

Unfortunately, the hard work and low pay of the job made it difficult to fill with worthy men. The president asked his former secretary, Tobias Lear, and Maryland Senator Richard Potts to fill a seat, but both declined. The first person to accept an appointment to the second board was Gustavus Scott from Maryland's Eastern Shore. Like all previous commissioners, Scott was an investor in the Potowmack Company, and as a state legislator, he had promoted the interests of improved navigation on that river. Scott was a forty-one-year-old lawyer who brought much needed legal expertise to the board.

Scott's appointment was made in August 1794 and was followed a month later by that of Dr. William Thornton, the amateur architect whose elevation of the Capitol so delighted the president. Thornton's artistic talent was not the reason Washington named him to the board, however. It was his enthusiasm for the Potomac capital that convinced the president that he would work tirelessly to advance construction of the city. The president wrote: "The Doct. is sensible and indefatigable, I am told, in the execution of whatever he engages; to which might be added his taste for architecture, but being little known doubts arise on that head."[61] With Hallet gone, Thornton could

Thornton (1759–1828) was born into a Quaker family on the island of Tortola in the British West Indies. He spent his youth in Lancashire, England, and trained in Scotland as a physician. He rarely practiced his profession, preferring instead to dabble in literature, drawing, architecture, mechanics, and horse racing. He is best remembered for drawing the winning elevation of the United States Capitol, which earned him $500 and a building lot in the new federal city (lot fifteen in square 634).

In 1794, President Washington appointed Thornton to the board of commissioners overseeing the affairs of the federal city. He served until the board was abolished in 1802. In that year, President Jefferson appointed him the clerk in the State Department in charge of issuing patents, a post he held until his death. During his long residence in the city of Washington, Thornton used much of his time, energy, and wit defending the Capitol design from its critics.

ensure that the Capitol would be built according to the approved design.

Filling the final seat on the second board was Alexander White, the former congressman from Virginia who played a small but crucial role in passage of the Residence Act. In Jefferson's Philadelphia dining room, White had dropped his opposition to Hamilton's assumption plan in exchange for northern votes to pass the Residence Act. Unlike Daniel Carroll's, White's vote had not cost him his seat in Congress, and his subsequent appointment to the board of commissioners was partly due to his support for the Potomac capital. White's financial interest in the Potowmack Company and his willingness to serve were factors as well.

Before White took his seat on May 18, 1795, the board was made up of Daniel Carroll, Gustavus Scott, and William Thornton. This interim board dealt with many of the same problems that nagged its predecessor, namely the perpetual lack of money, building materials, and workmen. They ordered Elisha Owens Williams to keep up the supply of foundation stone for the Capitol and to purchase blankets, bedding, porringers, and pots for the public hospital, where sick workmen recuperated. He was also to find fresh provisions of rice, sugar, and vinegar for the hospital.[62] To help supply

the manpower needs of the city, the commissioners resolved to hire "good laboring Negroes by the year, the Masters clothing them well and finding them a blanket." The commissioners would feed the slaves and pay their masters sixty dollars a year.[63] Williams was asked to hire 100 slaves under these terms and to buy Indian meal to feed them.

During the first week of December 1794, the commissioners focused on the stone supply for the next building season. Williamson was asked to estimate the amount of stone needed to finish the foundations and basement story of the Capitol, but he said such an estimate was impossible unless he was "privileged with the plan," indicating that Hallet still held on to the only plans of the building.[64] He could, however, say that the foundations required 608 perches of stone to raise them one foot. Two thousand tons of ashlar were ordered from quarries on the Chapawamsic Creek in Stafford County, Virginia, owned by James Reid, James Smith, and George Walker, who had "free and uninterrupted" use of the cranes for unloading vessels at the wharf.[65] (Much of that stone, however, was later found to be unfit.) A second order for 4,500 tons of sandstone was placed with Daniel Brent and John Cooke, who were given free use of the public quarry at Aquia.[66] The commissioners provided three cranes for loading stone as well as a $1,000 cash advance. A stone worker from Norwich, England, named John Dobson was hired at the end of 1794 to cut, prepare, and lay the freestone at the Capitol. Each type of stone cutting task was priced according to the skill and time involved in its execution. Simple ashlar used for the plain wall surfaces was valued at three shillings ($0.40) per foot, while more complicated modillions and dentils commanded eight shillings ($1.05). Molded, circular column bases were most expensive at ten shillings ($1.33) a foot. Dobson was in charge of one of the most visible and important aspects of the construction of the Capitol and was given use of a house on the grounds as a part of the bargain.[67]

On New Year's Day 1795, the commissioners reported how they had spent £20,000 ($53,000) on the Capitol. Temporary buildings had been constructed, including the carpenters' hall, lime house, stone shed, and others for workmen. Five hundred tons of freestone was being worked by twenty of Dobson's men. Timber from Col. Henry Lee's "Stratford Hall" plantation in Westmoreland County, Virginia, accounted for £1,000 ($2,650). About 200 perches of foundation stone was on Capitol Hill while another 1,250 tons was at the wharf. They also had a contract for 5,000 bushels of lime. The only major item not on hand or under contract was northern white pine needed for flooring, but the commissioners thought it could be found near Norfolk.[68]

Two days after their report was issued, the commissioners wrote the president about the inadequacy of their funds, complaining of difficulties with the "Virginia donation."[69] Both Maryland and Virginia had promised cash donations when they offered land for the federal territory. Virginia now found it difficult to follow through with its $120,000 pledge, and the cash-strapped commissioners began to feel the squeeze. Aggravating the situation was the real estate syndicate of Greenleaf, Morris, and Nicholson, which had negotiated a purchase of 6,000 city lots in 1793 on very favorable terms: eighty dollars for each lot, payable over a seven-year period. The deal promised a steady flow of cash into the city's coffers, yet after a year or two, the coffers were still empty. The overextended speculators could not uphold their part of the bargain.

Broken promises and sour deals left the commissioners without the financial resources necessary to build the public buildings at the brisk pace President Washington wanted. They needed to find ways to economize. On January 29, 1795, before the first block of sandstone was laid on the Capitol's walls, the commissioners asked the president if it would be wiser to "forgo carrying on more of that building than the immediate accommodation of Congress may require."[70] They implied that the Capitol could be built in stages, one wing at a time. With limited means it was logical to divide the project into phases. The north wing, they contended, would be finished first because it had the most rooms and would better accommodate Congress than the south wing. That section, with its one large room for the House of Representatives, would be built second. The central rotunda area was largely ceremonial and its construction would be put off until last.

Despite its common-sense approach, Washington was disappointed with the idea of building the Capitol piecemeal. He had known that the building was an ambitious undertaking but had thought—until now—that it could be put under roof by the

year 1800, with only its expensive decoration delayed. He had written in March 1793 that

> it should be considered, that the external of the building will be the only *immediate* expense to be incurred. The internal work and many of the ornamental without, may be finished gradually, as the means will permit, and still the whole completed within the time contemplated by law for the use of the building.[71]

That strategy was unfortunately impractical. The most expensive, ornamental parts of the building were the exterior Corinthian pilasters, columns, and entablature, and these could not be easily separated from the rest of the building like tacked on decorations. It would be folly to build plain walls and try to apply the Corinthian order at a later time. Given the financial situation, the only course was to build the Capitol bit by expensive bit.

Lack of funds also affected personnel matters. When Hallet was dismissed in June 1794, the commissioners did not seek a replacement for some months. Learning of the opening, however, John Trumbull, then the secretary to John Jay's delegation in London, wrote them about a promising young architect named George Hadfield, whom he thought perfectly suited to carry on with the Capitol. On December 18, 1794, the commissioners replied that there were no vacancies but assured him that a general "Spirit for improvement" would present possibilities for Hadfield's future employment in America.[72]

If the truth were told, the commissioners had an opening for an architect but no money to pay him. By the middle of the next month, however, a promising development offered some hope of relief from the city's cash crisis: the commissioners were going to ask Congress for a loan. In February 1795 Dr. Thornton went to Philadelphia to begin negotiating a loan, an idea that was approved by the president. It would take more than a year for the loan to be secured, but the promise of financial assistance lifted the commissioners' spirits. They could now consider filling the vacancy at the Capitol with Trumbull's young friend.

Hadfield and Trumbull had become friends in 1784, when the architect attended the Royal Academy and the artist was a student of the American expatriate Benjamin West. For six years Hadfield worked in James Wyatt's office. He was awarded the first Traveling Royal Academy Fellowship in 1790, which paid for a four-year stay in Rome. Upon returning to England, the depressed conditions in the building trades left little work for him. The economy and his pro-American father may have influenced Hadfield's decision to accept the commissioners' offer to come to the United States and supervise construction of the new Capitol, a project that offered prestige and steady employment. Sight unseen, Hadfield accepted the job on March 7, 1795. Trumbull arranged passage to Washington.

While the commissioners waited for Hadfield, they managed the work as best they could. William O'Neale proposed to deliver foundation stone to the Capitol for $1.31½ per perch if given "the liberty to quarry [it] from the Publick property on Rock Creek."[73] He told them that the Capitol's wharf was blocked by stones that had fallen into the river, making it necessary to clear them away so cargo ships could unload.[74] After his deliveries began, O'Neale's supply of foundation stone did not come fast enough to keep the masons busy, and the commissioners threatened to sue unless it was delivered faster. There was also a problem with where some of O'Neale's stone was coming from. He had been given permission to gather stone from the streets, but he was hauling stone from privately owned property.[75] This left the streets cluttered with fieldstone, while building lots were being cleared at public expense.

By June 1795, the commissioners finally took notice of the slipshod construction on the Capitol's foundations—a section of the foundation that fell to the ground got their attention—and began inquiries into the matter. James McGrath, who had worked on the south wing foundations for a year, testified that he never used the continental trench method himself, although he had observed other masons neglecting their work.[76] The commissioners found that the foundations of the south wing were so bad that demolition and reconstruction were the only remedies. Although work on the north wing was also defective, it could be repaired and secured by laying large bond stones. In a report to the new secretary of state, Edmund Randolph, the commissioners tried to put the best face on an unfortunate situation:

> Bad work has been put up the walls in some parts, prudence requires they should be taken down . . . the outside walls of the North Wing

are good which will amply employ the free stone setters so that no delay will ensue. And these people have given ample security so ultimately the public will not be losers.[77]

Reported "scenes of villainy" among the contractors were apparently true. The excellent reputation of the principal contractor of the south wing foundation, Cornelius McDermott Roe, had not justified the faith placed in his work, the true character of which escaped detection. Roe attributed criticism to the "malaise of a party against him," but his excuses did him no good.[78] He was dismissed and later was sued for the cost of repairing the faulty foundations.

On Monday, July 13, 1795, the first block of Aquia Creek sandstone was set into place on the outside walls of the north wing. During the following week George Blagden took over the supervision of stone setting; this work would previously have been done by Collen Williamson, but he too had been dismissed at the beginning of the building season. Williamson was old and cantankerous and did not get along with Hoban. Upon his dismissal he blamed the architect and some of the city's other Catholics for his fate. In a letter to the commissioners he boasted of having taught "archastry" (his term for vaulting) in Scotland and New York and asserted that he was more experienced in "weighty" (his term for masonry) buildings than anyone else on the North American continent. He claimed to have been persecuted by the "Irish vegbond," but neither the commissioners nor the administration was moved to restore him to his former position.

During the summer of 1795, the height of the Capitol's third building season, dismal weather and more problems with contractors slowed progress. It was so hot at the end of July that the Scottish masons threatened to quit unless they were housed closer to the Capitol. They claimed that walking to and from their hotel three times a day injured their health. The heat wave finally broke when heavy rains came during the first week of August. John Mitchell complained that he could only keep five brick kilns going on Capitol Hill; the wet weather prevented more from being fired up. By the terms of his contract he was obligated to supply 500,000 bricks for the Capitol, but because of the rain he could furnish only 360,000. Despite the shortfall, Mitchell asked the commissioners to pay him $100 a week in hauling fees so he could meet his "calls."[79] And, troublesome

as it was, the shortage of brick was a minor problem compared to the sudden disappearance of stone worker John Dobson. He forfeited his contract, deserted eight stone cutters in his employ, and fled the city owing $2,000. The workmen clamored for their pay from the commissioners.

"STABILITY, ECONOMY, CONVENIENCE, BEAUTY"

Soon after George Hadfield arrived in the federal city in October 1795, he ventured to give a frank opinion regarding the design and construction of the Capitol. He examined what few drawings there were and went all over the work. His first letter to the commissioners contained some general observations, none of which were particularly flattering. Even so, he realized that it was important to get along with his employers and hoped his remarks would be viewed as professional advice. He was equally polite about the architectural shortcomings of the Capitol:

> I find the building begun, but do not find the necessary plans to carry on a work of this importance, and I think there are defects that are not warrantable, in most of the branches that constitute the profession of an architect, Stability—Economy—Convenience—Beauty. There will be material inconvenience in the apartments, deformity in the rooms, chimneys and windows placed without symmetry. . . .[80]

Studying Hallet's plans and Dr. Thornton's east elevation, Hadfield soon learned that the floor plan was not reconciled with the outside of the building. It was evident that the principal rooms of the Capitol were destined to begin at ground level. To solve the problem he proposed removing the rusticated basement from the outside elevation altogether. Thus, the exterior pilasters, columns, and windows with pediments—architectural elements associated with the most important part of the building's hierarchy—would be lowered to the same level as the principal rooms. To give the building proper height, five feet would be added to the upper story and the exterior columns, pilasters, and entablature would be enlarged accordingly. In Hadfield's

plan the portico became a grand entrance instead of a balcony:

> I think the design may be improved by omitting the basement throughout the building, by this means, expense would be saved; the Legislative Body ought occupy the principal part of the Building instead of the basement; the Portico would not be useless, and grandeur and propriety would be increased from the Order beginning from the ground.[81]

Hadfield pointed out that, while eliminating the basement would save a third of the building's cost, enlarging the upper story and the outside columns would add only one sixth to the cost. The existing foundations were "in a state not to be depended upon and any means that were made use of to lessen the wait [i.e., weight] of the building would certainly be advantageous."[82] But if it were absolutely necessary to have a three-story Capitol, Hadfield suggested adding an attic. Thus, the columns would still begin at the ground level, the same level as the principal rooms. Both proposals solved a nagging architectural problem while utilizing the existing foundations. Only a few courses of rusticated sandstone already in place would be lost to either plan.

Five days after Hadfield offered his proposal, Dr. Thornton wrote a long letter to the president stating his objections. He apologized for its length but thought the issue was important enough to justify intruding on the "weighty concerns of state." After acknowledging Hadfield's "genius," Thornton complained that the alterations were suggested only to enhance the young architect's reputation by "innovating throughout," thus earning him fame for redesigning America's Capitol. And if Hadfield succeeded, Thornton's unstated fear was for his own place in its history.

Thornton never acknowledged the problem Hadfield was trying to solve, nor did he explain its roots in Jefferson's desire for a House chamber topped by a dome. Instead, he touted a list of famous English country houses with basements to show the president that this feature was popular in some of the best buildings of Britain and therefore unobjectionable:

> Wentworth house, which is an elegant palace belonging to the Marquis of Rockingham six hundred feet in length of the same order viz.

Revised Design of the Capitol
by George Hadfield, 1795
Maryland Historical Society, Baltimore, Maryland

*H*adfield proposed eliminating the basement story so the Corinthian order could begin at the ground story where the legislative chambers were to be located. Thus, the ground story would become the most important level in the building's architectural hierarchy. His revised design conformed to the foundations already laid out by his predecessor, Stephen Hallet.

the Corinthian with a rustic basement. Worksop Manor House belonging to the Duke of Norfolk three hundred feet in extent yet only a small part of a superb building yet contemplated. It is of the same order & has a rustic basement. Holkham House—345 feet—Heveningham Hall, which is a very elegant structure has a line of pilasters supported on a rustic arcade that runs the whole length—Chiswick House, the seat of the Duke of Devonshire has a rustic basement supporting fluted columns of the Corinthian order. Wentworth Castle abt. 6 miles from Wentworth House, seat of the Earl of Strafford, is of the same order on a rustic arcade. Wanstead House is also Corinthian on a rustic basement & is considered as a very chaste & beautiful building. It was designed by the author of the Book on Architecture called Vitruvius Britannicus. These may serve to show that a basement (rusticated) is not only proper but adopted by many of the first architects.[83]

Thornton may have sounded knowledgeable, but his letter failed to address the issues at hand. (In fact, none of the houses cited placed principal rooms in the basement story. That level contained the kitchens and pantries, while the drawing rooms were always upstairs.) Hadfield's resolution of the Capitol's most serious architectural problem was an affront that Thornton found too great to bear in silence.

Hadfield and Hoban soon went to Philadelphia to confer with the president about the proposed changes. Washington was annoyed by the dispute and refused to make any further decisions regarding matters he felt lay outside his area of expertise. In a letter to the commissioners he pleaded ignorance of architecture (a plea that was too modest) and said that he did not have the means of acquiring sufficient knowledge about the merits of the case. He was too busy on the eve of a session of Congress to do the job he expected the commissioners to perform. As long as the changes did not involve a loss of time and money, Washington declared that he would not object because "the present plan is nobody's, but a compound of everybody's." He sternly reminded the commissioners that their position in the federal city, with access to all the information regarding materials and labor, placed them in a better position to make decisions.

With Blagden's help, Hadfield estimated the savings that would be realized with his two- story design. Eliminating the basement story would save $20,736, while the cost of increasing the height of the upper story and enlarging the Corinthian order would cost an additional $15,460. Despite the sorry state of the city's finances, saving more than $5,200 did not impress the board. Hoban sided with Thornton and both condemned Hadfield's plan on the grounds that it posed serious structural dangers (the exact nature of which was not recorded). Hoban declared that if Hadfield was unable to build the Capitol on the adopted plan he would do it himself. Thus, faced with the determined opposition of one commissioner allied with a trusted architect and builder, Hadfield's case was hopeless. By the third week of November his proposal was rejected. He had been on the job less than six weeks.

Soon after the commissioners decided not to alter the elevation of the Capitol, the winter of 1795–1796 set in, bringing the building season to a close. The quarry stockpiled stone for the next year's work, and Hadfield reported that there were enough bricks on hand to keep the masons busy if only the north wing were carried on.[84] As workmen drifted away from the city, Commissioner Alexander White went to Philadelphia to attend the opening of Congress. He took with him a memorial on the subject of the public buildings and the prospect of finishing them in time for the removal of government in 1800. The memorial, which President Washington transmitted to the House and Senate on January 8, 1796, explained the commissioners' predicament. Unless they had a steady supply of cash, the public buildings would not be finished in time. They had raised $95,000 from the sale of lots and had an inventory of 4,700 unsold lots worth at least $1.5 million but could not secure a loan from Europe because lenders scoffed at the 6 percent cap on interest imposed by Maryland law. Rather than depend on the sale of property or the collection of debts, the commissioners wanted a loan guaranteed by Congress secured by the value of unsold lots. They did not want an appropriation, simply a promise from the government that the debt would be repaid: "All the buildings . . . will be erected in a convenient and elegant style, and in due time, and (what is, perhaps, unparalleled among nations) at private expense."[85]

A select committee headed by Jeremiah Smith of New Hampshire was appointed by the House of Representatives to study the commissioners' memorial and reported its findings on January 25, 1796. The committee determined that $140,000 would be needed annually over the next five years to bring

the public buildings to a reasonable state of completion and predicted that the commissioners could raise only $40,000 a year on their own. It therefore recommended that Congress guarantee a loan of $500,000 at a rate not exceeding 6 percent for the federal buildings, with no more than $200,000 available in any one year.[86]

Smith's report released a flood of questions regarding the city, its management, its relation to Congress, the rights of private landowners, the state of public confidence, and the regard of world opinion. It was the first time that Congress took up the issue of federal buildings and the opinions expressed were diverse and remarkably uninformed. According to Jeremiah Crabb of Maryland, those against the loan guarantee were in "impolitic violation of public faith and private rights," and a vote against the loan was a vote of no confidence in the Potomac capital.[87] On February 22, 1796, John Nicholas of Virginia rose to give his thoughts on the measure but was drowned out by the noise of cannons firing and drums beating in celebration of the president's birthday. Zephaniah Swift of Connecticut made himself heard over the outside noise when he declared that the good name of the United States was sufficient and he did not see the necessity of guaranteeing it in a bill. Others spoke that day for and against the loan on principle, and still others wished the bill to take other forms. Near the end of the day's business, Joseph Varnum of Massachusetts confessed that he did not know anything about the public buildings, how big they were, or how expensive. Although he did not feel inclined to support the measure he would not vote on something unless he knew more about the subject.

Long speeches, sometimes reasoned, sometimes humorous, but more often tedious, filled the hall of the House during the debates on the loan guarantee that took place during the last week of February 1796. On the 25th, a congressman from the Maine district of Massachusetts, Henry Dearborn, introduced a resolution to inquire whether any alterations should be made to the plans of the public buildings.[88] This simple question caught the friends of the city off guard because few knew anything specific about what was being built in the federal city. They did not know what the Capitol was supposed to look like or how big the President's House was going to be. He was not sure but Dearborn thought the President's House was prob-

ably too big and suggested converting it into the Capitol. Crabb replied that if the President's House was too big it should be torn down and a smaller residence put in its place. John Swanwick of Pennsylvania, one of the few members who had actually visited the federal city, said that the plans for the Capitol had been changed so many times that it would not hurt to change them again. According to another congressman, rumors about the extravagance of the federal buildings were hurting the prospect for the loan guarantee. In reply, Theodore Sedgwick of Massachusetts made a few farsighted remarks that could have been scripted by Washington himself. He said: "The better the buildings are the more honor it will be to those who erected them, and to those who occupy them."[89] Dearborn's resolution passed the House, forty-two to thirty-eight, and Smith's committee was instructed to examine the question.

On March 11, 1796, Smith reported that his committee could find nothing to suggest for alterations to the Capitol or the President's House. Included in his report was White's description of the progress made on the Capitol so far:

> The foundation of the Capitol is laid; the foundation wall under ground and above is of different thickness, and is computed to average fourteen feet high and nine feet thick. The freestone work is commenced on the north wing; it is of different heights, but may average three feet and a half; the interior walls are carried up the same height. The estimate to finish the north wing is . . . $75,141. . . .

> A. White has no estimate of the remainder of the building, but would observe, that as the south wing is to be occupied by one large room only, the expense must be much less than that of the north wing, which is considered as sufficient to accommodate both Houses of Congress during the present state of representation. The main body, too, will be finished in the same way; and the grand vestibule may or may not be covered with a dome; architects differ in opinion with regard to covering it. If it should not be covered, it will consist only of an arcade, twenty feet high and ten feet wide; and over that a colonnade sixteen feet high, affording a communication from the grand staircase to all other parts of the building. Upon the whole, A. White thinks he goes beyond the necessary sum, when he estimates $400,000 for finishing the whole building.[90]

From White's remarks, it is clear that the design of the central section was still undecided.

Apparently, the commissioners still considered Hallet's courtyard scheme a viable alternative to Dr. Thornton's rotunda vestibule.

Further debate on the congressional loan guarantee took up much of the members' time on March 31, 1796. It was a day of long speeches that, not surprisingly, included a discussion about staying in Philadelphia. But by the end of the day, the friends of the federal city and the administration prevailed. The loan guarantee (reduced to $300,000) was approved by the House in a lopsided vote, seventy-two to twenty-one. The Senate passed the legislation on May 4 and the president signed it two days later. The Capitol and President's House could now proceed, and work on plans for two office buildings for cabinet departments could be made as well.

HADFIELD DISMISSED

While the city's financial future was looking up, the 1796 building season was beset by labor problems. The cost of living made it difficult for carpenters to make ends meet, and the expense of repairing and sharpening their tools made matters worse. They asked for an increase in wages. Building temporary lodgings was suggested as a means to stop the extraction of high rents from workmen, who told the commissioners that "some indulgence is necessary to live in this expensive place."[91] Labor problems worsened when Hadfield handed in his resignation on June 24, 1796, giving three months notice as required by his contract. Admittedly, there was little respect among the commissioners for the young architect, and his opinion of them was equally low. Yet they needed someone to direct work at the Capitol and no replacement was readily available. They were, therefore, relieved when he reconsidered and withdrew his notice a few days after it had been given.[92] What prompted Hadfield's change of heart is unknown, but his relationship to the board was not improved by his resignation threat.

In the summer of 1796, carpenters were engaged in cutting and preparing the wooden joists, flooring, and rafters that would be installed once the masonry work was further along and dry. They also erected the scaffolds used by the masons building the brick and stone walls. Over the course of the 1796 building season (which lasted from mid-May to mid-November) the brick exterior walls and sandstone facing were carried up to the bottom of the second floor windows. Interior brick walls reached the same height. Most of the stonework was done by cutters, who transformed the rough blocks into precisely dimensioned, plain, squared stone called ashlar. Each stone was destined for a specific place on the walls as determined by the architect. In October idle masons waited for stone intended for the plinths under the exterior pilasters. Slow delivery meant the work was at a standstill for a while, but the delay was not serious.

As winter set in, the commissioners ordered supplies for the next season. One million bricks and 6,000 bushels of lime necessary to make mortar were purchased for the walls of the Capitol and the President's House. Brick kilns were erected on Capitol Hill, where workmen extracted clay from nearby pits. Other brick contractors, such as Bennett Fenwick, delivered brick fired elsewhere. Unhappy with the general quality of brick, Hadfield asked the commissioners if a better sort could be purchased for the arcade of the Senate chamber, but he cautiously added that the decision was entirely theirs to make. To feed laborers and slaves, 150 barrels of pork, forty barrels of beef, and 1,500 barrels of Indian meal were also ordered.

At the close of Washington's second term, he urged the commissioners to concentrate all their resources on the Capitol. More that anything in the city, that building would inspire public confidence in the Potomac capital. If it were not ready in time, the whole enterprise would be seen as a failure. On January 29, 1797, he wrote:

> I persuade myself that great exertions will be used to forward the Capitol in preference to any object—All others indeed depend, in a high degree, thereon, and are or ought to be subordinate thereto.—As such therefore with a view to remove those unhappy jealousies (which have had a baneful influence on the affairs of that City) as to invigorate the operations on that building . . . there are many who intermix doubts with anxiety, lest the principal building should not be in a situation to accommodate Congress by the epoch of their removal.[93]

Lack of money was still the city's most vexing problem. To the board's chagrin, Congress's loan

guarantee did not easily attract lenders. Indeed, finding a source from which to borrow took well over a year. Especially disappointing were "Dutch Capitalists," who were the commissioners' first hope to grace the city with cash. While they explored other avenues, Washington's instructions to push the Capitol meant that work on the President's House would be curtailed and the executive offices postponed.

On March 24, 1797, the commissioners hired Allen Wiley to lay brick at the Capitol. He was paid seventeen shillings ($2.26) for every thousand bricks laid in straight walls, six pence ($0.07) more for curving walls. Arches were turned for eleven shillings, three pence ($1.50) each. In July, a contract for additional brick was made with Middleton Belt, who agreed to deliver 200,000 hard bricks to the Capitol. Bennet Fenwick's brick contract was renewed. To build the north wing, more than 100,000 bricks were needed to raise the walls three feet. By the end of the season, Wiley raised the walls thirty-five feet more, reaching the level of the roof. The sandstone facing was up to the tops of the pilaster capitals, fifty-seven feet above the foundations. After four years of construction, one wing of the Capitol began to resemble its intended appearance.

On the inside, carpenters laid almost all of the rough flooring and were preparing the roof trusses that would be put in place before the spring of 1798. Once under roof, the interior finishes could begin. As winter approached, carpenters were told not to throw away their "chips," which would be distributed between the laborers and slaves for firewood. Hadfield was responsible for the structural design of the roof, a complex series of flat and sloping surfaces that was kept as low as possible. He pledged in writing that the roof would not exceed the height of the balustrade.[94] (During this period steep roofs were considered old-fashioned, reminiscent of the days when thatch was used as a roofing material.) Eighty thousand wooden shingles were on hand to cover the roof, but the commissioners had come to think that slate might be used instead. On June 8, 1797, they asked Graham Haskins to sell the shingles at a price reflecting their high quality. The sale, however, was canceled and shingles were used to cover the roof. Once in place, they were protected with a coating of paint and sand, a precaution against rot and fire.

Construction details were routinely discussed at the commissioners' weekly meetings. On June 20, 1797, Dr. Thornton brought up the subject of warming the Senate gallery with stoves. Providing for the comfort of visitors was not important to his fellow commissioners and the proposal was overruled. After all, the Senate had only opened its doors to visitors in 1795 and might close them again at any time. In another matter, Thornton noticed sections of the exterior cornice had modillions that were too far apart. He blamed the mistake on Hatfield's inattention and asked his colleagues to order the blunder corrected.[95] When they refused, Thornton deplored their decision, and claimed that the cornice would "remain forever a laughing-Stock to architects."[96] Apparently Scott and White did not believe the mistake was serious enough to justify the cost to fix it.

More than a year had gone by since Congress passed the loan guarantee, but the city's coffers were still empty. At about the time that lenders in Amsterdam refused to cooperate, the commissioners were turned away by the Bank of the United States. Annapolis was the next place they looked. On November 25, 1797, the board dispatched Gustavus Scott to lobby the Maryland legislature for a loan. There, despite some opposition from the Baltimore interests, Scott was ultimately successful in securing a loan for $100,000. However, because it was paid in United States debt certificates, which were selling below face value, Maryland's loan actually translated into about $84,000 for the city.

Disappointed by the lack of cash generated by the loan guarantee, the commissioners again petitioned Congress for relief. In February 1798, Alexander White returned to Philadelphia with a second memorial from the board, this one asking for an annual appropriation to finish the public buildings. A total of $200,000 was needed over the next three years: $120,000 for the north wing of the Capitol and the President's House, and the rest for two office buildings to house cabinet departments. The House of Representatives appointed a committee to study the memorial and asked White to describe the accommodations provided in the Capitol. White enumerated the rooms and lobbies in the north wing, giving dimensions, and reported that the stone and brick work was nearly complete along with the rough flooring. The commissioners needed about $46,000 to finish the wing. White also briefly

West Front

by Dr. William Thornton, ca. 1797

*A*bout 1797, Thornton proposed covering the conference room with a temple consisting of a dome carried on columns. Another colonnade in front of the conference room carried an entablature and balustrade with allegorical statuary. Faint markings indicate that bas-reliefs were planned to decorate the walls flanking the portico. Without indications of doors or windows, the semicircular projection of the conference room was a vast blank wall.

described sections of the Capitol that had been postponed for lack of funds. In contrast to their memorial written two years earlier, the commissioners now decided that a dome should be placed over the grand vestibule, a decision that rejected Hallet's courtyard proposal. In addition, a second dome over the conference room, carried on columns in the form of a circular temple, was described for the first time. Affecting only the area between the wings, the double dome plan was drawn in ca.1797 by Dr. Thornton as his contribution to the Capitol's floor plan. (See Plan D, page 39.)

When the commissioners sent their memorial to Philadelphia, they were not prepared for the reckless ideas that it would inspire in economy-minded congressmen and senators. Few members of Congress had visited the federal city and fewer still knew anything about the plans for the public buildings. However, unfamiliarity with the city did not stop them from making proposals that would have altered the essential character of the nation's capital forever. Proposals that were floating through Congress included one to house the president on Capitol Hill, another to convert the President's House into the Supreme Court building or the Capitol, and a third to put cabinet departments in the south wing of the Capitol. In White's opinion, the proposals were motivated by notions of economy and expediency. Alarmed, the commissioners replied with the hope that their friends would defeat these schemes because changes would "shake public confidence to its centre." [97] The plans had been approved by George Washington, the original proprietors had given their lands based on the approved plans, and investors had purchased property on the premise that the plans were fixed and unalterable.

While Congress discussed the appropriation to assist the federal city, the commissioners hoped that nothing would come of the proposals to change

the plans or locations of the public buildings. The House passed the appropriation, but amendments were attached in the Senate changing the appropriation to a loan and reducing the amount of assistance to $100,000. Fearing it was this or nothing, the House accepted the amended legislation on April 13 and President Adams approved it five days later. The commissioners immediately asked the secretary of the treasury for instructions on collecting their loan.

Meanwhile, when White was in Philadelphia, his colleagues had been making arrangements for the Capitol's doors and windows. Once the building was closed in, workmen could begin the interior finish. For the exterior doors, the commissioners selected mahogany; clear pine was ordered for interior doors, which could later be painted to imitate a more expensive wood. For window sash, Hadfield drew designs and the board asked several carpenters to make samples. They then ordered Hadfield

and a local builder, William Lovering, to report on the relative merits of each. Both liked Clotworthy Stephenson's sash, calling it an example of excellent workmanship. The commissioners initially decided the sash would be made of mahogany but soon changed their minds and ordered walnut used as well. The strength of mahogany was necessary for the large windows of the first and second floors, but walnut was probably considered adequate for the smaller third floor windows.

Hadfield's roof design drew criticism from the foreman of carpenters, Redmont Purcell. On February 20, 1798, Purcell wrote the commissioners to

Model of the Thornton Design of 1797

*T*his modern model illustrates the design of the Capitol as it was in 1797 when a stilted dome was designed to cover the conference room. A low dome fronted by a portico was the central feature of the east front. (1994 photograph.)

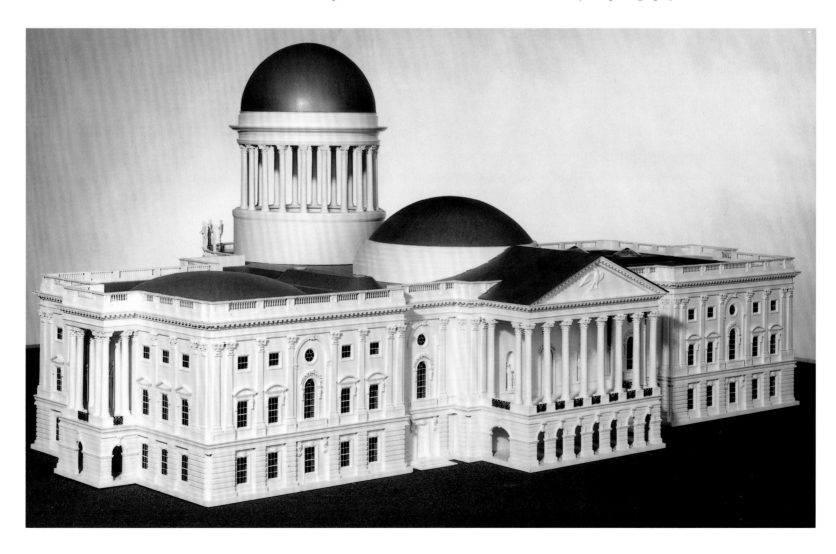

condemn the gutters, bracing, and connections of the roof framing to the ceiling joists. Hadfield defended his design and the commissioners, suspecting Purcell of unnecessary trouble making, absolved the architect of neglect. The board was more concerned with Hadfield's progress on designs for the cabinet offices, a pair of buildings flanking the President's House. The executive offices were conceived as detached wings in harmony with the President's House, yet simpler, smaller, and plainer. Hadfield's design for these two-story rectangular structures with Ionic entrance porticoes was approved by the commissioners, who were anxious to put the project out for bid. Like any architect, Hadfield was eager to see his design built, yet wished to oversee the work himself. On the same day the commissioners gave final approval to Hadfield's roof design, they asked him to return his drawings for the executive offices. Hadfield refused until his official relationship with the buildings was explained to his satisfaction. The board did not believe further explanation was necessary, thought the architect would "have all the honor flowing from a full appropriation of it," and considered the plans as belonging to the United States and not the architect's personal property, as he now claimed.[98] This dispute was quickly settled. On May 18, 1798, the commissioners gave Hadfield three months notice, saying: "Your conduct of late has rendered it proper that your occupation as Superintendent at the Capitol should cease as soon as the time for previous notice, required by your contract shall have expired."[99] The president was informed of the board's action dismissing "a young man of taste" who regrettably was also "deficient in practical knowledge of architecture."[100] While his dismissal was not directly related to the Capitol, Hadfield joined a growing fraternity of architects whose careers were derailed or wrecked by their work in the federal city.

HOBAN'S DOUBLE-DUTY

*I*mmediately upon Hadfield's dismissal, the commissioners put Hoban in charge of the Capitol's day-to-day operations. In theory, both Hallet and Hadfield had worked under Hoban's direction, but he had spent his time mainly at the President's House. He was now directly responsible for both buildings, and finishing the north wing of the Capitol became top priority. In spite of his expanded workload, Hoban still found time to bid as a private contractor on the Treasury Building, one of the two executive offices designed by Hadfield. While he lost the job to Leonard Harbaugh, Hoban was paid extra to supervise that work. Ambitious and energetic, Hoban was the best hope that the federal buildings would be ready in 1800.

During the first three months of Hoban's control of the Capitol, Hadfield was still employed there. On May 18, 1798, the day he was fired, he made his last report on the building's progress. He stated that the exterior stonework was up to the frieze and only the cornice and balustrade were needed. The rough flooring was in place throughout the interior, except in the large room above the Senate chamber. Most of the roof was in place and all the shingles were ready to install. Once the roof was finished, the "carcase" of the building would be ready for interior finishing.[101]

On August 15, the commissioners wrote the firm of Rhodes & McGregor in New York City, asking if it could supply the public buildings with window glass. Two months later, an Albany firm was asked to give the cost of 656 panes of glass in three graduated sizes. In addition, the board wanted four cribs of glass for circular and semicircular sash and several cribs for skylights. In 1799, they ordered 560 square feet of glass from Isaac Harvey in Philadelphia for the skylight above the elliptical stair hall. These orders required many months to fill and, due to the brittle, fragile nature of glass, caused the commissioners considerable trouble.

By the end of the 1798 building season, Hoban reported that the roof was finished and the gutters were in place and coated with lead.[102] The brickwork was complete and all the sandstone was in place on the north, east, and west walls. Still missing was a small section of the balustrade. Bridging, ceiling, and flooring joists were all made and, for the most part, installed. More than 50,000 feet of northern clear pine, one to two inches thick, was on hand for floors and interior trim. There remained nearly 500 tons of stone, 30,000 bricks, and 40,000 shingles on hand that were not needed—an inventory that represents some dramatic miscalculations.

Evolution of the Capitol's Early Floor Plan

Thornton's original plan for the Capitol (A) consisted of wings for the House and Senate connected by a central building with a rotunda, a windowless presidential office, and a conference room. After Washington approved the plan, however, problems with its staircases, windows, and columns were identified. To overcome these faults, Stephen Hallet offered a substitute plan, which became known as the "conference plan" (B). In this plan an elliptical House chamber was the principal feature of the south wing. The Senate was accommodated in the eastern half of the north wing along with committee rooms and lobbies. The plan of the wings was approved, but the center section was disapproved because of the recessed portico and the absence of a rotunda. After construction began on the wings, Hallet devised a new plan for the center building bringing the portico forward but still leaving out the rotunda (C). When he began laying foundations for the central section without approval, he was promptly dismissed.

About 1797, Thornton adapted Hallet's plan of the wings to a revised plan of the center building (D), restoring its three major features: portico, rotunda, and conference room. More revisions to the Capitol's floor plan awaited in the near future.

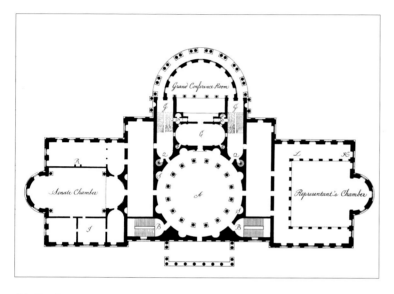

A) Conjectural Reconstruction of William Thornton's Original Plan, 1793 (second story), by Don Alexander Hawkins, 1984
Reproduced by permission

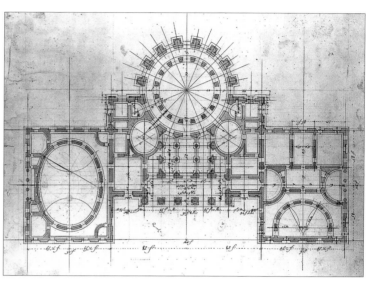

B) Conference Plan (ground story), by Stephen Hallet, 1793
Library of Congress

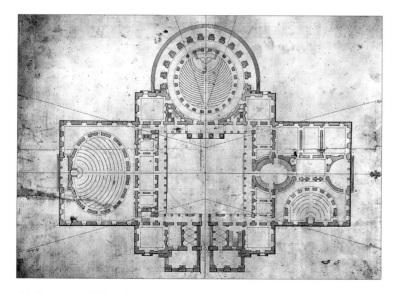

C) Courtyard Plan (ground story), by Stephen Hallet, ca. 1794
Library of Congress

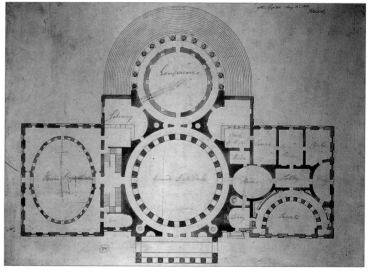

D) Plan (ground story), by William Thornton, ca. 1797
Library of Congress

Plastering was the most important task undertaken in the next building season. In November 1798, the commissioners ordered 60,000 sections of wooden lath four feet long and "thicker than usual." Delivery was expected the following May. To help bind the plaster, 1,000 bushels of hair were ordered from a Boston merchant, costing the federal city $279. Archibald Campbell was asked to find workmen to trowel 10,000 square yards of plaster, for which the commissioners offered to pay three cents a yard.[103] They also needed mechanics to run plaster of Paris cornices and ornamental work in the "handsomest style."[104]

The plastering contract went to John Kearney of Baltimore, who began work in the third week of April 1799. Twenty tons of plaster of Paris was ordered by the commissioners, who did not care if it was foreign or domestic as long as it was a good white or blue color.[105] By the middle of May, Kearney had scaffolds up in three committee rooms on the first floor and his crew was at work boiling vats of plaster. In June, hot weather aggravated the misery of the work and the commissioners allowed laborers a half pint of whiskey a day to help them cope. Most of the plaster was applied directly to bare brick walls or to laths nailed to ceiling joists. Hoban probably consulted with Kearney when he designed the cornices, which were an important part of the Capitol's interior decoration. The two vestibules, four committee rooms, and Senate chamber on the first floor had cornices with molded ornaments, while the large library room and its lobby on the second floor had cove cornices. Because the library would be used by the House of Representatives as a temporary chamber, Hoban added a row of dentils to give it a higher finish. Four rooms for clerks apparently had no cornices at all.

About the time the plastering began, Hoban wrote the commissioners asking for drawings of the staircases, Senate chamber, and library. He said that he had no idea about the trim or finish for these rooms, but if necessary would devise them himself. Scott and White forwarded Hoban's letter to Thornton, inquiring if he intended to make any drawings. They recalled that the 1792 competition advertisement required sections of the building and they were needed now. In reply Thornton explained that he expected the superintendent to supply drawings for the board's approval: because he was always available to give advice and ideas, he did not see why he should be bothered making drawings. He explained some of his thoughts about the interior in the letter to show how a verbal description could be substituted for an illustrated one. He wanted the columns in the Senate chamber to be marble, but since that was beyond the city's means, he thought scagliola or porphyry should be used instead. The entablature should be "full but plain & without modillions" and painted white. The walls should be painted a "very pale blue in fresco or in distemper [i.e., tempera]." Two flights of elegant marble stairs were needed in the elliptical hall, but wood could be substituted for the time being. Private staircases had to be narrow enough to allow light from the skylights to penetrate three stories through the wells. He concluded by reiterating his belief that drawing was Hoban's duty.[106] It was obvious that Thornton found architectural drafting laborious and difficult, and he was never asked for drawings again.

As the plastering was going forward, the first shipment of glass arrived. On August 1, Robert King from the surveyor's department examined the glass and reported that it appeared to be "Newcastle crown, of the Quality of Seconds."[107] The glass had been packed poorly, was too weak for the size of panes required, and was too crooked to be of any use. Dissatisfied, the commissioners refused to pay the $1,700 charge. Another order was placed for crown glass from London, at least a quarter inch thick and securely packed. Until the glass arrived, the window sash could not be installed. Workmen boarded up the openings to keep warm during the winter and sat idly in the dark. To overcome this problem, Hoban suggested making a temporary window sash glazed with small, cheap panes of American glass. Later, when the permanent sash was installed, the temporary ones could be sold for residential use.

At the close of the 1799 building season, the north wing was almost complete. The exterior was finished, lightning rods installed, cisterns and cesspools leaded, and the roof painted and sanded. On the interior, some of the plastering was incomplete but work on the important rooms was almost done. Sixteen Ionic columns in the Senate chamber were in place, standing on a brick arcade that was sheathed with wood paneling. The shafts were made of wood skimmed with plaster, and the capitals were plaster as well. The columns were in the

"ancient Ionic order but with Volutes like the modern Ionic."[108] Thus, the volutes were set at a forty-five-degree angle and probably looked like smaller versions of the Ionic order Hoban used at the President's House. Windows in the Senate chamber and elsewhere were trimmed with backs, elbows, soffits, and architraves. Double-hung sash were held with rope on brass pulleys and counterweights. Doorways were similarly finished with paneled jambs and molded architraves. Other woodwork was limited to chair rails, baseboards, and mantels. Each hearth was laid with three pieces of sandstone. In the event marble mantles and hearths were installed in the future, the sandstone could be reused to pave the city's footpaths. All in all, the original interior of the north wing was simple and straightforward, lacking the elaborate materials and designs that were beyond the city's means.

"A RESIDENCE NOT TO BE CHANGED"

The year 1800 opened with the commissioners finishing up last minute details. Hardware was still needed for the doors in the Capitol and the interior woodwork needed another coat of paint. In the spring Kearney's men resumed the plastering that had been stopped by the first frost in November. A particularly violent storm damaged the roof and gutters and caused some of the new plaster to fall. John Emory was ordered to repair the gutters, and when his work failed to stop leaks, the commissioners threatened him with a lawsuit.

In a bill signed by President Adams on April 24, 1800, the government prepared for its move to the new capital.[109] An appropriation of $9,000 was made to furnish the Capitol and to transport the books, papers, and records belonging to the House of Representatives and the Senate. To ease travel between the Capitol and the President's House, Congress lent the commissioners $10,000 to pave sidewalks along Pennsylvania Avenue. While in Philadelphia, the Library Company extended Congress the free use of its holdings, but no comparable facility existed in the new city. The void was filled with an initial $5,000 appropriation to buy books for the use of Congress in its new home. Thus, the Library of Congress, the modern world's largest library, was quietly established in Washington.

Thomas Jefferson's direct influence on the affairs of the capital city ended when he left Washington's cabinet at the end of 1793. But now, as vice president and the Senate's presiding officer, his concern with order and decorum prompted him to advise Dr. Thornton on the proper arrangement of the new chamber. He suggested placing the vice president's chair and platform several feet from the wall. This would allow senators to pass behind the presiding officer as they crossed back and forth across the room. In Philadelphia, Jefferson complained, he sat against the wall and senators were continually walking in front of him. He also thought senators should sit at two rows of curving tables: three rows were too many. The space behind the back row should have a balustrade creating a space sufficiently wide to allow a person to pass but not so wide as to allow members to pace back and forth. He also suggested a private room for the Speaker, a suggestion that came too late to implement.[110]

On May 15, 1800, President Adams asked department heads to arrange for the removal of government to the new capital and directed them to be ready to leave in a month. When employees began arriving in the federal city that summer, last-minute work was still going on at the Capitol. Since Congress was not due until November, a little time remained to tie up loose ends. In August, Kearney finally finished the plastering, or as much as would be finished—the clerks' room above the Senate chamber was never plastered. Mortise locks were still needed and the commissioners were waiting for seventy boxes of window glass to arrive from Boston. William Rush, the Philadelphia sculptor, was asked to carve a wooden eagle that the commissioners hoped would cost no more than forty dollars. They took care of one last detail a month before Congress arrived: a wooden privy was built near the Capitol. It was seventy feet long, eight feet wide, and thirteen feet high, and cost $234.

The second session of the Sixth Congress convened in the north wing of the unfinished Capitol on November 17, 1800. For some, leaving Philadelphia was a bitter pill to swallow, but the sickly conditions in that city over the previous summers made it seem wise to relocate. Friends of the federal city extolled its healthful environment, noting the absence of yellow fever and cholera that plagued

more heavily populated places. (In a particularly dreadful outbreak in 1793, Philadelphia lost 10 percent of its population to yellow fever.) A sense of homage to the memory of George Washington, dead less than a year, also helped smooth the way to the Potomac. President Adams addressed Congress in the Senate chamber on November 22, congratulating it "on the prospect of a residence not to be changed." He acknowledged the cramped conditions in the Capitol and city, noting that their accommodations were not as complete as might be wished, but he thought things would improve quickly. The president then offered an eloquent prayer for the future of the nation's new capital:

> May this Territory be the residence of virtue and happiness! In this city may that piety and virtue, that wisdom and magnanimity, that constancy and self- government which adorned the great character whose name it bears, be forever held in veneration! Here, and throughout our country, may simple manners, pure morals, and true religion, flourish forever![111]

The government's removal to the new capital city was one of the most spectacular accomplishments of George Washington's accomplished career. His singular determination overcame many

Watercolor View of the Capitol

by William Birch, ca. 1800

Library of Congress

*T*his charming depiction of the Capitol was drawn about the time the federal government moved from Philadelphia. Although the outside masonry had been complete for some time, Birch drew a stone cutter and carver hard at work in the foreground. Another instance of artistic license can be seen in the oak branches over the arched windows, decorative items appearing in Thornton's elevation but never carried out.

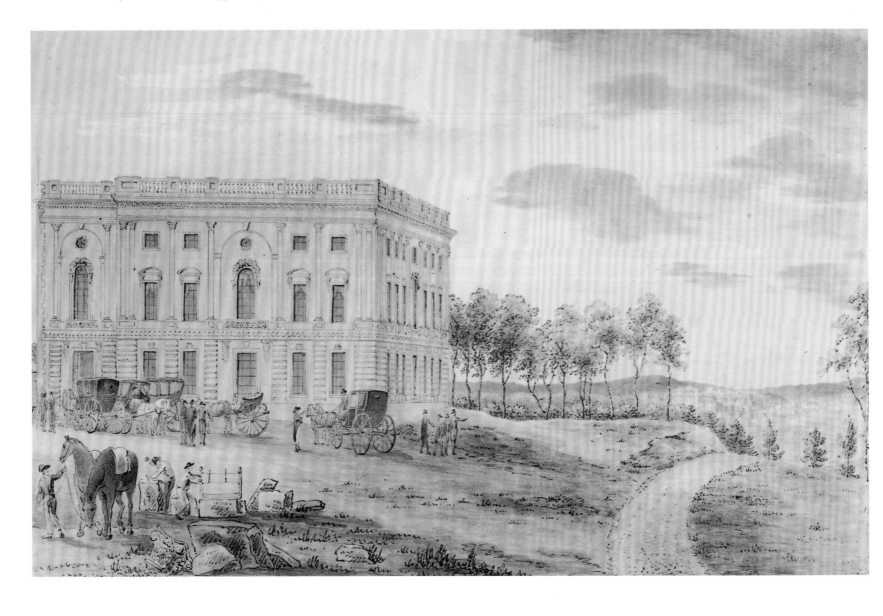

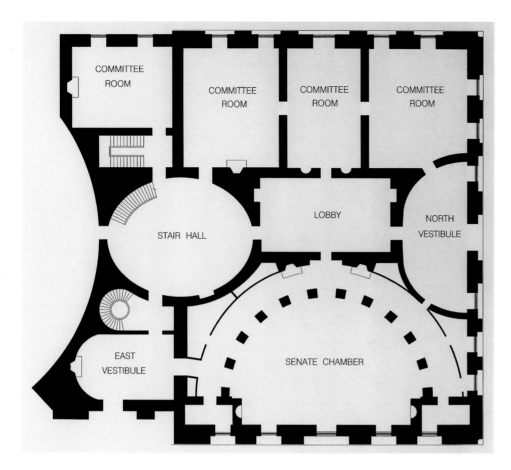

First Floor Plan of the North Wing
As Completed in 1800

Conjectural Reconstruction, 1997

This reconstruction of the north wing's floor plan was based on measured drawings made in 1806 by B. Henry Latrobe. A notable feature is the thin wooden wall in the Senate chamber, which transformed the oddly shaped room into a graceful semicircle. This improvement was suggested by either George Hadfield or James Hoban.

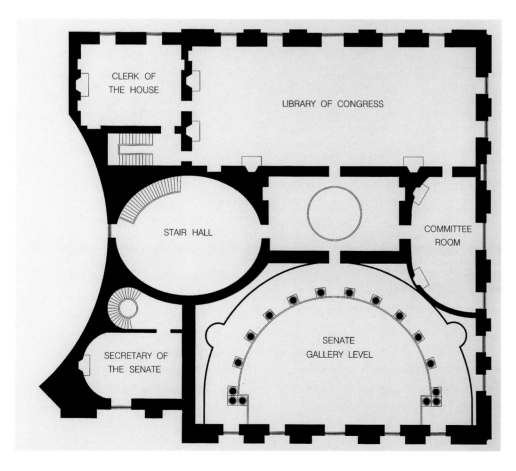

Second Floor Plan of North Wing
As Completed in 1800

Conjectural Reconstruction, 1997

The principal floor of the north wing was occupied by the Senate gallery and the library room, where the House, the Senate, and the Supreme Court held their sessions on different occasions. Throughout the plan are indications of false doors, placed for reasons of balance and symmetry. In the office of the clerk of the House, for instance, there were twice as many false doors as real doors.

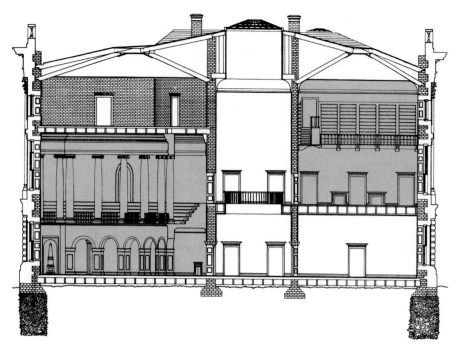

Section of the North Wing Looking South, ca. 1800
Conjectural Reconstruction, 1989

The Senate chamber (left) and the Library of Congress (right) were both two-story rooms, but the floor of the Senate was originally at ground level while the floor of the library was on the main story. Designs for raising the Senate chamber to the principal story were drawn in President Jefferson's second term.

obstacles blocking the path to the Potomac and, though he was helped along the way, it was his vision that gave the United States its unique capital city.

THE BOARD'S DEMISE

When President Adams welcomed Congress to the Capitol, Vice President Jefferson was en route to Washington. His empty chair sat below a tall window with a semicircular top, the largest of the six windows in the new Senate chamber. The galleries were full of spectators, including Dr. Thornton and his wife, Maria, who noted in her diary that a pair of magnificent portraits of the ill-fated King and Queen of France, Louis XVI and Marie Antoinette, were hanging in the chamber. These portraits, given to Congress by the government of France in 1784, were part of the public property moved from Philadelphia to Washington that summer. (During the Revolutionary War, Congress asked the King of France for these portraits so that "the representatives of these States may daily have before their eyes, the first royal friends and patrons of their cause." They also congratulated the King on the birth of his first child and asked for more money to fight the "common enemy."[112])

Hanging in Washington sixteen years later, the portraits were now sad reminders of the bloody excesses of the French Revolution and America's strained relations with its former ally. Despite these associations, the paintings and their golden frames were wondrously luminous and rich, imparting a rococo splendor unusual in an American public building. One blemish, however, appeared on the portrait of the queen. It was damaged by a Dutch woman who, while touring Federal Hall in New York City, poked her finger through the canvass while examining the material used to make Marie Antoinette's petticoat.[113]

On Christmas day 1800, Commissioner Gustavus Scott died. To fill his seat on the board President Adams first appointed his wife's nephew, William Cranch, but he resigned two months later when he was promoted to the bench of the District of Columbia's courts. Tristram Dalton, a former senator from Massachusetts, was named to replace Cranch. While Cranch and Dalton were both New Englanders, they also had financial ties to the federal city. Both were investors in Tobias Lear's merchant company, which handled goods throughout the Potomac region. Through Lear, they had ties to the Potowmack Company, as had most of the previous commissioners.

Dalton's appointment, made on the last day of Adams' term, was one of the so-called "midnight appointments" that so infuriated the supporters of his successor, Thomas Jefferson. "The Revolution of 1800," as Jefferson's presidential election was sometimes called, had not been easily won and Jeffersonian Republicans were eager to turn out Adams' loyalists and replace them with members of their party. The "midnight appointments" denied Jefferson the opportunity to fill many offices with his own men. Jefferson's election was a hotly contested affair that was decided in the House of Representatives over a seven-day period in February 1801. Meeting in the library room on the second floor, members of the House wrestled with the

deadlocked contest between Jefferson and Aaron Burr. Although Burr stood for vice president, he received the same number of votes for president as Jefferson in the Electoral College and he refused to concede. The tie vote threw the election into the House of Representatives. Thirty-six ballots were cast during the contest, with each state delegation casting one vote. After a seven-day impasse, Jefferson finally carried ten states to Burr's four. Two states cast blank ballots. Alexander Hamilton convinced moderate Federalists to abstain or vote for Jefferson as the lesser of two evils. Once again, as in his role in the passage of the Residence Act, Hamilton came to Jefferson's aid at a crucial moment. The election was the Capitol's first great political drama, one that led to a constitutional amendment providing separate votes in the Electoral College for president and vice president.

On the morning of Jefferson's inauguration, March 4, 1801, President Adams and his wife left the city at daybreak without staying for the swearing in ceremony. At noon, Jefferson walked from his boarding house to the Capitol, entered the Senate chamber on the ground floor, and took the oath of office. He delivered a conciliatory address in which he declared:

> We are all Republicans, we are all Federalists. If there be any among us who would wish to dissolve this Union or change its republican form, let them stand undisturbed as monuments of the safety with which error of opinion may be tolerated where reason is left free to combat it.[114]

Although Jefferson was not a good orator, he was capable of writing and delivering a great speech. After listening to it, members of the House of Representatives returned upstairs to their chamber to write letters and clean out their desks. The Sixth Congress ended the day before and the first session of the next Congress would convene in December. The representatives met in the library, a room eighty-six feet long, thirty-five feet wide, and thirty-six feet high. It was heated by four fireplaces and a stove. The stove was apparently placed too close to the wall, because on January 30, 1801, the commissioners asked Hoban to remove the baseboard, chair rail, and window trim behind it as a precaution against fire. Public galleries were provided, but their extent is unknown. The absence of supporting columns suggests that they were carried on wall brackets and were there-

fore quite shallow. The Speaker's chair was placed in front of the large arched window in the center of the west wall, one of eight windows that must have been hung with draperies or blinds to control the afternoon sun. Four additional windows were located at the north end of the room. By far the largest space in the north wing, the temporary House chamber comfortably accommodated the 106 members of the Sixth and Seventh Congresses. But with the results of the 1800 census promising an increased membership in the House, future Congresses would require more room.

On May 27, 1801, the board of commissioners asked Hoban to design a temporary House chamber to be built on the existing foundations of the south wing. The foundations laid in 1793–1796 consisted of two parts: the rectangular outline of the outside walls and the elliptical foundation for the interior arcade. Hoban devised three schemes for a temporary chamber from which the president could choose. Two of the plans called for building a portion of the south wing's permanent structure so the expense of the work would not be wasted once the wing was resumed in earnest. How much to build and how much to spend were the distinguishing factors. Building the one story arcade, putting window sash in the openings, and covering it with a temporary roof was the basis of the first proposal. The second plan called for building the interior arcade and the outside walls to half their intended height. Hoban's third plan called only for a cheap wooden building that would be removed altogether once the south wing was begun.

Working quickly, Hoban produced the plans with cost estimates in about five days. They were sent to Jefferson on June 1, 1801, and the commissioners were informed of the president's selection the following day. In the president's opinion, the wooden building was a waste of money because none of it could be used in the permanent construction of the south wing. Conversely, the plan calling for both the arcade and the outside walls was too expensive. Jefferson approved the middle course, building the arcade and roofing it at an estimated cost of $5,600. Only the roof and window sash, representing about $1,000 of its expense, would be lost when further construction of the south wing was undertaken in the future.

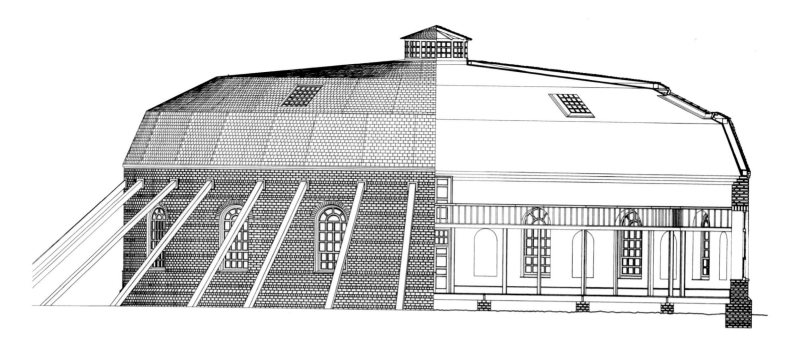

Temporary House Chamber (the "Oven"), Looking North

Conjectural Reconstruction, 1989

A provisional chamber for the House of Representatives was built in 1801 upon the central foundations of the south wing, which were laid in 1793–1796. It was a hastily constructed, elliptical room with a notoriously stuffy interior, which helped earn the building its unflattering nickname. (The roof lantern and outside bracing were added in 1803.)

Advertisements appearing in local newspapers invited builders to submit bids for "an elliptical Room in the south Wing of the Capitol."[115] Seven offers were received and the commissioners accepted William Lovering and William Dyer's bid of $4,789. Their contract was signed on June 20, 1801, and stipulated that the room be finished by November 1. Lovering and Dyer received a $1,600 advance when their contract was signed, with the balance due in three installments. According to the *Washington Universal Gazette,* the walls were nearly done by September 10, but by the first day of November the room was still unfinished. Lovering and Dyer apparently fell behind schedule and the commissioners were obliged to put one of their best men, master carpenter Peter Lenox, on the project. He was reimbursed for traveling expenses to Alexandria where he had gone in search of carpenters to help finish the work. Nine carpenters were preparing the floor in the middle of Novem-

ber; a week later they were working day and night, for Lenox bought candles to enable them to continue after sundown. He reported that all the arched window sash were made and put up, the gallery's railing installed, and lantern posts put up outside. The elliptical room measured ninety-four feet long and seventy feet wide with sixteen arches and fourteen windows. The walls and ceiling were plastered, the roof was shingled, and a 120-foot long gallery had been fitted with three rows of seats. Connecting the new room to the north wing was a one story wooden passage 145 feet long containing the gallery stairs and three water closets.[116]

Soon after the temporary House chamber was occupied, it became known as the "oven." The nickname was bestowed partly because of the structure's shape, which reminded some of a huge Dutch oven, and partly because of its notoriously stuffy interior. Ventilators were installed on the roof to improve the chamber's atmosphere, but they never worked satisfactorily. Manasseh Cutler, a representative from Massachusetts, complained that workmen could not fix the ventilators because the House refused to adjourn for Washington's birthday. Not only was the House disrespectful to the memory of the first president, but every member suffered that day from the bad air and broken ventilators.[117] Later in the session, Cutler noted that four Federalists were compelled to miss a late night

vote because of the "suffocating feeling of the air in the Hall."[118] Spectators crowding the gallery did not improve the situation.

During much of President Jefferson's first term the Capitol was a distinctly odd-looking building. Three sides of the north wing were finished, but the south elevation had been left as a bare brick wall that would eventually be covered by the center building. The elliptical "oven" and its long, narrow passage to the north wing made the Capitol look even more peculiar. The commissioners expended more than $370,000 on the Capitol and owed the State of Maryland more than $200,000. They had not been able to sell enough lots to cover the interest on their loans from the Maryland legislature. On January 15, 1802, Secretary of the Treasury Albert Gallatin suggested that the United States government repay the loan to avoid its unnecessary prolongation. He wrote that "no act of Government can more effectually . . . strengthen the internal union of the United States than the prompt and complete extinguishment of public debt." There was money enough in the treasury, he stated, to cover the commissioners' obligations.[119]

On January 11, 1802, President Jefferson sent Congress a message recommending repaying the Maryland loan and applying receipts from future land sales to the treasury as reimbursement. While he did not condone the commissioners' debt, he acknowledged that "their embarrassments have been produced only by over strained exertions to provide accommodations for the government of the Union."[120] A committee of the House of Repre-sentatives then recommended abolishing the board and paying its debts from the treasury. The recommendations were enacted into law on May 1, 1802.

The money problems that had plagued the commissioners from the beginning of their work were not the only reason for which the board was abolished. Another was that it had been the creature of the Federalist past and had been stocked with Federalist partisans; although both Alexander White and William Thornton were friendly to the new administration, Tristram Dalton, an old ally of John Adams, was a holdover who needed to be stricken from the public rolls. Further, their handling of the city's financial affairs indebted the nation and resulted only in a small number of buildings less than half finished, set in a landscape that had seen few improvements in roads, walks, or gardens. Finally, now that the government was "fixed" on the Potomac, there was no further need for commissioners to handle the city's affairs for an absentee administration. With Jefferson's love of architecture and building, he would personally direct future development, and he did not want middlemen.

The final entry into the board's minutes ordered accounts settled and salaries paid in accordance with "An Act to abolish the Board of Commissioners in the City of Washington." Dr. Thornton, whose hopes for the future were pinned to the city's fortunes, concluded the entry with a flourish of swirling lines under the words: *"Finis Coronat Opus!"* The End Crowns the Work!

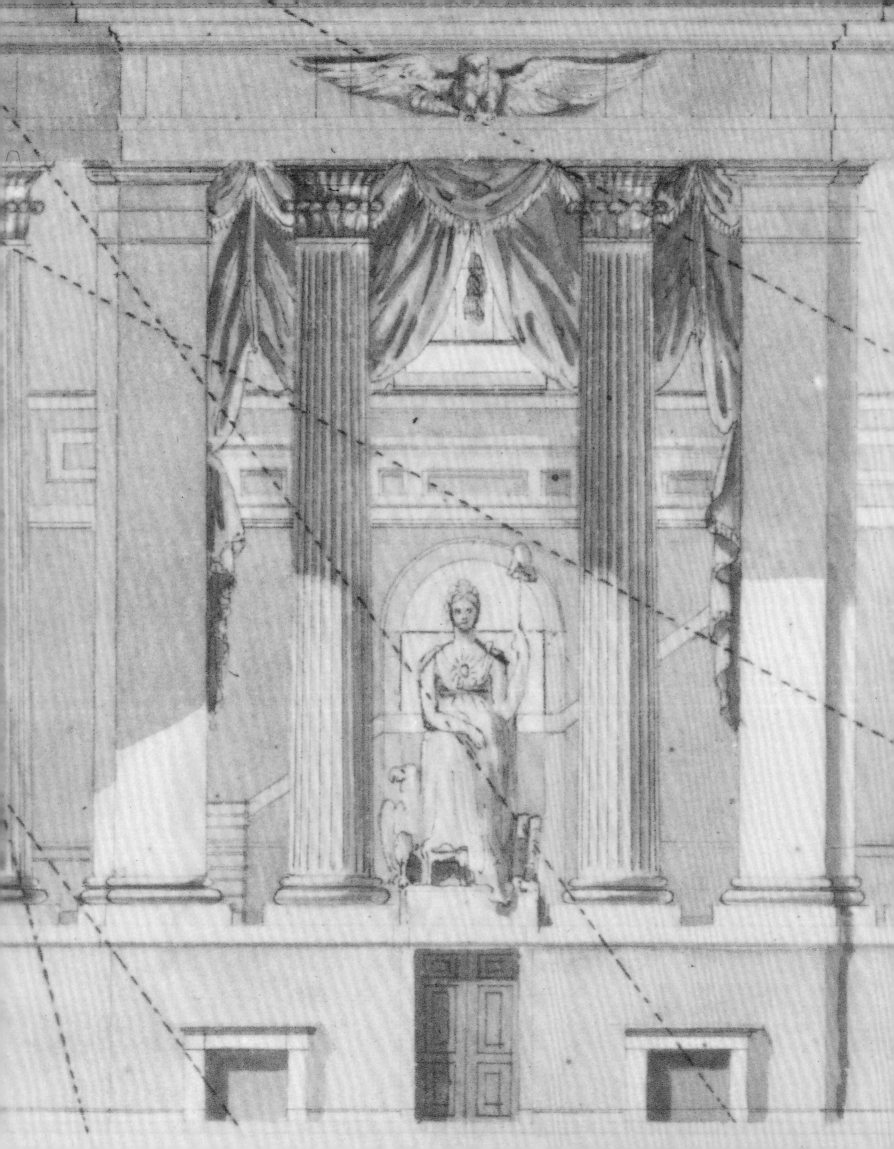

JEFFERSON AND LATROBE

*F*ew people had such an enduring influence on the Capitol's early history as Thomas Jefferson. He nurtured the compromise that led to passage of the Residence Act and counseled President Washington throughout the process of selecting a design for the Capitol. He presided over the conference that put one man's floor plan into another man's exterior elevation. As president he approved the congressional action abolishing the old board of commissioners, freeing him to personally direct future construction. Until his retirement in 1809, Jefferson managed affairs at the Capitol with the same care and attention he lavished on his beloved Monticello, and later on the University of Virginia. Working with the president was B. Henry Latrobe, an architect of exceptional ability and experience. Theirs would be an association without parallel in the history of the Capitol.

The act of Congress abolishing the board of commissioners transferred its duties to a superintendent of the city of Washington. On June 2, 1802, Jefferson appointed Thomas Munroe, the clerk of the old board, to the new office. Munroe was apparently a man of few words: his entire annual report for 1802 ran just two sentences. He recorded that there were about 830 private buildings in the city—100 more than the previous year—and that the condition of the public buildings had not materially changed.[1]

Although Munroe did not report any problems with the public buildings, the roofs of the President's House and the Capitol needed repair. They were said to be "so leaky as to threaten both edifices with ruin."[2] On February 12, 1803, New York Congressman Samuel Mitchill offered a resolution in the House of Representatives calling for an investigation into the state of the public buildings: he said they were near a state of "ruin and dilapidation." In addition to maintenance problems, the House was about to gain thirty-eight new members as a result of the 1800 census and the admission of Ohio into the Union. John Dawson of Virginia wanted a provision added to provide more space for the future accommodation of Congress. A colleague from the Old Dominion, Richard Brent, said that an architect had already estimated the cost of finishing the south wing beyond what had already been spent for the "oven." The estimate, he believed, was $40,000. Either George Hadfield or James Hoban prepared the estimate but there is no record of what it covered. The figure was too low to finish the south wing and more likely indicated the money needed for one season's work.

Section of the South Wing (Detail)

by B. Henry Latrobe, 1804

Library of Congress

On March 3, 1803, President Jefferson approved an appropriation of $50,000 for the "repairs and alterations in the Capitol . . . for the accommodation of Congress in their future sessions."[3] It was understood that $5,000 to $10,000 was meant for repairs to the Capitol and President's House while $40,000 to $45,000 would be available to begin construction of the south wing. Coming twelve years after passage of the Residence Act, this appropriation was the Capitol's first.

Soon after he signed the appropriation bill, Jefferson wrote B. Henry Latrobe, America's foremost architect/engineer, offering him the position of "surveyor of the public buildings." The job was not a permanent government office, but a temporary position necessary to carry out the intent of the appropriation. The president informed Latrobe that the appropriation was to be expended under his direction, but that Munroe would keep the accounts and provide administration. He wanted work to begin in April, so if Latrobe accepted the position, he should make a "flying trip" to start ordering stone from Aquia.[4]

Along with his official letter, Jefferson enclosed a private note saying that he expected another appropriation for the south wing in 1804, which he thought would be enough to finish it. (Why Jefferson thought it would take only two years to build the south wing is not easily understood.) While Latrobe's work on the south wing might therefore seem short-term, other projects in Washington suggested the "probability of a very steady employment for a person of your character here." Jefferson mentioned his dry dock proposal for the Navy Yard as one example of potential projects that could earn Latrobe additional income.[5] Although the president had known Latrobe since 1798 (both were members of the American Philosophical Society), their collaboration had begun over plans to build a dry dock to house twelve frigates at the Washington Navy Yard. In 1802, Jefferson asked Latrobe for help in designing the dry dock because the architect's work on the Philadelphia waterworks had

Statue of Thomas Jefferson

by Pierre Jean David d'Angers, 1833

Received in 1834, the bronze portrait of Jefferson was the first statue placed in the Capitol's rotunda. It was a gift to the nation from Uriah P. Levy, a Jewish naval officer who admired Jefferson's stand on religious freedom. Levy and his family also honored Jefferson by preserving Monticello, which they owned from 1834 to 1923.

Jefferson hoped the public buildings in the federal city would educate fellow citizens about classical architecture, elevating their taste at home and their reputation abroad. As secretary of state, as president, and in retirement Jefferson nurtured these high-minded aspirations in a variety of ways. He thought that by examining the Capitol, for instance, Americans could acquaint themselves with correct examples of Roman and Greek architecture, and apply the lessons at home. Thus, the Capitol would help spread classical architecture across America. During his retirement, Jefferson approached the design of the University of Virginia with the same regard for its potential for architectural education. (1971 photograph.)

given him experience in hydraulics. Jefferson thought the dry dock would save the expense of maintaining a large fleet by having ready fewer but better maintained ships. A huge structure 175 feet wide and 800 feet long would be built with a roof modeled on that of the Paris grain market, the Halle au Bled. Ships raised and lowered in the dry dock would use technologies similar to those employed by Latrobe at the waterworks.[6]

Congress never funded the dry dock, but Jefferson was doubtless struck by Latrobe's beautiful drawings for it and the project afforded him ample opportunity to observe architectural talents that were complemented by a keen and sympathetic mind. Writing from Philadelphia, Latrobe replied to the president's offer, saying that the recent failure of his business partners made it impossible for him to give an answer immediately. He would, however, come to Washington soon and give his reply in person. He left little doubt what the answer would be when he concluded: "My sincere wish is to be employed near you, and under your direction."[7]

Jefferson's decision to hire Latrobe to build the south wing was the beginning of one of the most fascinating collaborations in the history of American architecture. It was, however, a blow to George Hadfield, who wanted to be restored to his former position at the Capitol. Hadfield's hopes were raised after Jefferson's election brought to the presidency a man who had over a decade previously enjoyed an intimate friendship with his sister, Maria Cosway. Within weeks of his inaugural, Jefferson received a letter from Hadfield pleading "the case of an artist." Hadfield recounted his suffering at the hands of the old board of commissioners, and his mortification at seeing his buildings credited to the board when its members were responsible for his ruin. He wanted the president to know that he would endeavor to make himself useful, and "obtain a substance in a country which I have chosen to spend the remainder of my life in."[8] Commissions for a barracks, an arsenal, and a jail were awarded to Hadfield during Jefferson's term, but the prized commission for the Capitol's south wing was given to Latrobe.

Portrait of B. Henry Latrobe
by Charles Willson Peale, ca. 1804
The White House Collection

*B*orn near Leeds, England, Latrobe (1764–1820) studied engineering under John Smeaton and architecture under Samuel Pepys Cockerell. During Latrobe's early career he designed a few large houses and was offered other work, but future prospects in Great Britain were hampered by an economy stagnated by the Napoleonic Wars. After the death of his first wife, Latrobe set sail for America in 1795. A few years in Virginia were followed by a move to Philadelphia, where he designed the Bank of Pennsylvania, the country's first neoclassical building displaying a Grecian order and one of his best works. He later provided the city with its first municipal water system.

At the invitation of President Jefferson, Latrobe became the fourth architect to test his skill at the Capitol and was the first to develop a comprehensive vision of the building's architectural potential. Though he disliked the exterior, he found plenty of opportunities to improve on it. He devised a new interior plan that was spectacularly inventive, overcoming numerous obstacles imposed by the existing work. During restoration work following the War of 1812, he created a series of neoclassical interiors that are among the finest in the history of American architecture. His designs for the House of Representatives (now Statuary Hall), the Senate, and the Supreme Court brought the antiquities of Athens to the Capitol and helped associate the young republic with that ancient cradle of democracy.

Three years after leaving the Capitol, Latrobe died of yellow fever in New Orleans and was buried there in an unmarked grave.

A SOLID FOUNDATION

On April 4, 1803, Latrobe made his first report on the conditions at the Capitol and the problems with the arrangement of the south wing. Like Hadfield's seven years before, Latrobe's first observation concerned the relationship of the building's plan to the exterior elevation, which produced a "radical and incurable fault." The problem was the location of the House and Senate chambers in the basement. A grand stair on the west would lead to the principal floor but would force legislators to immediately descend an interior stair to reach the main rooms. The portico on the east front seemed to require a grand flight of steps, but that too would lead only to a narrow passage to the galleries overlooking the two chambers. A "poverty of design" plagued the Senate, the House, and the rotunda, because each was formed on the same idea: a one-story arcade carrying a colonnade. One was semi-elliptical (the Senate), one was fully elliptical (the House), and one was circular (the grand vestibule or rotunda), but their different shapes could not compensate for the monotonous repetition of arches and columns. These problems worried Latrobe, but he had no solutions to offer quite yet.

Turning to the south wing's plan and accommodations, Latrobe said they were inadequate, expensive, inconvenient, unsafe, and unattractive. There was nothing about the interior arrangement that warranted approval. The plan did not provide any committee rooms, nor were there offices for the Speaker, the clerk, the engrossing clerks, or the doorkeeper. There were no fireproof storage rooms for records or "closets of convenience" (a common euphemism for privies). The plan did not provide adequate lobbies or galleries. All of these facilities would be necessary for the smooth operation of business in the House of Representatives. External walls of the south wing were sixty-five feet high and could not be supported from within due to the absence of interior partitions. The dome over the chamber would exert dangerous pressure on these high, thin walls, and Latrobe said that he did not have the courage to build it. He admitted that the chamber's thirty-two columns would be visually striking, but he questioned the effect of arranging the colonnade on an elliptical plan. After working on a schematic design for an elliptical ceiling he found

it impossible to devise suitable decorations. He estimated the cost of the columns and the entablature, all made of sandstone, at $62,000. The entablature would be disproportionately expensive because half of all the stones had to be cut on different radii. If the entablature were circular, by comparison, all stones would be cut on the same radius. So much money would be spent on the columns and the elliptical entablature that the rest of the wing would have to be built with inferior materials and would not be as permanent or magnificent.

Occupying fifty-six handwritten pages, Latrobe's first report was a devastating evaluation of the Capitol's plan, particularly as it concerned the south wing and the elliptical colonnade. (It is clear that the architect was unaware of Jefferson's significant role in the design of the House chamber developed during the conference of July 1793.) Latrobe proposed an alteration to the plan that would save money and better provide for the business and comfort of the House. To illustrate the alternative scheme, Latrobe presented a ground plan (now lost) of the new arrangement. The design was in the form of a half-domed semicircle without columns. Windows in the south wall and a large lantern in the center of the ceiling would provide the room with light and air. Three hundred sixty members could be accommodated, a number somewhat larger than provided in the elliptical plan. The configuration of the room was "that of the ancient theater (exedra), a form which the experience of ancient and modern times has established as the best for the purpose of speaking, seeing, and hearing." A lobby eighty feet long behind the Speaker's chair could also be used as a retiring room for members. Access to the galleries was provided by separate lobbies and stairs that kept the public from interfering with members. Committee rooms, offices, storage space, and privies were provided around the perimeter of the hall or in the "recess," Latrobe's term for the hyphen connecting the wing to the center building.

Latrobe's report concluded with an evaluation of the structural problems plaguing the north wing. He discovered that no provisions had been made to ventilate the foundations and warned that unless openings were made the wooden timbers, flooring, and joists would be consumed with dry rot. The roof and its shingle covering were sound, but leaks could be traced to bad gutters. He condemned the

quality of the lead lining the gutters and found their defects difficult to pinpoint due to the tar and sand coating. Some gutters discharged into a rooftop cistern that was not provided with a drain. Latrobe could find no purpose for the cistern and recommended its removal. He also suggested placing new down spouts discretely on the outside walls to replace those built into the walls. The four skylights leaked badly and should be protected by lanterns with vertical sashes and closed tops. In Latrobe's opinion, the skylights were a disgrace to the men who built them. He generally disliked skylights, calling them "great evils," because "in summer they heat the house, and in winter they become darkened and often broken by the snow."[9]

While Jefferson studied the report, Latrobe appointed John Lenthall clerk of the works. This appointment, dated April 7, 1803, was necessary because Latrobe anticipated long absences from the city overseeing work on the Chesapeake and Delaware Canal. He needed a trustworthy deputy to take charge of the day-to-day operations at the Capitol, and in Lenthall he found a perfect partner. With approvals from both Jefferson and Munroe, Latrobe empowered his clerk of the works with control over all workmen, to hire and fire them without appeal. Contractors' performance would be evaluated by Lenthall, who would bring any problems to the attention of the superintendent. There were already contracts for freestone from Aquia, local building stone, and scaffold poles. A mason named Timothy Caldwell had been hired to tear out the foundations left over from the 1790s. Contracts for sand, lime, lumber, and hauling were still needed. Lenthall was to supervise the foremen of laborers and masons and to serve as the head carpenter. Work paid by measurement was measured by Lenthall. Accounts paid by Munroe were authorized by his signature. In short, Lenthall was invested with all powers necessary to make him absolute master of the works.

Construction of the south wing began with the demolition of the old foundations. Latrobe discovered that stones had been loosely thrown in the foundation trench without mortar and without being made to bear upon each other. He determined that they would have to be removed down to the "first offset," which he was told was well built.[10] The existing footings were five feet eight inches thick and would be increased four more feet

to measure a total of nine feet eight inches. While the final plan had not been settled, Latrobe's penchant for vaulted construction required massive foundations to bear the loads that would be imposed on them.

Just two weeks after his appointment, Lenthall was summoned by Jefferson to discuss the pace at which demolition was proceeding. The president thought that the work did not have sufficient "spirit," but he was assured that all the old stonework would be removed in two days and the new foundations would begin soon. Twenty-three weeks remained in the building season and Jefferson suggested dividing the stonework into twenty-three portions to ensure that it did not fall behind schedule.[11] The outside walls would rise, fencing in the "oven," while the president considered whether to retain the original plan or to approve Latrobe's revisions.

Writing from Philadelphia, Latrobe instructed Lenthall on May 5, 1803, to "pull up or knock down" the stonework in order to build "*my* plan." The bad stonework in Thornton's plan was "new proof of the *stupid genius* of its Author."[12] This characterization of Thornton was the first of many times the architect denounced the doctor, whom he considered nothing more than a charlatan. Latrobe tended to blame Thornton for all the faulty construction he encountered at the Capitol in addition to the countless faults he found in its design. For his part, Thornton tended to take credit for all aspects of the Capitol design, even Hallet's plans for the wings. Both strong-willed and self-assured, Latrobe and Thornton embarked upon a collision course that eventually landed them in court and would ultimately reflect little credit upon either man.

A discrepancy that Lenthall noted in the elevations of the north wing added to Latrobe's already low opinion of Dr. Thornton. The west elevation was sixteen inches shorter in length than the east. For the sake of appearance and consistency, Lenthall wanted to know if it was best to repeat the mistake in the south wing. Latrobe determined that unless his east and west walls matched precisely, the internal vaulting would be thrown off. It would be better to suffer a small evil on the outside in order to have the advantage of working symmetrically on the interior. And since the central conference room (a feature not yet discarded) would project beyond the western walls of the two

wings, the fact that they did not exactly match would hardly be noticeable.[13]

Just when Jefferson and Latrobe decided to do away with the conference room is not precisely known. Both surely recognized the architectural problems that room created, chiefly how to cover it with a roof that did not conflict with the dome over the rotunda. Design issues aside, the president had no use for the conference room because of his republican views and his aversion to speaking publicly. Unlike his two predecessors, Jefferson chose not to deliver his annual message before joint sessions of Congress. Instead, his secretary carried the message to the Capitol where a clerk read it to representatives and senators. This saved Jefferson the necessity of making a speech and avoided the annoying spectacle of legislators coming to the President's House en masse to make their reply. Endless speeches, courtly bows, tedious protocol, and pointless ceremony were all things the third president found objectionable in the previous Federalist administrations, and he intended to eschew them as far as possible in his. The trappings of monarchy had no place in a democracy, where all citizens were supposed to be equal. As his biographer Dumas Malone pointed out, Jefferson may have promoted classical public buildings as "civic temples," but he wanted no part in "glorification of rulers."[14] Because the conference room in the Capitol was intended as a stage for presidential pomp and pageantry, it would crumble to dust before Jefferson would appear there. His notions of republican decorum were better served by simply staying home. (Jefferson's policy continued until 1913, when Woodrow Wilson went to the Capitol to deliver his annual message in person.)

In the fall of 1803, the wife of Congressman Samuel L. Mitchill heard that the Senate adjourned for three days so its members could attend the horse races that were such a popular pastime in early Washington. Without an apology her husband replied: "The Senate actually did adjourn for three days, not on account of the races . . . but merely to admit a mason to plaster the ceiling of their chamber, which had fallen down a few days before." Mitchill then confessed that he and a number of ladies and clergymen were at an "exhibition of the speed of horses," but claimed the recreation was needed because members had worked so diligently on the "Louisiana business."[15] Latrobe asked Lenthall about the ceiling's tumble and wanted to know the cause of the accident.[16] Luckily, the room was empty at the time the ceiling fell and no injuries were reported. It was, however, yet another indication of the shoddy workmanship plaguing the north wing.

RETHINKING THE SOUTH WING

*L*atrobe reviewed his first year's accomplishments in a report to Congress on February 20, 1804. He had been in Philadelphia or Delaware during much of the previous summer and fall but did not believe his absence from Washington affected the work there. The building season had not produced dramatic results and he blamed the slow progress on wet weather, which flooded the freestone quarry, and the lack of workmen, who were not easily reassembled for the resumption of the Capitol's construction. Work ceased when Congress convened in mid-October, cutting short the building season by six weeks. The perimeter walls of the south wing reached only half the height of the

**A Section of
the House of Commons Dublin**

by Rowland Omer,
Engraving by Peter Mazell, 1767

*T*he first building designed specifically to
accommodate a bicameral legislature was the Parliament
House in Dublin (1728–1739) by Sir Edward Lovet
Pearce. The House of Commons consisted of a one-story
arcade supporting two-story columns supporting, in
turn, an entablature and a domed ceiling. This
arrangement was cited as the prototype for the House
chamber depicted in the "conference plan" of 1793.
Jefferson envisioned the ceiling with tapering skylights
like the ones he admired at the Paris grain market.

ground floor, yet were high enough to block some
of the light to the "oven." Lenthall added a roof
lantern to help compensate for the loss. He also
relaid the floor to accommodate the 142 members
of the Eighth Congress. Stout braces were installed
to shore up the walls, which threatened to col-
lapse under the weight of the roof. In all, $555 was
spent to repair the temporary House chamber. For
the Senate, a stove was added under the floor to
help heat the room, the cellars were plastered to
control dampness, and vents were cut through the
foundations to expel trapped moisture that threat-
ened to destroy the wooden joists and flooring.
The roof and skylights were also repaired.[17]

Soon after the House of Representatives
received Latrobe's first annual report, it responded
with questions about plans for its future accommo-
dation in the south wing. A committee asked Latrobe
to describe the original plan of the Capitol,
specifically the part that was intended for the House,
and to give his opinion regarding opportunities for
improvement. Latrobe replied with a description of
the original plan for the south wing as a three-story
room, about 108 by 84 feet with an elliptical arcade
supporting columns that in turn helped support the

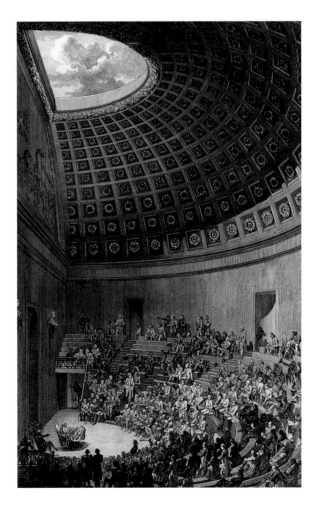

**Ecole de Chirurgie
[School of Surgery]**

Engraving by Claude-
Rene-Gabriel Poulleau

In Jacques Gondoin's
*Description des
ecoles de chirurgie:
Paris, 1780*

Boston Athenaeum

*I*n Latrobe's opinion,
the best form for a leg-
islative chamber was
semicircular in plan cov-
ered by a half-domed ceil-
ing. One of the precedents
cited was the surgical
theater in Paris, consid-
ered an excellent room
for speaking, hearing,
and seeing. It was also an
appealing classical form
that recalled the architec-
ture of ancient Rome
and Greece.

roof. To visualize the design, he told his readers to imagine the Senate chamber doubled and formed into a complete ellipse. The description was followed by a list of eleven objections, including the absence of committee rooms or offices, and the need for such things as privies and fireproof repositories for records. All of these objections had been expressed to the president, but now Congress learned of them as well. Major improvements to the plan, which the president was then considering, involved raising the hall of the House to the second, or principal, floor and devoting the first floor entirely to offices and committee rooms. The change would not alter the exterior appearance of the wing.[18] The idea of moving the hall of the House to the second floor occurred to Latrobe after the president rejected his semicircular plan as too great a departure from the original elliptical configuration.

President Jefferson had the authority to approve the changes that Latrobe proposed, but he did not want to exercise that authority without Dr. Thornton's concurrence. To smooth the way, Latrobe arranged a meeting with Thornton to explain his proposals. It was not a pleasant encounter. Using a defense first employed against Hallet, Thornton dismissed Latrobe's objections to the plan by saying that any and all difficulties could be overcome unless those in charge "were too ignorant to remove them." He abruptly refused to discuss the subject further except to say that he considered Latrobe unfit to execute the plan. His manner, tone of voice, and expressions were highly offensive to Latrobe, who had not expected to be treated so rudely. Latrobe left with a determination to resign but thought better of it by the time he wrote Jefferson an account of the meeting.[19] The president regretted that it had been a failure. He was still ambivalent about the proposed changes to the plan and observed (from firsthand experience) that "Nothing impedes progress so much as perpetual changes of design." He also thought the chamber devised in the "conference plan" would be "more handsome and commodious than any thing which can now be proposed for the same area." The Halle au Bled dome would doubtless make it the finest room in America. And while its structural problem presented "difficulties to the Executor," the president said that "it is to overcome difficulties that we employ men of genius."[20]

Jefferson's letter was meant to coax the architect into giving up his quest for changing the plan of the south wing. Latrobe's mind, however, was made up. His job now was to demonstrate how a domed chamber could be accommodated in a two-story space built atop a floor devoted to offices and committee rooms. On February 28, 1804, Latrobe promised Jefferson that he would soon send drawings of the south wing and pleaded for the office story: "If the house be raised to the level of the top of the basement story, I will withdraw all further opposition to the colonnade and its elliptical form."[21] He began working on the drawings soon after returning to Delaware. Latrobe bemoaned his latest challenge in a letter to Lenthall:

> I am laboring at the plan, retaining the elliptical colonnade. My conscience urges me exceedingly to throw the trumpery, along with my appointment into the fire. When once erected, the absurdity can never be recalled and a public explanation can only amount to this, that *one* president was block headed enough to *adopt* a plan, which *another* was fool enough to *retain,* when he might have altered it. The only discovery which I have made in *elaborating* the thing . . . is that the Doctor was born under a musical planet, for all his rooms fall naturally into the shape of fiddles, tambourines, and Mandolins, one or two into that of a Harp.[22]

It is evident Latrobe was unaware that Dr. Thornton did not draw the plan of the wings that included so many rooms shaped like musical instruments. Most of the credit (or blame) for that belonged to Stephen Hallet. Latrobe also thought the domed rotunda was George Hadfield's idea, when in fact it was the one part of the plan that Thornton could rightly claim as his own.[23] Such was the confused state of attribution, even at that early date.

On March 16, 1804, the House of Representatives passed an appropriation of $50,000 to continue work on the south wing. The appropriation was sent to the Senate, where dissatisfied members sought to kill or amend it. Robert Wright of Maryland proposed removing the capital to Baltimore as a means to scare local citizens into making more comfortable accommodations available to legislators. After a day of debate, Wright's bill was defeated. Soon, another proposal was offered by Joseph Anderson of Tennessee. He wanted the President's House transformed into the Capitol and a house rented for the president. The Senate

agreed, but the House refused and the appropriation languished in congressional deadlock.[24]

When Latrobe learned of the proposal, he blamed the "Blockheads" in the Senate.[25] On the last day of the session, Anderson reported that the conference could not agree on his recommendation and advised deferring it until the next session. Faced with causing work to stop, the Senate disagreed with Anderson's report and dropped its objections to the appropriation. It was approved on March 27, 1804. Construction would continue on the Capitol and Jefferson could stay in the President's House.[26]

Two days after the appropriation was signed, Latrobe sent Jefferson a roll of drawings for the south wing illustrating his latest idea for the House chamber. The most important drawing showed the elliptical colonnade converted into "two semicircles abutting upon a parallelogram." The slight alteration offered several distinct advantages: it would

be less expensive; it could better accommodate chimney flues rising from below; and it could give the location of the Speaker's chair a "decision of character." Yet, the curving colonnades preserved "*the principal, and the great feature of the original design.*" In the first story, Latrobe provided six committee rooms and a large room for clerks. The spaces deep within the wing, without access to natural light and ventilation, were devoted to fireproof record storage vaults, privies, and furnace rooms. The principal way to the chamber would be through a series of domed vestibules, vaulted lobbies, and a staircase closely confined by thick masonry walls. Proceeding along this path, encountering a variety of spacial experiences, lighting conditions, and "scenery," would be one of the special architectural treats offered by Latrobe's new plan.

Along with the plans, Latrobe sent two sections of the wing, both of which showed the House

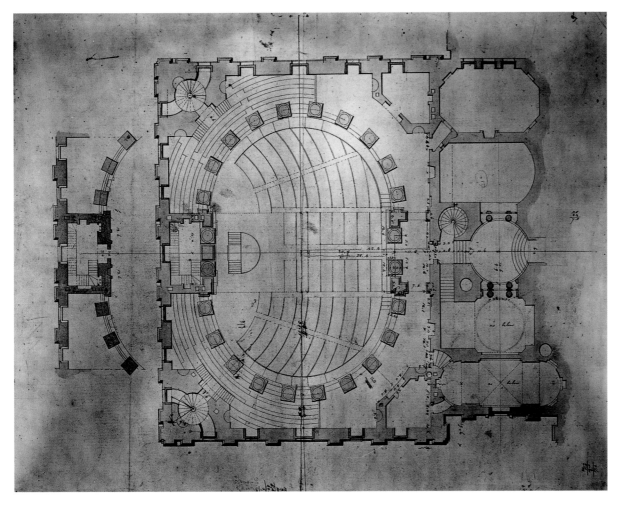

Plan of the Second, or Principal Story of the South Wing

by B. Henry Latrobe
1804

Library of Congress

*I*n place of an elliptical chamber, Latrobe designed two semicircular colonnades connected by a "parallelogram." In the area between the wing and the rotunda he planned a committee room, a parlor, a courtyard, and a circular vestibule ornamented with stone columns.

Plan of the Ground Story of the South Wing of the Capitol

by B. Henry Latrobe
1804

Library of Congress

*L*atrobe's plan provided six committee rooms, a large office for the clerk, indoor privies, and other useful facilities not found in earlier plans. Committee rooms were placed along the east (bottom) and west (top) walls with windows that provided light and air. The middle parts were occupied by furnace rooms, record vaults, and passageways. Structural considerations imposed by the chamber above resulted in an unusually complex arrangement.

Despite British incendiaries and minor remodeling, most of the office story survives today, containing some of the Capitol's oldest interior features.

chamber in its newly proposed configuration. One drawing illustrated the ceiling held by columns based on the ancient Tower of the Winds in Athens. He suggested that the capitals be made of cast iron with the lower range of leaves attached to the bell by rivets or screws. (Such an idea was prophetic, but metal column capitals would not appear at the Capitol until 1828.) A second section showed the chamber in the Doric order, which the president apparently preferred, accompanied by a long explanation regarding the difficulties with its entablature. It was impossible to regulate the metopes and triglyphs without violating the rules governing their disposition. The Tower of the Winds order was easier to work with, and would produce a richer effect in any case. Latrobe placed

the drawings into the president's hands asking him to acknowledge his hard work even if he did not approve the results.[27] Working in his temporary quarters in New Castle, Delaware, Latrobe took just three weeks to conceive the new design for the House chamber, arrange an office story, and consider which order to use. Communicating these ideas through beautifully rendered drawings made Latrobe's efforts all the more remarkable.

Jefferson received the drawings at Monticello on April 6, 1804, and wrote Latrobe three days later with his general approval. Moving the chamber to the second floor was finally accepted, but he wanted more time to think about the shape of its colonnade. The plans for the recess were also approved, but its construction was postponed

Section of the South Wing, Looking South

by B. Henry Latrobe, 1804

Library of Congress

*S*hown in the center of the drawing is a seated figure of Liberty later modeled by Giuseppe Franzoni. The statue presided over the Speaker's rostrum (not shown) and, along with the drapery and carved eagle, helped give the chamber a strong focal point.

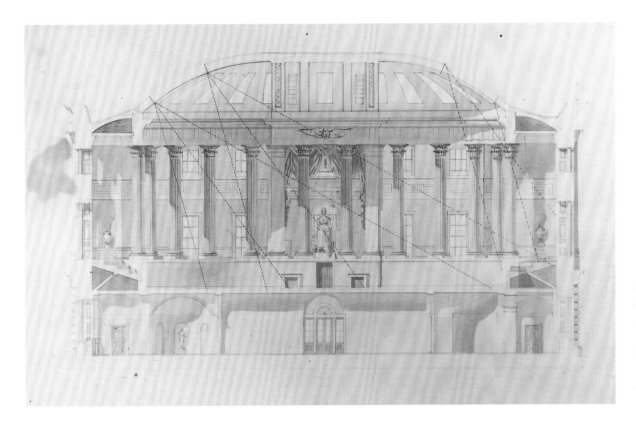

Sketch of a Section of the South Wing of the Capitol of the United States at Washington, of the Doric Order, Roman style

by B. Henry Latrobe
1804

Library of Congress

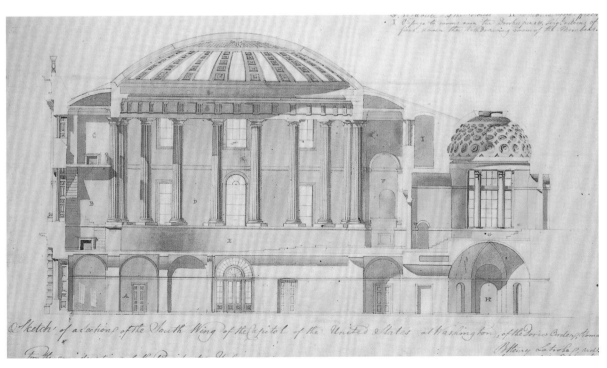

*T*o demonstrate that the Doric order would not work for the House chamber, Latrobe drew this section showing the distribution of metopes and triglyphs belonging to the entablature. He could not make the metopes square, as dictated by the rules of classical architecture, and felt therefore that the Doric order was unworkable. President Jefferson, also a stickler for architectural rules, subsequently abandoned Doric in favor of Corinthian.

because the appropriation covered the south wing only. On the matter of what order to use in the chamber, Jefferson acknowledged the problem with the Doric entablature and concluded that "we must make this [room] Corinthian, and do the best we can for the capitals and modillions." The drawings were returned to Latrobe with the president's appeal to push mightily and finish the outside by summer.[28]

TROUBLE WITH THORNTON

Soon after Jefferson approved the revised plan of the south wing, the "oven" was demolished. Pulling down the unsightly and unsound building was a victory for Latrobe and his aspirations for a House chamber that would be a credit to himself, the president, and the country. Dr. Thornton, however, saw matters quite differently. The Capitol's original design had been sanctified by George Washington's blessing and was being altered for no reason. Thornton did not appreciate the improvements made to the interior architecture or the practical accommodations provided in the revised plan. Nor could he remain silent when criticism was heaped upon the Capitol's plan, which was one of Latrobe's special talents. Latrobe's report to Congress containing the scathing (and entirely justified) critique of the original plan was too much for Thornton to take. On April 23 he responded by declaring Latrobe's report insulting, uncivil, ungentlemanly, and false.[29]

On April 28, Latrobe poured out his scorn and anger in a letter to Thornton. He reminded the doctor of his rude, insulting behavior when they discussed alterations to the plan of the south wing, a pattern of conduct that was repeated whenever they met. Despite "the confusion of your conversation, and the rubbish of your language" Latrobe tried to keep Thornton informed about his thoughts regarding the Capitol but was continually rebuffed. "Those who despise you most in Washington," Latrobe wrote, "can bear witness to my perseverance in this resolution." In one of its calmer passages, he said:

> Open hostility is safer, than insidious friendship. I cannot therefore regret the declaration

of War contained in your letter . . . I now stand on the Ground from which you drove Hallet, and Hadfield to ruin. You may prove victorious against me also; but the contest will not be without spectators.[30]

Each man continued to pelt the other with insults for nine years until a court of law put the matter to rest. Confident in his professional skills and prerogatives, Latrobe was matched against a master of slander whose attacks occasionally took the form of sarcastic little poems that were circulated around Washington. One such rhyme involved the grave of a woman of ill repute named Moll Turner, whom Thornton imagined had been led to ruin by Latrobe:

> The monument of poor Moll Turner!
> Whose clay so soak'd that Hell can't burn her.
> How died poor Moll?—Moll died of spleen,
> Because she found Latrobe too keen:
> In other words, he broke Moll's heart,
> He so out play'd the blackguard part!
> What! Out-matched Moll?—yes, rough or civil,
> He can out-jaw—out-lie the Devil.
> Hell dries the clay of poor Moll Turner,
> And waits Latrobe as fuel to burn her![31]

As if Thornton were not making life miserable enough, Latrobe's relationship with the president faltered during this period. The architect convinced Jefferson that the "oven" had to be removed before work resumed on the south wing in the spring of 1804. Jefferson was hesitant to approve demolition, thinking the House of Representatives could meet in the little building for one more session. But the arguments in favor of its removal were strong and the president relented. The House would be returned to the library in the north wing for its next session. Jefferson spent the summer away from Washington and upon his return in the last week of September he found no progress at all on the interior walls, which were supposed to have been built simultaneously with the outside walls. That was the premise upon which he had permitted the "oven" to be demolished. According to Lenthall, who took the brunt of the president's displeasure in Latrobe's absence, the problem was sickness among the workmen. Jefferson dismissed the excuse, saying that replacements should have been employed.

The real problem was the result of a misunderstanding of the president's wishes. Lenthall thought Jefferson wanted work concentrated on

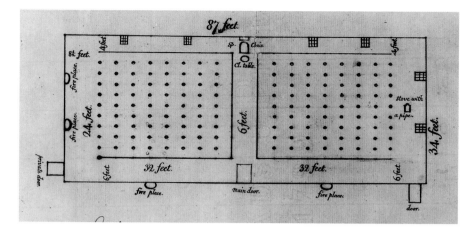

\mathcal{F}ollowing demolition of the "oven" in the spring of 1804, the House of Representatives was again obliged to hold its sessions in the north wing. This plan (with west at the top) shows the Library of Congress arranged to accommodate 142 members of the House.

the outside walls, which were then up to the attic window sills. With little time remaining in the building season, Jefferson ordered all efforts redirected at the cellar walls so there would be something new to show where the old building had once stood. Overall, more effort would be needed to finish the south wing, which was falling behind schedule: "Nothing but the greatest exertion can render possible the completion of the work the next year, and the cramming of the Representatives into the library a second and long session," Jefferson wrote.[32]

Jefferson ordered Latrobe to return to Washington as soon as possible. He arrived on October 11 and immediately wrote the president an apologetic letter to explain his long absence. His wife's mother had died suddenly. Commitments had detained him in New Castle. When traveling with his son to Baltimore, where the lad was enrolled in a "French Academy," sickness detained them en route. Such were the circumstances surrounding Latrobe's summer away from the Capitol. Having sent letters and drawings to Lenthall, he did not believe that he had neglected his duty, but he suspected that his absence had cost him the president's confidence.[33] Despite the apologies and explanations, Latrobe's part-time approach to his Washington work was beginning to cause problems.

The second session of the Eighth Congress convened on November 5, 1804. A week later Jefferson instructed Latrobe to write a report on the progress made at the Capitol, giving an estimate of the probable cost of finishing the south wing. He detected opposition in Congress to further appropriations due to the slow pace of construction. After the

report was submitted, Latrobe was expected to brief key members to give them the information necessary to secure the appropriation.[34] Writing from Wilmington, where he was attending a meeting of the Chesapeake and Delaware Canal Company, Latrobe promised to have the report ready upon his return to Washington.[35]

Latrobe's report was finished on December 1 and, after some judicious editing by Jefferson, transmitted to Congress five days later. After discussing the repairs made to the roof of the President's House, Latrobe turned to the Capitol, beginning that section with a long explanation of the reasons why more progress had not been made during the past building season. "The first and principal of these," he wrote, "have been the time, labor, and expense of pulling down to the very foundation all that had been formerly erected." Sickness and rain were retarding factors as well. While he acknowledged it would have been best to carry up the inside walls along with the outside ones, he explained that building the outside walls kept the stone cutters from being idle. (This excuse may have been valid, but was not what the president wanted.) He reported that the southern half of the cellar was finished, and while it might not appear significant, the work there had been considerable.[36]

Latrobe's report did not contain an estimate for completing the south wing, but it asked for an appropriation exceeding the usual annual stipend of $50,000. In a letter to the chairman of the committee to which the report was referred, Congressman Philip R. Thompson of Virginia, Latrobe stated that $109,100 would be needed to finish the wing and $25,200 to build the recess. He reasoned that

one appropriation of $100,000 would guarantee that the House would occupy its new chamber in December 1805.[37] Latrobe would soon regret making a promise that he could not keep, but it helped secure the appropriation because no representative wanted to be crammed into the library any longer than necessary. On January 25, 1805, Jefferson approved $110,000 for the south wing and another $20,000 to repair the north wing and other public buildings.[38]

ITALIAN SCULPTORS

*E*ncouraged by the generous appropriation, Jefferson and Latrobe now acted upon the idea of using allegorical as well as architectural sculpture in the House chamber. Skilled modelers and carvers were needed to carry out the scheme. It would be necessary to look to Europe for artists who might be enticed to Washington by the promise of steady and reasonably well paid employment. Two days after Jefferson's second inaugural, Latrobe wrote Philip Mazzei asking for "assistance in procuring for us the aid of a good Sculptor in the erection of public buildings in this city, especially the Capitol." Mazzei was an old Italian friend of the president who had come to Virginia in 1773 and settled near Monticello. Mazzei was interested in growing Italian olives and grapes in America, and became friends with his famous neighbor. He returned home in 1785 but saw Jefferson occasionally in Paris. Now, twenty years later, Mazzei was the person Jefferson thought best able to recruit sculptors for the Capitol.

Latrobe described the kind of work that would be expected from the persons engaged in the sculptural program. First, he needed someone to carve twenty-four Corinthian capitals, two feet, four inches in diameter and an "enriched" entablature 147 feet long. Next was a colossal eagle for the frieze with wings extending twelve feet, six inches. Wages offered the best carvers ranged from $2.50 to $3.00 a day, while assistants could expect $1.50 to $2.00. Although only skilled sculptors would do, he also wanted men who would feel comfortable in Washington:

> There are however other qualities which seems so essential, as to be almost as necessary as

talents, I mean, good *temper* and good morals. Without them an artist would find himself most unpleasantly situated in a country the language and customs of which are so different from his own, and we could have no dependance on a person discontented with his situation. For though every exertion would be made on my part to make his engagement perfectly agreeable to him the *irritability* of good artists is well known and is often not easily quieted.[39]

The American consul in Leghorn would arrange passage for the sculptors, who should be prepared to sign a two-year contract. Single men were preferred, but if married men were selected they were welcome to bring their families to America. Upon conclusion of the work return passage would be provided by the American government.

Before closing his letter Latrobe asked Mazzei if he could find out how much Antonio Canova would charge for a seated figure of Liberty nine feet high. If the marble were too heavy for a transatlantic voyage, perhaps Canova would model a plaster statue that could be more easily shipped. It could later be carved in American marble. If Canova refused the commission because of his age, could he recommend another first-rate sculptor?

Jefferson had not always approved the notion of stone columns with stone capitals for the House chamber. Just a year earlier he asked Latrobe if it would be possible to make the interior columns of brick with a coating of plaster. He cited Palladio as one authority who approved of this practice and indicated that there were such columns in Virginia twenty feet tall that were executed by a "common bricklayer."[40] Such shortcuts were anathema to Latrobe, who strove to build with only the finest, most long-lasting materials available to him. While he won the fight for stone columns, his preference for capitals modeled after those at the Tower of the Winds was overruled. Jefferson preferred the Roman order of the Temple of Jupiter Stator (known today as the Temple of Castor), which came highly recommended by Palladio. Its sculptural complexity helped create the need to import skilled carvers.[41] A final decision on which order to use had not yet been made, and Latrobe still hoped that he could introduce a Grecian order in the House chamber.

UTILITY VERSUS BEAUTY

While Jefferson was satisfied with construction progress, he was disappointed to learn of Latrobe's concerns regarding the Halle au Bled dome over the chamber. Of all the things Latrobe could object to, the ceiling based on the Parisian grain market was the most dear to the president. It had made an indelible impression upon his mind while he was living in France, and from his earliest involvement in the Capitol he had hoped to recreate it over the House chamber. The long, tapering ribbons of glass set between the ribs of the dome would dazzle the room with light, surprising the visitor with unexpected brilliance. Latrobe wrote the president on August 31, 1805, with a list of reasons to abandon the scheme and drawings to illustrate his points. He showed how light would enter the hall during different times of the day and at different times of the year. Sunlight would be annoying during the winter and troublesome in summer. But the real problem was the difficulty of preventing leaks. Each of the twenty skylights was five feet wide, fifteen feet long, and made up of forty panes of glass. With a total of 800 panes and 2,400 joints, the skylights were guaranteed to leak. It would take just one leak dropping water on the head of a congressman to disrupt the whole House. Frost would make leaks unavoidable, while "careless servants" clearing snow off the roof would surely break the skylights. A hail storm would break the glass in a minute. Even if the skylights did not leak, condensation would drip from the cold glass. Other difficulties were mentioned, such as the price and quality of glass or the use of blinds to control sunlight, but keeping water off members' heads was Latrobe's primary concern.[42]

Jefferson was distressed to learn that Latrobe thought it impossible to build a watertight dome over the House chamber with the skylights that he so admired. Yet, despite a deep sense of regret, he was prepared to yield the point. He reiterated his contention that the Halle au Bled dome would have made the chamber the handsomest room in the world.[43] But, uncharacteristically, Jefferson left the decision to Latrobe. This put the architect in the unenviable position of choosing either to disappoint the president or to soak members of the House. He declined to make the choice, suggesting to the president that they review the topic in the near future.[44]

Latrobe spent most of the fall of 1805 in Delaware. While there, he searched his mind for a solution to the skylight problem and by mid-November had developed a variation of the Halle au Bled dome that he thought just might prove satisfactory. Instead of a continuous expanse of glass between the ribs, Latrobe proposed a range of five graduated skylights resembling coffers but with glass backs. Twenty ranges would be necessary bringing the total number of "panel lights," as he called them, to 100. Because each panel was small enough to be covered by a single sheet of glass, the problem with joints was virtually eliminated. Wire

Halle au Bled

In L. V. Tiéry's
Guide des amateurs et des étrangers vouageurs à Paris (1787)

Jefferson was "violently smitten" by some of the newer buildings in Paris when he was American minister to France (1785–1789). He was particularly taken by the grain market and its wooden dome, finished just before he arrived in France. He regarded the Halle au Bled as "the most superb thing on Earth." Its dome and tapering skylights literally dazzled him. Jefferson proposed such a dome for the President's House (in his anonymous competition entry of 1792), the Capitol (over the House chamber), and the Washington Navy Yard (over the dry dock). A variation of the Halle au Bled dome for the Capitol's south wing was the only one built.

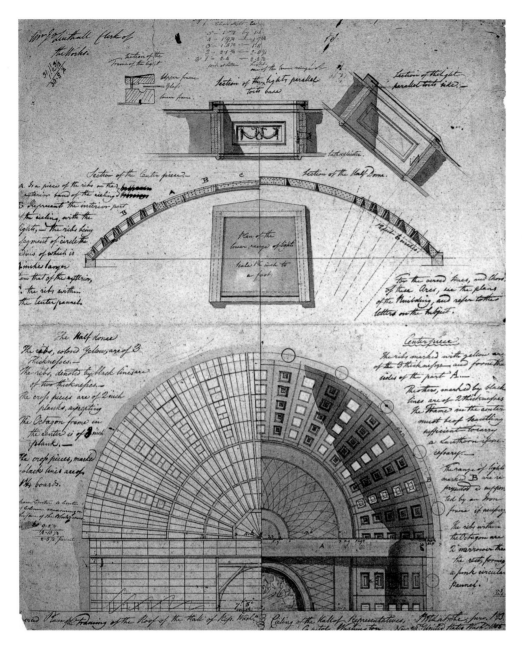

House Chamber Ceiling and Roof Details

by B. Henry Latrobe, 1805

Library of Congress

*L*atrobe struggled to reconcile Jefferson's desire to recreate the Halle au Bled dome over the House of Representatives with his own hopes for a watertight ceiling. In the fall of 1805, he hit upon the idea of using "panel lights," which promised to give much the same effect but could be made watertight. This sheet shows a reflected plan (bottom) of half of the ceiling with fifty individual "panel lights" along with waterproofing details.

screens could protect the glass from hail or careless servants. The new arrangement approximated the visual effect that the president wanted but avoided many of the problems. Latrobe sent Lenthall a detailed drawing of the proposed ceiling on November 25 but wanted to wait until he returned to Washington before telling Jefferson about the new plan.[45]

Just before the roof drawing was sent, Lenthall received detailed drawings for the wooden trim of the rooms in the office story. The paneled window jambs in the "squint eyed" committee rooms (modern day H–109 and H–153) were troublesome, and Latrobe encouraged his clerk to come up with better designs if he could. Due to the thick mass of masonry at the southeast and southwest corners of the wing, Latrobe was obliged to connect end windows with interior rooms via jambs that were splayed at a steep angle, earning the rooms their "squint eyed" nickname. The architect wanted to pave the corridors with marble and floor the offices and committee rooms with wood, but he feared that he might have to yield to Jefferson's preference for French tiles. Window shutters would not be made to match those in the north wing, which Latrobe considered "ill framed and ill paneled." Shutters with three equal flaps worked best, but, again, he left the details for Lenthall to decide.[46] Designs for the window sash, frames, doors, and trim were settled and the carpentry work could proceed while Lenthall tinkered with details.[47]

On December 22, 1805, Latrobe finished his third annual report. He began by blaming the "limited resources of this City" for disappointing his hope of seating the House in its new chamber. He explained that a number of large construction projects in Washington and Baltimore were competing for a limited supply of materials and workmen. Problems with the quarry also delayed the work. Yet, the cellars and the office story were finished, and most of the columns for the chamber were received although none had been installed. Of the $110,000 appropriation, a balance of $34,605 remained, and Latrobe wanted an additional $25,000 for the wing and $25,200 for the recess.[48] Annoyed by the architect's broken promise, a committee of the House instructed the president to have their new chamber ready next year without fail.[49] Congress then appropriated $40,000 for completing the south wing and the recess.[50]

FRANZONI AND ANDREI

While in Philadelphia, Latrobe learned that Giuseppe Franzoni and Giovanni Andrei, two sculptors recruited by Phillip Mazzei, had arrived in Washington at the end of February 1806. Mazzei turned out to be a diligent agent who was delighted to help his old friend Jefferson. He scoured the Italian countryside looking for sculptors to work in America, traveling to Rome and Florence before finding two excellent artists whom he thought would exceed all expectations. Mazzei described them as well tempered, not too old or too young, and "republicans at heart." They had good morals and even tempers, and they were more than capable of performing the work expected of them. Both Andrei and Franzoni could model and carve marble. On the matter of the figure of Liberty, Canova did not have the time to make it, but Mazzei mentioned it to Bertel Thorvaldsen, the great Danish sculptor who worked in Rome. (He later discovered that Thorvaldsen's fee was astronomical.) Franzoni could certainly make the statue of Liberty as well as anyone, but Mazzei thought that it should be carved in Rome, "where the mind of the Artist is sublimed . . . by the sight of so many and so grand Objects."[51]

Latrobe immediately set Franzoni to work on the enormous eagle for the frieze above the Speaker's rostrum. Having never seen an American eagle, he modeled the body and head from memory, producing a distinctively un-American –looking bird. To give Franzoni a better idea of the appearance and character of an American eagle, Latrobe wrote Charles Willson Peale in Philadelphia asking if he could send a drawing of the head and claws of the bald eagle, the "general proportions with the wing extended and especially of the arrangement of his feathers *below* the wings when extended." The eagle that Franzoni started looked Italian, Roman, or Greek, but Latrobe knew that unless it became authentically American it would be "detected by our Western Members."[52] Peale promptly sent a box containing the head and neck of the "American white head eagle, that was not bald, 'tho commonly called so." Peale promised that a drawing of the wings and feet would soon follow.[53]

After working on the sculptural decorations for two months, Andrei and Franzoni had proved them-

selves complete masters of their art. Jefferson and Latrobe were delighted with the prospect of further enrichments for the House chamber. Unsolicited, the sculptors were given a pay raise, free housing, and the right to take apprentices. The president ordered these extraordinary measures to make them content in their new jobs.[54] Latrobe wrote Mazzei an especially warm letter of thanks for his efforts on behalf of the Capitol and art in America. Mazzie was told that Andrei would model the "roses and foliage and capitals" while Franzoni would do the figural sculpture, although much of this would not be needed for some time. Between the two, Latrobe "distributed the department of *animals* to Franzoni and of *vegetables* to Andrei." The letter concluded with a "very prolix" account of the federal city, in which the author heaped scorn on the designs of the Capitol and President's House that were selected by the first president. "General Washington knew how to give liberty to his country," Latrobe wrote disdainfully, "but was wholly ignorant of art." Thornton and Hoban were treated in a similar fashion: the first was "very ignorant in architecture," while the second produced "a badly mutilated copy of a badly designed building near Dublin." Further, L'Enfant's plan had in it everything that could retard the city's growth. According to Latrobe, the only reason the government moved to the federal city was to win southern votes in President Adams' reelection bid. The history of the city preceding the Jefferson administration, particularly before 1803, when Latrobe became the surveyor of the public buildings, was a *"Gigantic Abortion."*[55] It was not unusual for Latrobe to vent his opinions among family or close associates, but unloading such indignation on Mazzei, whom he had never met, was unwarranted.

In an effort to keep construction on schedule, Jefferson asked Latrobe to predict the progress that would be made from May 1 to October 1, 1806, and to report actual progress every two weeks. The architect projected that by the first of July all the columns on the east side of the House chamber would be installed, the west architrave would be up, and all of the first-story window sash would be in place. The report filed for that period, however, shows that although the columns were in place only half of the architrave was up and none of the sash was in.[56] Work was falling behind schedule. Blagden could use at least six more stone cutters

View of the Capitol from the Northeast

by B. Henry Latrobe, ca. 1806

Maryland Historical Society, Baltimore, Maryland

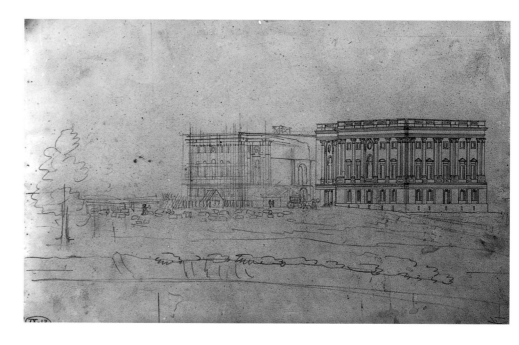

*T*his unfinished sketch shows the south wing under construction standing next to the mostly completed north wing. Although identical on the exterior, the interior finishes of the two wings were very different.

Since the end of the north wing is shown as five bays wide, instead of seven, this otherwise charming sketch testifies to an imperfect memory.

and the president urged Latrobe to hire them in Philadelphia, paying traveling expenses and beginning their wages from the day they started off for Washington. But Latrobe soon discovered that master stone cutters were hard to find at any wage and thought that he might have to hire less skilled hands. He also tried to recruit cutters from New York but held out little hope for success.[57] Five stone cutters were eventually found in Philadelphia, three came from New York, and six more were expected from Albany.[58] Yet, despite these successes, the president found the stone work falling more and more behind and holding back the carpenters and plasterers. He now wanted at least twelve cutters, saying that "every day's delay in their arrival still must add to the number to be sent on. Price must not be regarded."[59] Unfortunately, the president's last statement gave Latrobe an excuse to overspend his accounts.

By mid-August all the columns were set in the House chamber and only one rough capital remained to be hoisted. Part of the frieze was also completed. The increased number of stone cutters placed a greater demand upon the quarry, which could not keep up with orders. The recess was under way at last, its first story complete and the centerings struck for the second-floor rooms.[60] (Centerings are the temporary wooden frames on which masonry arches and vaults are constructed.) A great deal of progress could be seen; however,

only a miracle would finish the new chamber by December as promised.

After an absence of ten weeks, Jefferson returned to Washington at the beginning of October. He soon went to the Capitol to inspect the roof of the south wing and was dismayed to find that no provisions had been made for the panel lights. Instead, the roof framing was prepared for a central lantern. Jefferson and Latrobe had agreed that a lantern could be used temporarily if the glass for the panel lights did not arrive in time for the meeting of Congress in December. But now it was obvious that the room would not be occupied that soon, and Jefferson saw no reason to build the lantern. He wrote a stern note to Lenthall ordering the lantern abandoned and the panel lights built. Upon learning of the president's displeasure, Latrobe wrote another apologetic letter saying that the roof framing would accommodate the panel lights but hoped the president would reconsider using them. Twenty years of experience convinced the architect that the panel lights would permit unpleasant light to fall upon members' desks every sunny day and water to drip upon their heads when the weather changed from warm to cold. The glass for the skylights, ordered from Germany in December 1805, had not yet arrived and Latrobe postponed making the frames. His apology concluded with two more objections to this method of lighting the House chamber: it

would give the room an inappropriate "air of the highest gaiety," and would lack a "unity of light" that was necessary to show architecture and sculpture to advantage.[61]

Despite all the appeals, Jefferson refused to abandon the Halle au Bled dome. He was delighted with the architect's substitution of glass panels for the continuous skylights because the lighting would be milder, the light could be easily controlled by venetian blinds, the chance of leaks was far less, and the arrangement was original. The beauty of the ceiling could not be doubted because the world had already handed down its verdict in Paris. If the experiment failed, the lantern could be built, but Jefferson was not willing to abandon the panel lights without a trial.[62]

EXPLANATIONS AND EXCUSES

Latrobe's 1806 annual report was another explanation of the reasons why the south wing remained unfinished. Difficulty with stone delivery was cited as the principal cause of disappointment, although "every encouragement was offered to the quarriers to make extraordinary exertions." The roof framing, plastering, and carpentry, which depended on finishing the interior stonework, also lagged behind schedule. Lack of an established building industry in the infant city put a strain on those who undertook large projects such as the Capitol's south wing. The need to bring in materials from distant places, such as lumber from Maryland's Eastern Shore or lime from New England, also tended to retard progress. And while he had already been granted two appropriations for completing the south wing, Latrobe asked for more money to finish the work in 1807.[63]

Latrobe had promised the president that the wing would be ready for the House by December 1, 1806, and now found that promise impossible to keep. Jefferson, too, was chagrined at not being able to seat the House in its new chamber. When the president transmitted Latrobe's report to Congress he claimed to have taken every step possible to complete the room and deeply regretted that it was not possible to fulfill the commitment.[64]

Fearing that his annual report would not adequately explain the matter, Latrobe spent three nights writing a pamphlet that he printed with the title *Private Letter.* It was ready to distribute to members of Congress when the session began but was not shown to Jefferson because it had to be rushed to the printer.[65] Latrobe anticipated the disappointment that was sure to be felt by those who expected to occupy the new hall and knew he would be blamed for cooping them up in the library for yet another session. Latrobe was attacked in the press for purposefully drawing out construction in order to keep his salary, and he was accused of neglecting his duty during long absences from Washington. These accusations were, in Latrobe's words, "extremely scurrilous."[66] His *Private Letter* was the best way to defend himself against the storm of criticism that was brewing and sure to break once Congress convened.

Why the south wing remained unfinished was the main topic of Latrobe's letter. Despite a painful and dangerous illness he believed his duties had not been neglected due to the hard work of his zealous clerk, John Lenthall. As much work was done to finish the south wing as could be done, and no amount of money or manpower could have done more. He regretted that anything he might have said during the last session was construed as a pledge to finish the hall. Latrobe apparently forgot his letter to Philip Thompson, written at the end of 1804, in which he stated that $100,000 would guarantee completion of the hall in 1806. He also forgot that Congress granted $110,000 in 1805 and another $40,000 in 1806 on the strength of that promise. Although the promises were in writing, Latrobe now claimed the pledge was a minor misunderstanding.

Switching to offense, Latrobe embarked on yet another denunciation of the architecture of the Capitol and the method employed to select its design. Architectural competitions, such as the ones held in 1792 for the Capitol and President's House, were common but self-defeating. Trained architects would never think of entering such a race, which attracts only charlatans who win through influence. With Dr. Thornton in mind, Latrobe wrote:

> It brings into all the personal vanity of those who think they have knowledge and taste in an art which they have never had an opportunity

to learn or practice—of all those who enticed by the reward think that personal influence and interest will procure it for them—and all those who know of design nothing but its execution: and it keeps out of the competition all who have too much self-respect to run the race of preference with such motley companions.

As for the style of the Capitol, Latrobe flatly said that it was hopelessly old fashioned. He realized that most people reading the *Private Letter* would not understand matters of architectural style, but he thought it worthwhile to instruct them. Unless his audience was aware of the profound change in architectural thought following the first published illustrations of Grecian antiquities in the 1760s, there would be no way that they could appreciate the rising preference for "graceful and refined simplicity" inspired by the "chaste and simple building of the best days of Athens." This aesthetic was relatively new and contrary to the teachings found in publications written prior to the 1760s. He was against the common practice of overloading walls with useless wreaths, festoons, drapery, rustic piers, and pilasters. If ornament did not contribute to the strength of a building, or convey a sense its function, it had no place in its design. He further observed that a reliance on ornamentation was usually accompanied by a decline in art and a general increase in artistic ignorance.

Latrobe's statement would be better understood a generation later by devotees of the Greek revival. But to his audience in 1806, it may have seemed little more than an artistic temper tantrum. Legislators were probably more interested in Latrobe's final topic, which was money. He was able to show that the south wing would ultimately cost $216,000 [sic]. While not an inconsiderable sum, it was $61,000 less than what the board of commissioners had spent to build the north wing. And the south wing was completely vaulted, except for the wooden ceiling over the chamber, while plaster was falling off rotting laths in the Senate chamber. Stairs were stone instead of wood. The roof would be covered with iron instead of painted shingles. Freestone columns holding a stone entablature carved with an American eagle were found in the south wing, compared with decaying wooden columns in the other wing. The architect's ability to provide such elegance, permanence, and convenience in the south wing for less money than was expended to build its inferior counterpart must

surely acquit him of any blame for its slow construction. "What has been done, excepting those parts necessarily made of wood, will be as permanent as the hill upon which the building is erected," Latrobe proudly proclaimed.

Despite his best efforts, Latrobe's *Private Letter* failed to quiet criticism. On December 15, 1806, one of the administration's most acerbic critics, John Randolph of Virginia, called on the president to give the House a full account of the money spent on the Capitol, the President's House, the cabinet offices, the Navy Yard, and the Marine Barracks. Congressmen Willis Alston of North Carolina and Gideon Olin of Vermont noted that such a detailed disclosure might embarrass public officers, but Randolph said the information was necessary to form a standard of comparison when it came time to vote another appropriation for the Capitol. He wanted to know what "this sink of expense" had cost the nation. In the case of the Capitol's south wing, he recalled that each appropriation made over the past several years was supposedly the last. Latrobe was the culprit, Randolph thought, for it was he who had "always fallen short of the promises made."[67]

On February 13, 1807, amid grumbles from unhappy congressmen, the House of Representatives began debate on an appropriation of $25,000 that would hopefully finish the south wing. A separate appropriation of $20,000 was sought to buy new furniture. Andrew Gregg of Pennsylvania noted that Congress had been in the federal city for seven years, and from the look of things, it would be another seven years until their hall would be ready. And while the south wing was not yet finished, the north wing was crumbling around them. Philip Van Cortland of New York did not understand why some of his colleagues considered the appropriation unnecessary. If none were made, he pointed out, the building would not be finished in "seventy times seven years." John G. Jackson of Virginia found it hard to believe that $20,000 was needed to furnish one room. If the money were granted, he thought the surveyor of public buildings would be obliged to buy "gilded chairs" and "plated tables." The Speaker of the House, Nathaniel Macon of North Carolina, supported the appropriation for furniture which, considering the size of the new hall and the number of committee rooms and offices, would require the full $20,000.

He thought reducing the appropriation might spoil the room for want of one or two thousand dollars. Saying that sitting in the House of Representatives was honor enough, Joseph Lewis of Virginia declared that he was willing to sit on a stool if necessary but supported the appropriation for new furniture because the old would not suit. By the time the votes were taken, the full $25,000 was appropriated to finish the south wing and $17,000 was voted to furnish it.[68]

The two main issues concerning Latrobe during the 1807 building season were decorating the vast ceiling above the chamber and procuring glass for the panel lights. On December 30, 1806, he wrote John Joseph Holland, a set designer and decorator in Philadelphia, asking him to paint the ceiling. Latrobe described it as a "plain surface of stucco . . . to be painted in imitation of panels enriched with roses, and carved moldings." Apparently they had discussed the matter before, but the artist was reluctant to come to Washington. Trying flattery, the architect declared that it would be a great honor to have his building "overshadowed by Your ceiling."[69] Holland first accepted the offer but later backed off. Latrobe turned to Boston architect Charles Bulfinch for help in finding someone to paint the ceiling. He said he eventually wanted a "first-rate hand in chiaro oscuro" from Italy or England to paint the ceiling, but for now would settle for an artist to paint simple panels and borders.[70]

It is not known if Bulfinch played a role in the outcome, but the artist who painted the ceiling was George Bridport from Philadelphia, a native of England who was an architect as well as a decorative painter. Although Latrobe wanted the painting done by the time the chamber was occupied in the fall of 1807, Bridport did not begin the work until June 1808. It took all summer to complete. Working on a scaffold, Bridport suffered from the heat, which caused him to lose weight and groan loudly.[71] Yet he survived, and the results of his labor delighted the architect. To the president, Latrobe wrote: "Mr. Bridport's ceiling will do him great honor. I fear the Members will think it too fine, and I doubt not but Mr. Randolph will abuse it."[72] Bridport was paid $3,500 for the labor, paint, and gold leaf used in decorating the ceiling.[73]

Glass ordered from Germany in December 1805 had still not arrived by January 1807. Latrobe gave up hope and tried to find other sources for glass in Philadelphia, New York, Albany, and Boston without success. He was obliged to order it from England and, failing a transatlantic disaster, expected delivery by July 1807. To compensate for breakage, he ordered exactly twice the quantity needed. At the same time, he ordered a chandelier and ten lamps for the chamber and more for the passages, offices, and committee rooms.[74]

While waiting for the glass to arrive, Latrobe directed that the panel lights be boarded over. In mid-April heavy rains driven by high winds forced water through the openings into the roof structure and ruined a great quantity of the fresh plaster in the hall. To prevent a recurrence of the problem, Latrobe proposed to replace the wooden coverings with $1,000 worth of lead. Again Latrobe pleaded with Jefferson to allow him to substitute a lantern for the panel lights: "there is no order of yours that would add more to my happiness," he wrote. A watertight roof was a practical consideration that should, in his view, overrule all other considerations—including beauty. Latrobe asked: "Can beauty still be sacrificed to the *certainty* of a practical security?"[75]

Jefferson would not budge from his opposition to lanterns and lectured the architect on matters of history, precedent, and taste. He could not recall seeing a lantern or cupola on classical buildings and supposed them to be invented in Italy for hanging church bells. They were therefore "degeneracies of modern architecture," which he found quite offensive.[76]

There could be no doubt that lanterns would never appear on the Capitol as long as Thomas Jefferson was president. The whole episode showed Jefferson rigidly bound to his books and, like the lawyer he was, devoted to the high authority of precedent. Latrobe replied with a discussion of the difference between the buildings of the classical world and classical architecture in their epoch. He would copy Roman or Greek buildings if they would suit the climate or could meet modern functional requirements. But modern churches were necessarily different from ancient temples, modern legislative assemblies and courts were different from ancient basilicas, and modern amusements could not be performed in open-air theaters. Liberties were sometimes taken to adapt classical architecture to the American climate and society and the issue of cupolas was one such case. He again

emphasized that it was not the visual effect of a cupola that he wanted, but its usefulness.[77] The argument, however, fell on deaf ears.

July came and went without the arrival of the glass shipment. In mid-August, Latrobe wrote the president at Monticello to report on the leaking roof over the House chamber, again despairing for his reputation and his standing among members who would soon be seated under it. He was already unpopular and did not want to aggravate the situation by appearing to be insolent. "To place Congress at their next session under a leaky roof," Latrobe warned, "would be considered almost as an *insult* to the Legislature after what passed at the last Session." Latrobe traced the leaks to brittle putty and a large buckle in the iron. Water entering through cracks caused small streams to run down the ceiling, staining it with the rust from thousands of nails.

Latrobe feared for Jefferson's reputation as well. A leaking roof over the heads of congressmen would put them in no mood to support the president's ambitions for the public buildings in Washington. "The next Session is to decide," he told the president, "not my fate only, but the whole dependance which congress shall in the future place upon anything which may be proposed by you on the subject of public works." And what a pity it would be, he suggested, to deprive the nation of Jefferson's taste in the arts:

> It is no flattery to say that *you* have planted the arts in your country. The works already erected in this city are the monuments of your judgement and of your zeal, and of your taste. The *first* sculpture that adorned an American public building, perpetuates your love and your protection of the arts. As to myself, I am not ashamed to say, that my pride is not a little flattered, and my professional ambition roused, when I think that my grandchildren may at some future day read that after the turbulence of revolution and of faction which characterized the first two presidencies, their ancestor was the instrument in *your* hands to decorate the tranquility, the prosperity, and the happiness of your Government.[78]

Despite Latrobe's eloquence, Jefferson retained the panel lights. The leaks would be fixed by shingling between them, preserving the skylights and securing the dazzling effect of the Halle au Bled dome.[79] Persistent in the cause of a roof that would not leak, Latrobe was thwarted at every turn by Jefferson, who was equally persistent in the cause of beauty.

In mid-August 1807 the glass for the panel lights at last arrived in Philadelphia. With it came an invoice for $4,130, a great sum that promised to cripple the Capitol's accounts.[80] But at least the glass could be installed, and the House would finally have use of its new chamber. Jefferson had called Congress into session on October 26 to consider America's response to the outrages inflicted by Great Britain on the nation's neutrality during the Napoleonic Wars. British warships routinely stopped American vessels on the pretext that deserters from her navy were on board. Without proof of citizenship, American seamen were routinely forced into British service, and the call for retaliation and justice grew stronger every day. In an effort to avoid an open conflict with a superior enemy, Congress and the Jefferson administration enacted an embargo that closed American ports to foreign trade. The legislation passed in December 1807, as members of the House of Representatives sat under 100 skylights glazed with British glass received a few months before the embargo took effect. Had the sequence of events been slightly different, Jefferson would have been forced to abandon his skylights and allow Latrobe to light the chamber with a lantern glazed with small panes of American glass.

DRAPERY AND DEFICITS

Following discussions about which order to use in the House chamber, Jefferson abandoned his initial preference for Doric and decided it should be Corinthian. Which example to draw upon was another matter. Latrobe preferred Grecian models, while Jefferson was decidedly partial to Roman ones. Eventually a compromise was struck. For the columns, Jefferson approved using the exquisite Grecian order from the Choragic Monument of Lysicrates, but he urged Latrobe to design the entablature with modillions—something he admired in Roman architecture. Latrobe obliged and modeled a Roman entablature to go with the Grecian columns.[81] Before the chamber opened

Andrei had time to finish only two capitals and would attend to the rest as time permitted. Franzoni completed a figure of Liberty, and while it was only a model, it did the artist "infinite credit." He also began carving four allegorical figures to be mounted opposite the Speaker's chair representing Art, Science, Agriculture, and Commerce. Marble mantels from Philadelphia were installed in the first-floor offices and committee rooms. As the wing was being finished, it became something of a tourist attraction, drawing unwanted visitors who interrupted the work and souvenir hunters who carried off whatever they could. Latrobe asked Jefferson to order the building off limits to anyone not employed there. If presidential intervention was considered too high a sanction, Latrobe was prepared to issue the order himself.[82] Scaffolding was removed from the chamber in mid-September, but while the hall was ready for use, Latrobe thought it still looked somewhat incomplete.[83]

To celebrate the virtual completion of the Capitol's south wing, Latrobe hosted a banquet for workmen. The treat was a custom expected by the workmen as a reward for their labors and "contributed considerably to the good humor and alacrity with which they performed their duty." Held on Saturday, October 17, the supper was attended by 167 people and was marred only by the conspicuous absence of John Lenthall, who boycotted in a dispute over the guest list. All skilled hands were invited, as were men from the Navy Yard who helped out occasionally, but Latrobe deliberately did not invite the lower-class laborers. Lenthall felt that all workers should have been included and his boycott greatly embarrassed Latrobe.[84]

Reaction in the press to the new House chamber was mixed. Newspapers sympathetic to the administration ran favorable reviews, while the Federalist press focused on the room's faulty acoustics. Samuel Harrison Smith, editor of Washington's *National Intelligencer,* called it "the handsomest room in the world occupied by a deliberative body." He recalled that on entering the hall, the spectator was overwhelmed with a "strong sensation of pleasure, from the splendor and elegance of all that surrounds him."[85] But the *True American and Commercial Advertiser* of Philadelphia noted that the room suffered from a "very material defect." A speaker's voice was lost in echoes and nothing could be distinctly understood.

Only by close attention was it barely possible to gain an idea of what was happening amid the chamber's "floating reverberations."[86]

The *Washington Federalist* reported that John Randolph considered the room "admirably suited to every purpose which would be required except one . . . that of debate." According to this anti-administration paper, hearing in the House chamber was so difficult that only a forge, a mill, or a coppersmith's shop would offer a less hospitable environment for debate.[87]

Latrobe complained privately to Lenthall (who had returned to the architect's good graces) that his original proposal for a half domed semicircular room of a lower height would have made a much better speaking room. He also noted that while newspaper writers condemned the chamber's acoustics, "they report the debates as regularly and minutely as if they caught every word."[88] To his brother, Latrobe admitted the room had an acoustical problem, but he planned to "go to work with Tapestry &C. to destroy the echoes."[89] Draping the

Corinthian Order of the Choragic Monument of Lysicrates, Athens

From the 1825 edition of *The Antiquities of Athens* by James Stuart and Nicholas Revett

*J*efferson approved using the Grecian Corinthian order of the Choragic Monument of Lysicrates in the House chamber. (A different entablature was designed by Latrobe so that it might have modillions, which the president admired in Roman architecture.) The details of the order were illustrated in *The Antiquities of Athens,* published in three volumes in London in 1763, 1790, and 1795. Jefferson owned the first volume and the Library Company of Philadelphia had a copy as early as 1770.

The intricate capitals were carved in the House chamber by Giovanni Andrei. After the room was destroyed in 1814, Andrei supervised replication of the capitals in marble during a trip to Italy.

colonnade would muffle the echoes and add even more texture and color to an already splendid room.

Latrobe wrote a detailed description of the south wing for the *National Intelligencer*. The newspaper asked for the article in order to satisfy the public's curiosity, but Latrobe used the occasion to defend the work against slanders printed in the Federalist press.[90] Latrobe's essay began with a short history of the Capitol, its dimensions, and a description of its exterior appearance and the original plan. Before describing the alterations made to the internal arrangements of the south wing, Latrobe thought it necessary to pay Dr. Thornton a left-handed compliment for his talents "which a regular professional education, and a practical knowledge of architecture would have ripened into no common degree of excellence." Thus, the only things missing from Dr. Thornton's potential as a real architect, Latrobe said, were training and experience. More sincere praise was given George Hadfield's contribution to the exterior design. His "exquisite taste" was responsible for the introduction of the "impost entablature," which gave "an harmonious character to the whole mass." While Latrobe wanted to publicly acknowledge Hadfield, he was probably mistaken in the instance cited. The Capitol's belt course (carved with a guilloche) was more likely part of Thornton's original design. But this was not the first time Latrobe was mistaken about who designed what in the building's murky past.

With the preliminaries dispensed with, Latrobe began a description of the wing as it was redesigned and built: "All the apartments are vaulted with hard bricks, and scarcely anything in the whole building is of timber, excepting the doors, windows and their dressings, the platforms of the House and galleries, and the roof of the Hall itself." He was particularly proud of the plan and accommodations of the office story because of the difficulties that were overcome. The size of the challenge made his success all the more gratifying.

Upstairs, the House chamber "consists of two semi-circles 60 feet in diameter . . . united by straight lines 25 feet in length . . . so that the internal space . . . is nearly 85 by 60." A wall seven feet high carried the twenty-four Corinthian columns, which were twenty-six feet, eight inches high; these in turn, supported an entablature six feet high. Latrobe paid high compliments to Andrei for the skillful carving shown in the two completed capitals and to Franzoni for his "colossal eagle in the act of rising." Franzoni's personifications of Art, Science, and Agriculture in the frieze above the main entrance to the hall were finished; the figure of Commerce was incomplete. They were carved in high relief and, in Latrobe's opinion, were "exquisitely beautiful." The statue of Liberty behind the Speaker's chair was a hastily completed plaster model that Latrobe hoped would soon be reproduced in Vermont marble. It was a seated female figure, eight and a half feet tall, holding a liberty cap in one hand and a scroll in the other. An eagle stood guard to one side of the figure, its foot resting on a crown and other emblems of monarchy and bondage. Above the statue was a crimson silk curtain with green lining. "The effect of this curtain, of the statue, and of the Speaker's chair and canopy," Latrobe wrote, "is perhaps the most pleasing assemblage of objects that catches the eye in the whole room." Other subjects were covered in the article, but the sculptural decorations seem to have been the architect's greatest source of satisfaction.[91]

A "sound committee" of the House approved Latrobe's plan to combat echoes by hanging heavy flannel drapery—with black, yellow, and red fringe—between the columns.[92] Lenthall was asked to devise something from which to suspend the curtains, preferably a strong plank held by the abacus of the column capital. Latrobe wanted the curtains to hang down nearly twenty feet, reaching within seven or eight feet of the column bases. "The thing will be handsome," Latrobe wrote, "and take half the echo." He did not care if those behind the curtains could see or hear: "Why should there not be an embargo on Sound as well as on Flour?"[93] The curtains were in place by the end of February and were, according to Latrobe, both beautiful and effective.

Usually the annual report of the surveyor of public buildings was transmitted soon after the opening of Congress. The 1807 report, however, was not submitted until March 25, 1808, only four weeks before the end of the first session of the 10th Congress. Latrobe excused the delay by saying he was unable to close the accounts because work was still going on at the Capitol and the President's House. In the part of the report concerning the south wing, he listed those few details that were needed to finish the building. The woodwork

Tower of the Winds, Athens

From the 1825 edition of *The Antiquities of Athens* by James Stuart and Nicholas Revett

Capital Detail

*L*atrobe modeled the columns after the ancient Tower of the Winds but added a stem between the upper water leaves. (1999 photograph.)

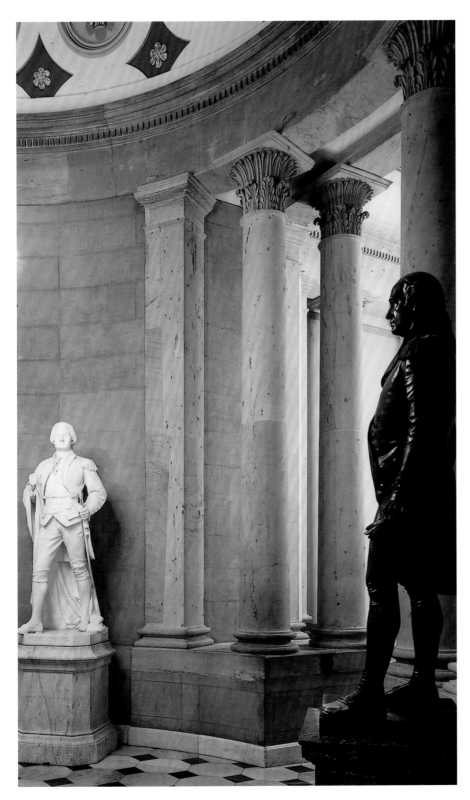

Vestibule of the House of Representatives

*T*he earliest example of a Greek order extant in America is exhibited in this small circular vestibule, located between the rotunda and the old House of Representatives. The vestibule was completed in 1807 and left undamaged by the fire of 1814. Paint analysis indicates that a light straw color was originally used on the dome, coffers, and ornaments. (1999 photograph.)

was only primed and needed to be painted. Twenty-two column capitals in the chamber and two in the circular vestibule (today called the "small House rotunda") still needed to be carved and the cornice in the chamber was not yet finished. Ten mantels awaited installation and the pavement along the south front needed to be laid. Latrobe praised the work of Franzoni and Andrei and reminded his readers that their work would take time to finish. He asked for funds to erect the western part of the recess containing three committee rooms and an apartment for the doorkeeper. In addition to providing these internal accommodations, this part of the recess was necessary to buttress the wing's northwest corner. Settlement in that area had been noticeable for some years, and while there was no immediate danger of collapse, it required "counterpoise" for stability. (It remained without "counterpoise" until 1818–1822.)

Without a hint of modesty, Latrobe's report asserted that the House of Representatives sat in a room less "liable to an objection as any other hall of debate in the United States." After minor adjustments were made, it would be "second to none in every legislative convenience." But such high praise for his own work did little to shield him from the furious storm that broke over his accounts. Latrobe nonchalantly reported that he had incurred a deficit of more than $35,000 for work on the south wing and another $4,000 deficit for furnishing it. (He had also overspent the President's House and public highways accounts.) At the beginning of the 1807 building season, Congress had appropriated $25,000 to finish the south wing—all that Latrobe asked—yet he managed to spend more than $60,000. His success with the $17,000 furniture budget was better, but that overrun was a grave embarrassment as well. Latrobe soon learned that fiscal mismanagement, whether real or perceived, could damage a reputation beyond all that allegorical statuary and crimson drapery could redeem.

Overspending the appropriations put Latrobe in the unenviable position of defending himself against the administration's friends as well as its enemies. On April 5, 1808, the House of Representatives considered an appropriation to cover the deficits. John Randolph condemned Latrobe's actions as "illegal and unjustifiable." Joseph Lewis, a Federalist from Virginia, took an opposite view of the issue. He understood that Latrobe and the

workmen proceeded on their own to finish the hall despite the lack of funds. In doing so, they were only motivated by a desire to complete the room so that the House could use it and be free of the tight quarters of the library. The honorable intentions of the surveyor of public buildings and the generosity of the workmen justly demanded Congress repay them promptly. The president's son-in-law, John Wayles Eppes of Virginia, thought that Latrobe had "grossly abused his trust," but worried that innocent tradesmen and merchants would be ruined if the government failed to fund the deficits. Randolph replied that he too wished to see creditors paid but thought the accounts should be presented to the Committee on Claims. And while he thought the House chamber did Latrobe "great honor," he reminded his colleagues that "artists were not very nice calculators in money matters." David R. Williams of South Carolina, an administration supporter, gave a long speech in which he severely condemned Latrobe and his "outrageous audacity." Others spoke either of Latrobe's bad judgment or of his devotion to duty, as the case might be viewed. By the end of the day's business, the House could not agree on how to treat the deficits. On a motion offered by Eppes, the House asked Richard Stanford, chairman of the committee handling Latrobe's annual report, to inquire into the circumstances that produced the deficits. It also asked his committee to look into the wisdom of abolishing the office of the surveyor of public buildings.[94]

Latrobe replied to the committee's inquiries in a long letter written on April 8, 1808.[95] It was an admirable defense, free of the pontifical rhetoric that occasionally showed up in his writings. He began by saying that he held no government office as such, but that the surveyor's position was necessary to carry out the appropriations for the public buildings. As long as these appropriations were made, it would be necessary to have an architect in charge. He then compared his work to that of the "unprofessional," but "patriotic" commissioners and showed that the south wing cost $61,000 less than the north wing. The saving was a result of professional management. To explain how he incurred the deficits, and justify his actions in the matter, Latrobe referred to the desire of the House to occupy its chamber, its resolution asking the president to do all in his power to have the room ready, and his efforts to obey the command.

Because he was not able to have the room ready in 1806, it would have been unforgivable not to finish it in 1807. The appropriation was fully spent by September but the hall was still not finished, leaving the architect few options. He could dismiss the workmen and leave the hall unfinished or advise them of the financial situation and trust that their labors would not go unrewarded for long.

Completion of the south wing was Latrobe's first duty. To his way of thinking he had not expended unappropriated public funds but, rather, incurred debt in the public interest. To show that the workmen fully understood the situation, he presented an affidavit signed by George Blagden, stonecutter, Thomas Machen, stonemason, Simeon Meade, foreman of carpenters, Henry Ingle, cabinetmaker and ironmonger, and Griffith Coombe, lumber merchant. The document verified Latrobe's forthright dealings with the men building the south wing.

On April 21, 1808, Stanford reported the findings of his committee to the House.[96] It was a full and absolute vindication of Latrobe and his actions that incurred debt. According to the committee members, Latrobe pursued his duties with "laudable zeal" and "integrity." Considering the circumstances, questions regarding the legality of Latrobe's actions were groundless.

Four days after the Stanford report was issued, the House discussed an appropriation to cover the debts. John Randolph, of course, spoke at length against the measure. If the bill passed, Randolph warned that "they might as well open the Treasury and dismiss their accounting officers at once." But Stanford stated that Latrobe had acted in accordance with their resolution and had done his duty by finishing the chamber. His actions were, therefore, fully justifiable. By a vote of seventy-three to eight, the House appropriated $51,500 to cover the

Latrobe Committee Room

*L*atrobe's plan for the south wing's office story provided meeting rooms for some of the five standing committees and for the various select committees that were appointed from time to time. Structural constraints prohibited large rooms, but committees did not require much space. Shown here is a typical committee room, which retains its original marble mantel and woodwork.

Today the room (modern day H–153) serves as the office for the clerk of the House of Representatives. (1998 photograph.)

debts.[97] On the same day, a vote was taken on funding the remaining part of the recess. That measure failed, but $11,500 was given for finishing and painting the interior of the south wing.[98]

While Latrobe enjoyed his partial victory in the House, his financial dealings placed a cloud over his relationship with the president. Jefferson neither claimed responsibility in the affair nor did he blame Thomas Munroe, who was supposed to keep track of accounts. The day Congress made good on the deficit, Jefferson wrote the architect:

> The lesson of last year has been a serious one, it has done you great injury & has much been felt by myself—it was so contrary to the principles of our Government, which makes the representatives of the people the sole arbiters of the public expense, and do not permit any work to be forced on them on a larger scale than their judgment deems adopted to the circumstances of the Nation.[99]

Latrobe considered resigning. He felt that the attacks in the House by the president's son-in-law might as well have come from Jefferson himself. Blame for the deficits had been "copiously and coarsely heaped upon me by the friends of the administration in the house as well as by the federalists and the third party." Latrobe claimed that the state of the accounts was unknown to him because Munroe had spent the summer in upstate New York. He had been guided solely by Jefferson's order to hire more workmen and finish the chamber.

Writing from Monticello, Jefferson replied that Latrobe had no one to blame for the deficits other than himself. Appropriations were made from his estimates, and because these were defective, he had not enough funds to finish the wing. When he urged Latrobe to hire more workmen, it was on the assumption that "it would cost no more to employ 100 hands 50 days, than 50 hands 100 days." He never intended to suggest that money was no object. And as John Eppes was too independent to be influenced by his father-in-law, Latrobe should not consider him the president's mouthpiece. Without mentioning Latrobe's hint at resignation, the letter ended on a friendly note.[100]

Small appropriations were made in 1809 and 1810 to keep Andrei carving the capitals in the House chamber. With the room virtually complete Latrobe turned his attention to rebuilding the interior of the north wing, which would be a more difficult, and in some ways a more satisfying, task.

The arrangement of the office story in the south wing, and the many conveniences it provided within a difficult space, was an accomplishment that made Latrobe proud. Although later altered in small ways, the rooms continue to be used by the House of Representatives to this day. The House chamber upstairs, however, perhaps the most beautiful room designed by Latrobe, can only be viewed in the architect's drawings. Used only six years, it was destroyed by fire in the summer of 1814.

THE NORTH WING

From the time he was appointed the surveyor of the public buildings, Latrobe was alarmed by the north wing's structural problems. Despite its recent construction, the north wing had defects more usually associated with an older building. He condemned the gutters lined with tar and sand, which disguised fissures that allowed rain to pour into the building. He disliked the skylights and wanted to protect them with lanterns, not yet having learned of Jefferson's dislike for these "degeneracies of modern architecture." In addition to water penetration, the wing was plagued by rotting timbers and falling plaster. Each year Congress granted for repairs a small sum that was split between the north wing and the President's House. Latrobe could barely keep up with the progressing decay he found in both buildings.

At the end of August 1805, Latrobe told the president about the sundry repairs made in the north wing and stated his belief that one day the entire interior would have to be removed and rebuilt. The ceiling in the northwest committee room (modern day S–143 and S–144), where the Senate had met during the second session of the Eighth Congress (1804–1805), threatened to collapse. (Ironically, it had been the dangerous condition of the Senate chamber's ceiling that forced the lawmakers to seek refuge in that committee room.) Now, the room's ceiling was cracked and Lenthall was asked to examine it. Because the laths were too closely spaced to allow the plaster to grip properly, the ceiling was deemed unsafe and was taken down. A new ceiling was installed, but it soon sagged six inches. Latrobe climbed on the scaffold and discovered a girder riddled with dry rot. He had it propped

up with a strong wooden partition that divided the room in half. The situation could not wait for Jefferson's approval: if the girder failed during the approaching session of Congress, members of the House meeting in the library above would have been thrown down into the committee room, causing certain injuries and deaths.

While saving the lives of congressmen, the partition created two small committee rooms where there had been only one before. With the Supreme Court set up in one committee room (modern day S–146 and S–146A) and clerks using another, rooms for Senate committees were in short supply. Only one room was available, and it was commandeered by the first senator who laid claim to it. Other committees huddled together in the Senate chamber in whatever space they could find. "Thus a Committee on a trifling business were in possession of the room," Latrobe informed the president, "while the most important affairs were transacted in a corner amidst the bustle, usually preceding the opening of the house." Another room could be created by partitioning the north vestibule, a semi-elliptical lobby with a central door flanked by two windows. Latrobe asked permission to build a wall that would capture a third of the space for a committee room.[101] The plan would result in two oddly shaped rooms, and the president was unwilling to sacrifice the beauty of the vestibule for the accommodation of Senate committees.[102]

Repairs were also needed in the Senate chamber. Particularly bothersome were the columns, which were made of wood covered with a thin coat of plaster. Cracks half an inch to an inch wide appeared down the length of three shafts. To repair these, Latrobe wrapped the columns with strong linen tied in the back. Secured by these improvised corsets, the column shafts were then freshly whitewashed. After a piece of the ceiling fell (barely missing the vice president's chair), Latrobe inspected the damage and repaired the plaster.

Such patching and mending made Latrobe impatient for the day he would rid the north wing of its rotting timbers and rebuild it with brick arches and vaults. Only such drastic measures would secure the interior from the legacy of bad materials and workmanship. The rebuilding would also present an opportunity to reconfigure the floor plan to better accommodate the Senate and the Supreme Court. While he despaired for the structural integrity of the

Senate chamber, Latrobe told the president that he looked forward to "the period at which your idea of raising it up to the next story can be carried into effect."[103] Now that the House chamber was on the principal floor, Jefferson apparently wanted the Senate raised to that level as well. Raising the Senate finally resolved the old disagreement between Thornton's exterior elevation and Hallet's interior plan. (One must wonder at Jefferson's thoughts as the chambers were relocated to the principal floor during this period.) A one-story room for the Supreme Court would be built below the Senate, occupying what had been the lower portion of the old chamber. Other areas, such as the Library of Congress, committee rooms, and lobbies, would be retained in place but reconfigured by the necessities of vaulted construction.

In his 1805 annual report, Latrobe informed Congress of the decayed state of the north wing's interiors, which hardly came as news. A survey of the structure revealed alarming failures in the floors and timbers that were the result of "extremely injudicious" construction methods aggravated by widespread dry rot. Cracks in the library ceiling were investigated, but no structural defect was found. Minor repairs were made but substantial work would be postponed until after the south wing was completed.[104]

By the end of 1806, the condition of the ceiling of the room in which the House sat rattled the nerves of more than one of its members seated below. David R. Williams of South Carolina was sufficiently alarmed to offer a resolution to pull the ceiling down or otherwise secure it from what appeared to be imminent collapse. The motion stirred a lively discussion among the members, some of whom doubted Latrobe's earlier assurance of the ceiling's safety when it looked so insecure. A section of plaster had already fallen, while other parts "swagged." The clerk of the House made his own investigation and found the ceiling mostly secure, but some sections also looked dangerously weak.[105] Adding to the mounting concern, the cornice and part of the ceiling over the central lobby fell. More cracks appeared in the Senate columns, and the ceiling appeared ready to fall again. It was beyond repair and was accordingly re-plastered on new laths. Disasters became routine and convinced even recalcitrant legislators that reconstruction was necessary. Members of the House were

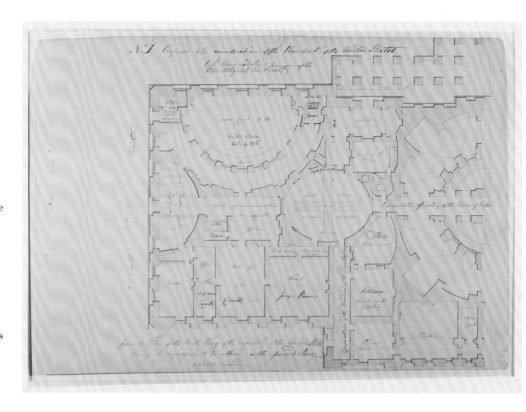

Ground Plan of the North Wing of the Capitol of the United States shewing it, as proposed to be altered, on the Ground Story

by B. Henry Latrobe, 1806

Retaining as much of the brick partition walls as he could, Latrobe reconfigured the plan of the north wing to accommodate a vaulted interior. This plan (with east at the top) is a preliminary scheme that would be more fully developed.

Latrobe separated those with Court business from those attending sessions of the Senate. The north door (left) was reserved for the Supreme Court and the east door (top) was exclusively for the Senate. Although this plan does not yet show columns in the east vestibule, Latrobe later designed "corn cob" columns for that space to support the weight of its vaulted ceiling.

anxious to leave the cramped and decayed library, especially when they saw what awaited them in the south wing.

Latrobe's 1806 annual report gave the first detailed account of what he and the president had in mind for the north wing's new interior. A set of plans was submitted with the written report. The whole ground floor (called the "office story" in the other wing) was reserved for the Supreme Court. The Senate would move upstairs, having use of the second and third floors. Visitors to the Court would enter through the north door, while those on Senate business would use the east door. Thus separated, neither body would interfere with the workings of the other.

The report also covered logistical matters. As soon as Congress adjourned in March 1807, Latrobe proposed to begin demolition of the eastern half of the wing, preserving much of the brick partition walls but removing all the laths, plaster, and timber from the cellar to the roof. The first phase would involve gutting the Senate chamber, the unfinished room above it, the east vestibule, the staircases, the central lobby, and the north vestibule. When Congress reconvened in the fall, the House would occupy the south wing, the Senate would meet in a committee room, while the Supreme Court would

continue to use a first-floor committee room or the library. With his usual optimism, Latrobe promised that the work could be done quickly, particularly because it would be protected by the roof. He claimed that the eastern half of the wing would be finished by the time Congress convened in 1808. Work on the western half would begin in 1809 and would be finished a year later. Thus, the entire north wing would be rebuilt in only three years. To get the job started, Latrobe asked for an appropriation of $50,000.[106]

When the House reviewed the reconstruction plans on February 13, 1807, confusion gripped those who did not understand Latrobe's report or the drawings accompanying it. Some thought the plans called for the Senate chamber to be divided in half so that the Supreme Court would meet in the upper part of the old room. Others thought a new Senate chamber would replace the library in the western part of the wing. David R. Williams of South Carolina was certain the changes were proposed so the Senate would be in a physical position to send bills literally downward to the House. "If the alteration really takes place . . . " he said, "this House will be about fifteen feet lower than the Senate."[107] How he reached that conclusion is unfathomable, but it demonstrated the architectural

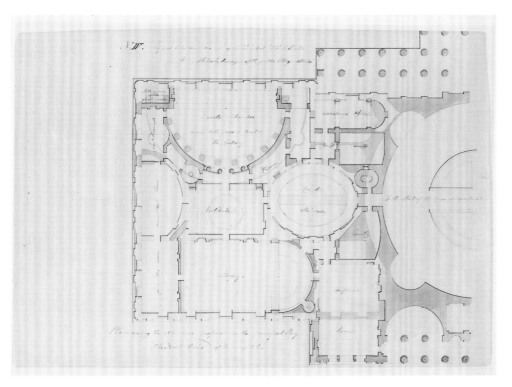

illiteracy flourishing in the House that day. While it
is not surprising that some were unable to under-
stand the floor plans, Latrobe's clearly written
report should have been intelligible to all.

At the end of debate, the House decided not to
vote for any alterations. Instead, it granted $25,000
for a new roof and other repairs to the north wing.
Alarmed, Latrobe wrote Pennsylvania Senator
George Logan warning that if the appropriation
passed in its current form, the Senate would be left
with all the problems plaguing its chamber and com-
mittee rooms. The chamber needed to be cleared of
arches and columns that obstructed views and
blocked voices, but this was beyond the scope of
repair work. He hoped the Senate would loosen the
wording of the bill to allow some alterations. Yet,
the Senate retained the language of the House
appropriation, and the bill was approved by Jeffer-
son on the last day of the session, March 3, 1807.

Finishing the south wing for the House of Rep-
resentatives kept Latrobe busy during the 1807
building season, and he could hardly spare carpen-
ters to re-roof the north wing until they were no
longer needed on the other building. Rainy weather
and a shortage of workmen meant that there was
only time and manpower enough to re-roof about
half the wing.[108] When the center part of the roof

was stripped off, Latrobe found the timbers in an
advanced state of decay. All the floors and ceilings
of the Senate chamber, the library, and the lobbies
were discovered to be rotten as well. Because of
time constraints and the limits of the appropria-
tion, Latrobe could do nothing to the chamber or
the library, but focused instead on the central lobby
and oval stair hall directly under the part of the
roof being replaced. In those spaces, Latrobe
removed the timber floors and laid stone or brick
floors on new vaults carried by the old walls. The
coved ceiling and wooden skylight over the oval
stair hall were removed and replaced by a "solid
brick cupola . . . crowned by a lantern light." (Con-
sidering the president's silence, the lantern pre-
sumably could not be seen from the outside.) The
weak, decayed principal staircase was merely
propped up for the time being.[109]

What little was done to the north wing in 1807
was just enough to show how much work was
needed to put the building into first-class condi-
tion. Without debate Congress appropriated
$25,000 on April 25, 1808, "for carrying up, in solid
work, the interior of the north wing, comprising
the Senate chamber." Congress granted these funds
at the same time it made the appropriations to
cover Latrobe's public debts. While this period may

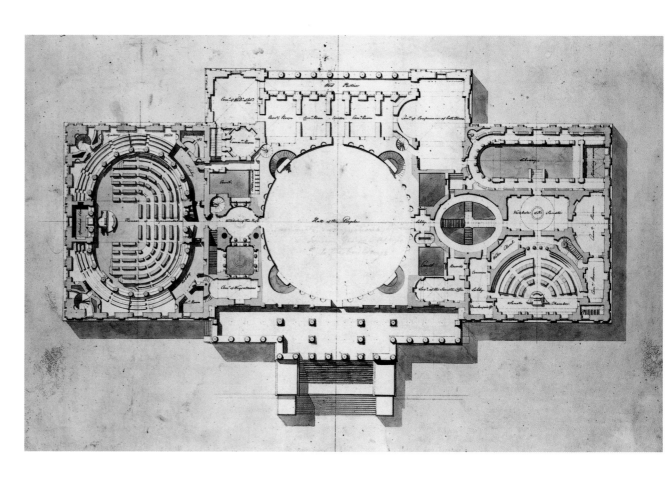

**Plan of the
Principal Story of the Capitol. U. S.**

by B. Henry Latrobe, ca. 1808

Library of Congress

*L*atrobe's overall scheme for the Capitol was presented in this drawing. It shows the south wing as finished, the north wing that was undergoing a partial reconstruction, and the center building that was not as yet approved or funded. The rotunda was labeled "Hall of the People" with the notation that it was intended for "Impeachments, Inaugu[r]ations, Divine Service, General access to the buildings."

have been a low point in the architect's popularity, the appropriation for the north wing was a small but a welcome vote of confidence.

LIBEL

he day after the appropriation for the north wing passed, Latrobe opened the *National Intelligencer* to find a letter from Dr. Thornton publicly attacking him. Considering the unflattering way Latrobe

had depicted Thornton in print, this assault should not have come as a surprise. But its severity and fanatic assertions were shocking. Supposedly, the letter was in response to Latrobe's description of the south wing, printed in the *Intelligencer* on November 30, 1807, in which he "had the presumption to assume the character of a public Censor." To defend himself Thornton described Latrobe's reports to Congress as "full of miscalculations and misrepresentations." He denied Latrobe's assertion that the design of the Capitol had been improved by George Hadfield and defended the original design and parts of the composition that Latrobe criticized. In his writing, Thornton used a sort of verbal smoke screen that is difficult to follow, employing maxims and rules of his own invention that had a ring of authority. For example, Thornton wrote about a small feature of the Capitol's elevation—the shallow arch in the center bay of each wing—and greatly exaggerated its significance. He said the arch was "bold" and so "neatly equidistant" that it produced a "fine effect and great harmony." Sounding profound, Thornton proclaimed: "Minute beauty may terminate where grandeur and

sublimity commence." Beneath the rhetoric, there was no real meaning to the statement.

There was similar bombast about the oak foliage above the arched windows. Next came the matter of education and experience: "Because I was not educated as Architect, am I therefore to permit Mr. Latrobe to decide upon my merits or demerits? —No." After all, Thornton had traveled in Europe, was acquainted with the best buildings from antiquity, and knew something about the orders of architecture. As a profession, medical doctors examined a variety of subjects during their course of study, and it was common for them to pick up one or two other specialities later on. Thornton proudly reminded readers of the *Intelligencer* that Claude Perrault, the architect of the Louvre, was also a doctor.

The latter part of Thornton's attack was pure fantasy. He claimed that Latrobe had been educated not as an architect but as a "carver of chimney pieces in London." Thus, an upholsterer had as much right to call himself an architect. The next fabrication was about Latrobe's immigration to America as a *"Missionary of the Moravians."* Rather than to design churches, Thornton said, his rival was sent to this country to build up the Moravian church. These silly taunts paled in comparison to the story about George Washington's lack of faith in Latrobe. Thornton said that a "very respectable gentleman now living" asked Washington why he did not employ Latrobe and was told: "Because I can place no confidence in him whatever." Thornton's next accusation was that the architect had changed his name. Using satire, sarcasm, and wit, Thornton then ventured into a wholesale condemnation of Latrobe's south wing. The sculptural group over the Speaker's rostrum was ridiculed in a manner that nicely illustrates Thornton's style of attack:

> To embellish the room, he had the Eagle carved so often, that it equals the Ibis in the Tombs of the Egyptians, but they are as much like the Harpies as Eagles. The one on the Frieze of the Entablature is so flat, that the country people mistake it for the skin of an owl, such as they nail on their barn doors: Glumdalca, [queen of the giants in Fielding's farce *Tom Thumb*] fabricated of straw, and plaster of Paris, to represent the Figure of Liberty resting on the Eagle, is taken for a gigantic representation of Leda and her Swan: and the minikin eagle over the Speaker's head, is taken for a Sparrow.

The gate at the Navy Yard, the wall around the President's House, the Bank of Pennsylvania, and the Philadelphia Waterworks shared Thornton's scorn. His final ridicule was directed at the gate into the president's garden: "Though in humble imitation of a triumphal Arch, it looks so naked, and so disproportionate, that it is more like a monument than a Gateway; but no man now or hereafter will ever mistake it for a *monument of taste.*"[110]

Latrobe's response was swift and calm. Writing to the *Intelligencer* on April 26, 1808, he characterized the abuse as "coarse" and regretted that his previous references to Thornton had been "too flattering." People who knew Thornton would pay no attention to his latest rant, but it was due his family as well as himself to refute some of the more atrocious accusations. The stories about carving chimney pieces and missionary work were both groundless, although he would not have been ashamed if either were true. He recalled his last visit with Washington at Mount Vernon, during which time he had no favors to ask nor did his host have any to grant. "The whole story," Latrobe wrote, "is a malicious fabrication—impossible in all its circumstances of time and place." He defended his design for the Bank of Pennsylvania against Thornton's assertion that it was nothing more than a copy of a Greek temple. Thornton's observations were stupid and he was "too ignorant, vain, and despicable for argumentative refutation."[111]

Strangely, President Jefferson did nothing to stop these men from airing their differences in public. Both held positions in the administration and would have yielded to a presidential command to desist. But Jefferson remained quiet. The next volley was lobbed by Thornton in the *Washington Federalist* of May 7, 1808, in what was an amplification of his earlier letter. In it Thornton railed with gusto, skewering Latrobe with his special brand of contorted sarcasm. In one passage, Thornton expanded upon his assertion that Latrobe's career in London was spent carving mantels:

> To call him a carver of chimney pieces was meant to shew that his high assumption of the character of an architect has not been of long standing. His mode of behavior to me must have originated in his old habits of carving chimney pieces. He cut and hewed at me in a very rough manner, in private (in his private letters to Congress) then polished and smoothed down to give a kind of gloss, in public; but I had not

forgotten the chisel strokes in private, and understood better than the public his subsequent meaning.

The letter concluded with a story that stretched Thornton's credibility to the limit. He said that he had accepted a challenge to a duel, but when he went to the field, Latrobe was no where to be found. For three days, Thornton waited with his second and surgeon, unaware that Latrobe had been "bound over to the peace." He returned to town and sent a note saying that while the matter was now settled, he was nonetheless ready to take up the challenge again. Latrobe, the coward, failed to reply and Thornton concluded: "I received no answer, and despise his threats, as much as I despise the man."[112]

The *Washington Federalist* carried a short reply from Latrobe saying no more would be heard from him due to a libel suit filed on his behalf against Thornton. Thus a jury would decide "whether the Doctor be an original inventor, or only a second hand retailer of falsehood."[113] Latrobe's complaint, filed on May 28, 1808, asked for $10,000 in damages plus court costs.

A FATAL ACCIDENT

While lawyers prepared their cases, Latrobe began work on the east side of the north wing by demolishing all the flooring and ceilings from the cellar to the roof. As a public exhibit, he laid out rotten girders, plates, and joists for all to see. Although he had hoped to reuse it, Latrobe also tore out the brick arcade in the Senate chamber after discovering the piers were built on wooden plates, which were rotten. The arcade was also found to be laid out on a partly circular, partly elliptical plan and it would have been nearly impossible to contrive a uniform vault to spring from it.[114] A month earlier,

Jefferson had told Latrobe to leave the arcade in place and reuse the old wooden columns unless it was clear that they could afford stone columns.[115] Jefferson's instructions were shaped by his dread of incurring another deficit, a fear that surely clouded his judgment. Impractical and unwise, the shortcuts were mercifully ignored.

Latrobe's plans for reconstructing the interior of the north wing were as inventive and daring as anything he had attempted before. Unlike building from the ground up, this job involved preserving the outside shell and most of the interior walls and inserting a vaulted structure within that tenuous envelope. The new work could not depend on old walls for support. Rather, the new skeleton was used to strengthen the outside skin. Like builders in the Middle Ages, Latrobe used the outside walls as screens that performed virtually no structural function. Instead of transferring structural loads via exterior flying buttresses, the north wing vaulting was supported on new interior columns and piers built within inches of the old walls. Each room presented its own challenge, and Latrobe's solutions were as ingenious as the problems were difficult.

During the summer of 1808, while Latrobe was in Philadelphia, Lenthall pushed the work with

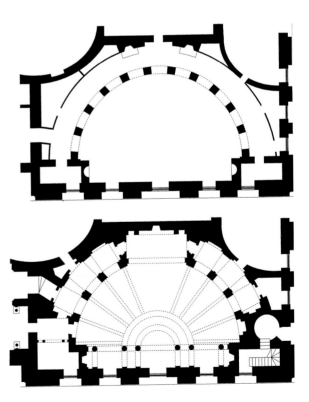

Lower Plan of the Original Senate Chamber Prior to Reconstruction (top). Supreme Court Vaulting Plan (bottom)

Comparing "before" and "after" plans illustrates the transformation that took place within the existing walls of the north wing. In creating the Supreme Court chamber, Latrobe built new masonry supports to hold heavy ceiling vaults while imposing little additional weight or lateral pressure on the old walls.

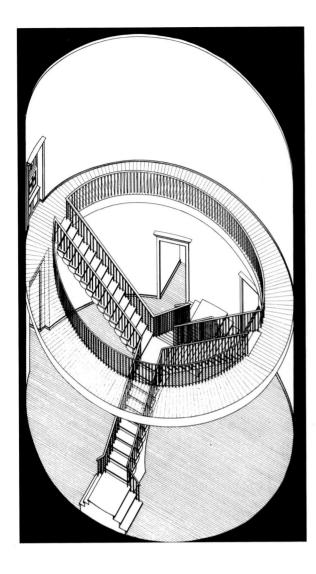

North Wing Principal Staircase
Conjectural Reconstruction, 1989

*T*his unusual stone stair was built in the north wing's oval hall in 1808, heavily damaged by the fire of 1814, and not rebuilt during the subsequent restoration. Latrobe's design was probably inspired by Sir William Chambers' Navy Staircase (also called the Oval Stair) located in Somerset House, London.

The floor of the new Senate chamber rested on the vaults covering the Supreme Court. Because the Court was only one story high, the rise of its dome was quite shallow compared with its span. Latrobe planned to divide the semicircular dome into nine tapering sections with conically shaped vaults between stone ribs. To build the vaults, each section would require its own center, which Lenthall thought was too expensive and time-consuming. He devised a simpler, cheaper plan by which a smooth half dome could be constructed without ribs and support the Senate floor above by means of annular vaults built upon its haunches. While Latrobe did not care for Lenthall's simplified structure, he approved it in deference to his clerk's experience. Lenthall had, after all, devised the centerings upon which all the vaults, arches, and domes in the south wing were built, and he knew as much about this type of construction as anyone.

By the end of July, the carpenters completed the centers in the Supreme Court. Once masons finished laying bricks on the framework and the mortar dried, Lenthall began removing the centering but detected an unaccountable warp in the new arch built against the old east wall. He immediately raised the centering and allowed the masonry to set for another two months. On Friday, September 16, the framework was safely removed from under the east arch and, despite some suspicious vandalism, he began dismantling the large frame under the half dome on Monday. Soon after the centering was lowered, workmen heard a loud noise—a frightening cracking sound—that sent them scrambling out windows and doors just before the whole ceiling fell, bringing down tons of brick and mortar. Lenthall was the only one who did not make it to safety.[116]

News of the fatal accident spread through Washington like wildfire. Even before Lenthall's body was recovered rumors were being spread by

great energy. By the second week in September all the arches and vaults were in place, including those over the Supreme Court and the Senate chambers. To cover the Senate, Latrobe devised a half dome sixty feet in diameter springing from a new, semicircular western wall to a stout arch built against the old east wall. Thus, the room's plan was similar to the previous Senate chamber but was slightly smaller and no longer had a flat ceiling. It was also unencumbered by the former arcade that took up space and blocked views and voices. At the crown of the brick dome were one semicircular and five circular skylights protected from the weather by a wooden monitor roof. Latrobe planned to paint the underside of the monitor roof with imitation coffers, thus giving it the appearance of a second dome. In a final sleight of hand, the source of light feeding the skylights from the roof was hidden from view.

Latrobe's enemies, and the editor of the *Monitor,* a friend of the administration, wanted to publish a true account of the accident.[117] Latrobe wrote the newspaper a few hours after the ceiling fell, saying that men were at that moment clearing debris hoping to find Lenthall alive—the chance of which was faint. By the time the piece was published the coroner had determined that Lenthall's death was an accident.[118]

Despite the tremendous force of the disaster, the vaults over the Senate chamber were not injured. The half dome stood firm, presenting an extraordinary sight when viewed from below. Latrobe began rebuilding the courtroom as soon as the rubbish was cleared. Funds were low but a number of private citizens were willing to cover the unforseen expense and all the workmen offered to donate a week's labor to "render the Mischief invisible by the meeting of congress." Instead of a single arch along the east wall, Latrobe built three arches carried on stout stone columns and pilasters. The dome was designed with ribs as he originally intended. All the material was on hand, and Latrobe felt the work could be finished in a month.[119] Like so many of his past predictions, this one also proved overly optimistic.

On December 1, 1808, President Jefferson transmitted Latrobe's sixth annual report, the last of his administration, to Congress. Most of the report dealt with the north wing, its reconstruction, and Lenthall's accidental death. Latrobe blamed the disaster on the two annular vaults carried on the back of the shallow dome that were intended to support the floor above. These structures literally broke the back of the Court's ceiling. In allowing Lenthall to proceed, Latrobe claimed, his better judgment yielded to arguments of economy. At the close of the 1808 building season, much progress had been made on rebuilding the Supreme Court vaults, but they were not finished until the spring of 1809.[120]

To continue work on the north wing, Latrobe asked for an appropriation of $20,000. He also wanted $25,000 to reconstruct the west side of the wing containing the Library of Congress as well as various committee rooms, offices, and storage rooms. This side of the wing was riddled with rot and the library was too small for the books already on hand, which were piling up in heaps.[121]

Details of the Supreme Court Chamber

by B. Henry Latrobe, 1808

Library of Congress

*O*n September 26, 1808, one week after John Lenthall was killed by the collapse of the vault over the Supreme Court chamber, Latrobe finished this drawing showing how the vault would be rebuilt. Instead of a single arch along the east wall, the architect designed a three-bay arcade carried on columns and piers as shown in the upper half of this drawing.

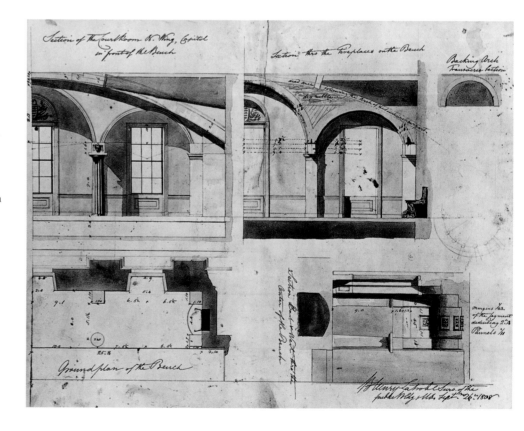

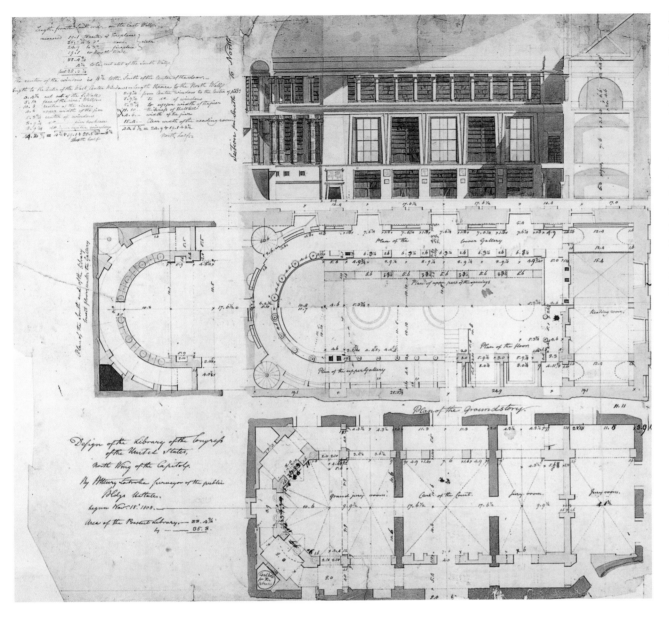

**Design of the
Library of Congress
of the United States**

by B. Henry Latrobe
1808

Library of Congress

A plan at the bottom of the sheet illustrates structural modifications to first-floor rooms that were necessary to accommodate Latrobe's new library room shown in the upper plan. The most captivating part of the drawing, however, is the section of the library shown at the top of the sheet. In this drawing, exotic papyrus columns, splayed openings, and cavetto cornices give the design its Egyptian flavor. Latrobe indicated sunlight from a large north-facing window spilling from right to left across the room. To make the drawing more appealing, there are books on the shelves, a map above the fireplace, and framed pictures between the alcoves.

Latrobe described the facilities provided in his design for the Library of Congress. It would hold 40,000 books arranged in three tiers against the walls while two rooms were available for unbound books, pamphlets, and printed copies of the laws. A private reading room was provided for members of Congress. Not said was how magnificently the library would be lighted through an arched window facing north, which would not be seen from the outside. Nor did Latrobe mention that his design would employ columns with papyrus capitals, battered alcove openings, and other references to the architecture of the ancient Egyptian world, which nurtured the arts of paper making and writing. Most members of Congress would have found the library exotic and unfamiliar. It was the earliest American design in what would afterwards be called the "Egyptian revival," one of the favorite styles for nineteenth-century cemeteries, prisons, and libraries. Latrobe's library design, however, never got off the drawing board.

On December 12, 1808, Senator James Lloyd, a Federalist from Massachusetts, introduced a resolution inquiring into the amount of money expended on the public buildings in Washington and asking how much more would be needed to finish them. The following day, Stephen Bradley of Vermont offered an amendment confining the inquiry to the President's House and Capitol. The amended resolution passed and Bradley and Lloyd

joined Samuel Smith of Maryland as members of a committee appointed to conduct the inquiry. Thomas Munroe reported that the north wing had cost $371,388, while $323,388 had been spent on the south wing. These figures supported Latrobe's repeated contention that his professional skill was responsible for delivering a better building for less money. But the committee was more interested in learning about future funding requests. Latrobe presented these figures in the form of a chart, which is reproduced below.[122]

	1809	1810	1811	1812	1813	Total
Finish South Wing	$6,000	$4,000	$4,000	$5,000	$1,000	$20,000
Paving and Steps		$5,000		$3,000		$8,000
Finish South Recess	$18,000	$6,000				$24,000
E. Side, North Wing	$20,000	$1,500				$21,500
W. Side, North Wing	$25,000	$15,000				$40,000
Finish North Recess		$30,000	$18,500			$48,500
Center Building			$100,000	$100,000	$25,000	$225,000
Landscaping		$5,000	$5,000	$5,000	$10,000	$25,000
Total	$69,000	$66,500	$127,500	$113,000	$36,000	$412,000

Legislators found the figures frightening. The country was in the throes of economic depression brought on by an embargo that closed American ports to foreign commerce. Customs receipts dropped 55 percent: the loss to the federal treasury has been estimated at $9.3 million.[123] New England was the hardest hit region and her citizens stirred up loud protests against the administration's policies. By the opening of Congress on November 7, 1808, Jefferson had received more than 200 petitions protesting the embargo; 90 percent were from Massachusetts.[124] The administration's policies, meant to punish England and France, were barely felt by those nations while maritime interests at home suffered badly. While hindsight would show its nurturing effects on manufacturing and industry, the embargo was despised as an economic and political failure.

The state of the nation's finances was not encouraging. On January 5, 1809, when Senator Andrew Gregg of Pennsylvania reported on a funding bill to complete the wings, the part aimed at rebuilding the west side of the north wing was immediately struck out by a vote of twenty to ten.

Twenty thousand dollars was granted for finishing the Senate chamber and Supreme Court, and an additional $6,000 was given for carving column capitals in the hall of the House. Thus, the Senate withheld about two-thirds of the funds Latrobe requested. The amended appropriation was returned to the House, which deferred action until it passed legislation to strengthen enforcement of the embargo.

The 10th Congress adjourned on March 4, 1809, but the press of business made it clear that the next Congress could not wait until fall to meet. The opening of the 11th Congress was pushed up to the fourth Monday in May. Anticipating a long session that might extend well into the summer, the Senate asked Latrobe to investigate relocation into a more airy chamber. When the request was made, the Senate was sitting in a small committee room on the first floor of the north wing (modern day S–146 and 146A). While the room was a comfortable accommodation during winter, the prospect of using it in summer was unpleasant. Latrobe responded with the idea of building a pavilion in the library space constructed with light frame walls and boards covered with painted or papered canvas. Although dilapidated, the library was high and airy enough to accommodate such a pavilion, and the room only needed to be cleared of the chairs and benches left over from the last term of the Supreme Court.[125] Ornamental painter George Bridport designed and installed the temporary chamber, receiving $950 for his efforts.[126]

RETURN TO MONTICELLO

For the 1809 building season Latrobe was granted funds to continue work in the north wing, to pay for the Senate's temporary pavilion, and to continue carving column capitals in the House chamber. Jefferson signed the appropriation on the last day of his presidency, March 3, 1809. The following day James Madison was inaugurated in the House chamber. Although Jefferson remained in the President's House another week, he "vacated it without regret, and with unfeigned joy took the road back to Monticello."[127] Latrobe's correspondence with Jefferson

Temporary Senate Chamber

by George Bridport, 1809

For what promised to be a long, hot summer session, Philadelphia architect and decorative painter George Bridport designed a temporary chamber located in the middle of the Library of Congress. For four months, the Senate met in the elegant pavilion, pitched like a tent in the center of the library room.

did not end with the president's retirement, but the two men never saw each other again. While Jefferson maintained his interest in the public buildings in Washington, he never returned to see them. His retirement ended the extraordinary patronage of a president whose involvement in public architecture remains unequaled in the country's history. Latrobe's dealings with subsequent chief magistrates would be stilted compared to the cordial, almost fraternal relationship he had with Thomas Jefferson. And while they often disagreed on such things as skylights and lanterns, their six-year collaboration ended in mutual admiration. In a memorable tribute to Latrobe, the retired president wrote:

> I shall live in the hope that the day will come when an opportunity will be given you of finishing the middle building in a style worthy of the two wings, and worthy of the first temple dedicated to the sovereignty of the people, embellishing with Athenian taste the course of a nation looking far beyond the range of Athenian destinies.[128]

On June 12, 1809, Latrobe assured Vice President George Clinton that there was no doubt that the Senate would sit in its new chamber at the opening of the next session of Congress. But he needed an additional $5,000 to cover the expense

of re-vaulting the Supreme Court and raising the wooden passage connecting the north and south wings. Now two stories high, the gangway allowed passage between the wings on the principal floor where both the House and Senate chambers were now located. Ten thousand dollars would also be needed to buy furniture, carpet, and new draperies for the Senate. The old desks were not suited to the new chamber and Latrobe wanted to replace them with new ones that were double, one desk for two senators.[129] With unusual ease, an appropriation for $15,000 was passed on June 28, 1809, the last day of the session. Sixteen hundred dollars was added to cover the higher-than-expected expense of fitting up the temporary Senate chamber and providing it with furniture.[130]

Corn Column

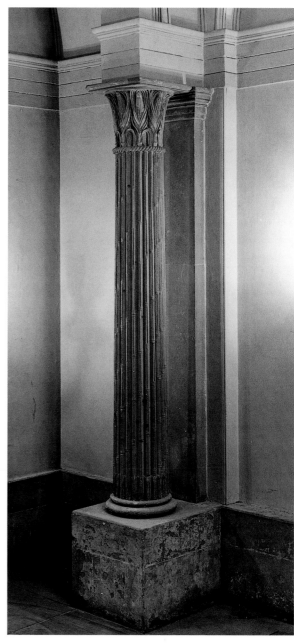

Perhaps Latrobe's most popular achievement during his years at the Capitol was his design for corn columns. Carved by Giuseppe Franzoni from Aquia Creek sandstone, they were installed in the east vestibule of the north wing during the spring of 1809. The fluting of a conventional shaft was recalled by bundled corn stalks. On the capital, husks were folded back to reveal the cob and kernels of corn. (1971 photograph.)

Detail

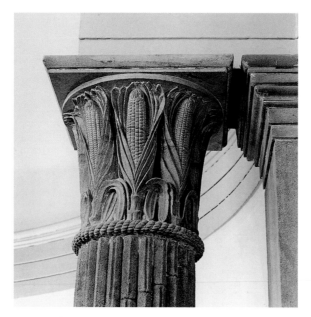

One likely reason for Latrobe's success in obtaining additional appropriations was the popularity of his "corn cob" columns, which had just been put up in the east lobby of the north wing. To carry the weight of the vaulted ceiling, Latrobe positioned sandstone columns a few inches from the old walls and designed them with capitals carved with American ears of corn. Bundled corn stalks recalled the fluting of a conventional column shaft and the necking was portrayed as rope. The corn order was an instant success. It was universally admired because it was undeniably appropriate and there was nothing esoteric about it. It was beautiful as well. On August 28, 1809, Latrobe sent the model of the corn capital to Jefferson and told him that it generated more praise than other, more splendid works at the Capitol. Congressmen nicknamed it the "Corn Cob Capital" for the sake of alliteration, he supposed, but he did not think the name very appropriate.[131]

Using the corn order in rebuilding of the east lobby scored a public relations coup. Latrobe turned a structural necessity into a popular attraction that continues to delight visitors to this day. Interestingly, the lobby is rarely—if ever—compared with its counterpart in the south wing, which has no columns at all. There Latrobe was able to build the vestibule with walls strong enough to support the weight of its vault without columns. Its geometry is strong and simple, and ornamentation is restricted to a few plaster moldings. There are

no eye-catching features, yet the spacial experience is eminently satisfying.

By the end of June 1809, the second vault over the Supreme Court was finished. Plasterers completed their work two months later. Although the ceiling in the Senate chamber was first reported uninjured by the collapse of the Supreme Court vaults, workmen were apprehensive about its security. To allay their fears, Latrobe had about one third of the vault rebuilt and reinforced the supporting walls. With some of the boldest hands, his son Henry (who was appointed clerk of the works following Lenthall's death) removed the centering on August 25, 1809, "an exertion of industry and courage which has seldom been equaled by any set of men." Latrobe considered the ceiling a daring feat and told the president that it was one of the most extraordinary vaults ever attempted.[132]

The Court was about to take possession of the first room designed for its use. Since moving to Washington in 1801, the Court had been accommodated in various ways. It first met in a poorly furnished and inconvenient committee room (modern day S–146 and 146–A). When work began to rebuild the interior of the north wing in 1808, it moved to the library on the second floor. That room was so "inconvenient and cold" that the Court moved in the spring of 1809 to Long's Tavern located just east of the Capitol. When construction began on its own room in the Capitol, there was alarm among real estate investors around Judiciary Square who had supposed the Court would soon be located there. Even Jefferson thought the Court's accommodation in the Capitol was temporary. He thought the Court would eventually move to Judiciary Square and its room in the Capitol would become a court of impeachment.[133] But the Court never moved to Judiciary Square and continued to borrow space in the Capitol until 1935.

The usual scarcity of workmen and difficulty with delivery of materials caused a brief delay in the opening of the new Senate chamber, which was used for the first time on Saturday, February 10, 1810.[134] The semicircular chamber was essentially an indoor theater reminiscent of ancient Greece and Rome. Latrobe had used a similar plan for the anatomical theater he designed for the University of Pennsylvania's medical school, which was completed in 1806. That, in turn, was based on Jacques Gondoin's 1769 anatomy theater at the *Ecole des*

Chirurgie (School of Surgery), the first *á la antique* room in Paris. Latrobe thought Gondoin's theater was "one of the most beautiful rooms and perhaps the best lecture room in the world for speaking, hearing, and seeing."[135] From a report by leading French architects, Latrobe learned that they considered the shape and form of a domed semicircle "the best adapted for the purposes of deliberation."[136] In 1803 he had proposed such a room for the House of Representatives and was overruled by the president. But Jefferson approved a domed semicircle for the Senate because it was not too different from the original plan, and it may also have reminded him of a famous landmark in his beloved Paris.

In his annual report for 1809, Latrobe again asked for funds to reconstruct the western half of the north wing; again he was denied. What was already under way could be finished, but the country was in no condition to pour money into new construction when the federal treasury was under such a severe strain. On January 11, 1810, a committee of the House reported that "it is not deemed prudent at *this* time, when a resort to loans may be necessary for the support of the Government, that any improvements whatever should be made, which can be, with any sort of propriety, dispensed with."[137] Clouds of war gathered as efforts to force England and France to respect America's neutrality failed. First the embargo closed American harbors to all foreign commerce. Then, at the beginning of the Madison administration, the Non-Intercourse Act opened ports to all nations except England and France. In May 1810, the Macon Bill No. 2 reopened trade with these two nations but threatened non-intercourse with one if the other agreed to respect neutrality. This last measure practically guaranteed war with one of Europe's great powers. None of these efforts would prevent war, and the economic hardships they brought prevented Latrobe from proceeding much further with his plans for the Capitol.

For the 1810 building season, Latrobe requested $77,500 but was granted $27,500. Work was limited to the columns in the House chamber and finishing work on the eastern half of the north wing. The appropriation passed and was signed in the last hours of the session, so late that Latrobe had begun to fear that nothing would be given at all. With so little money Latrobe dismissed all but

Details of the upper Columns in the Gallery of the Entrance of the Chamber of the Senate U. States

by B. Henry Latrobe 1809

Library of Congress

Special guests of the Senate were accommodated in a small gallery over the western vestibule that offered an intimate view of the proceedings below. The gallery was screened by small marble columns with magnolias incorporated into the capitals. Formerly thought to be cotton, the magnolia design was Latrobe's second American order. The magnolia columns did not survive the fire of 1814.

six or seven workmen and supplemented the building fund by selling surplus sheet iron, old desks, and other worn-out furniture. Aggravating the money problems, Latrobe discovered that furniture for the Supreme Court could not be charged to the Court's contingency fund, but was taken instead from his building accounts.[138]

The Italian sculptors were kept busy despite the scarcity of money. Andrei continued carving capitals in the House chamber and Franzoni worked on a figure of Justice for the Supreme Court and caryatids for the Senate. With two orders of columns and six caryatids Latrobe's sculptural program for the Senate was especially varied and ambitious. Positioned along the east wall under the visitor's gallery, the caryatids were carved figures that personified national prosperity and accomplishment—Arts, Commerce, Agriculture, Science, Military Force, and Civil Government.[139] Unlike the ancient caryatids of the Erechtheion in Athens, Latrobe's figures did not support the structure above but stood in front of sandstone piers that did. For the western entrance to the chamber, Latrobe designed a screen of four Ionic columns with monolithic shafts. They were ordered from James Traquair's marble yard in Philadelphia and were probably delivered carved and ready to install. The columns

President's Chair &c. Senate U. S.

by B. Henry Latrobe, 1809

Library of Congress

This sheet of details includes front and side views of the canopied rostrum, as well as its framing plans. What seems to most interest Latrobe, however, is the design for the tripods (top) intended to hold Argand lamps flanking the vice president's chair.

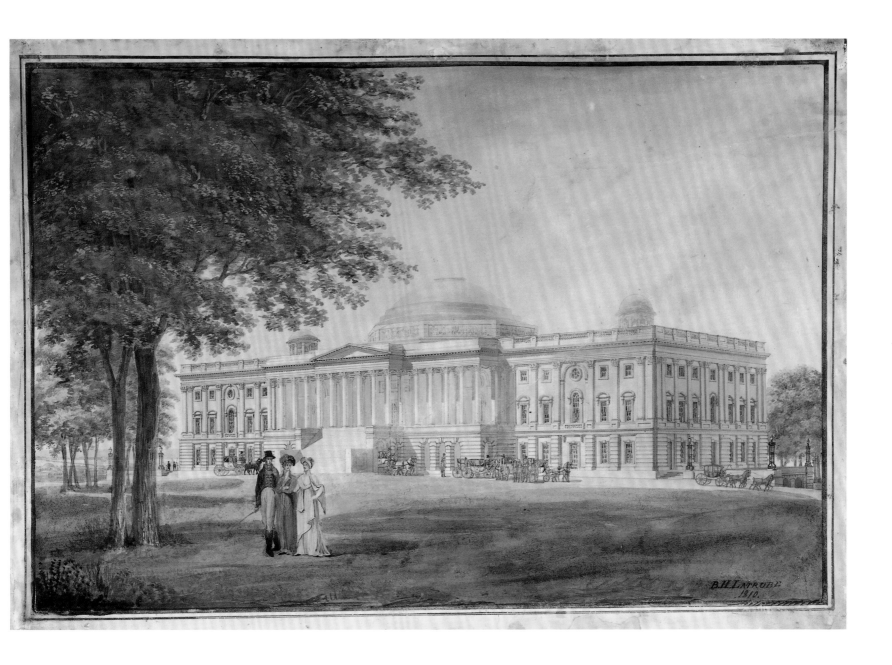

View of the Capitol from the Northeast

by B. Henry Latrobe, 1810

Maryland Historical Society, Baltimore, Maryland

*L*atrobe's elegant drawing illustrates his vision for the Capitol's completion. A variation of the center portico, flanking colonnades, and grand stair would eventually be built. The dome, however, would ultimately be built from a different design.

supported a small gallery intended for special guests that was screened by four dwarf columns. For these diminutive columns Latrobe designed his second American order, drawing upon the magnolia flower for the capital. Andrei carved them, undoubtedly welcoming the change from the Corinthian order that he had been working on for three years in the south wing.

For the want of money, very little was accomplished in 1810. In his annual report Latrobe alluded to some unidentified improvements made in the Senate chamber, but the plastering on the east wall was not up and the draperies still had not been installed. Because the sculptors were mainly

occupied in the south wing, their work in the Senate remained incomplete.[140]

Despite the economic conditions of the country, Latrobe bravely asked Congress for more money. The west side of the north wing was so

*M*ade during the last days of his first Capitol campaign, Latrobe's studies for the west (garden) front included a design to fill the 170–foot gap that then existed between the north and south wings. He proposed a rectangular building with a central nine-bay colonnade. It did not shelter an entrance like its counterpart on the east (carriage) front, providing instead a grand balcony overlooking the city and the Virginia hills beyond the Potomac. Entrance from the west was through a gate house, flanked by a pair of residences for the doorkeepers of the House and Senate. This entrance structure was inspired by the ancient Propylaea, the entranceway to the Acropolis in Athens. Between the doorkeepers' residences and the Capitol, were private yards where the families could dry laundry and grow vegetables. As seen in both the west and the south elevations, Latrobe intended for masonry terraces to accommodate the Capitol on its sloping site.

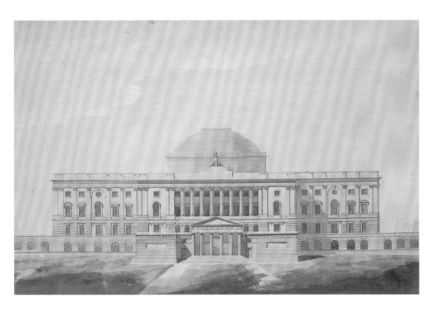

A. West Elevation of the Capitol

by B. Henry Latrobe, 1811

Library of Congress

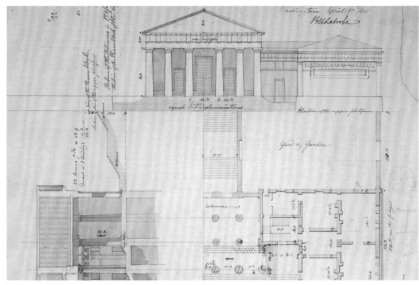

C. West Approach to the Capitol

by B. Henry Latrobe, 1811

Library of Congress

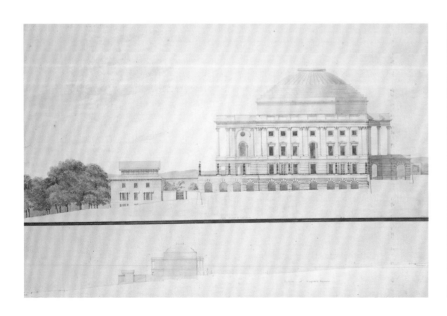

B. South Elevation of the Capitol

by B. Henry Latrobe, 1811

Library of Congress

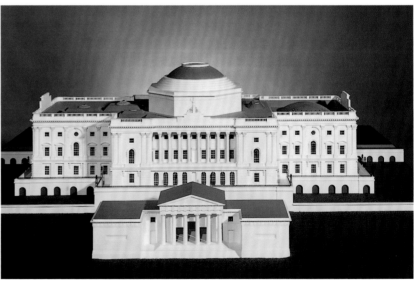

D. Model of Latrobe's Capitol Design, 1994

riddled with decay that repair was impossible and funds were sorely needed to begin reconstruction. Money was also needed to finish the recess, which was necessary to prop up the sagging corner of the south wing. Stone platforms would also be built at the north and south ends, and the sculptors needed to keep working. He also asked that the building fund be reimbursed the $2,432 spent to furnish the Supreme Court. Money was needed to buy glass, repair the grounds, and pay salaries and contingencies. In all, Latrobe asked for $47,432 and Congress denied the entire request.

WORK STOPS

On March 3, 1811, the 11th Congress adjourned without making an appropriation for the Capitol. Work stopped, such as it was, bringing an end to the first phase of Latrobe's Capitol career. Near the close of the next session, an appropriation was made to clear up past debts, to complete the sculpture in the Senate chamber, and to pay the return passage of the two Italian sculptors (which they did not take).[141] Latrobe was granted $1,811 for his salary up to July 1, 1811, when his duties as surveyor of the public buildings ceased. The legislation styled Latrobe as the "late surveyor," which he unaccountably took as a "public stigma."[142] The appropriation was approved on July 5, 1812, less than three weeks after the United States declared war on Great Britain.

Latrobe's standing among congressmen and senators was never high. He was accused of extravagance and wasting the public's money, and all the facts and figures supporting his claims of economy could not erase the impression of undue excess. His estimates, whether for construction costs or completion dates, were generally misleading. The commissioners had built a plainly finished wing that suited the simple taste of most legislators. There seemed to be no official dissatisfaction in Congress with the style of the north wing's interior finish, but the grandeur of the south wing was often construed as wasteful, contrary to the American notion of thrift. Legislators generally thought luxury had no place in the seat of a republican government. Criticism based on the perception of extravagance caused Latrobe much uneasiness.

Outside Congress, the Federalist press attacked Latrobe for a wide range of misdeeds, including insubordination, incompetence, waste, and complicity in Lenthall's death. Latrobe tended to attribute these articles to Dr. Thornton, but some were written by other enemies, including James Hoban and John P. Van Ness, a prominent local businessman and civic leader. In October 1808, Hoban, using the pseudonym "A Plain Man," blamed Latrobe for the faulty design of the vault that killed Lenthall. Latrobe's absences from Washington while "arching experiments" were underway were unforgivable, and blaming Lenthall for his own death was a "mean subterfuge." He accused Latrobe of forging ahead with the wholesale reconstruction of the north wing's interiors, while ignoring the president's wish to preserve the columns and arches from the former Senate chamber.[143] This charge was often repeated and troubled Latrobe considerably. The charges appeared again in 1809 in an article by John Van Ness, who signed himself "An Humble Citizen." He accused Latrobe of not following Jefferson's instructions in regard to the north wing and simultaneously demonstrated that the architect's enemies did not lack passion. Van Ness wrote:

> Let it not be said that nothing can escape your covetous grasp. That whenever an appropriation is to be expended, there you are. By turns the architect; the importer, the commission-broker; the upholsterer; the carriage purchaser &c. &c. Now soaring aloft on the cleaving wings of your transcendent genius; then crawling like a reptile through the humble dust: alternately acting the rampant lion, and the fawning spaniel. Unfortunate versatility, if you please![144]

To reassure himself that he had understood Jefferson's wishes, Latrobe wrote the ex-president asking him to recall the instructions regarding plans to rebuild the old Senate chamber. Jefferson replied that inquiries of that nature made "appeals to memory, a faculty never strong with me, and now too sensibly impaired to be relied on." Details may elude him but his general impression was that Latrobe performed his duties with "ability, diligence, and zeal." He was not, however, sufficiently guarded when it came to money. In the matter of the new Supreme Court and Senate chambers, Jefferson was certain that what had been built was from the

plans that he approved. Jefferson continued with friendly remarks on the architect's skill, which must have lifted Latrobe's spirits considerably:

> Besides constant commendations of your taste in Architecture and science in execution, I declared on many and all occasions that I consider you as the only person in the U.S. who could have executed the Representatives chamber or who could execute the Middle building on any of the plans proposed. There have been too many witnesses of these declarations to leave any doubt as to my opinion on this subject.[145]

Without building funds the post of surveyor of the public buildings simply evaporated into thin air. Informally, however, Latrobe continued to provide counsel in matters regarding the Capitol. In 1812 he certified the account of John Rea, an upholsterer hired by the Senate to make curtains for its chamber. Blue and yellow cambric, silk fringe, and tassels were used to make the window treatments.[146] In February 1813 Speaker Henry Clay visited the architect to discuss improvements for the House chamber and was given a full explanation of the events surrounding its design and construction. The Speaker was particularly concerned about the approaching summer session and wanted to know if something could be done with the skylights. Past remedies for too much light and heat included throwing canvas tarpaulins over some skylights or closing others with blinds. During the summer, nearly 90 percent of the skylights were partially blocked and the one operable skylight was totally inadequate for ventilation purposes. Feeling vindicated, Latrobe said the roof framing had been prepared for a lantern, and if it were built, the problems would be solved. There was also the matter of adding forty-four more seats to accommodate the increased membership in the House resulting from the 1810 census.[147]

Clay asked Latrobe to write his ideas in a report, which the architect duly sent to the Speaker on February 4, 1813. All of his suggestions were approved and the House appropriated $5,000 to put them into effect. But President Madison hired someone else to install the new chamber floor and nothing was done about the skylights or lantern because funding would not permit it. Madison told Latrobe that he could not engage him for work because of his low standing with members.

Latrobe recalled the conversation in a letter written to his business associate, Robert Fulton:

> He then said at once, that I was so unpopular, and such strong prejudices existed against me, that he could not venture ever to employ me, altho' he believed the prejudices to be unfounded: that nobody doubted my Skill or my integrity, but that I was thought extravagant, a waster of public money, and all the rest of the Trash that has as little foundation, as the stories told of yourself or any other man of talents not generally understood.[148]

THORNTON SILENCED

*T*he first session of the 13th Congress opened on May 24, 1813, with the House sitting under the glare of the noonday sun streaming through the skylights that had given Latrobe so much worry. A month later, in the splendid courtroom in the north wing, another of Latrobe's vexing problems was finally settled. The case of Latrobe v. Thornton was decided in the Circuit Court of the District of Columbia on June 24, 1813, more than five years after it was initiated. To give their lawyers the facts of the case, both the plaintiff and defendant wrote notes with their interpretations of the events that led to the suit. Latrobe's memorandum to Walter Jones and John Law was a brief account of his first meeting with Dr. Thornton in 1798, his opinions on the design of the Capitol, his appointment as surveyor of the public buildings, and the ensuing troubles. Some details were in conflict with the sequence of events, but generally Latrobe's affidavit was direct and dispassionate. He wanted his lawyers to concentrate on one particular aspect of Thornton's libel and "the rest would come in a corroborative of the attempt to destroy that professional reputation on which the support of my family, as well as the peace of my mind, and my acceptance in society depend."[149]

By contrast, Dr. Thornton's twenty-three page note to his lawyer, Francis Scott Key, was rambling and not very helpful.[150] Stories in Thornton's newspaper attacks, such as Latrobe the chimneypiece carver or Latrobe the Moravian missionary, were from men who either had recanted or were

now dead. To defend the missionary story, for instance, Thornton wrote:

> I heard that Mr. Latrobe came out to this country as a missionary or agent to the Moravians, a very worthy and religious Sect; but Mr. Nicholas King being also dead prevents my proving this, and some other points that would have borne very hard on Mr. Latrobe's architectural abilities. But Mr. Latrobe is not excluded from being an architect by his moravian uniform. However I think I have rather *libeled the moravians* by supposing he could be sent on so honorable a mission.

In another passage Thornton made fun of Latrobe's unfortunate luck with vaults and arches that fell. While accidents did occur, Thornton's exaggeration of them was used to question Latrobe's claims as a professional architect:

> It is well known the arches of the Penitentiary House in Richmond fell, the arches at the Treasury office of the U. S. fell twice, & the cost of that work was 13,940 Dolls. & the estimate only $8,000! Can an architect make such blunders? The arch at the Capitol fell, & killed poor Lenthall! If Mr. King had lived the secret of that work would have been known & shown to be Mr. Latrobe's [fault] & not Mr. Lenthall's as Latrobe pretended. The arch at the Secretary of State's office fell and after the failure in the construction of so many arches who can with propriety call him an *arch*—itect?

Page after page of similar explanations and excuses were lightened by puns and double entendres. Thornton sometimes turned to verse:

> Description
> He's about six feet two,
> Of an ash coloured hue.
> His face is of brass—
> His Eyes cas'd with Glass
> not to see
> as do we
> But, because they are green—
> To prevent being seen.

> When e'er he walks bye
> He looks in the sky,
> Like one in a wonder,
> As Ducks do in thunder.
> His manners are blunt,
> And his Laugh is a grunt.

A half dozen other poems of similar merit were incorporated in Thornton's defense, and it may have seemed to Key that his client considered a $10,000 libel suit nothing more than a joke. Indeed, Thornton proposed to address the court in verse, following a recital of his "Epitaph" of Moll Turner, the woman supposedly ruined by the plaintiff:

> Judges & Jury of the Court,
> I pray that you'll excuse my sport,
> In giving poor Moll's Epitaph,
> And hope I shall have no denial,
> In substituting in this trial,
> Instead of Fines—a General Laugh!

Year after year, Thornton and Key were able to postpone the trial by claiming that one witness, Ferdinando Fairfax, was unable to attend court. Fairfax was Thornton's witness to the claim that Washington had no confidence in Latrobe. After the delaying tactics could buy no more time, the case was tried in the summer of 1813 and Thornton was found liable. For unexplained reasons Latrobe did not press damages, but the moral victory was priceless. The court awarded Latrobe one cent plus costs. Thornton was silenced at last. But there would be little time to savor victory. In November, Latrobe left Washington to embark upon the next phase of his career, one he hoped would bring the financial security he longed to provide his family. As an agent of Robert Fulton's Ohio Steamboat Company, he would spend sixteen months in Pittsburgh, enduring one of the most disappointing episodes of his life.

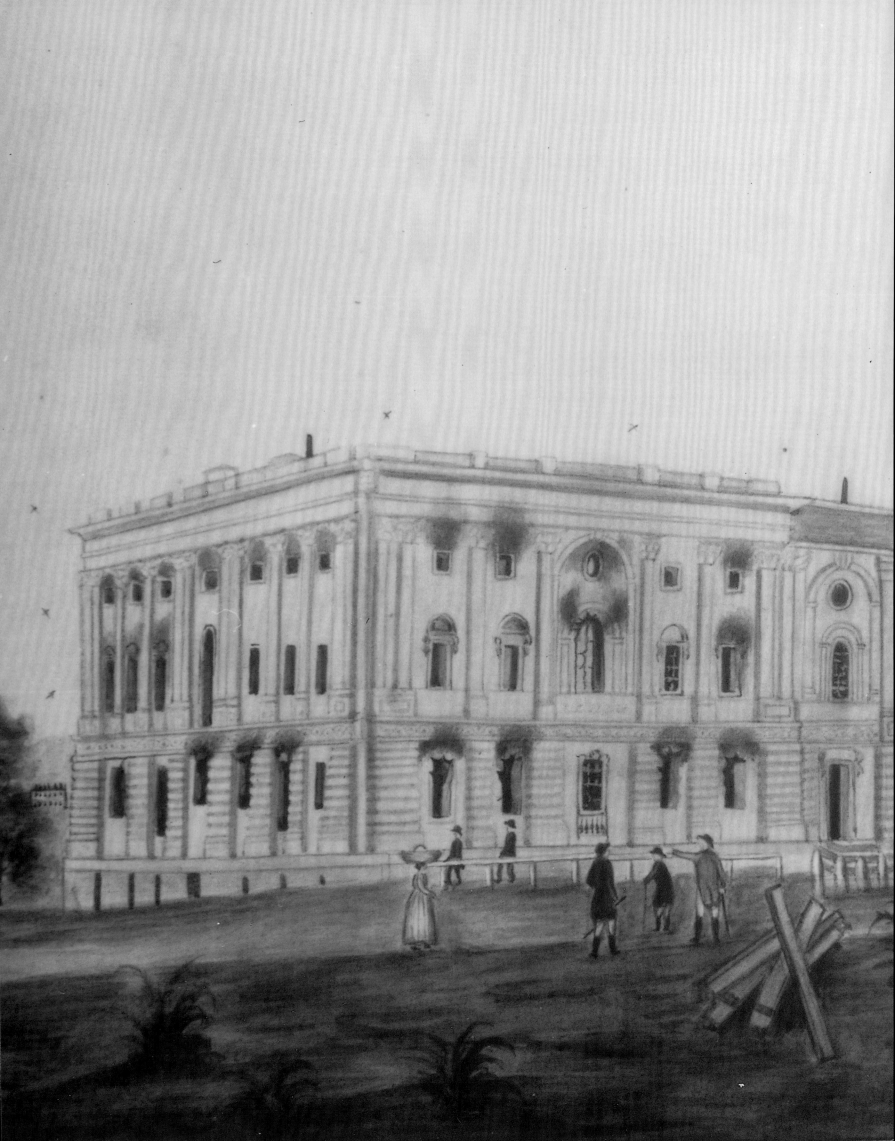

CHAPTER THREE

DESTRUCTION AND RESTORATION, 1814–1817

After two decades of construction, in 1814 the Capitol consisted of the north and south wings joined by a two-story wooden gangway spanning the area intended for the rotunda. Half of the north wing had been rebuilt with masonry vaults while the other half retained its decaying floors and sagging ceilings. The south wing boasted what was probably the most beautiful room in America, the hall of the House of Representatives. Progress was slow, but it was being built for the ages, a permanent ornament for the republic's future. Yet, in the span of a few minutes, the course of the Capitol's construction—and the nation's honor—suffered a humiliating blow when British torches and gunpowder reduced twenty-one years of hard work to a pathetic pair of smoldering ruins.

In the history of American military conflicts, the War of 1812 is perhaps the least understood—almost as little then as today. The unprepared country was nudged, then pushed, into declaring war on the United Kingdom by land-hungry congressmen with their sights set on securing the frontier by conquering Canada and driving British outposts and their Indian allies from lands east of the Mississippi River. Rights of neutrality and impressment of American seamen may have given the war a moral foundation, but it was the desire for territorial conquest that drove the country into hostilities with a far superior enemy. The leader of the "War Hawks" was Henry Clay, whose preposterous boast that the Kentucky militia alone could conquer Montreal and Upper Canada was taken as gospel by followers in the south and west. New England Federalists lent little support for the war, dubbing it "Mr. Madison's War." Their commercial interests suffered greatly from the policies of both the Jefferson and Madison administrations, and their sympathies were squarely with England, their largest trading partner.

The first year of the war was a virtual stalemate. American troops were unable to muster an invasion of Canada, and the English army was too distracted by Napoleon to win decisive victories in North America. In 1813, Oliver Hazard Perry's victory on Lake Erie and the death of Tecumseh at the battle of the Thames boosted American morale, although they failed to translate into a meaningful military advantage. In April 1813, a ragtag force led by Henry Dearborn slipped into Upper Canada and raided its capital city of York (now Toronto), burning the legislative hall and governor's house.

In 1814, with Napoleon's exile to Elba, the British navy was free to launch its own offensives to harass American ports. Its targets were Niagara,

Capitol in Ruins (Detail)

by George Munger, 1814 or 1815

Kiplinger Washington Collection

97

Lake Champlain, New Orleans, and the towns of the Chesapeake Bay tidewater. On August 22, 1814, about 4,500 British troops were in southern Maryland, only sixteen miles from Washington. They landed from ships that avoided the well-defended Potomac by sailing up the Patuxent River instead. In command were Admiral Sir George Cockburn of the Royal Navy and General Robert Ross of the British Army. Washington was their target, and their proximity triggered a stampede of 90 percent of the inhabitants out of the city. By August 24, about 5,000 men under the command of General William H. Winder awaited British soldiers and sailors at Bladensburg, a little town at the edge of the federal territory. The ensuing battle was quickly decided in the enemy's favor. The Americans swiftly retreated to Tenleytown and then further to Rockville, fifteen miles northwest of Washington. (So snappy were Americans in retreat, the skirmish was later referred to as the "Bladensburg Races.") To avenge the American raid on its Canadian capital, the British army and navy had come to pay a return call on the capital of the United States.

A considerable amount of public property was destroyed by retreating Americans. Commodore Thomas Tingey, head of the Navy Yard, set it on fire. Losses included a new frigate, a warship, gunboats, and valuable provisions, rope, canvass, and other supplies. The lone bridge across the Potomac was also destroyed before the invading army marched into the nearly deserted town.

Once the British captured Washington, enemy troops set about destroying the public buildings. Fires in the Capitol began to be set just after nine in the evening.[1] In the south wing, some rooms in the office story were vandalized by means of a gunpowder paste brushed on woodwork surrounding doors and windows and set ablaze. Papers and furniture in the clerk's office offered a large quantity of combustible material. After it was set on fire, the heat forced troops to withdraw, leaving nearby rooms on the west side of the wing uninjured. Among the irreplaceable losses were the secret journals of Congress kept by the clerk of the House. Upstairs in the House chamber, rockets were fired through the roof but its iron covering would not burn. Failing that, furniture was gathered into a pile in the center of the room, slathered with gunpowder paste, and set on fire. Helping fuel the fire was the new floor recently built over the old one,

which doubled the stockpile of seasoned wood there. The heat was so intense that glass in the skylights melted and the colonnade was heavily injured (but did not fall).[2] Although supported precariously, the entablature did not collapse; the wooden ceiling, however, was completely destroyed. Within minutes, Latrobe's magnum opus was reduced to ruins. But just outside, the circular vestibule with its elegant stone columns (called today the "small House rotunda") survived. The east lobby and principal staircase survived as well. Indeed, though the chamber was completely ruined, much of the scenic approach to it was not damaged at all. Still, the loss was horrific.

Damage to the north wing was more extensive due to the combustible materials located throughout the library area. That part of the north wing still had the wooden joists, laths, and floors installed in the 1790s, which burned fiercely despite widespread rot. The library's furniture, books, maps, and manuscripts helped fuel the flames. The intensity of the fire in that part of the north wing inflicted the heaviest damage to the exterior walls, part of which nearly collapsed. The marble columns in the Senate chamber were reduced to lime and fell down, and the room was left "a most magnificent ruin."[3] The Supreme Court was heavily damaged but its Doric columns stood— weakened but straight. Latrobe's prize "corn cob" columns were also spared. The incendiaries concentrated their efforts on the principal rooms and did minimal damage to lobbies, halls, and staircases, which were, after all, their escape route out of the wreckage. Still, the British undertook their mission thoroughly and professionally.

At the other end of Pennsylvania Avenue, troops continued their trouble making. Around 11 o'clock in the evening, the President's House was burned. The torch was put to the War and Treasury departments the next morning. While destroying the arsenal at Greenleaf's Point, about 100 British soldiers were killed when they accidentally ignited 130 barrels of gunpowder they were tossing down a well. The explosion hit like an earthquake, leaving behind a crater forty feet in diameter: mangled bodies were strewn far and wide.[4]

As a counterpoint to the destruction of the public buildings, British respect for private property was, on the whole, admirable. Samuel Harrison Smith's *National Intelligencer* printing office

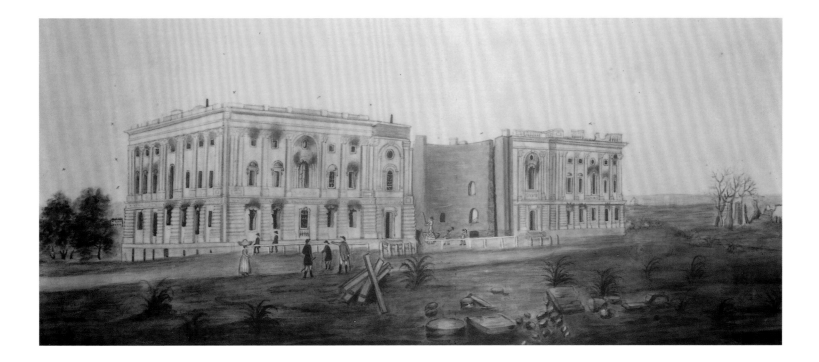

The Capitol in Ruins

by George Munger, 1814 or 1815

Kiplinger Washington Collection

*S*ightseers came to Capitol Hill to examine the forlorn wings after they were damaged by British troops on the evening of August 24, 1814.

was vandalized, but largely because of its role as an administration mouthpiece. Daniel Carroll's hotel was burned, but it may have been ignited by a wayward spark from the nearby Capitol. Two row houses built by George Washington were deliberately set on fire. But the Patent Office was saved by its superintendent, Dr. Thornton, who argued that patent models were owned by their inventors and were therefore private property.

Just before Washington fell to the enemy, President Madison fled to Virginia. At dawn on August 26, he crossed the Potomac into Maryland, reaching Rockville at six o'clock in the evening. There he expected to find the remnants of General Wilder's army, but they had left for Baltimore some hours earlier. The president and his party pushed eastward to Brookville, a small Quaker community where Madison took refuge in the home of Caleb Bentley and his wife Henrietta. In an ironic twist of history, the silversmith who made the cornerstone plate deposited by the first president at the Capitol in 1793 now fed and sheltered the fourth president while the Capitol smoldered in ruins.

On September 1, 1814, President Madison issued a proclamation calling on Americans to unite and "chastise and expel the invader." Despite the fact that peace talks were under way, the enemy had deliberately disregarded "the rules of civilized warfare." They had wantonly destroyed

public buildings, which according to Madison were not being used for "military annoyance."[5]

Three and a half weeks after British troops left, Congress returned to witness firsthand the extent of damage. Thomas Munroe was asked to prepare Blodgett's Hotel (home of the Patent and Post Offices) as a temporary Capitol, and there a committee was appointed to investigate the British successes in their "enterprises against this metropolis."[6] Yet the causes were understood all too well. An inadequate defense by an inadequate militia, in the face of seasoned and well-equipped troops, was only the latest humiliation suffered in this badly managed war. The real question before Congress was whether to remain in Washington or to move the capital to a more central, secure, and convenient location. The usual forces sprang into action at the mere mention of relocating the seat of government, a replay of the intrigues surrounding the Residence Act a generation earlier. By October 20 the decision was made to stay in Washington,

but other questions needed to be settled. Some did not believe the damaged buildings should be repaired and preferred to build new ones in new locations from new, more economical designs. A committee of the House was appointed to investigate the matter and reported its recommendation on November 21, 1814. It asked the superintendent of the city to examine the existing building shells with architects and builders. After conferring with George Hadfield, Munroe reported that the walls of the Capitol and President's House were safe and sufficiently strong to be restored. He reported that $1,215,111 had been expended on the public buildings so far and that it would require about $460,000 to repair the fire damage.[7] Thus, Munroe implied, it would be cheaper to repair the structures than to build anew. The committee agreed to restore the Capitol and President's House and to give no further consideration to the idea of replacing these buildings. Reminding the House that the location of the Capitol was selected by Washington, who considered it part of the original plan of the city and thus sacrosanct, the committee recommended making a small appropriation to protect the ruins from further decay. Most important, it reported that several banks in the District of Columbia had made offers to lend the government $500,000 for repairs. Banks were anxious to provide financial backing for something so vital to their interests, and while it was not part of the committee's assignment to report on money matters, it thought the loan offer not "irrelevant to the object of their inquiries."[8]

During the first week of February, Congress debated the questions surrounding the repair of the public buildings. Senator Eligius Fromentin of Louisiana urged his colleagues to authorize construction of a "large, convenient, and unadorned house" near Georgetown to serve as the new Capitol. The vast city dotted with small clusters of buildings reminded him of scattered camps of desert nomads. A plain building for Congress was preferable to an elaborate one because, he reasoned, "Our laws to be wholesome, need not be enacted in a palace." Building sites selected by the first president were not sacred because the conditions of the city and nation had changed so dramatically. The treasury was empty, prosperity had vanished, and commerce was at an end. What would Washington recommend under these circumstances? Repairing

the public buildings would take at least ten years and would cost much more than predicted. In Fromentin's opinion, the only sensible course was to abandon the remote Capitol and construct an inexpensive hall between Georgetown and the President's House. By a vote of twenty to thirteen, however, his effort failed to derail the movement to repair the public buildings on their original sites.[9]

In the House of Representatives, there was disagreement about which buildings should be given priority and whether the cabinet offices should be relocated. There was an idea, offered by Charles Goldsborough of Maryland, to rebuild the Capitol and offices but to postpone repairs to the President's House until times of "leisure and tranquility." While that Federalist congressman was in no hurry to return Madison to his palace, the House disagreed with him by a large majority. Another Federalist, Thomas P. Grosvenor of New York, wanted to relocate the executive offices nearer to the Capitol where members of Congress would have ready access to cabinet secretaries. After some debate, the House agreed.[10] The following day, Virginia Congressman Joseph Lewis, a member of the Committee on the District of Columbia, addressed the House with strong arguments against relocating cabinet departments. He spoke at length about Washington's reasons for putting the buildings next to the President's House and quoted correspondence between the first president and the old board of commissioners. Lewis explained that while the government was in Philadelphia, cabinet members complained about frequent interruptions by legislators who made it impossible to attend to their duties. Thus, when it came time to select sites for these departments in the new city, they were very properly located near the president, whose business with cabinet secretaries was routine. Lewis continued his address to include the subject of repairs to the public buildings, which he did not want delayed or curtailed. He said that he would rebuild them precisely as they had been, not changing one brick or stone.

Opponents, led by Daniel Webster of New Hampshire, wanted to postpone repairs until the end of the war when money would be in greater supply and consideration could be given again to removing the seat of government—preferably back to Philadelphia. Spending large sums of money to repair the buildings would anchor the government

more firmly on the banks of the Potomac. Webster and his friends wanted no more of the federal city, which they considered miserable and inconvenient. But Lewis argued that constant threats of removal inhibited investment in the city, thereby causing the discomforts that were the source of so much complaint. "The people of this District are political orphans," Lewis declared, "They have been abandoned by their legitimate parents Instead of extending to them the parental hand of affection, we do all in our power to blight and destroy their fair prospects." He believed that, if treated fairly by Congress, the city would rival the most important towns of the Union in both wealth and population. Following his speech, a vote defeated the proposal of relocating the executive departments to Capitol Hill.[11] In each vote, opponents of the federal city were thwarted. Cries for economy or for contracting the city plan were drowned by louder voices for restoration to the *status quo ante bellum.* On February 13, 1815, President Madison approved legislation authorizing the government to borrow $500,000 (at 6 percent interest) to repair and restore the President's House, the Capitol, and the cabinet offices "on their present sites in the city of Washington."[12] The battle over the permanent residence of Congress had been won a second time by the friends of the Potomac with an unexpected reaffirmation of Washington and L'Enfant's vision of an extensive capital city.

LATROBE'S RETURN

On March 10, 1815, Madison appointed a three-man commission to administer monies borrowed to repair the public buildings. Congress had not authorized such a commission, but the president took it upon himself to create one based on the precedent found in the Residence Act of 1790. At $1,600 per year, the salary fixed for members of the new commission was the same given members of the former board. A great deal of trouble and worry was lifted from the president's shoulders by such a body, shielding him from the controversies that inevitably spring up around large public projects. The first commissioner to be named was John Van Ness, whose

anonymous newspaper attacks caused Latrobe much embarrassment in 1809. A former congressman from New York, Van Ness was married to the daughter of David Burns, one of the original landowners of what became the city of Washington. Tench Ringgold, a member of a prominent Maryland family, filled the second seat. Last was Richard Bland Lee, a former Virginia congressman who had moved to Washington in 1814. All three were well connected, but like members of the old board of commissioners, none had experience in architecture or building. They quickly hired James Hoban to restore the President's House, which had been left little more than a burned-out shell by the British. The sandstone exterior walls, the brick interior walls, the kitchen stove, and a few scraps of hardware were all that survived.[13] Hoban was known for getting the job done and was their only choice. But the Capitol presented a different problem. Latrobe was, by his own admission, obnoxious to the president and Congress, and more convivial architects, including Robert Mills and J. J. Ramée, had applied for the position. The commissioners might have preferred either of them, but Latrobe's experience with the Capitol's surviving structure made up for his unpopularity.

Twelve days after the work was authorized, Latrobe wrote Madison offering his services. He stated that he was still sensitive to the charge of extravagance, which he claimed was shared with every architect "from the most ancient times, and in every nation." He said that he may not deserve the appointment, but he wanted it to avoid the embarrassment of someone else restoring the building he had done so much to create.[14]

The letter was written by a man in the throes of doubt and depression. Latrobe's time in Pittsburgh had been a disastrous strain on his mind and pocketbook, consisting of a failed adventure in steam engines and river boats. Troubled by debt and facing a future without hope or happiness, Latrobe was suffering a nervous breakdown that rendered him listless, confining him to his room. His wife, Mary Elizabeth Hazlehurst Latrobe, fearing for her husband's health, looked to Washington for help. Without her husband's knowledge, she wrote President Madison, Secretary of the Treasury Alexander J. Dallas, General John Mason, Pennsylvania Congressman Charles Ingersoll, and others to ask help in reinstating her husband to the

position of surveyor of public buildings. Her discreet intercession helped carry the day and on March 14, 1815, the commissioners wrote Latrobe with an offer of an interview that might lead to employment. A description of how the architect received the offer was written by his wife some years afterwards:

> The next day I received a large Packet with the President's seal, containing a recall for my husband to resume his former situation—never can I forget the transport I felt in going to him as he reclined in deep depression in the easy chair. I presented him the Packet. Behold, I said, what Providence has done for you! and what your poor weak wife has been made the humble instrument in obtaining. He threw himself on my breast and wept like a child—so true it is that women can bear many trials better than men! I received at the same time answers to the several letters I had written to the gentlemen, and of the kindest and most gratifying tenor, all acknowledging that there was 'No man in the country but Mr. Latrobe as filling the situation he had hitherto held.' Nothing could equal the surprise of my husband on the receipt of this packet, as he did not know of the means I had taken to procure his return.[15]

On the day he received the commissioners' letter (March 22, 1815) Latrobe wrote his acceptance of the offer it brought. Giving himself a few days to settle business in Pittsburgh, he promised to be in Washington by April 15. Annoyed by Latrobe's dally, the commissioner's replied that architects from New York, Philadelphia, and Baltimore awaited

their decision and the delay was hardly convenient.[16] Latrobe had taken the commissioners' letter as a job offer, while they had only asked him to come for an interview. Their testy reply to Latrobe's first letter did not bode well for a happy relationship in the future.

One day late, Latrobe arrived back in Washington on Sunday morning, April 16, 1815. He took a room at the Washington Hotel, where he changed clothes, and went immediately to see John Van Ness. Whatever quarrel Van Ness had with Latrobe in the past was apparently forgotten, because he received the architect with "wonderful friendliness," even inviting him to lodge in his home. Latrobe declined the invitation and soon they joined Tench Ringgold and visited the Capitol. Latrobe described the sight as a "melancholy spectacle." He was proud that so much had survived— "the picturesque entrance to the house of Representatives with its handsome columns, the Corn Capitals of the Senate Vestibule, the Great staircase, and the Vaults of the Senate chamber Some of the Committee rooms of the south wing are not even soiled." He had prepared himself for a scene of far greater ruin and was pleased that "the mischief is much more easily repaired than would appear at first sight."[17]

During his visit with Van Ness and Ringgold, Latrobe learned that Hoban had been hired to restore the President's House and that his work would be confined to the Capitol. Thus, his title

Ruins of the House Chamber

attributed to Giovanni Andrei, 1814 or 1815

*O*nly vestiges of the Corinthian colonnade remained after the fire. Long poles were used to prevent the entablature from falling and crushing the floor.

would not be the surveyor of public buildings, but rather architect of the Capitol or surveyor of the Capitol. The arrangement did not displease him, but he did wince at the salary—$1,600 per year—the same as that of a commissioner. Van Ness told him that there was no shortage of architects willing to be employed at that salary and, indeed, Hoban had agreed to it without complaint. After some negotiations Latrobe agreed to the salary so long as he also received $300 more to move his family to Washington and an allowance to rent a house.[18]

Latrobe was put under contract to restore the wings of the Capitol on April 18, 1815. The commissioners asked if work should proceed on both wings simultaneously or if it would be wiser to repair the south wing first and then turn to the north wing. In a remarkably naive question, they also asked if it would be possible to have the hall of the House ready for use in December.[19] Latrobe reported that a great deal of effort would be necessary to stabilize the north wing but after that it would possible (he did not say advisable) to focus entirely on the other wing. As for the likelihood of seating the House of Representatives in its chamber eight months hence, he answered *"in the negative."* Even if all the materials were on hand and all the workmen hired, it would be impossible. And, as he reminded the commissioners, *"rapid* building is *bad* building." Latrobe then said the hall would be ready in December of 1816 and both wings would be completely restored by the end of 1817. As if the past had taught him nothing, Latrobe again created expectations that would be impossible to fulfill.

Most of Latrobe's first report to the commissioners was an assessment of existing conditions and the steps necessary to protect the wings from further decay. He proposed to construct a board roof over the south wing pitched from the window sills of the attic story. Rain would be discharged through gutters out the window openings. A scaffold built on the floor of the chamber would help support the roof. Under cover, the colonnade would be dismantled, a job requiring great caution because of the danger of it falling and crushing the vaults supporting the floor. The temporary roof would also allow the rooms in the office story to dry. A temporary roof was needed over the north wing as well. Materials to be ordered immediately included 60,000 feet of rough boards, scaffolding

poles, 500 tons of freestone, 1,000 barrels of lime, and all the bricks that could be had. Carpenters were needed to enclose the grounds for a stone yard and to construct the temporary roofs. Laborers of all sorts were needed in vast numbers. Particularly important were stone cutters, whom Latrobe thought would be difficult to hire in sufficient numbers for the work ahead.[20]

RETHINKING THE HALL OF THE HOUSE

*W*hen discussing the need for an abundant supply of building stone, Latrobe reported that "The interior of the Hall of Representatives will be carried up entirely in freestone if the room should be rebuilt exactly upon the former design." This statement was the earliest indication that the architect had something different in mind. On the job just two days, Latrobe was mulling over an idea for a chamber that first occurred to him in 1803. His initial idea had been a chamber in the form of a half-domed semicircle without columns. Jefferson overruled the proposal because it was too great a departure from the accepted plan. With Jefferson now retired, Latrobe felt the time had come to again propose a half-domed semicircle for the House of Representatives. This one, however, would have a magnificent colonnade, which was such a popular feature in the former hall. It would replicate the former colonnade with Grecian columns modeled after the Choragic Monument of Lysicrates and an entablature with Roman modillions: an enduring Jefferson-Latrobe collaboration.

In a matter of days Latrobe wrote a report on the south wing to accompany a plan and section of a new design for the House.[21] He discussed the complaints lodged against the old room and explained how the new design would solve all former problems. Difficulties with acoustics, lighting, and ventilation would be vanquished by adopting the new plan. Latrobe indicated that acoustics was the least important defect and was usually the cause of gripes only when the chamber was filled with rowdy members or the galleries crowded with noisy spectators. When order prevailed, acoustics

was never a problem. Even so, the plan and form of the semicircular Senate chamber, "the best room of debate in America," made it a better model for the new hall of the House. His anatomical theater at the University of Pennsylvania, the ancient Theater of Bacchus in Athens, and the legislative halls erected in Paris since the revolution were other examples of semicircular rooms used successfully for lectures and debates.

Problems with light and ventilation would also be solved by the new plan. The hall would have direct access to the windows along the south wall and the ceiling would support a lantern twenty feet in diameter. "Not only will the room be ventilated in the most perfect manner and kept cool in the hottest weather," Latrobe promised, "but all complaint against insufficient light will be at once and forever removed." Although numerous, the former skylights had not provided enough light to the hall because so many were covered with canvasses to control glare or stop leaks. Protected by a dormer, only one skylight in the old hall could be opened

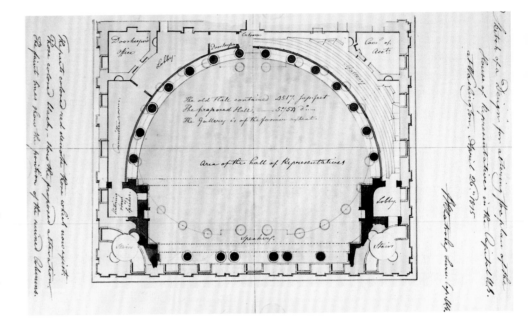

Sketch of a Design for altering the plan of the House of Representatives in the Capitol U. S. at Washington

by B. Henry Latrobe, 1815

A few days after Latrobe began his second career at the Capitol, he redesigned the hall of the House in the form of a classical theater. The plan shows alterations necessary to carry out the new design—the old walls are shown in light red and the new work is shown in black. Faint circles indicate the position of the former colonnade.

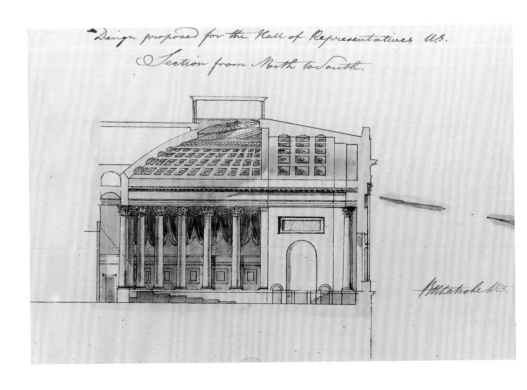

Design proposed for the Hall of Representatives U. S. Section from North to South

by B. Henry Latrobe, 1815

*T*his small drawing beautifully conveys the essence of Latrobe's second design for the House chamber with its semicircular colonnade, coffered dome, and central lantern. Columns shown against the south wall (right) would later be brought out to provide a loggia behind the Speaker's rostrum.

and was inadequate to the object of ventilation. A lantern with vertical sash would allow diffused light to enter the hall and a large volume of warm air to leave it. After years of battling Jefferson over lanterns, Latrobe hoped Madison and the commissioners would approve this practical feature.

Practical considerations aside, Latrobe also noted that the style of the old room was better suited to a theater than to a legislative chamber. He claimed it had "an air of magnificence bordering on ostentation and levity." The new design was less like a theater and, since he was the architect of both, he said he should be allowed to state his decided preference for the new plan.

Latrobe ended his description of the new design with a request for a speedy decision so he could begin ordering materials. The commissioners were impressed with the "improved plan," as they called it, and recommended it to the president but did not forward the architect's report or drawings to him. Writing from his Virginia estate, "Montpelier," Madison replied that it would be best not to deviate from the former design unless it was approved by Congress. He respected Latrobe's judgment but could not evaluate the merits of the case from where he was: "I suspend an opinion, until I can form one with the advantage of being on the spot."[22]

Had Madison been in the company of his friend and neighbor, Thomas Jefferson, to discuss Latrobe's plan it is unlikely that it would have been approved. At least the old subject of lanterns would have resurfaced. Jefferson first learned of the revised plan in a letter from Dr. Thornton, who wanted to restore the House chamber to the elliptical plan shown in the old "conference plan" of 1793. He had just learned of Latrobe's proposal for a semicircular hall and wanted to put a stop to it as soon as possible. A further deviation from the original plan would place Thornton farther away from his claim (which always ignored Hallet) as its author. Thornton claimed that the ellipse was a superior form because it lacked "those little breaks that destroy the unity, grandeur, and dignity of Architecture." It would foster a better room for debate because an ellipse contains no part of a circle that creates "repercussion of sound."[23] Jefferson, however, was not in the habit of interfering with Madison's administration and did nothing

about Thornton's letter. He had heard enough from Latrobe regarding the many defects of the elliptical plan. When Madison returned to Washington he was able to judge the case "on the spot" and, by June 20, 1815, Latrobe's semicircular plan for the House of Representatives had been approved.

ANDREI'S MISSION

While the commissioners studied the revised plan for the House of Representatives, Latrobe wrote them about the chamber's columns.[24] Whether the old plan was retained or the new plan adopted, either scheme would require a great deal of architectural carving for the column capitals. In the former room, Giovanni Andrei had carved the capitals in place and, after eight years, they were not yet finished when the room was destroyed. The work was done while Congress was out of session, and each time Andrei was about to begin, furniture had to be moved and a scaffold built. The whole process was slow and expensive. Latrobe calculated that each column capital had cost $600. He proposed the commissioners send Andrei to Italy, where in a few months he could supervise carving of all the capitals needed for the hall of the House. By Andrei's own estimate, capitals could be carved and shipped to America for $300 each. Not only would the work be faster and cheaper, but pure white Italian marble would be more beautiful than the coarse brown sandstone used formerly. Latrobe felt Andrei should supervise carvers in Italy because if they were left to their own devices each capital would be "the production of the fanciful taste of the Sculptor, cheap in execution and dashing in effect, but wholly unworthy of the situation it would occupy." Andrei was thoroughly converted to Latrobe's taste for Grecian architecture and he would insure that the design would be faithfully executed.

If the commissioners agreed to the proposal, Andrei could also undertake another mission, namely finding someone to execute the allegorical statuary formerly modeled and carved by Giuseppe Franzoni, who had died on April 6, 1815. Unless a replacement was found, Latrobe feared, "the decoration of the Capitol must be confined to

foliage." Andrei knew Washington manners and working conditions, placing him in an ideal position to find someone of the right temper to assimilate into American society.

In a few weeks the commissioners approved Latrobe's suggestion.[25] By the time Andrei's instructions were written on August 8, his mission had expanded to include the carving of Ionic capitals for four columns and two pilasters in the Senate chamber and four Ionic capitals for the President's House. He and his wife would depart Baltimore on the U. S. Corvette *John Adams* for Barcelona, where another navy vessel would provide passage to Leghorn. Andrei was expected to employ carvers in nearby Carrara, keeping in mind the commissioners' admonition to take care of the public interest by having the work executed in the best materials at reasonable prices. The entire cargo of thirty-four capitals should be packed and ready to leave Italy by April 1, 1816, a deadline so important that the commissioners stated it twice. While abroad, Andrei continued to draw his salary of $1,500 a year (he had been placed back on the public rolls on August 4) and was allowed $1,200 for expenses. He was authorized to employ a master sculptor as skillful as the late Franzoni, who should agree to come to America for three or four years to work on the Capitol. Passage to and from Washington would be paid by the commissioners. Two "inferior" sculptors should also be engaged as assistants with pay appropriate to their talents. The commissioners concluded their instructions by wishing Andrei "a pleasant voyage to your native country, a successful execution of your labors, and a safe return to Washington."[26]

The first three weeks of Latrobe's re-employment in Washington had been remarkably productive. He redesigned the House chamber, proposed Andrei's trip abroad, and organized the workmen. Many of the same men employed on the public buildings before the war applied for jobs soon after Congress authorized restoration and repairs. Upon Latrobe's return, he appointed Shadrach Davis clerk of the works, Leonard Harbaugh foreman of carpenters, and George Blagden foreman of stone cutters. Wartime conditions in the federal city had been miserable for most workmen, who were saved from starvation by the resumption of the public works. Things were now much better for the building trades, and Latrobe was happy to have so many talented and contented workmen at his disposal.

Latrobe set off for Pittsburgh on May 10, 1815, to pack up his family for their return to Washington. During the trip he made a detour to inspect a newly discovered deposit of marble near the Potomac River in Loudoun County, Virginia. From Cumberland, Maryland, he wrote Van Ness that it seemed inexhaustible and equal to Carrara marble. It also appeared infinitely superior to Philadelphia marble.[27] When he inspected the marble again, it appeared to be "first rate quality as to texture, and purity of Color," but due to its position in the ground with rock above and below it, Latrobe thought that it would be expensive to quarry. While impractical for present purposes, it was perhaps worth further investigation.[28]

On the same trip, Latrobe found an outcrop of a beautiful variegated marble southeast of the Catoctin Mountains. The rock was found on both sides of the Potomac River in Loudoun County, Virginia, and Montgomery County, Maryland. It was composed of geologically fused pebbles of different colors, which he thought exceptionally beautiful when polished. Belonging to the family of sedimentary stone called breccia, Potomac "marble" was sometimes referred to as "puddling stone" or "pebble marble." (It was not a marble but was usually referred to as such.) The existence of a beautiful variegated stone so convenient to water transportation was an exciting discovery that meant column shafts could possibly be wrought from single blocks and delivered with little land carriage.[29] Latrobe thought the Potomac marble more beautiful than any used in modern or ancient buildings, and it promised to be a fine replacement for much of the coarse brown sandstone universally used on the public buildings in Washington.

Characteristically, the quarries at Aquia were not delivering stone fast enough to keep pace with the demands of the Capitol and President's House. The need for "speedy completion of the National Buildings" prompted the commissioners to write stone merchants in East Haddam, Farmington, and Middletown, Connecticut asking about the quality, prices, and quantity of freestone available from quarries on the Connecticut River.[30] Letters back informed the commissioners that sandstone in Connecticut was plentiful enough, but was brown or red and not suitable for use at the Capitol or President's House. Returning from a disappointing visit to Aquia, Blagden soon located about 400 tons of freestone at a

quarry on the Chapawamsic Creek in Stafford County, Virginia, that was left over from the 1790s building campaign. In 1794, the old board of commissioners had ordered 4,000 tons of this stone for the walls of the north wing. Some of it proved satisfactory, yet a good deal did not, and the board canceled the order. The quarry's owner still had the remaining stone in the yard, and Latrobe thought that if those blocks had survived two decades of weathering they might prove useful for his present purposes.[31] The commissioners authorized Latrobe to purchase all the Chapawamsic stone that Blagden might approve.[32]

Scarcity of stone was matched by a scarcity of men to cut it. Latrobe blamed the shortage mainly on the method used to pay stone cutters. The commissioners paid them by the day rather than by the piece. Thus, a lazy stonecutter or one of lesser skill commanded the same wage as a talented and diligent workman, one who would not stand for his superior industry to go unrewarded for long. Given the pay structure there was no reason to complete a stone-cutting task expeditiously. Without the means to make more money to keep up with the high cost of living, the best men were leaving Washington. Wages were lower in New York, Philadelphia, and Baltimore, but rents were less and amenities greater in those places. Paying stone cutters by the piece would expedite the work, attract the best men, and cost no more than paying by the day. Latrobe recounted the story of a stone cutter named Haydock who was so motivated by piecework that he literally worked himself to death:

> In boasting the upper blocks of the capitals of the columns, a man working fairly could finish one in about 4 days, perhaps in 3½. They were given to Haydock at $8 each, and he began & finished one in a single day. It is true, he destroyed his health & lost his life ultimately by that day's work, but had he even taken two days to the business & saved his life, he would have earned double wages. By paying such a man $2 or $2.50 a day, while by the piece, he can earn $4, no money is saved & much time is lost.[33]

Perhaps Latrobe could have given a less extreme example to make his point, yet the commissioners agreed and authorized Latrobe to adopt the piecework system.[34]

One of the most delicate tasks undertaken in the first year of restoration was demolition of the colonnade in the House chamber. Normally a scaffold would be built to give workmen access to the upper parts of the stonework, but that was out of the question because of the danger of accidentally hitting a column. If one column were to topple, the whole colonnade and entablature would collapse, bringing down a hundred tons of stone and brick that would shatter the vaults supporting the floor. Workmen were afraid to touch the colonnade until it was shored up. Latrobe wanted to support the underside of the entablature with bundles of long sticks, but finding and cutting sticks would take time. Commissioner Ringgold came up with a better, money-saving plan. He suggested stacking common firewood between the columns up to the bottom of the entablature, which would thus be supported during demolition. Five hundred cords of wood would go half way around the room. Once the work was finished, the wood could be sold for cost, recouping a large expense. Using this approach, the colonnade was demolished in July without incident.[35]

To supplement his income, Latrobe took a job as one of the city surveyors at an annual salary of $1,200. Among outside architectural commissions, he earned $300 designing an addition to Long's Tavern, located just east of the Capitol grounds. Begun on July 4, 1815, the addition was built to accommodate Congress until restoration work on the Capitol was finished. Latrobe's clients were a group of investors who wanted to return Congress to Capitol Hill and, by providing comfortable and convenient accommodations, squelch the persistent talk of moving the seat of government. Built in just five months, the "Brick Capitol" was ready at the opening of the 14th Congress in December 1815. Latrobe was not certain if Madison would order Congress out of Blodgett's Hotel and into the new building, but it could just as well be used for supper rooms, assembly halls, and card rooms.[36] Yet Congress happily vacated their quarters in the old hotel and met in Latrobe's handsome brick building through the end of the 15th Congress in 1819.

At the close of the 1815 building season, the restoration of the Capitol's north and south wings had made a modest start. Much of the blackened stone around window and door openings had been cut away and replaced with clean blocks. Workmen scrubbed the outside walls to remove smoke damage from stones that otherwise survived the fire. Temporary roofs had been placed over the two

Brick Capitol

ca. 1865

Mathew Brady Photograph, National Archives

*F*or clients wishing to return Congress to Capitol Hill, Latrobe designed an addition to Long's Tavern for the House and Senate to use while the Capitol was undergoing repairs. (Rent was $1,650 a year.) Citizens worried that Congress would abandon the federal city and return to Philadelphia, a move that would have devastated the Washington real estate market.

After 1819, the "Old Brick Capitol" served as a rooming house where members of Congress boarded, particularly those from the south. Senator John C. Calhoun of South Carolina, for example, died there in 1850. During the Civil War the building was commandeered by the government and converted into a military prison. It was demolished in 1867.

wings, demolition work had begun, and a vast quantity of rubbish had been removed. The new vaults in the committee rooms under the library in the north wing were completed, but this was the only new construction finished in 1815. A philosophical yet resolute Latrobe wrote an acquaintance in London:

> The labor of 10 Years of my life were destroyed in one night, but I am now busily engaged, in reestablishing them with increased splendor. I have already gotten rid of the sooty stains here, and hope your Government are taking the necessary means of washing them out of the history of England. The only fact that I regret deeply, is the destruction of our national Records. Every thing else money can replace.[37]

RETHINKING THE SENATE CHAMBER

*I*n 1813 Vice President Elbridge Gerry talked with Latrobe about how the Senate chamber would accommodate members from new states. A year before, Louisiana had been admitted to the Union, and a fresh crop of new states awaited in the Mississippi, Michigan, Missouri, and Illinois territories. With each new state, two senators would be sent to Washington and Gerry feared the chamber was too small to seat them. The conversation was informal because Latrobe had been out of office since 1811 and his advice would have been given unofficially. His removal to Pittsburgh put aside any ideas that might have occurred to him at the time.

After the vice president's death in 1814, his concerns were taken up by a number of senators who consulted with Latrobe about space problems: they asked him to explore the options and put his ideas on paper. On February 21, 1816, he submitted a short report outlining his solution to the problem, illustrating it with plans and sections showing the old room and how he proposed to enlarge it.[38] The chamber could be rebuilt on an enlarged diameter, retaining the same form as the old room that the architect found so well suited to its purpose. To capture more space, Latrobe suggested removing the small staircase and the narrow range of water closets occupying the area behind the curving wall. By eliminating these features, it would be possible to enlarge the Senate chamber to a diameter of seventy-five feet, the greatest dimension possible without interfering with the central lobby. The new plan increased the diameter of the room by fifteen feet, giving enough room to accommodate senators from twenty-four or more states. The small gallery over the entrance lobby would be sacrificed but two larger galleries along the east wall (one on top of the other) would more than make up the loss. Ionic columns, some of which were already ordered, would support the lower gallery while the upper one would be upheld

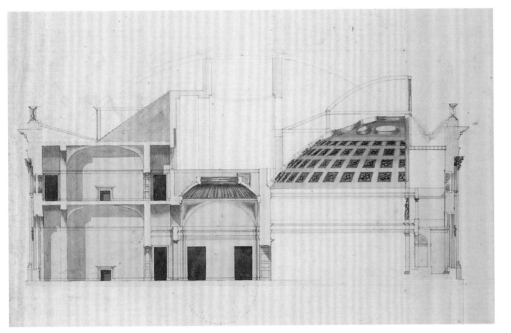

Section of the North Wing, Looking North

by B. Henry Latrobe, 1817

Library of Congress

*A*nticipating a new roster of standing committees, the Senate asked Latrobe to provide more meeting rooms in the north wing. He was able to fit eight rooms into what had been the old library space (left). An enlarged chamber (right) could accommodate a greater number of senators.

by caryatids. Although his report was silent on what the caryatids would represent, Latrobe later wrote that he intended them to be allegorical representations of the states.

Enlargement of the Senate chamber caused Latrobe one regret. He was proud of the brick dome that had withstood the British attack and needed nothing more than fresh coats of plaster and paint to put it back in first-class condition. To enlarge the room the dome would have to come down and a larger one be built in its place. Latrobe considered the sacrifice worthwhile, however, and, supposing most of the bricks could be cleaned and reused, estimated the new masonry would cost no more than $3,000.

The Senate appointed a special committee to evaluate Latrobe's proposal and to discuss other ways to improve its accommodation. In making the appointment the Senate sidestepped the commissioners, who were not pleased with this breach of their authority. (They did not complain to the Senate but rather to Latrobe, whom they suspected was party to the snub.) The committee met with Latrobe to give him ideas about the needs of the Senate, its members, officers, and evolving committee system. On March 6, 1816, Latrobe wrote the chairman, Rufus King of New York, saying he had "digested a plan by which your objects will be perfectly accomplished and provisions made for

the Library elsewhere."[39] Three weeks later, King asked the architect to report the effect that the change would have on the general expense of the Capitol. Latrobe explained that the plan of the whole building had not yet been approved, but in the case of the Senate wing, the proposed changes would actually decrease the cost of that part of the building.[40] The crux of Latrobe's plan was to relocate the Library of Congress to the center building and to rebuild its former space into eight committee rooms. Because the library was intended to be a magnificent room with stone columns and extensive galleries, it would be one of the most expensive interiors in the Capitol—but if it were placed in the center building, its cost would not be charged to the north wing.

The need for additional committee rooms was due to the pending formation of the Senate's first roster of standing committees. On December 5, 1816, Senator James Barbour of Virginia introduced a motion to create eleven permanent committees to help modernize the old system of select committees, which were created from time to time to take care of temporary assignments. The new system promised greater continuity and stability in the conduct of the Senate's business.[41] Permanent committees needed accommodations that were private, where they could meet at will, where papers could be securely stored, and where committee members might work.

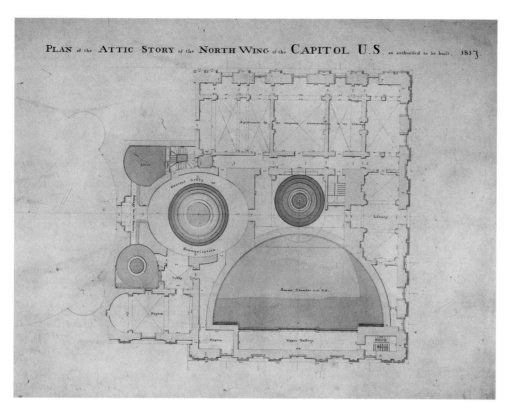

PLAN of the ATTIC STORY of the NORTH WING of the CAPITOL U.S. as authorized to be built 1817

Plan of the Attic Story of the North Wing of the Capitol U. S. as authorized to be built

by B. Henry Latrobe Drawn by Frederick C. DeKrafft, 1817

Library of Congress

*T*he rooms along the western side of the north wing's top floor were designed for Senate committees but were labeled here as "Apartments for the temporary accommodation of the Library." In 1815, Thomas Jefferson sold his library of 6,487 volumes to the government for $23,900 to replace the books lost in the fire.

On April 3 Senator King introduced a resolution approving Latrobe's revised plans for the north wing: it was agreed to two days later. The plans were sent to President Madison, who referred them to the commissioners for approval. The commissioners asked Latrobe if the library could be relocated to the third floor instead of waiting to accommodate it in the center building. Latrobe replied that the Senate had strong objections to sharing its vestibule with the library and the situation would not be improved by moving it upstairs. People going to and from the library would still pass through the lobby in front of the Senate chamber. Climbing an additional flight of stairs would be another source of complaint. However, these rooms could house the library temporarily, "altho' they are low."[42] The commissioners accepted Latrobe's explanation and approved the revised plan, but regretted it had not been suggested before considerable progress was made in rebuilding the former plan.[43]

The reconfiguration of the north wing's floor plan occupied so much of Latrobe's time that he neglected (or so the commissioners thought) the south wing. Much of that work hinged upon the selection of material for the columns, and the commissioners were anxious for Latrobe to revisit vari-

ous quarries along the upper Potomac so that a decision might be reached. On February 7, 1816, they reminded him of the necessity of making the trip.[44] Two weeks later they again implored him to examine the quarries.[45] Under this pressure and that exerted by Senator King's committee, Latrobe unexpectedly and uncharacteristically advised the commissioners to abandon the idea of marble columns and to use sandstone instead. The commissioners were unhappy with the recommendation, saying that it was their duty not to give up so easily.[46] They ordered Latrobe to examine "Mr. Clapham's pebble marble in Maryland near Noland's ferry, & the white marble above Harper's ferry." Latrobe scheduled his trip for the first week in March but then wanted to delay it a week because of the pressing business with the Senate. The commissioners denied the request, citing the importance of the journey and said that they would deal with the Senate themselves.[47]

Latrobe finally set out on his journey, arriving at Noland's Ferry on March 13, 1816. With him were a marble mason named John Hartnet and a laborer who carried the tools needed to bore and polish stone. Over the next five or six days they examined the Potomac marble from the "Big springs to the Catoctin mountains" and the "white marble strata from Waterford to its final termination on the river." The party then set out for Harper's Ferry, where limestone deposits containing a variety of marble were said to be located. They examined a marble quarry on the banks of the Monocacy near Woodbury in Frederick County, Maryland, and proceeded to a recently discovered marble deposit four miles inland. The expedition then left for Baltimore to examine the quarries supplying that city. Latrobe stayed there until March 26, taking care of some personal business and allowing his lame horse to rest. He was exhausted by the rigors of the trip, during which he had covered a considerable area of rough terrain on foot and on horseback. While the party was at Harper's Ferry, seven and a half inches of snow fell one night, and it snowed again on the way to Baltimore. He had also suffered a painful fall from his horse.[48]

When Latrobe returned to Washington, he was too unwell to come to the Capitol for a few days. But he immediately reported his findings to the commissioners, who were anxious to settle on a marble for the House chamber. Some of the

marbles examined were exceptionally beautiful, some could be easily quarried, and some were convenient to water transportation, but only one had all three advantages. Latrobe recommended the pebble marble located on Samuel Clapham's land on the banks of the Potomac River. He had tested the stone and thought it would supply all the column shafts needed for the House of Representatives.[49]

Without a quarry in operation, the commissioners would have to find someone to extract the stone, polish it, and transport it to Washington. Luckily, there was a nearby mill race that could provide power to cut and polish the stone, and the immediate access to the Potomac would simplify transportation to Washington. The owner of the marble was also willing to give it to the government gratuitously.[50] (He later changed his mind.)

Despite earlier misgivings, Latrobe was now in favor of using the pebble marble instead of freestone in the House chamber. It was, he said, "acknowledged to be more beautiful than any foreign variegated marble hitherto known," and would be well suited to the marble capitals that were being carved in Italy. It was stronger than sandstone and would better support the brick dome he intended

to build over the chamber. Admittedly, sandstone shafts would be less expensive. Shafts in the former chamber had cost about $500 each (exclusive of fluting), but now they would cost $625. According to an offer made by John Hartnet, Potomac marble shafts would cost $1,550 apiece. Thus, marble for twenty-four shafts would cost $22,200 more than sandstone. By manipulating the cost of the capitals, however, Latrobe argued that marble columns would actually cost $16,000 more than sandstone. The difference was therefore trivial.[51]

THE COMMISSIONER OF PUBLIC BUILDINGS

*H*artnet's offer to deliver each marble shaft for $1,550 was, in Latrobe's opinion, an excellent bargain. Comparable shafts at the Union Bank in Baltimore cost $2,000 apiece, and he was confident no one in Baltimore could beat Hartnet's price.[52] The commissioners had already made inquiries about the cost of marble columns in other cities,

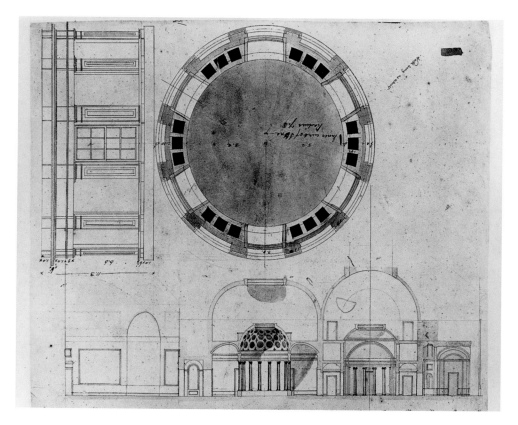

Details of the Center Building and the North Wing

by B. Henry Latrobe, 1817

Library of Congress

*A*t the lower part of this drawing, Latrobe sketched a section showing the rotunda, the "ornamental air shaft" (called today the "small Senate rotunda"), the Senate vestibule, and a committee room. Except for the latter room, each space was lighted and ventilated from above.

The top part of the drawing illustrates Latrobe's latest plan to gather flues in the central stone lantern to avoid cluttering the roof with chimneys. The idea had been a favorite with him since the Jefferson administration but he was not allowed to proceed until his second campaign.

but before replies were received they discovered that Congress had abolished their office. On April 29, 1816, President Madison approved an appropriation to enclose the Capitol grounds with a fence and authorized alterations to the plans of the north and south wings.[53] The legislation also abolished the three-man board as well as the office of the superintendent of the city, which had been occupied by Thomas Munroe since 1802. The duties were combined into the new, one-man office called the "commissioner of public buildings." The salary was $2,000 a year.

The change of authority was a mixed blessing for Latrobe. While the legislation was still before the Senate, he wrote Madison asking to be named commissioner.[54] He complained that the board had treated him in the most "coarse and offensive" manner. They constantly reminded him that there were other architects ready to take his place. The commissioners were a condescending lot who told Latrobe that pity for his family was the principal reason they kept him on. Contracts were made and workmen dismissed without his knowledge, and their ignorance had cost the public dearly. He recalled his relations with Jefferson, which illustrated the necessity of having direct access to the president without meddlesome middlemen. The new arrangement offered little hope for improvement but he had to endure because he was too poor to quit.

The letter did not convince the president to make the appointment Latrobe hoped for. Instead Madison nominated John Van Ness on April 29; however, he was rejected by the Senate the following day. The president intended next to nominate Richard Bland Lee but learned that the Senate would not confirm any of the former commissioners to the new post. Samuel Lane, an old friend of Secretary of State James Monroe, was nominated instead. Lane was a wounded veteran of the last war who was first considered for the post of claims commissioner to pay for property destroyed, lost, or captured by the enemy—what Latrobe called the "Commissioner of Dead Horses."[55] Considering the politics of the situation, Madison switched the appointments and nominated Richard Bland Lee claims commissioner and Samuel Lane commissioner of public buildings. The Senate confirmed Lane on April 30, 1816.

Latrobe was delighted that Congress had abolished the old board, "the most villainous board of Commissioners that ever had the power of tormenting in their heads." He was also happy the Senate rejected Van Ness, whom he characterized as an "insolent brute."[56] He looked forward to meeting the new commissioner, "a disbanded Officer, with one arm useless, and a ball thro' the thigh," but felt his subordination to a nonprofessional man would cause trouble in the future.[57] His fears, as it turned out, were fully justified.

In military fashion Lane demanded regular reports. He had forms printed to report the number of workmen at the Capitol, what tasks they performed, and what salaries they were being paid. On May 29, 1816, the clerk of the works, Shadrach Davis, reported that (not counting foremen) ten carpenters were making centers for vaults and arches, twenty-nine men were cutting stone, five men were laying brick in the north wing, and twenty-eight laborers were "attending."[58] Three sculptors were on the payroll, engaged in repairing the exterior carvings and making the entablature for the hall of the House. Two American carvers, named McIntosh and Henderson, were joined in 1816 by a talented Italian sculptor whose brief career had a lasting impact on the Capitol. Carlo Franzoni, younger brother of Giuseppe, was recruited at the commissioner's request by Richard McCall.[59] Other Italian sculptors, including Antonio Capellano, Francisco Iardella, and Giuseppe Valaperti, were also employed in the restoration of the Capitol.

Lane was a stern task master. Latrobe thought that although he was not a bad man he was entirely unfit for his place.[60] After returning from a trip to Baltimore where private business detained him for several days, Latrobe received a letter from Lane scolding him for allowing work to suffer for want of attention. A new master mason named John Queen started laying brick in Latrobe's absence, which Lane thought was just the time he should be watching closely. Latrobe's hours were only from 10 o'clock in the morning until three o'clock in the afternoon, which left enough time for other business and gave Lane the right to expect the architect to be "punctual and regular."[61] While testy, Lane's letter was hardly impolite, yet Latrobe took offense. He returned it with a note that said: "The enclosed has been sent by mistake to my

address: that it was apparently intended for somebody who was supposed to have neither the habits, the education, nor the *spirit* of a Gentleman."[62] Lane's reaction can only be imagined, but the episode did nothing to promote harmony at the Capitol.

Another letter Latrobe received about this time was most welcome. Thomas Jefferson wrote an account of a sundial he mounted on the "corn cob" capital that Latrobe sent to Monticello in 1809. Latrobe responded to this friendly letter with news that the corn columns were barely injured by the British and he wished to leave them alone.[63] But some things in the north wing would be changed, including the location and design of the principal staircase. The former staircase had survived but was damaged when the lantern above it crashed down and broke some of the stones. In rebuilding, Latrobe relocated the stair just off the east lobby and designed it to be "less curious." In its former location a vestibule was being built with a circular colonnade supporting a dome with an oculus to admit light and air. Here, the capitals were designed with tobacco leaves and flowers—Latrobe's third exercise in Americanizing the classical orders. Iardella made a plaster model of the tobacco capital, which Latrobe promised to send to Monticello after the carvers were done with it.

Work done during the 1816 building season disappointed members of the House and Senate upon their return to Washington for the opening of the second session of the 14th Congress in December. Latrobe's annual report stated that nothing could be done inside the south wing until the columns were delivered, but he assured members of Congress that the beauty of the marble made the wait worthwhile. Only one pilaster was ready to be sent and it would be some time before all the column shafts were delivered and ready to put up. In the meantime, 106 blocks of sandstone had been carved for the entablature—about a third of what would be required—and all the stone for the gallery front was ready to set.[64]

Progress was more apparent in the north wing. The columns and vaults in the Supreme Court chamber had survived the fire but were greatly weakened and had to be removed. A new vault was

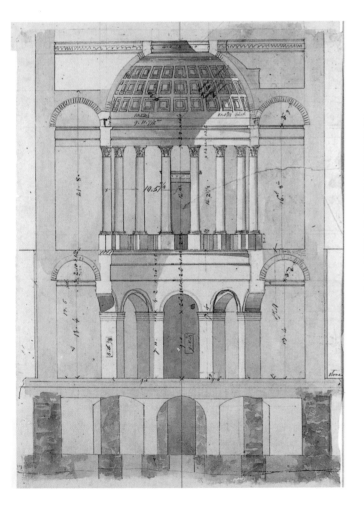

Tobacco Capital

\mathcal{S}ixteen columns in the small Senate rotunda were designed with tobacco capitals, another case of Latrobe's assured and original adaptation of native plants to classical usage. The capital was modeled by Francisco Iardella in 1816. Latrobe admired his faithfulness to the botanical character of the tobacco plant. (1961 photograph.)

Preliminary Design for the Small Senate Rotunda

by B. Henry Latrobe, ca. 1816

Library of Congress

\mathcal{W}hile repairs to the north wing were under way, Latrobe built a domed air shaft where a stair had formerly been located. The oculus of the dome provided an unexpected and welcome source of light and air.

Supreme Court Chamber

There are no known views of this chamber drawn during the half-century the Supreme Court met here (1810–1860). Perhaps artists were daunted by the unusual architectural setting, or perhaps the Court simply discouraged such endeavors. (1975 photograph.)

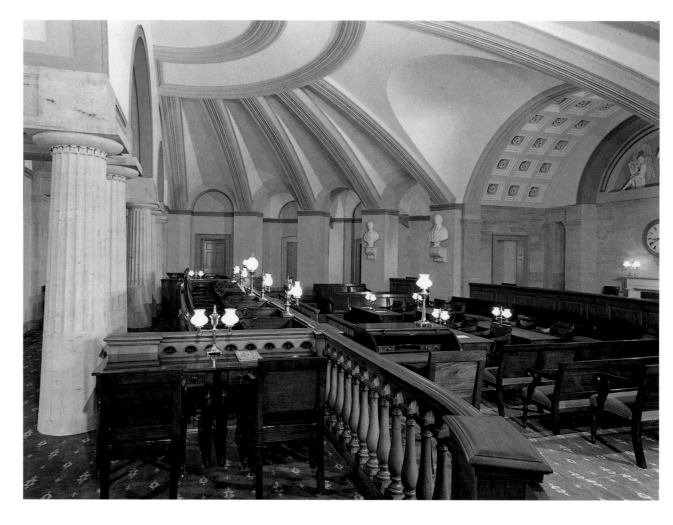

built along the lines of the old one but no columns were used along the semicircular arcade. Instead, the arcade was built with stout piers, and columns were used only to support the three-bay arcade along the eastern wall. In the Senate chamber upstairs, the fire had destroyed everything that was marble or sandstone, but the great brick dome survived. The enlargement of the room meant that it too was removed. Latrobe reported that ten feet of the new semicircular wall was in place. The new plan also required removal of the vaults over the first-floor rooms in the western half of the north wing in order to raise them to the proper level. (Had it been built, the floor of the Egyptian library would have been five feet lower than the general second-floor level.) New vaults for three stories of committee rooms in this section were completed during the 1816 building season.

As members of the House of Representatives could plainly see, repairs to the Senate wing were proceeding apace while nothing was being done in the south wing. The chairman of the Committee on Expenditures on Public Buildings, Lewis Condict of New Jersey, asked the commissioner to provide an account of the monies spent to repair the Capitol and to explain why work on the south wing was at a standstill. Lane reported that from April 30, 1815, to January 1, 1817, $76,000 had been spent on the Capitol—about $40,000 for materials, $31,000 for labor, and $5,000 for incidentals such as freight, wharfage, and tools.[65] Construction of the House chamber depended on delivery of the marble columns to support the ceiling and roof structure and without them nothing could be done. It was not only the pebble marble that was slow in coming: the Italian marble capitals that were supposed to be shipped in the spring of 1816 had not been received either. The cause for the delay was unknown: Andrei had not been heard from. Lane quickly pointed out that the delay could not be

blamed on him because the order for Italian capitals had been made by his predecessors.[66]

Condict and his committee also wanted an estimate of the cost to complete the wings. Latrobe reported that the probable expense of finishing the north wing was $108,000 and $126,500 would be needed for the south wing.[67] The figures were given without an explanation of how they were calculated or broken down into labor and material categories. Latrobe wrote the commissioner a letter explaining the difficulty of compiling estimates on short notice when the plans for the wings had been altered and there were not sufficient drawings from which to make calculations. Lane forwarded Latrobe's numbers to Condict without explanation, leaving the architect exposed to the committee's censure. Condict's committee said the estimates were "deficient in point of detail, and by no means satisfactory to the committee."[68] On February 22, 1817, Latrobe wrote a memorial to the House of Representatives explaining why his estimates were so terse and expressed his "utter surprise and mortification" that they were sent without the explanatory letter.[69] He did not show the memorial to Lane, accusing him instead of deliberately trying to embarrass him. "Under such circumstances of official hostility," Latrobe wrote, "I could only appeal to the Legislature in explanation, which I have done."[70]

TROUBLE IN THE "ERA OF GOOD FEELINGS"

With the close of the 14th Congress came the end of James Madison's presidency. He attended the inauguration of his successor, James Monroe, which was held in front of the "Brick Capitol," and returned to his Virginia estate to begin a long, quiet retirement. In contrast to his earlier career, Madison's two terms as president were only marginally successful, clouded by diplomatic blunders, a mismanaged war, the humiliating fall of the capital, and his own embarrassing flight just ahead of British troops. He took no interest in the work to repair the public buildings, shielding himself with inept commissioners. Latrobe longed for the days of frequent and friendly counsels with Thomas Jefferson, which were intellectually invigorating, occasionally frustrating, but always cordial. In Jefferson's administration, he had held a position of trust and was a complete master of his works. With Madison, a man never known for warmth, the best Latrobe could hope for was icy indifference and frustrating deferrals to the citizen commissioners. Monroe's assent to the presidency could only improve his situation, or so Latrobe thought.

Monroe was no stranger to Washington, having served the previous administration as secretary of state and, after the city's capture, secretary of war as well. He did not think the repairs to the Capitol and President's House were proceeding as quickly as they might, and he became determined to expedite matters. Monroe had every intention of pushing the works forward and becoming more involved than his predecessor. To advise him on ways to speed things along, he appointed an informal board consisting of Lieutenant Colonel George Bomford of the Army Ordinance Department and General Joseph Swift of the Army Corps of Engineers. Latrobe thought they would make all the important decisions while the commissioner would merely carry out their orders.[71] Mistakenly, the architect believed that Lane's behavior had discredited him and that the new council was created to sidestep his authority. Instead, Monroe merely wanted to consult with men who knew about construction and procurement and, as army officers, appreciated economy and efficiency.

In office less than a month, Monroe began deciding issues regarding the Capitol based largely on expediency. It became clear that the overriding consideration in his mind was speed. The first question Monroe decided was which material to use for the ceilings over the House and Senate chambers. Latrobe planned to build both semicircular domes with brick and cover them with plaster. Masonry domes would be permanent, fireproof, and worthy of the beautiful marble columns that were destined for these rooms. Monroe put the question of masonry domes to Bomford and Swift, who reported their thoughts on March 19, 1817. They did not doubt that brick domes could be built, but did not consider the time and money worthwhile. Timber ceilings would last fifty years and would help calm the public's fears regarding the danger of falling masonry vaults.[72]

Against his objections, Latrobe was ordered to build timber-framed ceilings over the chambers. These were neither permanent nor fireproof and, in the architect's opinion, were unworthy of the magnificent rooms they would cover. Yet, as this drawing illustrates, framing such a ceiling was no simple matter. It required the skill of an engineer and the experience of a master carpenter.

Heeding expert advice, Monroe ordered the chambers covered with wooden domes. On April 2, 1817, Lane informed Latrobe of the president's decision, and he immediately reacted with a bitter letter of protest.[73] The matter was of great importance and he hoped it would not be necessary to act contrary to his judgment and experience. It was particularly important that the ceiling over the Senate chamber be made of brick so it could help support the stone lantern intended for the center of the roof. Latrobe proposed to gather many of the wing's chimney flues in the lantern in order to preserve the symmetry of the roof line.

George Blagden, like Bomford and Swift, also favored wooden domes and helped the president make up his mind on the issue. Coming from the most experienced and trustworthy mason in the city, Blagden's advice carried at least as much weight as Latrobe's, and his reputation as a practical man placed him higher in many minds. Blagden offered his opinion on brick domes in a long letter written on March 14, 1817.[74] He entered the subject gingerly, saying: "From my youth I was taught to look up to the character of an architect, as a workman however, and one that has grown grey in the service, I give you my opinion freely." It was clear that he had little taste for Latrobe's heavy vaults and other things he considered extravagant. Blagden thought the form of the House chamber was changed to a semicircle so that it could be "arched," and he asked himself if such an arch could stand. To this question he replied: "I think not, first because of the work beneath, if conjuncted to the load of the columns and entablature, 'tis enough the arches of the Basement story must ever groan . . . why run this risk, why give an additional weight of nearly five hundred tons to these arches." He was reminded of the dangerous consequences of extensive arches and vaults, which the architect knew from "terrible experience." The east wall of the Senate chamber was forced out almost four inches from the pressure of the interior vaulting. Even the relatively small arches over the gallery in the former House chamber pushed the walls out of plumb. Blagden thought it best to abandon the idea of a domed House chamber, suggesting instead to suspend a flat ceiling from roof trusses. He would also abandon the circular colonnade and bring the galleries out four feet to give more space to the committee rooms underneath, thereby making them more useful. Moving to the north wing, Blagden observed that the span of the proposed vault over the Senate chamber posed the same dangers that threatened the House. He dreaded Latrobe's extravagance in both the extent of the vaulting and the expense of using costly materials. Particularly bothersome was Latrobe's design for the Senate galleries, with marble columns holding a row of marble caryatids, that Blagden thought wildly and excessively expensive.

Blagden's letter dealt the fatal blow to Latrobe's plans for brick domes and emblematic caryatids for the Senate gallery. A few days after the letter was written, the commissioner asked Latrobe about what was needed "to supply the place of the caryatids formerly proposed for the Senate chamber."[75]

Latrobe suggested using a row of dwarf columns of variegated marble. Although he did not tell Lane, he intended to retain six caryatids in the corner piers, but these too would eventually drop from the room's final design.[76]

Latrobe was genuinely upset by the president's decision to build wooden domes. He reacted by saying that he could not devise a plan or method of framing these ceilings but would attempt to build them if plans could be obtained from another source. Perhaps it would be best, Latrobe told the commissioner, for him to resign, as "the Public could do very well without him."[77] In a short time, however, he swallowed his pride and submitted an estimate of the lumber necessary to build the dome over the House chamber and the roof over the south wing.[78] The domes and roofs for both wings would be framed on the ground, disassembled, and reassembled in place. The commissioner first thought the ground west of the Capitol was the best place to frame the domes, but Latrobe objected because it would be too far from the lumber yard (presumably on the east grounds), and it would interfere with masons making mortar near the pump located between the wings.[79] Who won the argument is not known, but it seemed that the architect and the commissioner could not agree on any issue, large or small.

THE MAJESTY OF MARBLE

The 1817 building season was Latrobe's last at the Capitol. It was a stressful time, with the commissioner applying pressure to speed construction and the president demanding heroic exertions from all concerned. Because most of the old drawings were rendered useless by the changes to the design of the wings, Latrobe worried that he could not produce new drawings fast enough to keep up with demand. The president allowed him to hire two draftsmen to help. William Small, son of Latrobe's friend Jacob Small of Baltimore, was employed full time at $750 a year. It was the same salary he had earned assisting his father and directing carpenters building the Baltimore Exchange, one of Latrobe's largest outside jobs. A draftsman from the city surveyor's

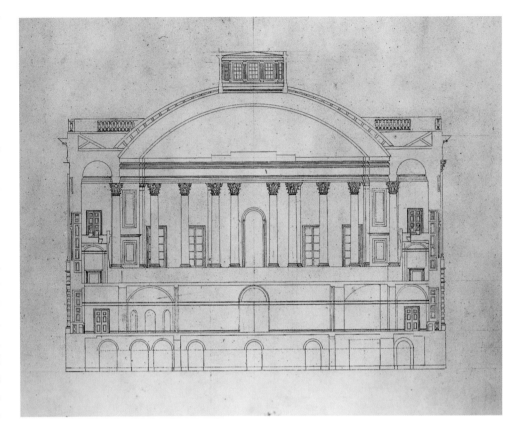

Section of the South Wing, Looking South

by B. Henry Latrobe
Drawn by John H. B. Latrobe, 1817

Library of Congress

*L*atrobe's son drew this section showing the House chamber covered with a wooden dome, a construction shortcut ordered by President Monroe over the architect's strenuous objections. The smooth wooden ceiling promoted echoes that plagued the room from the beginning.

office, William Blanchard, was hired part time at $350 a year. With these men, Latrobe was able to hand over original drawings to be copied, either for explanatory purposes or to be used (and used up) by workmen.[80]

Some thought that slow delivery of Potomac marble would delay restoration of the wings for many more years. Lane wanted to abandon the marble altogether and use sandstone columns. To decide the case, President Monroe went to Noland's Ferry on March 28, 1817, personally inspected the stone, and became convinced that its beauty was worth the trouble and time it would take to deliver it to Washington. But the master of the works, John Hartnet, found it beyond his means to quarry and

**Ground Story of the
Capitol U. S.**

by B. Henry Latrobe
Drawn by
William Blanchard, 1817

Library of Congress

*T*his plan illustrated only
those parts of the Capitol
undergoing repair. The plan
of the south wing remained
virtually unchanged from its
pre-fire configuration, while
the north wing plan reflects
changes brought about with
Latrobe's post-fire adjust-
ments. In that wing, only the
east vestibule with its corn
columns was left exactly as it
had been from the pre-fire
period. With the plan still
undecided, the entire center
building was left blank.

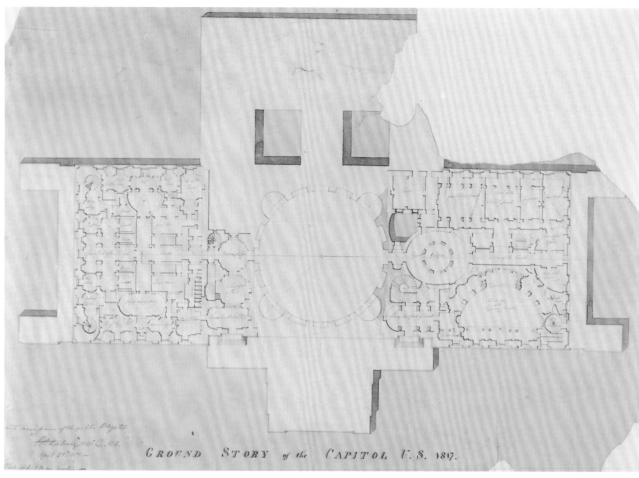

GROUND STORY of the CAPITOL U.S. 1817.

**Plan of the
Principal Floor
of the Capitol U. S.**

by B. Henry Latrobe
Drawn by
William Blanchard, 1817

Library of Congress

*P*repared for President
Monroe, this plan shows the
wings under repair and a
proposed plan for the center
building. For the western
projection, Latrobe proposed
a large, three-part room for
the Library of Congress that
would be lighted from above.
Reading rooms, committee
rooms, stairs, and two rooms
for the librarian were pro-
vided nearby.

The rotunda was
labeled: "Grand Vestibule.
Hall of inauguration, of
impeachment, and of all
public occasions."

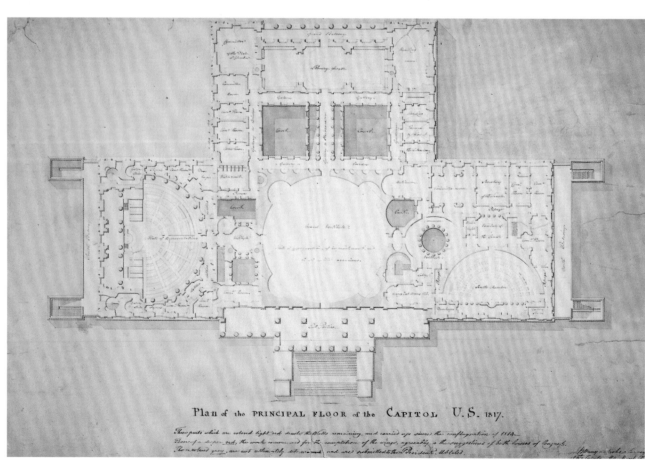

Plan of the PRINCIPAL FLOOR of the CAPITOL U.S. 1817.

polish the pebble marble with anything approaching the speed the president wanted. Monroe detailed Robert Leckie, "the conductor of all the Arsenals U. S. and a famous Quarrier," to assist in the effort.[81] After Monroe instructed the commissioner to divide the work into two parts, Leckie was placed in charge of getting the stone from the quarry and Hartnet was made responsible for shaping it. A clerk was hired to keep accounts, pay workmen, and take care of provisions. To keep the pressure up, the president wanted to see concise reports every Monday morning.[82]

Latrobe wrote Jefferson that he had nine blocks of what he now called "Columbian marble" that would "render our public buildings rich in native magnificence."[83] While its beauty was undeniable, Latrobe suggested that the stone was more generally admired because it was American. The sentiment was echoed in *Niles' Weekly Register,* when it praised Latrobe for using the "internal riches of our country" for the Capitol's embellishment.[84]

While Potomac marble supplied column shafts, and Italian marble would be used for most capitals, other marbles were employed for bases, entablatures, stairs, and statuary. Latrobe wanted to use white marble from Baltimore for the main staircase in the north wing. It was harder and cheaper than Philadelphia marble and was much more suitable for stairs than the sandstone used previously.[85] On August 13, 1817, Lane agreed to pay Thomas Towson $1,200 for steps and landings and asked him to complete the order as soon as possible. The commissioner thought Towson's price was high and asked if a discount would be considered in return for prompt payment.[86] Once the marble was delivered to Washington, it was turned over to Blagden and his stone cutting department. He predicted that the marble could be boasted, molded, polished, and installed in about seven weeks.[87] For the dwarf columns in the Senate chamber, Latrobe wanted to use veined marble from Thomas Traquair's stone yard in Philadelphia. Traquair offered to furnish the short column shafts for ninety dollars each, a price Lane again thought too high. He wanted to pay five dollars less and hoped Traquair would agree. Lane also wanted to buy bases and cinctures for the columns in the House chamber from Traquair, who offered to deliver the bases for $200 apiece and the cinctures for forty dollars. Lane countered with an offer of

$200 for both.[88] But Traquair would not budge and Lane was obliged to pay the asking prices.[89] Time was running out and Traquair could deliver the stone promptly. Lane enlisted the help of a prominent architect from New York, John McComb, to secure white marble bases and entablature for the Senate colonnade. These were sent to Washington in mid-June 1817.[90] Carvers finished the Philadelphia and New York marble after it was received at the Capitol.

A cargo of beautifully carved white marble capitals accompanied Andrei upon his return to Washington in June 1817. He had fulfilled his mission admirably and, although he returned more than a year late, his time in Italy had not delayed construction. During his absence the plans for the Senate chamber were changed. Instead of four columns and two pilasters, the revised design called for eight columns in the chamber and four more in the lobby plus dwarf columns, antae, and pilasters. Apparently Latrobe or Lane wrote Andrei about the additional capitals that were needed. He procured eight additional capitals in Italy but the less intricate caps for antae and pilasters were carved in Washington. Luckily, there were four blocks of Italian marble on hand that Latrobe intended to use for these capitals as well as for the doorframe around the entrance to the House chamber. What remained could be used for statuary. He was horrified to learn that Blagden had other plans for the stones, including cutting them up into hearths for the President's House, and immediately sent a letter of protest to Lane, who put a stop to Blagden's scheme.[91] Five carvers worked on the antae and pilaster capitals for the Senate chamber and lobby, copying as best they could the exquisite models from Italy. Andrei carved the capitals of the dwarf columns in place just as he had done years ago for the columns in the former House chamber.[92]

The best of the sculptors, Carlo Franzoni, was engaged in 1817 on two allegorical groups: a figure of Justice for the Supreme Court and the *Car of History* for the hall of the House. The first was a reproduction of the destroyed sculpture by his brother Giuseppe. The *Car of History* was substituted for the four allegorical figures over the principal entrance to the old House chamber. The new work was "a figure of history in a winged Car, the wheel of which forms the face of the Clock or time piece."[93] Only the *Car of History,* one of America's

foremost neoclassical sculptures, was translated into marble. The Justice figure was never carved in marble due to the lack of materials. Latrobe also planned additional sculpture, including an eagle for the frieze in the hall of the House to replace the one destroyed by the British. Carved by Giuseppe Valaperti, it formed a part of the sandstone entablature. Above the eagle was a figure of Liberty holding the constitution in one hand. An eagle and a serpent, symbolizing America and wisdom, flank the central figure. The grouping recalled a similar work of art that was admired in the former hall, except that this figure of Liberty was standing rather than seated. Enrico Causici sculpted the plaster models that, like Franzoni's figure of Justice, were never carved in marble.

On the outside of the building, Latrobe planned to incorporate sculpture into the attic panels located in the center of the south end of the House wing and the north end of the Senate wing. A "phoenix rising from burning ruins" was intended for one while "the last Military Achievement of the War" was proposed for the other.[94] Thus an allegory of the destruction and restoration of the Capitol would be seen on one end of the building and a commemorative representation of the Battle of New Orleans would be on the other. By the time the panels were completed by Latrobe's successor, however, the sculptural enrichments were greatly simplified.

Commissioner Lane, seemingly without Latrobe's knowledge or advice, sought out marble mantels in Philadelphia, New York, and Italy. He wrote his agent in Philadelphia about mantels and other matters related to marble. Ready-made mantels were available and the price depended only on the marble selected. Lane received drawings of various designs with a key to explain the kinds of marble available.[95] Lane also asked John McComb about mantels available in New York City and was shocked by the prices they commanded: $300 to $450 for plain mantels, and $600 for those with sculptural enrichments.[96] It would be cheaper, Lane concluded, to obtain them from Italy. Lane sent an order to a London firm for mantels, hearths, and paving tiles made from Italian marble. Purviance, Nicholas & Company was asked to ensure that the materials were genuine and the workmanship excellent, as the American public wished to have its money's worth.[97]

The chambers remained unfinished and little could be done until the marble was delivered. The first floor of the south wing had been restored and was occupied by a few workmen as their temporary residence. Three floors of offices and committee rooms on the west side of the north wing (the former Library of Congress space) were vaulted and the curving wall in the Senate was nearly completed. But when Monroe returned to Washington in September he was greeted by two wings that were still far from finished. Unavoidable setbacks, such as the collapse of a lock on the Chesapeake and Ohio canal in July that interrupted marble delivery, meant little to the president. He wanted results, not excuses.

Latrobe thought that some unknown adviser had tricked the president into thinking the restoration of the wings could be finished in three months. He was not surprised when Monroe appointed yet another commission to look into the management of the works, but regretted that it would isolate him further from the president. In a letter to John Trumbull, Latrobe recounted the president's actions upon returning from his gratifying trip to New England:

> On his arrival, the President, misled by I don't know who, expected the Capitol to be finished; of course he was disappointed, and in his first emotions would have ordered my dismissal, had he not been prevented by some very disinterested friends. He however appointed Genl. Mason, [Colo]nel Bomford, and Mr. Geo. Graham, a com[mission] of enquiry into the conduct at the Capitol. These are honorable and good Men. But what a system is that, which shutting out from the President all direct and professional information, interposes that of men, whom neither leisure nor knowledge of the subject qualifies to give it, or explain the

LATROBE'S FINAL DAYS

In the summer of 1817, President Monroe embarked on a three-month tour of New England, traveling to the very core of Federalist strength. The so-called "Era of Good Feelings" marked a lull in party differences, and for a short time the nation thrived without political factions. Before he left, Monroe made it clear that he wanted the public buildings finished by the time he returned to Washington. Everything was in place, everyone knew his duty, there was money enough, and Monroe had no intention of remaining in rented quarters or denying Congress the use of the Capitol any longer than necessary. The president threatened to dismiss Latrobe or Lane if they did not proceed with greater harmony and expedite the completion of the Capitol.[98] The old colonel was determined not to disappoint the president while the architect seemed less concerned about matters beyond his control.

difficulties, or remove the misrepresentatives of ignorance or Malice. And under such a system it is expected that Genius shall freely act, and display itself?[99]

The popular wisdom around Washington blamed the pace of work at the Capitol on Latrobe's absences from the city. His work on the Exchange and Cathedral in Baltimore took him out of town regularly, and it seemed obvious that the Capitol suffered accordingly. It was rumored that Latrobe would go to Baltimore and stay three weeks at a time. To defend himself, Latrobe wrote the president an account of his absences.[100] Since moving back to Washington, he had never left the city unless to go to the marble quarries or to Baltimore. In all, he had missed only thirty-seven and a half days of work over the last twenty-nine months but was sometimes detained because of unforeseen sickness or family distress. He did not feel the journeys affected the Capitol in the least, but he could not prevent the public perception of neglect.

The commissioner wrote foremen about the state of affairs in their departments while Latrobe was asked to compile answers to a long series of questions posed by the latest advisory board.[101] Were there enough workmen? Was all the lumber bought for doors and windows? Did he have enough bricks, lime, and sand to complete the brickwork? When would the roof be ready? How many blocks of pebble marble were at the Capitol and how many were ready to be sent from the quarry? How much sandstone would be needed to complete the entablature in the House chamber? Question after question was asked, most of which Latrobe or the foremen had answered before, but there was now another set of "experts" to educate.

Shadrach Davis, Latrobe's plodding yet dependable clerk of the works, reported to Lane the number of workmen employed at the Capitol for the week ending October 27, 1817.[102] There were twenty-three stone cutters working on both wings, twenty marble cutters and nine polishers working on the columns for the House chamber, twelve sculptors and carvers working on ornaments, eighteen bricklayers working on the north wing, and forty carpenters building the dome over the north wing and making centers for arches and vaults. One hundred and thirty-five laborers, many of whom were slaves, brought the total number of workmen at the Capitol to 257. By contrast, Davis' first report five months earlier showed only eighty-two workers and illustrated the effects of Monroe's push to accelerate construction.

A day or two after Davis wrote the report, he was fired by the commissioner. Latrobe was enraged by this breech of his professional prerogative and accused Lane of lording his power over the workmen while denying the architect his rights. Latrobe liked Davis and was sorry he was mistreated by the commissioner. He suspected the foreman of carpenters, Leonard Harbaugh, was behind all this. Harbaugh and Davis had never gotten along, and Lane tended to trust the master carpenter's opinion because he respected his industry and attention to duty. When Lane would show up at the Capitol at daybreak, Harbaugh was there. Members of Congress were politely escorted around the works by Harbaugh, who courted their favor. Davis, on the other hand, was gruff and slow but was "a capital Ship joiner," which prepared him well for building the curving centers for Latrobe's complicated vaults.[103]

Lane replaced Davis with Peter Lenox, who had been the foreman of carpenters under Hoban at the President's House. Although still unfinished, the residence was sufficiently habitable for the Monroes to move in during the month of October. Diligent workmen such as Lenox could help speed restoration of the Capitol, and Latrobe's feelings or opinions were of no concern to the commissioner. Lenox was an excellent carpenter who had helped build the "oven" in 1801. He had also worked under John Lenthall, but Latrobe thought he was something of a showoff. Latrobe preferred Davis's quiet, methodical ways, and following his dismissal, a protest letter was written by the architect on October 29, 1817. Two days later the commissioner shot back with a letter of his own saying the matter was not open for discussion and scolded Latrobe for broaching the topic. Lane continued with a harsh condemnation of Latrobe for his habit of overreaching the bounds of his office, for recommending incompetent men for employment, and for not preparing estimates and plans with enough speed. Although there was a perfunctory remark acknowledging Latrobe's "professional talents," Lane's response indicated a wholesale lack of confidence in the architect: "My anxious desire is to accelerate not retard the work. . . . Knowing my

duties I shall scrupulously perform them. All that I wish of you is attention to your own."[104]

Lane's open hostility chipped away at Latrobe's confidence. His nerves were rattled by the incessant attacks on his skill, faithfulness, judgment, and professionalism—and this from a commissioner who had no business in the office he held, lacking the experience or temperament to oversee the work under his charge. To him, the creative process of architectural design was a luxury that went well beyond necessity, certainly nothing to command respect. Like so many Americans of his time, Lane did not appreciate the skill of an architect and considered bricklaying or carpentry a worthier occupation. Proud of his training and confident of his talents, Latrobe jealously defended his professional "rights" to a man who could not understand the concept. The two men were temperamentally, intellectually, and socially mismatched. And Lane had power where Latrobe had none.

As if Lane were not making life difficult enough, Latrobe was haunted by the prospect of bankruptcy. The old debts incurred in Pittsburgh had not been satisfied, and there were numerous new debts to compound the problem. His rent had not been paid for months. (His landlord was John Van Ness.) Investments in the Washington Canal Company, the Chesapeake and Delaware Canal Company, Fulton's Ohio Steamboat Company, and lesser ventures were assets on paper only. He kept afloat by taking outside jobs to supplement his meager government salary.

Worries about money and Lane nipping at his heals were aggravations that were sadly put aside when Latrobe learned of the death of his eldest son, Henry, in New Orleans. His death occurred on September 3, 1817, and his father learned of it three weeks later. The young Latrobe was in New Orleans developing plans for a municipal waterworks when he was stricken with yellow fever. His father took the news hard and slipped into a depression that lasted weeks.[105]

With his mind clouded by grief and his self-confidence compromised, there can be little wonder that Latrobe's last audience with President Monroe turned into a senseless act of aggression directed at the crippled commissioner. Lane had already dressed down the architect shortly after his return from yet another trip to Baltimore. "No schoolboy," Latrobe recalled, could have "borne patiently" his mistreatment at the hands of the dictatorial commissioner. Latrobe left the office in a fury and refused to speak to Lane until he had cooled down. But the commissioner would not drop the matter, insisting that Latrobe make "immediate concessions for leaving him in a rage, [or] he would immediately look for another Architect."[106] The scene was replayed on November 20, 1817, at the President's House with Monroe looking on. This time, Latrobe struck back. As retold by Mary Elizabeth Latrobe, he lunged at the commissioner,

> seized him by the collar, and exclaimed, 'Were you not a cripple I would shake you to atoms, you poor contemptible wretch. Am I to be dictated to by you?' The President said looking at my husband, 'Do you know who I am, Sir?' 'Yes, I do, and ask your pardon, but when I consider my birth, my family, my education, my talents, I am excusable for any outrage after the provocation I have received from that contemptible character.'[107]

Latrobe returned home and wrote a letter of resignation. It was the only course left to him after the scene he made at the President's House. The letter was addressed to Monroe instead of Lane. He said that he had chosen to leave office over "the sacrifice of all self respect," apologized for causing worry, and thanked the president for never doubting his skill and integrity. The restoration of the Capitol might be "inconvenienced" by his sudden resignation but he promised to finish all the drawings for the completion of the work.[108] On November 24, 1817, Lane—not Monroe—accepted the resignation.

Less than two weeks after his resignation, Latrobe filed for protection from creditors by declaring bankruptcy. Judge William Cranch (who had served briefly on the old board of commissioners in 1801) ruled that Latrobe could not keep his architectural books and declared that they too must be sold along with his household goods. Latrobe borrowed $198 to save his library, but everything else was lost to the auctioneer's gavel. While William Small helped Mary Elizabeth Latrobe pack up books and papers, Latrobe went to Baltimore to arrange for his family's removal there. During the first week in January 1818 he was committed to the Washington County jail as punishment for debt, and after his release on the 5th he left the federal city to begin again in Baltimore.[109]

THE BULFINCH YEARS, 1818–1829

*A*rchitects generally found the Capitol an unlucky place to work. Hallet, Hadfield, and Latrobe saw their work hampered by inexperienced and unsympathetic commissioners and quit the Capitol worn out and discouraged. Latrobe alone was able to leave a notable architectural legacy, and even this was appreciated only after his departure. The Capitol seemed more a place to ruin reputations and wreck careers than to build them. Yet the architect who replaced Latrobe, Charles Bulfinch of Boston, was able to break the curse and to prove that it was possible to thrive in the politically charged atmosphere of Washington.

Well before Latrobe resigned in November 1817 it was common knowledge that he could not last long. William Lee, a Massachusetts native living in Washington, wrote Bulfinch on September 17 with news of Latrobe's pending removal. Lee was an auditor in the Treasury Department, a friend of Latrobe, and a confidant of President Monroe. Knowing the situation well, he advised Bulfinch to

View of the Capitol (Detail)

by Charles Burton, 1824

The Metropolitan Museum of Art, New York, Purchase
Joseph Pulitzer Bequest, 1942

apply for the position. "I am sorry, for Latrobe, who is an amiable man, possesses genius and has a large family," Lee wrote sympathetically, "but in addition to the President not being satisfied with him there is an unaccountable and I think unjust prejudice against him in the Government, Senate and Congress."[1] Lee went on to say that the climate of Washington was not as bad as most New Englanders thought, and from April to December it was as comfortable as the south of France. Society was "on the best footing" and the opportunities for gaining a national reputation were good. In short, moving to Washington would not be as bad as one might think.

Bulfinch's response was a mixture of deference to Latrobe, intrigue at the prospect of a prestigious commission, and dread of breaking up his household and family ties in Boston. He especially disliked the idea of being party to Latrobe's removal:

> I have always endeavored to avoid unpleasant competition with others, that opposing their interest would excite enmity and ill will. I should much regret to be an instrument of depriving a man of undoubted talents of an employment which places him at the head of his profession and which is necessary to his family's support.[2]

Concern with the disruption of his own family, particularly the education of his younger children,

Portrait of Charles Bulfinch

by George Matthews, 1931
after Alvan Clark, 1842

Descended from a prominent New England family, Bulfinch (1763–1844) was educated at Harvard in mathematics and drawing. His understanding of ancient and modern architecture was gained principally through books and during an extensive European tour mapped out by Thomas Jefferson. In England he admired the work of Robert Adam and William Chambers, whose differing styles of neoclassicism influenced his subsequent work. After his return to Boston, Bulfinch's first major project was the Tontine Crescent, a row of sixteen townhouses that, while beautifully designed, brought financial disaster to the young architect. A more successful project was the elegant Massachusetts Statehouse, which landed him at the top of his field in New England and secured his reputation in the realm of public architecture. Samuel Adams and Paul Revere laid its cornerstone on July 4, 1795.

Bulfinch balanced a career as an architect with public service, holding a number of top posts in Boston's city government. While his finances were slow to recover, his reputation and standing in the community rose steadily. When asked to succeed Latrobe at the Capitol he accepted with reluctance yet grew to like the job as well as the city of Washington. He was justifiably proud of his accomplishments, such as the beautiful room he designed for the Library of Congress, which was unfortunately destroyed in 1851. He completed the building in 1826, finished the landscaping in 1829, and quietly retired to Boston a year later.

was the principal reason Bulfinch winced at the thought of moving to Washington. Yet the chance to complete the nation's Capitol presented a strong inducement. Bulfinch would consider it only if a vacancy occurred for reasons entirely unconnected with himself.

Over the following few weeks Lee kept Bulfinch abreast of developments in Washington. At the beginning of October he wrote that the president returned from New England determined to dismiss Latrobe but was prevented by friends of the architect. Lee thought the situation would not allow both Latrobe and Lane to continue much longer and predicted that the architect would be dismissed because the commissioner had more friends. Again he described the plight of the beleaguered architect with sympathy:

> I do not know how it is, but so it is, Latrobe has many enemies; his great fault is being poor. He is, in my opinion, an amiable, estimable man, full of genius and at the head of his profession. Every carpenter and mason thinks he knows more than Latrobe, and such men have got on so fast last year with the President's house (a mere lathing and plastering job) that they have the audacity to think they ought to have the finishing of the Capitol, a thing they are totally unfit for. That superb pile ought to be finished in a manner to do credit to the country and the age.[3]

Bulfinch's name was mentioned to the president in case Latrobe was forced to leave. Lee urged him to write the president directly but he refused to make a move as long as Latrobe remained in office. Bulfinch thought Latrobe's "talents entitle him to the place, and that he is the most proper person to rebuild what he had once so well effected."[4]

A few days after Latrobe left office, Senator Harrison Gray Otis of Massachusetts went to see Monroe to ask if the architect's office should be filled by "looking to Boston."[5] The reference to Bulfinch was all too obvious and the president replied: "Sir, we are looking to him, but Mr. Latrobe is a great loss, and it will require perhaps two persons to supply his place, and we think also of a Mr. McComb." Monroe asked Otis to provide background information on Bulfinch's character, qualifications, family, and current circumstances. Monroe told the senator that the commissioner of public buildings had been instructed to write Boston with an offer. "I am thus led to suppose," Otis wrote Bulfinch, "that the business may be

considered done." Dropping the idea of hiring two architects, the next day Lane wrote Nehemiah Freeman of Boston, asking him to inform Bulfinch of his appointment as architect of the Capitol. Not wanting the least ambiguity about their relative positions to cause problems in the future, he wished the architect to be reminded that "the appointment is entirely at the disposal of the Commissioner."[6]

Although Bulfinch's appointment was handled through friends, the groundwork had been laid during two visits that brought him face-to-face with President Monroe. The first, his tour of Washington in early January 1817, was followed by the president's trip to New England during the summer of the same year. While Bulfinch was the de facto mayor of Boston as chairman of the board of selectmen, most of his income was made through an architectural practice. After the close of the War of 1812, Massachusetts embarked on a program of public improvements that included construction of two hospitals—one general and one for the insane. Bulfinch was the architect of both. While on a fact-finding tour of medical facilities in New York, Philadelphia, and Baltimore, Bulfinch made a three-day visit to Washington to see Congress in session at the Brick Capitol. During this sightseeing trip, former Senator James Lloyd of Massachusetts introduced him to President Monroe, who asked the commissioner of public buildings to escort their distinguished guest over the works at the Capitol. Before dashing off to Baltimore, Latrobe met Bulfinch at the Capitol on January 7, 1817, showed him the restoration plans, and took him around. Hoban showed similar courtesies at the President's House. Bulfinch was entertained in Dolley Madison's drawing room two nights in a row, where he found "a great display of beauty and a collection of distinguished persons from all parts of our country."[7] During this short stay he made friends in Washington and, more important, made the personal acquaintances of the president and commissioner, acquaintances that would pay unexpected dividends in the near future. They were obviously impressed by an architect of such high political stature, a calm, deliberate man with polished manners and an impeccable New England pedigree. The contrast with their brilliant but high-strung architect must have been

startling. Having enjoyed his visit, Bulfinch parted company never expecting to see them or the Capitol again.[8]

Six months after Bulfinch left Washington, news reached Boston that Monroe planned a visit to the city on his New England tour. A committee was appointed to provide the president with a warm and cordial reception, and, as chairman of the selectmen, Bulfinch was put at its head. They met the president and his party in Providence, Rhode Island, and escorted them to Dedham, Massachusetts, and on to Boston, where they arrived on July 2, 1817. After a brief speech by Senator Otis, a parade marched through the streets of Boston amid the cheers of an enthusiastic crowd of spectators. Monroe on a white charger, Bulfinch and other committee members in open carriages, and military officers and citizens on horseback, they rode two and a half miles accompanied by music from bands positioned along the way. Coming upon a throng of four thousand children holding red and white roses, Monroe stopped a moment to admire the extraordinary sight. The parade ended at the Exchange Coffee House, where Bulfinch welcomed the president in the name of the people of Boston. Monroe made a suitable reply, after which the party adjourned for a dinner attended by former President John Adams, the president of Harvard College, and the lieutenant governor of Massachusetts. Over the next four days, Monroe was escorted around the city; to church services; to Cambridge where he received an honorary degree from Harvard; and to dinners and receptions. Much of his time was spent with Bulfinch, who may have pointed out some of the beautiful buildings he designed that were such conspicuous ornaments of the city. By the time the presidential party departed for Salem, the former seat of Federalist discontent had given Monroe a welcome as warm, friendly, and hospitable as could have been wished. Here began "The Era of Good Feelings," and the president may have asked himself why things at the Capitol could not proceed with similar harmony.

Through his office, education, and family, Bulfinch's place in Boston society was high; his financial situation, however, was meager. Moving to Washington was a venture not to be undertaken lightly, but a steady paycheck was an important consideration. Unlucky ventures in real estate had

cost him dearly. In 1796, bankruptcy took not only all of his property but also that of his wife and parents. Earnings from his architectural practice were erratic, and petty debts landed him in jail for a month in 1811. The prospect of a dependable income was enough to induce him to leave his home, his relatives, and his friends. When he first heard of the Capitol job, it was rumored that the architect's position and the commissioner's job might be blended together with a salary of $4,000 or $5,000 a year. The prospect of earning that much money was perhaps the strongest consideration Bulfinch gave to his removal to Washington. He calculated that $3,500 would support his family in decent comfort and allow for entertainment expenses and hosting friends from Boston.[9] Lee thought that $3,000 would be sufficient to live in the best manner, but when the job was offered the salary was $2,500.[10] But it was still enough to entice Bulfinch to uproot his family and move to Washington.

AT THE OFFICE

On December 22, 1817, Bulfinch presided over his last meeting of the board of selectmen. The following March his service to Boston was acknowledged at the city's annual meeting when the thanks of the town were presented in a resolution. While grateful, Bulfinch privately considered the resolution thanking him for almost nineteen years of public service somewhat stingy, referring to it as "the cheap reward of republics."[11] Leaving his political career behind, Bulfinch departed Boston in the company of his son and reached Washington during the first week of January 1818. They went immediately to the President's House to see Monroe. Father and son were received in a beautifully decorated apartment by the president, who welcomed them to the federal city, promised his support, and encouraged the elder Bulfinch to confer frequently with him on matters relating to the Capitol.[12] Following a courtesy call on Secretary of State John Quincy Adams the next day, Bulfinch went to the Capitol to take possession of his office. There he received his official appointment from the commissioner and was perhaps surprised to find that his salary had started on December 11, 1817.[13] He took posses-

sion of the architect's office in the Capitol, a room about 20 feet by 25 feet, that was furnished with tables, desks, drawing paper, and drafting instruments. Bulfinch's office hours were from 10 o'clock in the morning until 3 o'clock in the afternoon.[14]

Led by the head carpenter Peter Lenox, Bulfinch made a minute examination of the two wings, was introduced to the foremen, and visited the sheds, where he found most of the 120 workmen cutting and polishing Potomac marble. He was favorably impressed by Lenox, whom he called "an intelligent, middle-aged man," and was grateful to have him lead the way. "Without such a guide," Bulfinch wrote his wife, "it would be impossible for a stranger to tread the mazes of this labyrinth." He returned to his office to study the drawings left by Latrobe. Some showed the approved design of the wings and some showed the plan for the center building, which was still unsettled. Initially struck by the stunning quality of Latrobe's artistry, Bulfinch soon found fault with some aspects of the designs:

> At first view of these drawings, my courage almost failed me—they are beautifully executed, and the design is in the boldest style—after longer study I feel better satisfied and more confident in meeting public expectations. There are certain faults enough in Latrobe's designs to justify the opposition to him. His style is calculated for display in the greater parts, but I think his staircases in general are crowded, and not easy of access, and the passages intricate and dark. Indeed, the whole interior, except the two great rooms, has a somber appearance.

Bulfinch was critical of the staircases and passageways in the two wings. He also did not care for the spareness of decoration that seemed unnecessarily "somber." Bulfinch's own approach to interior design would be more clear and direct, less complicated than the plan of the wings. Room arrangements would be straightforward and easily understood. Stairs would be easy to find, broad, and gentle. Passages would be straight, wide without being wasteful, and well lighted. And, where appropriate, delicate moldings and carvings would be used as ornamental trim to provide refined elegance. Part of Bulfinch's architectural style had been developed in Boston and part was a reaction to what he disliked about Latrobe's taste. He would not be unduly influenced by his predecessor's work except where there was no other choice

but to carry on with what had been started. There would be plenty of opportunities to make his own mark on the center building, which he began to design soon after arriving in Washington. Naturally, the outside would follow the basic design of the wings, but there was also room for invention, particularly around the porticoes and dome. Everything inside the center building would showcase Bulfinch's taste.

At the beginning of 1818, Congress appropriated $200,000 to continue repair of the public buildings. The Senate requested an up-to-date report on expenditures, an account of the progress made so far, and an estimate of the cost of finishing the wings. Lane reported that $159,655 ("Errors excepted") had been spent to repair the Capitol in 1817 and transmitted a statement from the architect about conditions at the Capitol.[15] Bulfinch acknowledged that the designs of his predecessor would produce splendid public rooms that would "exhibit favorable specimens of correct taste and the progress of the arts in our country." He was preparing several designs for the center building from which the president might choose. As soon as the weather permitted, the principal and back staircases in the north wing would be installed and the roof would be ready for its copper covering. The framing of the roof over the south wing was about two-thirds prepared. Most of the doors and all the window frames and sashes were made, and there was enough glass on hand for glazing. Only three columns and two pilasters for the House chamber were finished, but fifteen columns and two pilasters were in the hands of the cutters and polishers; the rest were at the quarry. Bulfinch estimated that $28,000 was needed to finish the marble work and predicted that all the columns would be completed by August. Other marble work included three styles of mantels: twenty for small committee rooms at eighty dollars each; twenty for larger committee rooms at $100 each; and ten mantels for the principal rooms at $200 each. He estimated that the sixteen pilasters on the upper wall of the Senate chamber would cost a total of $3,200. (These were omitted later.) It was impossible to estimate the cost of the allegorical statuary, but the sculptors' salaries would amount to $8,000 for the year ahead. A total of $177,803 was needed to finish the restoration of the Capitol's two wings.

In the House of Representatives, the Committee on Expenditures on Public Buildings, chaired by Henry St. George Tucker of Virginia, made its own inquiries into the financial state of affairs. It found the probable cost of restoring the Capitol, President's House, and executive offices would be one million dollars—twice the original estimate. It duly noted that the cost of restoration was likely to come very close to the amount originally spent to build these structures. It blamed the exorbitant cost overruns on the changes made to the plans of the Capitol, particularly those made to the north wing.[16] The expense of the marble columns greatly aggravated the situation. Lane wrote Tucker's committee about the columns and the trouble they caused. He described the history of Potomac marble, the original contract with John Hartnet for shafts needed for the House of Representatives, and Hartnet's inability to uphold his part of the bargain. Not wishing to abandon the marble, and not finding anyone else to partner with Hartnet, the president and the commissioner decided to operate the quarry with public funds, hiring a large gang to speed the work along. Temporary huts furnished with bedding and cooking utensils were built for workmen. Clothing for slaves was also provided. These extraordinary expenses accounted for much of the cost overrun, but Lane hoped the expense and headache would be worthwhile. He confessed that the marble had been a source of "perpetual anxiety and vexation."[17]

A few weeks later Lane again wrote Tucker explaining how the works had been affected by increasing labor and material costs. He stated that from February 1, 1815, to January 1, 1818, a total of $324,100 had been spent to restore the north and south wings, which compared favorably with the $788,071 expended to build them initially. He also provided a chart to compare the price of goods and services during different periods.

	1793–1800	1800–1812	1815–1818
Stone cutters' daily wage	$1.25 in winter $1.33 in summer	$1.50 in winter $1.75 in summer	$2.50 in winter $2.75 in summer
Brick layers' daily wage	$1.50 in winter $1.75 in summer	$1.50 in winter $1.75 in summer	$2.00 in winter $2.75 in summer
A laborer's daily wage	75¢	75¢	$1.00
Sandstone per ton	$7–$8	$8–$9	$10–$12
Brick per thousand	$7	$7–$7.50	$9–$9.50

Tucker's committee was satisfied that work was being done as quickly and economically as conditions permitted. Lane assured the committee that the wings would be ready by November 1818. Inadequate funding was the only thing that could disappoint congressional hopes of returning to the Capitol. On the last day of the session, Congress passed a series of appropriations specifically for the Capitol in addition to the $200,000 already given for the public buildings. Eighty thousand dollars was allocated to complete the wings, $30,000 was given to furnish the hall of the House and committee rooms, and $20,000 for furnishing the Senate chamber and committee rooms. It was clear that there would not be enough committee rooms until the center building was completed. The shortage would be particularly annoying to the House of Representatives in the south wing, which had only nine rooms available for committee use. Bulfinch designed a temporary wooden structure a hundred feet long, forty-two feet wide, and ten feet high containing twelve rooms and a passage; he estimated that it would cost $3,634, which Congress readily granted. One hundred thousand dollars was also appropriated to begin the center building.[18] It was the most flush day in the history of the Capitol's accounts in the twenty-five years since the building was begun.

At the beginning of the 1818 building season, labor troubles and construction problems set the works back sufficiently to shatter hopes of seating Congress in the Capitol that fall.[19] First, stone cutters struck for higher wages, bringing their critical work to a standstill for a month. On May 25, 1818, Blagden was instructed to find replacements in Baltimore, but he had to warn the newcomers of possible reprisals from the striking workmen.[20] The menacing behavior of seven or eight discharged stone cutters landed them in jail and a detachment of Marines was deployed to keep fellow masons from attempting a rescue. Tempers cooled and the masons' union was dissolved. Lane did not want to rehire stone cutters who went on strike, but Blagden could not find enough hands in Baltimore to replace them all.[21]

At the end of April 1818 workmen were preparing to build the stone lantern that would crown the roof of the north wing. Unlike its twin on the south wing, which was made of wood, the Senate's lantern was built of stone because it contained flues snaking up from eighteen fireplaces. Latrobe had designed a barrel vault forty feet long and thirty feet wide to carry the lantern, but when work progressed under Bulfinch's supervision the vault did not appear strong enough to support the flues and lantern. When the centering was removed, the curb encircling the opening at the top of the vault twisted out of shape by four inches and collapse appeared imminent.[22] Workmen scattered and would not go near it until it was shored up. With the help of General Swift and Colonel Bomford, Bulfinch devised a way to support the lantern and prop up the vault. Under the aperture a hollow cone was built that was similar to (but much smaller than) the one devised by Sir Christopher Wren to support the cupola at St. Paul's in London. The crown of the cone was fifteen feet in diameter, matching the interior diameter of the lantern. Light and air passed through this opening to the skylight over the Senate lobby and to interior windows in the third-floor corridor and the small staircase sometimes referred to as the "library stair."

While the cone successfully solved a potentially dangerous problem, its construction delayed completion of the roof by four weeks. Bulfinch wrote an account of the problem, which he transmitted to Congress along with his annual report. Soon thereafter Latrobe retaliated with a printed pamphlet entitled *Vindication of His Professional Skill.*[23] Bristling under what he considered harsh censure, Latrobe argued the case of an "Old public Servant." He stated that the arch was not begun until after he resigned, yet he had been so concerned about it that he returned to instruct the masons on how to build it. He blamed George Blagden for spreading unfounded fears about the security of his arches and for working behind the scenes to discredit the vaulting system used in the two wings. Properly built, such an arch would have supported ten times the weight it was expected to carry. He had intended to lay in an iron hoop at the circular opening for strength and to use more iron in the lantern itself. If his intentions had been followed, no problem would have been encountered and his engineering skill would not have been questioned. In the end, Latrobe's pamphlet accomplished nothing and probably struck readers as new evidence of a particularly thin skin.

During this period Lane continued searching for mantels. In 1817 he sent a large order for Italian mantels via an English merchant and learned that 161 cases of chimney pieces had been shipped from Leghorn in the beginning of October. How many mantels were included in the shipment is unclear, but it was not enough. On July 20, 1818, Lane sent a drawing of a mantel to Senator David Daggett of Connecticut, taking advantage of his offer to negotiate with the owners of the Milford verde antique quarry for four green marble mantels needed for the Senate chamber. "I confide to your discretion," wrote the commissioner, "to procure them on the best terms in your power."[24] Ten days later Daggett replied with prices that alarmed Lane. He wanted to oblige the senator's wish to see Connecticut marble in the Capitol, but did not wish to waste the public's money and incur the wrath of "an august body that pays us an annual visit."[25] Speaking as a member of that august body, Daggett replied that he too wished to avoid spending funds foolishly and assured Lane that mantels from New Haven would not cause complaint.[26]

Lane's concern about the mantels for the Senate chamber poses intriguing questions regarding mantels ordered for that room from Traquair's marble yard in Philadelphia before the fire of 1814. Those mantels were designed by Giovanni Andrei, ordered by George Blagden and Thomas Munroe, made, and boxed up but stayed in Philadelphia after news of the invasion was first heard. On April 17, 1817, Traquair wrote the commissioner that these mantels had not been paid for and would remain with him subject to orders from Washington.[27] Five months later, Blagden and Andrei were in Philadelphia and inspected the mantels to determine their value.[28] Lane was anxious for more mantels, especially those with appropriate carvings, and sent for them. Why then did he need four mantels for the Senate chamber the next year? And why were only two of these mantels in the chamber when its restoration was undertaken in the 1970s? The answer may lie in a letter written in 1822 by Lane's successor to William Seaton, one of the editors of the *National Intelligencer.* To help settle Lane's estate, Seaton was asked about the price paid for a chimneypiece sold him by the deceased commissioner. Seaton replied that it was presented to him as a gift.[29] If Lane were, indeed, in the habit of handing out chimneypieces to influential members of the press, it would well explain why multiple sets of mantels were ordered for the Senate chamber.

On June 15, 1818, the last cargo of Potomac marble left the quarry headed for the federal city. Lane's overseer there, Solomon Davis, made preparations to sell the public property on Samuel Clapham's land. Virtually worthless things such as workmen's huts, bedding, blankets, pots, pans, and other utensils, as well as more valuable items like handpicks, hammers, axes, wedges, and derricks had to be sold. Clapham initially did not want compensation for the marble but changed his mind near the close of the project. Lane agreed to pay, and they asked William Stewart and Thomas Towson, quarriers from Baltimore, to join them at the quarry to determine the price. John Hartnet and Solomon Davis were also there to explain how much stone was extracted from the site. Together, the two impartial judges determined that the commissioner should pay Clapham $1,500 and recommended that someone else put a price on the value of firewood and other timber consumed during two years of government occupation.[30]

When Congress returned to Washington in November 1818, the House Committee on Public Buildings inspected the wings to see if everything that could be done to finish them was being done. It reported that more had been accomplished during the previous year than during any other period. The chairman of the committee, Joseph Bellinger of South Carolina, asked the commissioner to explain why they were not ready as promised. Lane forwarded Bulfinch's annual report containing the answers, but prefaced it by saying he too felt disappointed and promised to have everything ready for the next Congress.[31] Perhaps the delay was just as well, Lane wrote, because airing out the interiors for another season would prevent the "green and damp" conditions that otherwise would injure the health of congressmen and senators.

Bulfinch's report gave a succinct account of the troubles preventing completion of the work. More important, it detailed some expenses unforseen in his last funding request and some that would be incurred in finishing the restoration. Two thousand dollars was spent to build the brick cone supporting the lantern over the north wing. New York marble for the Senate chamber would cost $15,000 by the

time the order was filled. Marble fashioned in Philadelphia for the hall of the House would cost an additional $1,300. Iron work and copper from London intended for the roof had been received but the bill had not arrived by the time Bulfinch made out his last funding request. Those materials cost $14,282. And finally, $10,750 would be needed to cover the invoice just received for the marble capitals carved in Italy for the Capitol. In all, Bulfinch asked for $51,332 to cover these expenses.[32]

The reasons for the delay in completing the restoration were fully understood and accepted by the committee, which sympathetically thought the sheer magnitude of the undertaking was a powerful mitigating circumstance. More than once while Latrobe was in office, Congress was informed about delays and cost overruns and usually reacted harshly, often with attacks on the architect. But the reaction to the current situation marked a new and welcome era of tranquility. Without hesitation, the funds Bulfinch requested were appropriated on the last day of the session, as was the custom. In addition, $136,000 more was given for the center building.[33] Since it would no longer be needed, Congress ordered the Brick Capitol returned to its owners.[34]

Even as Lane and Bulfinch apologized for the unfinished state of the Capitol, a few rooms in the north wing were being occupied. On December 3, 1818, Senator Mahlon Dickerson of New Jersey, chairman of the Joint Committee on the Library, authorized Lane to start moving books into the rooms on the third floor, which would house the Library of Congress until the center building was completed. In 1815 cash-strapped Thomas Jefferson sold Congress 6,487 volumes to replace those lost in the fire. His personal library formed the nucleus of the new congressional library, which was first housed in the Brick Capitol. In March 1819 the secretary of the Senate was informed that his room on the second floor (modern day S–233) was ready, signaling the return of Senate officers.

During the 1819 building season all the columns in the House chamber had been set, the entablature completed, and the wooden ceiling finished. Bulfinch asked the Italian artist Pietro Bonnani to develop schemes for painting the ceiling that would imitate a masonry dome with coffers. On April 20, 1819, he informed the commissioner that the sketches were done and a deci-

sion was needed. A design derived from the Pantheon in Rome was selected, and Bonnani was put to work transforming the smooth ceiling into what would appear (until it was replaced in 1901) as a coffered dome. While Bonnani worked above, Carlo Franzoni's magnificent clock, the *Car of History*, was placed over the principal entrance at the north end of the chamber. It was carved from one of the scarce blocks of Italian white marble that Latrobe had rescued from Blagden's scheme to slice them into hearths for the President's House. Enrico Causici modeled *Liberty and Eagle* from twenty-five barrels of isinglass plaster bought from a Baltimore merchant.[35] The sculpture was never carved in marble due to the lack of materials. The plaster group was placed high above the Speaker's chair.

In the Senate chamber, circumstances conspired to dilute much of Latrobe's ambitious design. Where the original plan called for a procession of caryatids representing the union of states, the completed room had no allegorical sculpture at all. Plans to cover the room with a brick dome were canceled for reasons of safety, economy, and expediency. A plaster ceiling carried on wooden trusses gave the impression of a masonry dome and was elegantly decorated with plaster ornaments such as stars, arrows, and Grecian honeysuckle. But the overall effect was less than Latrobe had hoped and, indeed, less than what had been seen in the old chamber. After the room was rushed to completion, crimson drapery, mahogany furniture, and brass lighting fixtures did something to restore the overall impression of luxury and taste. While the Senate chamber ranks high among Latrobe's finest interiors, he undoubtedly would have considered it inferior to the room destroyed in 1814.

PLANNING THE CENTER BUILDING

Bulfinch had been on the job less than a week when he was asked by the commissioner to give a plan and estimate for the center building.[36] The time had come to begin the middle section, which had been deferred since Stephen Hallet was dismissed in 1794. A committee of the House of Representatives wished to review a plan and Bulfinch wasted no time in preparing one.

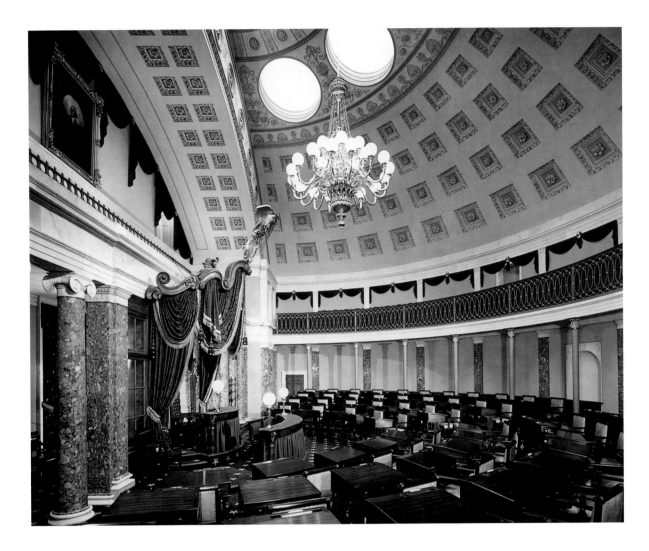

Senate Chamber

Latrobe's plans remained in the office and would be used as a point of departure. Bulfinch might also have been aware of Hallet's proposals for this part of the Capitol because some of his square courtyard foundations still remained in place. Dr. Thornton's thoughts on the subject were doubtless given when Bulfinch visited him at the Patent Office shortly after arriving in Washington. To his wife Bulfinch described Thornton as "a very singular character," who still complained bitterly about Latrobe.[37]

One consideration governed Bulfinch's thoughts about the center building: he was obliged to provide as many committee rooms as possible. There was talk of doing away with the Capitol's grandest room—the rotunda—in order to gain more space for committees. There were not enough rooms for all the standing, joint, special, and select committees, and there was a growing need for offices as well. Some thought the space taken up by the rotunda was enough to supply all the committee rooms Congress could ever use. They believed that the room could be better devoted to the business of Congress. To some, it was just a wastefully large vestibule. A more modest entry flanked by committee rooms, some legislators thought, would better suit the purpose of the Capitol.

Although its construction had been long delayed, the idea of a central rotunda was one of the few aspects of the original plan to survive from the beginning. In 1793 Thornton proposed placing the equestrian statue of George Washington voted by Congress in the center of the room. (This was

at odds with the L'Enfant plan, which placed it on the Mall.) Soon after Washington's death Thornton suggested building a mausoleum for his remains in the rotunda. He wrote that the monument was intended to be made

> of large blocks of white marble enclosing a Tomb meant for the reception of his Body, with that of his consort. The rocks of marble should be crowned by a cloud & on this cloud the angel of Immortality should be leading Washington by the hand & pointing upward with expanded wings ready to take flight with the enraptured Chief, accompanied by the partner of his life. In the lower region of the rocks there would be subservient figures.[38]

However improbably, Thornton claimed that his design was blessed by the Italian sculptor Giuseppe Ceracchi. In Jefferson's administration, the idea of a hero's mausoleum in the rotunda was scrapped: it was to be the "Hall of the People." Latrobe's revisions to the rotunda's design eliminated the columns and placed large-scale niches between the four doors located at the cardinal points. A later design included twenty-four smaller niches for portrait busts. Perhaps Jefferson wished the rotunda to serve as a "most honourable suite," like the tea room at Monticello where busts of Washington, Franklin, Lafayette, and John Paul Jones were displayed.

In 1817 the first concrete step was taken to define the role of the rotunda aside from being the Capitol's grand vestibule. The government commissioned John Trumbull to paint four scenes from the American Revolution specifically for the room. The artist had already sketched ideas for several scenes and actively sought the federal commission. Among his Revolutionary War scenes, the *Declaration of Independence in Congress, at Independence Hall, Philadelphia, July 4, 1776* was the most popular. Trumbull began sketches for the painting in 1786 while visiting Jefferson in Paris. There the Declaration's author gave him a detailed description of the setting and provided other information to guarantee an authentic depiction of the event. In addition to the *Declaration of Independence,* Congress wanted three more Revolutionary War pictures and appropriated $32,000 on January 27, 1817, to pay for them. A noble series of history paintings mounted in the heart of the Capitol would honor the events surrounding the country's quest for independence and self-determination.

Questions still remained about how large the paintings should be and what events other than the signing of the Declaration should be depicted. The artist met with President Madison to discuss the size and subjects of the paintings, and he recalled the conversation at length in his autobiography:

> The size was first discussed. I proposed that they should be six feet high by nine long, which would give to the figures half the size of life. The president at once overruled me. Consider, sir, said he, the vast size of the apartment in which these works are to be placed—the rotunda, one hundred feet in diameter, and the same in height—paintings of the size you propose, will be lost in such a space; they must be of dimensions to admit the figures to be the size of life.
>
> This was so settled, and when we came to speak of the subjects, the president first mentioned the battle of Bunker's Hill. Observing me to be silent, Mr. Madison asked if I did not approve that. My reply was that if the order had been (as I had hoped) for eight paintings, I should have named that first; but as there were only four commanded, I thought otherwise. It appeared to me, that there were two military subjects paramount to all others. We had, in the course of the Revolution, made prisoners of two entire armies, a circumstance almost without parallel, and of course the surrender of General Burgoyne at Saratoga, and that of Lord Cornwallis at Yorktown, seemed to me indispensable. True, replied he, you are right; and what for the civil subjects? The declaration of independence, of course. What you have for the fourth? Sir, I replied, I have thought that one of the highest moral lessons ever given to the world, was that presented by the conduct of the commander-in-chief, in resigning his power and commission as he did, when the army, perhaps, would have been unanimously with him, and few of the people disposed to resist his retaining the power which he had used with such happy success, and such irreproachable moderation. I would recommend, then, the resignation of Washington. After a momentary silent reflection, the president said, I believe you are right; it was a glorious action.[39]

In gratifying detail, Trumbull recorded one of the few contributions Madison made to the Capitol's evolution. His decision in favor of full-size figures established the scale of Trumbull's works as well as those to follow. Small studies were displayed in the Brick Capitol and, according to *The National Intellegencer,* gave every indication that the paintings would be a "credit to the artist and to his country" when finished.[40]

Latrobe, who was still in office at the time, was pleased by the congressional action that promised great works of art for the rotunda, telling Trumbull that he was "honored in having my Walls destined to support your paintings."[41] But determining how they would be displayed was another matter. Latrobe worried about the paintings hanging within reach because the canvases could be damaged by poking fingers or walking sticks. If hung too high, they would have to be tilted and would block views of sculpture he planned to install above. Should the canvases be stretched on frames to follow the curve of the walls? Or would it be better to have them stretched flat and straight? Letters passed between the architect and artist discussing these matters, with Trumbull first in favor of hanging the paintings in straight frames from bronze rings with the bottoms about twenty-two feet above the floor.[42] Latrobe countered with a suggestion to insert the pictures on ledges built into the walls leaving enough room for wooden frames. They would stand almost six feet off the floor and could be guarded by iron railings.[43] While Trumbull thought about Latrobe's proposal, the architect's career in Washington was falling apart around him. Six weeks after writing Trumbull, Latrobe had resigned his position. Hanging Trumbull's paintings was now Bulfinch's job.

During his first few weeks at the Capitol, Bulfinch tackled the problem of reconciling the need for committee rooms with the importance of providing a suitable place for Trumbull's paintings. On January 19, 1818, he wrote the artist (a friend of twenty years) with an idea of replacing the rotunda with committee rooms on the principal floor and placing a picture gallery in the story above. Access to the gallery would be provided by a striking double circular staircase like the one he admired in New York's new city hall, and the works of art would hang opposite windows facing east under the central portico. Trumbull, however, considered this placement highly objectionable. After describing a similar situation at the Louvre in Paris, which he thought "execrable," he lamented: "I should be deeply mortified, if, having devoted my life to recording the great events of the Revolution, my paintings, when finished, should be placed in a disadvantageous light. In truth, my dear friend, it would paralyze my exertions."[44] He urged Bulfinch

to retain the rotunda on the strength of its serving as a perfect place to show his paintings. Trumbull suggested protecting the paintings by placing downward-leading staircases in front of them. Having a stairwell in front would put the paintings out of reach, and access to the rotunda would be easier and more accommodating for sightseers.

The suggestion did not please Bulfinch, who was not particularly happy with his initial idea either. Fortunately, by mid-March he hit upon a solution to provide enough committee rooms to save the rotunda. The center section would take advantage of the sloping hill on which it was to be built, rising four stories on the west while remaining three stories on the east. A new ground floor in the western projection could provide twelve committee rooms and offices. By reducing the size of light wells, corridors, and the rooms themselves, he was able to increase the number of rooms in that part of the center building from the twenty-four shown in Latrobe's plan to forty. They could also be fitted into a smaller and less expensive structure.

To facilitate a fair comparison, Bulfinch drew a plan showing his ideas along with a copy of Latrobe's plan. Solomon Willard of Boston was employed to build a scale model of the building with exchangeable parts illustrating the differences between the two plans. Both the drawings and model would assist the president and committees of Congress in making a decision. Yet one design problem still preyed on Bulfinch's mind. Although it would be seen only from the west, the additional story was sunk below the ground level of the wings, resulting in an odd composition. It would not be strange to see a four-story building flanked by lower three-story wings, but in Bulfinch's design the wings were not lower than the center building, and the oddity might subject him and the Capitol to criticism. To make the extra floor less obvious, Bulfinch planned to face it with granite from Boston, thus leaving the line of brownish freestone unbroken.[45] Writing with news of his plan, he asked Trumbull to recall a similar situation that might be cited as a precedent.[46] The artist was delighted with the idea and assured Bulfinch that the benefits to be gained from this plan were worth enduring a minor architectural idiosyncracy:

> It appears to me, that you have extricated yourself most happily from the multitude of

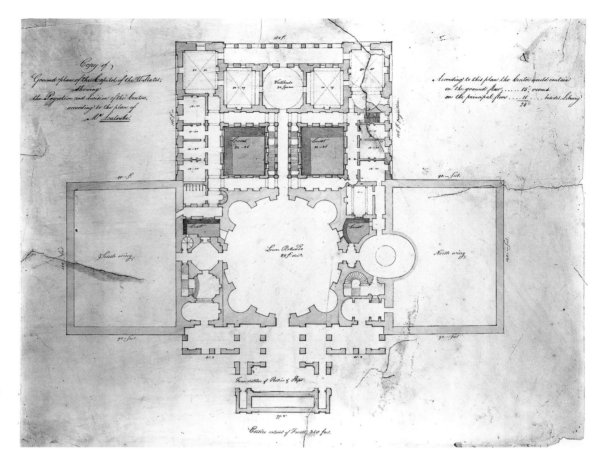

Copy of Ground plan of the Capitol showing the Projection and division of the Center according to the plan of Mr. Latrobe

by Charles Bulfinch, ca. 1818

Library of Congress

*I*n Latrobe's preliminary plan, the west center building projected 106 feet beyond the face of the wings and accommodated twenty-four committee rooms and the Library of Congress.

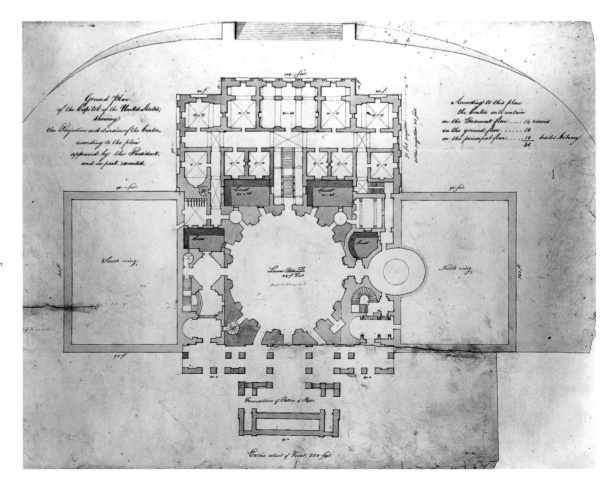

Ground plan of the Capitol of the United States showing the Projection and division of the Center according to the Plan approved by the President and in part erected

by Charles Bulfinch, ca. 1818

Library of Congress

*W*ith an extra floor at the basement level, Bulfinch's west center building accommodated forty committee rooms and the Library of Congress, yet projected thirty-five feet less than Latrobe's plan.

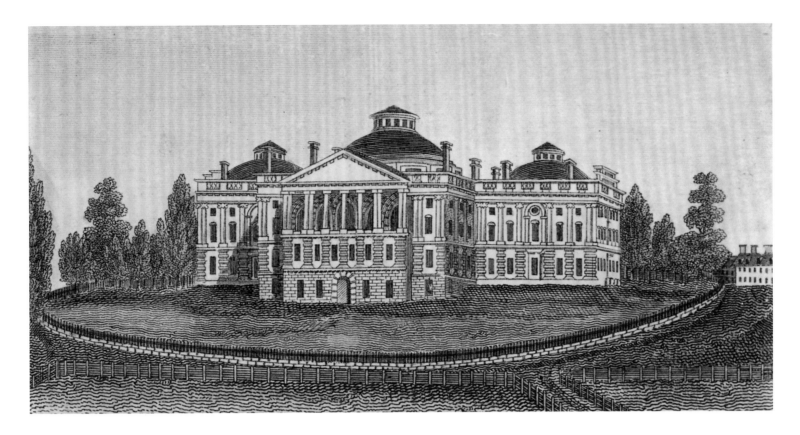

contradictory projects with which you were surrounded. The granite basement is, I presume, original; I cannot recollect any example of the kind, nor do I find any among a collection of views of country seats in England, which I have . . . the necessity of the case justifies the novelty; and nothing can be easier than to disguise it by what the English call planting it out, that is, screening it from distant view by shrubs.[47]

By the end of March 1818, Bulfinch's plan for the center building had been approved, and the initial funding of $100,000 was given on April 20. During the building season most workmen were employed on the two wings, but those who could be spared began removing the old center foundations left from the 1790s. Much of the hill was cut away to prepare the site for the western projection and its new foundations. On the fourth anniversary of the burning of the Capitol, August 24, 1818, the cornerstone of the center building was laid. Although the ceremony was conducted without a fanfare, the symbolism of the event was inescapable. *The National Intelligencer* reported:

> The cornerstone of the Capitol of the United States was laid at 12 o'clock on Monday last, the 24th inst. in the presence of the Commissioner of the Public Buildings, and the Archi-

tect of the Capitol; after which the workmen and labors employed about the building partook of refreshments, provided by direction of the Commissioner.

> This ceremony took place, it will be recollected, on the anniversary of that day, on which a barbarous enemy here made war upon the arts, upon literature, and upon civilized laws, and hoped to perpetuate his infamous exploit, by laying in a heap of irreparable ruins the edifices raised by taste and genius to the peaceful purposes of legislation and the promotion of human knowledge and happiness.[48]

At the end of the 1818 building season, Bulfinch reported that the foundations of the basement story had been laid, the cellar walls under the crypt (sometimes called the "lower rotunda") were ready for the arches to carry its floor, and walls and partitions of the lower story were begun.[49] By the end of September of the next year, the walls were up to the level of the principal floor, and there was enough sandstone on hand to reach the eaves. Blue stone was bought to back the "angles" of the rotunda and two million bricks were ordered for walls and arches. When not building centers, carpenters spent the winter making doors, shutters, and window sash that would be installed later.[50]

The Crypt

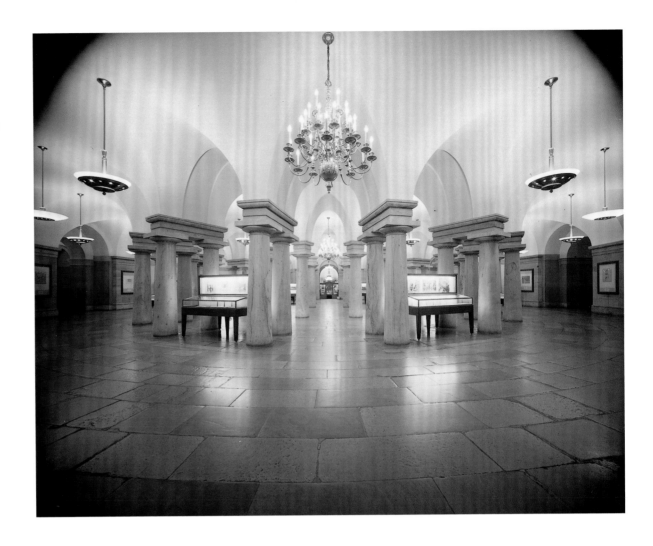

Except for modern lighting fixtures and display cases, the crypt remains today as Bulfinch built it. Forty sturdy columns help support the floor of the rotunda above. (1981 photograph.)

Ionic Order

by Charles Bulfinch, ca.1822

Bulfinch's manipulation of interior ornamentation tended to be more delicate and decorative than Latrobe's bold but simple trim. Evidence of this taste may be seen in the woodwork and stone carving done under Bulfinch's supervision. Traces of white paint removed in the early twentieth century are visible in this view of a Bulfinch capital. (1964 photograph.)

Plan of the First Floor, Center Building

by Charles Bulfinch, ca. 1818

Library of Congress

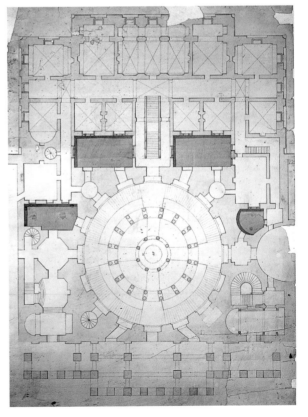

In this preliminary plan, Bulfinch indicated four staircases in the crypt leading to the rotunda above. These were suggested by John Trumbull as one way to protect his Revolutionary War paintings, which would hang out of reach above the stairwells. While the stair idea was never carried out, the crypt's forty columns were erected as indicated. The committee rooms, passages, and stairs west of the crypt were also constructed as shown.

Western Staircase

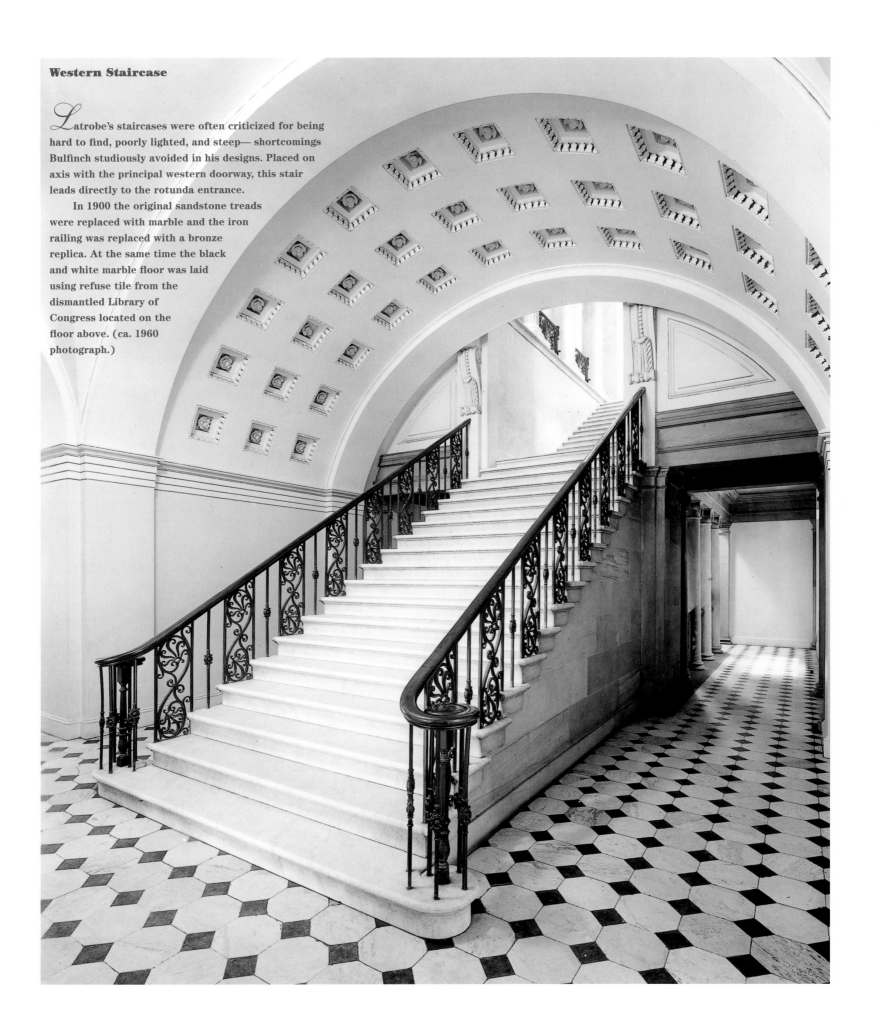

Latrobe's staircases were often criticized for being hard to find, poorly lighted, and steep— shortcomings Bulfinch studiously avoided in his designs. Placed on axis with the principal western doorway, this stair leads directly to the rotunda entrance.

In 1900 the original sandstone treads were replaced with marble and the iron railing was replaced with a bronze replica. At the same time the black and white marble floor was laid using refuse tile from the dismantled Library of Congress located on the floor above. (ca. 1960 photograph.)

CONGRESS RETURNS TO THE CAPITOL

The first session of the 16th Congress convened on December 6, 1819, in the restored wings of the Capitol. While veteran members were delighted to be out of the spare quarters in the Brick Capitol and back in their magnificent chambers across the street, they were greeted with the distressing news that the appropriation had been overspent. In the rush to complete the wings, Lane was obliged to tap funds specified for other purposes, but he still did not have enough money to cover expenses. The story was remarkably similar to Latrobe's push in 1807 to seat the House in its new chamber, during which time he incurred both debt and Jefferson's anger. Yet unlike Latrobe, Lane presented his dilemma to the president, who approved a scheme to borrow funds from a local bank to assure completion of the work. The loan brought in $50,000 and juggling accounts provided another $49,100.[51] All totaled, there was a $75,000 deficit to report to Congress. On December 15, 1819, Bulfinch wrote an account of money spent on the Capitol not covered in earlier estimates. The marble for the Senate gallery, for instance, had been estimated to cost $15,000 but had exceeded that sum by $6,375. Glass cost $5,300 more than expected, and mantels from Italy were $600 over budget, but the largest unforseen overrun was for Potomac marble. It was first estimated at $28,000 but had in fact cost more than $58,000 for the year.

Another unexpected expense was the three thousand dollars spent to paint the outside walls in 1819. The Aquia Creek sandstone was found to be susceptible to cracking and spallation due to the action of rain and frost, and paint was the only coating that could protect it. Every workman who handled the stone knew it was unpredictable and liable to fall apart without warning; a few of its more annoying characteristics were described in an extensive account of the stone that Latrobe had written years earlier:

> The Quality of the stone is also in other respects various. Of the stone more even in its grain & texture, most pleasant to work and of the most durable appearance, great part cracks and falls to pieces on exposure to the air & sun. Sometimes contrary to all expectations & appearance the frost tears it to pieces. All of it expands when wet, and contracts when dry. This property it seems never to lose though buried ever so long in the Walls of a building, unless, as at the Capitol it is contracted by the excessive weight of the incumbent mass. But in any part of a work in which it lies at liberty at one or both ends, the joints regularly open in dry & close in wet weather. Window and door sills therefore which are confined at both ends & are open in the Middle, generally break and the fissure opens and shuts with the dryness or moisture of the weather, to the amount of the 10th of an inch in six feet.[52]

Paint could protect the stone from the weather, or so Bulfinch thought, and would cover blemishes that disfigured many blocks of Aquia sandstone. Ever since the first stones were delivered in 1795, careful attention had been paid to color and quality. Stones with imperfections such as rust-colored streaks would not be used on the exterior but would be buried in walls or sent to the President's House, where the exterior was whitewashed. Latrobe spent the early days of his second campaign at the Capitol supervising the cleaning of the exterior stone that was scarred by smoke and flames from the fire. Bulfinch's decision to try preserving the walls of the wings with a coat of paint meant that blemished freestone could now be used because paint would hide cosmetic defects. Stone used for the center building would not need to conform to the high standards previously held for Capitol stonework, and with less of it subject to rejection, the work on the center building would be accelerated.

Money borrowed to buy marble, glass, mantels, and paint needed to be repaid. For an hour, the House debated the deficit, focusing not so much on whether it should be covered as on the circumstances under which it was incurred. John Randolph attacked the president for running up debt without the constitutional power "to pledge Congress to make good sums which he should raise and expend, without the authority of law."[53] He had made much the same argument against the deficit incurred in 1807 and now was joined by a fellow Virginian, James Johnson, in condemning this one. A half-dozen members spoke favorably of the doctrine espoused by Randolph but supported the president, who was following the congressional mandate to finish the wings. Monroe had only done his duty. On a voice vote, the funds necessary to

**View of the Capitol
Looking Southeast**

**by Michael Esperance
de Hersant, ca. 1819**

Private Collection,
Reproduced by permission

cover the deficit were appropriated on January 24, 1820. It passed the Senate and was approved by the president a few days later.[54]

Also in 1820 a small appropriation was made to paint the inside of the wings and a large sum was given to continue construction of the center building. The next season's work included setting stone for the walls of the western projection, beginning the eastern walls, and raising the columns in the crypt. Six hundred tons of sandstone was needed for building the rotunda the next year. Also needed were two million bricks and roofing materials. Corinthian capitals for outside columns and pilasters were to be carved. In all, Bulfinch estimated that $111,769 worth of work would be performed on the center building, and on April 11, 1820, Congress granted the amount requested.[55] Despite the deficit, there was little unhappiness in Congress with the management of the works at the Capitol.

After sitting in its new hall a few months, however, the House of Representatives became painfully aware of the room's singular defect. Like the old hall, this one suffered from dreadful acoustics. In very short order the chamber was found to be a terrible room for debate, a room in which a voice might be inaudible to members seated nearby and a reverberating babble to those farther away. The smooth, arched ceiling was the culprit, acting as a sounding board that redirected voices with bewildering effects. On April 12, 1820, the chairman of the Committee on Public Buildings, Thomas W. Cobb of Georgia, wrote Lane to ask for a solution. This was the first of many such requests that would follow over the next thirty years as successive Congresses grappled with a problem that was not well understood. Lane asked Bulfinch to consider how the acoustics could be improved, and he asked James Hoban the same question. Dr. Thornton was also asked to give his

*V*iews of the center building under construction are scarce. This sketch shows the Capitol when only the lower two floors of the western projection were completed. A cluster of workmen's houses may be seen in the foreground.

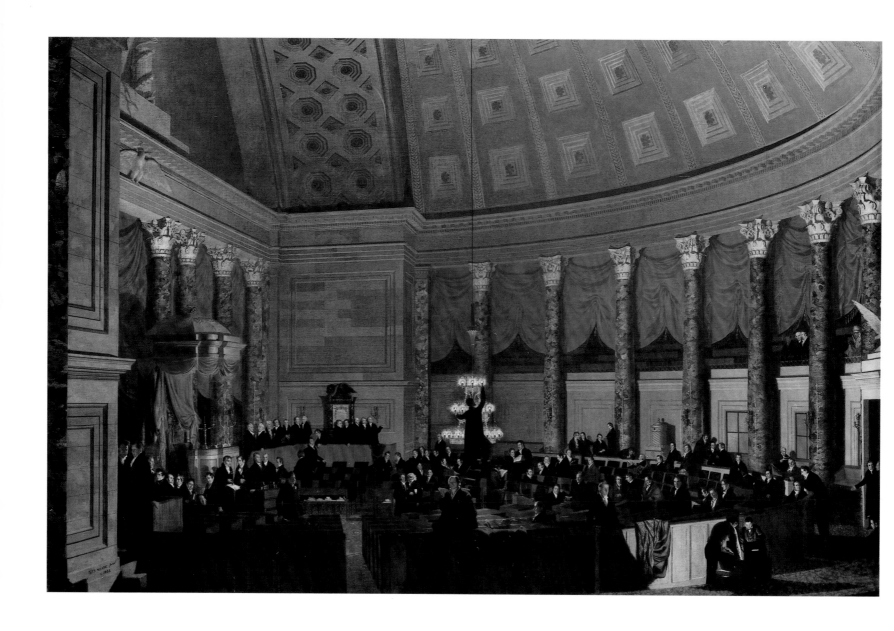

Night Session in the House

by Samuel F. B. Morse, 1822

The Corcoran Gallery of Art, Washington, D. C.
Museum Purchase, Gallery Fund

*N*o painting of a Capitol interior surpasses Morse's depiction of the House of Representatives preparing for an evening session. The chamber glows under oil lamps being lighted by the clerk and his assistants while members gather beneath the great wooden dome. Then as now, the sweeping colonnade was the room's most distinguished feature.

opinions on the subject, which came in a long letter.[56] In his epistle Thornton recited the acoustical virtues of an elliptical hall, following it with a scathing history of the first chamber. He blamed Latrobe for altering the ellipse into semicircles

that reverberated sound. Thornton then claimed that he came up with the idea for muffling echoes with curtains and thus solved the problem in the former hall. "I hoped the first member of Congress that should rise," he wrote bitterly, "would give a curtain lecture to the presumptuous & innovating architect." The second hall, in which Congress now sat, had identical problems: "The same Errors have been repeated & we still find nothing but segments of circles." His solution this time was covering the gallery fronts with woolen cloth dipped in arsenic to protect it from moths. If echoes persisted, he suggested another covering of lethal wool for the ceiling.

Having addressed the main subject of Lane's inquiry, Thornton then attacked Bulfinch for

following Latrobe's alterations of the Capitol's original design. The spacing of the columns along the south side of the House chamber was, in Thornton's opinion, "sickening," but he thought the colonnade could be taken down and re-erected without disturbing the entablature. He did not suggest how this could be accomplished but admitted that it would require "great care." (Apparently, Thornton did not recognize that the interior intercolumniation mirrored that on the exterior and was governed by it.) The center building would be "universally condemned," Thornton warned, unless the circular conference room was built and the subbasement abandoned. Every departure from the old design was condemned with Thornton's gifts of sarcasm and exaggeration. The monitor on the roof feeding light and air to skylights above the Senate chamber was "borrowed from some carpenter's shop, for there never was so mean a window exhibited before in any public building on the face of the globe." The dwarf columns and the upper gallery in the Senate were "perfectly fantastic," reminding Thornton of the platform at London's Newgate prison "where the convicts are executed wholesale, for never were such galleries seen in any building of dignity and national grandeur."

Access to the Senate galleries was likened to an Italian mule path. On the exterior, the Capitol's three domes would strike the eye of a "chaste architect" as ridiculous, and would recall "the old-fashioned Tea Canisters, Bohea at one end, Green Tea at the other, and in the center the large sugar dish." Thornton's letter made it clear that his bitterness had not been soothed by time, and his pretensions to architectural authority were as delusional as ever.

Bulfinch proposed three ways to cure the hall of its acoustical ailment: raising the floor, building a glass partition behind the last row of desks, or installing a flat ceiling.[57] Building up the floor promised to be the least effective because, as Bulfinch noted, the confusion of sounds was the fault of the high, smooth ceiling. The glass partition would also do little good unless it was built so high that it would prevent visitors in the gallery from hearing the proceedings. On the other hand, a new flat ceiling would reduce the room's height by twenty feet and would check much of the reverberation and echo. To avoid obstructing the beautiful dome, and permit the lantern still to light the room, Bulfinch proposed making the ceiling of glass held in a gilded framework. The glass ceiling would cost $5,000.

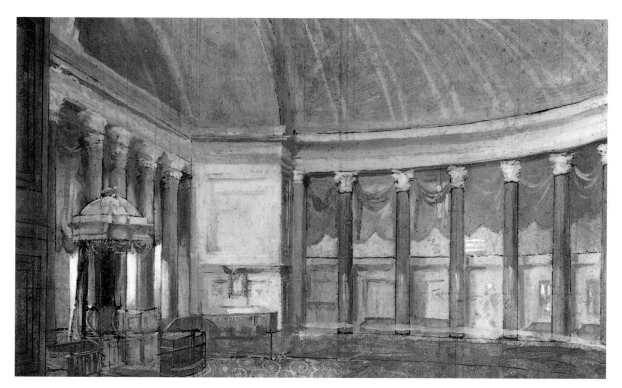

Study for
Night Session in
the House

by Samuel F. B. Morse
ca. 1822

National Museum
of American Art,
Smithsonian Institution,
Museum Purchase through
a grant from the Morris
and Gwendolyn
Cafritz Foundation

Some members looked to the center building as a place to build an entirely new hall of the House. They asked if that was a good idea and Bulfinch replied that it was not. The library, at ninety-two feet long and thirty-four feet wide, was the largest room in the center building yet was still too small for the House. It was even smaller than the House chamber in the Brick Capitol (which measured eighty by forty-six feet) and could not be arranged nearly as well for desks and chairs. Galleries could be only installed at the ends of the room, and they would be small and inconvenient. And although the walls were almost finished it would take another two years for the room to be ready for use. Bulfinch thought members were becoming accustomed to the chamber and that once they knew the pitch of voice necessary to be heard, many objections to it would be removed. He recommended that members address the House from selected stations instead of from their desks and noted that when the room was used for religious services the preacher was clearly understood in every part of the hall. Admittedly, this was perhaps due to the solemnity of a worship service.

On January 19, 1821, Congressman Silas Wood of New York, chairman of the Committee on Public Buildings, issued a report on the various proposals to defeat echoes in the chamber. The glass ceiling was thought to be the best solution, but it would greatly injure the beauty of the room. The committee found that it was easier to be heard now than formerly because, it believed, the walls were dryer. As the room became more and more dry, they were sure, the acoustics would continue to improve. The only action recommended was carpeting the galleries to muffle the sounds there.[58]

Wood's committee also made a second report, this one looking into the wisdom of decreasing the annual appropriation for construction of the center building.[59] The economic depression following the Panic of 1819 gripped the country and put heavy strains on the treasury. Some in Congress thought curtailing construction was an appropriate response to the country's financial difficulties. The committee, however, found that depressed prices of materials and labor meant savings, while diminishing the building funds would only mean slower progress, and they did not believe funds should be reduced until the walls were finished and the center building put under roof. Wood's report recom-mended an appropriation of $80,000 for the 1821 building season to supplement $26,000 unex-pended from previous years. When the appropria-tion passed, it also directed that all unexpended balances left over from any other public building be applied to the completion of the Capitol's center building. President Monroe approved the appropri-ation on March 2, 1821.

At the time of the appropriation, 126 men were at work on the center building. Eight were carving blocks of sandstone for the entablature and Corinthian capitals; forty were cutting stone for the walls and drums that would make up the col-umn shafts for the western portico; twenty-one carpenters were making doors, window sash, and frames; and fifty-seven laborers worked at a variety of backbreaking tasks such as hauling and hoisting stone. In April masons began laying brick and stone and in July coppersmiths began covering the roof. At the height of the building season, nearly 230 hands were at work, a number that dropped to eighty-one by December. Illness among the work-men prevented the western projection from being finished in 1821, but the goal was not missed by much. Walls were finished and the roof covered except for a small portion over the library. Although chimneys were unfinished and some ornamental carving was needed, when viewed from the west the Capitol appeared virtually complete. From the east, however, it was far from finished. The walls of the rotunda, both interior and exterior, were up but there were no signs yet of either the dome or the eastern portico.

THE BULFINCH DOME

The Capitol's crowning dome was one of Bulfinch's most difficult and impor-tant designs. On his initial visit with Dr. Thornton, he was shown the original elevation approved by George Washington, who was particu-larly fond of its low, graceful dome. The president may have been reminded of engraved views of the Pantheon in Rome and was pleased by the associa-tions with the world of ancient Roman virtue and greatness, but he could not have compared it with anything he had ever seen in person. In 1793 the only domes in the United States were drawings on

paper. Indeed, Bulfinch himself constructed the first dome in the country at the Massachusetts Statehouse, which he designed in 1787. Washington probably had seen small, dome-like roofs on garden pavilions but it is more likely that he never saw a classical dome except in illustrated form.

Thornton's elevation of the Capitol showed a dome rising on a platform of six steps in front of a central portico. The first revision to this design was undertaken by Latrobe during the Jefferson administration to solve a fundamental problem. Unless the dome was raised on a drum, the platform would rise awkwardly from the gable of the pediment, creating a disturbing juxtaposition of intersecting, incompatible shapes. Adding a drum gave the pediment a place to stop and the dome a place to begin. Latrobe's drawings from this period showed variations on this solution, including an octagonal drum with sculptural panels. All of Latrobe's drawings showed that he intended to preserve the idea of a low, neoclassical dome.

Bulfinch's studies for the dome illustrate a preference for a drum with panels but without sculpture (unless he simply chose not to draw sculpture). He may have preferred a higher dome than either Thornton or Latrobe or may have drawn higher domes in response to outside suggestions. Certainly events forced him to build one higher than his taste or judgment would have otherwise allowed. In 1842, long retired from public life,

Bulfinch wrote an account of the political process twenty years earlier that led to a tall dome, one that was frequently ridiculed. Defending his good name, Bulfinch wished to set the record straight for the sake of his family:

> Upon my taking charge of the Capitol, I found a number of drawings of the manner in which it was intended to finish it, but it was very difficult to give the Building Committee [Swift and Bomford] any clear ideas upon the subject, and absolutely impossible to convey the same to the more numerous body of the members of Congress. I accordingly proposed to have a model made to show the building in its completed state. This was made and inspected by the President and all the members of Congress and I believe had a favorable effect in convincing them that I understood what work I had to do, and that there was some prospect of the building being finished. But there was one universal remark, that the Dome was *too low*, perhaps from a vague idea that there was something bold and picturesque in a *lofty dome*. As the work proceeded I prepared drawings for domes of different elevations, and, by way of comparison, one of a greater height than the one I should have preferred: they were laid before the Cabinet, and the loftiest one selected, even a wish expressed that it might be raised higher in a Gothic form, but this was too inconsistent with the style of the building to be at all thought of by me.[60]

Like Latrobe before him, Bulfinch found his professional judgment overruled by those in charge

for reasons at odds with his taste and experience. Unlike his predecessor, however, Bulfinch bore the command in silence. He knew the decision was irrevocable and to avoid unpleasantness he yielded the point. The disparaging remarks made about the height of the dome were of little consequence to Bulfinch, who wrote philosophically: "Architects expect criticism and must learn to bear it patiently."

In making his funding request for the 1822 building season, Bulfinch submitted a "Comparative view of the expense of a Dome of Brick and of Stone."[61] A brick dome required considerable carpentry for the centering, 600,000 bricks, and 180 tons of stone for a bond course. Copper, painting, and plastering brought the total estimated cost of a brick dome to $25,000. For a stone dome, $20,000 would be needed to purchase freestone and another $35,700 to cut, shape, and install it. Copper and paint brought the estimated cost of the stone dome to a little more than $60,000. By way of comparison, Bulfinch appended an estimate of almost $20,000 for a wooden dome, which made the cost of a fireproof brick dome seem all the more reasonable. He preferred a brick dome and included it in his request for 1822.

It appears that none of the estimates Bulfinch presented to Congress anticipated building a double dome. The figures given for the two masonry structures included an amount for an exterior covering of copper ($4,500 in both cases), but there was no mention of a separate roof structure for an outer dome. Soon after the estimates were given, the call for a high dome forced the architect to design a double dome—one over the rotunda and another to be seen from the outside. The interior dome would rise ninety-six feet above the floor and cover a room ninety-six feet in diameter. Thus, the rotunda would imitate the classical proportions of the Pantheon in Rome, the interior of which is also as high as it is wide. But for the exterior, Bulfinch devised a separate wooden structure rising 140 feet above the ground (seventy feet above the top of the building), giving the Capitol the visibility that politicians wanted.

On May 1, 1822, the president approved an appropriation of $120,000 for the center building. During the building season, the outside of the western projection was finished, its walls painted, sashes installed, and the copper roof completed. Inside, most of the plaster had been troweled and carpentry was greatly advanced. Most of the season's efforts were directed at building the dome. The sandstone walls of the rotunda were completed soon after the appropriation passed and the interior dome was finished before the close of the year's work. Rough boards served as temporary flooring until the paving stone was set the following year. About two-thirds of the inner dome was constructed of stone and brick, while the upper third was wood. At the crown, an oculus twenty-four feet in diameter provided the room with light. The outside dome was also finished except for the copper covering, which would be installed the next year. Upon seeing the outer dome framed and sheathed, Bulfinch realized that his fears regarding the aesthetics of its height and profile were fully justified. He mentioned to the commissioner that lowering the dome now would also lower the cost of copper, but he was rebuffed. In the past, arguments of economy had usually prevailed, but in the case of the Capitol's dome, nothing could persuade the authorities to abandon its disproportionately tall profile.

In this case the intransigent commissioner was not Samuel Lane, who died in the spring of 1822, but his successor, Joseph Elgar, who had been a clerk in Lane's office. President Monroe appointed Elgar on May 8, 1822, after Congress rejected a proposal to blend the commissioner's office with that of the "principal Architect." A committee of

Section of the Rotunda and Dome As Completed by Bulfinch

Conjectural Reconstruction, 1989

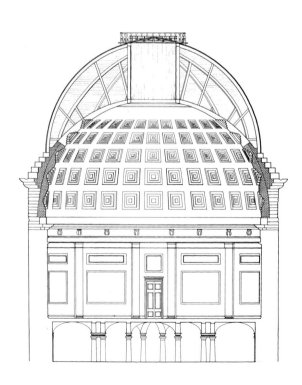

*T*he Capitol's outer dome rose 140 feet above the ground while the interior retained the pleasing proportions of the Pantheon. The rotunda was made ninety-six feet high to match its diameter exactly.

the House had been appointed to study the matter and reported its findings on April 8, 1822. The report traced the history of the commissioner's office back to the Residence Act of 1790 and through its various incarnations as a one-person post and a three-man board. Among the duties of the position were selecting workmen (including the architect), determining their pay, inspecting plans, and superintending the work. Like positions for carpenters or bricklayers, that of architect was created out of a temporary necessity. When the buildings were completed, the commissioner would dispense with the architect. The committee therefore recommended that the offices continue separate and distinct but recommended the salary of the commissioner be reduced by $500 a year because his duties were "less arduous than they formerly were."[62]

The economic strains brought on by the Panic of 1819 were still being felt three years later. Elgar was not the only government officer to see his salary cut as a general reduction of pay was ordered throughout the bureaucracy to take effect at the end of 1822. On September 30, Elgar informed Bulfinch that his salary would be reduced $500 a year. Bulfinch immediately appealed the matter to the attorney general, who claimed to be too busy to decide the case right away. Falling back on his Massachusetts connections, Bulfinch asked Secretary of State John Quincy Adams to intervene. The architect considered his relationship to the government as a matter ruled by an implied contract that could not be altered unless both parties agreed to a change. He reminded Adams that his pay was less than the states of Virginia, North Carolina, and South Carolina allowed their civil engineers and much less than the salary given the head engineer at the Susquehanna and Schuylkill canal. Family obligations made it impossible to accept a reduction in income. His style of living was "prudent" and a reduction in pay would be "irksome and humiliating."[63]

In a few days Monroe asked the attorney general to spare five minutes to consider "whether the invitation to him to come here at a given salary formed a contract not to be altered."[64] William Wirt upheld Bulfinch's view of his contractual relationship with the government and stated that it was "unalterable by the mere will of either party."[65] His salary could not be and was not reduced.

On March 3, 1823, the last day of the 17th Congress, the president approved an appropriation of $100,000 for the center building.[66] During the building season, much of the interior was finished and only a few details remained incomplete by year's end. On April 26 Elgar ordered four blocks of marble fourteen feet long and twenty inches square from Thomas and Joseph Symington of Baltimore for the columns needed in the Library of Congress. Bulfinch designed the columns after the Tower of the Winds. Each capital took about forty days to carve and all were finished by the first week in September. The commissioner allowed eighty dollars each for three capitals, but one carved by a Mr. Joyce was not as good and his compensation was docked ten dollars.[67] The library was designed to hold 40,000 books arranged in deep alcoves on the main level and in shallow alcoves reached by means of a narrow balcony. A gracefully arched ceiling was laid out in panels with plaster decorations, with three circular skylights to supplement light and air received through four arched windows.

Copper was installed over the wooden sheathing covering the outside dome and most of the stone pavers (but not all) were laid on the rotunda floor. Except for those on the third floor, the committee rooms and offices in the western projection were finished. The clerk of the House of Representatives moved into his suite on the second floor in mid-October. Alterations in the House chamber increased seating capacity from 192 to 216. More floor space was gained by removing two stone platforms extending from the south colonnade, and some single desks were joined to accommodate two members. The alterations were necessary to accommodate an increase in the membership of the House following the 1820 census.

THE EAST PORTICO

*P*erhaps the most visible sign of progress made in 1823 was the start of the grand portico on the east front. Left to the last, the portico would bring the outside of the Capitol to a fitting conclusion after so many years of fitful construction. Like that of the dome, the design of the portico was derived from Thornton's original elevation as modified by Latrobe and

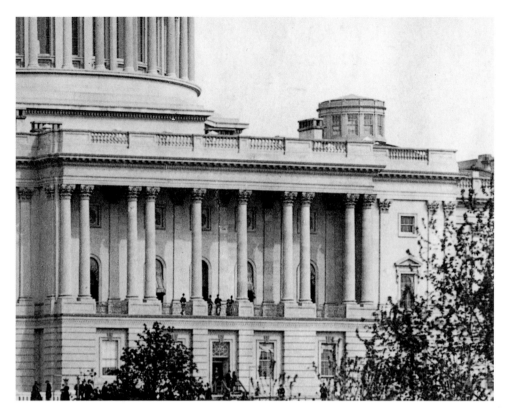

West Portico

Detail of a ca. 1890 photograph

\mathcal{F}rom 1824 until 1897 the Library of Congress was located behind the west portico. The sculpted panels at the third-floor level were converted into windows in 1900, when the library space was rebuilt into offices and committee rooms.

With four sets of coupled columns and the absence of a pediment, Bulfinch's design of the Capitol's west portico recalled his design for the Massachusetts Statehouse portico. Neither shelters a major entrance, but they both provide pleasant vantage points for admiring city and water views.

The Capitol's west portico appears to be an example of post and lintel construction, yet the columns actually support brick arches. Five arches spring from iron beams held by the columns and their corresponding pilasters. (The entablature and the portico's plaster ceiling screen the arcade from view.) Although somewhat deceiving, this mode of construction was simple, economical, sturdy, and fireproof. It was also the earliest use of iron beams in the Capitol's construction history.

Stoves in the Library at Washington
by Charles Bulfinch, ca. 1824

Library of Congress

\mathcal{A}n urn and the partial column shaft on which it stands were classical images Bulfinch employed in this design for an iron stove. By using stoves, the Library of Congress was warmed without open fires. Despite this precaution, the room was damaged by fire in 1826 and completely burned out in 1851.

View, Congress Library Capitol, Washington

by Alexander Jackson Davis and Stephen H. Gimber, 1832

I. N. Phelps Stokes Collections, Mirian and Ira D. Wallach Division of Art, Prints and Photographs, The New York Public Library, Astor, Lenox, and Tilden Foundations

\mathcal{B}ulfinch's most elegant and popular interior design was the reading room of the Library of Congress, finished in 1824. Comfortably furnished with sofas, chairs, and writing tables, the library was a favorite place to read, write, admire works of art, or enjoy the view.

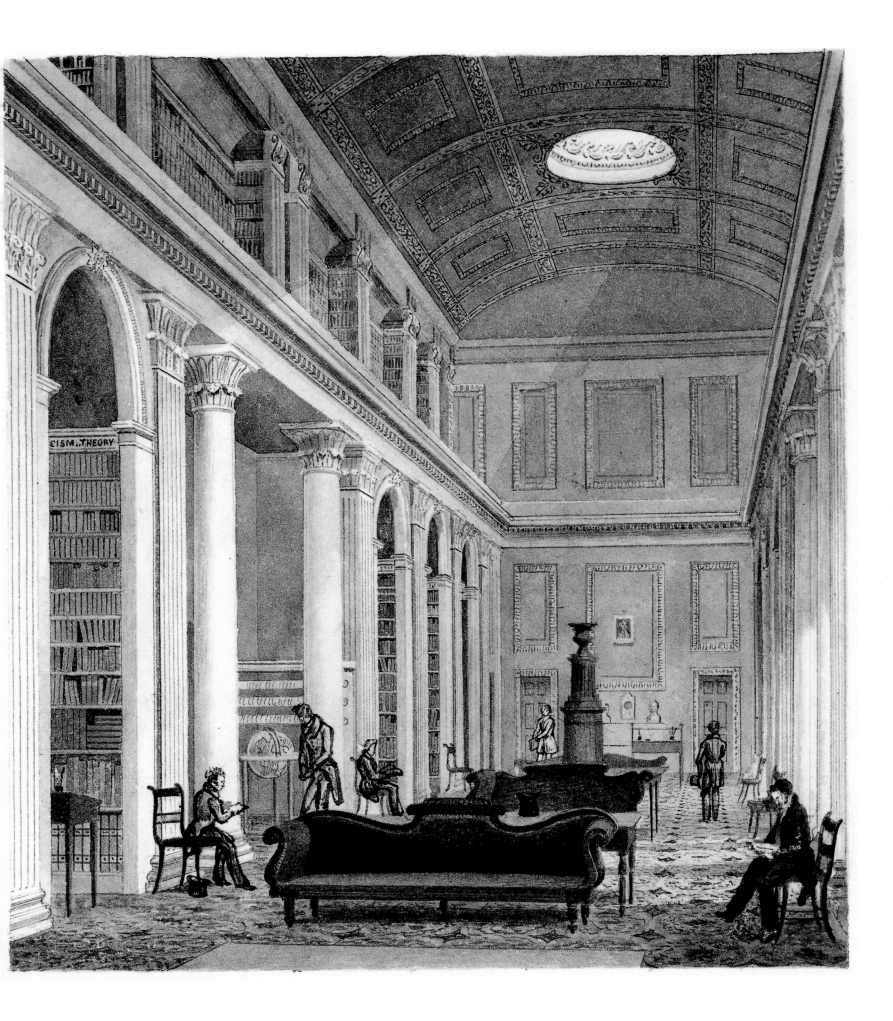

Bulfinch. Thornton's design for the east portico consisted of eight columns thirty feet tall standing on pedestals and a one-story arcade. The side elevations would each show two additional columns, bringing the total number to twelve. A rich entablature and a broad pediment with sculptural decoration completed the composition. To this basic design Latrobe added a monumental flight of stairs to land visitors on the principal level of the building. He increased the depth of the portico and extended it with colonnades to the corner of each wing. Attached to the corner of the north wing, Latrobe planned a square column to help buttress the interior vaulting. Considerations of symmetry demanded a similar (yet unnecessary) treatment at the south end of the portico. In addition to the two attached columns, Latrobe's portico design called for twenty-four conventional columns, twice as many as Thornton's scheme.

Aside from structural considerations, the alteration improved the use of the portico and the appearance of the building. Adding a flight of stairs allowed the portico to become the grand entrance instead of a balcony. The colonnades extended the portico over the recesses and helped unify the parts into a better defined unit. Instead of a five-part composition, the east front with Latrobe's portico appeared as one large building with a dominant central feature, trading a "staccato effect" for "an effect of crescendo."[68] The fact that the columns of the flanking colonnades could not line up with the existing pilasters of the recesses was a small sacrifice to the greater good offered by Latrobe's design for the east portico.

In 1806 Latrobe wrote that his portico design was taken—at Jefferson's suggestion—from Diocletian's portico that was illustrated in a drawing hanging in the President's House.[69] Because the view has been lost, it is uncertain where it came from or what it showed. There has been speculation that the mysterious portico may have actually been the Temple of the Signa illustrated in Robert Wood's *The Ruins of Palmyra*, published in London in 1753.[70] That elevation shows a portico with a pediment flanked by colonnades—features similar to the Capitol's portico. Although the attribution has been challenged, this drawing may have inspired Latrobe's design and given it the authority from antiquity that Jefferson found reassuring.[71]

Initially Bulfinch seemed to prefer Thornton's original portico design. But by the time work was begun in 1823, the simpler scheme had given way to Latrobe's grand design. The decision to build Latrobe's portico may have been made for the sake of grandeur or for structural reasons, but it was clearly made without considering cost. In another decision that defied economy, Commissioner Elgar directed that all column shafts were to be wrought from single blocks of stone instead of built up with drums, as was done with the west portico. Monolithic shafts would indeed contribute to the impression of perfection and grandeur, but their use was opposed for practical reasons by George Blagden, the venerable head of the stone cutting department.[72] In the fall Elgar and Blagden visited the quarries at Aquia, where they met Thomas Towson of Baltimore, who had been hired by the commissioner to quarry the shafts. (Towson had been one of the impartial judges who determined the value of the Potomac marble five years earlier.) There Towson convinced Elgar that he could extract blocks of sandstone large enough to supply the column shafts. While Blagden remained doubtful, Elgar ordered Towson to proceed.

In November Towson informed the commissioner that he had extracted the first shaft from the quarry.[73] The second and third quickly followed but remained on the island throughout the winter months. A fourth shaft was quarried in March 1824. Once navigation opened on the Potomac the shafts were transported by scow to Washington. The firm of Waller & Morton was paid two dollars a ton for freight.

As each block arrived in Washington, Blagden carefully inspected it. He found cracks and flaws in some stones and declared them unfit. He made no apologies for the anxiety he felt regarding the monoliths:

> I cannot divest myself of fear as respects the strength and durability of these stones and though I might feel much gratification and perhaps some pride as a workman in seeing to, and executing these shafts in one stone, yet to have a dread as to their Capacity which I do feel . . . it absorbs all other feelings and makes me feel miserable.[74]

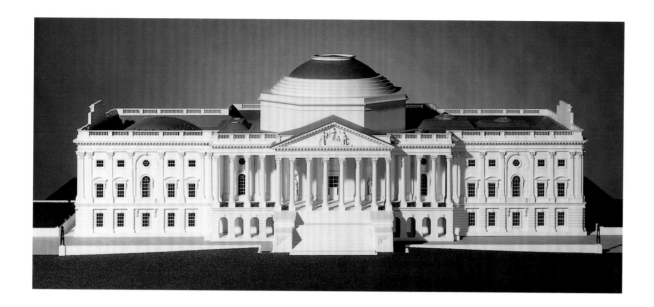

Model of the Capitol with Portico and Dome Designs by Latrobe

*I*n studies for completing the Capitol, Latrobe expanded the original portico design by adding flanking colonnades and a grand flight of steps. He also raised the dome upon a drum. When the dome was constructed by Bulfinch it was unlike the one shown here, but he built the portico according to his predecessor's design. (1994 photograph.)

Elgar wrote the quarry with hopes that future deliveries would prove acceptable. Otherwise, his expectations would be disappointed:

> If then there is not an absolute certainty of the Quarry having so far improved as to furnish shafts which cannot be objected to, the undertaking must be abandoned, and the columns be procured as heretofore. . . . Pray let me hear from you the moment you have matured your opinion upon this distressing subject.[75]

Towson insisted that the quarry could supply monoliths, but Blagden suffered fearful doubts. To resolve these conflicting opinions, Elgar asked Colonel William Stewart to go with Blagden to the quarry and decide the question. (Stewart had been Towson's fellow judge in the 1818 Potomac marble case.) On July 27, 1824, Stewart reported that he considered the stone of sufficient quality and quantity to supply each shaft in one block. He warned the commissioner, however, not to expect more than eighteen before the close of the season in November. In the middle of September Elgar heard that no more shafts could be expected for a month and he wrote Towson that this would "derange all calculations."[76] Thirteen shafts were delivered in 1824. They cost $296 apiece.

The rough column shafts for the east portico were delivered from the quarry to the Navy Yard on the Anacostia River. There they were unloaded and hauled by hand to Blagden's shop at the Capitol, where men transformed them into smooth, round shafts. According to an eyewitness account,

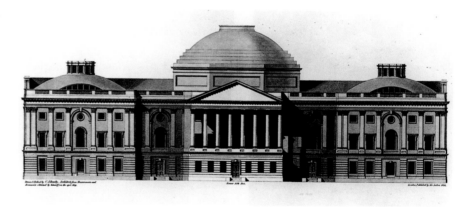

The Capitol At Washington

by C. A. Busby, 1823

*B*usby, an English architect, visited the Capitol in 1819, took measurements of the wings, and conferred with Bulfinch about plans for the center building. As seen here, Bulfinch considered returning to Thornton's original portico design, one without a grand stair or flanking colonnades. It also shows third-floor windows under the portico, possibly intended to light a picture gallery that was never built.

the appearance of these stones at the wharf was cause for much excitement and merriment:

> They are taken from the wharf, without the aid of horses, upon a strong carriage, with a hundred men pulling. Sometimes the members of Congress will turn out in the evening to assist 'the big wagon' and join in all the pleasantry to which the novelty gives rise. When the column arrives at the Capitol, it is cheered by loud huzzas . . . [among the workmen] there are perhaps not half a dozen sober men. They drink *scute* (as they call whiskey) on the job. When the day's work is ended, they hie to the grog shops and taverns to spend their earnings.[77]

Liquor was occasionally given workmen at the Capitol to mark special milestones or as an incentive to stay on the job in blistering weather. For example, sixteen and a half gallons of whiskey were "furnished the hands while handling the columns" on May 27, 1825.[78] A more extensive fete was provided by the commissioner as the columns were being put into place: on September 1, 1825, Robert Isherwood was paid "for treats furnished the hands while employed hauling and raising the columns." Three barrels of crackers and thirty-two wheels of cheese were washed down with twenty-six gallons of whiskey, one barrel of beer, and one gallon of brandy.[79]

While the shafts were being prepared, stone carvers working in Giovanni Andrei's shop produced the elaborate Corinthian capitals that were the most distinctive part of the columns. The carvers were guided by a full-scale model sculpted by Andrei in plaster of Paris. It was undoubtedly the same model used to prepare the capitals for the west front portico. While the rage for Grecian architecture was sweeping the country and most of the Capitol's interior columns were inspired by the antiquities of Athens, Andrei's model for the exterior column capitals was necessarily made to match the Roman Corinthian order shown in Dr. Thornton's design and already used for the exterior pilasters. Thornton found the order for the Capitol's columns and pilasters in Sir William Chambers' *Treatise on The Decorative Part of Civil Architecture* (1791). In the *Treatise,* Chambers illustrated only one example of the Corinthian order, which was derived from the remains of the Temple of Jupiter Stator and blended with the interior order of the Pantheon. The hybrid was "uncommonly beautiful," Chambers assured his readers, having "all the perfections of [the] originals . . . far preferable to either of them."[80] Chambers' authority in the matter of Roman architecture was unquestioned and appealed especially to amateurs such as Dr. Thornton, who called the *Treatise* an "inestimable" work.[81] But by the time Andrei and his men translated Chambers' Corinthian order from paper to stone, its Roman pedigree had already rendered it somewhat old-fashioned.

It would take one carver about six months to finish one Corinthian capital. In addition to their daily wage, the commissioner allowed the workmen an extra $260 for each capital they completed. Andrei's shop produced stonework of a type and quality rarely seen in American architecture and there was a sense among the men that their job was special. They were, after all, finishing the United States Capitol. Their pride was publicly displayed during the Fourth of July celebration in 1824. The *Washington Gazette* told its readers:

> We have this morning been informed that the Stone Cutters at the Capitol are preparing an appropriate and imposing spectacle . . . A Committee of their body has been appointed on behalf of 60 or 70 others, who will march in the procession and exhibit the operative part of their employment in cutting a Corinthian capital, intended to crown one of the Eastern front columns, and a keystone for one of the arches. Suitable colors are preparing for the occasion. We mention these facts to show the public spirit likely to manifest itself on our approaching National Anniversary.[82]

The stone carvers and cutters marched in the parade just behind President Monroe and his cabinet with a capital mounted on a "movable stage." According to a later edition of the *Gazette,* they gave a "fine specimen of their art."[83]

"ABILITY, PROMPTITUDE, AND FAITHFULNESS"

With an end of construction in sight, the mood in Congress was unusually convivial when it took up the appropriation for the 1824 building season. On December 8, 1823, Elgar submitted his report on the expenditures along with Bulfinch's funding request for the next year's work and a similar

request from James Hoban, who was building the south portico at the President's House. In the House of Representatives, the committee on public buildings reported its reaction with a rare display of official appreciation:

> Upon a full survey of the subject, the Committee find reasons to be highly gratified with the ability, promptitude, and faithfulness, displayed by the Commissioner in the management of the public interest committed to his trust. They are also disposed to award due praise to the Architects, not only for their assiduity and zeal in prosecuting the work on the public edifices; but also for the style of the workmanship—uniting ornament with strength, and giving solidity to grandeur.[84]

Bulfinch's estimate included money to finish the interior of the Capitol and to raise the columns of the east portico. Funds were needed to pave the rotunda, crypt, and passages; to carve and paint stonework; to finish the main stair in the west center building; and to erect two back stairs. In all, Bulfinch asked for $87,153. The committee noted that the necessity of the work was too obvious to require comment. On April 2, 1823, $86,000 was appropriated for the center building and a month later $3,289 was given to buy furniture.[85] The small difference in the sum appropriated and the sum needed to finish the center building would be made up from other sources such as the $593 raised by selling surplus copper or the $13,000 due from the estate of the late Samuel Lane.[86]

A week before the close of the first session of the 18th Congress, a joint committee reported its recommendations on the distribution of rooms in the west central building among the House, Senate, Supreme Court, and Library of Congress.[87] Senator Mahlon Dickerson of New Jersey and Congressman John W. Taylor of New York reported that the center building contained thirty-seven rooms suitable for committees. Two rooms near the Library of Congress were designated as reading rooms, one was given to the Supreme Court as a consultation room, and the large room under the library was given to the Columbian Institute (forerunner of The George Washington University). Otherwise, all rooms in the basement, ground (first), and principal (second) floors north of the center line would be used by the Senate and all rooms south of it would fall under the jurisdiction of the House of Representatives. The House would also have use of all rooms on the attic (third) floor. The commissioner was ordered to dispose of the temporary frame building formerly used by committees.

Work on the interior of the center building was, as Bulfinch and Elgar promised, finished in 1824. But on the outside, only thirteen columns were in place on the portico. Progress had been hampered by the slow delivery of sandstone from Aquia. But even with the portico half finished there was enough to show "the convenience which this addition to the building will afford, and the effect which this principal feature of the Eastern front will produce."[88]

Except for painting the stone walls and undertaking some sculptural decorations, the rotunda was complete and soon became one of the building's great attractions. It was the largest room in the Capitol, and at 7,000 square feet, one of the largest rooms in America. Once called the "Grand Vestibule" by Thornton and the "Hall of the People" by Latrobe, Bulfinch called this noble room the "rotundo":

> In the rotundo, a bold simplicity has been studied, suitable to a great central entrance and passage to more richly finished apartments. This room is ninety-six feet in diameter, and of the same height; its walls are divided into twelve compartments, by stone pilasters, or Grecian Antae; four of these compartments are occupied by doors, and the others by panels to receive paintings. The Antae supports a Grecian entablature, decorated with Isthmean wreaths in the frieze, apparently in honor of the subjects of national history to be exhibited below. The concave of the dome is divided into five ranges of large and deep caissons, finished plainly; and a border of Grecian honeysuckle surrounds the opening of the sky-light twenty-four feet in diameter, which gives light to the whole rotundo.[89]

The principal difference between Bulfinch's design for the rotunda and that of his predecessor was the absence of large niches, which were to be nearly thirty feet high. Latrobe had planned the monumental niches before Congress commissioned Trumbull's history paintings and then tried to accommodate both in later studies for the room. Bulfinch eliminated the niches altogether, providing shallow wall recesses for Trumbull's paintings as suggested by his predecessor. He added the Doric pilasters, which were originally put up with plain shafts. Apparently unhappy with the simple pilasters, he dispatched stone carvers to flute the shafts in place, paying them thirty-six dollars for

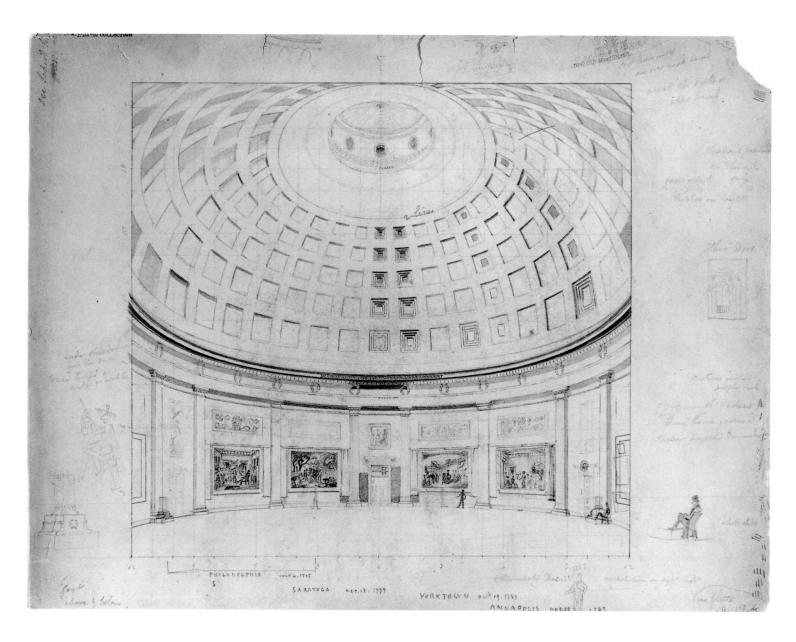

The Rotunda

by Alexander Jackson Davis, ca. 1832

Avery Architectural and Fine Arts Library, Columbia University in the City of New York

𝒱iews of the original rotunda are scarce. This sketch shows the inner dome, the oculus, the Trumbull paintings flanked by drapery (noted as being reddish purple), two iron stoves, and a few sightseers.

each. One critic, Latrobe's biographer Talbot Hamlin, wrote that Bulfinch made a mistake by eliminating the niches, which he thought "would have given scale and interest to the whole; as it stands, it is cold, thin, and in spite of the paintings barren."[90] Despite Hamlin's authority in such matters, Bulfinch's design was practical and more structurally sound (an important factor in light of future events). Niches of the size contemplated by Latrobe would have weakened the walls and might well have looked forlorn and vacant.

Heating a room the size of the rotunda was an unusual problem, and one that had no satisfactory solution by today's standards of comfort. It was also the subject of an unusual exchange between

the commissioner and the architect, two men who normally worked together well. Bulfinch wrote the commissioner about furnaces to convey warm air from the crypt to the rotunda above. Elgar replied in a stern letter in which he reprimanded the architect for failing to submit drawings for the work that might be reviewed by heating experts. The cost of stoves had not been included in the estimates and the commissioner was upset that Bulfinch was about to obligate funds without his knowledge.[91]

Bulfinch was taken aback by the tone and implications of Elgar's letter but not intimidated in the least. He stated that all the plans for the center building had been approved by the president of the United States and he did not consider the commissioner's

approval necessary for small details like stoves. He regretted not mentioning his intentions earlier but thought "it a thing so necessary to be done, & so simple & cheap in execution, that I could not imagine any possible objection—especially as flues are already built to convey smoke from the lower Rotundo." [92] As for the cost of heating, Bulfinch thought that stoves could be had at a reasonable rate and the expense of iron pipe would be no more than twenty dollars. He expected the money could be found in the contingency account. And as to their relative roles, Bulfinch remarked that Congress and the public looked to him for the "correct construction" of the Capitol, for its beauty and convenience. He was expected to devise a way to warm the rotunda, which was necessary to stop dampness streaming down its walls. The heating plan was cheap and easy to implement now but would entail a great expense if put off to a future day.

The rotunda opened in 1824 without stoves to warm it or history paintings to decorate its walls. By October the wooden picture frames designed by Bulfinch were sufficiently advanced to be put in the hands of a gilder. Elgar hired Ephraim Gilman to gild the frames, warning that if he failed to finish his work in a timely fashion he would hire someone else to do the job and would send him the bill. In 1819 the first painting Trumbull finished in his New York studio, *The Declaration of Independence*, was hung in the Supreme Court chamber after being exhibited in New York, Boston, Philadelphia, and Baltimore. The artist earned a tidy sum charging the public to view his picture, which unexpectedly stirred a reaction in Congress among members who considered the work public property. (Trumbull earned even more after the picture was engraved by Asher Durand in 1823.) *Surrender of Cornwallis at Yorktown* was completed in 1820 and was shown in New York, Boston, and Baltimore before being hung temporarily in the Senate chamber. During the next year *The Surrender of Burgoyne* was completed but was exhibited only in New York due to the disappointing gate receipts from the *Yorktown* showing. The final canvas, *George Washington Resigning his Commission*, was finished in April 1824 and was immediately put on public display in New York. Trumbull traveled with his picture to Albany, Boston, Providence, Hartford, New Haven, and Philadelphia before bringing it to Washington in December. All four

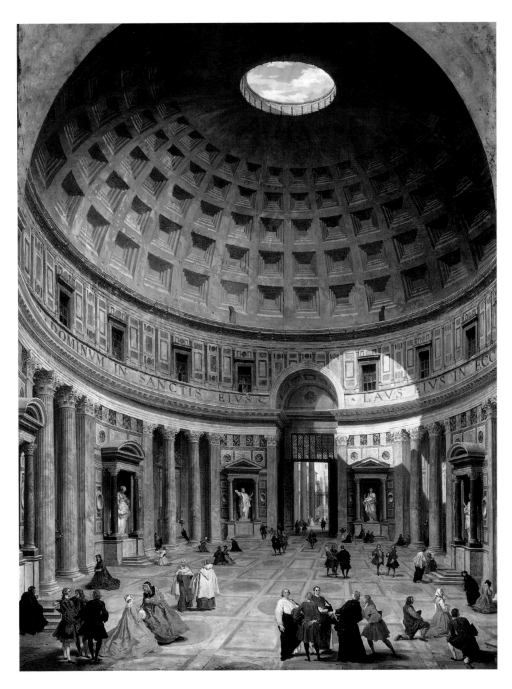

canvases hung in the north wing while the rotunda walls dried sufficiently to be painted. Trumbull returned to Washington on November 18, 1826, more than two years after the rotunda opened, to supervise installation of the paintings in their permanent location.

To finish the eastern portico and take care of small details on the interior, Congress appropriated $80,000, which was approved by the president on February 25, 1825. Just over two weeks had passed since the House of Representatives decided the

The Pantheon

by Giovanni Paolo Panini, ca. 1750

National Gallery of Art, Washington

*T*he rotunda of the **United States Capitol was intended to replicate the grandeur and proportions of the ancient Pantheon in Rome.**

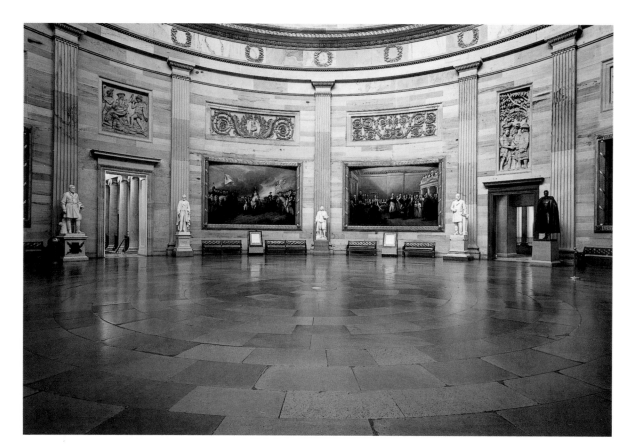

The Rotunda

The lower forty-eight feet of the rotunda's walls, the floor, carvings, plaques, and Trumbull's Revolutionary War scenes remain essentially as Bulfinch left them. (1980 photograph.)

Choragic Monument of Thrasyllus

From the 1825 edition of *The Antiquities of Athens* by James Stuart and Nicholas Revett

The Choragic Monument of Thrasyllus was a plain Doric composition notable for its simplified entablature with wreaths instead of the more usual triglyphs and metopes. Bulfinch modeled the rotunda walls after this design, seeking a "bold simplicity" that would not compete with the more richly ornamented legislative chambers.

election of Monroe's successor, narrowly electing John Quincy Adams as the country's sixth president. With the supporters of Andrew Jackson crying foul, the topic of discussion throughout Washington had little to do with construction matters. The appropriation was made without debate. One week later, Monroe—the last president of the Revolutionary War generation—attended Adams' inauguration in the House chamber.

Work on the east portico resumed in the spring and continued slowly throughout the building season. By June only four column shafts had been delivered; seven more were needed before the entablature could be completed and the pediment

begun. While work continued, it became time to discuss the subject of sculpture for the pediment. In the last days of his administration, Monroe advised the commissioner to offer a prize of $500 to whoever would present the best design for a statuary group to reside in the pediment. The response to the contest was overwhelming. Thirty-six designs from at least thirty artists were submitted for consideration. Among those asked to evaluate the designs was old and ailing Dr. Thornton, who thought the prize money should be split four ways. The design he liked best was a figure of Justice flanked by Wisdom and Truth, but he also admired a "model of the chariot & 4 horses with two figures of America & Liberty."[93] President Adams took a keen interest in the project, but he did not like the idea of displaying "triumphal cars and emblems of Victory, and all illusions to heathen mythology."[94] He wanted the duties of the government expressed in an obvious and intelligible manner. The president conferred with Elgar, Bulfinch, and an Italian sculptor named Luigi Persico, and they eventually decided upon a simple composition of three figures with easily understood emblems. In a letter to his son, Bulfinch described the sculpture destined for the Capitol's pediment:

> After several attempts, the following had been agreed upon: a figure of America occupies the center, her right arm resting on a shield, supported by an altar or pedestal bearing the inscription *July 4, 1776,* her left-hand pointing to the figure of *Justice,* who, with *unveiled* face, is viewing the scales, and the right hand presenting an open scroll inscribed *Constitution,* March 4, 1789; on the left of the principal figure is the eagle, and a figure of Hope resting on her anchor, with face and hand uplifted, — the whole intended to convey that while we cultivate *Justice* we may *hope* for success.[95]

The public's ability to understand the message conveyed by allegorical statuary troubled Bulfinch and perhaps others in the president's informal committee. To assist the untutored, he predicted an inscription would be provided to explain the meaning to "dull comprehensions." Despite the prediction, no caption was provided when the sculpture was unveiled in 1828.

FIRE IN THE LIBRARY

On December 5, 1825, the first session of the 19th Congress convened in the nearly completed Capitol. The rotunda walls were still too wet to paint, Trumbull's paintings hung in temporary locations in the north wing, and the east portico needed a few more columns raised and the pediment built. But soon the building would be finished and the grounds cleared of sheds and storage yards. Sculptural embellishments would continue but the masons, carpenters, and painters would be soon gone.

One of the new members of Congress from Massachusetts was Edward Everett, a professor of Greek literature and future president of Harvard. Although a freshman legislator, Everett's reputation as a scholar landed him the chair of the House Committee on the Library. On the evening of December 22, 1825, he and his wife were entertained at a dinner party given by Senator Josiah S. Johnston of Louisiana. Returning to their lodgings on Capitol Hill at 11 o'clock, they saw a suspicious flickering light through the windows on the west side of the Capitol where the Library of Congress was located. Knowing the library normally closed at seven o'clock, and that there were no fireplaces in the room, Everett decided to investigate. When he approached the building, a guard challenged him but was soon convinced that what the congressman had seen might warrant action. Going to the western grounds they encountered a Capitol policeman who saw nothing to be worried about. He agreed, however, to go inside with Everett and peek through the keyhole to see if the library was on fire. When they got there, they discovered that an inner baize-covered door blocked the view but there were no signs of smoke or heat. The policeman did not have a key, which was kept by the librarian. The two parted and Everett returned to his lodging.[96]

In a few minutes, the policeman went outside and saw the light coming through the library windows growing brighter. Not thinking he had the authority to break down the doors, he went searching for George Watterston, the librarian of Congress, who luckily lived nearby. They hurried into the building and, once the doors were opened, discovered a fire in the upper gallery but had no water to fight it. They ran to the yard in front of the Capitol and

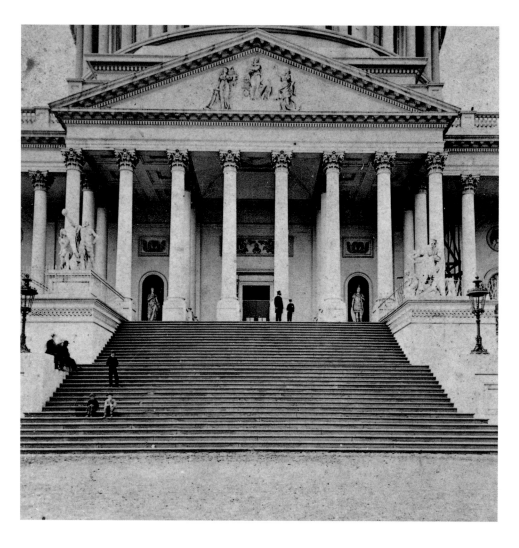

East Portico

ca. 1870

This view of the east portico shows the wealth of sculpture associated with it: Luigi Persico's *Genius of America* (1828) is seen in the pediment; statues of War and Peace (1834), also by Persico, occupy the niches flanking the entrance to the rotunda; and Antonio Capellano's *Fame and Peace Crowning George Washington* (1827) appears above the door.

Above the niches are panels designed with oak wreaths and thirteen arrows (ca. 1825) carved by Thomas McIntosh and Jeremiah Sullivan. Bulfinch's design was likely influenced by similar panels L'Enfant installed on the upper walls of Federal Hall in New York.

On the left cheek block flanking the stairs is *Discovery of America* (1844) by Persico opposite *Rescue* (1853) by Horatio Greenough.

furiously rang the bell used to summon workmen at daybreak. In bed at the time, Everett heard the alarm and hurried to the scene where other neighbors, including Daniel Webster and Sam Houston, had come to help save the Capitol. A fire engine was found locked in a little shed and no one had the key. The doors were torn off and the equipment was hauled to the foot of the east portico. In the library flames licked at the ceiling, which was built with large wooden trusses that would surely spread the fire to the dome. But firefighters using the pump and hose liberated from the Capitol's fire station managed to extinguish the blaze before it spread beyond the ceiling. Just as the flames were brought under control, the water supply gave out.

The cause of the fire was determined to have been a candle left burning in the gallery and not noticed when the library closed for the evening. Apparently, a patron left without extinguishing the flame and, by his carelessness, inflicted heavy damage to one of the Capitol's handsomest rooms. Earlier that year, the *National Intelligencer* had called it "the most beautiful apartment in the building. Its decorations are remarkably chaste and elegant, and the architecture of the whole displays a great deal of taste."[97] When the architect's wife, Hanna Apthorp Bulfinch, informed her sons of the accident, she wrote: "Your good father has felt concerned and anxious, as he is very reasonably proud of that room."[98] She also said that the damage was not great although a carpet worth $1,000 was ruined. Many books were removed by firefighters and most of those consumed were duplicate copies stored on the gallery level.

About $3,000 was needed to repair the damage. Aware that the accident could have been far worse, legislators asked Bulfinch to see how the room could be rebuilt in a fireproof manner. Other hazards, such as the hundreds of cords of wood stored in the cellars, were also examined with fire prevention in mind. On January 3, 1826, the House Committee on the Library began its own investigation into the possibility of making the room perfectly fireproof; a month later its report concluded that little could be done short of tearing everything out and starting over. Wooden shelving could be replaced with stone but the committee considered the dampness of masonry an evil to paper almost as bad as fire. Bulfinch estimated that more than

$18,600 would be required to build stone bookcases, which he too thought would be "in a few years ruinous to the books, from the condensation of moisture, from the atmosphere upon freestone." An iron railing might replace the wood parapet on the gallery but the effort was not worth the expense. Unable to recommend any way to fireproof the library, the committee simply advised proper care of the lights and fires.[99]

Looking to other areas where the chance of fire was great, congressional committees soon focused on the cellars under the House and Senate wings where fuel for the Capitol's furnaces, stoves, and six score fireplaces was stored. Workmen going into these windowless areas to retrieve wood or coal were guided by handheld candles or lanterns, and there was always a good chance of accidentally starting a fire. The intricate labyrinth of columns, piers, and walls built to accommodate the changes to the building's floor plans would have made it nearly impossible to fight a fire if it started in the cellars. It soon became obvious that some other place would have to be found to store the Capitol's fuel supply.

In 1826 Bulfinch presented four plans to store fuel outside the Capitol.[100] Each plan provided a permanent place for a fire engine and other things such as privies best kept near but not in the Capitol. Three of the four plans called for building a terrace some distance from the west front separated from the Capitol by a pair of courtyards. No matter what other use the terrace might have, it improved the architectural effect on that side of the building. It would hide the extra story at the basement level of the central building while allowing the committee room windows to remain unblocked. The view to the grounds and Mall might be obstructed, but windows looking onto courtyards still allowed light and air into the rooms. This clever design solved the old architectural problem of the west front by giving it a uniform ground line. With his plan to screen the basement with a terrace faced by a sloping grass-covered berm, Bulfinch expanded mightily on Trumbull's advice to "plant it out."

Bulfinch's first plan for "external offices" called for a pair of buildings 140 feet long positioned near the north and south ends of the Capitol. They provided space for guard rooms, porter lodges, stables, and perhaps more committee rooms. The new buildings and a west terrace with provisions for fuel storage were estimated to cost about $122,000. His second plan provided vaults under the terrace to store vast quantities of wood and coal as well as courtyards where privies could be located. Lodges for a fire engine, guards, and porters were planned for the north and south entrances to the grounds. That scheme would cost about $99,000 to implement. The third proposal called for two crescent-shaped buildings to house the stables, engines, guards, and carriages. In this plan, the terrace was eliminated and fuel storage was provided under platforms at the ends of the Capitol, with colonnades leading to the privies. At $125,000, this was the most expensive proposal, and the most difficult to understand without drawings. "Plan No. 4" was the cheapest. It called only for a terrace and privies in the courtyards and would cost $89,600.

After considering the options, a House committee recommended that Congress adopt the second scheme. Opposition to flanking buildings was strong since, as it was pointed out, it would be foolish to begin additions to the Capitol when the main building itself was not yet finished. Charles Anderson Wickliffe of Kentucky said the Capitol was already large enough and "to a stranger, there was already, from its being a perfect labyrinth, almost as much difficulty to get out of it as some find in getting into this House."[101] James S. Stevenson of Pennsylvania regretted that the end of the session would be occupied by "a grave debate about a wood house." Another opponent to the terrace was Elisha Whittlesly of Ohio, who claimed that the west elevation was decidedly the handsomest and did not need "concealment." Despite the opposition, funds for the terrace were included in a $100,000 appropriation for the Capitol that President Adams signed on May 22, 1826.[102]

About $18,750 was used from the appropriation to finish the grand flight of stairs to the east portico. Except for the allegorical figures intended for the pediment, the east front of the Capitol stood complete at last in 1826, more than three decades after George Washington laid the building's cornerstone. The west, or garden, front had been finished for four years but was now again the site of construction activity with carpenters and masons building the terrace vaults. During the first week in June work was interrupted by a strike among stone

cutters. Even more dramatic and unfortunate was the accidental death of George Blagden, who was killed when a section of the west terrace collapsed. The loss to the works was felt immediately. Blagden had been at the Capitol since 1794, had firsthand knowledge of the complicated construction history, and was a reliable, trustworthy, and talented mason. His opinions were always held in high regard by the succession of architects, commissioners, and presidents with whom he had worked. Bulfinch learned of the tragedy in a letter written by Elgar on June 4, 1826. "We have met with an irreparable loss;" the commissioner wrote, "Mr. Blagden was killed last evening at the falling of the bank at the south angle of the Capitol." [103] In his annual report to Congress Elgar included a tribute to Blagden:

> The work suffered a severe loss by the accidental death of Mr. Blagden, which happened early in the season. Possessing in a high degree the science, and practical knowledge of his profession, he had conducted in its most important branch, the construction of the Capitol, almost from its commencement, with a precision, and fidelity, which he carried into all relations of life.[104]

Preliminary Terrace Plan and Landscape Improvements

by Charles Bulfinch ca. 1826

Library of Congress

Two privies (each with six stalls) were proposed to be built in the courtyards created by a new west terrace. Under the terrace were provisions for a guard room, two stables (each with four stalls) with adjoining hay storage areas, and a place to park the Capitol's fire engine. A slightly different plan was eventually carried out.

"THIS COLOSSAL LABYRINTH"

With the Capitol complete and the terrace underway, the mood in Congress suddenly turned sour. Proposals for improvements to the grounds, the construction of small ancillary buildings, and minor alterations to the interior all met with resistance from some legislators worn down by constant requests for money. Although funds continued to be appropriated, the amounts were pared down after some members proclaimed their exasperated belief that the Capitol would never be finished. Charles Miner of Pennsylvania said in the House that he wanted an accounting of all monies spent on the public buildings to draw attention to the never-ending construction that was sapping the public purse. After thirty years and three million dollars, the sight and sounds of construction were still common. He had been coming to Washington for twenty years and witnessed the same confusion about the Capitol—the same rolling of huge stones, and the same din of workmen. Was this ever to cease? Solomon's Temple was finished in seven years, but these buildings had been in the hands of workmen more than seven and twenty years.[105] And it was not only the Capitol that was in a perpetual state of incompleteness. The President's House was another case in point:

> The President's garden was, and always had been, a scene of confusion—to him it seemed as if the same cartman, who was there ten years ago, were still employed hauling dirt from one part of the enclosure to the other—there was none of the elegance, the repose, and the beauty, which there should be in the garden of a private gentleman. Last year it was proposed to take down the wall around the President's House, to rebuild it on a different plan—the work was like Penelope's web; what was done at one time was undone at another and never finished.

John Cocke of Tennessee agreed, but blamed the prolonged construction on the architects and superintendents who brought plans and estimates before the House year after year and who would lose employment if they failed to concoct things to build. He thought a mere accounting of money would not achieve anything and wished Miner to change his motion so that it would preclude the

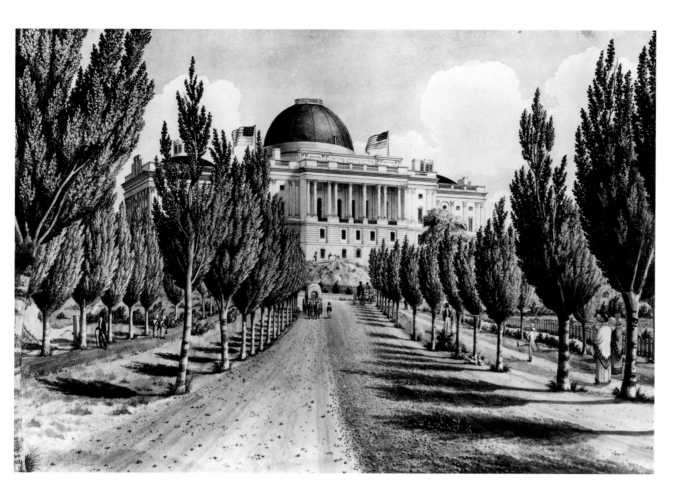

View of the Capitol

by Charles Burton, 1824

The Metropolitan Museum of Art, New York, Purchase, Joseph Pulitzer Bequest, 1942

This carefully drawn view shows the west front at the time it was finished and before the terrace was begun. Lining Pennsylvania Avenue were double rows of Lombardy poplars planted during the Jefferson administration.

submission of any further plans. He suspected that architects and builders would continue to devise ways of spending money as long as Congress permitted it.[106]

An alternative point of view was provided by Ichabod Bartlett of New Hampshire, who reminded his colleagues that plans and estimates were made in obedience to congressional instructions. The reason yearly appropriations were requested was due to the manner the House chose to make funds available. If yearly requests were too annoying, the House should be prepared to make one large appropriation to finish the Capitol and grounds. After Bartlett finished his short, well-reasoned talk, Miner withdrew his motion.

The funding needed for the 1827 building season totaled $104,789, but due to a surplus only $79,244 was requested in a new appropriation. These funds were necessary to complete small jobs around the Capitol, to landscape the grounds, and to erect buildings for gate keepers, an engine house, and stables.[107] About $1,200 was needed to

purchase a second fire engine. At first the stables were to be located on the Capitol grounds but it was subsequently considered more economical to relocate them to adjacent property. Simple brick structures would suffice there, whereas, if built within the enclosure, something grander would have been called for. Also contained within the request were monies to build a bridge from the new terrace to the Capitol and to convert a window into a door in the large room under the library. Thus, the west front would gain a second entrance.

Part of the appropriation was earmarked for stoves to warm the passages leading to the rotunda

and for guard rails to protect the history paintings that were recently mounted in that room. John W. Campbell of Ohio thought these items unnecessary and moved to reduce the appropriation accordingly. But Congressman Everett thought the stoves were needed to avoid the abrupt change in temperature upon entering long, cold passages. The moist chilly air of the Capitol's corridors reminded him more of the Bastille than any other building he was ever in.[108] Campbell, however, was unmoved by his colleague's explanation. He still thought too much money was spent on unnecessary improvements and remarked: "What may be considered economy in Massachusetts, would be considered extravagance in Ohio." Wickliffe of Kentucky agreed and voiced opposition to building anything new, even plain brick stables. His views were similar to those expressed by John Cocke earlier in the session—both blamed the architect for prolonging construction—but Wickliffe suspected there was a nefarious plot afoot to keep the Capitol unfinished forever:

> The root of the whole evil, the cause of the immense expenditure and waste of public money, upon this Colossal Labyrinth, may be traced to the fact that we have some four or five gentlemen who are drawing an annual salary from the public Treasury, whose interest it is, and whose ingenuity is tasked, between the end and commencement of Congress, to project some new scheme or fancied improvement upon which to expend the public money. These salaries will continue until you finish this building; they will never finish it, as long as you furnish them money to waste upon it. Unless Congress will check the appropriations, the finishing of the Capitol, like the payment of the public debt, will always be 'anticipated.'[109]

Legislators asked why the rotunda needed to be heated, why the new entrance from the terrace was necessary, and why stables should be built. One member argued that if the rotunda were warmed, it would only create a comfortable resort for "loungers and idlers."[110] Spending money to build a "wall," as the terrace was called disparagingly, was foolish enough in some minds, but spending more money to "get over it so as to get into the Capitol" was ludicrous. One critic said that he would gladly vote to tear the terrace down rather than fund the bridge. Providing stables at public expense would only lead to buying horses and feed with public money. Some members thought there would be no end to the business of building the

Capitol. But at the close of debate, their suspicions were insufficient to carry the day: the House approved an appropriation of nearly $84,000 on March 2, 1827. Despite the rancor, the only items dropped in the final bill were the railings in front of Trumbull's paintings and the bridge to link the west center building with the terrace.

Most of the work done during the 1827 building season took place outside. Antonio Capellano finished a sculptural group over the portico entrance to the rotunda entitled *Fame and Peace Crowning Washington* while his compatriot, Luigi Persico, worked on *Genius of America* in the pediment. Cartloads of dirt removed from the east garden were hauled to the terrace, where they were unloaded to help build up a berm that would later be planted with grass. The top of the terrace was paved with Seneca stone from Maryland and an iron railing was installed to guard against sightseers falling into the courtyards. To build the privies in the courtyards, the earth in front of the foundations of the two wings was excavated and small, one-story structures erected against the newly exposed walls. Openings cut in the old foundations connected with interior staircases in the cellars to allow senators in the north wing and congressmen in the south wing to access their privies without venturing outside. Twelve stalls were provided in the south privy, while the north privy had just six. Skylights were used in lieu of windows and the flat roofs provided places for fragrant plants. At night, workmen emptied pails of waste into the canal at the foot of Capitol Hill.

Landscape improvements had begun before Bulfinch's arrival in Washington. In 1816 Congress appropriated $30,000 to enclose and improve the garden east of the Capitol. The following year $38,658 was given to continue fencing the grounds. By 1819 Griffith Coombs' bill for iron and stone for the Capitol's fence alone totaled $67,925. More than ornamental, the fence was necessary to prevent wandering cows, goats, and hogs from ruining the grass and shrubbery. Bulfinch continued the landscape improvements by extending the fence completely around the twenty-two and a half acres then comprising the Capitol's grounds. He also designed a fence to separate the east garden from the carriage drive. Gideon Davis of Georgetown contracted with the commissioner on June 12, 1828, to supply the extensive ironwork for the

fence. Vehicular and pedestrian entrances from A Street north and A Street south were regulated by gates erected in the spring of 1829.

Inside, the walls of the rotunda were painted in 1827, two powerful stoves were installed in the crypt to warm the room above, and the principal sculptural decorations were completed. In panels over the four doors, sculpted vignettes showed early encounters between Europeans and American Indians, each implicitly promoting the idea of "Manifest Destiny." Two were violent, two were peaceful, and each took place in a different part of the country. *Landing of the Pilgrims* and *William Penn's Treaty with the Indians* illustrated cordial relations occurring in New England and the mid-Atlantic region, while *Preservation of Captain Smith by Pocahontas* and *Conflict of Daniel Boone and the Indians* depicted fierce encounters in the south and west.

At the close of the 1827 building season Bulfinch claimed the effects of the stoves could not be felt until the opening in the rotunda floor was closed to stop cold air entering from the crypt. The circular aperture had been provided to help light the crypt but was soon considered a nuisance. He also called attention to the four vacant panels and said that the rotunda could not be considered complete until additional paintings illustrating significant "national subjects" were commissioned. (Trumbull seldom missed the opportunity to declare his willingness to paint more scenes from the Revolutionary War era.) The architect proposed a new visitor gallery for the Senate chamber to prevent the necessity of visitors being admitted to the floor. This would allow the upper gallery along the east wall, which had little headroom and was difficult to access, to be removed. For the House wing, Bulfinch again recommended removing the principal staircase, which had survived the fire of 1814 but was worn and poorly lighted. He proposed building a more graceful, light, and airy staircase in its place. The brick and tile paving on the first floor passages was so worn that Bulfinch wanted to re-pave the areas with stone. Gate houses were needed to help control access to the grounds.[111] Bulfinch provided estimates for these small items on what modern builders call the "punch list." They were submitted to Congress on February 1, 1828.[112]

When the funding request was taken up by the House on April 28, 1828, the number of gate and guard houses was the first topic of discussion. Two lodges were proposed for the western entrance to the grounds at Pennsylvania Avenue and one each at the carriage entrances from A Streets north and south. John Woods of Ohio moved to strike them from the legislation. Everett immediately rose to support the lodges and was joined by John W. Taylor and Dudley Marvin of New York. Henry Dwight of Massachusetts offered a compromise—retain the western lodges and forgo the others. His suggestion was approved. Wickliffe of Kentucky wanted to remove funds that were earmarked to rebuild the main staircase leading to the House chamber. Everett condemned the old stair, which he called "very confined and inconvenient," and explained the advantages of a new circular one. Other adjustments, such as moving the private stairs and creating a new lobby, were also contemplated and would, in Everett's opinion, greatly improve access to the chamber. Despite Wickliffe's opposition, the proposal to rebuild the staircase was approved.[113]

Fortified by the staircase victory, Everett moved to add funds to build the bridge connecting the center of the Capitol with the terrace. He claimed that the entrance from the terrace would be a great convenience to those approaching the building from the west and was "indispensable to the symmetry of that front of the building." How the door and bridge resolved matters of symmetry is hard to imagine, and it was not questioned at the time, but James Mitchell of Tennessee "warmly opposed" Everett's amendment as another useless expense. He did not care about the terrace and only wanted the "speedy payment of the public debt." But the question before the House pertained to a new entrance, and it was approved seventy-two to thirty-six.[114] Three days later the Senate agreed, and the president approved $56,400 for the Capitol and $3,121 for the connecting bridge.[115]

On the last day of the session (May 26, 1828), Everett submitted a resolution asking the commissioner of public buildings to "secure the paintings in the Rotundo from the effects of dampness."[116] Although the paintings had hung in the room less than two years, they already showed the effects of moisture and were destined to ruin unless measures were taken. After a brief debate, it was

decided that Trumbull should direct the operation and be allowed a reasonable compensation.

As soon as he learned of the resolution Trumbull wrote Elgar to say that he would come to Washington once the opening in the rotunda floor was closed. It was useless to begin restoration until the source of dampness was eliminated. The aperture was duly filled in, and after the workmen were gone Trumbull arrived to supervise removal of the paintings from their frames; they were then taken to a warm, dry room for examination. As the artist had feared, mildew was discovered on the backs of the linen canvases. They were laid out—paint down—on carpets to air out. Drawing on published reports from French chemists who studied Egyptian mummies and antiquarians in England who examined the body of King Edward I, Trumbull learned that wax had been used as a preservative and it did not affect the brilliance of colors. He determined to coat the unpainted backs with common beeswax and turpentine, brushed on and then gone over with hot irons. Meanwhile, the niches in the walls

were coated with cement and vents cut to let air circulate behind the paintings. The paintings, after their wax treatment, were stretched across flat boards drilled with hundreds of holes to allow the canvases to breathe. With this backing, the pictures were protected from "careless or intentional blows of sticks, canes, &c., or children's missiles." The four paintings were then put back into their places, cleaned, and lightly revarnished. Curtains were hung that could be closed when the floor was swept or in summer when Congress was in recess. Thus the canvases were protected from clouds of dust and "the filth of flies," which Trumbull claimed were the "most destructive enemies of paintings." Self-closing doors covered with baize were hung at the entrances to keep the room warm and damp-free. By keeping the doors closed and the furnaces lighted, Trumbull found that the temperature remained at sixty-three degrees, a level that would keep the paintings "perfectly and permanently secured against the deleterious effects of dampness." He still wished to install railings at least ten feet from the walls but did not have the authority. The right foot of General Morgan in the *Surrender of Burgoyne* had previously been cut off using a common penknife, and while the wound had been repaired, railings were desirable to prevent further acts of vandalism. Trumbull spent seventy days in Washington supervising the restoration of his paintings, for which he was paid $560.[117]

The commissioner of public buildings reported that $59,020 was spent on the Capitol and grounds during the 1828 building season—$500 less than anticipated. Lack of materials prevented the first-floor corridor paving from being completed and the landscaping, being a "progressive work," was also unfinished.[118] A local blacksmith named James Martin installed the new visitor's gallery in the Senate chamber in the fall of 1828. Thin iron columns with capitals modeled on the Corinthian order were used to support a curving platform while twenty-five iron joists supported a wooden floor. A railing weighing almost a ton was installed as well.[119] Bulfinch designed the new gallery and was thus responsible for the introduction into the Capitol of architectural ironwork, which would become a favorite material for the next generation of Capitol builders.

Bulfinch did not write an annual report for the year 1828. Whatever he might have said, it would not have diverted attention from the presidential

Gate House

*U*ntil they were relocated in the 1870s, small stone houses were used by gate keepers tending the entrances to the Capitol's western garden. Unless the gates were closely guarded, cattle, sheep, hogs, and goats would enter and feast on the garden's lush vegetation. Bulfinch designed the structures in 1828 with belt courses and panels derived from the exterior stonework of the Capitol. (1960 photograph.)

South Gateway of Capitol at Washington, D. C.

by August Kollner
1839

Library of Congress

The carriage entrances to the Capitol grounds were protected by high iron gates and stone column shafts topped by lanterns. A lone congressional boarding house, pastures, and forests appear in the background.

election, a rematch between the cold, reserved, and austere incumbent, John Quincy Adams, and the charismatic hero of the Battle of New Orleans, Andrew Jackson. Old Hickory's followers had waited four years for the rematch, suspecting that Henry Clay's support for Adams in 1824 had cost their hero the presidency. After Adams named Clay secretary of state, they had evidence of what they called a "corrupt bargain." But four years later Jackson rode to the President's House in a landslide that was seen as a victory for the frontier west over the stale aristocracy of the east. Emotions ran high before and after the results were tallied, and there is little wonder that Commissioner Elgar wrote only a two-sentence report on the Capitol's progress in 1828 and Bulfinch wrote nothing at all.

On March 3, 1829, the last day of the lame duck session, Congress appropriated $18,762 for repairs around the Capitol and grounds. Bulfinch requested money to build a railing along the central walk in the western grounds to protect the grounds from cattle.[120] He found that when the western gate was left open, cattle wandered onto the grounds and did great harm to the newly planted trees and shrubs. Other small items needed

to be completed, but most of the money granted was to keep things in good repair.

The day after the appropriation was made, Andrew Jackson was inaugurated president on the east portico of the Capitol, setting off a raucous celebration that lasted weeks. As the grand, sheltered entrance to the "Temple of Liberty," the portico became the preferred stage for presidential inaugurals until the event was relocated to the more spacious west front in 1981. Throngs of supporters came to Washington for Jackson's swearing in, and one supporter wrote a newspaper in the president's home state of Tennessee that he witnessed an astonishing sight in the rotunda. It was an exhibition of a new railroad car loaded with eight passengers pulled across the room by a single thread of American-made sewing cotton.[121] Such displays were not then uncommon in the rotunda but would later be discouraged.

On June 25, 1829, Elgar wrote Bulfinch a terse note informing the architect that his services would no longer be needed after the end of the month. Admittedly, little work remained, but the sudden dismissal smacked of reproach. In earlier conversations with members of Congress, Bulfinch had

Representatives' Principal Staircase

\mathcal{T}he circular stair and scalloped niche were installed in 1828 within a two-story space built twenty-one years earlier. While the remodeling disrupted Latrobe's sequence of changing spatial and lighting experiences, the new stair provided a more graceful approach to the House chamber. (1975 photograph.)

indicated that he was prepared to leave at the end of September and wished to complete his government service without a hint of unpleasantness. Two days after Elgar's letter was written, however, Bulfinch wrote a memorial to President Jackson asking to be continued three more months in order to finish up and avoid the impression of censure.[122]

The president denied Bulfinch's request, saying it was his duty to guard against wasteful expenditures. The order, he explained, was issued simply because the commissioner decided the Capitol no longer required architectural services. But there was no intention of implying any dissatisfaction with the architect's conduct or talents. Jackson stated that he did not wish "to manifest the slightest disapprobation of the manner in which you have discharged your duties."[123] Thus, with five days' notice, Bulfinch's eleven and a half years of service came to an end.

After leaving the Capitol, Bulfinch found enough work to keep him in Washington for another year. He designed a penitentiary for the capital city, a jail for Alexandria, and a naval hospital in Norfolk. For these extra services Bulfinch received $600 and was allowed an additional $500 to pay for returning his family to Boston.[124] He departed Washington during the first week of June 1830, leaving friends behind with sincere regret. The city had given him a pleasant home for twelve years and he seemed almost as reluctant to leave as he had been to go there in the first place.[125] Bulfinch had the satisfaction of concluding the longest running architectural drama in the nation's history, one with more players and critics than he cared to recall. He was the first architect to leave the Capitol without a cloud over his head, the only one to look upon his years there with affection. Perhaps his success as a Washington architect was due to his political and social experiences in Boston, or perhaps it was his common sense and unwillingness to pick fights he could not win. George Hadfield had called the Capitol a "seat of broils, confusion, and squandered thousands," but Bulfinch left it with a profound sense of professional and personal satisfaction.[126]

Model of the Capitol As Completed by Bulfinch

*T*hese views look northwest (above) and northeast (below). Note the exterior stair leading to the top of the dome in the bottom view. (1994 photographs.)

AN UNSETTLED TIME,

1830–1850

Throughout the 1830s and 1840s, the Capitol's architectural evolution was virtually dormant. Small things were done to keep the building up-to-date, but most people considered it finished. Charles Bulfinch's departure left the Capitol under the care of the commissioner of public buildings; except for Bulfinch and James Hoban, all the architects in its past were dead: Benjamin Henry Latrobe died in 1820, Stephen Hallet in 1823, George Hadfield in 1826, and William Thornton in 1828. If the services of an architect were needed, the commissioner hired local men on a case-by-case basis. The most frequently consulted architect was Robert Mills, a native of South Carolina who studied architecture under Latrobe and Thomas Jefferson. While Mills was often called upon for architectural advice during the 1830s and 1840s, the jobs were generally small and his suggestions, while numerous, were not often implemented. A master carpenter named Pringle Slight, who came to the Capitol in 1825, served as the general superintendent and took care of the building's everyday needs. Until enlargements were begun in 1851, the Capitol was maintained essentially as Bulfinch left it.

The Capitol's exterior belied its convoluted construction history: although oddities abounded inside due to the alterations that had occurred over the years, the outside appeared remarkably unified. The building was surrounded by well-tended grounds that only improved with age. Visitors from around the country and abroad came to see Congress in action and explore the Capitol's vast (by American standards) interior. Few left without forming an opinion about the artistic merits of the building and its contents. For those unable to make the trip, enterprising engravers and lithographers sold views of the Capitol. Household items such as sheet music, candle sticks, and dinner plates carried the image of the Capitol into the everyday lives of countless Americans. Despite the wide variety of artistic skill evident in these images, the building always appeared noble and serene, giving no hint of the political battles waged inside. Sectional turmoil during the period, pitting north against south, slave state against free, was an ominous sign of things to come. Fights over tariff issues divided protectionists in the north from southerners, who generally backed free trade. The Bank of the United States, nullification, state's rights, and other issues were hotly argued in Congress and throughout the nation, filling the Capitol, political meetings, and newspapers with inflammatory rhetoric. Legislative debates were rarely depicted, however, and views of the Capitol's peaceful exterior were both popular and profitable.

The Capitol (Detail)
by Christopher P. Cranch, 1841

The Capitol, Looking Southwest

attributed to George Strickland, ca. 1830

*T*he artist of this perspective view avoided showing the Capitol's roof line, with its low domes, chimneys, and lanterns. Instead, the drawing focused on the rich wall treatment, portico, and dome.

HONORING WASHINGTON'S MEMORY

*O*n the day after Christmas in 1829, Robert Brown gave the commissioner an estimate for building a tomb for George Washington under the lower rotunda and paving the passages leading to it.[1] Brown, who had succeeded to the head of the stone department upon George Blagden's death, figured that $1,300 would be needed to prepare the tomb with plastered brick, stone paving, steps, and an iron gate secured by a strong lock. A little over two years remained until the centennial of Washington's birth, and, according to a congressional resolution passed thirty years earlier, it was hoped that his remains would be interred at the Capitol.

Soon after Washington's death on December 14, 1799, the House of Representatives had appointed John Marshall of Virginia chairman of a committee to report on a suitable way to honor his memory. The committee recommended that Congress ask the Washington family's permission to remove his body to a tomb in the Capitol once the building was finished. A monument would be erected over the tomb to commemorate the events of his military and political life.[2] Martha Washington agreed to the request, asking only that her remains in due course lie next to her husband's. Marshall received a letter from Dr. Thornton asking permission to include Washington's widow in the Capitol mausoleum scheme:

> The body of her beloved friend and companion is now requested and she does not refuse the national wish—but if an intimation could be given that she should partake merely of the same place of deposit it would restore to her mind a calm and repose that this acquiescence in the national wish has in high degree affected.[3]

Thornton was delighted at the prospect of Washington's body being interred at the Capitol because he saw it as an incentive to complete and sanctify the building. Earlier, upon learning of Washington's final illness, he had gone to Mount Vernon to offer medical advice but he was too late. Washington died the day before he arrived. Undaunted, Thornton proposed reviving the corpse with a tracheotomy and a transfusion of lamb's blood, but this preposterous idea was squelched immediately. As Washington's reputation took on an almost divine dimension after his death, Thornton maneuvered himself as close as possible to the hero's legend. He rarely lost an opportunity to invoke Washington's name when defending his design of the Capitol and claimed Washington was the "best friend I had on Earth."[4]

In 1783 Congress voted to erect an equestrian statue of Washington in the capital city once its location was settled. L'Enfant sited the statue on the Mall at the intersection of the Capitol's west axis and the south axis of the President's House. Thornton wanted it placed in the Capitol's rotunda, but nothing came of the statue proposal. The absence of a memorial to Washington in the city he founded embarrassed some in Congress, who saw the centennial of his birth as a perfect time to correct the situation. A member of the House from

Maine, Leonard Jarvis, deplored congressional inaction in a short speech delivered on February 15, 1832, one week before the 100th anniversary of Washington's birth:

> At the close of the revolutionary war, the Congress of the United States, ten states being present by their representatives, had unanimously voted a statue of General Washington, as a testimony of their esteem for his virtues, and the service he had rendered to his country. A resolution had passed unanimously in 1799, for a monument instead of a statue. In 1800, the monument was exchanged for a mausoleum. This last resolution had, in effect, proved as fruitful as those which had preceded it. Several of the States had, in the meanwhile, showed their sense of Washington's virtues and service, by erecting statues to his memory. The United States had done nothing but pass resolutions. When we look around for the statue, the monument, the mausoleum they had ordered, it is not to be seen. These things existed nowhere but in the journals of Congress.[5]

Robert Mills described his idea for a monument to Washington in a letter to the Committee on Public Buildings. He wanted to unplug the opening in the floor of the rotunda and cut a new opening in the floor of the crypt to allow light to fall on sarcophagi containing the bodies of George and Martha Washington.[6] An alternative plan suggested placing a cenotaph in the center of the rotunda. In either case, Washington's remains would be deposited in the tomb below the crypt. Mills predicted the interment would have a conciliatory effect on otherwise contentious politicians. He thought that

> a consciousness of the presence of even the lifeless remains of Washington within the walls of the Capitol would awe the most depraved, and check the emulations of passion, & political party . . . his sage advice would reoccur to our minds, to heal all our political bickering, and make us like a band of brothers, united in love, and determined to preserve the interests of the Union.[7]

A joint committee was appointed on February 13, 1832, to arrange the congressional commemoration of Washington's birth. Letters were sent to Washington's heirs requesting permission to inter his remains and those of his wife in the Capitol as specified in the 1799 resolution. George Washington Parke Custis, writing from his home, "Arlington," across the Potomac from the federal city, quickly approved: "I give my most hearty consent to the removal of the remains, after the manner requested, and congratulate the government upon the approaching consummation of a great act of national gratitude."[8] But the proprietor of Mount Vernon, John A. Washington, refused the request. He did not wish to circumvent the burial arrangement that Washington himself specified in his will, nor did he wish the family plot to be disturbed. The bodies of Washington and his wife were interred in a handsome new tomb and "repose in perfect tranquility surrounded by those of other endeared members of the family. I hope Congress will do justice to the motives which seem to me to require that I should not consent to their separation."[9] Thus, in these few words, the plan to remove Washington's body to the Capitol came to an end. Instead of a place of patriotic pilgrimage, the tomb under the crypt became a storeroom. At mid-century such items as tools, pieces of gas pipe, thirty lamps, and a broken chandelier were stored there.[10]

MARBLE MEMORIAL

Congress devised other ways to commemorate the centennial of Washington's birth. The House Committee on Public Buildings reported a resolution on February 16, 1832, instructing President Jackson to commission Horatio Greenough to sculpt a marble statue of Washington for the Capitol's rotunda. The statue would be full length, pedestrian rather than equestrian, and would copy the head of Jean-Antoine Houdon's famous statue of Washington, which was placed in the state capitol at Richmond in 1796. For better or worse, the resolution left the "accessories" to the judgment of the artist.[11] Discussion of the resolution's merits was brief. Only Elisha Whittlesey of Ohio spoke against it, saying he was opposed "to every proposition for a statue, monument, or mausoleum," but did not mention the reasons for his hardline position. James K. Polk of Tennessee, future Speaker of the House and president of the United States, wanted to know more about the artist named in the resolution. The chairman of the committee, Henry Dearborn of Massachusetts, replied that Greenough was not well known in America but was famous in Europe, where he worked. The sculptor was at the top of

East Elevation and Floor Plans of the Capitol

by Alexander Jackson Davis, ca. 1832–1834

Library of Congress

*H*oping to issue a portfolio of Capitol views, Davis made measured drawings of the building and sketched important interior rooms as well as an appealing view of the east front. Because of his fidelity to the subject and attention to minute detail, Davis left the most reliable record of the Capitol as completed by Latrobe and Bulfinch.

A. East Elevation

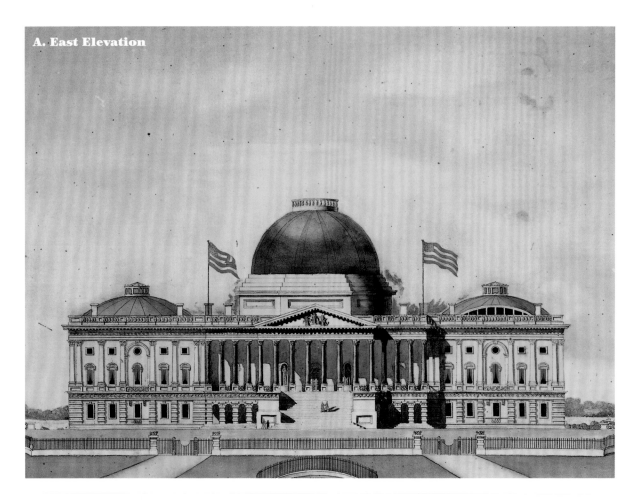

B. Foundations and Basements

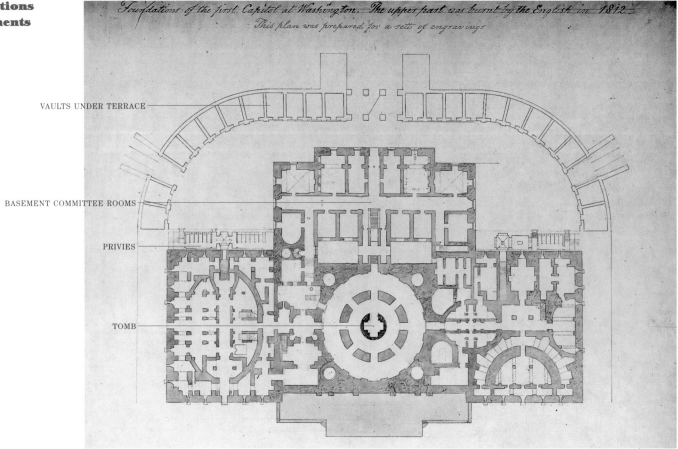

VAULTS UNDER TERRACE

BASEMENT COMMITTEE ROOMS

PRIVIES

TOMB

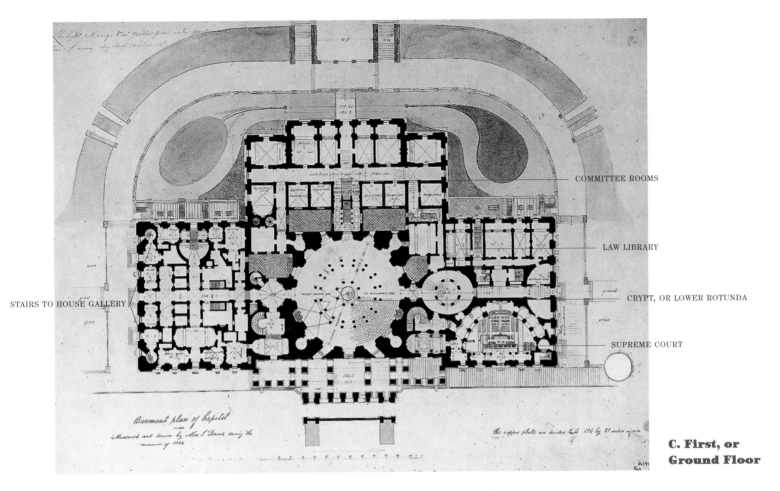

COMMITTEE ROOMS

LAW LIBRARY

STAIRS TO HOUSE GALLERY

CRYPT, OR LOWER ROTUNDA

SUPREME COURT

**C. First, or
Ground Floor**

**D. Second, or
Principal Floor**

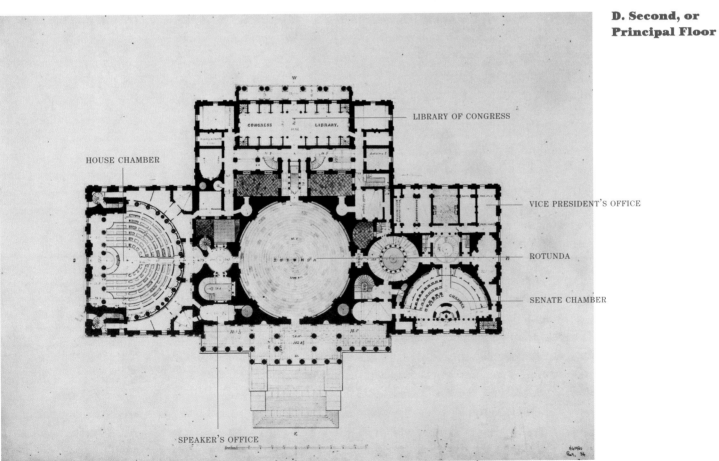

LIBRARY OF CONGRESS

HOUSE CHAMBER

VICE PRESIDENT'S OFFICE

ROTUNDA

SENATE CHAMBER

SPEAKER'S OFFICE

his art, recommended by connoisseurs both here and abroad. "No other American sculptor," Dearborn explained, "had yet appeared who was fit to be entrusted with the execution of Washington's statue." The fact that Greenough was an American was emphasized again and again, implying that no foreign artist should be given such an important commission. With these matters explained, the House passed the resolution by a wide margin.

The Senate took up the resolution, as amended by its Committee on the Library.[12] (Works of art usually fell under the jurisdiction of this committee because the Library of Congress was an art gallery as well as a repository of books and manuscripts.) It inserted an appropriation of $5,000, which was opposed by John Forsyth of Georgia: while in favor of the resolution's intent, he thought the sum mentioned would be insufficient to accomplish the object. The chairman of the Library Committee, George Poindexter of Mississippi, explained that $5,000 would enable the president to begin contract negotiations and that an additional appropriation would be needed in the future. Stephen Miller of South Carolina objected to "yearly and indefinite grants" without knowing where they might end. Henry Clay of Kentucky followed with an eloquent speech in favor of the resolution, declaring that of all places for a statue of Washington, the capital city, "the center of the Union—the offspring, the creation of his mind of his labors" was not only appropriate but long overdue. Clay reminded his colleagues of the objection of the proprietor of Mount Vernon that thwarted the scheme to bring Washington's remains to the Capitol. There was no use in attempting to revive the interment plan because the proprietor himself had just died and the fate of Mount Vernon was now uncertain. Washington's home and tomb could fall into the hands of either "a friend or stranger," but Congress should not wait to commission an enduring likeness. After Clay took his seat, the Senate voted thirty to ten in favor of the resolution.

In the fall of 1841, more than nine years after the resolution passed, Greenough's heroic sculpture was unloaded at the Navy Yard and hauled to the Capitol. William Easby, a local stone contractor and rigger, charged $2,500 to move the twenty-ton cargo and place it on a pedestal in the center of the rotunda. The pedestal had been made under Mills' direction in accordance with a design sent by Greenough. A year before, Mills constructed a sturdy pier in the crypt to support the statue's weight, which would bear down on the rotunda's weakest spot—the former opening in the floor.

At 10 o'clock in the morning on December 1, 1841, President John Tyler entered the rotunda with the secretary of the navy (who had overseen the statue's journey from Italy) to witness the final installation. About twenty minutes later, the heavy marble portrait was hoisted above its pedestal, but the ropes became twisted, the weight shifted, and one leg of the derrick nearly broke. Disaster was averted when additional pulleys and guy ropes brought the statue back into position. At one o'clock, three hearty cheers greeted the placement of Greenough's Washington on its pedestal in the center of the rotunda.[13]

After the cheers subsided the American public took a closer look at the statue of Washington, which Greenough chose to portray with the body of the Roman god Zeus wearing only a toga and sandals. The sculptor had rejected the idea of portraying Washington in period costume on the grounds that eighteenth-century clothing would be an unnecessary distraction that diminished the timelessness of the subject. One eyewitness said that Greenough's Washington was the most "Godlike" thing he had ever seen, and noted that dauntless Daniel Webster did not approach it readily.[14] But Washington's bare chest was a blasphemy few Americans were prepared to accept without comment. A wiseacre said the first president looked as if he had jumped out of bed, managing to grab only a sheet. Many, including Charles Bulfinch, thought it showed Washington preparing for a bath. While he appreciated the sculpture as art, Bulfinch knew that the majority of his countrymen would take the portrait too literally. He warned his son:

> I fear that it will cause much disappointment—it may be an exquisite piece of work, but our people will hardly be satisfied with looking on well developed muscles, when they wish to see the great man as their imagination has painted him . . . [I] am not convinced the sculpture is suited for modern subjects; the dress presents insuperable difficulties. . . . And now I fear that this with you will only give the idea of entering or leaving a bath.[15]

What was perhaps Greenough's most famous work was a failure with the public. The artist thought it suffered from being badly lighted from

Statue of George Washington
by Horatio Greenough, 1841

\mathcal{W}hen the controversial statue of Washington was moved out of the rotunda to the east garden, it was positioned on a granite base designed by Boston architect Isaiah Rogers. Behind the statue is East Capitol Street, stretching through the residential neighborhood of Capitol Hill before fading into farmland less than a mile away. In 1908 the statue was transferred to the Smithsonian Institution and its base was laid as the cornerstone of the Capitol Power Plant. (ca. 1860 photograph.)

the oculus directly above and asked that it be moved halfway between the center of the rotunda and the west door leading to the Library of Congress. Even after this repositioning, critics were not satisfied. The statue was moved out of the rotunda in 1843 and placed in a wooden shed in the east garden. Within a few years, the shed was employed only during the winter months.

CANVAS MEMORIALS

\mathcal{O}n July 5, 1832, the Senate paid Rembrandt Peale $2,000 for an original portrait of George Washington, which he had painted in 1824. Peale began sketching the subject in 1795 while his father, Charles Willson Peale, was painting his last portrait of Washington. The younger Peale considered his likeness superior and hoped it would become the "standard likeness." A few weeks before the painting was finished, Peale wrote Bushrod Washington, a nephew of the first president:

Never was there a portrait painted under any circumstance in which the whole soul of the artist was more engaged than mine is in this of Washington. It has been my study for years, and tho' its final completion has been deferred to this period, it will, I trust, be found the more mature and worthy of the approbation of the nation. There is a time for all things, and this is the moment for me, before the opportunity should have passed away forever, now that my command over the materials of my art is better matured to accomplish so difficult and important an undertaking as this National Portrait.[16]

After the painting was completed, it was hung in the vice president's office (modern day S–231), where many who knew Washington firsthand came to see it. Their testimonials were eagerly sought by the artist, who published them in newspapers in order to attract customers to his exhibition hall. Bushrod Washington's assessment appeared in a Philadelphia newspaper, *Poulson's American Daily Advertiser,* on May 26, 1824:

I have examined with attention and pleasure the portrait you have drawn of General Washington, and I feel no hesitation in pronouncing it, according to my best judgment, the most

exact representation of the original that I have ever seen. The features, as well as the character of his countenance, are happily depicted.[17]

On July 5, 1832, Pringle Slight hung Peale's portrait of Washington in the north corner of the Senate gallery (five years later he moved it to the center of the east wall, where it could be seen more easily).[18] In 1834 he installed another portrait of the first president, this one commissioned from John Vanderlyn by the House of Representatives for its chamber. The resolution authorizing the portrait, passed on February 17, 1832, instructed the artist to copy the head of Gilbert Stuart's Washington but otherwise to use his best judgment in working out the composition. The painting was to be full length and of the same dimensions as the portrait of the Marquis de Lafayette already hanging in the chamber. (That painting had been a gift of the French artist Ary Scheffer on the occasion of Lafayette's visit to the Capitol in 1824.) One thousand dollars was initially appropriated for Vanderlyn's companion portrait, but eleven years later, on June 27, 1843, the House allowed an additional $1,500.[19]

The only discussion in the House concerned the artist selected for the commission. To some, Vanderlyn was given an unfair advantage over other artists, such as Henry Inman or Thomas Sully, who were both noted for their exquisite portraiture. But these grumbles were silenced by testimony noting Vanderlyn's special talent for copying, and the House wanted the head copied from Stuart's famous likeness. The commission was not to be an original portrait, but part imitation, part imagination. Once the canvas was delivered Vanderlyn's success in carrying out his commission was considered satisfactory but unspectacular. The painting is little noticed in the artist's oeuvre and remains less famous than Peale's Washington hanging in the Senate chamber.

Vanderlyn was also among four artists tapped in 1837 to produce history paintings for the vacant panels in the rotunda opposite Trumbull's Revolutionary War scenes. In addition to Vanderlyn, a committee of the House contacted Robert Weir, Henry Inman, and John Chapman and commissioned them each for a painting at $10,000 apiece. The subjects were to be selected by the artists themselves from general topics regarding the discovery and settlement of America, the Revolution, and the Constitution.[20] Chapman selected a topic from the early history of the Jamestown settlement in Virginia, which well suited the romantic inclinations of the day, and his *Baptism of Pocahontas* was received in 1840. It was followed three years later by the second canvas, Weir's *Embarkation of the Pilgrims*. One writer considered Weir's painting the best of the series, not for its historical accuracy or composition, but for the "specimens of manly and female beauty" it displayed:

New England still retains a few women who are blessed with the loveliness which makes Rose Standish so attractive to the gazer, and seems to have been given what is left to us of such men as those whom Weir has chosen for his heroes. This type of masculine beauty is found chiefly in Connecticut.[21]

Vanderlyn's *Landing of Columbus* was placed in the rotunda in January 1847. The fourth panel remained vacant until *Discovery of the Mississippi by De Soto* was installed in 1855. It was painted by William R. Powell, who was asked to fill the final panel after Henry Inman died and efforts by friends of Samuel F. B. Morse failed to have him named Inman's successor.

FIRE AND WATER

Fire had always been one of the greatest threats to buildings in the federal city. The Capitol was no exception, and the library fire of 1826 pointed to the value of a plentiful and reliable supply of water. By the time Bulfinch left the Capitol in 1829, there were only two pumps on the grounds and one in a courtyard supplying firefighting or watering needs. These did not provide potable water, so another pump 400 yards from the Capitol was tapped for drinking and cooking. In 1832, while memorials to Washington were being discussed in Congress, the chairman of the House Committee on the District of Columbia, George Corbin Washington of Maryland (a grandnephew of the first president), asked the commissioner of public buildings to investigate the cost of bringing a reliable supply of water to the Capitol by means of a private aqueduct. Commissioner Elgar, in turn, called on J. A. Dumeste of the Army Corps of Engineers to survey nearby water and to estimate the cost of cast-iron pipes, reservoirs, and hydrants needed for the aqueduct. Two springs on

**The Ascent
to the Capitol,
Washington**

Robert Wallis after
William Bartlett, 1840

When approaching
the Capitol from the west,
it was necessary to
ascend a long flight of
stairs to overcome the hill
on which it was built. At
the head of the stair was
the monument to naval
officers killed during the
Tripoli War. The monu-
ment was first erected at
the Navy Yard in 1808,
relocated to the Capitol
in 1831, and removed to
the Naval Academy at
Annapolis in 1860.

John A. Smith's farm not quite three miles north of
the Capitol, another known as Dunlap's Spring,
and a fourth spring were examined. They were all
at higher elevations than the Capitol and could
supply water by the power of gravity alone. The
largest spring, one of the two on Smith's farm, was
capable of providing fifteen and a half gallons per
minute; three gallons a minute trickled from the
smallest source. Bringing water to the Capitol from
any of the four sources cost about the same—three
were estimated at $31,000 apiece, while the largest
spring could be tapped for $1,000 more.[22]

Robert Mills condemned the idea of taking
water from springs instead of "large streams" such
as Rock Creek or the Potomac River. These waters
were, in his opinion, "softer, more wholesome, and
better adapted for culinary purposes."[23] But the
committee favored tapping Smith's large spring

and authorized the commissioner to purchase it,
to build a holding reservoir, and to run pipes to
the Capitol, where receiving reservoirs would be
constructed on the east and west grounds. The
east reservoir could store 111,241 gallons of water,
while its counterpart at the foot of the western
terrace held 78,827 gallons.[24] Once the reservoirs
were filled, excess water was piped into the Capi-
tol for cooking and drinking, with the surplus
drained into the canal at the foot of Capitol Hill.
During the summer of 1834 it was discovered that
the discharge of water was sluggish and the pipes
were clogged with debris. Another of Smith's
springs was diverted into the Capitol aqueduct,
bringing the rate of discharge to about forty gal-
lons per minute. While Smith did not object to the
government's use of the second spring, he did wish
to be compensated.[25]

Drinking and cooking water was piped into the Capitol's restaurant, which was located in two rooms in the basement adjacent to one of the courtyards in the center building (modern day SB–17 and SB–18). There legislators could feast on oysters (raw, roasted, stewed, or fried), beef, veal, venison, mutton, pork, or green turtle soup, washed down with coffee, tea, wine, beer, or water.[26] In 1834 water was also conveyed to a public drinking fountain situated between the staircases leading to the upper terrace on the west front. Robert Mills designed the fountain with columns modeled after the Tower of the Winds supporting a plain entablature and capped by a graceful urn. The water spilled from a bronze faucet into a vase and then into a marble basin. It was, according to one critic who decried its location, "entirely too handsome to be hidden away."[27] While the fountain was under construction, the commissioner undertook a welcome improvement to nearby privies serving the House of Representatives. He had a cistern built to collect rain water, which was conducted to china basins in the privies through lead pipes. Opening or closing stall doors activated valves that flushed the basins with water.[28]

CRUTCHETT'S LANTERN

*I*f the 1830s was the decade of running water, the 1840s was the decade of gas lighting. In 1847 James Crutchett conducted experiments converting cotton seed oil into gas in a temporary laboratory on the Capitol grounds, and success led him to propose lighting the Capitol with that fuel.[29] Mills, too, advocated the introduction of gas lighting, citing economy and safety as its principal advantages.[30] Members of the House were eager to bring gas to the Capitol after the cut glass chandelier in their chamber fell

The Capitol

by Christopher P. Cranch, 1841

*W*riters during the antebellum period often described the Capitol standing "high and alone" on the heights of Jenkins Hill. Looking southwest, Cranch's view conveys an authentic sense of rural isolation but exaggerates the rugged condition of the Capitol's grounds.

CAPITOL

South West View

on December 18, 1840. Although no one was injured in the accident, several desks were "broken to atoms."[31] That lighting fixture had seventy-eight oil lamps arranged in two tiers and weighed 3,408 pounds. Including the balance that allowed it to be lowered for lighting, the whole apparatus weighed an astonishing 7,111 pounds.[32] The lamps burned whale oil, a fuel that added to the dangerous weight looming over congressional heads. Converting lighting fixtures to gas or buying new ones would not only remove the heavy weight of oil, but the cleaner-burning gas produced a brighter light.

Crutchett seems to have been as much showman as businessman. On his own initiative and at his own expense (but with congressional permission), he constructed a mast above the Capitol's dome to hold a gas-burning beacon capable of being seen from miles away. The lantern was not only an exciting addition to the spectacle of the Capitol at night—it was also a conspicuous advertisement for Crutchett's gas business. The mast was ninety-two feet high, while the glass and gilded iron lantern was twenty feet tall and six feet in diameter. Crutchett devised a clever scheme of reflectors to throw light into the rotunda at night. Together the mast and lantern weighed about two tons. Before Crutchett had been permitted to begin, the clerk of the House and the secretary of the Senate had asked Mills to evaluate the safety of the fixture,

and he concluded that it posed no danger during lightning or high winds. The mast would be supported by an extensive web of guy wires that Mills claimed would actually strengthen the structure of the outer dome.[33] Crutchett was granted permission to install the Capitol's most unusual lighting fixture in the summer of 1847.

Some members of the House were concerned about the safety and cost of operating the lantern and asked the commissioner of public buildings to investigate. On April 12, 1848, Commissioner Charles Douglas (whom President Polk had appointed in 1847) wrote the Speaker about the lantern and his concerns about the introduction of gas into the Capitol generally.[34] Cutting the walls and boring through arches to run gas lines caused structural damage to the building, but Douglas did not indicate the extent of the injury nor did he propose a remedy. He observed cracks in the outside walls, particularly on the west front that he ascribed to inadequate foundations, settling, and weakness caused by cutting away walls for gas pipes. He was particularly fearful of the lantern, which vibrated in light breezes and acted like a "great lever" in high winds. He declared that vibrations rattling the dome would eventually cause structural damage. It also consumed a considerable quantity of gas and was dangerous to light. Each night, a nimble workman climbed a ladder eight

inches wide in order to light the lamp. Douglas' report predicted dire consequences unless the mast and lantern were taken down. On June 28, 1848, after less than a year in place, work began to remove Crutchett's lantern.[35] Riggers from the Navy Yard took down the fixture that many considered expensive, unsightly, and dangerous.

SPACE AND SOUND: CAPITOL DEFECTS

*A*s the Capitol kept abreast with advances in science and sanitation, there were other problems that needed attention. The dreadful acoustics in the hall of the House had caused many grumbles since the room was first occupied in 1819. The smooth, rounded ceiling was the cause of the problem, but no one was willing to alter it to improve acoustics. When proposals were made to suspend a glass or plaster ceiling over the hall, they were defeated by those who defended the room's architectural splendor. In 1832 Mills attempted to solve the problem by placing the Speaker's chair in front of the principal entrance (which was closed temporarily), turning the members' desks and chairs around, and raising the floor. At the same time Mills added a visitor's gallery behind the south colonnade and opened five windows at the third story for light and ventilation. (Why Latrobe had designed these blind windows was not understood by Mills, nor can their purpose be explained today.) A thin, wooden partition was constructed behind the main gallery following the curve of the colonnade. The rearrangement failed to improve acoustics, however, and the room was returned to its original configuration in 1838. A Washington newspaper carried a report of other improvements made to the House chamber at the time the seats were moved back, and was particularly pleased by the new Speaker's rostrum:

> On the immense floor of this superb Hall, a new handsome Brussels carpet has been laid, which of course adds much to the neatness and beauty of its present appearance.

> We notice with pleasure that the gaudy trappings which were hung above and around the Speaker's chair last winter have been judiciously removed for more simple, chaste, and appropriate drapery.... The curtain is composed of rich crimson silk damask, lined with silk, and trimmed with rich crimson silk fringe of a foot in depth, with tassels to correspond. The ornamental part consists of a massive shield, blazoned in dead and burnished gilt, the outer margin of which is bronzed to give relief. The carving, which appears to be excellent, is executed by Mr. Thomas Millard, Jr. of New York; the gilding by Messrs. Kreps & Smith, of the same city. The upholstery and design are by Mr. Burke, of New York.... The curtain occupies a space of 23 feet in height by 12 feet in width. The chair is of highly polished mahogany, covered with crimson silk velvet; it is heavy and massive.... From the floor, about two feet in front, is an excellent imitation of marble, painted by Mr. Sengstack of this city.[36]

Complaints persisted, however, about the acoustics in the chamber. Some thought the chamber should be abandoned altogether and a new one built in a new wing. Others wanted to convert the library into a legislative chamber as first suggested in 1821. Zadock Pratt of New York, the chairman of the House Committee on Public Buildings and Grounds during the 28th Congress, prepared two reports on the problem. In the first, issued on May 24, 1844, he discussed the idea of converting the library into a House chamber. His committee had called upon the Army Bureau of Topographical Engineers to study the feasibility of the scheme and it, in turn, had consulted with Philadelphia architect William Strickland. All agreed that the library could not be easily or economically adapted because of space and structural constraints. Instead, they recommended adding a new wing to the south end of the Capitol that would contain a new chamber and additional committee rooms. In 1843 Strickland and the topographical engineers had prepared drawings for such a wing and estimated its cost at $300,000. It was presumed that a similar wing would be added to the north end to preserve the building's symmetry, but it could be delayed until the Senate ran out of space.[37] Strickland's recommendation, made in agreement with the topographical engineers, acknowledged that no place in the Capitol could be converted into a good speaking room for the House, and only a new chamber in a new addition could solve the problem.

Pratt's committee issued a second report in 1845 dealing with the state of the "National Edifices At Washington."[38] Going beyond the problems of the House chamber, the report lamented the

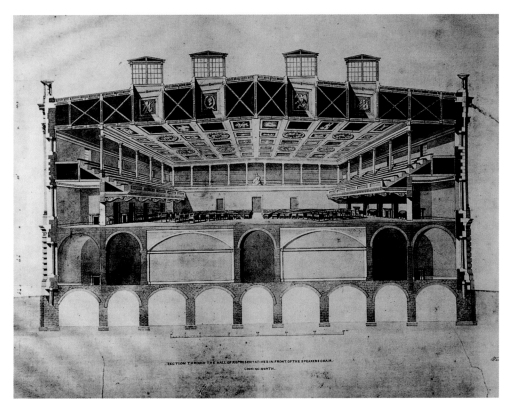

Section Through the Hall of Representatives in front of the Speaker's Chair, Looking North
by William Strickland, 1843

Manuscript drawing CONS 55 [Architectural Records]; Civil Works Map File; Records of the Chief of Engineers, Record Group 77; National Archives at College Park, College Park, Maryland.

Beginning in 1820, various schemes were devised to muffle echoes in the House chamber. In 1843 the Army Corps of Engineers and consulting architect William Strickland suggested building an addition to the south end of the Capitol housing an entirely new chamber. A nearly flat ceiling and a room without curving walls were their solutions to babbling voices and reverberating echoes. Also seen here is an early suggestion for a metal roof structure.

cramped conditions found throughout the Capitol, noting that the House and Senate had a total of fifty-seven standing committees while only forty rooms were available for their use. No provisions whatever were made for select committees. "This deficiency of rooms," Pratt's committee observed, "is a great drawback to the convenient transaction of the public business, as members attending committees have often experienced." The Library of Congress needed more space and the Supreme Court would benefit from a "better position." Evidence of the space problem was seen throughout the building: storage closets spilled out into corridors, courtyards were filled in, and rooms formerly high and airy were crowded with mezzanines. And while the Capitol was undeniably a spacious building—containing more than 60,000 square feet—Pratt's committee concluded that "it does not furnish the accommodation for the public business which so large an area would warrant us to expect." It recommended asking the president to have plans drawn for the enlargement of the Capitol. It also suggested that the present hall be converted into a library and that the former library room be rearranged for the Supreme Court. Congressional

preoccupation with the annexation of Texas, however, prevented action on Pratt's resolution.

A QUICK WAR, A TROUBLED PEACE

Soon after the United States annexed Texas on March 1, 1845, Mexico severed diplomatic ties with Washington. President Polk deployed troops under General Zachary Taylor to the Rio Grande, well below the Nueces River, which had been the southern boundary of Texas since Spanish colonial days. While the Mexican government considered its response, Polk dispatched an envoy to negotiate the boundary question, as well as the purchase of California and New Mexico. Most citizens considered westward expansion America's "Manifest Destiny," its inevitable and irreversible path to the Pacific Ocean. Mexico, however, saw Taylor's troops as trespassers on its soil, and the prospect of losing its northern provinces to land-hungry Americans was neither preordained nor particularly fair. To check what it considered unwarranted imperialism on the part of

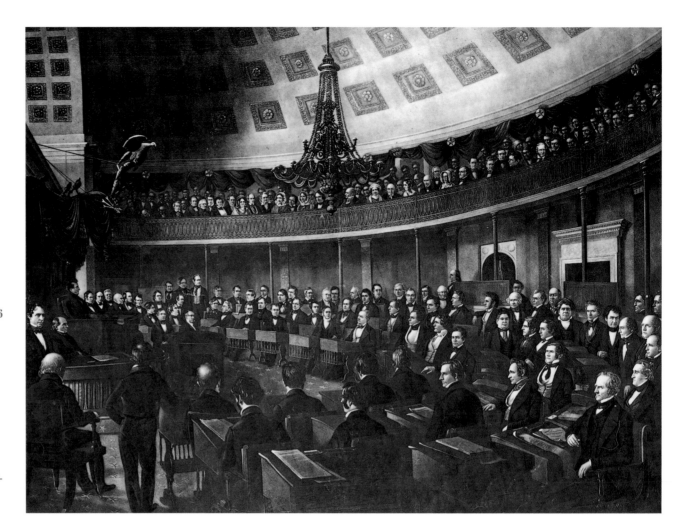

United States Senate Chamber

Thomas Doney after James Whitehorn, 1846

*C*rowded with the nation's leaders and Washington's social elite, the Senate chamber was one of the most popular theaters in America. Dolley Madison, the widow of the fourth president, is among those depicted in the gallery.

its northern neighbor, Mexican soldiers crossed the Rio Grande in April 1846, engaging Taylor's troops in a skirmish that left sixteen Americans dead. On May 13, 1846, the United States declared war on Mexico. In less than a year, the American army occupied New Mexico and California, annexing them to the United States. A series of victories over the large but ill-equipped Mexican army at Monterrey, Buena Vista, and Cerro Gordo presaged the fall of Mexico City on September 14, 1847. At the end of the war, the United States acquired 500,000 square miles of land from Mexico.

Interest in improving and enlarging the Capitol eased off during the quick war, but it was soon revived at the end of hostilities. During this time, Mills was in the forefront with ideas about enlarging the building. It was apparent that there was more than one way to add to the Capitol. Before the outbreak of war, Mills had proposed building an addition on the east front that would be the same

size as the west-central building.[39] He continued to press the plan after war's end. A new chamber for the House would be built in the new wing, the Senate would move to the room occupied by the Library of Congress, the old House chamber would be refitted as a library, and the Supreme Court would occupy the former Senate chamber. This version of "musical chairs" would result in a modest enlargement to the building. It would also, coincidentally, solve an architectural problem that some found bothersome. Building an addition to the east front would place the dome in the center of the Capitol when viewed from the north and south. As it stood, the dome was very much shifted to the east side of the building. Mills' proposal was published in Robert Dale Owen's *Hints on Public Architecture* in 1849 and was the first enlargement scheme to appear in printed form.

While architectural ideas and plans circulated around the Capitol, California and New Mexico

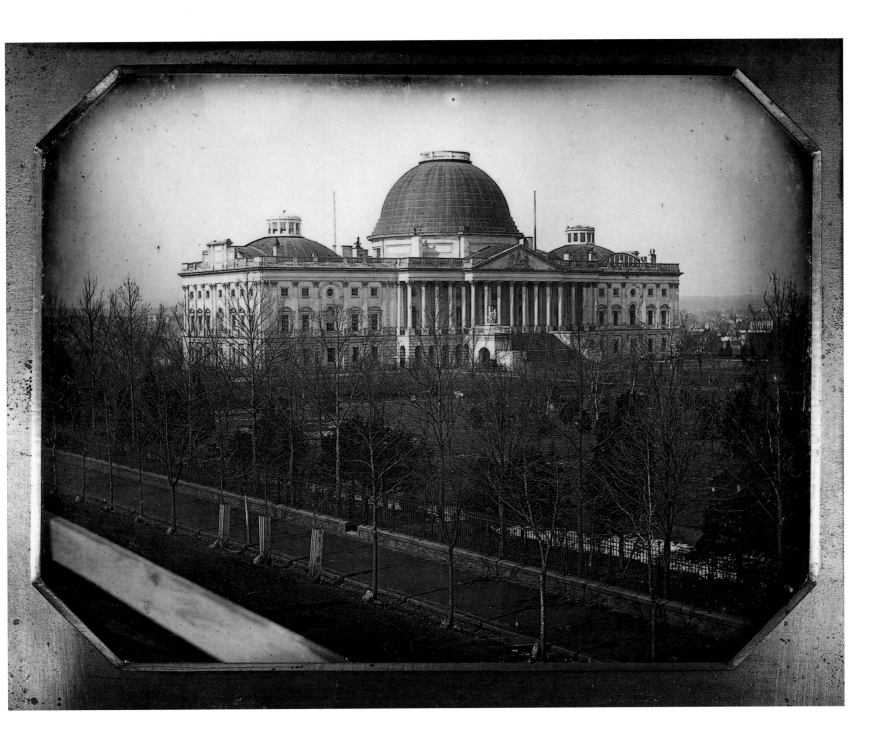

The Capitol

Daguerreotype by John Plumbe, Jr., 1846

The J. Paul Getty Museum, Los Angeles

*P*lumbe's daguerreotypes are thought to be the earliest photographic images of the Capitol. Taken from the southeast, this view shows the tall stone and iron fence that enclosed the grounds until 1873.

were left under military rule. Neither place was organized into a territory with a civilian government because Congress was too deeply divided on the subject of slavery to allow it. But after gold was discovered on the American River in California, and its population swelled with fortune-hunting "49ers," a civil government was needed immediately to restore order in that rowdy, far away place. Soon after Zachary Taylor succeeded Polk to the presidency in 1849, California applied for admission to

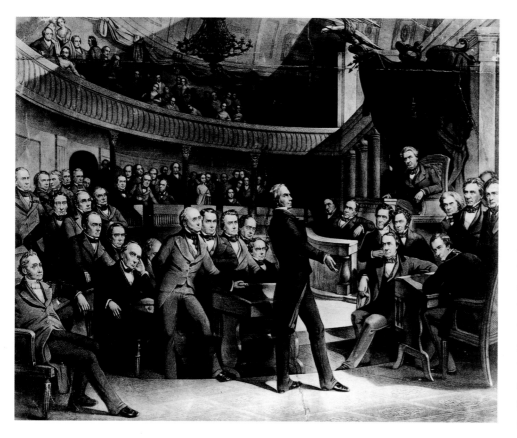

Henry Clay Addressing the Senate, 1850

by Peter Rothermel 1855

This scene was drawn five years after Clay's compromise was enacted and three years after his death.

the Union as a free state, setting off an explosive battle in Congress that threatened to divide the nation more deeply along sectional lines. Southerners saw the balance in the Senate tipping in favor of northern opponents to the expansion of slavery. They feared that New Mexico might also want to exclude slavery, further strengthening the northern hand. It seemed that talk of enlarging the Capitol might prove premature, or worse.

At the end of January 1850, Henry Clay proposed a series of laws that together became known as the Compromise of 1850. It was his final attempt to appease both sides of the slavery question, ease sectional conflict, and avert civil war. In addition to California statehood, other issues included the treatment of slavery in the rest of the territories won in the war with Mexico, the definition of the border between Texas and New Mexico, the slave trade in the District of Columbia, and the enforcement of the fugitive slave act, a law meant to return runaway slaves in the north to their owners in the south. Anti-slavery forces in the north opposed extension of slavery into the territories, considered slavery in the nation's

capital a national disgrace, and wanted the despised fugitive slave act repealed or unenforced. Southerners supported a man's right to move his property, including slaves, into territories, and insisted upon a more vigilant enforcement of the fugitive slave act.

Debate on Clay's compromise measures lasted from January through September, taking up most of the first session of the 31st Congress. Clay himself delivered seventy speeches during this period. The very existence of the Union was at stake, and there was little doubt that the nation's destiny, whether it be as one country or two, hung in the balance. Mills offered one of the few diversions taking minds off the weighty business at hand. With plans under his arm, he met with members of the House and Senate Committees on Public Buildings, finding the Senate particularly receptive to the idea of enlarging the building by adding a pair of wings. The House seemed to prefer adding a single wing to the east front. Robert M. T. Hunter of Virginia chaired the Senate committee, with Jefferson Davis of Mississippi and John H. Clarke of Rhode Island filling the two other seats. Davis was particularly interested in the issue and on April 3, 1850, asked Mills to prepare plans, sections, and estimates for an extension of the Capitol by north and south wings. Mills responded with a design for wings 100 feet wide and 200 feet long, projecting sixty feet beyond the east and west fronts of the old building and separated from it by courtyards. A new Senate chamber, capable of seating 100 members, and thirty-two rooms for committees and officers would be accommodated in the north wing; the opposite wing would contain a hall large enough for 300 congressmen and another thirty-two rooms. The entire west-central building would be devoted to the Library of Congress, with enough space to shelve 250,000 books. Works of art would be removed from the library and displayed in the old hall of the House, where sightseers would not disturb the studious quiet of the reading room. The Supreme Court would occupy the former Senate chamber and its room on the first floor would be converted into a law library. Mills believed that second-floor accommodations for the Court would be healthier for the justices; in fact, he claimed that some of the most talented former members of the Court had died because of their chamber's

unwholesome ground-level location, and providing them with a lighter, better-ventilated space would be no more than common courtesy.[40] Elevations of the outside showed the effect of the new wings on the Capitol's appearance. In one drawing, Mills proposed removing the wooden dome and adding a new one similar to those at St. Paul's in London and Les Invalides in Paris. It would rise 210 feet above the ground, seventy feet more than Bulfinch's dome.

Although Hunter's committee reported favorably on the extension plan, which it said was "originally suggested by the topographical bureau, but altered by Mr. Robert Mills," it wanted to join with its counterpart in the House to evaluate the interior arrangements before making a final recommendation.[41] But the House Committee on Public Buildings, chaired by Richard H. Stanton of Kentucky, was in no mood to accept the Senate's recommendation, especially since it preferred to enlarge the Capitol eastward and not with north and south wings. Stanton's committee considered an eastward expansion more economical because the east plaza and garden offered an ample, level, and firm site on which to build. Wings, on the other hand, would have to be constructed on the sloping ground west of the building and would encroach upon nearby streets.

Debate on Clay's compromise continued throughout the summer of 1850. Little by little, moderates on both sides of the slavery question gained strength as the country longed for a peaceful resolution. The threat of a presidential veto suddenly ended when Taylor died on July 9, the victim of cholera morbus brought on by consuming a huge bowl of cherries and a pitcher of iced milk, one or both of which were contaminated with deadly bacteria. Millard Fillmore, who supported Clay, was sworn in as the thirteenth president before a joint session of Congress in the House chamber on July 10. In September he signed a string of bills that admitted California to the Union as a free state, created the territories of New Mexico and Utah with slavery to be deter-

mined by the "popular sovereignty" of voting residents, established the west boundary of Texas, prohibited slave trade in Washington (although slavery remained legal), and enacted a tough fugitive slave law. For each concession it made, each side received something in return. Not everyone was happy, but most were relieved that these divisive issues seemed to be settled at last. Senator Stephen Douglas of Illinois was so relieved that he thought it would be unnecessary to speak of slavery ever again. The president called the measures "a final settlement of the dangerous and exciting subjects which they embrace."[42]

Ten days after signing the last of Clay's compromise resolutions, President Fillmore approved the Civil and Diplomatic Appropriation Bill for 1851. Buried among monies to keep foreign missions opened and light houses burning was an appropriation of $100,000 for the extension of the Capitol. The manner by which the building would be enlarged and who would be named the architect were matters left to the president to decide. The legislation originally written by Jefferson Davis read: "For the extension of the Capitol by Wings according to such plans as may be adopted by the joint committee of both houses of Congress, one hundred thousand dollars for each wing."[43] Because it did not agree with the notion that the Capitol would necessarily be enlarged by wings, the House struck Davis' language from the bill. In conference, it was decided to leave the matter for the president to decide and to restore half the money to begin the project. Congress adjourned on September 30, and legislators poured out of the city. By the truce hammered out in the Compromise of 1850, they felt assured that the Union would go on and that the Capitol would not be abandoned as a redundant relic of a failed experiment. Beyond merely acknowledging the necessity of enlarging the Capitol, the appropriation was a concrete expression of their faith in the peaceful future of a united nation. A dormant period in the Capitol's history was about to end.

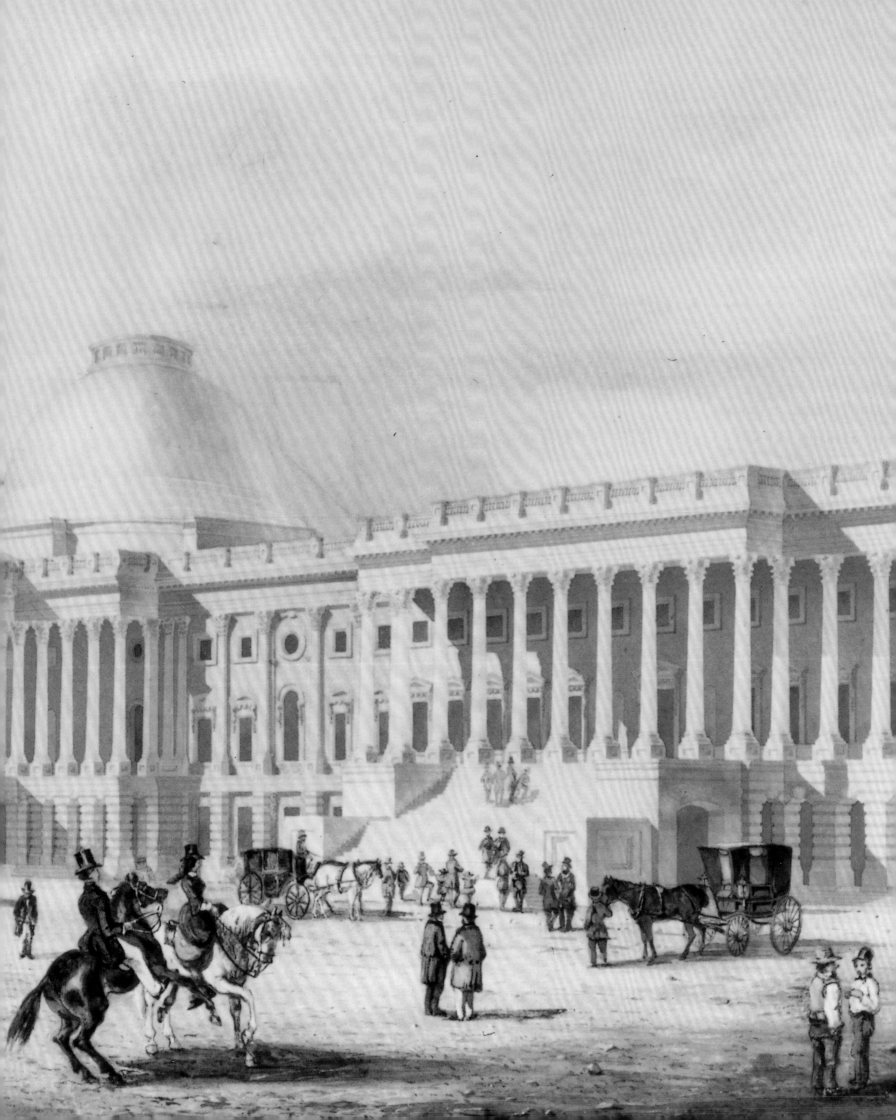

THOMAS U. WALTER AND THE CAPITOL EXTENSION

*W*ashington and Jefferson's Capitol was designed for a nation straddling the Atlantic seaboard. Two generations later, the country stretched across North America, and its increasing number of lawmakers needed more room to conduct the nation's business. The astonishing growth of the country prompted a major building campaign that tripled the size of the Capitol. Spacious legislative chambers were designed, the Library of Congress was expanded, and scores of new committee rooms and offices were built. Elegant public lobbies, corridors, and stairs were decorated with exquisite marbles and murals to rival the great palaces of Europe. The Capitol of the Latrobe-Bulfinch period was transformed into a sparkling jewel glittering with the finest materials, art, and architecture money could buy. A remarkable new dome—a breathtaking feat of architecture and engineering—completed the transformation and became a symbol of American self-government and democracy.

On September 25, 1850, the Senate instructed its Committee on Public Buildings to hold a competition for the enlargement of the Capitol.[1] Four days later, Congress gave President Millard Fillmore responsibility for deciding how the Capitol would be extended. While neither he nor the House of Representatives was under any obligation to accept the results of the Senate competition, the competition proceeded anyway: there was nothing to lose except $500 from the contingency fund. While some eager architects may have thought that the Senate competition would determine who would get the prized commission, it merely set the stage for the real competition over which Fillmore would later preside.

An advertisement from the Senate committee began appearing in Washington newspapers on September 30, 1850, the day Congress adjourned. As in Hadfield's, Latrobe's, and Bulfinch's day, the prospect of long-term employment on the nation's most prominent building was a powerful enticement. The advertisement read:

Enlargement of the Capitol

The Committee on Public Buildings of the Senate, having been authorized by a resolution of that body "to invite plans, accompanied by estimates, for the extension of the Capitol, and to allow a premium of $500 for the plan which may be adopted by the Committees of Public Buildings (acting jointly) of the two Houses of Congress," accordingly invite such plans and estimates to be delivered to the Secretary of the Senate on or before the 1st day of December next.

It is required that these plans and estimates shall provide for the extension of the Capitol,

The Capitol Extension (Detail)

by Thomas U. Walter, 1851

The Athenaeum of Philadelphia

either by additional wings, to be placed on the north and south of the present building, or by the erection of a separate and distinct building within the enclosure to the east of the building.

The committee do not desire to prescribe any conditions that may restrain the free exercise of architectural taste and judgment, but they would prefer that whatever plan may be proposed may have such reference to and correspondence with the present building as to preserve the general symmetry of the entire structure when complete. Although but one plan can be adopted, the committee reserve to themselves the right to form such plan by the adoption of parts of different plans submitted, *should such a course be found necessary,* in which event the committee also reserve to themselves the right to divide or proportion, according to their own judgment, the amount of premium to be awarded for the whole plan to those whose plans may in part be adopted, according to the relative importance and merit of each part adopted.

In composing the newspaper advertisement, the committee repeated some of the same mistakes made by the old board of commissioners when it advertised for a Capitol design in 1792. It offered little guidance and did not give architects enough time to adequately study the problem and make presentable drawings. The only architectural guideline given was that the addition must blend with the existing building. No variance from the neoclassical style would be considered, no stylistic transformation would be allowed. Committee mem-

bers seemed not to expect any single design to fulfill every requirement and therefore provided for several architects to be compensated for ideas that might be blended into a hybrid scheme.

Perhaps the strangest aspect of the advertisement was the suggestion to build a separate structure in the east garden. This solution to Congress's space problems was entirely novel. An anonymous writer referred to the proposal as the *"Siamese twin plan"* or—supposing the two buildings would be connected with a courtyard between—the "square *Barrack plan.*"[2] It was, by any reckoning, a distinctly odd idea.

At least thirteen architects responded to the advertisement—seven from the Washington area, two from New York City, and one each from Philadelphia, Boston, Hartford, and St. Louis.[3] A few were prominent members of the architectural profession: Robert Mills of Washington and Thomas U. Walter of Philadelphia enjoyed national reputations and are well-remembered today. Others, such as Charles B. Cluskey of Washington (recently relocated from Georgia), Charles F. Anderson and Cyrus W. Warner of New York, and Frank W. Vodges of St. Louis, were less famous, although well known in their regions.

On December 3, 1850, the competition drawings were put on public display in the Library of Congress. Soon thereafter they were moved to a room where the House and Senate Committees on

Eliza and Robert Mills

Daguerreotype by Jessie H. Whitehurst, ca. 1851

National Portrait Gallery, Smithsonian Institution

*T*his photograph was taken about the time Mills (1781–1855) was competing for the commission to enlarge the Capitol. No living architect knew the building better than Mills, nor had given its expansion greater thought.

At the time Mills sat for this photograph he was near the end of a long and distinguished career that included close ties (as architect or builder or both) to five major Washington landmarks: the Patent Office (1836); the Treasury Building (1836); the General Post Office (1839); the Smithsonian Institution (1847); and the Washington Monument (1848). At age nineteen he had worked for James Hoban at the President's House, and he later joined B. Henry Latrobe at the Capitol as a student, draftsman, and clerk. Despite his long experience, Mills could not match the vigor and talent of a younger generation of architects competing for the honor of enlarging the nation's Capitol.

Public Buildings could inspect them privately. While only a few drawings survive, the designs were described in cover letters that give valuable insight into the thoughts behind the lost drawings.[4] In accordance with the newspaper advertisement, most of the architects submitted at least one design for wings and one for a separate building. Some submitted multiple designs showing small variations on the two themes. William P. Elliot of Washington, for instance, submitted twelve drawings illustrating eight schemes. Charles Anderson's design called for wings enclosing the east plaza into a forecourt similar to the one he admired at Buckingham Palace in London. A tall fence would enclose the eastern perimeter of the forecourt, and he proposed relocating Greenough's statue of Washington to a new pedestal on top of a ceremonial gateway. Colonel J. J. Abert of the Army Corps of Topographical Engineers resubmitted a design for wings originally drawn in 1844 by his corps with William Strickland's help. He also sent another design for wings, drawn by Phillip Harry, that was more ornamental and consequently more expensive.

The design Robert Mills submitted for north and south wings was similar to what the committees had already seen. He proposed detached, rectangular buildings connected to the Capitol by covered, open-air colonnades.[5] But it may have surprised senators to find Mills more enthusiastic about two schemes he designed for a "duplicate Capitol." Both called for a replica of the Capitol positioned 300 feet east of the existing structure. One plan showed the buildings connected by a central hyphen 160 feet wide containing a huge new room for the Library of Congress. A grand colonnade and stairs were placed along the north and south elevations, making these the principal fronts of a vastly enlarged building. A new dome 200 or 300 feet high designed after that of St. Paul's Cathedral in London crowned the central library section. Chambers for the House and Senate were located in the new east wing with a central rotunda somewhat smaller (seventy-six feet in diameter) than its counterpart in the old Capitol, which, in turn, became the west wing in this plan.

Mills also proposed a second way to connect the Capitol with its mirror image, one that eliminated the library hyphen in favor of a central courtyard created by enclosing the north and south

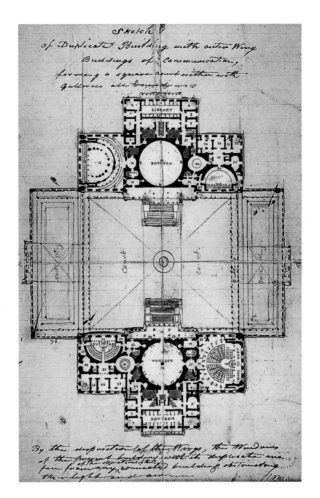

Sketch of Duplicate Building with outer Wing Buildings of Communication forming a square court within with Galleries all round

by Robert Mills

With 1850 unpublished report of the Committee on Public Buildings, Senate Report 145, 31st Congress (SEN31A–D1); Records of the U. S. Senate, Record Group 46; National Archives, Washington, D. C.

*P*lans of the two Capitols were cut from Mills' *Guide to the Capitol* and pasted on a sheet of paper and the connecting features added. A soaring column dedicated to the Revolution was intended to occupy the center of the courtyard.

perimeters with "colonnaded terraces." In the center of the courtyard, Mills proposed to erect a column 200 feet high dedicated to the American Revolution. On top of the column would be a fifteen-foot-tall bronze statue of Liberty, which would hold the American flag when either house of Congress was in session. Near the top of the column, Mills proposed placing a great clock with four illuminated dials ten feet in diameter. His memorial to the Revolution would have surpassed the Washington monument in Baltimore and Nelson's column in London by more than thirty feet.

In one of his eight designs, William P. Elliot proposed a duplicate Capitol connected to the old building by a glass-topped central gallery that would be used perhaps as a library or simply as a promenade from the old to the new rotunda. One variation would crown the connecting building with a new dome covering a third rotunda, which he called "The Great Public Hall." Another Washington architect, James King, planned new chambers in a duplicate Capitol with the intervening

Thomas U. Walter
1854

*B*efore being named architect of the Capitol extension, Walter (1804–1887) was closely associated with one of the country's great works of architecture and philanthropy: Girard College for Orphans in Philadelphia. Stephen Girard left the bulk of his $7.5 million estate to the college in a will that dictated the size, materials, and plan of its buildings. In 1832, Walter won an architectural competition for the college complex and, at age 28, topped a field of older and more experienced architects that included his former master, William Strickland.

While Girard College was under way, Walter was commissioned to build a breakwater at La Guaira, the port of Caracas, Venezuela. From 1843 until 1845, Walter served as the project's chief engineer. To transport stone to the site of the breakwater, Walter supervised construction of one of the first railroads in South America.

After Girard College Walter's career was dominated by fourteen years at the Capitol, a period of creativity and hard work seldom matched in the life of an American architect. What promised to be a quiet retirement began in 1865, but it was shattered by financial reverses brought on by the Panic of 1873, which left the architect bankrupt. He accepted a low-paying job at the Pennsylvania Railroad and later joined James McArthur in building the colossal Philadelphia City Hall. He labored there until his death at age 83.

In 1836 Walter called together twenty-three architects from Boston, New York, Philadelphia, Baltimore, Washington, and New Orleans to form the American Institution of Architects. Although short-lived, the institution laid the groundwork for the founding of the American Institute of Architects in 1857. Walter hoped that membership in the AIA would be a badge of honor, helping to cultivate respect for the profession and safeguard its prerogatives. In 1876 he was elected the AIA's second president, and he was serving as such at the time of his death.

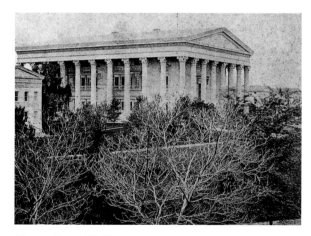

Founders Hall

Girard College, ca. 1860

Author's Collection

space set aside for the newly created Department of the Interior.

One of the more sensible schemes to build eastward came from the Philadelphia architect Thomas U. Walter. He ignored the "duplicate Capitol" idea, designing instead an addition to the east front of the existing building. Unlike Mills' design for an east extension published in 1849, Walter's proposed addition covered the entire east elevation of the Capitol, burying it behind courtyards and connecting corridors. From the carriage front, the Capitol would be totally transformed into a single, massive block with a twenty-five-bay portico between small end pavilions. From the west the Capitol would appear unchanged. The strength of the design lay with its floor plan. A monumental passage lined with forty columns connected the new entrance to the rotunda door. Just off this corridor were the new chambers for the House and Senate, designed without curving walls or domed ceilings that might promote echoes.

One of America's leading architects, Richard Upjohn, was in Europe when the competition was announced. Upon returning home, he learned of the contest but realized there was not enough time to prepare drawings and estimates. He nonetheless

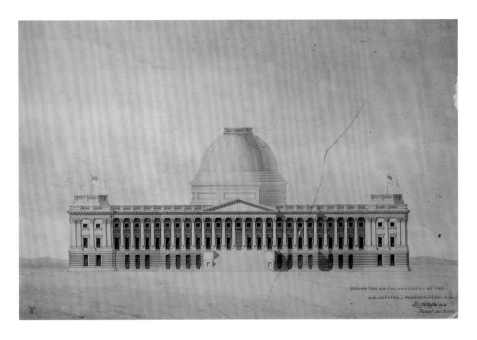

Design For An Enlargement of the U. S. Capitol Washington, D. C.

by Thomas U. Walter, 1850

The east elevation was dominated by an extensive portico with thirty-four columns, some of which were to be reused from Bulfinch's portico.

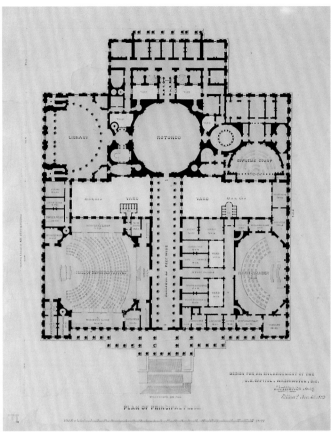

Design For An Enlargement of the U. S. Capitol Washington, D. C.

by Thomas U. Walter, 1850.

The close proximity of the chambers was a feature admired in this plan. Not having to purchase additional land or deal with the sloping ground of the west lawn were two others. This plan was favored by the majority of the House Committee on Public Buildings, as well as the chairman of the Senate Committee on Public Buildings.

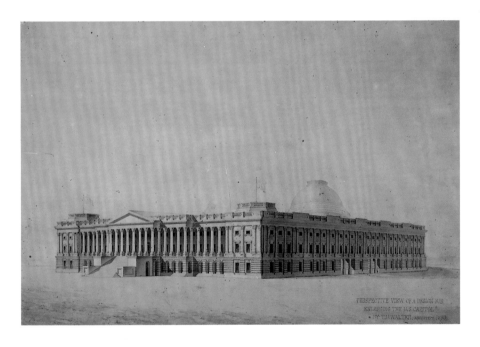

Perspective View of a Design For Enlarging the U. S. Capitol

by Thomas U. Walter, 1850

From the east and side elevations, Walter's proposed addition would have transformed the Capitol into a totally different building. The design was not approved in the Senate, chiefly because of Jefferson Davis' opposition.

wished to be considered and wrote a letter to the Senate committee expressing interest. He offered to take on the duties of architect for a negotiated fee and suggested the $500 prize money be deducted from his first paycheck. In offering his services, Upjohn said he was motivated by the desire to see American public buildings "alike creditable to our country, to our age, and to the profession to which I am devoted." He excused himself for not entering the competition, saying such a contest was highly disagreeable, a sentiment widely held by architects both then and now:

> I have not been in the habit of joining in the scramble for employment by presenting competition plans as such a mode of doing business is not agreeable to my views and feelings as a professional man and does not commend itself to my judgement.

> . . . I hope to see the time when architects may be employed as we employ painters, sculptors, physicians, and lawyers, because we believe them to understand their business and can best do what we commission them to do. Whenever I can meet parties on such grounds I have no fear of the result.[6]

Upjohn's tactic did not win him the commission he sought, and he would not be the only one disappointed in the long, perverse process of naming an architect to enlarge the Capitol. After the designs had been reviewed by the House and Senate Committees on Public Buildings, it became clear that there would be no agreement on how the building should be enlarged. The Senate still preferred wings and the House was equally adamant about an eastward expansion. While they waited for the president to begin his selection process, the Senate divided the $500 premium among five contestants. William P. Elliot and Philip Harry shared first-place honors and were awarded $125 each. Robert Mills and Charles F. Anderson tied for second place and were each given $100, while Thomas McCleland of Alexandria, Virginia, earned $50 for his entry.[7]

Soon after the awards were made, the Senate Committee on Public Buildings asked Mills to study the entries and incorporate their best features into a new composite design. He quickly finished the job and the design was presented to the full Senate by Jefferson Davis on February 8, 1851. (While not the committee's chairman, Davis was its most dynamic member.) The plan called for north and south wings directly attached to the ends of the Capitol. They were recessed from the western elevation to avoid the expense of sinking foundations into the slope of Capitol Hill and were necessarily extended beyond the eastern elevation. Thus positioned, the new wings would put the dome in the center of the building's mass when viewed from north or south. The committee considered this an important point and mistakenly thought it would "restore to the rotundo the central position which it had in the original design."[8] Again citing restoration to the "classic

Proposed Enlargement of the Capitol

by Robert Mills ca. 1851

*A*fter the 1850 competition closed, Mills was asked to combine the best features of several entries into a composite design, which came to be known as the "Senate Plan." Wings were attached directly to the ends of the old building while a new dome crowned the center.

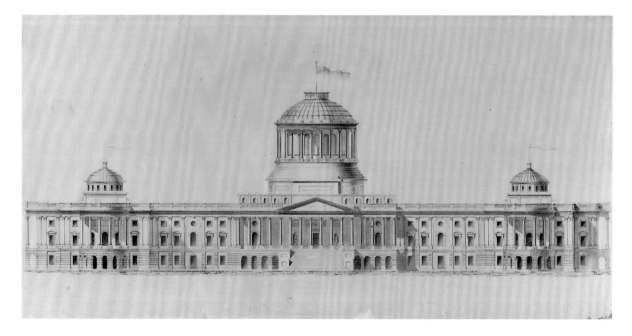

beauty and simplicity of the first plan," Davis proposed to reduce the height of the central dome and remove the domes over the House and Senate wings, and he argued that the appearance of each elevation would be improved by the addition of the new wings. All future requirements of the House and Senate, their committees, and the library would, he was sure, be satisfied as well. Davis promised it would not cost half as much as a duplicate building, and the committee considered the expense of wings the lowest expenditure that would accomplish the project goals. The cost of the enlargement was an estimated $1,291,000.

While the Senate took a public position on the Capitol extension, the House of Representatives did not. Its Committee on Public Buildings failed to issue a report because one of its members, Andrew Johnson of Tennessee (future president of the United States), objected and it could not report unless its members were unanimous. To satisfy public curiosity, however, the committee chairman, Richard Stanton of Kentucky, decided to publish an account of the committee's findings in the *National Intelligencer* of March 7, 1851.[9] After giving a synopsis of the enlargement question, he explained that his committee objected to building wings because of the expense involved in enlarging the grounds and altering the terraces. It also objected to placing great distance between the two chambers, which would be reached through narrow and intricate passages inside or balconies outside. Stanton condemned the necessity of shutting the light and air out of the old building and noted that noise and dirt would infiltrate the halls of Congress while the wings were under construction. In his opinion, all objections would be avoided by adding an eastward extension as favored by the House Committee on Public Buildings:

> The plan adopted by the majority of the House committee, and approved in all its main features by the chairman of the Senate committee, is one designed and presented by Thomas U. Walter, Esq., of Philadelphia, a gentleman of great practical experience, and eminently distinguished for his skill and genius as an architect. It combines all the conveniences desirable in the proposed enlargement, is harmonious and beautiful in architectural design, and may be constructed without excessive expenditure.

Stanton wrote that columns and steps from the old east portico would be reused in a new por-

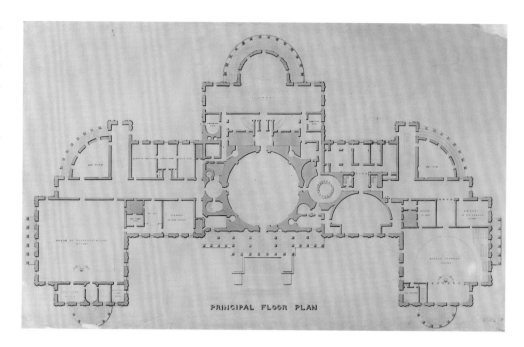

PRINCIPAL FLOOR PLAN

Principal Floor Plan
by Robert Mills, ca. 1851

By advancing the wings eastward, Mills avoided the embankments of the west terrace, which would save on construction costs. In place of the old hall of the House, Mills drew a suite of rooms for the clerk, a post office, and a library. New House and Senate chambers occupied most of their respective wings. The congressional library was enlarged by an apse as well as its extension across the entire west central building.

Jefferson Davis wanted this plan adopted but encountered opposition in the House of Representatives.

tico, which would be enlarged with eight new columns. Two new porticoes would add interest and grandeur to the north and south sides of the building. The chambers were designed with particular attention to acoustics. Ceilings were to be no higher than thirty feet, horizontal, and deeply paneled. No curving surfaces would promote reverberations or echoes. The old hall of the House would be converted into the Library of Congress and its former room either continued as a library or divided into committee rooms. Hot water pipes connected to boilers in the basement would be used to warm the extension. It was Walter's preferred method of heating, one that avoided the "carbonic acid-gas" produced by hot air furnaces. Although unnecessary, fireplaces would be built in every room to provide cheerful fires for those unaccustomed to central heating.

THE PRESIDENT'S DECISION

During the second session of the 31st Congress, which ran from December 2, 1850, to March 3, 1851, Washington swarmed with architects. Contestants in the Senate competition came to explain their designs and to meet with anyone who could help them gain favor in Congress or with the president. Those who lived nearby had a natural advantage, but reliable, fast, and cheap railroad transportation gave architects from Philadelphia, New York, and Boston quick access to the nation's capital as well. Several new faces were seen around town, most notably Ammi B. Young of Boston, while William P. Elliot and others dropped out of the contest. Almost daily, the president's mail brought letters of recommendation from politicians and other influential friends. Some architects wrote eloquent testimonials of their political support or damning testimony against their competitors. Charles Frederick Anderson seemed to have been a particularly industrious letter writer, offering advice and indulging in grand self promotion. In one missive, he recounted with alarm a rumor he heard in New York suggesting the president would not appoint an architect who did not support the Whig party. Thinking it would help his cause, Anderson wrote that he strongly believed whomever was appointed should "strain every nerve to keep in power the party or individual by whose means they obtain such extensive and honorable employment."[10]

One of the competing architects, Thomas U. Walter, kept an account of his trips to Washington as well as a record of the meetings he had with the president and other politicians.[11] His activities illustrate what was necessary to compete for an important federal commission. Eight days after the competition was announced, he was in Washington meeting with Senator Hunter, chairman of the Committee on Public Buildings, as well as Congressman Joseph R. Chandler of Philadelphia. Walter and Chandler had been friends for a quarter-century, brought together by their mutual association with Girard College—Chandler was a member of the board of trustees and Walter had been the architect and later a fellow board member. Walter made a second trip on October 17, 1850, when he carefully examined the Capitol and studied the problem of making additions to it. A third trip began on November 22, soon after he completed the eight drawings he submitted to the Senate Committee on Public Buildings. During his twelve-day stay, Walter met with Robert Beale, the Senate sergeant at arms, who introduced him to President Fillmore at the White House. He had several meetings with members of Congress, met with Joseph Henry, the secretary of the Smithsonian Institution, attended the opening of Congress, met a second time with the president, was introduced to the secretary of the treasury, and met again with Senator Hunter. When he returned to Philadelphia, Walter worked on a perspective of his design to enlarge the Capitol with an eastern extension, which he presented to the Senate committee during his fourth visit beginning on December 12. He spent an evening in the company of Congressman Stanton, beginning a warm and friendly relationship. With Stanton and Senators Hunter and Davis, Walter explained his plans for the extension and took the opportunity to review designs submitted by others. Until he left the city, on December 20, Walter paid calls on congressmen and senators, which he repeated during his fifth visit—a short stay of only two days on January 10 and 11, 1851. During his sixth trip to Washington, beginning on February 11, Chandler took him to see the president and he passed another pleasant evening with Chairman Stanton.

During these meetings and visits, Walter was swamped with ideas and suggestions that he was obliged to digest and reconcile. Throughout the spring of 1851 he kept up the backbreaking combination of visiting Washington and spending grueling hours over the drafting board in Philadelphia. On February 20, Fillmore and the cabinet had a meeting with all the architects, which lasted four and a half hours. The next day, participants reconvened at the Capitol, where they staked the outline of their plans on the ground. By April 10 Walter finished a series of variations for an eastern extension, north and south wings, and another design combining wings with an east addition. On April 12 he was back in Washington to deliver plans to Colonel Abert, who acted as an advisor to the president. Walter's tenth visit was cut short by the illness of his daughter, which suddenly called him home to Philadelphia. Ten days later he visited Robert Mills, William P. Elliot, and Colonel Abert but was again

obliged to hurry home to his daughter's side. On May 1, just four days after the death of his daughter Irene, Walter and his wife traveled to Washington where he again met with the president and his cabinet. By this time Fillmore had decided to enlarge the Capitol by adding flanking wings, but the question remained of just how the old and new structures should be attached. Placing the wings directly against the ends of the Capitol seemed the most obvious way to connect them, but this meant that all the side windows and doors of the old building would be covered over. Several architects—Mills and Walter among them—had at one time proposed courtyards between the old and new buildings, but no one had devised a satisfactory way of going from one to the other. Secretary of State Daniel Webster finally suggested building the wings some distance from the Capitol and connecting them by narrow corridors. Thus, the light and air coming into the Capitol would not be disturbed, construction activity would be kept away from the occupied building, and as much of the old building as possible would stand free of the additions. It was a superb suggestion.

During a cabinet meeting on May 1, the location of the chambers within the new wings was discussed. Placing them in the eastern part had the practical advantage of allowing the wings to be advanced eastward and thus recede from the sloping western grounds. Such a placement would avoid the trouble and expense of sinking foundations thirty or forty feet below the surface. But eastern chambers would also expose legislators to the dust, noise, and smells of the east plaza with all its clanking of horse-drawn carriages and wagons. Fillmore decided that congressmen and senators should instead enjoy the charming prospect and fresh air of a garden view westward toward the Mall.

On May 2, after one more visit to the Capitol, Walter returned to Philadelphia to work on a new plan for the extension with detached wings, connecting corridors, and western chambers. A month later he was back in Washington with new plans, which were immediately sent to the president. On June 4 he explained features of the design to Fillmore and the cabinet. Another meeting took place on June 9, and the next afternoon Walter was notified that the president had appointed him architect of the Capitol extension. He immediately

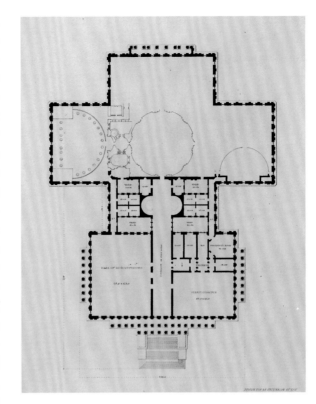

Design for an Extension of the U. S. Capitol

by Thomas U. Walter
1851

*I*n the spring of 1851 President Fillmore interviewed architects during cabinet meetings where suggestions were made and revisions encouraged. This design was made to show a more economical version of an east extension. The figure $1,259,000 was lightly penciled under Walter's signature.

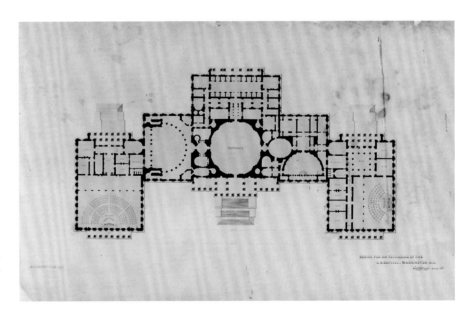

Design for an Extension of the U. S. Capitol, Washington, D. C.

by Thomas U. Walter, 1851

*I*n a scheme similar to Mills' "Senate Plan," Walter designed wings attached directly to the ends of the old building and advanced them eastward to avoid the west terraces. Here the principal entrances to the wings were from the west.

telegraphed his wife and went to the Capitol to find a room to use as an office. On June 11, Walter took the required oath and returned to Philadelphia to pack up his family for their move to Washington. Eight days later he was back and living in a boarding house with his wife and young children. At a meeting with the president on June 20, Walter was notified that his salary had been set at $4,500 per year and that he should report to the secretary of the interior, Alexander H. H. Stuart. The arrangement was a change from that in Latrobe's or Bulfinch's day, when the architect reported to the commissioner of public buildings, and the incumbent commissioner, William Easby, was not altogether pleased. While he had no authority over Walter, Easby was in a good position to cause trouble in the future.

Walter's appointment was greeted with quiet resignation by most architects who wanted the job. Two, however, bristled. Robert Mills had helped father the movement to enlarge the Capitol and he felt that he deserved the appointment by parental right. He bore his loss silently until 1853, when a change in administration opened what he thought was an opportunity to replace Walter, but his efforts to dislodge the victor failed. Another competitor, Charles Anderson, was more embittered and troublesome. He spent the remaining fifteen years of his life engaged in a smear campaign against Walter, eventually landing them in court. But aside from these exceptions, all seemed to agree that President Fillmore made a wise selection when he appointed Walter. It was, after all, an astute political move. In the prevailing spirit of compromise, the president chose the architect favored by the House of Representatives to enlarge the Capitol in the manner favored by the Senate.

Capitol with the Approved Extension Design

by Thomas U. Walter, 1851

The Athenaeum of Philadelphia

*O*n June 10, 1851, President Millard Fillmore approved Walter's design for wings placed forty-five feet from the ends of the old building and connected to it by narrow corridors. Each wing had three porticoes, with the eastern ones sheltering the principal entrances.

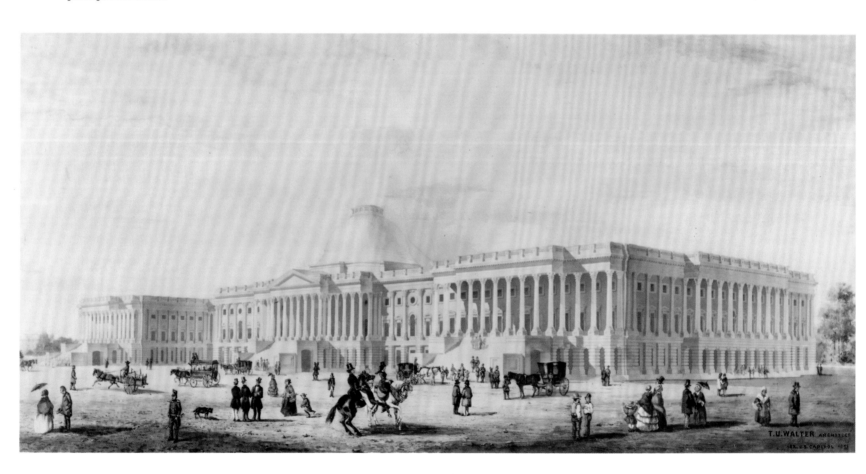

Plans of the North Wing

by Thomas U. Walter, 1851

The Senate chamber was originally to receive light and air from twenty-five windows arranged in two tiers. Light would also be admitted through a skylight in the center of the iron ceiling. The Supreme Court was to have a new chamber on the first floor while the upper story accommodated committee rooms and the galleries.

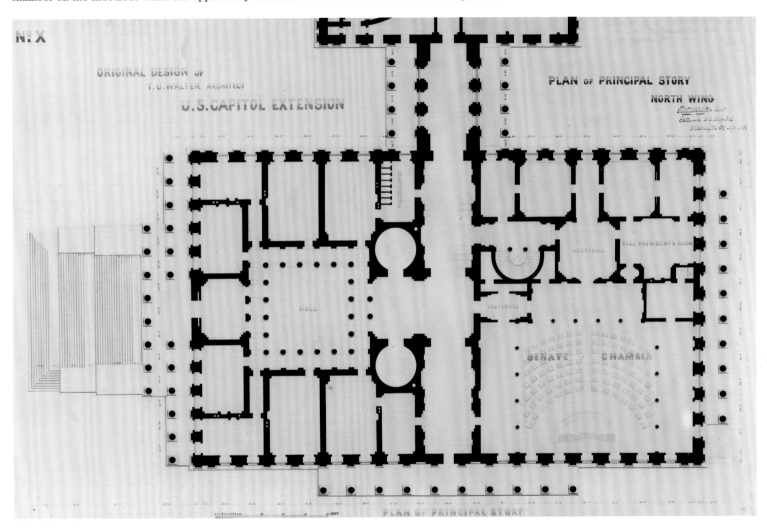

First Floor

Third Floor

Plans of the South Wing

by Thomas U. Walter, 1851

*T*he House chamber occupied the western half of the south wing. There, representatives would enjoy fresh air and garden views away from the dust and noise of the east plaza. On the first floor Walter planned a series of committee rooms, offices, workrooms, storage rooms, and water closets, while the third floor was occupied by more committee rooms and the gallery overlooking the chamber.

The notation indicating that this was the "Original Design of T. U. Walter Architect" was added to the drawing about 1858.

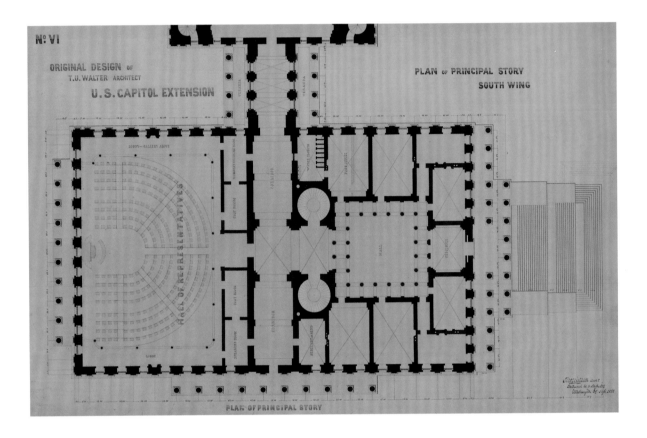

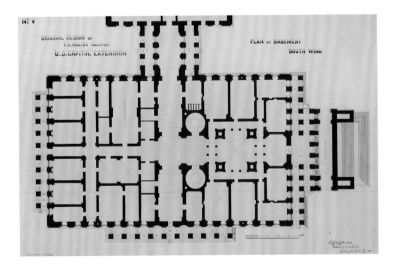

First Floor

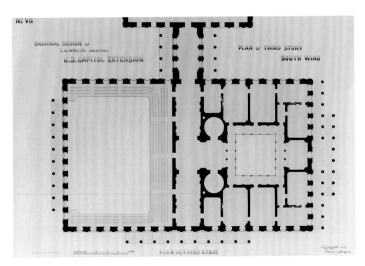

Third Floor

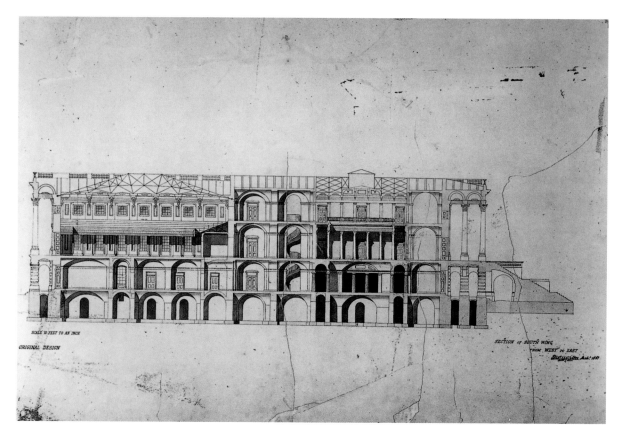

*P*rogressing up the
exterior stairs through a
columned, two-story hall
before reaching the House
chamber was simple, clear,
and direct. The chamber
was designed with an iron
ceiling carried from
trusses in the attic. A
gallery was to be sup-
ported by slender iron
columns similar to those
installed in the old Senate
chamber in 1828.

THE THIRD CORNERSTONE

*M*onths before Fillmore appointed
Walter, it was generally under-
stood that the cornerstone of the
Capitol extension would be laid on July 4, 1851.
The approaching national anniversary gave the
president, the cabinet, and the competing archi-
tects a useful deadline. Initially, the president did
not wish to lay the cornerstone with Masonic rites,
feeling that if Masons were invited then Odd Fel-
lows would have to be invited as well. Sentiments
against the Masonic fraternity had begun in the
days of Andrew Jackson's presidency, when critics
complained about the group's alleged exclusive-
ness and its acknowledged secrecy. Fillmore him-
self was considered anti-Mason, and it was not until
July 1 that he agreed to a Masonic ritual at the cor-
nerstone ceremony.

Despite hurried arrangements, events sur-
rounding the laying of the extension cornerstone
went smoothly. The commissioner of public build-
ings hired Nicholas Acker to prepare a granite block

to serve as one of the two cornerstones. An awning
of coarse linen was stitched to protect the speaker's
platform from rain or sun. J. V. N. Throop was paid
eighteen dollars for engraving the metal plate. One
of Walter's apprentices, Clement West, ordered
$40.44 worth of coins from the Philadelphia mint
to be deposited in the cornerstone along with views
of Washington, newspapers, and other materials.
Laborers dug the foundation trenches following
the lines staked out by the architect.

Prior to the ceremony, newspapers printed the
program drawn up by Richard Wallack, the marshal
of the District of Columbia. They called on parade
participants to assemble at city hall at 10 o'clock
on the Fourth. The parade's first division was
mostly made up of the marshal, his aides, and offi-
cers of the army and navy, including veterans of
the Revolution, the War of 1812, and the war with
Mexico. The second division, by far the most
diverse, included three persons who had been pres-
ent at the 1793 cornerstone laying; President Fill-
more; present and past cabinet members; members
of Congress; the architect of the Capitol extension;
Supreme Court justices; the diplomatic corps; the

clergy; state governors; the corporate authorities of Alexandria, Georgetown, and Washington; and the Society of Cincinnati. The third division was composed of about 200 Masons from Virginia, Maryland, Pennsylvania, and the District of Columbia. The final two divisions included temperance and benevolent societies, literary associations, colleges, and schools.

July 4, 1851, was an unusually mild day, a welcome respite from Washington's notoriously steamy summers. The day began with church bells ringing and artillery salutes from various spots around the city. At eight o'clock a procession headed by President Fillmore marched from the White House to the Washington Monument, where a stone quarried at Valley Forge was presented by the Pennsylvania Sons of Temperance. After the usual speeches, salutes, and benedictions, the president's party went to city hall to join the parade that would soon march to the Capitol. Newspaper accounts described the procession with enthusiastic approval:

> We have never witnessed, under such short notice, a finer display of our volunteer companies: the Washington Light Infantry Band deserve high credit for their recent improvement, and the Sharpshooters paraded their fine new set of musical instruments for the first time. The visiting companies of Baltimore, though few in number, attracted considerable attention.
>
> The array of Officers of the Army and Navy was one of the most imposing features of the pageant, including amongst them thirty or forty brave veterans, many of whom had faithfully spent the flower of their lives in the service of their country. . . . When again will our countrymen be favored with an opportunity like this?[12]

The procession reached the Capitol at 11:30. The Senate chaplain delivered a "fervent" prayer opening the ceremony. Into the hollow granite cornerstone Walter placed a glass jar containing newspapers, documents, coins, and a patriotic statement written by Secretary of State Webster. The stone was then laid by the president with "great dignity and solemnity." With that done, the Masons took over, making deposits in their stone, lowering it on top of the first stone, and consecrating it with the "corn of nourishment, the wine of refreshment, and the oil of joy." Holding the same gavel used by Washington in 1793, the grand master, Benjamin

Brown French, tapped the stone and pronounced it "well laid, true and trusty." Turning to Walter, he handed over tools of the architectural profession— a square, a level, and a plumb—with a prayer that the work might be successfully completed.

Following the presentation, the ceremony continued on the platform on the steps of the Capitol. French was the first to speak. He described the nation's progress since the Capitol's first cornerstone was laid and spoke of the "sacred fire of liberty" and the "dark and dismal clouds of disunion," which, he was happy to say, had been weathered by the "good old Ship of State." Henry Clay headed a list of patriots whom French called the "saviors of this glorious galaxy of American States . . . the pillars of their country in the hour of her darkest trial."

Ready to deliver the principal address was the venerable secretary of state. As Webster approached, he was greeted with enthusiastic cheers. His reputation as a mighty orator attracted a large audience, many of whom came early to stand close to the platform so as not to miss a word. And Webster did not disappoint them. For two hours the eloquent statesman held his audience captive, reciting statistics illustrating the growth of the country and its industry, agriculture, commerce, population, and government. He evoked the memory of Washington, praised the blessings of liberty, and called the secession of southern states "the greatest of all improbabilities." It was an address full of classical allusions, long, learned quotations from Cicero (delivered, of course, in Latin), and proud reminders of America's own progress and history. It was to be Webster's last great speech, his last plea for the preservation of the Union.

An artillery salute followed the conclusion of Webster's address. The military and civic organizations "returned in excellent order to their respective places of rendezvous." At nightfall, the celebration concluded with fireworks on the Mall. The Capitol's third cornerstone had been set amid one of the most elaborate ceremonies ever held in Washington. For the moment, the nation's future appeared peaceful and secure.

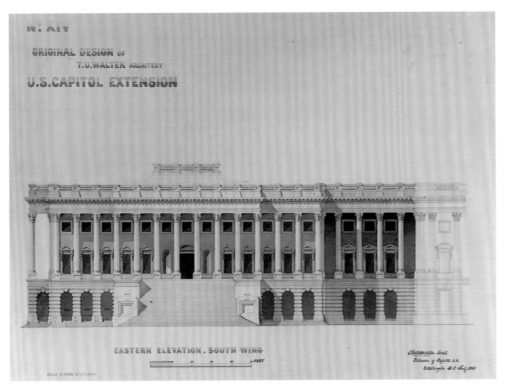

Eastern Elevation, South Wing
by Thomas U. Walter, 1851

A few weeks after the cornerstone of the extension was laid, Walter completed a series of exterior elevations showing the design in detail.

ON THE JOB

Initially, Walter's office was set up in one or two empty committee rooms in the Capitol, which he surrendered when Congress returned in the fall. On December 18, 1851, the office moved into rented rooms above the Adams Express Office on A Street north. There, Walter's room was the center of drafting activity while an adjacent clerk's room was the business center. Both were plainly furnished with carpets; coal stoves; wash stands with pitchers, basins, and hand towels; and looking glasses. The architect's office had three pine drawing tables, two mahogany writing tables with cloth covers, eight drawing boards, a bookcase, three armchairs, and eight Windsor chairs. A fireproof safe protected building contracts, proposals, and other important documents. Official letters from the Department of the Interior, applications for employment, bills, and invoices were filed in a large mahogany case. Drafting paper came in long rolls, and finished drawings were hung in racks. The number of draftsmen working under Walter varied from time to time. At the beginning of the work two young students from Philadelphia, Clement West and Edward Clark, came to Washington to continue their apprentice-

ships. They were soon joined by August Schoenborn, a German architect whom Walter considered a master of perspective and coloring. (Both Clark and Schoenborn would work at the Capitol for the rest of their long careers.)

The clerk's office contained two pine writing tables with baize covers, a pine desk, a swivel chair, and three Windsor chairs. The office journal, ledger, day book, bid book, check book, and cash box were kept in the clerk's safe. Duplicate vouchers were stored in the safe as well. Presiding over the office was Zephaniah W. Denham, whom Walter appointed on July 21, 1851, at an annual salary of $1,200.

The day after he appointed Denham, Walter named Samuel Strong general superintendent of construction. Most likely Strong came to this important job through political influence wielded by backers in New York City and Albany, who had sent Fillmore letters in Strong's favor well before the architect was named. The president may also have recalled that Strong was superintendent of construction for the arsenal in New York City while he was comptroller of the state. With responsibilities similar to those of the position of clerk of the works in Latrobe's day, Strong oversaw work performed by day laborers and insured the quality of

contractors' work. Materials delivered to the site were inspected to guard against fraud, and if any delinquencies or improprieties were discovered, Strong was to report them immediately. His salary was set at $2,000 per year.

Walter recommended that the extension project be advertised for bids and placed under a single contract. The second-best approach, in his opinion, would be to divide the project into multiple parts to be sent out for bids. Either manner of executing the work was preferable to the "dayswork system," which he thought suffered from an absence of incentive and motivation.

Fillmore and Stuart agreed with Walter's second recommendation and instructed him to divided the work into as many parts as possible to enlarge competition to the greatest extent.[13] Walter replied that it was too early to consider contracts for such things as roofing, painting, or glazing and he would therefore confine his remarks to parts of the building that lay immediately ahead. His recommendations, approved on September 13, divided the work into six basic contracts:

—Granite work of sub-basement of both buildings, including materials, in one contract.

—Marble work of the entire exterior, including materials, also in one contract.

—Brick by the thousand.

—Lime and cement by the barrel.

—Sand by the bushel.

—Lumber for centering and scaffolding by the thousand feet.[14]

The first contracts Walter signed were with John Purdy for lumber, Andrew Hoover and Samuel Seely for lime, Joseph Piper for foundation stone, Matthew Emory for granite, Christopher Adams for brick, George Schafer and Alexander Boteler for cement, and A. N. Clements for sand. A quarry just beyond Chain Bridge upriver from Washington supplied the gneiss used to build the foundations of the south wing, while a nearby quarry supplied stone for the north wing. Using hundreds of day laborers, work on the foundations began in August, and by the time the money ran out in December, almost 50,000 cubic yards of earth had been excavated and 18,000 perches of stone laid. The footings were eight feet, nine inches wide and were sunk fifteen feet below

ground on the eastern front and forty feet on the west. So much of the western lawn was what Walter called "made ground" that it was necessary to begin the foundations on undisturbed strata located deep below the surface.

By mid-December, the first appropriation for the extension was exhausted. Work came to a halt and the hands were dismissed. Unemployed laborers presented a petition asking Congress to appropriate funds so they might regain a means of support. Many in their ranks had moved to Washington thinking employment would be steady and now found it difficult to find other work due to the cold and wet weather. However, their straightforward request soon became entangled in a political web aggravated by the shenanigans of disgruntled contractors.

On December 16, 1851, Democratic Representative Richard Stanton offered a resolution authorizing the architect to keep the workmen employed until such time as another appropriation was made. Stanton and his friends wanted to see the work—barely four months under way—continued. Other members of the House saw it as a dangerous precedent guaranteeing government employment for anyone who wanted it. Many who opposed Stanton did not wish to abandon the project but objected to the workmen's claim that the government owed them jobs. A member of the Whig party, Daniel Wallace of South Carolina, sounded the alarm in the House:

> I do not recognize the right of any class of persons to come here in person, or by their representative, and demand that appropriations be made to give them employment. Such ideas, sir, as have been advanced on this floor by the honorable gentleman from Kentucky should, in my judgment, be met with the unqualified reprobation of this House and the country. These ideas are but the reflex of those of the French school of communism and the right to labor, which erected the barricades in the streets of Paris in 1848, and from the destructive tendencies of which, France has sought present repose by the restoration of the Empire under military rule of Napoleon II.[15]

Friends of the extension simply wanted funds to restart the project and did not believe that the laborers posed a threat to the republic or to capitalism. Another question was raised that further postponed funding. On January 12, 1852, the House appointed a committee to investigate the firmness

and stability of the foundations.[16] An enemy of the administration and the extension project, John McNair, a Democrat from Pennsylvania, was appointed chairman. After two months of investigation—but before the committee reported its findings—McNair let it be known that he considered the foundations to be in a "dreadful" condition.[17] In his opinion, the mortar was insufficient to bond properly and he claimed to have found many stones loose enough to be dug out by hand. The pronouncements were made a few minutes after Stanton introduced an appropriation to continue the extension through the fiscal year ending June 30, 1853. Seeing the prospects of the appropriation endangered, Stanton reacted with a defense of the project in which he tried to expose outside influences acting on McNair and his committee. He suspected disappointed applicants had attempted "to throw doubt upon the stability of the work."[18] Contractors who failed to get government business came to the chamber "to harass this House, and . . . to lead intelligent and honorable members of Congress into dilemmas, of which, when they learn the whole truth, they will be ashamed."[19] He described the scientific tests that proved the foundations capable of sustaining more than 200 times the weight to be placed on them. The allegations regarding the bonding of stones were rebutted by the facts as well as descriptions of similar foundations that were still standing in Greece after thousands of years. Stanton was well prepared in his defense of the workmanship of the foundations, while McNair seemed ill-equipped to support his position. Reluctantly McNair admitted that his opinions were influenced by a man named Knowles— "one of the best architects, perhaps, in the state of Pennsylvania"—who condemned the foundations after spending a few minutes inspecting them.

A congressman from Ohio, David K. Cartter, spoke of very different fears regarding the foundations. He was not concerned about their stability but warned that they were laid in the wrong place. "They are too near the eastern skirt of the empire," he cautioned,

> and I have no apprehension at all but that it will rest, mechanically, firmly upon its present foundation, and bear upon its surface the edifice you propose to place upon it, until the weight of the empire transfers it to the center of the empire. You had better address yourself to that consideration; for the time is soon com-

ing when the difficulty will not be in the weight upon it, but in keeping the foundation still. The foundations will partake of the spirit of the Republic, and make a western trip.[20]

Cartter was not alone in his belief that the capital would one day be moved to a location closer to the geographical center of the nation. This prediction, often used as a reason to oppose new construction in the federal city, would be heard time and again throughout the remainder of the nineteenth century. One cynical member suggested that the only reason a western congressman would oppose moving the seat of government westward was because those who lived far from Washington received more money for mileage than those who lived close by.[21]

In the Senate, opponents to the Capitol extension were led by Solon Borland of Arkansas, who introduced a resolution calling for their own investigation into the solidity of the foundations. Borland questioned the cost of the project, rejecting the architect's estimate as deceivingly low and warning against greedy workmen who wished the government to operate "a great national almshouse" for their benefit.[22] He painted a dramatic and exaggerated picture of doom and destruction that would ensue if construction were allowed to proceed. The extension was, according to Borland, a "house built upon the sand" that would surely topple and become a "mausoleum to its dupes."[23]

The Senate instructed its Committee on Public Buildings to investigate the foundations and authorized it to call experts into consultation. The committee, in turn, called on the Army Corps of Engineers and the Corps of Topographical Engineers to examine the work. Both bureaus reported favorably. Frederick A. Smith and J. L. Mason of the Corps of Engineers noted that the gneiss or blue stone was excellent and well suited for foundations. The mortar was made properly from hydraulic cement and sand, and the workmanship was excellent. The committee could see no reason to delay construction any longer, especially in view of the fine spring weather. It recommended restarting the work at once.[24]

Senator Borland was unmoved. Facts could not change his mind about the architect or his belief that the Capitol extension was a waste of money. On April 9, 1852, while Senator Hunter tried to

secure an appropriation for the extension, Borland proclaimed that it would be better to sacrifice the $100,000 already expended rather than pursue the wasteful project that would cost many millions in the end. He also criticized the extension on aesthetic grounds, claiming that the building was already too low for its length. To make it any longer without making it taller would, Borland predicted, court architectural disaster. He lamented that the distance between the new chambers would be so great that traveling to and from them would entail a quarter mile round trip. One of Borland's allies, Senator James W. Bradbury of Maine, suggested easing overcrowding by removing desks from the two chambers. Space problems would disappear and legislators would stop writing letters and pay closer attention to the business at hand. Another senator, Joseph R. Underwood of Kentucky, thought that abandoned foundations would do no credit to the nation. He asked his colleagues to imagine a country dotted with similar relics of unfinished business and wondered how the American people would come to view Congress. Clearly, it would not be a sight to honor the country.[25]

At every opportunity, Borland and his lieutenants threw obstacles in the path of the appropriation. Yet at the end of the day, a resolution from the House of Representatives appropriating $500,000 was agreed to by the Senate. On April 14, 1852, it was signed into law. Idle for months, workmen at last went back to their jobs.

MASSACHUSETTS MARBLE

During the debates, Borland occasionally alluded to a contract supposedly worth one and a half million dollars that Walter had signed, which the senator claimed was illegal. Only $100,000 had been appropriated and the architect had no authority to obligate the government beyond that sum. Although he was never specific, Borland was referring to a contract signed on January 13, 1852, by John Rice and John Baird, marble merchants from Philadelphia. The senator was correct in believing that the contract was lucrative and long term, but he was mistaken in believing it did anything more than state the mutually agreed upon prices for marble delivered from their quarry at Lee, Massachusetts. Walter recommended cladding the extension with American marble because the sandstone used in the old building had proven unsatisfactory, especially where it was exposed to the weather. Despite layers of paint protecting the surface, spallation and exfoliation marred its appearance, a condition no one wished to see repeated on the new wings. (During this period only one other public building in Washington was faced with marble. Robert Mills' General Post Office at F and 8th Streets, N. W., was completed in 1842 using marble from Westchester, New York.)

Walter received eighteen bids for marble in response to a newspaper advertisement published on September 19, 1851. Proposals were invited for all the exterior marble, including the material, workmanship, and installation. The bids were accompanied by samples of stone that the contractors proposed to use. After the opening of bids on October 21, 1851, a proposal from Provost, Winter, & Company at $773,918 was the lowest. The firm had executed the stonework at the Patent Office and came highly recommended by the chairman of the House Committee on Public Buildings, Richard Stanton. Before a contract was signed, however, the president wanted the marble tested for strength and evaluated for beauty.

Secretary of the Interior Stuart appointed a five-man commission to test marble samples: General Joseph G. Totten of the Army Corps of Engineers; Joseph Henry, secretary of the Smithsonian Institution; Thomas Ewbank, commissioner of the Patent Office; and Thomas U. Walter. Joining them was America's foremost architectural critic and aesthete, Andrew Jackson Downing of Newburgh, New York, who had recently been engaged by the government to plan landscape improvements for the Mall.

The commission made its one and only report on December 22, 1851.[26] After citing the difficulties of conducting an impartial evaluation of marble given "the present state of science," the report described various experiments carried out on twelve specimens of marble submitted from quarries in Massachusetts, New York, Pennsylvania, and Maryland. The tests were meant to approximate

the effects of weathering and measured such things as density and the pressure necessary to crush the stone. Masons prepared the samples by cutting them into one and a half inch cubes. These were subjected to crushing tests at the Navy Yard using a machine that determined the strength of gun metal. Another test measured the amount of water absorbed by the marbles. Samples were frozen and thawed twenty-eight times in secession to study the probable effects of weathering.

The commission determined that marbles from East Chester and Hastings, New York; Lee, Massachusetts; and Baltimore, Maryland, were appropriate. Letters were sent to the proprietors of these quarries asking them to submit offers while unsolicited testimonials were received explaining the properties that made one marble better than another. Horatio Greenough, for instance, recommend the Lee, Massachusetts, marble. He had personally examined and tested it and found it to be an excellent stone with an even tint and texture. No marble pleased him better for sculpture.[27]

Walter visited the quarries to see if there were enough stone to complete the extension. He did not wish to begin with one marble and finish with another. He found that the Baltimore quarry operated by Provost & Winter (the low bidder) did not contain a sufficient supply, and that firm was therefore eliminated from consideration. By virtue of its beauty, abundance, and strength, the Lee, Massachusetts, marble was selected instead. John Rice and John Baird offered to supply blocks of less than thirty cubic feet for sixty-five cents per foot and larger blocks for $1.98 per cubic foot.

Rice & Baird's contract covered the delivery of marble but not the cutting, carving, or setting. The administration thought it best to separate these aspects of the marble work. Walter recommended Provost & Winter for this work, partly as consolation for having their original bid disqualified but also because he knew them to be faithful and responsible workmen whose rates were quite reasonable. The secretary of the interior forwarded the recommendation to the chairmen of the House and Senate Committees on Public Buildings, who returned it with their approval. On July 12, 1852, Walter signed a contract with Provost & Winter spelling out the prices for cutting, carving, and setting the exterior marble.

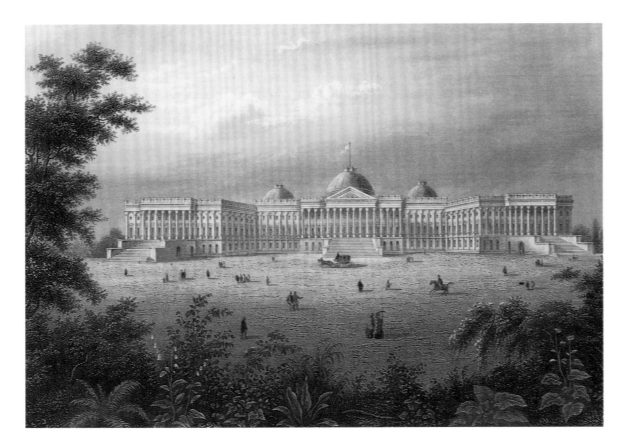

The New Capitol

artist unknown
"Drawn After Nature"
for Herman Meyer
ca. 1851

*S*oon after Walter's design was approved, views of the Capitol with its new wings were published to satisfy the public's curiosity about the "new" building. Even crude depictions such as this conveyed a sense of the intended appearance of the enlarged Capitol.

ANOTHER FIRE
IN THE LIBRARY

Two days after the marble commission issued its report, a disastrous fire destroyed the main reading room of the Library of Congress. The fire was discovered around eight o'clock in the morning on December 24, 1851, by John Jones, a guard who noticed a suspicious flickering through the library windows. Having no key, he broke the door down and, once inside, saw a small fire burning near the north end of the room. Later Jones testified that if water had been available he could have easily extinguished the flames on the spot. But he had to run downstairs for water and, by the time he returned, the fire had spread all over the two-story apartment. Alarms were sounded and seven fire companies responded. The first to arrive was the Columbia. Its hose, still wet from fighting a fire elsewhere, was frozen solid by the extremely cold weather and had to be taken to the nearby gas factory to be thawed. The Anacostia engine company arrived next and was the first to fight the fire effectively.[28] Soon other companies were on the western grounds, throwing water on the fire through the library's windows. One fire engine was brought up the east portico steps and a second was hauled into the rotunda. A hose was run into the library to combat the fire, which was done with "power and efficiency." The fire companies were joined by a detachment of U.S. Marines, who assisted in the bucket brigade and wielded axes to cut away sections of the roof that lay in harm's way. The staircase to the dome caught fire and was chopped away to prevent flames from spreading to the vast store of dry wood that comprised the outer dome. Had the dome gone up in smoke, the disaster would have been devastating. Firefighters worked all day and well into the night. On Christmas day, they were still spraying water on the wreckage.

The toll of the disaster was great. Thirty-five thousand volumes—65 percent of the library's holdings—were destroyed. About two-thirds of the books purchased from Thomas Jefferson in 1815 were gone. Manuscripts, maps, and unspecified "articles of *vertu*" had been consumed by the flames. Gilbert Stuart's portraits of the first five presidents were lost, as were two portraits of Christopher Columbus and likenesses of Hernando Cortes, Peyton Randolph, Simon Bolivar, Baron von Steuben, and John Hanson. Busts of George Washington, Thomas Jefferson, Zachary Taylor, and the Marquis de Lafayette, were also destroyed, as was a figure of Apollo. The elegant room damaged by fire in 1826 was now a burnt-out shell: nothing remained but the bare brick walls. No trace of the ceiling or roof could be found. The heat had been so intense that pieces of the sandstone columns of the west portico scaled off, but miraculously there was little damage outside the main library room.

John S. Meehan, the librarian of Congress, wrote the Speaker an account of the fire. He described the public property destroyed by the fire but was pleased to report that about 20,000 volumes housed in adjacent rooms survived, including the entire law library. Having throughout his tenure prohibited the use of candles, lamps, or other artificial lighting devices in the room, Meehan considered the fire's origins mysterious and asked that it be the subject of a "searching investigation."[29]

Commissioner Easby oversaw the removal of rubbish and the installation of a temporary tin roof over the library. To cover these expenses and to pay for the axes and buckets bought to fight the fire, Easby requested an appropriation of $5,000. The secretary of the interior asked the commissioner to investigate the origins of the fire, and he in turn passed the request to the architect of the Capitol extension. On December 26, 1851, Walter reported that the fire was caused by the framing of one of the alcoves coming into contact with a chimney flue. A fire laid in the room under the library used by the Senate Committee on Indian Affairs (modern day S-152), was left to burn unattended on the morning of the disaster. The sooty flue caught fire and a small hole in the chimney allowed a spark to ignite one of the library's wooden alcoves. "No human forethought or vigilance," Walter concluded diplomatically, "could, under the circumstances, have prevented the catastrophe."[30]

On January 13, 1852, Congress appropriated the money Easby requested as well as $10,000 to begin replenishing the library's holdings. Soon more money was provided to fit up the document room and nearby corridors to serve as a temporary library. Senator James A. Pearce of Maryland, the chairman of the Library Committee, submitted a resolution

on January 27, 1852, asking Senator Hunter's Committee on Public Buildings to look into the steps necessary to repair the library, making it entirely fireproof and capable of future enlargement.

As the most handy architect, Walter was called upon to design a new interior for the Library of Congress reading room. Two days after the fire, he was asked by Easby and the secretary of the interior to prepare plans and estimates for the library's reconstruction. On January 17, 1852, Walter submitted a report accompanied by architectural plans, sections, and elevations for a new library room. In the short time since the fire, Walter had designed one of the most extraordinary rooms in the history of American architecture—a sparkling, incombustible cast-iron library free of any wood except what might be used for furnishings. The proliferation of architectural applications of iron was as rampant in the 1850s as the exploitation of plastics or aluminum a century later. Iron had played only a small role in the building arts until the industrial revolution permitted widespread use of its strength, resistance to fire, and mass production possibilities. Iron seemed ideally suited for fireproof construction, and Walter used it for the

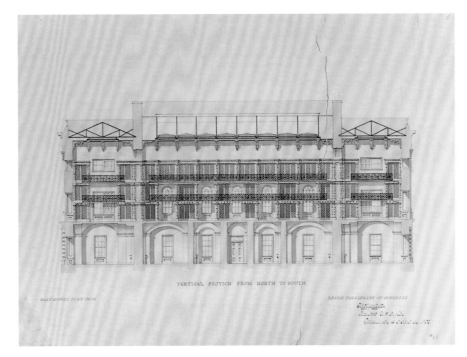

Section of the New Library Room, Looking West
by Thomas U. Walter, 1852

The central library room was flanked by north and south extensions begun thirteen years after the principal space was reconstructed.

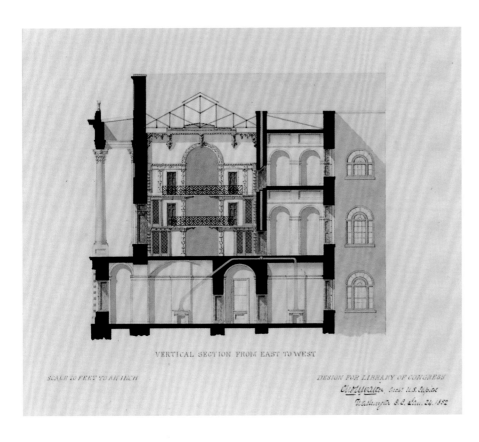

Section of the New Library Room, Looking North
by Thomas U. Walter, 1852

An iron ceiling was the library's most innovative feature. Instead of a single balcony as before, Walter designed two balconies to provide as much shelving capacity as possible.

Perspective of Console Supporting Ceiling

by Thomas U. Walter, 1852

*W*eighing almost a ton apiece, the consoles Walter designed for the library's ceiling were fine specimens of the rococo taste then current in American decorative arts. Swirling scrolls and shells joined grapes, corn, and acanthus in a decorative and imaginative combination.

Details of Roof of Congressional Library

by Thomas U. Walter, 1852

*A*merica's first iron ceiling was constructed in 1852 over the Library of Congress.

library's alcoves, bookcases, galleries, floors, and doors. But the most daring feature of the room's design was its iron ceiling—the first in America and one of the earliest examples in the world. Suspended over the room from iron trusses, the ceiling was made up of thin iron plates cast into deep panels and ornamented with decorative moldings and pendants. Eight skylights, six feet square, were glazed with colored glass. Imposing brackets five and a half feet long weighing almost a ton apiece would help support the ceiling.

To maximize the room's shelving capability, Walter's plan called for a three-tier arrangement with deep alcoves at the first level, shallow alcoves and a walkway above, and bookcases against the upper walls reached from a second balcony. Iron plates were used as balcony flooring, while the main floor would be paved with black and white marble tiles. Double leaf doors at the library's main entrance were made of iron painted to resemble mahogany.

For the future expansion of the library, Walter planned to dismantle a dozen neighboring committee rooms and replace them with a pair of rooms similar to the central reading room but with four levels of book alcoves and shelves. This work would be delayed until committees using the rooms relocated into the Capitol extension. For the work immediately ahead, Walter estimated that $72,500 was needed to build the new iron library in the old, burned-out room. In the House of Representatives, consideration of Walter's report and estimate was urged by his friend, Congressman Chandler of Pennsylvania, on February 12, 1852, but parliamentary wrangling delayed action until the following month. On March 19, 1852, President Fillmore approved the legislation authorizing the repairs and appropriating the funds to carry out the work. Eleven days later, the secretary of the interior appointed Walter the superintendent, architect, and disbursing agent for the library's reconstruction. He was required to post a $20,000 bond to guarantee the faithful discharge of his new responsibilities.[31] Despite the architectural success of the iron library, Walter was never to receive a dime in compensation or a word of thanks for designing it and supervising its reconstruction.

Walter invited ten iron foundries to submit bids for the library work. Eight firms responded, including the Ames foundry in Chicopee, Massa-chusetts ($77,492), Bogardus and Hoppin in New York ($72,518), and Janes, Beebe & Company in New York ($59,872). The latter offered the lowest bid, indeed the only bid within the appropriation, and was awarded the contract. "I have the satisfaction to say," Walter told the secretary of the interior, "that the work has been executed as well and as faithfully as it could have been done by anyone."[32] Walter had been acquainted with the firm since 1846, when he went to New York in search of furnaces for Girard College and visited the foundry of G. Fox & Company, the predecessor to Janes, Beebe & Company.[33] The friendly collaboration between the architect and the New York ironworkers continued with the Library of Congress reconstruction and flourished throughout Walter's years in Washington.

At first it was thought that the library could be rebuilt in a few months. But by mid-September, when much of the ironwork had been received but not yet installed, it became clear that the room would not be finished by December 6—the opening of the second session of the 32nd Congress. Walter explained to Secretary Stuart that despite working day and night the room would still be unfinished when Congress returned.[34] He also found it would cost about $20,000 more than originally thought. The usual grumbles were heard in Congress when the additional funds were requested. Fayette McMullen, a Democratic congressman from Virginia, complained that Walter had made "a very wide mistake" in his estimate and hoped more accurate calculations would be submitted in the future.[35] Richard Stanton defended the architect, telling his colleagues that much more damage had been caused by the fire than was previously known. Unforseen problems were uncovered once repair work was under way, and these factors justified the architect's request for more money. Similar arguments were heard in the Senate, with Richard Hunter of Virginia supporting the architect and Solon Borland of Arkansas speaking against him. Richard Brodhead of Pennsylvania found it difficult to understand how more than $95,000 could be spent on one room. Hunter responded with a review of the financial aspects of the project and defended the architect's management. He concluded by praising the beauty and novelty of iron architecture, which he

thought would be especially interesting to Pennsylvania industrialists.[36]

Brodhead withdrew his objection and the appropriation passed. Twelve thousand dollars was spent for gilding, bronzing, and painting.[37] The decorative painting, Walter said, was devised especially "to keep up the idea of the whole being composed of metal." He intended the room to dazzle with a "brilliancy and richness consistent with its architecture," and he provided a sketch of the room's decoration in a letter to the secretary of the interior written at the end of 1852:

> All the plain surfaces of the ceiling, both horizontal and vertical, to be gilded in three shades of gold leaf, so disposed as to give depth and effect to the panels.
>
> All the ornamental moldings, pendants, and drops of the ceiling to be finished in gold bronze, and the prominent parts to be tipped with gold, burnished, so as to produce a decided and sparkling effect against the dead gold surfaces.

Library of Congress, Looking North

ca. 1870

𝒜lthough it does not appear as such in this view, the iron library sparkled with gold leaf highlights.

> The large consoles to be painted in light bronze green, tipped with gold bronze and burnished gold, for the purpose of giving relief to the fruits and foliage.
>
> All the cases, the railings, and the remaining iron work to be finished with light gold bronze, tipped on all the parts which receive the strongest light with burnished gold.
>
> The wall to be frescoed in ornamental panels, corresponding with the rest of the work.[38]

William De Lamano & Company of New York did the decorative painting and gilding in the iron library. (Later that year, De Lamano was hired to retouch the ceiling over the House chamber.) Work was begun in May 1853, and particularly warm weather made conditions in the room intolerable. Lest a breeze disturb the delicate procedure, windows remained shut while gilders laid on thousands of sheets of gold leaf. Somewhat aghast, the *New York Tribune* reported that men were compelled to work without wearing shirts. It also wrote that the room was hot enough for a Turkish bath.[39] Happily, the efforts of the bare-chested gilders were appreciated by the press and public. The brilliance of the plan and execution of the color scheme excited interest, and Walter was asked about the pigments and gold leaf used to achieve the effect that was so admired. In 1855, he told the editor of the *American Builder's News:*

> The pigments used were the best pure English lead, and the coloring matter umber, Roman ochre, and other ordinary pigments—the whole was ground in boiled linseed oil—The gold leaf was of the best quality—deepest shade—the bronze was what is usually called 'gold bronze.'[40]

In a letter to one of the owners of the foundry that cast the ironwork, Walter described Michael Raleigh's reaction to the room when he saw it for the first time. A native of Ireland who helped built Decimus Burton's Palm House at Kew Gardens near London, Raleigh supervised in New York the casting of each piece of iron for the library. Castings were done from drawings sent by the architect, and Raleigh had not seen the installation in Washington until it was completed. Although well acquainted with every piece of iron, he was not prepared for the splendor of the whole room assembled and decorated with paint and gold leaf:

> Raleigh has got through and is almost leaving for Gotham—I think his visit has been an effective

one—I wish you could have seen him when the Library in its fullest blaze of noonday glory *busted* on his astonished vision from the little door where Meehan has been so often wont to anchor himself and feast his enraptured *peepers*—It was quite affecting to see how his eyes sparkled.[41]

The reconstruction was completed on July 1, 1853, and over the following weeks books and furniture were moved into the new room. In early August the president and his cabinet came to the Capitol to inspect Washington's newest attraction, taking Walter by surprise—he had invited the president but received no advance word of the visit. On August 10, 1853, he wrote an account of the sightseeing excursion to Charles Fowler, one of the partners in the Janes, Beebe company:

> Yesterday I went up to the Library to make some arrangement about covering the inner door, and to my surprise there was the whole cabinet with the President (except Judge Campbell) and they had been there an hour—the room was dirty; the furniture stacked up and covered, and every thing in uproar—I made the best of it I could—the President said he wrote me a note some time ago, and all I could say was, I did not receive it—This morning it came to hand by mail, having been 3 days in the post office.[42]

Less than two weeks later, however, the "uproar" had apparently quieted: the new Library of Congress was opened officially to the public on August 23, 1853.

AN ADMINISTRATIVE TRANSFER

The president who visited the library was Franklin Pierce, who had become America's fourteenth president on March 4, 1853. Handsome, gracious—and alcoholic—Pierce was elected partly because he was uncontroversial, having taken few stands in his public career that would anger partisans in the north or south. One of the more striking campaign slogans chanted by his Democratic supporters was: "We Polked you in 1844; we shall Pierce you in 1852!" Because of his inexperience, the president depended heavily on the cabinet, particularly Jefferson Davis, the secretary of war and the cabinet's

most forceful personality. A month after taking office, Pierce agreed to let Davis control the work at the Capitol, transferring the extension project from the Department of the Interior and placing it under the War Department. (Meanwhile, the commissioner of public buildings, who took care of the old Capitol and grounds, remained under the Department of the Interior.) The transfer reflected Davis' long-held interest in the enlargement of the Capitol and was a partial triumph for Walter's Senate enemies led by Solon Borland of Arkansas.

Two weeks before Pierce's inauguration, Borland introduced legislation making the commissioner of public buildings the disbursing agent for the extension project. Commissioner Easby, unlike the architect, held an office created by law and had been confirmed by the Senate. In Borland's view, Easby was a vigilant public servant who exposed fraud and waste in Walter's management. The commissioner had first brought charges against Walter in a letter to Fillmore written in July 1852. He claimed the architect was using public money to purchase poor stone, which he called "the refuse of the quarry."[43] Walter refuted the accusation and the matter was dropped until Easby caught the eye of the senator from Arkansas. Borland had recently been named to a special investigative committee inquiring into abuses, bribery, or fraud in government contracts. Chaired by Sam Houston of Texas, the committee had been appointed under a Senate resolution passed on August 6, 1852. Although they looked into several different areas of illegal activity, such as blackmail in the navy, members of the Houston committee spent a good deal of time investigating the Capitol extension project. Over a period of weeks they took testimony from Easby and about thirty of his confederates, most of whom were dismissed workmen or disappointed contractors; Walter was not able to ask questions or otherwise cross-examine the witnesses. Some of the charges were minor, such as a story regarding Sam Strong's offer to pay some of the men to burn Senator Borland and Congressman McNair in effigy.

Easby's accusations were far more extensive. He testified that the marble contract with John Rice and John Baird would cost the government much more than necessary. Blocks of more than thirty cubic feet were being bought for $1.98 a foot and cut up into small blocks that would have cost only sixty-five cents. So far, the commissioner

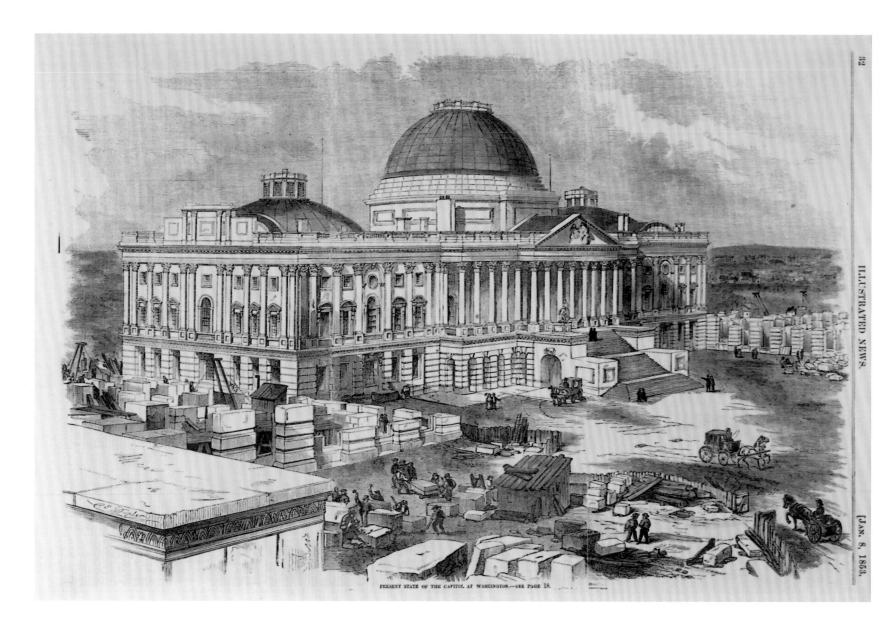

PRESENT STATE OF THE CAPITOL AT WASHINGTON.—SEE PAGE 18.

Present State of the Capitol at Washington

Illustrated News (New York), 1853

By the end of the Fillmore administration, the Capitol extension had risen just above ground level.

calculated, the government had been "fleeced of $44,326." The gneiss purchased for the foundations was bad, he asserted, and bricks were inferior as well. Easby claimed that Provost & Winter had a "private" contract in violation of the law and suggested that they must have paid $50,000 under the table to land such a deal. And so it went, Easby piling slander upon slander on Walter, while the architect sat silently in the committee room taking notes.

Other witnesses took the stand to grind their axes before Houston's committee. Some registered complaints against Sam Strong, telling tales about his extraction of money as a condition of employment, paying favorite workmen for labors never performed, or appropriating public material for private gain. Most of these complaints were unfounded, but a few did have merit. For example, a few masons sneaked their apprentices onto the public rolls, where their pay was more than their skills would otherwise command; once the deception was discovered the masons and their apprentices were dismissed. Also, and more damningly, Strong was accused of having an interest in the brick contract, a conflict of interest that caught Walter off guard. On November 18, after the truth

of the accusation became known, the architect accepted the superintendent's resignation.

Walter replied to the accusations against him in a manuscript covering 123 handwritten pages. Where fraud had been exposed, he supported prosecution of the villains. The charge of accepting unskilled workmen, which had some truth to it, was particularly galling to the architect who valued craftsmanship and hard work above just about every other virtue. Walter wrote: "I would have not suffered them to remain on the work a single hour had I known they were inferior workmen. The whole system of apprenticeships . . . was kept entirely from my knowledge until the men were dismissed this winter." These cases were rare, especially when it was considered that more than 800 men were employed on the Capitol extension. Responding to the baseless accusations—which were plentiful—Walter carefully, methodically, and forcefully rebutted them with facts and by revealing the disreputable motivations of his accusers.

Walter explained the history of the two marble contracts, showing the step-by-step process that led to hiring Rice & Baird (the suppliers) and Provost & Winter (the installers). Each step was taken with the approval of the president of the United States, the secretary of the interior, and the Committees on Public Buildings of the House of Representatives and Senate. If the contracts were illegal as Easby claimed, they reached that unfortunate status under the watchful eyes of some of the nation's most astute legal minds.

A similar history of the brick contract was given, and again the whole truth exposed Easby's accusations as groundless. Walter admitted that brick made by Christopher Adams was unfit, but it also had been rejected. The contract was assigned to another brick maker, who made improvements but still failed to come up to Walter's high standards. The contract then passed to a third brick maker, Byington & Company of Washington, which delivered very good bricks. Thus, the architect reported that the government now paid $6.37 per thousand bricks, which ordinarily cost eight dollars on the open market.

Workmen, stone masons, and contractors testified to the faithfulness of the work. President Fillmore and Secretary of the Interior Stuart wrote letters in response to questions posed by the committee. Strong said that he knew why the commissioner of public buildings held such a grudge against those in charge of the Capitol extension. He recalled Easby's son arriving at the Capitol one day with two loads of stone from his father's quarry. The stone had been rejected by builders of the Washington Monument and the younger Easby then tried to pawn it off at the Capitol. Strong inspected the stone and saw that most of it was hard, flinty, and shaped like pancakes. He refused to accept it. Strong concluded that "had Captain Easby's son had the furnishing of the stone from his father's quarries, these complaints would not have been made."

By the start of the 33rd Congress, Houston's committee had finished its work and on March 22, 1853, Senator Borland issued its voluminous report.[44] Despite Walter's explanations, the committee's conclusions were dictated by Borland's unexplained vendetta against the architect. It concluded that Walter's administration of the works was characterized by "great irregularities" and "gross abuses." Public funds had been spent wastefully and should be put under the control of another official.

Walter seemed to take the report in stride. Perhaps he knew of Latrobe's troubles and took solace in the fact that architects in public service are fair game for political sport. The sole recommendation made by the report was to take the disbursement of money out of the architect's control and place it in "more trustworthy hands." Exactly whose hands they might be was left to the president to decide.

On March 23, 1853, the day after Borland presented the Houston committee report, President Pierce issued an executive order transferring the Capitol extension project from the Interior Department to the War Department.[45] An officer of the Corps of Engineers would be appointed to exercise a "general supervision and control of the whole work." For the next nine years the Capitol extension and its architect would be governed by military rule.

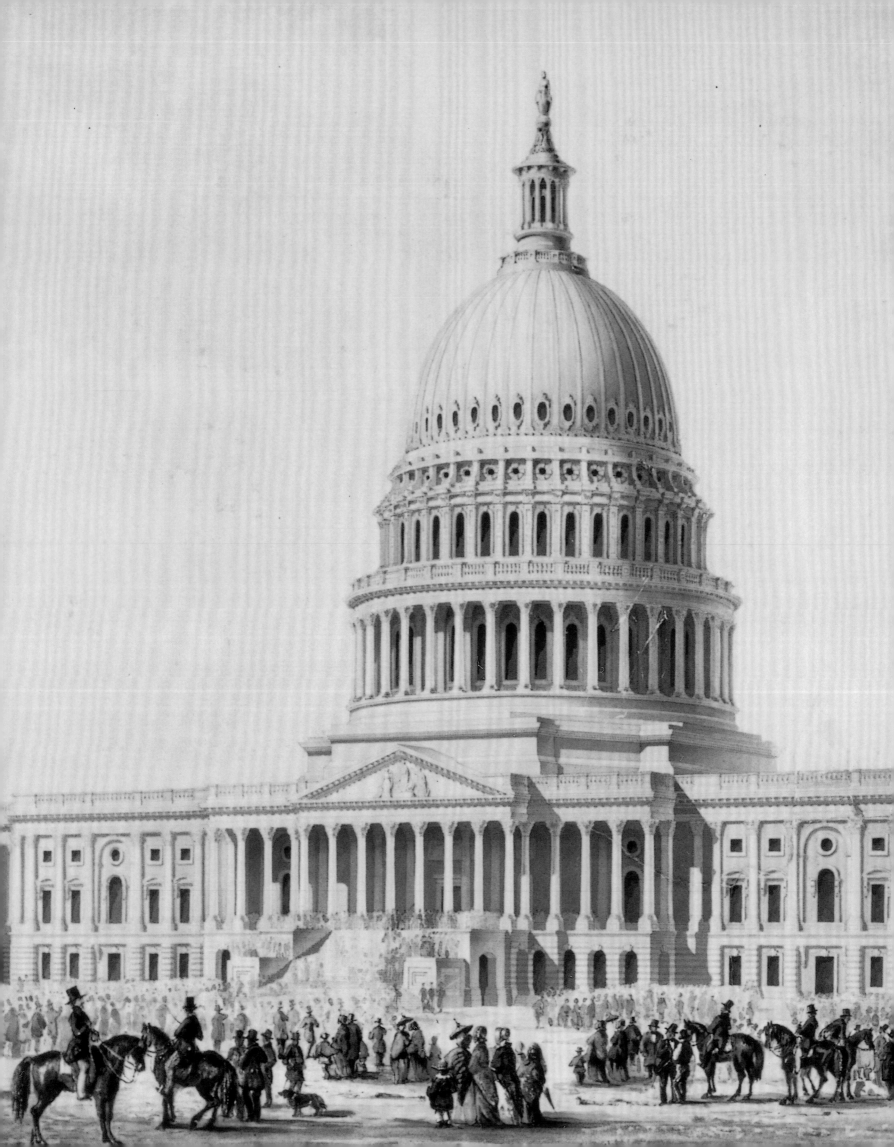

CAPTAIN M. C. MEIGS, ENGINEER IN CHARGE

*T*he Capitol extension project had been under way less than two years when it was transferred to the War Department. It was not immediately clear how the architect would function within the new arrangement, but Walter would no longer engage in business dealings, contract negotiations, or the hiring of any workmen except those in his drafting room. This aspect of the change was not altogether unwelcome, as he considered the business part of the job bothersome. Glad to be rid of that headache, Walter looked forward to spending more time engaged in purely architectural pursuits. He could not have easily foreseen that from his drafting board he would watch the Capitol extension project veer from the course he and the Fillmore administration had charted for it.

The newly appointed secretary of war, Jefferson Davis, was responsible for taking the extension project from the Department of the Interior and placing it under the authority of the War Department. His early role in the matter ended when he quit the Senate on September 23, 1851, to run (unsuccessfully) for governor of Mississippi. Davis'

interest in the Capitol extension was undiminished by his two-year absence from Washington, however, and soon after joining President's Pierce's cabinet on March 7, 1853, he maneuvered the project into his department. To manage day-to-day affairs, Davis appointed Montgomery C. Meigs engineer in charge. Meigs was a captain in the Army Corps of Engineers, the government bureau most experienced at dealing with large construction projects. At the same time, Davis put Meigs at the head of the Washington Aqueduct and the Patent Office extension, thus giving the engineer charge of three of Washington's most ambitious public ventures. Both graduates of West Point, Davis and Meigs saw eye-to-eye on most issues, and, despite the obvious difference in rank, they were compatible and sympathetic colleagues.

At age 36 Meigs took the reins of the Capitol extension project with gusto, immersing himself in the study of architecture, acoustics, heating, ventilation, and decorating. Included in the orders he received from the secretary of war were instructions to pay close attention to the practical aspects of the new legislative chambers. The overriding objective was to provide healthy chambers where the nation's legislators could hear and speak with ease. Inspections of acoustically successful assembly rooms and visits to the marble quarry in Massachusetts were authorized in the orders. Meigs was instructed to make a thorough examination of the

The Capitol with a New Dome (Detail)
by Thomas U. Walter, ca. 1855
The Athenaeum of Philadelphia

Jefferson Davis

Mathew Brady Photograph, ca. 1860

Senate Historical Office

*S*oldier, statesman, and only president of the Confederate States of America, Davis (1808–1889) represented Mississippi in the House and Senate prior to becoming secretary of war under President Franklin Pierce in 1853. His direction of the war department was one of the few successes in an otherwise lackluster administration. Through Captain Meigs, he supervised the work on the Capitol extension and new dome, approving changes to the floor plan and encouraging a comprehensive approach to interior decorations. Davis' taste and opinions greatly influenced design decisions.

At the end of the Pierce administration Davis returned to the Senate where he chaired the Committee on Military Affairs. He defended military control of building projects in Washington and used his influence to keep Meigs in power. Davis continued to promote their plans following Meigs's removal in 1859. After Mississippi seceded from the Union in 1861, Davis left the Senate to embark on another phase of his career, one that would overshadow his contributions to the design and construction of the Capitol extension and dome.

foundations as well, because "unfavorable reports have been spread abroad." Of course, the strength of the foundations had already been well documented. Apparently motivated by a determination that the Capitol not become the laughingstock of condescending foreigners, Davis' directive is indicative chiefly of his desire for the favorable opinion of the European community.

Construction of the Capitol extension and the Patent Office extension was left to Meigs to devise as he saw fit. There could be no question about Meigs' authority or the power Davis vested in the captain of engineers:

> As upon you will rest the responsibility for the proper and economical construction of these buildings, you will consider yourself fully empowered to make such changes in the present administration as you may deem necessary, and to regulate the organization hereafter as your experience may dictate.[1]

Walter reacted silently to the change in administration. Although the recent events could hardly be viewed as a vote of confidence, neither had he been dismissed; further, the move to make William Easby the project's disbursing agent had thankfully failed. The biggest thorn in Walter's side was plucked when the president appointed Solon Borland minister to Nicaragua. With these antagonists out of the picture the prospects for peace looked good.

With the administrative changes made at the Capitol, Robert Mills, now seventy-two years old and out of work, saw an opportunity to replace Walter. At the end of Fillmore's presidency Mills presented petitions signed by members of the House of Representatives and Senate asking the president to "restore" him to the office of architect of the Capitol, a post he supposedly held in the Jackson, Van Buren, and Taylor administrations. (Mills never held such an office, nor did an office with the title of "architect of the Capitol" exist during his lifetime.) In the opening days of the new administration he wrote Pierce, Davis, and Meigs claiming that although his plans had been adopted by the Senate and approved by the president, Walter had been hired to execute them. Simple justice, Mills argued, demanded Walter's removal.[2]

Possibly Mills justified the misrepresentation as a means to put food on his family's table. When this application failed, he asked to be appointed

commissioner of public buildings. After Pierce appointed an old friend and fellow New Hampshirite Benjamin B. French to that post, Mills asked Davis to recommend him for a job in the Capitol extension drafting room. He would consider any employment because he was "without means of providing the necessary wants of my family." Davis forwarded the request to Meigs, who endorsed the letter with a stern memorandum:

> There would be manifest impropriety in employing upon the Capitol a gentleman who is a rival of the architect who made the designs & who claims the merit . . . I have seen some of Mr. Mills working drawings of the Patent Office & I should not be willing to trust to his assistance in carrying on this work. As a draftsman Mr. Mills was tried in the Engineer office & not found qualified.[3]

Captain Montgomery C. Meigs
ca. 1855

ALTERING
THE FLOOR PLANS

By the end of May 1853, Meigs had exposed the foundations to the bottom of the footings and bored through them in various spots to allow a thorough inspection. He concluded that they were sufficient to bear the weight of the proposed structure but noted that the mortar would have dried sooner if more hydraulic lime had been used.[4] While the foundations were being reexamined, Meigs and Walter were working on significant changes to the floor plans of the extension, relocating the legislative chambers from the western half of the wings to their centers. The changes were Meigs' idea, and the plans were worked out and drawn by Walter. The engineer reported:

> The plans were prepared by the accomplished architect, Mr. Thomas U. Walter; and I am happy in being supported in his opinion, that not only will the legislative halls be better adapted to their main purpose as rooms for debate, but that the architectural beauty and the convenience of the buildings will be increased by the changes which have been made.[5]

President Fillmore had favored chambers with a western exposure to allow views of the well-tended lawn and the tree-shaded Mall. In Walter's 1851 plans the Senate chamber was designed with

After six and a half years as supervising engineer of the Capitol, Meigs (1816–1892) left indelible marks upon the extension and new dome. From mechanical ventilation to painted decorations, from tile floors to sculptural enrichments, Meigs' imprint was seen everywhere. He came to believe that the Capitol was more a legacy than a job, and he worked tirelessly to make it as sturdy and beautiful as possible.

Meigs' most significant engineering achievement was the Washington Aqueduct, authorized in 1852 to provide the federal city and Georgetown with a municipal water system. Among its feats was the Cabin John Bridge, a 220-foot single-span masonry arch—the world's largest for more than forty years. At the beginning of the Civil War President Lincoln named Meigs quartermaster general, a crucial post that was perfectly suited to his organizational and management talents. In 1882 Meigs began construction of the Pension Building in Washington, D. C., which he designed using the Palazzo Farnese in Rome as a model. Today it houses the National Building Museum.

twenty-five windows and the House chamber was to have twice that number. But the plans also showed that legislators going to and from their chambers would be obliged to pass through public corridors that were likely to be thronged with lobbyists and sightseers. A similar situation already existed in the old Capitol and was the source of many complaints. Meigs came up with the idea of relocating the chambers to the center of each wing, placing doors on all four walls, and surrounding them with lobbies and corridors, some of which could be made strictly private. Thus, the public could be kept at arm's length if necessary. "No one who has seen the crowds which collect in the public lobbies of the houses during the last days and nights of a session of Congress," Meigs wrote, "can fail to understand the disadvantages of this single entrance, and the great advantages of the public and private communication of the new plan."

While the new plan would improve circulation and egress, it also meant that the pleasant garden views were never to materialize: the new chambers were designed without windows. Light and air would be supplied by artificial means, challenges that perfectly suited Meigs's love of science and mechanical engineering. Every aspect of the interior environment could be mechanically controlled, freeing it from the vagaries of the outside weather. Steam-powered fans could ventilate the chambers, while gas lighting and skylights would eliminate the need for windows. However, although the power of gas and steam made it possible to design windowless chambers, Meigs failed to anticipate the psychological effect such rooms would have on future legislators. Windowless chambers and mechanical ventilation were to become the most controversial features of the Capitol extension project, hotly debated and routinely condemned well into the twentieth century.

Meigs claimed that rooms without windows were well suited for speaking and hearing. He reasoned that in winter windows separating warm air inside from cold air outside promoted descending sheets of cold drafts that were harmful to persons of "sensitive nerves" or "feeble health."[6] By preventing drafts, windowless rooms would be healthful, which, in turn, would nurture strong speaking voices. From skylights, Meigs claimed,

> we obtain a pleasanter light, ample for all useful purposes, as proved by its adoption in all the best constructed picture galleries. We also exclude the sounds of the exterior, which, saturating the air as it were, distract the attention, and even overpower the voice we wish to hear.... Open windows for hearing will be worse than closed ones; they not only let irregular, disturbing currents of air in, but they let the voice out....[7]

In the revised plan, galleries could be placed around four sides of the chambers. Visitors would ascend to the gallery level on broad flights of marble stairs. "These stairs will be the most stately in the country," Meigs promised, "and when embellished with our beautiful native marbles will, I trust, compare favorably with any abroad." A corridor on the first floor lined with Corinthian columns was designed to run the width of the south wing, and vestibules with coupled marble columns were provided at the principal entrance to each wing on the second floor. Emphasis would be placed on architectural and decorative variety to avoid monotonous repetition.

Meigs described the new plans in terms of richness, luxury, and elegance, reflecting the administration's determination that the Capitol extension should compare favorably with the great buildings of Europe. The previous administration had been more economy minded, intending the interior finishes to match the old building's whitewashed walls and stone floors. But with Meigs in charge—encouraged and backed by Davis—the interiors of the new wings were destined to showcase the finest materials worked by the best artists and craftsmen to the everlasting credit of the nation and the administration of Franklin Pierce. Walter, too, was pleased at the notion of high style interiors, although he would later disagree with some of the methods used to achieve the effect.

The new plans and the new embellishments were accommodated within the exterior that Walter had already designed. Adjustments to the foundations were necessary, but the work was at a point where that could be done without much loss. The only exterior alteration that Meigs suggested was the addition of pediments to the east porticoes. Walter's original design did not call for pediments because he felt that the entrances to the wings should not overshadow the central entrance into the rotunda. But Meigs intended the entrances to the extension—both outside and inside—to be as grand as possible and ordered pediments placed

on the porticoes. American sculptors would be commissioned to fill them with beautiful specimens of their art, making up for the poverty of design that Meigs found in Persico's three figures standing in the central pediment. For the doorways sheltered by the porticoes, as well as the entrances into the connecting corridors inside, monumental bronze doors would be commissioned to greet legislators and the public with artistic grandeur rivaling Ghiberti's baptistery doors in Florence.

On May 19, 1853, Meigs submitted the revised plan of the south wing for the president's consideration, intending to present a similar plan for the north wing if the first one was approved. Before a decision was made, the engineer was off to Philadelphia, New York, and Boston inspecting auditoriums to help evaluate the probable success of the chambers as rooms for speaking and hearing. Meigs left Washington on June 8 in the company of Joseph Henry, the secretary of the Smithsonian Institution, and Alexander D. Bache of the Coast Survey. In Philadelphia, the trio visited Girard College, the Music Fund Hall, Eastern Penitentiary, and Robert Mills' circular Sansom Street Baptist Church.[8] They then traveled to New York to inspect hotels, churches, and lecture halls. In Boston they visited the new music hall, the Massachusetts Statehouse, Faneuil Hall, and the vaults under the Beacon Hill reservoir. Upon returning home Bache and Henry recommended to the president that Meigs' revised plans be adopted pending further study.[9] Their recommendation was made on June 24, 1853, and the president approved the revised plan for the south wing three days later. The revised plan for the north wing was finished on July 5 and approved immediately.

Construction of the wings had been suspended while the president decided whether to adopt the new arrangement or continue with the old one. Walter regretted that the lull occurred during nice weather but kept busy finishing up the last details of the library reconstruction. In July he took his family to Cape May for a holiday, and upon returning he wrote a friend describing the perils of leaving town for a vacation:

> Here I am again in this center point of civilization, with as uncivil a set of fellows about me as you could well imagine—one would think that after being away some time they would have forgotten me and learned to go on their own hook, but no such good luck; almost every body I meet seems to have a string of questions as long as a fence rail, and my Capt. keeps after me with whips and spurs from morning to night—this going away to rusticate is not what it is cracked up to be; every thing gets behind hand. . . .[10]

While the architect was "rusticating" at the New Jersey seashore, granite from Richmond was being installed on the foundations. Above the granite, the lower courses of marble were being put on the outside walls. The marble was shipped by railroad from Lee, Massachusetts, to Bridgeport, Connecticut, where it was transferred to steamers for the Atlantic voyage to the Chesapeake Bay and up the Potomac River. Rice & Baird leased a wharf at the foot of New Jersey Avenue, on the banks of the Anacostia River, where cranes were used to unload the ships. As the stone came off, John C. Harkness, the government's "sworn measurer," made an account of each block, measured its size, determined its value, and rejected any that was unfit. Walter observed that Harkness had a large private business and "don't choose to give Uncle Sam more time than he finds convenient," but the architect also felt he was not paid nearly enough for the responsibilities of the job.[11] Keeping track of the inventory was "old grannie Bryant," the marble clerk who was slow, dishonest (in Walter's opinion), and was working only for his salary, "not for the love of being useful." The bills were made out by Zephaniah Denham and sent to Meigs for signature. If any question arose, Meigs sent the papers back for clarification or correction. It could take weeks or months for the contractors to be paid for their marble, and Walter occasionally tried to speed things along. In Meigs' judgment, the architect sometimes appeared too friendly with the marble contractors.

When Meigs first took charge, he discovered that the outside walls were at least one inch, and sometimes as much as four inches, too thick. The window sills on the east front were more than an inch higher than those on the western side. He vowed to keep a closer watch on the masonry department. In his private journal Meigs kept a careful account of the number of bricks laid each day, noting which masons laid the most bricks, how much bricklaying cost, and indeed every aspect of the Capitol's brick business. On August

Revised Plan of the South Wing, Principal Story

by Thomas U. Walter and Montgomery C. Meigs 1853.

Soon after Meigs took control, he and Walter revised the floor plans to bring the legislative chambers to the center of each wing. There, Meigs thought, the absence of windows would result in better rooms for speaking and hearing, and mechanical ventilation would be more dependable than nature's own breezes. Multiple sets of doors on all sides of the chambers also improved circulation.

President Franklin Pierce and Secretary of War Jefferson Davis approved the revised plan for the south wing on June 27, 1853.

Revised Plan of the North Wing, Principal Story

by Thomas U. Walter and Montgomery C. Meigs 1853

Principal features of the revised plans included two sets of monumental stairs for the public to use when coming to see Congress in session and two sets of private stairs exclusively for legislators.

President Franklin Pierce and Secretary of War Jefferson Davis approved the revised plan of the north wing on July 5, 1853.

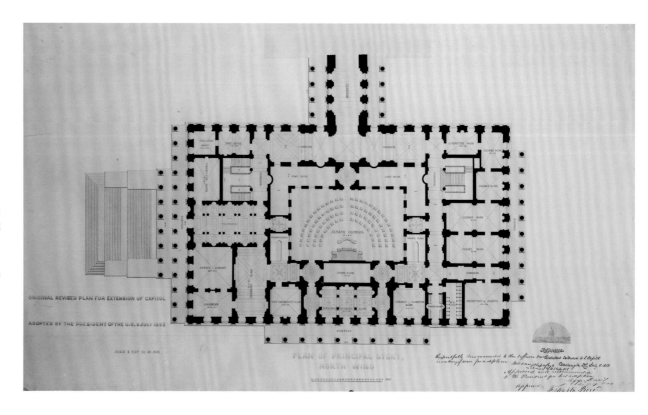

3, 1853, for instance, he noted that he had fifty bricklayers on the job but hoped to hire twenty more. The following week he had sixty men, who laid a total of 43,000 bricks a day using ninety-one barrels of cement. Three weeks later the number of bricks laid climbed to 53,000 a day. At that rate Meigs calculated that it cost exactly $4.07 to lay 1,000 bricks.

Brick was bought from six suppliers, whose daily deliveries barely kept up with demand. In September Meigs went on a brick-finding expedition; while away he wrote Walter with the suggestion to use what was called "clouded marble" for caryatids intended for the lower vestibules. The pronounced blue veining of some of the Lee marble made it unsuitable for the exterior walls, but for interiors it might prove useful as well as beautiful. Walter's reply illustrates the cordial nature of their early collaboration and provides insights into the workings of an architect's mind:

> I like your suggestion as to Heebner's clouded marble for the interior of the Basement; I think it would be very beautiful and appropriate. —the colonnade running through the south wing would look well of the lighter shades of blue and white, as the light at both ends will be bright—by the way I hope we shall yet get the ceiling and all the pilasters of this corridor in marble, or whatever we adopt for the columns; I think this ought be the grand feature of the basement—The eastern vestibule will be dark, and as it is entered directly from the deep double arcade, and has no other light, I think it should have a crypt-like appearance, and I have even questioned whether it would not look better to repeat the outside rustic piers, but of smaller proportions, and polish them. Your idea of Caryatids is a very beautiful one, but don't you think they would do better in the principal story where they would be in a good light?[12]

As in Latrobe's experience almost forty years earlier, caryatids were not to materialize inside the Capitol, but a considerable quantity of "clouded marble" would be used.

These sculptural musings did not distract Meigs from his immediate quest to find a reliable supply of brick. The need was urgent because of Cornelius Wendell's failure to make good on a contract for ten million bricks. Meigs visited brickyards in Baltimore, Philadelphia, and New York, striking deals to buy all the bricks he could. He was afraid the lack of brick would delay construction and make it possible for Congress to order a

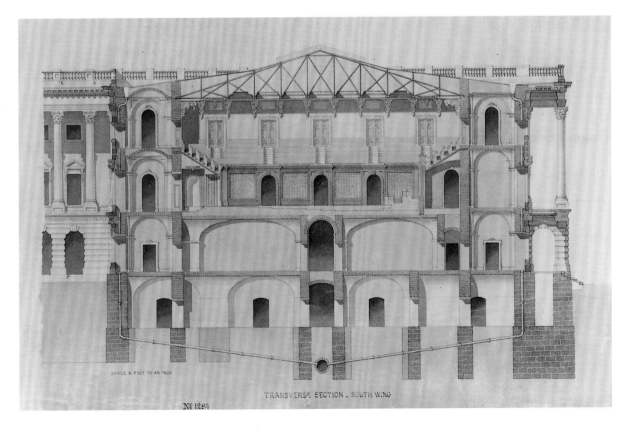

Transverse Section, South Wing, Looking East
by Thomas U. Walter
1857

Although the chambers were relocated in 1853, their general size and architectural treatment remained essentially as Walter had designed them in 1851. The rectangular House chamber remained two stories high, surrounded by a gallery, and covered by a flat iron and glass ceiling carried from iron trusses in the attic space.

restoration of the floor plans back to Walter's originals. Any claim he might have as an architectural collaborator would then be dashed, and history would remember that he merely built someone else's design. And that was not enough credit for Meigs, who was particularly sensitive to his legacy and to his place in history. He drove the works relentlessly to the point of no return.

DISTANT THUNDER

Considering past experiences, Walter dreaded the opening of Congress. He did not know what would upset members this year, but he knew that something would become the center of controversy before long. He faced the gathering storm with a sense of helplessness.[13] Although the bitter battle over the Kansas-Nebraska Act would soon drive factions in Congress farther apart over the slavery issue, the session started quietly. Visits to the new iron library were a favorite diversion and brought its architect well-deserved and almost unanimous praise. An unflattering comment, however, was made by Henry A. Wise, a former member of the House from Virginia, who dismissed the room as "all gammon, frippery, [and] tinsel." The remark was overheard by Librarian of Congress John Meehan, who was happy to hear someone complain because if everybody liked it, something was surely wrong.[14] In a contemporary account of the room written for *The Crayon,* a New York art journal edited by John Durand, another critic thought the new room was more forbidding than the old one:

> I should have liked an opinion of the new, and fire-proof library—all iron, save the floor, of stone. Despite its delicate tint of 'Portland Stone,' its heavy iron cornices, massive brackets, cast into every vegetable beauty of *corn-u-copiae,* its liberal sprinkling with two thousand dollars worth of California gold, its straightest of all strait lines, so sharp, so many, that I never dared to lean anywhere—despite all these improvements and expenses, the old library, simple and unostentatious, its arched recesses affording something like retirement, (each one containing a chair and a writing table) the sober hue of its mahogany woodwork, was far pleasanter to my unlearned eyes and imagination. Cases of medals hung around then, portraits of our elder Presidents,

> and some others, agreeable to all beholders. Such things are no longer permitted: they would interfere with the supremacy of the cast-iron ornaments.[15]

As the session dragged into summer, heat buildup in the attic made the library's reading room uncomfortable. To exhaust hot air from the space between the iron ceiling and the roof, Walter asked Pringle Slight to replace a solid door with a louvered one. "Please attend to it as soon as possible," Walter wrote, "as Mr. Meehan is being roasted alive."[16] The underside of the glass skylights on the roof was painted to block direct rays of the sun to help cool the library. Following the architect's suggestion, white paint was tinted with sky-blue to promote an atmospheric effect.[17]

While Walter tried to control the temperature in the iron library, his friend and congressional champion Richard Stanton was steaming for purely political reasons. At the start of the session he was deposed as chairman of the Committee on Public Buildings, and he intended to stir up trouble to show his unhappiness.[18] He planned to introduce a resolution inquiring into the cost of changing the plans of the extension, plans about which he had had a good deal of say in 1851. The resolution also inquired into the circumstances surrounding "military rule" at the Capitol and other civilian projects. Walter tried to dissuade the congressman from making these inquiries because he was satisfied with things as they were and wished to avoid squabbles. Battles like the one he now foresaw produced only "calumny, slander, lies, and every demon that envy and malice can conjure up from all of which I say *'Good Lord deliver us.'*" But Stanton pressed his inquiry, and Walter's prayers for peace went unanswered.

On January 23, 1854, the Senate took up consideration of an army appropriation bill containing $325,000 for the Capitol extension. Robert W. Johnson, who had taken Borland's seat in the Senate, addressed his colleagues with concerns about a civil project being undertaken by the military:

> This Capitol is not a fort. It is not an arsenal. It is not a barracks for troops. It has no connection to military affairs. I would gladly vote to keep the Army disconnected from this portion of the public buildings. The appropriation does not rightly belong to this bill. To retain it here is against all precedent. There is no sympathy,

no connection between the object of the appropriation and its position in this bill.[19]

Johnson admitted that he understood the president assigned the extension project to the secretary of war because of Davis' "capacity, taste, and judgment." The assignment had, however, nothing to do with the military affairs of the country. He wondered who would replace Davis if he left the cabinet. Would the works go to the postmaster general next?

Lewis Cass of Michigan voiced concerns about the new plan for the Senate chamber. He had studied the new scheme in Meigs' office and thought that too much emphasis was given to appearances and not enough to utility. "Architects," Cass concluded gravely, "sacrifice everything to beauty." But the lack of windows in the chamber was what worried Cass the most:

> Mr. President, it has seemed to me that the air and light of heaven were good enough; but the new room designed for the Senate Chamber, in the Capitol extension, I understand is not exposed to the atmosphere on any side. It is absolutely in a state of isolation. There are passages between the walls of the new Senate Chamber and the extension wall of the building, preventing the air of heaven from coming in. The air is to be pumped up, or pumped down, by some kind of machine, nobody knows what. I think, however, it is too late now to make any changes in it. I must leave to my successors to ascertain whether the building will suit them or not.[20]

Senators then bantered back and forth about the merits of the plan until Senator Johnson demanded to know where the steam-powered fans would be located. "I should be glad to know," he said, "because I have heard of explosions of steam engines."[21] This statement drew gales of laughter, which encouraged Johnson to elaborate on the thought and pose a second question: he wanted to know what horsepower the steam engines were to be. In any event, the concept reminded him of Guy Fawkes and the pile of combustibles once placed under the Parliament building in London.

Amid nervous chuckles, Johnson's question was referred to the architect. The image of the Senate being blown sky-high seemed to deflate any seriousness left in the day's business. The last word came from George E. Badger of North Carolina, whose common sense challenged the modern manner of mechanically heating and ventilating the new chamber:

> I would go back to the old-fashioned notions of our forefathers. When we want cool air in a room, I would open a window and let it come in itself. It needs no forcing. It comes with readiness if you give it a fair opportunity. Then with regard to the heated air, which, by a provision of nature, I am told, for I do not understand these things philosophically, will gradually get higher and higher as it gets warmer and warmer, you have nothing to do but to have a comfortable little ventilator at the top, and you will soon get rid of it. But this, sir, is the age of improvement; this is the age of progress; and I fear that my friend from Michigan [Lewis Cass] and myself will, in consequence of the remarks we have made today, be stamped 'old fogies' forever.[22]

Shortly after Badger took his seat, the Senate adjourned without voting on the appropriation to continue the Capitol extension. But it had been a jolly, good-natured afternoon.

During this period Meigs studied Rice & Baird's contract and hoped to amend it so that the outside walls could be faced with thicker blocks of marble than originally specified. He also wanted most, if not all, of the 100 exterior column shafts to be wrought from a single stone. As it stood, the contract allowed shafts to be made of drums four or more feet long. Like Joseph Elgar during the Bulfinch era, Meigs felt that monolithic shafts would contribute to the building's grandeur and stability. Shafts wrought from a single stone would cost $1,400 apiece, which was $300 more than a shaft composed of two or more stones. Congress agreed to Meigs' recommendations without debate, and on March 1, 1854, he was granted the authority to enter into a supplemental contract for these items.

Meanwhile, on February 13, 1854, the House had appointed Richard Stanton chairman of a select committee to investigate military superintendence at the Capitol, armories, and custom houses. Stanton's committee was strikingly similar to Houston's Senate committee, which had hounded Walter a year earlier. There was considerable sympathy with Stanton's position among those who saw "military rule" (as it was invariably called) as expensive and arbitrary. Walter dreaded Stanton's work and hoped it would not alter the administrative arrangement that he

liked so well. He recounted his admiration for Meigs to his father-in-law just as Stanton began his trouble making:

> The Capt. is as noble a man as the country can produce, and he is better fitted for his post than any one they could find whether *soldier* or *civilian,* and I most sincerely desire that he may not be removed; such a thing would be a disaster for the country in general and me in particular—you have no idea what a luxury it has been to me during the past year to be able to devote myself to the legitimate professional duties, and be freed from the annoyances of contractors, appointments, disbursements, and the like, all of which take time, unhinge the mind, and create an army of enemies.[23]

Walter's position was growing awkward. Despite his admiration for Meigs, friends such as Stanton attacked military rule as, among other things, contrary to law. When the responsibility for disbursements was taken from the architect, Stanton claimed, Congress had intended to place it in the hands of a minor official who would simply look after accounts. Instead of assigning a clerk to write checks, however, President Pierce placed the works in the hands of a dynamic engineer who made changes to the approved plans, fiddled with architectural details, and commissioned expensive works of art. That was certainly more than Congress had bargained for. Defending the status quo were some of Walter's other friends; Congressman Chandler, for example, was among those who spoke in favor of Meigs and the Army Corps of Engineers. Meanwhile, Davis grew to distrust Walter, viewing him with suspicion and thinking he might be behind the efforts to wrest the Capitol extension from the War Department. Meigs did not share the secretary's suspicions and defended Walter. For his part, Walter thought his best stance among the competing interests was to keep a low profile and stay quiet for the time being. When summoned before Stanton's committee, Walter expected its members wanted him to speak out against the War Department, but he was ready: "I have been too long under the harrow," he said, "not to know how to dodge the prongs."[24]

After completing his investigation, Stanton gave a long address in the House on the subject of military rule at the Capitol. He began by questioning the fact that Meigs was permitted to draw money from the treasury without posting a bond or giving security as civil agents were required to do. "Are Army officers a better order of men? Have they more integrity than other men?" Stanton asked sarcastically. The intent of the law separating the architect from disbursements had been that monies should be handled by a civilian, Stanton claimed, but its effect had been that an army officer now acted as the disbursing agent, architect, and superintendent. Meigs had

> complete control over every other officer, and every part of the works. He makes contracts with whom he pleases; he purchases materials when and where he chooses; he employs mechanics and laborers, and pays for all of them by his own check or order Captain Meigs may be accomplished in his profession; he may know how to lay out the grounds for encampments and fortifications, to construct fortifications and military roads. These are the duties in which he has had experience, and for which the Government educated him. I will not deny him the merit of being a proficient in these duties; but that he was qualified for the intricate and elaborate architectural details of such a work as the Capitol is beyond all reason.[25]

Meigs' handling of the brick buying business was also questioned. According to Stanton's version of the story, Meigs rejected offers from local brick makers and went off to Philadelphia and New York, where he struck deals that resulted in brick costing almost eleven dollars per thousand—local bricks, "of infinitely better quality," would have cost just seven or eight dollars. Aggravating this outrageous business was the fact that brick from other cities was about 30 percent smaller than Washington brick.

Stanton went on to denounce the changes that Meigs made to Walter's original design. The architect was a civilian with an appreciation for what things cost, as well as how things looked. He was a man of refined taste, a man of great skill and experience. The design for the Capitol extension, "in all its beautiful proportions and elaborate details," was his creation. Being a military man, Stanton claimed, Meigs liked neither Walter's plans nor Walter's economy. The increased thickness that he had ordered in the marble facing would entail a needless additional expenditure. His desire to use monolithic shafts would increase the price of these parts of the columns from $680 to $1,400. "Here, then, is an additional expenditure of over $700 on each of a

hundred columns" Stanton said, "made necessary by the magnificent ideas of the engineer."

Stanton next condemned on principle the notion of military officers overseeing civilian projects. Before concluding with a call for change, he denounced the revised design for the House and Senate chambers. Particularly bothersome was the proposed method of ventilating the windowless rooms by forcing air down through holes in the ceilings and out through openings in the carpets. A similar plan, he asserted, had been adopted for the House of Commons in London and found to be "a noxious folly." Stanton quoted an English source saying that members of the House of Commons sat in their hall with their feet at sixty-eight degrees, their middles at seventy-one degrees, and their heads at seventy-three degrees. "Thus their feet would be freezing," Stanton concluded, "while their heads were scorching." Now Americans were about to repeat Britain's mistakes, thanks to this "specimen of military engineering." Until he lost his seat in 1855, Stanton kept up his attacks on Meigs and rarely lost an opportunity to praise Walter, which unintentionally caused a strain in the Capitol extension office.

Meigs took scant notice of Stanton's speech. During the height of the 1854 building season the engineer kept up his breakneck pace and pushed the works with all his might. Most members of Congress did not share Stanton's view, and when it came time to vote an appropriation no one spoke against it. On July 7, 1854, an additional $750,000 was appropriated by the House to continue the extension: it was approved by the Senate and signed into law on August 4. With about $450,000 unexpended from the previous appropriation, Meigs had a princely sum—about $1.2 million—on hand for the Capitol.

A FIREPROOF DOME

The same day that Stanton attacked Meigs in the House, Representative Joseph Chandler spoke strongly in favor of the Washington Aqueduct. A modern municipal water system was necessary for many reasons, but Chandler thought fire protection was the most

vital. He was quite concerned about the Capitol in general and its wooden dome in particular:

> I hope, sir, this Capitol is not destined to burn again. I hope not; but I say to you, there is not a shanty within a hundred miles of this city which is such a complete tinder-box as is this Capitol. You may look around and see these marble cornices; and you may look on the floor and see it laid in brick and mortar, and say that fire cannot reach them.

> But, sir, there is a dome over the center building of this Capitol which invites fire. There is a nest of dry materials there, covered over with tarred paper, that seems almost to threaten conflagration without the use of the torch—a spontaneous combustion. When, two years since, the library of this House was destroyed for want of a little water—when $200,000 were lost there for want of a little water—then, sir, it was nothing but the accidental placing of a military force upon the spiral stairs of the House that kept the fire from reaching that dome.[26]

When Chandler addressed the House, on June 14, 1854, Walter was already in the throes of designing a new cast-iron dome for the Capitol. Considering their long friendship, the congressman doubtless had seen drawings in Walter's office and was laying the groundwork for its authorization. Exactly who originated the latest idea for a new dome is unclear, but talk of one had been around for years. A new fireproof roof over the rotunda, in the form of a noble dome, would be an improvement appreciated by almost everyone. Not only would it be safe from fire, but it would also rid the Capitol of the wooden dome that had been the source of national embarrassment since the Monroe administration. Replacing it would be a fitting conclusion to the architectural improvements then under way.

Walter recorded working on a dome design for the first time in his diary on May 31, 1854. His second reference was contained in a letter written on July 20, 1854, to Charles Fowler, whose iron business was lagging during a depression in the construction industry. To cheer him up, Walter (who referred to himself as "Mr. Fogey," a playful version of "old fogey") wrote about the prospects of large orders for iron coming from his office:

> Mr. Fogey has also completed a magnificent dome for the Capitol all to be of cast iron.—it is 264 feet high, of such proportions as throw all other domes in the shade—every member

of Congress who has seen it is enthusiastically in its favor, and is ready to vote the supplies whenever asked—will cost half a million at least—such a design was never made by your friend—the drawing is 7 feet long—I wish you could see it—now the Capt. agrees with me that nobody but you can do it—and my opinion is that you will do it; but like everything else at Washington, it will be a long time before we get at it—I think we shall have an appropriation next winter.[27]

While designing this new dome, Walter studied prints of the great domes of Europe, scrutinizing Renaissance, baroque, and neoclassical designs for ideas. He had firsthand knowledge of some of these domes, having been sent to Europe in 1838 by the building committee of Girard College. While in London, Paris, and Rome, he encountered many domed buildings and examined the best and most famous of them, and he set forth his observations on the public buildings of Europe in a 180-page report.[28] This fascinating document contains information about new building technologies, the performance and longevity of materials, and mechanical and sanitary improvements, all of which were deemed useful in planning the college. Walter paid close attention to St. Paul's in London, St. Peter's in Rome, and the Panthéon in Paris.

Although at the time too steeped in the aesthetics of Grecian architecture to admire the bravado of Wren's baroque masterpiece, Walter had kind words to say about its dome and particularly admired the sweep of the unbroken entablature above the colonnade. To his eye it provided a welcome sense of unity:

St. Paul's

As respects the Architectural taste of St. Paul's, I can say little in its favor . . . the multiplicity of breaks and incongruous forms which the whole composition abounds (excepting only the Dome) is found to destroy all repose and harmony; and to produce a confused effect that interferes with every idea of beauty.

In the design of the Dome, and the peristyle from which it rises, an opposite practice has been pursued, and a most agreeable effect is the result. Here we have breath of parts in the Dome that affords repose to the eye, while the continuous entablature of the Peristyle forms a beautiful girdle around its base: but all below this point fails to produce a single agreeable sensation.

Moving to another great domed building, Walter's thoughts on the papal seat in Rome were probably colored by his strong Protestant upbringing:

St. Peter's Church

Notwithstanding the magnitude and costliness of St. Peter's, it possesses very little architectural merit . . . the immense dome the outside diameter of which is 160 feet 'swells vast to heaven' with a majesty and grandeur that atones for the many faults in the minutia of its design.

His favorite dome in all of Europe was the one in Paris crowning Jacques-Germain Soufflot's great neoclassical church, which was originally built to honor St. Genevieve but later dedicated to French national heroes. He was particularly struck by the manner in which the interior was formed, with a monumental painting viewed through the wide oculus of an inner dome:

The Panthéon or Church of St. Genevieve

This is undoubtedly the most beautiful specimen of Architecture in Paris. . . . The cupola is 66 feet in diameter in the clear and consists of three separate arches. . . . The inner or lower arch is pierced with a large opening, through which is seen the ceiling formed by the second arch, which is ornamented with a painting representing an apotheosis of St. Genevieve. . . . The exterior dome is made with the single object of producing a graceful contour to the composition.

To refresh his memory, Walter referred to prints of the domes cited in his report, as well as a few others. According to draftsman August Schoenborn, Walter also had views of the domes over Les Invalides in Paris and St. Isaac's Cathedral in St. Petersburg, Russia. All influenced the initial design for the Capitol's new dome: all were classical; all were set upon high, multistoried drums; and all were topped by distinctive towers or lanterns.

Walter's first scheme, illustrated in his seven-foot-long drawing, showed a tall, ellipsoidal dome standing on a two-story drum with a ring of forty columns forming a peristyle surrounding the lower half of the drum. The upper part of the drum was enriched with decorated pilasters upholding a bracketed attic. Crowning the composition was a statue standing on a slender, columned tholus (the lantern under the statue). The opulent ornamentation was in keeping with the French-inspired rococo taste of the time, which had superseded

the notions of "chaste" simplicity expounded in the heyday of the Greek revival. Hand-in-hand with contemporary taste was the modern material selected for the dome—a material with great advantages over stone in terms of weight, expedition, and cost. Cast iron, cheaply and rapidly mass produced in a factory, would permit a dome to be built as big and as elaborate as one could wish. Structural and decorative components that would be expensive and time-consuming to carve in stone could be imitated in iron at a small fraction of the cost. Anyone doubting Walter's talent at designing ornamental ironwork needed only to visit the Library of Congress to see firsthand the dazzling effect of his skill.

The second session of the 33d Congress convened on December 4, 1854. When not in their chambers, representatives and senators were drawn in increasing numbers to the architect's office, where they could feast their eyes on Walter's drawing showing the enlarged Capitol crowned by a beautiful new dome. It would complete the Capitol's transformation from a somewhat awkward building into a magnificent triumph of classical grandeur. Although the drawing has been lost for years, it is known through a surviving photograph—a black and white image that surely conveys only a fraction of the picture's original visual impact. Judging from Walter's surviving presentation drawings, the large rendering must have been a breathtaking sight. Elegant carriages, prancing horses, and fashionably dressed gentlemen and ladies enhanced its artistic appeal. One of the factors behind Walter's success as an architect was the sense of prosperity and well-being he was able to convey in his exquisite drawings.

Visiting Walter's office was easier for legislators than in previous sessions. They no longer had to cross A Street north and climb the stairs to the rooms above Adams Express, for Meigs had outfitted three rooms in the new House wing for temporary offices. Walter himself felt the move was premature, and when he took up quarters there during the first week of September 1854 he was nearly swamped in dirt and wood shavings and upset by workmen finishing the room.[29] By the opening of Congress, however, everything was put into place and the office was ready to welcome the steady stream of visitors who came to inspect the works. Meigs escorted legislators around and carefully recorded any compliments they paid him. He showed them plans of the wings and pointed out the dome drawing hanging in Walter's neighboring office (modern day H–142). While looking over the

Original Design of New Dome on the U. S. Capitol
by Thomas U. Walter 1854

This period photograph of Walter's long-lost drawing shows the original design of the iron dome. The drawing was seven feet long and attracted considerable attention when it was hung in the architect's office. Just ten weeks after the drawing was finished, Congress authorized and funded work on the new dome.

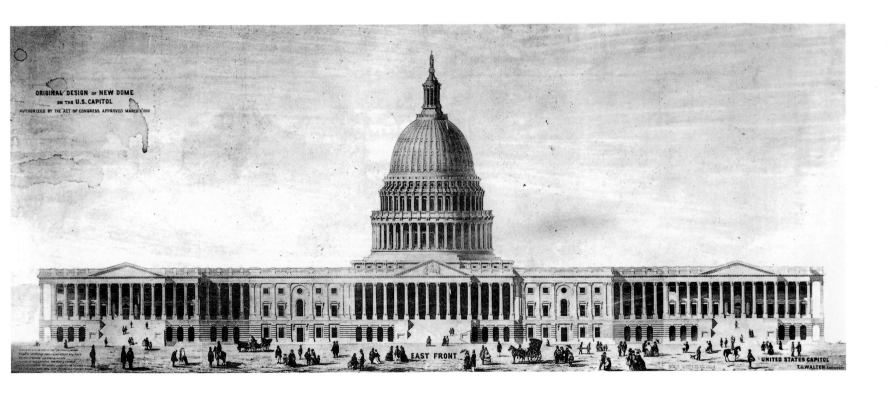

drawing, Meigs was occasionally asked about the cost. Although an estimate had not been made, he thought $200,000 might be a fair guess and quickly added that he would be happy to build it. One enthusiastic member cried "Let's have it done!" Meigs, however, concluded that "this is a joke and probably will lead to nothing."[30]

With each congressional visit, momentum grew for building the new dome. Walter preferred putting off construction until his workload subsided, but Meigs could hardly wait to begin work. Dome fever ran so high that some members wanted the new dome to cover the whole Capitol.[31] Caleb Lyon of New York thought the new dome should be the biggest one in the world.[32] Meigs began sketching alternative designs for a dome, including one with flying buttresses for the sake of variety.[33] Whatever his sketches may have shown, he wanted the dome to be as good as he could make it:

> I wish to have something to do with this design myself. I can make a little greater height and more graceful outline and a very noble and beautiful interior arrangement. I have in Parallels Des Edifices most of the domes in the world of any celebrity, and I think mine is better than any one of them. I only wish I had it to begin from bottom. The famous Pantheon in Paris is only 60 or 70 span. . . . There are in this church and in many other domes great beauties of detail, and the inside effects are generally better than the outside ones, I think. With ours, I hope to have both good.[34]

Horatio Stone, the sculptor, stopped by Meigs' office (modern day H–144) on December 28, 1854, and introduced him to an Italian fresco artist named Constantino Brumidi, who would soon figure prominently into Meigs' art program at the Capitol. After arranging for the artist to provide a sample of his work, Meigs showed them Walter's dome drawing and a design that he had prepared. He claimed that Stone preferred his design because of its richness and grace.[35]

Writing in his journal the following evening, Meigs expended a considerable amount of ink ranting about Walter's dismissive and condescending attitude when shown a dome design drawn by the engineer. This was more than Meigs could bear. He was tired of the architect garnering all the credit for the architecture of the extension and new dome while he himself was in charge and was due more credit than was being given. He was tired of hearing Walter's dome drawing praised to high heaven while no one except Horatio Stone seemed to notice that his design was as good or better. He directed, he ordered, he controlled, he commanded—yet Walter got the credit. The suggestions he made to improve the appearance of Walter's dome design failed to receive the credit they deserved. Writing furiously in Pitman shorthand, Meigs complained:

> He [Walter] wished to have all the credit himself, and he will always claim all the credit of all the design of the Capitol, plans and all, I suppose, hereafter. The fact is that his designs for the interior are his but little more than they are August's [Schoenborn], for they have been made upon my directions. The arrangement of the rooms is mine. The form of the ceiling is mine. The style of decoration is that which I directed. And the mere details of leaves, etc. are worked up by him as they would have been by August or any other draftsman. . . . The flowers and leaves are his, but only adopted after having been subjected to my criticism and approval after alteration to make them suit my taste in almost every instance. So that, in fact, the design is quite as much, if not more, mine than his. As for the very dome which he will call his, it is very different that from what he first proposed. He altered and changed in consultation with me. . . . And for its construction he followed my hints. Yet he would never allow that I had the least claim of any merit in this design. I told him when it was finished that it was good, the best I had ever seen, but that it would require much more study and many changes before it would be in form to be built, and to this he agreed. Now I think that the design I have sketched out as a sketch is much better than the other. Whether it will work up as well, I can not tell till I try, and that I wish to do. If better, I shall try to have it built. Even if I am obliged to take my proper share of the credit of its design, he has assumed the whole merit till I am getting tired of it.[36]

In the privacy of his study, Meigs could rail about one of America's most distinguished architects without upsetting their working relationship at the office. Meigs' role in the design process was similar to that of an editor-in-chief at a newspaper, who consults with writers, approves certain things, and changes, or disapproves others. While the final product reflects his management and style, the byline still carries the author's name. Walter was the architect, and no matter how useful Meigs' suggestions or directions were he would not be

given the same credit as the architect. It was a dilemma that disturbed Meigs a great deal.

In casual conversations with the nation's legislators, Meigs recklessly promised that the new dome could be finished by the opening of the next Congress. To accomplish such an astonishing feat, he considered setting up a foundry on the Capitol grounds. That idea, however, was kept to himself as he lobbied for the dome. He used the depressed conditions in the iron industry as one reason to support the venture. The fabrication of pieces for such an enormous structure would revitalize foundries up and down the east coast, Meigs asserted, creating jobs and stimulating local economies. To Senator Pearce of Maryland, for instance, he wrote: "I think this season of universal depression in the iron trade a favorable one for this work. Prices will be lower than they were last year and the expenditures of money will be a most grateful relief to a large number of necessitous but worthy and industrious men."[37]

Meigs' idea of casting ironwork at the Capitol (which never materialized) would have done foundries in Baltimore, New York, or Providence little good. But swift completion of the dome would boost his reputation as a man capable of working wonders. On the last day of 1854, Meigs wrote in his journal: "This I would like to put up by such machinery and by such means as would make it seem like fairy work. No dome of the magnitude of this has ever been built on a great public building except by years of toil. This one being of iron, I could build with the money in a few short months."[38]

Early in January 1855, Meigs was taken aback to hear Congressman John Wiley Edmands of Massachusetts criticize Walter's dome design, not because Edmands' objections were unjust, but because Meigs was so accustomed to hearing the design praised so lavishly.[39] Yet criticisms of the dome or the architect were rare. Meigs was annoyed with newspaper editors praising it and giving Walter reason to boast.[40] The papers promised that Walter would likely join the ranks of Michelangelo in the world's pantheon of great dome designers. Feeling threatened and unappreciated, Meigs tried to come up with a design that would be preferred to Walter's.[41] Unfortunately, whatever dome studies he made have not survived.

On February 20, 1855, Meigs sent the House Committee on Public Buildings draft legislation to authorize construction of the iron dome. The chairman, however, did not think there was enough time before the close of the session for his committee to consider it. Two days later, while the House sat in Committee of the Whole, Richard Stanton offered his own amendment providing $100,000 for the dome. Stanton's legislation stated that the money would be expended under the direction of the architect, which would exclude Meigs and the War Department from the project. He wanted quick approval so the dome would be finished by the opening of the next Congress. His brief address included high praise for Walter and the architectural improvement promised by the new dome:

> The architect of the building has designed a dome, the plan of which I have seen, and which commends itself to my judgment; and which all who have seen it say is most beautiful and perfect. It is well known that the present dome is entirely too low to preserve the symmetry of the building when the extensions are completed. It will give it a squatty appearance, if I will be allowed the expression. Unless this is done the whole purpose of the extension, so far as its beauty of construction is concerned, will be defeated. Now, sir, I understand that the plan proposed by the architect is a proper one, and that it will not be attended with great cost. The dome has always been an eye-sore to architects and others who have taste in such matters; and it seems to me that now is the appropriate time to authorize the reconstruction of it. It can be, perhaps, completed before we get back here during the next fall.
>
> I am requested to say that it is designed to construct it of cast iron, and from the experience which the architect has had in these matters I have no doubt he will make it a very perfect thing. No man can look at the library, which is constructed entirely of cast iron, without being immediately convinced that such a structure can be erected as will be a credit to the architect and the country.[42]

While others would vote against the amendment, only August Sollers of Maryland and Alfred Greenwood of Arkansas spoke against the new dome as a needless expense. A friend of Captain Meigs, John Taylor of Ohio, thought the language of the legislation indicated a split between the architect and the engineer and asked why the current arrangement would not continue during

construction of the dome.[43] Stanton sensed that Meigs' friends would block authorization unless the engineer was brought into the project, and he therefore offered to strike the provision giving Walter control. Satisfied, Taylor withdrew his objections and the amendment was put to a vote. It passed after Harry Hibbard of New Hampshire, as chairman of the Committee of the Whole, cast an "aye" vote to break what had been a seventy-seventy tie.

Two days after the amendment passed, it was accepted by a vote of the full House. The commissioner of public buildings, Benjamin B. French, stopped by Meigs' office and mentioned how pleased he was to be given the opportunity to build the new dome. As commissioner, he was responsible for the rotunda and old dome, and he viewed the new dome as he would any repair to that part of the Capitol. Although the bill made no mention of who would be in charge, Meigs cited the debates during which his name was put forth as the proper officer to construct the iron dome. Still, French persisted in the belief that he would be in charge. Meigs immediately wrote senators to ensure that the matter would be clarified when the legislation was sent for their consideration. He was horrified that the great new dome might be put into the hands of "Goths and Vandals."[44] To Senator Thomas J. Pratt of Maryland Meigs said that he would be mortified to be excluded from the work, which the House intended for him.[45] He told Senator William C. Dawson of Georgia that he considered the new dome a great engineering work and therefore hoped to build it to reflect credit upon the Army Corps of Engineers and West Point.[46] These efforts succeeded in placing construction of the dome under the president, who would assign the work to the War Department. With satisfaction, Meigs noted that the "proper correction" had been made in the Senate.[47] On March 3, 1855, the president approved the appropriation directing Meigs to build Walter's dome design.

On the same day that Pierce approved the dome appropriation he also approved funds to enlarge the Post Office and the Treasury Department buildings. Secretary Davis placed Captain Alexander H. Bowman in charge of the treasury project and Meigs in charge of the Post Office. While both additions were designed by Walter, the buildings were more closely associated with the venerable Washington architect Robert Mills. Both were built by Mills in the 1830s, and Mills had been the architect of the Treasury Building. Although in his seventies, he wanted the appointment of supervising architect for either or both buildings, but he saw his hopes dashed when the works were put under the War Department. According to one account, his "disappointment was too much for him. He became deranged and died."[48]

PRACTICAL CONSIDERATIONS

Once legislation for the dome was signed into law, Meigs and Walter found themselves with $100,000 but without working plans or estimates of weight or cost. Except for Walter's handsome drawing, they had little to work from other than the confidence that such a dome could indeed be built on top of the nation's Capitol. There had been no studies, no blue-ribbon commissions, no outside experts to tell the architect or the engineer that their ideas were practical. With an undaunted confidence, however, and a belief that no problem was without a solution, the two men plunged into the gritty details to make the iron dome a reality.

The first problem to be addressed was how to support the columns of the lower peristyle. The large drawing hanging in Walter's office showed forty columns carried on a new attic story built on top on the center building. Part of the attic would be carried by the masonry walls and part by the columns of the east portico. After studying the problem of adding an attic, Meigs, or his assistant engineer Ottmar Sonnemann, devised a scheme that dispensed with the attic altogether.[49] Sturdy iron brackets would be embedded in new brickwork laid on top of the rotunda walls to extend the columns beyond the old structure. Thus the columns would be cantilevered and would require no support directly below: the expense of the attic was therefore avoided. An iron skirt would hang below the columns and give the peristyle the look of a solid base. The number of columns was reduced to thirty-six, a more convenient number considering their placement along the 360 degrees of a circle.

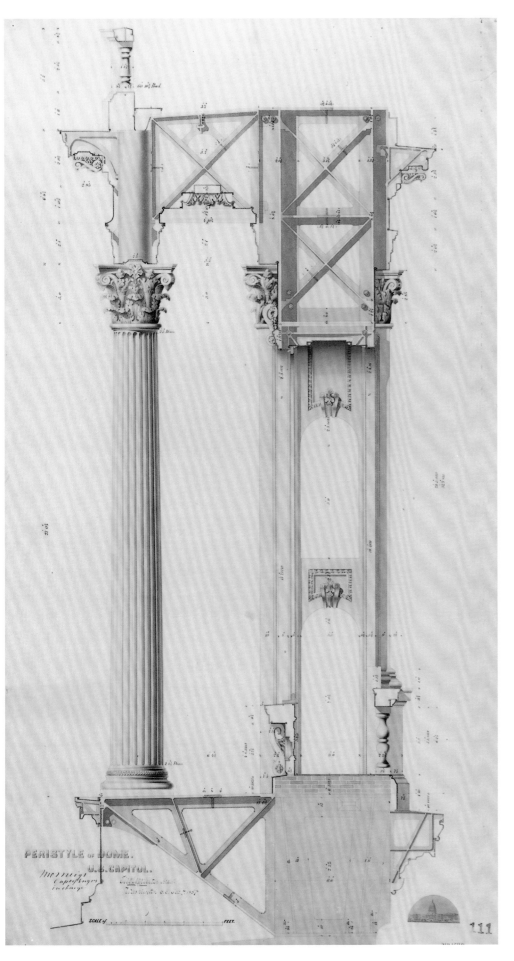

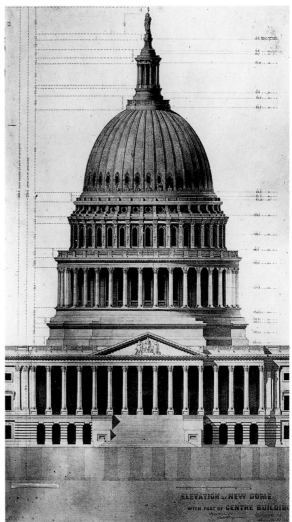

Elevation of New Dome

by Thomas U. Walter, 1855

Soon after Congress appropriated funds to build the new dome, Walter and Meigs worked out a practical design based on realistic construction considerations. The results differed somewhat from the first design. The number of columns in the lower colonnade, for instance, was reduced from forty to thirty-six to simplify their placement along the 360 degrees of a circle.

Peristyle of Dome

by Thomas U. Walter, 1857

Cantilevering the columns of the peristyle on brackets allowed the diameter of the dome to exceed the diameter of the rotunda, thus allowing the new dome to be as large as possible.

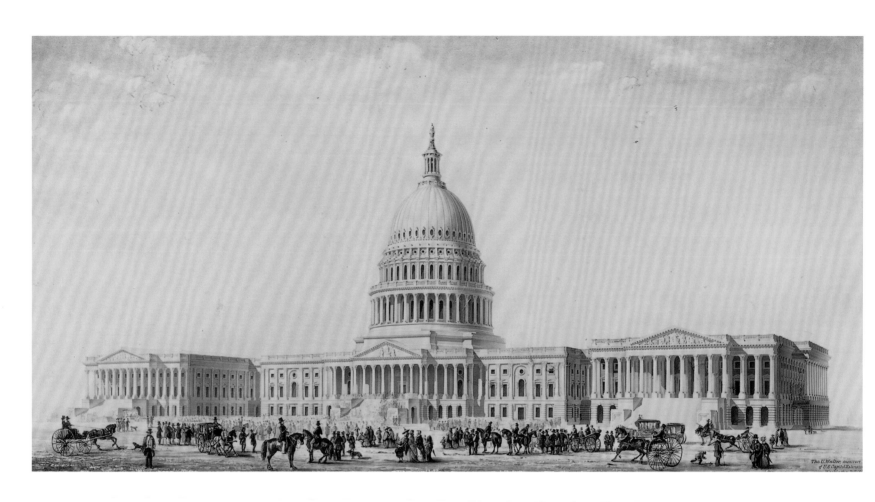

View of the Capitol with the New Dome

by Thomas U. Walter, ca. 1855

The Athenaeum of Philadelphia

*T*his beautiful perspective shows the extension completed and the center crowned by a new dome. Characteristically, Walter drew a spirited scene of carriages, horses, and crowds of people in the foreground.

Section through the New Dome and Rotunda

by Thomas U. Walter ca. 1855

*T*his early design sought to make the rotunda as high as possible.

Other refinements to the design that followed the dome's authorization included the addition of windows to the cupola, the simplification of the ribs, and the introduction of a band of anthemion (or Grecian honeysuckle) to the base of the cupola. The composition was still capped by a statue standing on a tall tholus. Who or what the statue portrayed would be decided later. The interior form and decoration were also studied. After the brick, wood, and plaster inner dome was removed, the lower forty-eight feet of the old rotunda walls would remain in place and act as a foundation for the new ironwork. Above Bulfinch's sandstone walls would be a row of iron panels and

a decorative frieze 300 feet long. Corinthian pilasters set between arched windows would support an inner dome that would rise to a wide opening through which a second inner dome with another set of windows and pilasters would be seen. The whole interior composition was a somewhat undisciplined piling of classical ornament and domical forms—literally creating a rotunda above a rotunda. While not well proportioned, it would have been very tall and very large, and, therefore, very acceptable to American taste.

Removing Bulfinch's dome was the first step taken towards building the new one. By mid-September 1855, a scaffold had been built around the outside dome to peel the copper covering off; a second scaffold inside facilitated removal of the inner dome. Meigs dispatched assistant engineer Sonnemann to the Patent Office to study a model of the scaffold used to erect Nelson's Column in London, hoping it would be useful in designing the interior scaffold for the rotunda.[50] Pringle Slight warned Captain Meigs about the weak spot in the center of the rotunda floor, where the circular opening had been until it was closed at John Trumbull's behest in 1828. Since Slight had helped to plug the opening, he knew the floor conditions well. Meigs designed the scaffold's base with a triangular footprint to stand clear of the floor's vulnerable center. Later, two "sticks" eighty feet long were hoisted to the top of the scaffold to function as a mast and boom to lift the ironwork into place. A steam engine housed in a shack on the roof provided the power for hoisting the iron. With characteristic efficiency, Meigs fueled the engine with wood salvaged from the old dome.

Before the inner and outer domes were demolished a temporary roof was placed over the rotunda to protect it from the weather and from plummeting tools, materials, or unlucky workmen. Meigs devised an ingenious conical roof resting on the upper cornice of the rotunda, with a center opening through which the scaffold would pass. Wooden rafters were covered with boards, which were then covered with painted canvas. Cotton canvas was also ordered to cover the rotunda's paintings. Twelve skylights were provided to light the rotunda during construction. By the end of November most of the demolition had been completed. Meigs was grateful when workmen finished removing the plaster from the inner dome because it was such a dusty job. He also noticed that some men crept around the dome while others were unable to stand upright.[51] More than a few otherwise sturdy workmen were seized with acrophobia, a problem that perpetually plagued construction.

In August 1855, the editor of *The Crayon* told its readers that a new dome was about to be placed on the nation's Capitol: "The whole work is to be of iron, from bottom to top, inside and outside. It will be the first structure of its kind ever built of this material." Editorially *The Crayon* saw nothing wrong with the notion of an iron dome, but at least one reader took exception. Writing anonymously, the critic observed:

> The construction of the new dome is a violation of the true principles of design. Iron is to be used in precisely the same form as if it were stone; of course, the pillars will be cast hollow, and they will be painted to imitate the marble. The extreme height of the dome, as it is to be, for it is piled up with range of pillars above range, and elevated as much as possible, will make violence in the general outline of the mass. . . .

> No! Mr. Thomas U. Walter will make a great mistake, if he attempts to rear upon this long line of building a dome of the greatest possible height in order to gratify individual caprice or personal ambition.[52]

As the writer made clear, not all Americans were enamored with the idea of iron imitating stone. However, although the importance of "honest" buildings and "truthful" materials was becoming a pesky issue within architectural circles, this philosophical matter did not bother Walter, Meigs, or the politicians in the least.

As members gathered for the opening of the first session of the 34th Congress on December 3, 1855, they were greeted by the sight of the Capitol without its old wooden dome or its new iron dome. About 60 percent of the members of the House of Representatives had served in the previous Congress, and a great many expected to see the new dome finished as promised. Not only was the new dome not finished, it had not been begun. Yet they were soon greeted by Meigs' request for another $100,000 to continue work. There would be plenty of questions to answer before any more money was granted.

View of the
Capitol After
Removal of the
Old Dome
January 1856

Soon after the dome
was removed, Walter had
one of the new iron
columns (marked "A")
hoisted in the air to
judge the sculptural
effect of the Corinthian
capital as seen against
the sky. Nearby was the
rooftop shack housing
the steam engine that
powered the hoisting
apparatus.

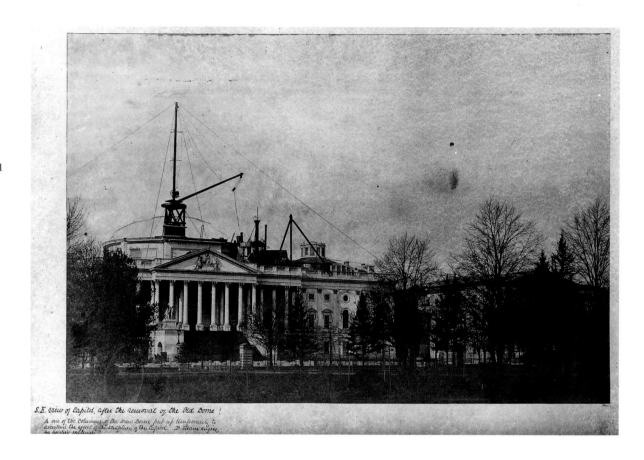

S.E. view of Capitol, after the removal of the Old Dome.
A one of the columns of the new Dome put up temporarily to
ascertain the effect of the sculpture of the Capitol. B Steam engine
to hoist material.

View of the
Capitol, Looking
Southeast
1856

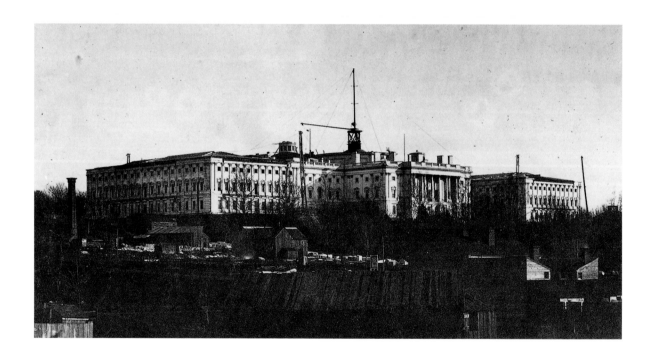

When Congress turned its attention to funding the dome, inquiries were made that should have come long before the original appropriation passed. These practical questions were about the feasibility of re-doming the Capitol, the strength of the foundations, and the probable cost of the project. Members could see that the dome was not finished, and they were not ready to believe any more

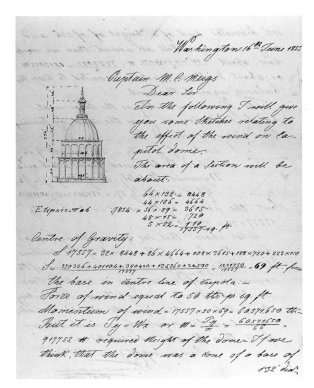

\mathcal{O}ne of Meigs' assistant engineers, Ottmar Sonnemann, calculated the probable effects of wind on the new dome and reported his findings in the letter shown here. Like other such studies, this one came after the dome was authorized and funded.

Sonnemann came to the Capitol after an earlier career as a railroad engineer. While employed by the Baltimore & Ohio Railroad, he worked under the company's chief engineer, Benjamin Henry Latrobe, Jr.

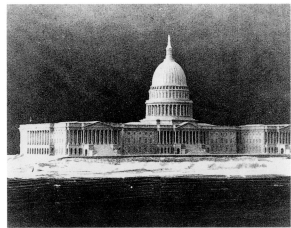

Model of the Capitol with the New Dome
ca. 1855

\mathcal{M}eigs had this model made to give an idea of the finished appearance of the Capitol with the extension and new dome. An engraving of this photograph gave many Americans their first glimpse at the design of the new iron dome.

promises without substantial backup. On March 6, 1856, the chairman of the House Ways and Means Committee, Lewis D. Campbell of Ohio, wrote Jefferson Davis asking if an examination of the rotunda walls had been made to determine if they were strong enough to bear the weight of the proposed dome. He also wanted to know what the dome would weigh. Davis forwarded the letter to Meigs, who confessed that he could not estimate the weight of the dome because he did not know the weight of each casting needed to build it. He would not risk making a mistake on such an important question. Walter, on the other hand, was willing to make an educated guess. He assumed the ironwork would average six inches in thickness and estimated the dome would weigh fifteen million pounds. Meigs used the figure to estimate that the new dome would load ten thousand pounds per square foot on the old walls.

When the dome was completed nine years later, it was found that 8,909,200 pounds of iron had been used in its construction. An additional 5,214,000 pounds of brickwork had been used to knit the new iron to the old masonry. As it was dismantled, Bulfinch's outer dome and inner dome were found to weigh 11,853,584 pounds.[53] Remark-

ably, the great iron dome was only 20 percent heavier than its significantly smaller predecessor.

On April 10, 1856, the House of Representatives took up an appropriation to continue work on the Washington Aqueduct. Russell Sage, a member from New York, expressed doubts about the funds Meigs requested because he did not trust the engineer's forthrightness in working up cost estimates. He noted that the dome would cost more than $100,000 and said that two-thirds of those who voted for it thought only one appropriation would

be needed to build it. Sage implied that Meigs purposely misled Congress with his estimates.

Meigs wrote congressmen and senators with his version of the case. To Senator Albert G. Brown of Mississippi, for instance, he declared:

> The fact is, that though repeatedly asked by members who saw the drawing to say about what it would cost, I always declined expressing any opinion, saying the mere elevation was not enough to make an estimate upon, and that I had too much regard for my own reputation to venture a guess upon so important a matter.[54]

Meigs also wrote a member of the Ways and Means Committee stating that he was not responsible for the estimates for the dome. "No man could have been more careful to avoid giving an estimate on insufficient data," he declared.[55] His denials, however, were not altogether justified. Perhaps he hoped members had forgotten the $200,000 figure pulled out of thin air and bantered about just before the dome was authorized.

The first cost estimate came from the architect. By taking into account the price of iron already bought for the Capitol extension and the approximate amount that would be needed to build the dome, Walter predicted that the cost would be around $945,000. The accuracy of the estimate would depend entirely upon the future price of iron. Nobody could have known in the spring of 1856 that the dome would ultimately cost $1,047,271, about 10 percent more than the architect's estimate. Because Walter had vastly overestimated the weight of the iron, however, it was more luck than skill that brought his estimate so close to the final figure.

While Walter and Meigs reassured skeptics in Congress, the first shipments of ironwork were being delivered to Capitol Hill from the Baltimore foundry of Poole & Hunt. It supplied seventy-two brackets weighing 6,116 pounds apiece and measuring more than seven feet high and fifteen feet long. Used in pairs to cantilever the columns of the peristyle beyond the old walls of the rotunda, the brackets were tied together by a riveted ring of plate iron one and three-quarters inches thick. More than five million pounds of brickwork was laid around, through, and over the brackets, binding them to their foundation. This masonry work was an immense undertaking. A circular wall 300 feet in circumference, twenty-six and a half feet high, in widths varying from about three to six feet, was built, reinforced with iron hoops, and knitted to a structure built thirty years earlier. The success of everything to follow would depend on the integrity and strength of that base. The work was finished just before the winter of 1857 set in. To cover the brickwork on the interior, Walter designed seventy-two cast-iron panels enriched with ornamental moldings, which were attached to the masonry and surrounded by painted plaster. The panels were made by Poole & Hunt for four cents a pound. Above this band, two cornices outlined a frieze about eight feet high. Originally the frieze was intended to be filled with sculpture in alto-relievo depicting the history of America, but this plan was thwarted by the death of the sculptor Thomas Crawford. Instead, Meigs' favorite fresco artist, Constantino Brumidi, would imitate the effect of sculpture using a painting technique called *grisaille*. This less expensive decoration was not begun until the 1870s, well after the dome was completed. Indeed, it was not finished until the 1950s.

After the brackets were installed and the brickwork was laid and allowed to dry, the dome was ready for the thirty-six columns that would

Center Building
ca. 1857

*T*he paired brackets that would hold the dome's columns may be seen in this construction photograph. Also shown are three workmen standing on the Bulfinch terrace amid marble debris.

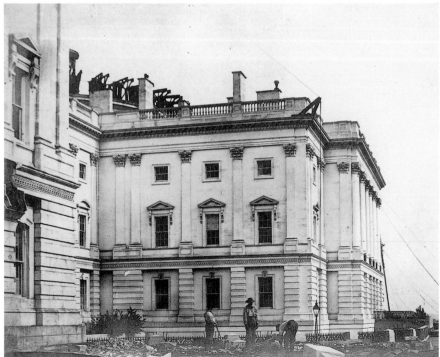

Delivery of Iron Column Shaft
1856

*S*hipped by train from Baltimore, the iron columns for the dome were then hauled from the station to the Capitol on horse-drawn carriages.

comprise one of its most conspicuous architectural features. Meigs asked ironworkers in New York, Pennsylvania, Delaware, Maryland, Virginia, and the District of Columbia to submit bids for the columns. By offering to cast the columns for three and two fifths cents per pound, the firm of Poole & Hunt received the contract. The columns were cast in sections: the capital and base would slip over the ends of the shaft, which was cast as a single piece. Foliage for the capitals was cast separately and attached to the bells by screws and rivets. Twenty-seven feet high, each column weighed approximately 10,000 pounds and cost $399 delivered to Washington. To save weight and money the shafts were cast hollow. This feature also increased their utility: some were used as down spouts to conduct water off the dome and others were connected to chimneys under the peristyle, the smoke from which would have no other means of escape. The last shipment of columns arrived from Baltimore in November 1856.

THE GREAT ORCHESTRATION

*M*eigs' talent for administration was complemented by amazing energy and stamina. His attention to detail brought him into the most minute aspects of the extension, its decoration, construction, and management. He arrived at his office between nine o'clock and ten in the morning, greeted by mounds of paperwork and visitors anxious for his attention. After noon he went to observe Congress, when it was in session, to see if anything was being said about his projects. The rest of the afternoon was spent going over the works from top to bottom to see if everything was being done correctly. "Sometimes I correct an error," he wrote, "but generally I find nothing to alter, for the workmen and the overseers are pretty well used to my methods, and I find all going right." [56] Although he relied on a staff of assistant engineers, foremen, craftsmen, artists, and clerks as well as various contractors, Meigs was responsible for everything concerning the project and defended his name and reputation against any hint of impropriety. As Walter learned, and as Latrobe had realized long before, there was never a shortage of critics whose slanders were motivated by jealousy, lost contracts, malice, and a simple love of the sport. Through the strength of his convictions and personality, however, Meigs was well equipped to defend himself, and as long as Davis was secretary of war he enjoyed the unswerving support of the administration.

Keeping control on the cost of the Capitol extension was a matter of considerable importance. Meigs was spending a great deal of money for such things as marble sculpture and English floor tiles that were never thought of when the project began in 1851, and only the strictest economy would help to pay for these luxuries. The most expensive aspect of the project was the marble

Detail of Exterior Marble Work
Principal Entrance, South Wing

*I*nstalled in 1855, this frontispiece illustrates the high-quality craftsmanship of Provost & Winter's carvers as well as the engaging detail of Walter's design. Similar in spirit to the iron consoles in the Library of Congress, the brackets were rich essays in the rococo revival taste in decorative arts. Corn, maple leaves, and grape clusters were incorporated into the imaginative composition. Above, the cornice was carved with a row of Grecian honeysuckle ornaments called "anthemion." (1965 photograph.)

work. He spent hours studying its details in order to determine the proper value of cutting, carving, and setting tasks. Some cutting and carving jobs were not spelled out in the contract with Provost & Winter and obliged Meigs to fix a fair value for specific work on a case-by-case basis. Peering through a spy glass or climbing on a ladder, Meigs studied the way George Blagden had pieced together the cornice of the old Capitol in the 1790s, comparing it to the way Provost & Winter pro-

posed to accomplish the same task for the extension. The contractor wanted to use four courses of stone to make the cornice, one more than used in the old building. But Meigs wanted to use three courses to reduce cost. Since the appearance would be the same, his decision combined the advantages of economy without sacrificing stability or beauty:

> I find by rough calculation, which I will make more carefully, that in the saving of material and work though I have made a much more durable and strong cornice than the 4-course one proposed in the contract, I have saved about $22 per foot; and as there are 1,800 feet of this cornice, this is in the whole a saving of $39,600.[57]

Meigs also established the price paid to Provost & Winter for carving the capitals for the columns ($930) and pilasters ($537) destined for the vestibules leading from the east porticoes to the House and Senate chambers. Following the tradition established by Latrobe forty years earlier, Walter Americanized these capitals, mingling tobacco, corn, and magnolia plants among the acanthus leaves and volutes that are trademarks of the Corinthian order. The design was put into the hands of Francis Vincenti, an Italian modeler and sculptor who prepared a plaster model for the carvers to follow. Meigs traveled by horseback to a farm in Maryland to gather tobacco leaves to ensure a faithful representation.

Two monumental staircases were provided in each wing for visitors going to the galleries overlooking the chambers. Ever since the floor plans were revised in 1853, these staircases had been envisioned as principal ornaments of the extension—majestically scaled, generously proportioned, and richly finished. They were intended to be as grand and good as those in European palaces. Sometimes described as "imperial," they consisted of a broad flight of steps rising to a landing where the steps split into two flights. A mixture of Italian white and Lee clouded marble was used for the steps of three of these staircases, the same three employing a deep reddish brown marble from east Tennessee for handrails, balusters, wainscoting, and supporting columns. The column shafts were topped with metal capitals cast in Philadelphia by Cornelius & Baker, a firm more usually associated with chandeliers and other lighting fixtures. The model for the capitals was made under Meigs'

watchful eye by sculptors working from the architect's drawing. After the first capital was received from the foundry in September 1855, Meigs thought the workmanship good but noted that there was room for improvement. He was particularly concerned that the acanthus leaves around the bell were too thick, which the engineer thought was a common fault in metal foliage. The defect was not fatal, but Meigs encouraged the foundry to make better castings if they could.

Walter was happy that metal capitals were used with the beautiful Tennessee marble, which

Western Stairway, South Wing
by Thomas U. Walter, 1858

\mathscr{F}our monumental marble stairways were among the great interior features of the Capitol extension. Large history paintings were intended to hang in the upper landings, which were lighted from above.

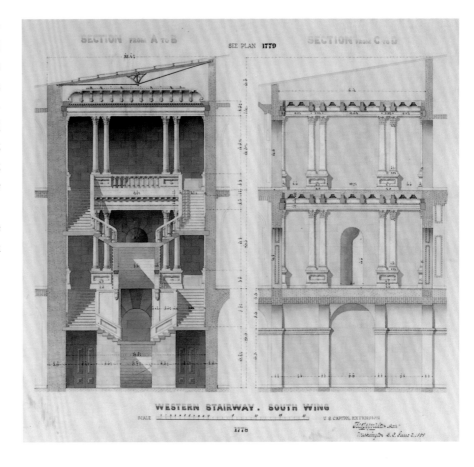

East Monumental Stairway, Senate Wing

\mathscr{R}ich brown Tennessee marble with metal capitals support a marble and iron ceiling over the stairs. (1995 photograph.)

**Section Thro'
CORRIDOR,
South Wing**

by Thomas U. Walter
1855

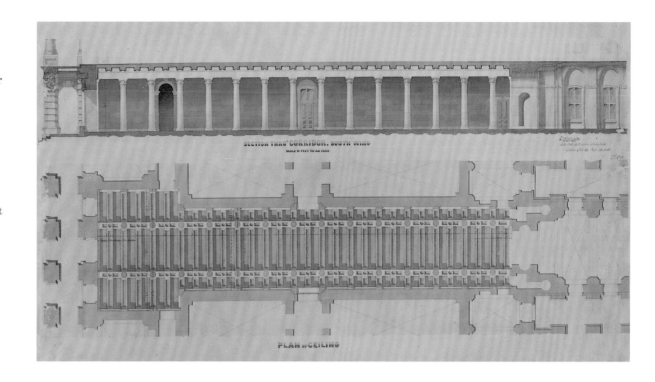

*T*he principal
feature of the south
wing's first floor was
an impressive corridor
lined with twenty-eight
Corinthian columns.

Hall of Columns Corinthian Order

by Thomas U. Walter

*W*alter blended the tobacco plant and thistle into a Corinthian capital in his first
American order. It followed the tradition begun by Latrobe in 1809, when he intro-
duced the corn order. Instead of pilasters, Walter used antae along the walls to corre-
spond with the columns. No tobacco or thistle was incorporated into these capitals,
which displayed more conventional classical carvings instead. (1960 photographs.)

he claimed had no equal for interior stonework.
Pure white Italian marble was used in the fourth
staircase, which was located in the western part of
the Senate wing. The exquisite capitals were
carved with a delicate skill unequaled anywhere in
the building. Meigs originally wanted to use a green
marble from Vermont (commonly called "verd
antique") for this stair but was not able to find
enough of suitable quality. When asked why Meigs
wanted to make one stair from a different marble,
Walter replied that the engineer acted on the prin-
ciple that "variety is the spice of life."[58]

A long row of marble columns with correspond-
ing antae was one of the remarkable features
planned for the ground floor corridor in the south
wing. Walter produced an Americanized version of
the Corinthian order for these columns by design-
ing a range of tobacco leaves above the obligatory
acanthus leaves. Between the tobacco leaves, he
introduced the thistle plant as an elegant embel-
lishment that fit well. When the corridor was first
designed, it was thought that the ceiling would be
marble, but it was later changed to iron. The
change was probably made because marble was in
such demand for other purposes and was more
expensive than iron. Five foundries were asked to
bid on the ceiling, and the job was awarded to Hay-
ward & Bartlett of Baltimore on March 6, 1855.

They offered to make the patterns, cast the iron, and deliver the ceiling for three and a half cents per pound. By comparison, the high bid came from Thurston Gardner of Providence, Rhode Island, who proposed six cents a pound. Installing the ceiling would be a task of some delicacy, and at one point Walter thought that Meigs would never allow the ironworkers to do it:

> We shall have a range of elegantly wrought marble columns of a new order of my own design, with delicately sculpted tobacco leaves, thistle, cotton &c. costing a mint of money, besides corresponding pilasters around all the walls, and I am sure he will never consent for any contractor to hammer and hoist and work in such a forest of fragile beauty.[59]

But, contrary to the architect's expectation, Meigs accepted Hayward & Bartlett's offer to install the iron ceiling for one and a quarter cents per pound, with the scaffold and hoisting apparatus supplied by the government.

Like all corridors in the Capitol extension, the so-called "hall of columns" was originally intended to be paved with thick slabs of marble. Brilliantly polished marble would be a startling contrast to the dull sandstone used in the passages of the old building. But again, marble was greatly wanted for other purposes and Meigs began seeking alternative flooring materials. In *The Engineer's Journal* he saw advertisements for encaustic tiles manufactured by the Minton Tile Company of Stoke-Upon-Trent, England, and he made a mental note to look into substituting tile for marble floors. The main advantage offered by Minton tile was its durability. Unlike glazed tiles in which the color and pattern are laid on top of the surface, an encaustic tile consists of patterns made of colored clays inlaid into the tile. As the tile wears down, the color and pattern are unaffected. For plain tiles, the whole thickness is made from colored clay.

At the time he was ready to inquire about the tiles in September 1854 Meigs grew concerned to see that the company had stopped advertising and wrote to ask if tile production had been abandoned. He was particularly interested in Minton's tiles because they promised to be as beautiful as durable. In fact, considering the style of decoration he planned for the interiors, Meigs hoped the company could make more elaborate and elegant floors than he had yet encountered in America.

"The examples of your tiles which I have seen in this country," he explained,

> are confined to the smaller size & plainer figures. Our building is a Roman Corinthian edifice of white marble—above 750 feet by 270 & contains many fine public rooms & Halls & corridors and I am desirous of obtaining the best floors that can be made.[60]

In a few weeks, he received samples of Minton tile from one of the company's American agents, Miller & Coates of New York City. He thanked the agents and advised them that work had not progressed to the point where finished floors would be laid any time soon. He also needed time to study the designs and determine their appropriateness for the Capitol.[61] With his letters to England and New York, Meigs initiated a long-term and mutually satisfying association with the tile makers and importers.

Convinced that Minton tile was the best flooring available, Meigs ordered it in vast quantities. Wooden casks packed with tile began arriving in New York from Liverpool in the fall of 1855. Through letters to the secretary of the treasury Meigs made sure they arrived duty free. The casks were forwarded to Washington by rail accompanied by Miller & Coates' workmen, who laid the tile over a five-year period at an average cost of about $1.75 a square foot. Elaborate designs could cost as much as $2.03 per foot. The designs for specific rooms and corridors were made by Miller & Coates, who sent detailed sketches for Meigs' approval. Undoubtedly, the opinions of Walter and others were sought, but the final selection of pattern and color rested with the engineer. More important rooms were treated with elaborate centerpieces surrounded by fields of color and multiple geometric or architectural borders. The effect was similar to the composition of large, intricately woven carpets, but the colors were bolder and the reflection of light off polished tile was more dazzling. During the winter months, floors in most offices and committee rooms were covered wall to wall with carpets held in place by lead weights sewn into the bindings. In other rooms Pringle Slight's men laid strips of walnut or cherry to which the carpets would be tacked. During the summer months the carpets were taken up and the cool tile left exposed. Less important spaces were treated with simpler and cheaper designs, but even

some of the dimly lit rooms in the cellars were paved with cheerfully colored tiles.

While acres of tile paved the corridors of the Capitol extension, the muddy streets and footpaths of Washington ensured that frequent cleaning would be necessary to keep the floors shining. Meigs anticipated the heroic scope of the task and thoughtfully provided low, shallow closets throughout the corridors where cleaning personnel could readily draw pails of water to mop the floors. Drains at the bottom carried off dirty water. These handy closets were barely thirty inches tall, with arched doors made of cast iron.

Plumbing for water and gas was installed by J. W. Thompson & Brothers of Washington under a contract awarded on June 15, 1855. A four-inch cast-iron water main was laid under corridor floors to supply water for wash basins and drinking fountains in the offices, committee rooms, and cloakrooms. The marble-topped wash basins were made in the carpenter's shop from walnut, a wood that Pringle Slight described as "very serviceable" for the purpose.[62] Air ducts built into the walls for ventilation and heating purposes were also used to run pipes vertically. Water closets were fitted with the "most approved apparatus" and were connected to iron waste pipes leading to the main sewer under the cellar floors. A three-inch gas main was laid under the floors except in the upper story, where four-inch mains were used. Principal spaces such as committee rooms, offices, and public corridors were fitted with elegant chandeliers hung in the center of the vaulted ceilings. Sconces were affixed to the hollow iron window trim, through which the gas pipes were conveniently run. By using flexible tubes made of gutta-percha (a material similar to rubber), portable desk lamps were fed gas from sconces or chandeliers. Out-of-the-way storage rooms and cellar passages were illuminated by simple pendant lights. With few exceptions the gas lighting fixtures were made by Cornelius & Baker, a firm that specialized in elaborate castings combining naturalistic foliage with human and animal figures. For evening sessions of Congress, Meigs wanted to cast enough artificial light into the House and Senate chambers through the skylights to turn night into day, hoping the effect would be wondrous. Just above the glass ceiling, hundreds of gas burners were installed so close together that only one ignition source was needed to light the whole apparatus.

During the second week of January 1856, Meigs announced that the first rooms in the north wing were finished. Six chambers on the west side of the first floor were ready to receive the U. S. Court of Claims, which senators allowed to be temporarily accommodated in rooms ultimately destined for their committees. The first key Meigs handed over was to the northwest corner room (modern day S–126) where the court was scheduled to meet on Monday, January 14, 1856. Although the heating apparatus was not yet operational, the rooms made a fine suite, which Meigs described just before the court moved in:

> These rooms have encaustic tile floors, marble skirting [baseboards], cast iron door and window casing, and are as permanent and indestructible as it is possible to make rooms. The door and the window shutters and sashes are all wood, for the sake of swiftness and ease with which they are maneuvered. Six of these rooms are nearly ready for use, and the court will have the use of the whole of them. Furnaces have been put up in the cellar and have been kept going for some weeks to try to warm them.[63]

The mass-produced door and window frames were another prominent use of cast iron. (It was not, however, a novel idea. In the early 1830s, Walter had used iron for that purpose in his first large commission, the Moyamensing Prison in Philadelphia.[64]) Meigs installed iron frames on the first floor as a trial to determine whether to continue with them throughout the extension or to adopt another material. After looking at the iron frames in the Court of Claims rooms Meigs decided to continue their use: "Those in the basement look so well and substantial," he wrote, "that I think nothing else will do, unless we build them of marble, and that takes too long."[65]

Forty-eight carpenters working for Pringle Slight made all the doors, windows, and interior shutters that constituted the greater part of the Capitol's limited woodwork. (Meigs originally wanted to use iron shutters "for the safety of valuable papers" but later abandoned the idea.[66]) Before the finish work was begun, these men were mainly engaged in building the centers on which the brick arches and vaults were constructed. At the beginning of 1855 Slight wanted to start making doors. After the doors were put together and wedged, he

Details of Doors, Basement
by Thomas U. Walter, 1855

*M*eigs used iron for door and window casings because marble was too expensive and took too long to install. Iron frames were mass produced in various foundries, an example of the increasing industrialization of the building arts during the mid-nineteenth century.

recommended storing them for six months in a dry place. He assured Meigs that he knew the door business, saying he personally had made all the doors leading to the Senate vestibule thirty-five years earlier and that they were still as good as new.[67]

Slight's pride in his handcrafted doors notwithstanding, the building arts were making increasing use of mechanical power and machinery, which Meigs celebrated as a blessing. He admired what machinery could do, the burdens it lifted, and the time it saved. Efficiency was important, and he made comparative analyses to show what labor and money his machines were saving the United States Treasury. For instance, one of his foremen compared three different modes of carrying brick to the top of the walls and the cost of each. He found that a good hod carrier could raise 1,000 bricks a day in cool weather at a cost of $1.25. Then he found that six laborers making $1.05 a day using hand-powered machinery could raise 9,500 bricks at a cost of sixty-six cents per thousand. Finally, with a small steam engine, 24,000 bricks could be hoisted to the same level at a cost of twenty-three cents per thousand. The advantage of using the power of steam to ease that expensive, back-breaking work was obvious. Meigs also noted that the work could thereby be carried on during the summer months, when it was too hot for ordinary

Details of Windows, Attic Story
by Thomas U. Walter, 1856

*U*nlike the double-hung sash used in the old Capitol, Walter designed casements for the third-floor windows in the extension. When fully opened, these casements allowed air to flow through the entire window area.

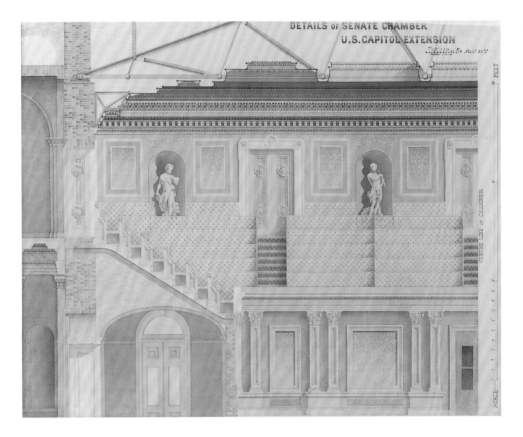

DETAILS of SENATE CHAMBER
U.S. CAPITOL EXTENSION

Details of Senate Chamber

by Thomas U. Walter, 1855

*M*ythological figures were drawn in the niches that would later be occupied by busts of early vice presidents.

Capitol Workshops

ca. 1857

*L*ooking northwest, this photograph was taken from the roof of the new Senate wing and shows Meigs' workshops in the foreground. Iron columns intended for the dome were stored nearby.

mortals to endure.[68] Such comparisons justified the government's investment in expensive machinery and showcased Meigs' attention to economy and efficiency.

Logan, Vail & Company of New York was one of several firms that sold Meigs portable steam engines for various tasks, such as raising brick or mixing cement. His favorite supplier of pulleys, drills, lathes, planners, vices, hammers, and saws was the firm of Gage, Warner & Whitney of Nashua, New Hampshire. Power drills were bought from Shriver & Brothers of Cumberland, Maryland. Wire rope was purchased from John A. Roebling of Trenton, New Jersey, who later became famous for designing the Brooklyn Bridge. Hydraulic lifts were bought filled with whiskey to keep them operational year-round (Whiskey, unlike water, would not freeze in winter.) With these lifts, a man of ordinary strength could raise a load weighing seven tons.[69] An extensive shop for cutting marble and turning column shafts was linked to a central steam engine that also powered a wood shop, machine shop, and finishing shop. The saw in the stone mill did the work of forty men at one fifth the cost. Hand-powered tools could drill fifty holes a day in the roof rafters and purlins; sixty holes an hour could be drilled with the power of steam. Each day this large steam engine consumed a ton of coal, but the time and money it saved repaid the government handsomely.[70]

Building materials were purchased from suppliers around the country and abroad. For the roofs Meigs bought copper weighing thirty ounces a square foot from Crocker, Brothers & Company in Massachusetts and sent it to New York to be corrugated; he was thus able to cover the roofs with a material that was lighter than and just as strong as his first choice—cast-iron tiles.[71] Plate glass from France was obtained through DeCourcy & Noell of New York (at $10.50 per pane), while

English glass for the dome was ordered from Theodore Roosevelt Sr.'s plate glass warehouse, also located in New York. With so much plate glass wanted at the Capitol—a market worth at least $150,000—Meigs hoped to encourage American manufacturers to begin casting glass.[72] Although for the time being he was forced to buy foreign plate glass, he could obtain high-quality domestic glass for skylights from William B. Walter of Philadelphia. Ornamental stained glass was obtained from J. & J. H. Gibson, a firm also located in Philadelphia.

The heating and ventilation system, one of the more daring and controversial aspects of the Capitol extension, was developed by Nason & Dodge, a large and experienced New York firm hired in 1855. They offered a 20 percent discount on all pipes and fittings from their warehouse, a deal Meigs found irresistible. But he was equally impressed with the firm's scientific and mechanical skill, an uncommon and most welcome combination. All drafting was done by the contractor under the supervision of Robert Briggs, the firm's civil and mechanical engineer, who was later hired by Meigs. After extensive consultations with the captain of engineers, Nason & Dodge developed a method of warming the extension that was an early version of a forced hot air system. Steam-powered fans of various sizes blew air over massive coils of pipe filled with hot water. For the House chamber, a fan sixteen feet in diameter turned by a thirty-horse-power steam engine delivered 1,250 cubic feet of air with each revolution. At eighty revolutions per minute, the fan could replenish the air in the chamber every five minutes.[73] Meigs calculated that the quantity of pipe needed to warm the House chamber alone was 50,000 linear feet, the equivalent of 16,000 square feet of heating surface.[74] The warm air was distributed throughout the two wings by ducts built into the thick brick walls. In the chambers, air could come through registers in the floor or, if the fans were reversed through apertures in the ceilings. For each wing two fans were provided—one for the legislative chamber and one for the remaining rooms and passages. Air was exhausted through grilles in the iron ceilings over the four grand staircases or over the chambers. Eight boilers of the "modified locomotive form" were supplied by Murray & Hazlehurst of Balti-more.[75] Weighing about 18,000 pounds apiece, they measured sixteen feet long by six feet wide, were made of double-riveted Baltimore charcoal plates, and cost fourteen and a half cents per pound. Spaces under the terrace were converted into boiler rooms, thus distancing the effects of an explosion while keeping them convenient to nearby fuel storage areas.

DECORATIONS

*I*n July 1853, soon after President Pierce accepted the revised design of the extension, Meigs wrote Massachusetts Senator Edward Everett asking him to recommend artists to fill the east pediments with sculpture. A former congressman, governor of Massachusetts, president of Harvard, and secretary of state, Everett had played a leading role in the Capitol's development during the Bulfinch period and was now asked to contribute his urbane and refined taste to Meigs' search for sculptors. The pediments were the engineer's special contribution to the exterior appearance of the wings, and he wanted to commission monumental sculptural groups that would do credit to the age. He also wished to top the principal doorways with marble statuary to complement the bronze doors that he intended to install in those openings. Everett recommended Hiram Powers and Thomas Crawford as artists whose statuary would honor both the Capitol and the country.

After receiving Everett's recommendation, Meigs spoke to the secretary of war and was directed to offer the artists work. Like Latrobe and Jefferson a half-century before, Meigs and Davis considered sculptural enrichment a permanent part of the building's fabric and, therefore, payable from funds appropriated for construction. In this regard architectural statuary for the outside pediments was different from statues that might be commissioned to fill the niches found inside. Meigs had no authority to commission works for these interior spaces but hoped they would not stand empty for long: the vacant niches would appear like open mouths needing to be fed statuary. Similarly, large stretches of empty wall space would cry out for great history paintings.

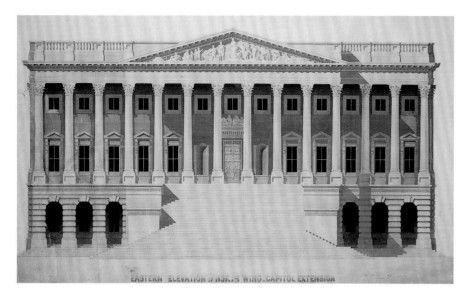

EASTERN ELEVATION OF NORTH WING-CAPITOL EXTENSION

Eastern Elevation of North Wing, Capitol Extension

by Thomas U. Walter
ca.1855

*P*ediments were added to the eastern porticos to accommodate sculptural decorations.

In August 1853 the commissioner of public buildings began installing a group of statues commissioned by Congress in 1837 for the north cheek block of the center steps. Commissioner French hired Washington sculptor Clark Mills to oversee moving the statuary from the Navy Yard to the Capitol.[76] Consisting of three main figures, *Rescue* by Horatio Greenough was a companion piece to another group entitled *Discovery of America* by Luigi Persico, which had been installed nine years earlier on the opposite cheek block. Both sculptures were far from satisfactory works of art. Although created by talented artists, they were embarrassingly clumsy displays of stiff gestures with little expression and awkward interactions among the figures. The sight of Greenough's *Rescue* being unpacked prompted Meigs to take up his pen and write the sculptors recommended by Senator Everett. His letters admirably conveyed his high hopes for the Capitol's artwork and contained the usual warnings about incomprehensible allegory and offensive nudity:

> The pediments and doorways should be a part of the original construction of the buildings, and I do not see why a republic so much richer than the Athenian should not rival the Parthenon in the front of its first public edifice. Permit me to say that the sculpture sent here by our artists is not altogether adapted to the taste of our people. We are not able to appreciate too refined and intricate allegorical representations, and while the naked Washington of Greenough is the theme of admiration to the

few scholars, it is unsparingly denounced by the less refined multitude.[77]

Powers replied from Florence in a terse letter saying that he had neither the time nor the desire to propose sculpture. Crawford, on the other hand, was delighted with the offer. He wrote from Rome with an acceptance of Meigs' proposal, agreeing to produce a "work intelligible to our entire population." He also thought that esoteric symbolism had no place in America, saying, "The darkness of allegory must give place to common sense."[78] With amazing speed, Crawford designed a group of fourteen figures, had the models photographed in Rome, and mailed the photographs to Meigs by the end of October. Along with the photograph came Crawford's bill for full-scale models: $20,000. With the approval of both the president and the secretary of war, Meigs accepted the artist's terms a month later. The approval began a patronage that, while not particularly long lasting, was mutually agreeable and wonderfully productive.

In the spring of 1854, Crawford finished the first full-size models of his pediment group entitled *Progress of Civilization*. A figure representing America stood at the center, flanked by groups of European pioneers and vanquished American Indians illustrating the establishment of European culture on the North American continent. The figures assumed an agreeable variety of expression, attitude, and costume that pleased Meigs considerably. He took the photographs to the secretary of war and was quickly instructed to tell the artist to change the head gear worn by the central figure. Crawford had the figure of America wearing a liberty cap, a device worn in ancient Rome by freed slaves. The cap had been revived in the iconography of the American Revolution as a popular symbol of freedom from English tyranny and was also part of the revolutionary iconography of France in the 1790s. Although the floppy cloth cap had been part of the American image for many years, Davis objected to it because, he reasoned, Americans had never been enslaved and, therefore, could not wear the badge of a freedman.[79] (For unexplained reasons, the cap was retained despite Davis' objections.) Later Davis criticized the design of the young Indian boy because it did not have the face or hair of an Indian.[80] The Woodsman did not please Davis either: he thought that the figure's attitude

was not that of a "wood-cutter chopping." Meigs agreed, thinking Crawford must not have had many occasions to observe wood being chopped because he was born and raised in New York City.[81] The artist took these objections in stride, preferring to make changes rather than fight battles that he would surely lose.

Sculpture was the first form of decoration that Meigs undertook, but its use was not as extensive or as controversial as the frescoes and other painting that he commissioned later. While in New York scouting the city for brick, or on his way to inspect the marble quarry in western Massachusetts, Meigs haunted book stores and libraries looking for material to help him devise painted decorations for the extension. He regretted that he had not traveled to Europe, but he hoped that by studying grand European buildings shown in books he might glean ideas to make the Capitol a building to stand a fair comparison with any of them. In August 1854, he was in New York's Astor Library looking at three volumes with colored engravings of Raphael's works at the Vatican. Recalling the splendor of the rooms, Meigs wrote: "They are very beautiful, rich, and harmonious in color, simple and beautiful in design. I wish I could see the rooms themselves. This book will give us ideas in decorating our lobbies."[82]

When they were available for purchase, the captain acquired illustrated books for his office. On November 18, 1854, for instance, Meigs returned to Washington with several books purchased from William Schaus in New York containing illustrations of architectural ornaments. He took the liberty of buying them because they contained examples of high-style decorations needed for the walls and ceilings of the extension. While he did not have the authority to make the purchase, Meigs hoped that Davis would approve, which was never a problem.[83] In another instance, he was given permission to buy *Galleries Historique de Versailles* from Eli French's bookstore in New York. It was extremely expensive—$510—but he thought it was worth every penny. It was beautifully bound, large, and extensive, illustrated with elaborate engravings of Louis XIV's palace. Meigs routinely purchased publications on ventilation, acoustics, fireproofing, ironwork, hydraulics, and bridge building for the office, but he especially prized illustrated volumes showing the great buildings of Europe and their interior decorations.

At the beginning of November 1854, Meigs was again preparing to leave Washington for a trip north, this time to Boston, where he was going to inspect a facility that made papier-mâché ornaments. On the way, he took the opportunity to catch up on the New York art scene and also stopped by the quarries to urge speedier delivery of marble. While in New York, Meigs went to see a painting by Emanuel Leutze showing George Washington rallying retreating troops at the battle of Monmouth. He thought the artist capable of producing a similar painting for one of the staircase landings. Meigs next went to a bookstore, where he ordered some more works showing ornaments that, although not in the classical style, would give him useful ideas for decorating a few out-of-the-way rooms on the third floor. With these books and the confidence gained by looking at, studying, and thinking about art, Meigs hoped to "make out a system of decoration for the extension without Mr. Walter's help."[84] For Meigs it was increasingly important to establish his own reputation as a designer as well as a builder. He envied Walter's celebrity and wanted to enhance his own standing in the world of art. With the resources at his command, Meigs intended to become a modern-day Medici, fully aware that history remembers great patrons as well as great artists.

While in New York Meigs stayed, as usual, at the Brevoort House, a large hotel with 140 rooms. He liked its varied, high-quality decorations and learned from the owner that Emerich Carstens designed every room, no two of which were exactly alike. After visiting Boston, Meigs returned to New York and called upon Carstens to ask if he would help design the decorations for the walls and ceilings of the Capitol extension and supervise the work when the time was right to start painting. Carstens readily indicated his willingness to move to Washington for a salary of $1,200, and he gave Meigs a sample of his work to show Walter. Meigs returned to the Capitol and, after consultation with the architect, wrote Carstens to "come on," which he did in 1856.[85]

The same day he met Carstens in New York, Meigs stopped by the Academy of Music to see the building's decorations. He was struck by the

beautiful plaster work and intricate papier-mâché that he learned was the work of Ernest Thomas and his brother Henri, both recent arrivals from France. Their work was superior to what he had seen in Boston. Visiting their studio on Wooster Street, he saw other examples of their skill at designing and making plaster and papier-mâché ornaments. Meigs was impressed with the high relief and crisp detail possible in cast or molded papier mâché. He also liked the fact that it was cheap.[86] He arranged for specimens of their work to be sent to Washington and soon ordered all the papier-mâché ornaments for the ceiling over the House chamber from the Thomas brothers. Some ornaments were classical (modillions, dentils, eggs and darts, etc.) and some were inspired by the "natural products of the country." The rosettes in the House chamber, for instance, were composed of cotton plants at various stages of growth. Walter designed these from nature without reference to published illustrations.[87] Meigs assumed that the Thomas brothers would do the modeling in New York, with the casting done in Washington to save the expense of packing and freight. Almost two years later, after the House ceiling was finished and the Senate ceiling was under way, Meigs persuaded Ernest Thomas to take charge of the ornamental plaster department at the Capitol.[88] Thomas' pay was set at $7.00 a day, while the four modelers he supervised earned from $2.50 to $5.00 per day.[89]

In employing the immigrant Thomas brothers and in hiring Ernest Thomas as a foreman, Meigs was guided by his estimation of their abilities rather than considerations of nationality. He used the same criterion in selecting artists to enrich the Capitol—and he had plenty from which to select. By the mid-1850s his office was besieged with painters, sculptors, and modelers hungry for work. Many left disappointed when their skill failed to impress but there was never a shortage of new applicants. Meigs' mailbox overflowed with letters of inquiry or support, and many artists came to the office on the arm of a friendly representative or senator. Critics scolded the engineer for refusing to commission some of America's most famous artists while he routinely gave jobs to the foreign born. Few asked, for example, if Hiram Powers had been offered a commission (he had) or if foreign artists such as Constantino Brumidi worked better or cheaper (they did). There was still a general

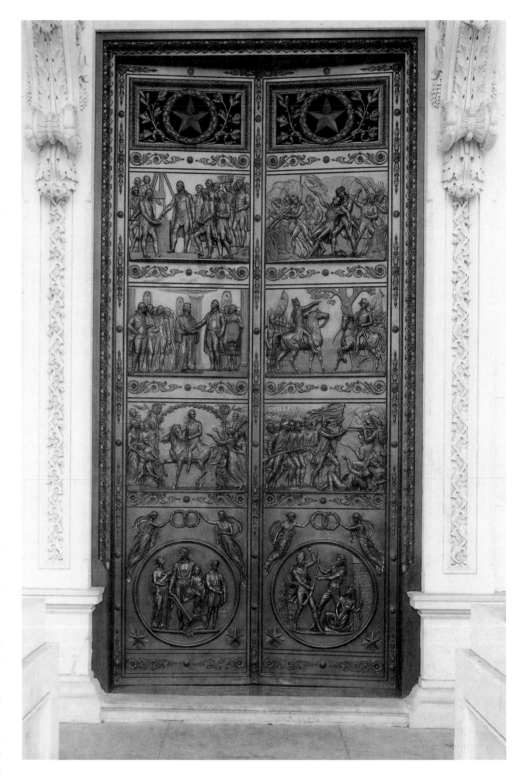

Bronze Doors

by Thomas Crawford, 1855–1857

*E*ntering the Capitol extension was intended to be a noble and educational experience. In 1855 Meigs commissioned Crawford to make a pair of doors for the Senate showing scenes in the life of George Washington and events from the Revolutionary War (above). Crawford designed similar doors illustrating episodes in American history for the House of Representatives (right). (1988 photographs.)

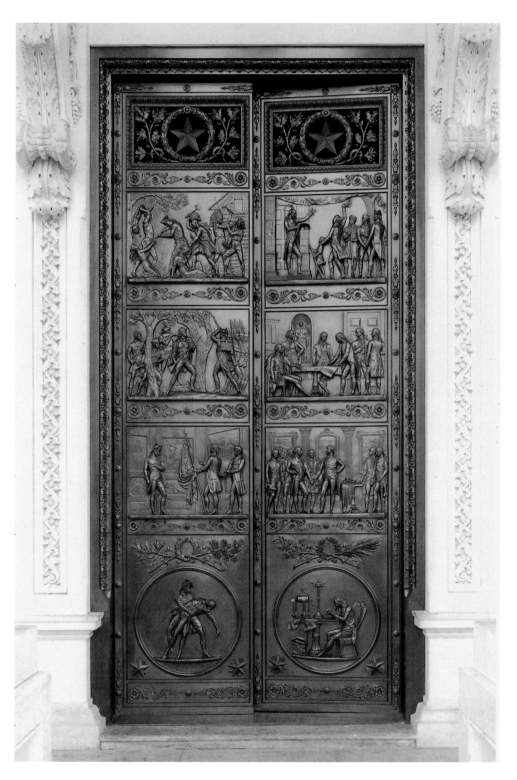

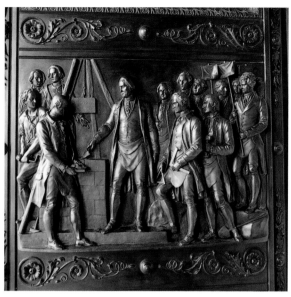

Detail from Senate Doors: *Washington Laying the Capitol's Cornerstone, 1793*

feeling among American artists that Meigs favored foreigners. In late 1854 a Washington newspaper, the *American Organ,* accused him of hiring foreign workmen because, it supposed, he could "kick and damn them with impunity," while native-born workers would never stand for such treatment.[90] This paper, a mouthpiece of the secretive Know Nothing party, was but one source of anti-immigrant prejudice that was strongly felt throughout the country at the time. This prejudice would continue to grow over the next few years and would prove a significant factor in the engineer's eventual removal from the Capitol extension office.

On January 6, 1855, Meigs learned that Crawford had shipped the first five models for the eastern pediment. He was also at work on bronze doors depicting events of the Revolution. About six weeks later a young sculptor from Michigan named Randolph Rogers called on Meigs with photographs of his work, much of which had been produced in Italy. In the course of their conversation, the subject of bronze doors came up and Rogers expressed an interest in making a set. Meigs thought that the entrances into the chambers might be a suitable place to hang bronze doors but later determined that the connecting corridors would be better: thus, whether entering the wings from the outside

or the inside, the public would be greeted with glorious gates laden with sculpture. It would be yet another way to distinguish the artistically decorated extension from the old Capitol.

Rogers was shown the window behind the Speaker's rostrum in the hall of the House of Representatives that would become a door once the connecting corridor was built. This opening had an arched top that presented another field for sculpture. Meigs promised to send a tracing giving the exact dimensions of the opening. In the meantime, Rogers was asked to think of an appropriate story for the doors to tell.

While Meigs and Rogers discussed sculpture, they were joined by another sculptor, Alexander Galt of Virginia, who wanted permission to display a bust of Thomas Jefferson in the rotunda. (Meigs referred him to the commissioner of public buildings, who subsequently denied the request.) The three men went to Francis Vincenti's studio and found the resident sculptor modeling a bust of a Chippewa chief named Beeshekee. Although the bust was made contrary to the prohibition against non-architectural statuary, Meigs considered it an important record to be made for the sake of posterity: it would be interesting "500 years hence."[91]

While in Vincenti's studio Meigs showed his guests plaster casts made from nature that were being stored until needed for decorations. Personally, he was quite taken by a fine cast Vincenti made of a coiled snake, and he hoped to expand the representations of animals in the collection to include fish, game, and "beaked fowl."[92] He had seen a cast of a plucked chicken in Philadelphia and made a mental note to have one made for the Capitol. But for decorative purposes, Meigs was particularly fond of snakes, bagging them during walks around the Washington Aqueduct. Returning to the Capitol, he set them loose in the office, fascinated by the bedlam that followed. On one occasion, Meigs marveled at a snake that had been injured during its capture but was still "full of life and of fight."[93] Understandably, visitors were taken aback at being greeted by the snakes, but the engineer admired how the reptiles would eventually come to rest among the cool marble samples stored on shelves lining the office walls. On another occasion, he coiled a snake around a walking stick and lifted it to the chandelier, where it wrapped itself around

the gas pipe and slithered furiously. Meigs was fearless himself but warned his employees to be careful when handling snakes. In the early winter of 1856, for instance, he found that the cold was killing all his rattlesnakes. One fine specimen remained and he wanted a plaster mold made before it too was "spoiled." He cautioned Federico Casali, one of his modelers and bronze casters, to be careful because a bite would be fatal. Despite the danger Casali produced wonderful castings, some of which Meigs thought were more perfectly detailed than the living creatures. These castings, or ones similar, were later incorporated into the bronze pulls decorating the maple doors leading into the House and Senate chambers.

When Meigs had begun to plan the Capitol decorations, he thought that most Americans who called themselves artists were not quite up to European standards of skill, taste, and talent. He worried that his high hopes for the interior decoration would be disappointed by using the domestic talent available to him.[94] By the time the project was far enough along to begin decoration, however, he may have realized that the revolutionary turmoil in Europe in the 1840s had flushed out many artists among the thousands of expatriates who came to America seeking peace, freedom, and opportunity. The Capitol extension and the captain of engineers fell heir to many of the best of them. One of the first to appear, Constantino Brumidi, was a political refugee who had spent time in jail before being allowed to leave Italy for good. He was soon joined by other European artists and craftsmen who would help fulfill Meigs' grand plans. Painters from Germany and England, ornamental plasterers and sculptors from France, and carvers from Italy were drawn to Washington, where Meigs was overseeing the largest building project of the era. It was a perfect example of America benefitting from old-world troubles.

The first mural decoration in the Capitol extension was undertaken by Brumidi at the end of January 1855 when he began drawing the cartoons for *Calling of Cincinnatus from the Plow*. Meigs allowed the artist to paint a sample of real fresco in the east lunette of his office, a room later assigned to the House Committee on Agriculture. In one of the great unselfish acts of George Washington's life, he had left his farm to defend his

House Committee on Agriculture Room

*I*n the lunette on the far wall is Brumidi's first Capitol fresco, *Calling of Cincinnatus from the Plow*. The artist later painted *Calling of Putnam from the Plow to the Revolution* on the opposite wall. Other paintings in the room include allegorical figures representing the four seasons, a view of the McCormick reaper, and portraits of Washington and Jefferson, two farmer presidents.

The room is currently occupied by the House Committee on Appropriations. (1995 photograph.)

country at the outbreak of the Revolution and, thus, was compared to Cincinnatus, the fifth century B.C. Roman soldier who abandoned his fields to save Rome. The patriotic lesson was clear, and Meigs considered Cincinnatus an appropriate subject for the House Committee on Agriculture.

With snakes slithering around and a constant stream of visitors coming and going, Meigs' office was full of unwanted distractions for the artist working on a scaffold at one end of the room. Brumidi started the fresco on February 14, assisted by A. B. McFarlan, foreman of the south wing plasterers. The rough coat of plaster was wet several times a day for a few days before a small, smooth patch of lime and sand about a yard square was laid in one corner. Brumidi roughened the surface with a broom, sprinkled it with water, and proceeded to lay on colors that were formed with lime into a paste. At first the colors were brilliant, too brilliant in Meigs' view, but the artist assured him they would become less intense as the plaster dried.

Over the next month, sightseers came to Meigs' office to witness the making of a work of art unlike anything else in America. Among those who came was Senator Stephen Douglas, "The Little Giant" from Illinois. After inspecting the painting's progress Douglas congratulated Meigs and told him how pleased he was at the prospect of frescoed walls. When Richard Stanton appeared at the door in the company of Thomas Walter on March 7, 1855, Meigs was a bit startled but greeted his guest cordially. The recently retired congressman, whom Meigs knew was no friend of military men, seemed uncomfortable at first but became relaxed and even animated once he saw Brumidi's nearly complete painting. He climbed on the scaffold to have a closer look and soon declared his complete approval of it. Walter later told Meigs that the painting had won Stanton over and he would be a friend henceforth. Such praise from the likes of Stanton and Douglas encouraged Meigs to proceed with his decorating plans.

Brumidi finished his painting in mid-March. The last element that he completed was the face of a corner figure of a child gazing up at Cincinnatus. Meigs' wife, Louisa, asked the artist to use their son Monty as a model, a request he was happy to oblige. Rather than creating a portrait, however, Brumidi studied the boy's character, which he then sketched into the child's face.[95] Completed in four weeks, *Calling of Cincinnatus from the Plow* earned Brumidi a place on Meigs' payroll. On March 20, 1855, he entered government service commanding the highest wage allowed by the supervising engineer—eight dollars a day. While he would eventually also design furniture and architectural elements, such as mantels and stair railings, Brumidi's name soon became synonymous with fresco decorations in the Capitol.

Just before Christmas of 1855, sculptor Henry Kirke Brown showed Meigs photographs of an unsolicited design he created for the second pediment, featuring a central figure of America with outstretched arms welcoming and protecting all who come to these shores. A distressed foreigner crouched at the feet of the central figure while other figures in contemporary dress engaged in various occupational activities. The figure of a slave contemplating his fate, however, was a bothersome element that doomed the composition. While admittedly "truthful," it was too controversial to immortalize in marble. Meigs told the artist that it "must absolutely go out."[96] Brown thought the slave might "awaken a national feeling in regard to its importance," yet Meigs understood that awakenings were not what Congress expected in the Capitol's artwork.[97]

In a few weeks Brown was back with a second design. Again he placed an allegorical figure of America in the central position alongside a distressed foreigner. New figures included a citizen voting at the ballot box, a farmer, a fisherman, a hunter, an Indian with the spoils of the hunt, a California '49er with a pick ax and pan, a little boy playing with a toy boat, and a weather-beaten navigator. With only one allegorical figure to ponder, there was little in the composition to confuse the average viewer. Despite the improvement, however, Brown's second design was also rejected. Failure to land a lucrative contract prompted the disappointed sculptor to explore ways to remove the art program from Meigs' control.

Erastus Dow Palmer of New York was the next artist to offer designs for the second pediment. In 1856, he made a group of statues depicting the landing of the pilgrims, which was highly praised in his local newspaper, the *Albany Journal.* The central figure, Elder Brewster, was depicted with

outstretched arms giving thanks for safe passage. A kneeling figure of Rose Standish and a standing figure of Miles Standish were positioned to one side of Brewster, accompanied by a young soldier and a mother and child. On the opposite side were "sturdy" yet nameless puritans of differing ages attended by such devices as axes, bibles, barrels, boxes, leafless trees, two wolves, and a crouching Indian. The *Journal* wrote that the scene was not "disfigured by any so-called 'classical' adjuncts often resorted to by modern sculpture."[98]

While Palmer's pediment design was supported by many of New York's most influential politicians, it was presented during the early days of James Buchanan's administration, which did not feel inclined to support the arts unless it meant political gain. As an administration with strong Southern leanings, it was not keen on Palmer's New England subject matter either. A friend of the sculptor offered a compromise in which he suggested putting Crawford's *Progress of Civilization* in the central pediment (at the expense of Persico's group) and placing Palmer's New England scene in the northern pediment. That would leave the southern pediment available for a depiction of the settlement of Jamestown, Virginia.[99] Although the suggestion was ignored, it was another indication of the role that sectionalism played in different aspects of American life during the period. Palmer's sculptural group was refused by the cabinet, but he was granted $1,000 for his troubles.[100] The second pediment would stand empty until 1916.

Thankfully, it was easier to commission a statue for the top of the new dome. Two months after Congress authorized the new dome, Meigs wrote Crawford telling him about the project and asked him to make a sketch for the statue. Walter's general design showed a figure on top but did not dictate the meaning, appearance, or nature of the statue. Meigs was unsure who or what the statue should represent. At one time he suggested a figure of Mercury, but that did not appeal to Crawford. The engineer could not tolerate another statue of George Washington, nor would he repeat the allegorical figure of America already designed for the pediment. A figure of Liberty was his best idea. He sent the request to Rome without a copy of the dome's design or any other indication that the figure was destined to stand upon a tholus, or lantern.

With his usual speed, Crawford responded with a design called *Freedom Triumphant in War and Peace,* an allegorical subject perfectly suited to military taste. Like personifications of Liberty, Virtue, Charity, or Philosophy, which are all feminine nouns in romance languages, Freedom was represented by a female figure. (Had the subject been War or Fire, the male form would have been called for.) Freedom wore a wreath of wheat and laurel and held an olive branch, a sword, and the shield of the United States, making Crawford's message clear and simple:

> I have endeavored to represent Freedom triumphant—in Peace and War. . . . In her left hand she holds the olive branch while the right hand rests on a sword which sustains the Shield of the United States. These emblems are such as the mass of our people will easily understand. . . . I have introduced a base surrounded by wreaths indicative of the rewards Freedom is ready to bestow upon distinction in the Arts and Sciences.[101]

The design was received on July 12, 1855, along with word of Crawford's fee: $3,000. While Meigs admired its grace, he had to send the design back so that the artist could add a transitional element between the statue and the tholus. A photograph of Crawford's second attempt was received on January 11, 1856. The artist took the opportunity not only to introduce a transitional pedestal but also to revise the statue itself. The figure now held a sheathed sword in her right hand and a laurel wreath resting on the shield of the United States in her left. And perhaps forgetting Davis' earlier objections, Crawford changed her headgear to a liberty cap. The sculptor's stay in Rome undoubtedly isolated him from the domestic passions that were stirred up by the mere mention of slavery, freedmen, or emancipation.

Meigs sent photographs of the two designs to the secretary of war. In a few days, Davis returned them with his general approval of the second design, commenting on its grace and power. But he still did not like the liberty cap. Opposed to the idea that American freedom should be portrayed by a freed slave, Davis complained that the liberty cap's

> history renders it inappropriate to a people who were born free and would not be enslaved

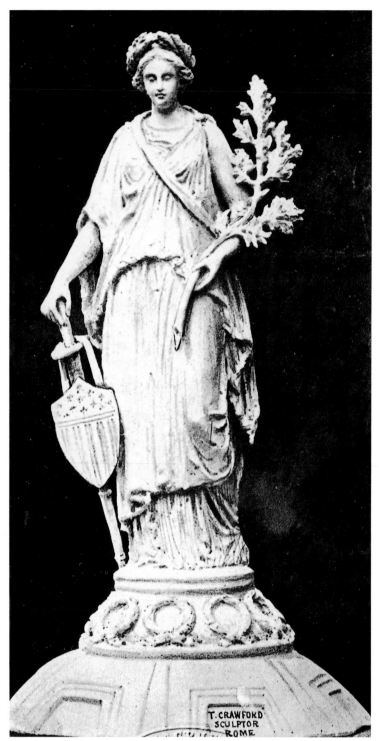

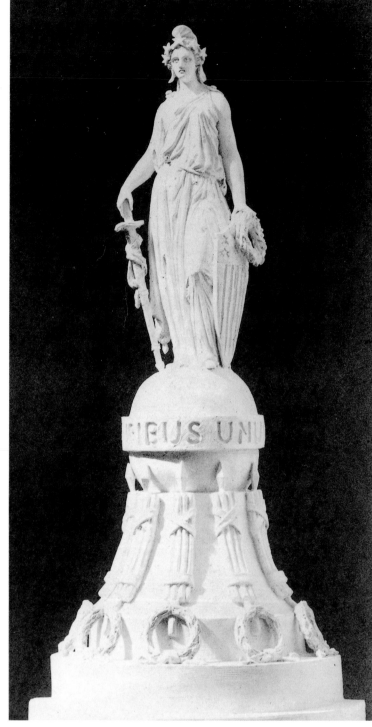

Crawford's First Design for *Freedom*

1855

Library of Congress

*T*he original design for *Freedom* is shown here in a
period photograph.

Second Design for *Freedom*

1855

Library of Congress

*A*lthough the general design was approved, Jefferson Davis
insisted that the headdress change from a liberty cap to a helmet.

Plaster Model of *Freedom*

*T*o satisfy the secretary of war, Crawford replaced the liberty cap with a helmet composed of an eagle's head and feathers. The model of the statue is shown here while it was on display in the old hall of the House after the room was converted into National Statuary Hall. (ca. 1871 photograph.)

. . . its use, as the badge of the freed slave, and though it should have another emblematic meaning today, a recurrence to that origin may give it in the future the same popular acceptation which it had in the past.

Why should not armed Liberty wear a helmet?[102]

The secretary referred the matter back to the artist and gave him final say on the issue. This time Crawford accommodated the wishes of his patrons and designed a helmet to be worn by the figure of Freedom. On March 19, 1856, the artist sent a photograph of the revised design with a letter to explain the new headdress as well as other, more subtle changes:

> I read with much pleasure the letter of the Hon. Secretary and his remarks have induced me to dispense with the 'cap' and put in its place a Helmet, the crest [of] which is composed of an Eagles head and a bold arrangement of feathers suggested by the costume of our Indian tribes. I have placed upon the head of the Statue the initials of our country and the drapery is so arranged as to indicate rays of light proceeding from the letters.
>
> No other explanation is necessary unless it be to say that I think the present design more original than the previous ones, and more *american.* I hope the Hon. Secretary will look upon it as a proof of my desire to merit the continuation of his confidence in my ability.[103]

In the same letter Crawford mentioned in an offhanded manner that this statue would be about two feet taller than his previous designs, standing eighteen feet, nine inches. (Without realizing it, the sculptor thereby forced the architect to revise the upper parts of the dome design to accommodate the larger statue.) He also wrote that the final three figures for the Senate pediment were ready to be shipped. In a final bit of news, he told Meigs that former President Fillmore had dropped by his studio in Rome and "expressed his unqualified approval of the Pediment and his pleasure in seeing the encouragement given to the Fine Arts by the present government."

Meigs immersed himself in thoughts of art and was always on the lookout for ways to use painting and sculpture in the Capitol extension. He sought to effect the harmonious interplay of those arts with architecture in the creation of a unified and artistically whole composition, unlike anything yet built on this side of the Atlantic.

Meigs foreshadowed the time when architects would routinely command teams of painters and sculptors laboring on decorations built simultaneously with the architecture. Architects of the late nineteenth and early twentieth century habitually employed the services of painters and sculptors, as well as cabinet makers, upholsterers, and landscapers, but in Meigs' day such teamwork on such a scale was far from usual.

BACKLASH

At the opening of the 34th Congress in December 1855, Davis transmitted Meigs' annual report to the House and Senate as part of the War Department's yearly accounting of its activities. It took more than five months for the House to officially notice the report, and that attention would not be particularly welcomed. The problems in Kansas were too worrisome to give legislators the leisure to consider matters at the Capitol extension. Hurriedly settled by both abolitionists from New England and competing pro-slavery emigrants from Missouri, Kansas was a state with a small but belligerent population, few peacemakers, and, at times, two governors and two legislatures. Weak and indecisive, President Pierce allowed matters to fester without restoring order to the plains of "Bleeding Kansas." Speeches in Congress packed the galleries with the anxious and idle alike.

In the spring of 1856 Edward Ball, a Whig representative from Ohio, asked the House to put Kansas aside for a moment and allow him to inquire into Captain Meigs' business practices. He introduced a resolution asking for an extensive accounting of all the funds spent on the Capitol and Post Office extensions. Ball was the chairman of the House Committee on Public Buildings and Grounds and a leading opponent of the Pierce administration. He intended to expose what he saw as fiscal irresponsibility in the War Department. Ball inquired about the cost of the marble and how much the changes to the original specifications had cost. He wanted a full accounting of the brick business; the number of horses, ox carts, carriages, wagons, and buggies used by the Capitol extension office; and all the shops, machinery, steam engines, turning lathes, stone saws, and all other tools belonging to the government. He asked how much was spent to remove the old dome and what contracts had been made for the construction of the new one. He inquired about the number of sculptors, modelers, and bronze workers employed and wondered under what authority or law they had been hired. He demanded a list of names of all persons (except laborers) employed on the Capitol extension and their compensation. And last, Ball called for copies of every contract ever made for every part of the Capitol extension, information regarding contract advertisements, and statements whether the lowest bid was accepted and, if not, why not. Nothing Ball could have added would have made his requirements more sweeping or comprehensive. To comply with the extraordinary demand would require a mountain of paperwork, an army of clerks, and the patience of Job. Ball insisted that such a report was necessary "so that it may be seen how the law has been disregarded and the public money wasted." [104]

Ball also condemned the sculpture being carved in shops filled with Germans and Italians. In his judgment, America's Capitol was "made to play the poor part of a wretched imitator of the broken-down monarchies in the Old World." Moving to painting and the crush of sightseers in the Agriculture Committee room, which his committee was using temporarily, Ball declared:

> There is in a room, over yonder, in the south wing, known as the frescoed room, now, by your favor, Mr. Speaker, occupied by the Committee on Public Buildings and Grounds—that is, when permitted to do so by the crowd of persons attracted there from day to day—a variety of pictures, some of them got up in bad taste; but no matter for that now; take them all in all, they are very beautiful to look at, but the great mass of the people of the country would think it strange inconsistency to expend $3,600 for such pictures, or $500 for the beautiful marble mantel which is there, in an Administration which can not spare one dollar to be expended in clearing out obstructions to navigation from the mouth of the Mississippi, or the lakes of the Northwest—also important to the commerce of the country. [105]

After touching on a few other subjects, the Ohio legislator came to the matter of the unfinished dome. He had distinctly understood that the new dome would be finished before the opening of

the 34th Congress. He had also understood that it would cost $100,000. Now it was clear that he had been duped: the cost would be at least a million dollars and it would take many years to finish. The fault, Ball insisted, was with military superintendence, and he declared that it would be better to board it up rather than continue with the wasteful, extravagant, and possibly illegal construction. Soon after Ball took his seat the resolution of inquiry was adopted by the House of Representatives.

Meigs thought it ironic that Ball's resolution really accused him of "building too strong and too well."[106] But just before he could begin to prepare his reply he fell dangerously ill. For more than five weeks he was confined to his home, taking calomel and quinine to ease what he called a "bilious remitment," a form of typhoid.[107] His father, a physician, and his mother were called from Philadelphia to help nurse their ailing son and to assist army doctors who were also in attendance. Although pained by severe headaches, Meigs never lost consciousness and wrote in his journal that he signed checks throughout his illness. Still recovering, he left on a trip north during the first week in July, visiting his family in Pennsylvania, looking at paintings in New York, and inspecting the quarry in Massachusetts. When he returned to Washington, he appeared to Walter to be "all cocked and primed for business."[108]

In his response to Ball's questions, Meigs accounted for the funds expended upon various components of the extension project and explained why the work was so far over budget. The original estimate developed in 1851 was for a plainer, less artistically decorated building. To illustrate the point, Meigs tallied the cost of sculpture commissioned for the extension. Crawford's bronze doors would cost about $13,600 each, while the Columbus doors by Rogers, which were slightly larger, would cost about $14,000. The doors could have been made more cheaply if the sculpture were cast in pieces and screwed to wooden panels, as was done at Walhalla in Munich or at the Madeleine in Paris. But the Capitol's doors were to be made like the most perfect ornamental doors in the world, those at the Baptistry in Florence, where everything—the figures as well as the panels—was cast as one piece.[109]

One of Ball's inquiries asked about the cost of the elaborate frames for the windows on the sec-

ond, or principal floor. These frames consisted of pediments supported by consoles carved with Grecian flowers and draped with acanthus leaves. Like many details of the outside marble work, the frames were similar in form and character to those of the old building but were more deeply and boldly carved and more elaborately designed, using elements borrowed from Grecian architecture. The original specifications stated that Provost & Winter should copy the manner by which the frames in the old building were made, but Meigs altered that provision in order to use larger blocks of marble. The change resulted in doubling the cost of the window frames (from $822 to $1,660), yet Meigs claimed that their stability and durability were increased fourfold. The engineer answered all of Ball's questions with confidence, backing each assertion with minute accountings from the project's well-kept records.

In another report Meigs stated that an additional $2,835,000 would be needed to finish the extension. Of this amount, he needed $750,000 immediately to carry on until a regular appropriation was made. The monthly expenditures on the extension averaged between $80,000 and $90,000, and work would stop unless an immediate infusion of cash was given by Congress. In response, Ball introduced a provision to remove the Capitol and other civilian projects from military control, and Meigs began to feel glum, thinking his days at the Capitol were numbered.[110] He cheered up, however, upon learning of stiff opposition to Ball's scheme in the Democratically controlled Senate. There a bipartisan group of senators, James A. Pearce of Maryland, Lewis Cass of Michigan, William H. Seward of New York, and Robert M. T. Hunter of Virginia, defended Meigs "with strength and vigor."[111] On August 15, the Senate gave what Meigs referred to as "3 separate votes of confidence."[112] Having already defeated Ball's plan to remove him from the public works, the Senate voted an additional $750,000 for the Capitol, $100,000 for the dome, and $500,000 for the aqueduct. There had been some discussion about the eventual cost of the extension and dome, but there was considerable support in the Senate for these projects irrespective of costs. Stephen Douglas of Illinois thought the purpose of the dome project was to build the finest one in the world, and he

was willing to see the project through to the end. Seward backed the extension project as a symbol the nation would continue whole and united. It was perhaps the first time that the continuation of either the Capitol extension or the dome was viewed as a symbol that the nation would continue. Meigs reported in his journal that the senior senator from New York was initially

> opposed to the commencement of the Capitol extension, but he found at that time base and weak men talking about the dissolution of the Union, and he had seized upon the Capitol extension and voted for and encouraged it as a reply to all such weak and foolish talk. He thought now that, when the same foolish words were being spoken, it was a sight well worth its cost to see the Congress, in the midst of all this agitation, going on quietly and voting a million for completing the Capitol of this Federal Union and thus showing the little regard they had for the foolish fears of those who talked about its end.[113]

In another show of support, Congress appropriated $20,000 to commission works of art under the authority of the Joint Committee on the Library. Meigs had encouraged such acquisitions by furnishing scores of niches calling for statues and vast walls begging for paintings. This money given to the Library Committee was the first effort to fill those vacant spaces. On August 18, 1856, the engineer wrote to a committee member to suggest filling the niches with statues of distinguished legislators and hanging great history paintings above the landings of the four monumental stairways. The first painting should be done by "the most eminent painter now living whether native or foreign." Thus, it would serve as a standard of excellence for all the paintings to follow. He recommended that the committee consider hiring a famous French artist and named three possible candidates, including Horace Vernet; considering the pivotal French participation in the final battle in the American Revolution, Meigs noted that the siege of Yorktown would be an appropriate subject for Vernet's brush. The committee wrote Vernet asking if he would paint a picture for $10,000. Vernet, however, was unwilling to accept the commission.[114]

The appropriation remained unspent for two years while the committee considered its next move. In 1859, it commissioned two statues from Hiram Powers, one of Benjamin Franklin for the House wing and one of Thomas Jefferson for the Senate wing. Powers had been offered commissions before, but his only work in the Capitol was a bust of Chief Justice John Marshall commissioned in 1836. American artists remained critical that his work and the work of other native-born artists were not better represented in the Capitol.

HARMONY'S FINAL DAYS

*M*eigs finished removing the last stones from the old dome during the fall of 1856. He marveled at how easily the steam-powered derrick lifted stones weighing three tons and set them down in strong wagons to be hauled away. (Meigs figured that it cost forty cents a cubic yard to remove the old stonework.[115]) He was also impressed with the speed at which drawings for the extension and dome could be copied by John Wood, a photographer hired on September 30, 1856, at $3.50 a day. By using photography, Woods copied drawings far more rapidly than Walter's draftsmen. He also recorded the work's progress in prints pasted into large volumes for office reference. Photographic albums were sent to libraries, museums, and schools both here and abroad, to satisfy the world's curiosity about America's great construction project. West Point was the first institution to receive photographs from the captain of engineers (class of '36). Meigs intended to send additional sets of photographs to Crawford for himself and the Academy of Rome.[116]

Throughout his service at the Capitol Meigs kept up a regular correspondence with the press and others, offering explanations about the works or responding to misinformation appearing in print or elsewhere. He wrote Joseph Henry a stern letter protesting his paper entitled "The Science of Sound applied to Public Buildings," read before the annual meeting of the American Association for the Advancement of Science. Henry's paper implied that the revised floor plans of the Capitol extension were the product of the commission on acoustics. Meigs wanted it made clear that he was the sole author of the plans, which he called "the

first intelligent plans for public buildings." The commission had merely approved them.[117] He did not wish to be placed in a subordinate position or appear to have lamely followed the superior wisdom of his fellow commission members. "It is of importance to me," Meigs wrote emphatically, "that I have the credit of these designs."[118]

In November 1856, Meigs wrote the last annual report that he would submit to Davis.[119] It was somewhat longer than usual, but filled with the captain's usual detail and brimming with confidence. The outside marble work was up to the architrave. Much of the stonework for the connecting corridors had been wrought and was in storage until needed next spring. It was thought best not to begin the corridors until a long recess allowed noisy construction to proceed with vigor. There was considerable progress to report on interior marble work as well. All the shafts, capitals, and pilasters in the hall of columns were set, the Senate vestibule was almost finished, and the private and public staircases were begun. Columns for the House vestibule and the Senate retiring room were carved but not yet installed.

Naturally, Meigs also said much about the artwork. All of Crawford's figures for *Progress of Civilization* were either in hand or on their way to Washington. Brumidi's frescoes in the House Committee on Agriculture room were finished, and Meigs asserted that he intended to carry out the same style of decorations in other rooms. The ceiling in the Senate Committee on Naval Affairs room (modern day S–127) had been painted in distemper and fresco and the walls in oil. "The decoration of this room," Meigs instructed his readers, "is in the style derived from the remains of ancient painting in the baths of Titus and the excavations of Pompeii. Panels on the walls are being filled with pictures of our naval battles." Other rooms were in the hands of a small band of decorators, who worked in a variety of styles and media.

At the conclusion of his report, Meigs wrote that almost $800,000 had been spent on the Capitol extension during the 1856 building season. Even after that large expenditure, more than $700,000 remained to his favor in the treasury. Without giving details, Meigs requested $900,000 to continue another year. Congress granted the request without debate, and Pierce signed the appropriation on the last day of his administration.

A second report gave an account of the progress made on the dome during 1856.[120] The last part of the old inner dome was removed following the adjournment of Congress in August. Once the rubble been hauled away, the remaining stone wall above the interior cornice was repointed with hydraulic cement and new brickwork laid with hoop iron reinforcement. The thirty-six columns of the lower peristyle had been delivered and the cantilevering brackets were about to be cast. Of the $200,000 appropriated for the dome in 1855 and 1856, $157,000 remained in the account. Meigs asked for and received an additional $500,000 for the next year's work.

Congress did not wish the lack of money to be used as an excuse for not finishing the extension promptly. It granted all that Meigs asked for, but still wanted to know how much money would be required and how much longer it would take before the wings were finished. When the secretary of war asked him about the completion date, Meigs estimated that it would require two more years to finish the wings. He calculated that 220,000 cubic feet of marble was still needed and proposed yet another trip to the quarry to see about its expeditious delivery. Meigs left Washington for Massachusetts on November 18, 1856, determined to press the importance of faster delivery of marble and to satisfy himself that next year's supply of stone would be adequate. While in Philadelphia, he received a letter from Walter with news that a fire had damaged his office. It started when a spark from a hot-air furnace under the floor ignited wooden planks, which were used as a floor covering until the tile arrived. Many of Walter's drawings, framed pictures, photographs, artists' sketches, drawing boards, instruments, and valuable papers were lost. Luckily the fire was contained in one room and did not damage the outside marble.

Upon his return, Meigs inspected his damaged office and went on a tour of the extension. In the Naval Affairs Committee room, he was disappointed with the work of George West, a temperamental artist who was painting marine scenes on the walls. West did not appreciate Meigs' criticism but declared that he would erase the paintings if naval men and artists agreed they were bad. Soon

Senate Committee on Naval Affairs

\mathcal{O}f all the highly decorated rooms and corridors by Brumidi and his fellow artists, this one appeared the most foreign to American eyes. Here, murals unearthed in Pompeii were the source of inspiration.

The room is currently occupied by the Senate Committee on Appropriations. (1995 photograph.)

West quit in a huff, saying that it was his misfortune to be born an American instead of English, Irish, Italian, or German.[121] Meanwhile, other rooms were being finished and handed over to committees anxious for meeting space. Because the central heating apparatus was not yet working, Meigs set up coal stoves as temporary measures in these rooms. The room intended for the House Committee on Territories (modern day H–128) was reported finished, painted, and decorated on January 12, 1857, and the Judiciary Committee room was suitable for use (although not yet decorated).

Near the end of the Pierce administration Meigs asked John Wood to print twenty-seven large

photographs, which included Crawford's models for *Progress of Civilization* and views and drawings showing the Capitol extension and new dome. He sent these to Davis as memorials of the great projects they directed.[122] Davis was returning to the Senate as soon as the next administration took over on March 4, 1857. There he would assume the chairmanship of the Committee on Military Affairs, a position he would use to defend military control of civilian construction projects. Pierce's lackluster term had been a great disappointment to his fellow Democrats, who denied him renomination. Instead, they picked James Buchanan of Pennsylvania, who had spent most of the time during the Kansas-Nebraska troubles quietly serving as minister to Great Britain.

On March 24, 1857, ex-President Pierce went to see Meigs at the Capitol and was disappointed to learn that he was in Georgetown attending to aqueduct business. He sat at Meigs' desk and wrote a letter to express his appreciation for the engineer's "personal kindness and friendship."[123] The former president was about to leave Washington with his wife to spend the month of April in Philadelphia. Pierce asked Meigs for a letter of introduction to his father, who might help restore Jane Appleton Pierce's health. (She had suffered from chronic depression since witnessing the accidental death of her young son Bennie in 1853.) Upon discovering the letter on his desk, Meigs wrote his father asking him to return the "kindness and confidence" that had supported him for the last four years. The president earned his family's gratitude along with the "affection" of the American people.[124]

Meigs' sympathies for the former president were understandable. During the past four years he had enjoyed the full confidence and support of the president and the War Department, but those days were over. Buchanan was now president and a new secretary of war, John B. Floyd, was in charge. A former governor of Virginia, Floyd saw the War Department as little more than a tool to reward the party faithful and to enrich his friends. Quarrelsome, corrupt, and duplicitous, he would help sink the Buchanan administration to a level of unprecedented incompetence and impropriety. Peaceful times at the Capitol were at an end.

Statue of America

by Thomas Crawford

1855

\mathcal{T}he central figure of Crawford's *Progress of Civilization* was a personification of America flanked by a rising sun and an eagle. Despite Jefferson Davis' initial objection, the liberty cap worn by the figure of America was retained in the final design.

This photograph was taken in Rome soon after Crawford completed the model. A similar photograph was given to Jefferson Davis upon his retirement from the War Department in 1857.

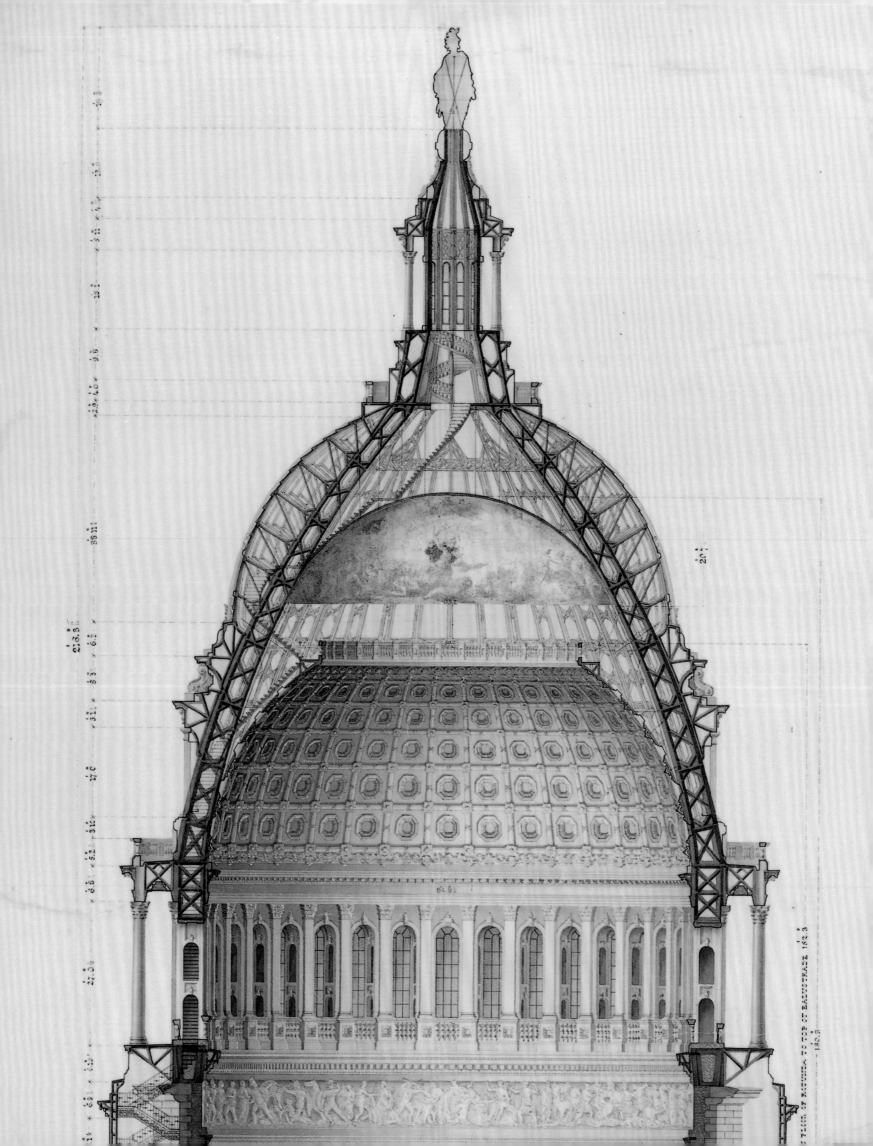

PRIDE AND STRIFE

As soon as James Buchanan was sworn in as president on March 4, 1857, senators and congressmen returned to their farms and offices, leaving the capital city to the small band of clerks and shop keepers who called it home. Captain Meigs had a foolproof way of knowing whether Congress was in town: if the streets were empty except for some carts and buggies—if there were no fancy carriages in sight—the lawmakers had left. While the streets were deserted, it was the busiest time of the year at the Capitol extension office. Meigs worked away on thousands of details relating to design, decoration, and construction, while Walter spent long hours at his drafting table. Their relationship had so far remained professional and cordial, but that would soon change. Meigs did not yet know that Walter was scheming to regain control of the design department, hoping to pull in the reins on the engineer's decorating frenzy.

Throughout the 1857 building season, Meigs drove the workmen to complete the House chamber in time for the opening of the 35th Congress in December. One of the biggest jobs was decorating the huge iron ceiling. Measuring 139 feet long by 93 feet wide, the ceiling was laden with decorative papier mâché moldings and pendants shaped like huge inverted pineapples. A central skylight was formed into forty-five panels glazed with colored glass made by the Gibson Company of Philadelphia. Described as having the appearance of enameled work, the glass included state seals copied by Johannes Oertel, an artist from New York. Meigs had difficulty finding accurate representations of the seals and was obliged to write officials in all the states and territories asking for authentic copies. He also borrowed from the House chamber an engraving of the Declaration of Independence that had a border made up of the seals from some of the older states.

Brumidi and a crew of painters began decorating the ceiling over the new House chamber at the end of 1856. Meigs provided some vague directions but mainly left the color scheme up to the artist's discretion. Strong, positive colors—red, blue, and yellow—were used with a generous sprinkling of gold leaf to ornament the intricate moldings with a degree of minute precision that was unlike anything seen before in American architecture. At first, Meigs thought the effect might be "too gorgeous," saying that "nothing so rich has ever been seen this side of the Atlantic."[1] He warned Brumidi not to make "too many little decorations" on the ceiling, but the result was a strong and varied application of bright colors and gold leaf that excited considerable comment.[2] Obviously impressed, *The Crayon* attempted to give its readers an idea of the ceiling's "surpassing gorgeousness." It claimed that the artistic effect was unequaled on the North

Section Through Dome of U. S. Capitol (Detail)
by Thomas U. Walter, 1859

John B. Floyd

**Daguerreotype by Mathew Brady
ca. 1858**

Library of Congress

*I*n 1857 President Buchanan appointed Floyd (1806–1863) secretary of war. A former governor of Virginia, Floyd's principal qualification for the cabinet post was being from the south. He was a fierce Democratic stalwart who used his power to award the party's faithful and punish its enemies. He routinely used his position over the Capitol extension office to steer contracts and jobs to friends of the administration. For his unabashed corruption and partisanship, Floyd is remembered as one of the most incompetent cabinet officers in American history. His later career as a Confederate general was hardly better. His inept command of Fort Donelson contributed to its capture by Federal troops in 1862.

Plan of Ceiling of House of Representatives

by Thomas U. Walter, 1856

*T*he iron and glass ceiling over the House chamber was its most elaborate feature. Artists highlighted the papier mâché pendants, moldings, modillions, and other ornaments using bright colors and gold leaf in a decorative treatment that excited considerable comment.

American continent and hardly matched anywhere in the world.[3]

Of course, not everyone approved of the color scheme. Senator Jacob Collamer of Vermont took exception to the use of so many bright colors and expressed his hope that the new Senate chamber would be spared a similar treatment:

> I think the architectural character of the Representative Hall, as now finished, is entirely over burdened and disguised and thrown out of sight by the great variety of colors put in. I think it sort of Joseph's coat: and I desire very much that kind of thing may be kept out of the new Senate Chamber; and I believe that a large portion of the Senators entertain the same taste and feelings. If anything can be done by way of securing a little more chastity in it, I should desire it.[4]

Jefferson Davis, on the other hand, defended the polychromatic color scheme, claiming no special expertise in the matter but expressing complete faith in Brumidi's skill:

> Rub off the gilding and paint out the colors; make them all one, if the Senator from Vermont desire not to have many colors. . . . But there is not an artist who would attempt to ornament a building by painting with one color. His skill is shown in the harmony of the colors, blending them so that no one rests on the eye and commands its single attention. I would be surprised at the American Congress if it were to wipe out these great efforts of art and introduce as a substitute the crude notion of single color.[5]

In March 1857, the Capitol's gardener granted permission to Meigs' chief bronze caster, Federico Casali, to pick all the flowers, leaves, and twigs needed to make metal ornaments to decorate the gallery doors in the House chamber. Twenty-four doors (seven of which were dummies) were made of baywood mahogany veneered with bird's-eye maple. Casali's small foundry produced figural and floral decorations that were used profusely on the gallery doors: cherubs, rosettes, acanthus, grapevines, rinceaux, masks, lizards, flies, beetles, and snakes. When the doors were opened, they recessed into the paneled jambs. Hung on the corridor side of the openings were double-leaf "fly doors" (swinging doors) that were made of red cedar covered with dark green baize held by silver plated tacks. Oval glass panels in each leaf were held by brass moldings. Fly doors were provided to allow access to the galleries without the noise and effort required to open and close the monumental mahogany, maple, and bronze doors. Below, fifteen doors gave access to the floor of the House. Each was closed by a pair of fly doors covered with red morocco with oval lights. The cast-iron frames were arched with clear glass transoms above the doors. Bronze sconces that were hung just below the spring line of the arch completed the rich decorative effect. These gas fixtures were formed into female figures with one arm outstretched, holding the burner, collar, and globe.

At the end of May 1857, Walter completed designs for members' chairs and desks. Meigs sent

Doors in Gallery Fronts
by Thomas U. Walter, 1856

*S*culpted female heads were intended to decorate the keystones above all fifteen doors leading into the House chamber. Only one, however, was fabricated and installed.

DOORS IN GALLERY FRONTS
HALL OF REPRESENTATIVES

SCALE ONE INCH TO A FOOT

a photograph of the desk design to Boston, where
the Doe Hazelton Company was paid ninety dollars
to make each of the 262 carved oak desks for the
new chamber. The firm was too busy to make the
matching chairs, so Meigs ordered half of them
from Bembe and Kimbel of New York (at seventy
dollars apiece) and the other half from the Ham-
mitt Desk Company of Philadelphia (at seventy-
five dollars apiece). The oak chairs, upholstered
with red morocco matching the leather on the fly
doors, had removable cushions to permit the cane
seats to be used during the summer months. Meigs
admonished the furniture makers to have the desks
and chairs delivered to the Capitol by December 1
at the latest.

Seating in the galleries was constructed by
carpenters working under their foreman, Pringle
Slight. Before work began, Meigs needed to know
the style of accommodations expected by the
officers of the House. He wrote the clerk of the
House, William Cullon, asking for guidance and
offering his advice. He suggested that the gallery
seats be cushioned in a red material. Spring seats
were best because people would show respect and
conduct themselves properly; wooden benches, on
the other hand, would be "trodden" and "defaced"
when the galleries were crowded.[6] Despite Meigs'
counsel, the clerk did not wish to provide guests
of the House with comfortable upholstered seats.
The gallery benches were made of wood with the
back rails and arms grained in imitation of
mahogany while the seats and backs were simply
painted and varnished.

Scaffolds in the House chamber were disman-
tled in mid-June while workmen were plastering
the cloakrooms under the galleries. On June 21,
the works were damaged by a violent hailstorm
that broke thirty-five large sheets of glass in the
skylight over the new chamber, while twenty-two
sheets of glass broke over the Senate chamber.
This thick glass had withstood the weight of work-
men but shattered under the force of hailstones
the size of eggs. Provost & Winter's marble cutting
sheds lost 8,000 panes of glass while Meigs' shops
lost 2,300 panes. The commissioner of public build-
ings reported that every skylight in the old Capitol
was broken and the copper roof was damaged as
well. Astonished by the severity of the storm, Meigs
recorded that "chickens exposed were killed imme-
diately. Cows and cattle ran about as if mad."[7]

Carpenters began laying the wooden floor in the House chamber on August 20, 1857. Their progress was interrupted when workmen ran out of materials, and Meigs went to the Campbell & Coyle sawmill to urge speedier delivery of lumber. By the end of the month, he was happy to report that work in the hall of the House was proceeding "bravely."[8] The floor was finished during the first week in September and awaited $1,800 worth of wall-to-wall carpet that Meigs had ordered from Clinton, Massachusetts. The clerk of the House felt that he should have been involved in the selection of carpeting, but since it had already been ordered he settled for selecting small accessories, such as spittoons.

From time to time Walter made inquiries about payments due the marble contractor, which Meigs thought was none of his business. The engineer warned him to stay clear of such matters, yet Walter secretly kept John Rice informed about every aspect of his business interests at the Capitol. On another subject, the marble contractors claimed they could not supply any of the exterior column shafts in a single piece. Their quarry could not fill the order as they once thought. Rice & Baird wanted to supply the shafts in four-foot drums, as allowed by their original contract, but Meigs insisted that the amended contract gave him the right to demand most—if not all—of the shafts in one piece. If they could not fulfill the contract, they would forfeit a 10 percent reserve withheld as a performance guarantee. Rice & Baird stood to lose $15,000.

In November 1857, Rice & Baird quoted the price of monolithic shafts at $1,700 each, $300 more than their contract allowed. (They would be obliged to purchase the stones from another quarry.) Meigs thought about sidestepping the firm altogether, ordering the shafts directly from Italy, and went to see the new secretary of war to discuss the matter. Floyd asked if it would be possible to substitute granite for marble shafts, an idea Meigs considered perfectly absurd. He reminded the secretary that the wings were faced with white marble, which would make granite columns look "rather dirty." Floyd then asked why the marble could not be removed and the wings refaced with granite, preferably granite from Virginia. Meigs said that Congress would never allow it because it would add five or six years to the project and cost an additional two million dollars. The foolish proposition was made, Meigs concluded, "only to get the money to go to Richmond."[9] Meigs' meeting left him thunderstruck. The secretary's proposal would not go far, but it spoke volumes about his motives and priorities.

Despite Floyd's shady dealings and crazy ideas, however, Walter wished he had more time to develop the secretary's friendship because he knew it would help improve his own situation at the Capitol. His control of the architectural department was steadily eroded by Meigs and his roster of artists and decorators, who provided various design services without the architect's knowledge. Walter was routinely left out of decisions that he felt should be made with his consultation. On May 4, 1857, for instance, he discovered that part of the architectural embellishments in the coffers over the ladies' retiring room in the Senate wing (modern day S–313) had been removed so that Brumidi could paint fresco pictures in their places. Walter complained privately that he had been ignored in the process and that the strength of the vault had been compromised. Meigs had Brumidi designing mantels and other conspicuous interior features, such as bronze railings for the four private staircases. All painted decorations were done without the knowledge or approval of the architect.

For a long time, Meigs did not sense Walter's unhappiness. But throughout 1857, Walter's private correspondence contained bitter complaints about Meigs' rule and his condescending attitude. He wished to return to the time when all the design work was generated in his office and the captain of engineers respected the prerogatives and role of the architect. Walter had once valued the way the captain lifted burdens from his shoulders, but he now grew tired of the autocratic way Meigs ordered, commanded, and lorded his power. He was weary of Meigs' insatiable appetite for fame, an obsession that gripped him like an addiction. He grew to detest Meigs' cravings for credit—credit for everything done under his rule, no matter whose intellectual property was stolen in the process. Walter's civilian ways were unavoidably at odds with Meigs' military disposition. Both were intelligent and cultured, but they were cut from very different cloth.

What had started as a cordial collaboration in 1853 degenerated into an icy relationship four years later. Walter wanted to stay with the extension and

dome until they were finished, but he wondered how much longer he could stand working under Meigs' rule. There were only two alternatives to resignation: the secretary of war could either muzzle Meigs or remove him. Walter wished to get to know Floyd better, but he found it unlikely given the demands of his work. To his most sympathetic correspondent, John Rice, he wrote:

> I have not yet seen the Secy. of War and have heard nothing fresh in reference to our *friend* [Meigs]; he still flourishes in fancied security, and thinks that he has the confidence and the admiration and the affections of the entire cabinet; . . .

> I wish that I could get time to see the Secy. but I am driven from morning to night and from night to morning in keeping up my designs for 15 draughtsmen, and in answering letters, refer to documents, making calculations, and then looking personally after every thing, so that it is next to impossible for me to make myself agreeable to anybody, or to cultivate the friendship of cabinet officers—My dear Rice I am on a treadmill, and if I stop one minute I shall get my shins broke—This is not as it should be—an artist's brains should never be cudgeled—he should be the master of his own time, but under

this reign that can not be—Tyranny and despotism is the order of the day.[10]

If Walter was unable to influence the secretary of war directly, he still had friends who had the leisure and the connections to do the job for him. William H. Witte, a former Democratic congressman from Philadelphia, was happy to help. Senator William Bigler, another Democrat from Pennsylvania, would also prove useful. Unfortunately for Walter, Joseph Chandler had lost his reelection bid and left the House at the end of the 34th Congress. (Chandler had not, however, lost clout with Buchanan, who appointed him minister to the Two Sicilies in 1858.) Walter's friendships with these influential politicians from Philadelphia would help him through the difficult times ahead. For his part, Meigs could depend on Jefferson Davis for support. In 1854, while in President Pierce's cabinet, Davis advised Meigs to dismiss Walter and claim the architectural honors for himself. At that time, the engineer replied that the architect was too valuable and said there was plenty of work and credit for both.[11] Soon, Meigs would regret his decision to keep Walter, but it is doubtful that either Davis or Meigs could have ordered Walter's dismissal on his own authority. He was, after all, appointed by the president of the United States, who was the only person who could fire him. Soon caught in the middle of these contentious forces were President Buchanan and Secretary Floyd, one old and indecisive, the other corrupt and devious.

THE OPENING SKIRMISH

Workmen swarmed over the new House chamber during the final days of November 1857 preparing it for the opening of Congress. Some of the ceiling glass had not yet arrived and Meigs feared that without it the room's opening would be delayed. But he thought everything else was ready. Walter, on the other hand, did not think the room would be ready for another six months. The heating apparatus was not finished, the stairways were still under construction, and thousands of little things needed to be done. Despite the "flourish of

Speaker's Clerk's and Reporter's Desks. Hall of Representatives

by Thomas U. Walter
1857

The chamber's focal point was the marble rostrum positioned in front of a cast-iron frontispiece.

SPEAKER'S CLERK'S AND REPORTER'S DESKS.
HALL OF REPRESENTATIVES.

trumpets of the superintendent," Walter did not believe the House would occupy the new chamber during the upcoming session.[12]

A former clerk of the House (and former and future commissioner of public buildings), Benjamin B. French, did not believe that the House would be in a hurry to occupy its new chamber, which he thought not nearly as tasteful as the old hall. He also felt the decorations of the new room were totally inappropriate for a legislative chamber:

> The new Hall of the House of Representatives is nearly finished. Capt. Meigs has *rushed* the work upon it so as to show it to Congress. It will not probably be occupied by the House till May or June. It is a gorgeous affair—too much so, to my taste, for a business room. The ceiling is magnificent, & perhaps not too elaborately ornamented, but the gilding around the Speaker's chair, the doorways and panels looks, to my eye, tawdry & out of place, worthy only of a theater, lager beer saloon, or steamboat cabin! It is in very bad taste.[13]

On December 7, 1857, Meigs officially reported to the secretary of war that the new chamber was finished. Walter wrote Richard Stanton, then retired in Kentucky, that he considered the room far from complete. He also complained about Brumidi's color scheme, which, like every other decoration in the Capitol extension, was planned and executed without his input:

> The Capt. has taken upon himself to have all the painting and gilding done under his special direction without any consultation with me and I must say that it is the most vulgar room I was ever in—I hope Congress will order it repainted and allow your old friend to have some say as to how it shall be done—it is susceptible of being made as handsome and dignified a looking room as any in the world—

Details of South Wing
by Thomas U. Walter, 1854

Although labeled "Retiring Room," the center space was destined to become the Speaker's office in the new south wing. The ceiling was the most elaborate design that Walter created for cast iron—one of his favorite building materials.

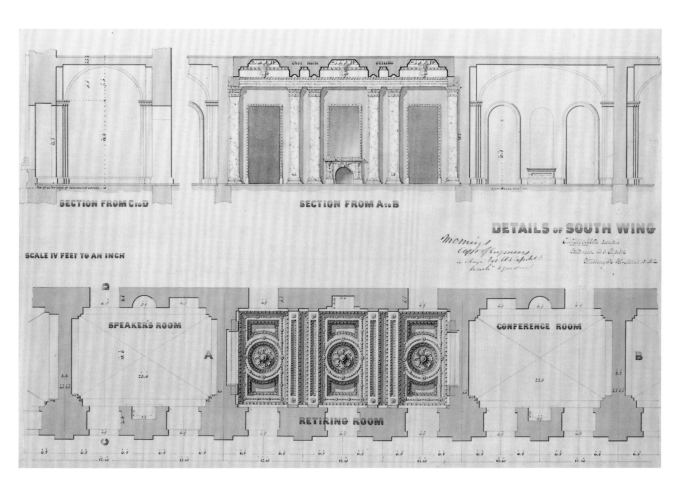

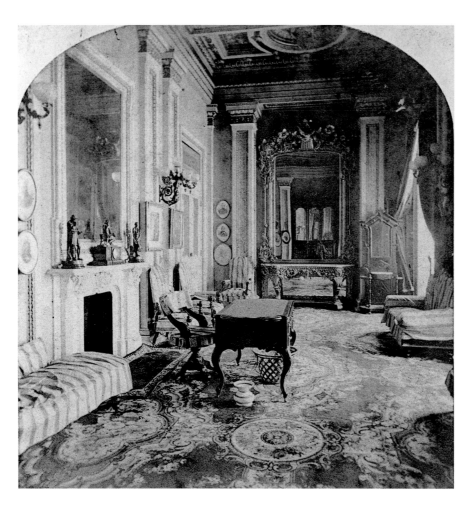

Speaker's Room

Historical Society of Washington, D. C.

Sconce in Speaker's Room

*A*mong the few gas lighting fixtures surviving from the 1850s are the cherubic sconces located in what was the Speaker's office, now part of the members' retiring room. (1972 photograph.)

*W*ith striped slip covers on the furniture, this photograph shows the Speaker's office partially in "summer dress." Such seasonal housekeeping rituals were common prior to the advent of air-conditioning. (ca. 1860 photograph.)

now it is the very worst I ever saw—and so says everybody.[14]

Many people who saw the completed room before it was occupied agreed with Walter's assessment. Hearing that some of the public's reaction to the color scheme was unfavorable, Meigs wrote a letter to the *National Intelligencer* in which he attempted to defuse criticism:

> The style is new in this country where our public buildings generally, through the poverty of the public purse or perhaps the greater poverty of the architect's taste, starve in simple whitewash. This, new in this country, rich and magnificent decoration, naturally, when first seen, excites surprise. The colors are so rich, so various, so intricate, so different from anything seen before, that the impression is that it must be, what? Gaudy? But what is gaudy? Are the colors of the autumnal forests gaudy? Is there anything in this Hall more brilliant than the scarlet leafage of the gum or the maple, or the yellow of the oak and other trees? . . . This is a great work. Let not the noisy babble of ignorance forestall public opinion upon its merits.[15]

The heating system was tried for the first time on December 7 and seemed to work well. To test the acoustics, Meigs entered the empty room just after dark, climbed into the Speaker's chair, and began reading from a book; assistant engineers scattered in the gallery and on the floor listened and responded. Two days later, similar experiments were conducted by Meigs in the company of fellow members of the acoustical committee, Joseph Henry and Alexander Bache. Louisa Rogers Meigs sang a song in the chamber that greatly pleased

her husband. He wrote: "The effect of her magnificent and rich voice in this great chamber was beautiful."[16] At no time were there echoes, and the voice could be clearly heard in every part of the room. Meigs was confident that his scientific approach to the design of the chambers would make them the best rooms in the world for speaking and hearing.

A committee of the House was appointed to determine if the new room was ready for use. It sent for Meigs and asked him whether the dampness of fresh masonry might make it unwise to occupy the chamber right away. Using a hygrometer, the engineer proved that the air was dry and healthy. On December 13, 1857, the reverend Dr. George Cummins preached before a crowd of 2,000 worshipers in the first public use of the chamber. Soon thereafter, the committee recommended that the House convene in the new hall on Wednesday, December 16, 1857.

Workmen cleared the corridors around the new chamber, removed scaffolds, cleaned up, and polished everything to welcome the House of Representatives to its new home. A temporary passage was constructed between the old and new chambers, and Meigs proudly instructed the Speaker, the doorkeeper, and the clerk about the proper operations of the room. At noon on the appointed day, members of the House assembled in the room with spectators sitting on the hard benches in the gallery. Meigs was relieved to hear so few complaints, especially about the room's heating and ventilation. The few grumbles he did hear were of so little consequence that he paid them no attention. He noted: "It is no easy thing to warm 241 gentlemen so that each thinks himself just right, especially when they have been told that the Hall is damp and new, etc."[17]

Benjamin B. French, who had not liked the hall when it was new and empty, did not like it any better when it was filled with congressmen. He described the conditions of the windowless room in a letter to his brother:

> I went over today and saw the House of Representatives down in their new cabin—for it seems as if you were in a monstrous salon—beneath deck. I don't like it at all, and in my opinion the House will adjourn back to the old Hall before two months! The idea of shutting up a thousand or two people in a kind of cellar, where none of God's direct light or air can come

in to them—where they are breathing *artificial* air, and seeing the secondary light, is one that does not jump with my notions *of living*. And then, so far as comfort is concerned, the arrangement of the Hall is by no means equal to the old one. It is a piece of gaudy gingerbread work, that will in the end, do no credit to anyone who has had anything to do with it.[18]

In light of all the bad publicity Meigs was getting from early reviews of the chamber decorations, Walter felt it was time to reassert his rights to control the design of the Capitol extension. He would try to convince the War Department that both economy and good taste would be better served if he were given veto power over Meigs' expensive and gaudy decorations. He wrote a draft order on December 4, 1857, and it was delivered to the secretary of war by former Congressman Witte. They hoped Floyd would sign it, have it delivered to Meigs, and, thereby, restore the

House Chamber
ca. 1865

*F*lanking the Speaker's rostrum are the portraits of the Marquis de Lafayette and George Washington that originally hung in the old chamber. In the corner is Brumidi's depiction of the surrender of Cornwallis, which was intended to be the first in a series of history paintings for the wall panels.

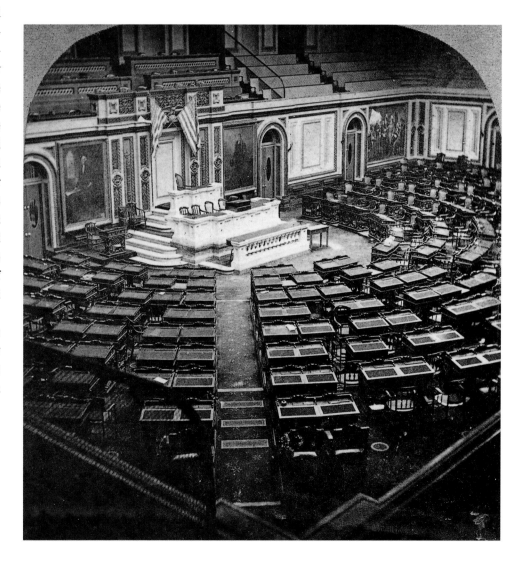

To display a fine pair of bronze figures by William Rinehart, Walter designed a clock case that was then made in New York City by the Bembe & Kimbel furniture company. The crowning eagle was modeled at the Capitol by Guido Butti and cast in Philadelphia by Archer, Warner & Miskey. The clock was given the place of honor over the north door and thus occupied the same relative position as Franzoni's *Car of History* in the old hall.

proper lines of responsibility at the Capitol extension office. The draft read in part:

> No contract or order for any work upon the building under your charge is hereafter to be made for any alteration or work upon any plan differing from the original plan adopted, nor is any change to be made in the original plan, except upon a distinct proposition for such change of plan, concurred in and approved of by the architect and authorized by the Department.[19]

Day after day Walter waited to see what action would be taken by the War Department. He heard occasional rumors that the order had been issued, but these turned out to be untrue. Week after week, month after month Walter waited for the War Department to act: the waiting continued for two years.

On December 19, 1857, Meigs and Walter attended a meeting of the House Committee on Rules and Accommodations to discuss the ventilation system in the new chamber. The question of downward versus upward ventilation had been debated among Meigs and the assistant engineers and consultants for years, and Meigs was more convinced than ever that the downward flow of air was best. He was afraid that forcing air up from the

floor would stir choking storms of dust and release the stench of tobacco odors from the carpet. He was quite satisfied with the effects of downward ventilation that had been demonstrated in the House chamber over the past three days. When asked for his opinion, Walter stated his objections to forcing hot air downward because it went against the laws of nature. He thought it was better to introduce warmed air from registers in the floor and to exhaust it through grills in the ceiling. This public disagreement with Meigs was most unwelcome and prompted a swift reaction. In front of a room filled with congressmen Meigs announced that the architect's opinions were of no consequence because he had nothing to do with the ventilation of the hall—he was not a "scientific man." Joseph Nason of Nason & Dodge, the heating and ventilation consultants, was also in attendance. Nason testified about improvements made by his firm to the Utica fan, which he claimed contributed to the success of the ventilation system. Meigs disagreed, claiming the improvements were his idea. All of the ventilating experiments were devised and paid for by Meigs and many of the ideas were Meigs' or came from men on his payroll. "It is a well-established principle that the engineer who takes the responsibility of ordering a particular work," he wrote soon after the meeting was over, "though he may not work out with his own hands its details, is entitled to the credit."[20]

The meeting was the opening volley in the public feud between the architect and the engineer. Walter dared to disagree openly with Meigs, who considered it nothing less than an act of insubordination. In response to the outrage, Meigs publicly insulted Walter, declaring him unfit to comment on scientific subjects. Considering his extensive experience, which included several large engineering commissions, Walter was deeply offended by the condescending, rude, and inappropriate behavior.

Two days after the encounter, Walter received a letter from the War Department asking him to suggest ways to economize at the Capitol.[21] It came with copies of two letters written by Meigs, in which he claimed to be the designer of the Capitol extension. Meigs did not say that he was the architect in so many words, but he asserted that the original designs were his and that they had been approved by President Pierce in 1853. Covering twenty-one pages, Walter's reply complained that Meigs'

Extension and Dome Construction
1857

This photograph was taken about the time the House of Representatives moved into its new chamber.

extraordinary statements were "unjust to me, prejudicial to the interests of government, and in opposition to the tasteful and philosophical development of the arts of peace, in public structures." While freely admitting that the original plans were altered at Meigs' suggestion, he maintained that they were his nonetheless. Walter wrote that Meigs

> has not designed the Capitol extension, nor any other work on which I have been engaged with him; —he is not an Architect, —his calling is that of a Military Engineer, in which profession, I have no reason to doubt that he is eminent, and it is highly proper that he should wear the honors of that Profession; —but to assume that he designed the Capitol extension, and that I have been 'assisting' him, is nothing less than to assume to practice in a profession for which he has never been educated, and about which he knows no more than the generality of well educated men.

In the second letter, Meigs claimed that his design for the House chamber was based on scientific studies, particularly the science of acoustics, and that he deserved credit for its success. He implied that Walter's original design for the chamber would have been a failure, but the architect vehemently disagreed. Walter pointed to the fact that both rooms were nearly the same size and both were covered by a flat iron ceiling thirty-five feet above the floor. The ceiling designs, with elaborate moldings, pendants, and ornamental glass, were virtually identical in both cases and were of the same style and character as the ceiling over the Library of Congress. With the exception of win-

dows, Walter said that what was "descriptive of my original plan of this room, is descriptive, in all essential particulars, of the present room."

While he awaited a reply to his long letter, Walter avoided seeing Meigs, who discovered that the architect was in "secret communication" with Floyd.[22] Even if the climate had been more hospitable, the engineer was too busy with members of

Senate Chamber Under Construction
ca. 1857

Congress to spare much time for the architect. Walter reported to Rice that "things have got so hot that I don't go near the fountain head anymore—M. is busy all the time, with members explaining his greatness and the unimportance of somebody else— he is vain to an extent amounting to insanity, bitter and vindictive."[23] A few days later Walter returned to his office after a brief absence and saw Meigs walk by with a "trail of senators after him headed by Jef. Davis." They did not stop, scarcely spoke, and seemed preoccupied with other business. He knew that Meigs was highly effective in bringing legislators to his point of view, and unless Witte could convince the secretary of war to act soon, Meigs would surely prevail. "Nothing can exceed M.'s industry, perseverance, sweet oil and soft solder," Walter wrote; "today [he] showed a deep seeded enmity on his part that can not be got over—this is the first time he ever looked belligerent."

In the war that was beginning over control of the architectural department, Meigs claimed the credit for the "original" design of the Capitol extension. Like everything else in this contest, there were two sides to the argument. By his commission from President Fillmore in 1851, Walter certainly had claim to the original design of the Capitol

extension—outside and inside. Subsequent alterations to one aspect of the design—the floor plans—were suggested by Meigs, but they were worked out by the architect who had to solve many design problems to transform the suggestion into a workable plan. For his part, Meigs claimed credit for the wings as they were then being built. He reasoned that the changes to the floor plans resulted in an entirely new design for which he could rightly claim credit. He already claimed credit in letters to the War Department, which drew an angry reply from Walter. But Meigs came up with another strategy to bolster his claim. He sent for the revised plans bearing the signatures of Franklin Pierce and Jefferson Davis, and added the following title: "ORIGINAL REVISED PLAN—BY CAPT. M. C. MEIGS U. S. ENGINEER—ADOPTED BY THE PRESIDENT OF THE U. S. 27 JUNE 1853." The drawings were sent to the photographer's studio with an order to make copies. The photographer was also instructed to destroy the negatives of the drawings taken prior to the application of the new title. When Walter discovered this, he wrote Meigs a letter describing his astonishment at the methods used to establish his claim and asked him to "stop all further proceeding in

Details of Roof of North Wing

by Thomas U. Walter and Montgomery C. Meigs, 1857

𝒯his drawing for a roof truss included details of its multiple connections as well as elevations of the web members cast with Meigs' name as the "inventor." The name of the fabricator, Newsham & Company of Baltimore, was also cast into the ironwork.

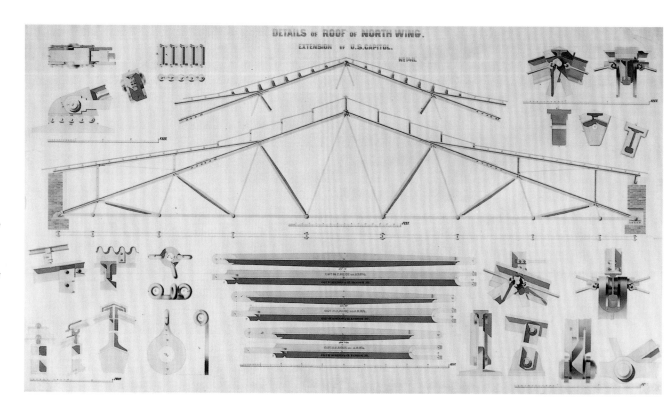

reference to photography of these drawings and return them to my office, that I may restore them to the condition they were when approved by the President."[24] The drawings were returned only after Floyd issued an order to do so. Walter erased all or part of the new title from most of the drawings.

Meigs stayed home all day on January 21, 1858, writing a response to Walter's latest letter. In his view, it contained a "preposterous claim to the design for the alterations I made in his plans for the extension of the Capitol." He also wrote Senator Davis, enclosing a copy of his letter to the architect along with photographs showing the drawings in their altered and original states. Davis could be counted on to take the case to the War Department and the president. Meanwhile, the engineer confided to his journal that Walter had done nothing more than make the "drawings under my direction, in obedience to my orders, in accordance with principles which I first announced, and which he did not and does not yet understand."[25] Meigs wanted to place the contest before the War Department, the chief executive, the press, and the world, to force the administration to choose between him and the architect. Walter wanted the same thing. To Meigs, the credit for the Capitol extension was all he expected in return for five years of intense labor on the job. Earning only $1,800 a year as a captain in the U. S. Army, his financial rewards were meager, but the honor of building the extension made it all worthwhile. Take the credit away, and he would be left with nothing to show for a great deal of trouble.[26]

"LOOKING OUT FOR SQUALLS"

*T*he contest between Walter and Meigs was played out in the shadow of the Kansas debate. Troubles in the Capitol extension office hardly compared to the troubles in Congress over the admission of Kansas as a slave state under its dubious Lecompton constitution. Led by territorial governor Robert J. Walker, a native of Mississippi, the constitutional convention held in the capital city of Lecompton had been boycotted by anti-slavery Kansans and, thus, drafted a document wholly along pro-slavery lines. The Kansas electorate was then allowed to vote on the constitution's article; with free-state forces again boycotting, the article passed easily despite its failure to reflect the will of the territory's majority. President Buchanan nevertheless supported the admission of Kansas as a slave state, but he was opposed in the Senate by Stephen Douglas, who noted that the Lecompton constitution was never ratified by a popular vote. Fueling the debate was the infamous Dred Scott decision handed down by the Supreme Court at the beginning of Buchanan's term. It ruled that Congress could not

North Corridor in Front of the House Gallery
ca. 1860

*B*ronze chandeliers suspended from saucer domes and sconces fixed to the iron window casings contributed to the corridor's sculptural effect.

outlaw slavery in the territories and declared that neither slave nor free blacks were citizens of the United States. Abolitionists were enraged, slave holders were emboldened, and Kansas was their battleground. There can be little wonder that such trifling matters as the differences between an architect and an army engineer failed to attract the attention that Walter and Meigs thought they deserved. While Congress and the administration did not ignore the Capitol completely, the nation was splitting apart and a resolution of the personnel problems at the extension office would have to wait—and wait.

The first session of the 35th Congress lasted more than six months—from December 7, 1857, to June 14, 1858. The Kansas issue dominated the session, but a few members also found time to look into matters relating to the Capitol, a diversion that was certainly less unnerving. On February 9, George Taylor, a representative from Brooklyn, introduced legislation in the House to establish a commission of outside experts to oversee completion of the Capitol. Since such a commission would oversee Meigs and curtail his power, the engineer assumed that Walter was behind it and asked friends in Congress to recast or kill the legislation.[27] Debate in the House did not question the wisdom of creating such a commission, but there was some confusion about which committee should handle the bill. Eventually, the legislation was referred to the Committee on Public Buildings, where it died. But the idea of creating a commission to curtail Meigs' decorations had been established and would resurface in a slightly different form at the end of the session.

As the session wore on, Walter and Meigs continued on their separate ways. The engineer juggled his jobs building the Capitol extension, dome, aqueduct, Post Office extension, Patent Office extension, and Fort Madison while making sure his political base remained strong and his profile high. The architect kept working at his board, producing drawings that he retained in his office for fear of "mutilation," his term for changes Meigs was prone to make. Without drawings, construction slowed to a crawl, particularly on the new dome. Walter kept up his extensive correspondence with friends and business associates, telling them how difficult things were at the Capitol and what a bad man Meigs was. Walter had not seen Meigs for about a

month when he wrote John Rice about the logjam at the office, with unpaid bills stacked up waiting for the captain's signature. Provost & Winter had been waiting for a large payment for two weeks and "can't get a cent." The iron men were in the same situation and were unhappy. Meigs moved his office back to the rooms over the Adams Express office on A Street north and ordered Walter to follow. Seizing the opportunity, Walter asked and received permission from the secretary of war and the Speaker to move his draftsmen to an empty committee room on the third floor of the center building (probably modern day H–328). There, in a fireproof office, he could store the drawings safely and guard them against unauthorized changes. Meigs viewed the move as a robbery of documents from the office and Walter as the thief. Unsuccessful attempts were made to take the drawings from the architect's control, and the War Department permitted Meigs only to examine the drawings in Walter's office and to take away copies of those needed. But the engineer would not go there under any pretense, and he would not acknowledge Walter's right to control anything as important as the architectural drawings. Thus, the drawings piled up in the architect's office.

Because he had no direct contact with the engineer or his clerks, Walter gained his knowledge of business matters through spies and rumors. A typical report that he sent to Rice about the chaos in Meigs' office also contained some of the most vivid language used by this Baptist Sunday school teacher:

> P[rovost] says that Denham remarked that things were in a very bad state, that every thing in their office was unsettled & in confusion, and that he couldn't get the Capt. to attend to anything—I guess he is half right—the Capt. hangs on in the face of the bitterest opposition of his chief, with all around him at enmity to him, nobody caring for him, every body wanting him away—he is a perfect excrescency—a nightmare on the public works, and still he sticks— he is the most immodest, indelicate man I ever heard of—I don't believe he ever intends to go.

> W[itte] was here yesterday, but he had no news; he said that they were waiting until the Kansas matter was settled before they made a move—they are better at *waiting* than at any thing else.[28]

Walter copied relevant correspondence and sent it to the War Department, where it would be

available in case Senator Bigler needed it for a speech. Walter would have no objection if Secretary Floyd took a look at it himself. Meigs learned of this from Charles Heebner, a partner in the Rice & Baird marble firm, who told the engineer that Bigler intended to read some of the letters before the Senate. Meigs, in turn, went to see Alexander Bache of the Coast Survey, who told him that there was support for his position in Philadelphia and that he could "get any quantity of help to fight this battle" by merely making it known that he needed some.[29] Senator Davis was sick, and unable to respond to Bigler in the Senate, so Meigs intended to recruit James Pearce to man that defensive position.

It was remarkable that so many players, so many parties, and so many alliances formed around the two combatants. The idea of tapping into the political machinery of Philadelphia to help win the contest over control of the Capitol in Washington suggests how widely felt the dispute was. It was not confined to the local press or the gossip of local drawing rooms. Rather, it was a competition with a national audience—not as exciting or as important as slavery in Kansas, of course, but wonderfully tantalizing nonetheless. Struggles among strong wills always attract spectators, who usually care more for the entertainment than for justice. The case of Walter versus Meigs was a worthy successor to the Latrobe–Thornton battles waged a half century earlier.

During this period of administrative contention, physical violence was also common in and around the Capitol. A workman was killed while crossing the grounds late at night on March 27, 1858, shot dead by an assassin who shouted politically charged epithets at his victim. Two weeks later, John A. Gilmer, a member from North Carolina, had an encounter with Burton Craig, another Tar Heel, as the House prepared to adjourn for the funeral of Thomas Hart Benton. What sparked the fight is unknown, but it probably had something to do with Gilmer's strong anti-slavery views. Craig, a stout man over six feet tall, lunged at Gilmer, himself a large man weighing more than 200 pounds. By the time they were separated, and before any injuries were inflicted, Craig was discovered to be armed with a revolver and a Bowie knife. Both men left the hall unharmed.

Perhaps the chilling memory of the brutal caning of Massachusetts Senator Charles Sumner by

South Carolina Congressman Preston Brooks helped restore civility between the two representatives. That incident, which took place on May 22, 1856, was one of the most violent ever to take place inside the Capitol. Sumner delivered an inflammatory address denouncing the "Crime Against Kansas," during which he condemned the south as the "harlot of slavery." Soon after the speech was over, Brooks went to the Senate chamber, found Sumner at his desk, and proceeded to beat the senator senseless with a cane. Sumner was unable to resume his seat in the Senate for three years. For his defense of the southern cause Brooks became the darling of the region (hundreds of admirers sent him canes as gifts), while Sumner rose from relative obscurity to become a hero of northern abolitionists.

At the end of April 1858, Walter reported that things around the Capitol were rather dull, the work virtually stopped. He had not seen Meigs for quite some time, nor had he seen Witte or the secretary of war. "Am just holding on from day to day," he wrote Rice, "looking out for squalls."[30] Some of his leisure time was spent writing about his troubles and damning the captain of engineers with a warmth that places him among the greater talents of that genre. On April 19, 1858, for example, Walter wrote

Dome Construction 1858

*B*y the time this photograph was taken on May 16, 1858, all of the columns for the dome's peristyle had been put into place.

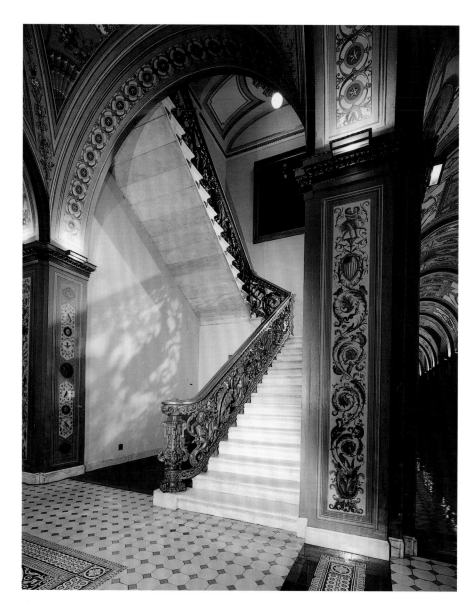

**Private Stairway,
North Wing**

*T*wo private stairs in
each wing offer the most
direct route to the chambers from the first floor.
When they were new, the
railings were admired as
unsurpassed works of art.
(1996 photograph.)

a long overdue letter to a friend who was a Baptist
minister living in Uniontown, Pennsylvania:

> I am under, probably, the most tyrannical,
> despotic, vain, and unscrupulous man the
> world ever saw, viz Capt. M. C. Meigs—he seeks
> to rob me of every thing he can to pamper his
> own vanity; to check me in all my works
> because I will not allow him to have credit for
> what he had no more agency in producing than
> you had—He is a shallow brained pippenjohn
> with epaulets and brass buttons claiming to be
> architect, painter, sculptor, philosopher, and a
> thousand other things about which he is wholly
> ignorant—he insults and vilifies me in every
> way he can because I will not concede to him
> all knowledge . . . he is so contemptible that I
> have refused to speak to him for months past,
> and had I not had the promise of those in power
> that he should be speedily removed I should
> have resigned long ago—I am daily looking for
> his removal, and if it don't come soon, I shall
> go myself, so you see I have been in no humor
> to write.[31]

On April 17, 1858, Meigs authorized Randolph
Rogers to have his Columbus doors cast in Munich.
One week later he went to the Senate wing to
supervise the installation of the first of four bronze
railings cast by Archer, Warner & Miskey of
Philadelphia. The general outline of the railings
was drawn by Brumidi in 1857, but the models
for the various components were sculpted by
Edmond Baudin. Earlier that year Meigs had visited the foundry, seen the sculptor at work, and
been glad he was working from good natural models. One reluctant model was a buck that had
been boxed up and transported to the fourth
story of the building where Baudin had his studio. The animal stayed three weeks and gave his
handlers quite a fight both coming and going.
Other models included snakes borrowed from the
Academy of Science.[32]

Bronze Eagle

*E*dmond Baudin, a French sculptor working in
Philadelphia, modeled this fierce looking eagle for the
bronze stair railings about 1857. Deer, birds, snakes, and
cherubs were also incorporated into the design.
(1977 photograph.)

THE POLITICS
OF PAINT

*A*s the congressional session wore on, time did little to mute criticism of the color scheme in the House chamber. Meigs usually dismissed such reviews as signs of ignorance, but he could not turn the tide of public opinion in favor of what many considered vulgar, tawdry, and gaudy colors. On May 19, 1858, a petition from 127 American artists was presented to the House. Signed by such well-known painters as Rembrandt Peale, Thomas Sully, and Albert Bierstadt, it was aimed at placing control of the Capitol's decorations in the hands of an art commission. On the day the petition was presented, Owen Lovejoy, an abolitionist Republican from Illinois, and Humphrey Marshall, a West Point graduate and a member from Kentucky, attacked Meigs' handling of the interior decorations. Lovejoy sarcastically evoked Christopher Wren's famous epitaph at St. Paul's Cathedral—*"Si monumentum requiris, circumspice"* (If you seek his monument, look around)—when asking his colleagues if they wanted to see a monument to military architecture. "Look at the meretricious and garish gilding of these walls," Lovejoy declared, "and the splendid specimens of fresco painting in these panels. And then go down into the Agriculture Committee room—at one end is a representation of Old Put leaving the plow; and at the other is Cincinnatus, also leaving his plow."[33] He thought that the decorations of the Agriculture Committee room should illustrate the current state of agriculture in America. In the ceiling he saw Brumidi's cupids, cherubs, and other images from "heathen mythology" and regretted that valuable breeds of cattle, sheep, and horses had not been painted instead. Lovejoy thought the worst part of the room's decoration was the lack of anything to do with corn. The absence of this American staple in the committee room was a great shame:

> A panel ought to have been given to this single production. It should have been represented in the different stages; as it emerges, weak and diminutive, from the ground; as it sways in its dark luxuriance in June and July; and then as it waves its tasseled crest, like the plumes of an armed host; and last, in its rich golden maturity.[34]

His poetic side soon gave way to a cynical suggestion that the picture of Israel Putnam would better suit the Committee on Revolutionary Claims. Its place in the Agriculture Committee room should be taken by a "picture of a western plow, with its polished steel moldboard, with a hardy yeoman." This image of free labor should be made to contrast with an ugly view of slave labor and thus show "the two systems of labor now struggling for the ascendency."

Lovejoy's speech was followed by extensive remarks from Congressman Marshall about an appropriation for the extension and the wisdom of forbidding Meigs to use any of the money to pay for decorations. He offered an amendment to prohibit any part of the appropriation from being spent on painting or sculpture unless the design were approved by a committee of American artists appointed by the president.[35]

Marshall's amendment grew out of the earlier proposal to establish a commission of outside experts to oversee completion of the Capitol extension. But the current legislation was limited to an art commission to oversee decorations. In his remarks, Marshall pointed to the empty niches in the gallery walls and warned that unless steps were taken they would soon be filled with statues commissioned by Meigs without anyone in Congress knowing anything about whom or what the statues would represent. He then pointed to the lone fresco in a corner panel that Brumidi had quickly painted just before the hall opened, a disappointing work entitled *Cornwallis Sues for Cessation of Hostilities Under the Flag of Truce,* and promised that additional "daubs like that" would be precluded by an art commission.[36] Meigs had not been pleased with the picture either, and he claimed it was only an example of the kind of art he wanted to see placed in the chamber. But Marshall took Brumidi's work as an ominous sign of things to come, as a threat of bad and distracting pictures placed in the chamber against the will of Congress.

The amendment creating an art commission failed on the first try but was successfully resurrected a few days later. Working on behalf of the commission were several artists who had tried and failed to land contracts with Captain Meigs. Horatio Stone and Henry Kirke Brown were two sculptors whose friends in Congress were behind the scheme to take control of the decorations away from Meigs.

Their motives were partly revengeful, partly pecuniary, and partly a disagreement over such matters as good taste and what constitutes American art. In the Senate, Meigs' faithful ally from Mississippi sought to replace the art commission with a generous appropriation to acquire works of art through the Joint Committee on the Library. Davis was against forming an art commission because it was an insult to Meigs, who was faithfully implementing the style of finish adopted by the Pierce administration. He recalled the days when, as secretary of war, he encouraged the highly decorated interiors, made the decision to cover the walls with fresco painting, and endorsed paving the floors with encaustic tiles. No formal vote was taken in Congress to officially approve such a course, but Davis said he received every indication that he and Meigs were on the right course:

> An opinion was sought from Congress. It was not given by any vote, but it came to me in every other form that they wanted the building finished in the very highest order of modern art. One expression I recollect distinctly, because it was very striking, that Brother Jonathan was entitled to as good a house as any prince or potentate on earth, and generally that they wanted the best materials and the best style of workmanship and the highest order of art introduced into the Capitol of the United States.[37]

Sam Houston of Texas took the floor in opposition and entertained the Senate with his homespun views about the sculpture destined for the pediment, which he mistakenly assumed was the work of a foreign artist. It was a long, extemporaneous talk frequently interrupted by hearty laughter from everyone but Davis. Houston had particularly harsh words for Crawford's personification of America, whose painful attitude seemed to indicate that she suffered from a boil under her arm. Then there were her shoes, "a very formidable pair of russet brogans, that would suit very well for laborers in the swamps of the South." He was taken aback by an Indian child whose neck was not big enough to hold its head. The child's head reminded him of a terrapin or an apple on a stick. Houston thought that works of art should "inspire cheerfulness and pleasure. Instead of that, a contemplation of this figure will inflict agony on every human being of sensibility."[38] And so it went until every figure in *Progress of Civilization*—and some miscellaneous others—was lampooned with Houston's amusing brand of criticism.

In the House, debate often centered upon the issue of decorations and ways to stop Captain Meigs' artistic pursuits. The idea of an art commission appealed to some members, while others simply wanted a blanket prohibition against any more art. Representative Taylor of New York, who had originated the notion of a commission at the beginning of the session, now wanted to cut off funding altogether, saying the two wings were so far advanced that any more money would be used only for decorations. The less money available to Meigs, he declared, "the better for us, the better for the Treasury, the better for the artistic taste of the country."[39] He called the decorations "contemptible"

Plaster Models for *Progress of Civilization*
by Thomas Crawford

*T*he first models of *Progress of Civilization* were shipped from Rome at the beginning of 1855 and carved by Italian sculptors working in the Capitol's marble yard. Eight years later the figures were installed in the Senate pediment. Seen here are the figures of the schoolmaster and child, two youths, the merchant, and the soldier. The models were put on display in the old House chamber in June 1859. (ca. 1859 photograph.)

and "disgraceful to the age and to the taste of the country." Taylor insisted that if his colleagues did not believe him, they should inspect the extension themselves:

> Go through this Capitol and see the insignificant tinsel work that has been prepared here to stand for ages as a representation of the taste and skill of the age. Have we no artist to illustrate the history of our country? Can we not write some portion of our country's history on these walls that will perpetuate the character of the present generation? Have we no commerce to illustrate—no history to perpetuate? Have we made no mechanical, no scientific discoveries worthy of record here, that we are compelled to employ the poorest Italian painters to collect scraps from antiquity to place upon these walls, as a lasting disgrace to the age—mere tinsel, a libel upon the taste and intelligence of the people.[40]

Muscoe Garnett of Virginia thought that Meigs himself was at the heart of the issue, and rightly so. He had not been a member of the House for long, but he had served in the new chamber long enough to call it a "sarcophagus for the living." He observed that members were

> inclosed in a vault, breathing a poisonous atmosphere, and suffering the close heat of an oven. . . . Again, what is the style of the adornment of this Hall? It is gingerbread and tinsel work. The attempt to defend it by talking of the harmony of colors and the polychromic style, is absurd. It is unjust to that style, which it does not illustrate, but caricatures.[41]

While many House members considered the appropriation and the various amendments as a referendum on Meigs' success at architectural decorating, few attacked him personally. Most recognized that he was a faithful public servant but felt he was engaged in a field for which he was not well suited. Humphrey Marshall of Kentucky, for instance, said: "I do not desire, sir, to attack the engineer who has charge of this work. Although I do not consider him a Phidias, or a Michael Angelo, I do not want to attack him. But I do not want to see the work of embellishment progress as it has gone on."[42] On June 7, 1858, the House agreed to prohibit any part of the appropriation from being spent on works of art unless approved by an art commission composed of three members appointed by the president. In the Senate, Davis inserted a clause to allow sculpture by Crawford (being sent from Italy by his widow) and Rogers to

proceed unaffected by the new provision. President Buchanan signed the bill into law on June 12.

During the debate Meigs had not sat idly by. His defense was played out in the newspapers that printed anonymous articles written by the engineer, who signed himself "M" or "A Private Amateur." To answer charges that foreign artists were giving the Capitol a foreign look, he told the reader that "the encouragement of art by works of the Capitol has been the care of the superintendent from the beginning. . . . All these are due to the foresight and careful provision of Capt. Meigs and of him alone."[43] In other words, the fact that there was fine art in the Capitol extension at all was thanks to Meigs. And he did not care where an artist was born as long as his talent justified employment:

> The point that is made of neglect in employing American artists is unfounded and unjust. He [Meigs] has a national pride, and is gratified when he can assist native talent, and is not likely to overlook it when the public interest will be benefitted. It matters not where an artist is born: that is beyond his control. At an age of maturity, if he seeks our nation and becomes one of us, and desires that his talent shall be exerted in decorating our edifices, that his works may remain in the country where his children reside and will deposit his bones, he should be encouraged. Our artists will readily perceive that advantage of employing the best talent, and they will improve by the lesson thus inculcated.[44]

Pleading the case of the American melting pot and suggesting that American artists stop complaining and start learning from foreign artists were hardly effective arguments. These newspaper articles and the backing of Senator Davis were not enough to stop Congress from putting an end to Meigs' grand plans for interior embellishments. If Meigs felt the sting of a congressional rebuke, he suffered in silence.

Walter, too, had closely monitored the actions in Congress. Since the War Department had not acted, he was pleased that Congress did. He read Meigs' newspaper articles with a tinge of disbelief. While these pieces were naturally self-serving, the vanity of Meigs' writings prompted Walter to remark:

> Meigs is out in the Intelligencer in an article in which he proves to the satisfaction of *himself* that he is the greatest man that ever lived—the inventor of every thing good that ever has been invented, the designer of the pivots upon which

the world revolves—I wonder that he don't order old Vulcan to stamp his name on the thunderbolts—the wheelbarrow man affects to believe it to be satire—but it is not *satire*—it is the candid opinion of a man about himself.[45]

After Congress created the art commission, Meigs' freewheeling days as a decorator were over. Nonetheless, Walter continued to press for his removal. The conflict between the two ran far deeper than brushes and paint. Too many insults had been hurled, too much pride had been wounded, and too many feelings hurt to ever hope for reconciliation. With so much work to do at the aqueduct, troubles at the Capitol barely affected

Senate Committee on Military Affairs Room

ca. 1900

*I*n 1856 Brumidi began decorating this room with scenes from the Revolutionary War. Only two lunettes and some wall panels were completed before work stopped in 1858. In 1871 Chairman Henry Wilson of Massachusetts had the decorations completed. Brumidi returned to paint three more scenes, including *Storming of Stony Point, 1779*, and *Washington at Valley Forge, 1778*, which are visible in this view. The room is currently occupied by the Senate Committee on Appropriations.

Meigs' daily routine. But every day Walter hoped the War Department would remove Meigs and assign someone else who would not meddle in design matters at the Capitol. He held on by the promise that a resolution was forthcoming. His frustration is evident in a letter he wrote to John Rice soon after the city emptied at the close of Congress:

> I am out of all patience with the delay, the procrastination—the *"next week"* talk—B[igler] ought not to have left Washington until he saw the matter through,—if he had gone to the Prest. explained the matter to him, and based the continuation of his support of the administration on the removal of M. it would have been done—I think now it is too late—They seem to be waiting until all the cabinet leaves the city, when to a certainty the Prest. won't act—already [Postmaster General] Brown, my best friend, has left—every day is an irrecoverable loss—every day I am expecting to hear of the resignation of Floyd, which would settle the matter—every day the Prest. is growing weaker and more childish and we may soon have an entire new cabinet, and still we hear continually of *'next week' 'very soon' 'before long'*—[46]

Rumors of Meigs' removal sent Walter flying to the War Department for verification. The captain of engineers, in turn, heard tales of the architect's pending resignation, and each man seemed poised to declare victory over the other. But they were mere dupes in the administration's absurd strategy to keep peace with Jefferson Davis and William Bigler simultaneously. Meanwhile, Walter and his draftsmen worked on details for the dome, Senate chamber, staircases, skylights, and porticoes, but the drawings stayed in the drafting room. For his part, Meigs continued negotiations with Rice & Baird over column shafts without reaching an agreement. In the summer of 1858, workmen were building the arcade of the Senate's east portico and would soon need column shafts to continue work. Meigs visited the masons armed with a stack of copper plates inscribed:

<div align="center">

CAPT. MONTGOMERY C. MEIGS. U. S. ENGINEERS

IN CHARGE OF

U. S. CAPITOL EXTENSION

EXTENSION OF GENERAL POST OFFICE

NEW DOME OF THE CAPITOL AND

WASHINGTON AQUEDUCT

A. D. 1858

</div>

He slipped one of the plates under a marble block just as workmen lowered it into place. He

hoped the inscription would be legible for centuries to come, and perhaps be of interest to some future archaeologist. Meigs also sprinkled his name all over the Washington Aqueduct and Post Office extension in an effort to keep history informed of his deeds and whereabouts. In one particularly clever instance at the aqueduct, he had the risers of an iron staircase composed of the letters M–C–M–E–I–G–S.

During this period Walter was biding his time, held on by the encouragement of his friends. His position was nonetheless mentally and physically draining. In the latter part of July 1858, he planned a trip to Atlantic City in the hope of restoring his health from the effects of "constant and anxious attention and watching, and waiting, and working, and fighting."[47] Gone only a week, he returned home to find that Meigs had fired one of his best draftsmen, Philip Schrag. The supervising engineer had ordered Schrag to report to his office and, when the young man refused, Meigs struck his name from the payroll and wrote the architect an "insolent and *ungrammatical*" letter explaining his action.[48] For Meigs, this was another case of insubordination, while Walter considered the episode an act of tyranny. The architect immediately rehired Schrag, paying the salary out of his own pocket until the matter could be settled by the War Department.

The secretary of war dispatched Meigs to inspect various quarries capable of suppling monolithic shafts for the outside columns. Floyd would not hear of using Italian marble (as some suggested) for such a visible part of the extension. While Meigs was away, Walter happened to see a design for the vice president's desk and chair drawn by Brumidi or someone else on the engineer's staff. "It is a hideous affair," he told Rice, "and would not be tolerated by the Senate a single day."[49] Walter went to see Floyd, who gave orders to stop fabrication. He returned the drawing to Meigs along with a Walter design with orders to fabricate it. The engineer obeyed but replied sarcastically that he would compensate for its poor design by using superior materials and craftsmanship.

Walter went to the new Senate chamber on October 21, 1858, to confer with workmen installing the vice president's rostrum. Quite by accident, he met Senator Davis and was greeted

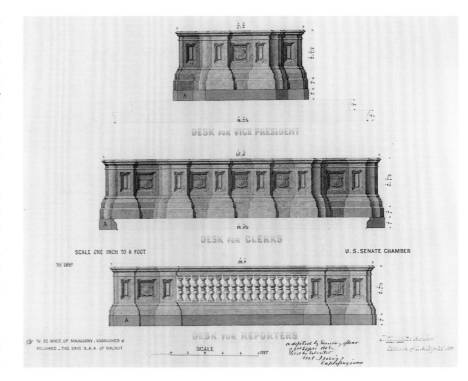

cordially, believing the senator showed him "a fraternal spirit." As he returned to the workmen, he noticed that Meigs had just entered the chamber, followed by Brumidi and a retinue of assistants. Walter pretended not to notice, keeping his back toward Meigs and later describing the maneuver as "rather laughable."[50]

In his journal, Meigs did not mention seeing Walter that day, but he complained that the design of some details for the Senate chamber had not been received from the drafting room. If the room was not finished by the opening of Congress in December, it would be the architect's fault. He again tried to regain control of the drawings but received a clarifying order from the War Department directing him to ask the architect for any drawings he might need. Seizing the opportunity, Meigs sent Walter a copy of the order along with a command to surrender every drawing ever made at public expense by the architect's office: all reference drawings; all construction drawings; all presentation drawings; all drawings for the Capitol extension; the new dome; the Post Office extension; and miscellaneous projects such as the marine barracks in Pensacola, Florida. Although the order was expected (Walter actually wanted it as a means to get his dome drawings into the hands

Design of the Desk Fronts for the Vice President, Clerks, and Reporters

by Thomas U. Walter 1858

*M*eigs was furious when the secretary of war preferred this design to the one he submitted. He characterized Walter's design as "pulpit" furniture, and absolved himself of any criticism the desk might attract. Just above his signature the disgruntled but obedient engineer wrote: "Let it be executed."

Portrait of Senator William Seward

by Emanuel Leutze, ca. 1860

From the collections of the Union League Club of New York. Reproduced by permission

*S*et in the new Senate chamber, this portrait included a glimpse of the lower wall with its cast-iron wainscot, pilasters, and wall panels. Its drab color scheme was relieved by gold leaf accents and contrasted with the riot of color seen in the Brussels carpet.

Seward was depicted seated at his desk surrounded by correspondence and papers with his hand resting on a book. Until the Senate acquired its first office building in 1891, most senators were obliged to use the chamber as their office.

of the ironworkers), Meigs' request for every scrap of paper in the architect's office had to be refused or the architect would be left completely bereft of the most important part of his professional tools. He painted a vivid image of his office if Meigs succeeded in stripping it of all the drawings:

> You see he asks for every scrap of paper of every description in my office, thus breaking me up root and branch—rump and stump; — were I to comply with this order of Meigs' you might imagine me standing in my empty room with my 10 draughtsmen around me, each with a pair of hands rammed into a pair of empty pockets and your old friend, with arms folded, rolling up the whites of his eyes and exclaiming with poetic pathos *"Othello's occupation's gone"*—no, no that won't do; there must be harder fighting before that comes to pass than we have ever had yet.[51]

With the opening of the second session of the 35th Congress fast approaching, Meigs was eager to seat the Senate in its new chamber as promised. He complained to Floyd that Walter's refusal to hand over drawings was a great impediment to progress, but this got him nowhere. Floyd reminded him that he was welcome to visit the architect's office to inspect the drawings, but the engineer absolutely refused to go into enemy territory. In vain, Walter pleaded with Floyd to let him resign or to reassign Meigs: either course would suit him equally well. While their offices on Capitol Hill were close by, all correspondence between the architect and the engineer was funneled through the secretary of war's office next door to the President's House. The effects of this inefficient situation were well illustrated in the fall of 1858, when Meigs needed a design for the arms of the gallery seats in the Senate chamber. Since he would not deign to ask Walter for a design, he directed Brumidi and other assistants to come up with something. When their design was completed, he sent it to the War Department for approval. Floyd forwarded the drawing to Walter, who thought it did not harmonize with the rest of the room.[52] The architect sent a design of his own, which the secretary immediately approved and sent to Meigs.

Work to finish the new Senate chamber was bogged down by numerous such squabbles. When senators returned to Washington for the opening of Congress on December 6, 1858, they gathered in their old room, where some would have preferred

to stay. Senator Davis, however, wanted to move as soon as possible. Meigs promised that the room would be ready after the Christmas holiday. All possible speed was urged and Meigs was authorized to attend to the remaining details, including buying the carpet and selecting the damask upholstery for the cushioned gallery seats. On the evening of December 22, the room was lighted for the first time. The painted decorations were not as vivid and bright as those in the House chamber and looked good under gas lights. The following day Meigs moved his desk into the Senate chamber to drive the workmen.[53] On Christmas eve, he met with the Senate Committee on Arrangements to discuss how the old desks and chairs would be positioned in the new room. They decided to nearly duplicate the arrangement in the old room but seat the senators in three tiers instead of four. On Christmas day workers laid carpet in the gallery and lined the gallery seats with cotton flannel before putting on the damask upholstery.

On the first work day of the new year, January 3, 1859, Meigs went to the Senate chamber to help arrange the furniture and attend to last-minute details before the room opened for business the next day. While there he received word that water had been let into the Washington Aqueduct and would reach the Capitol in a few minutes. He sent for Senator Davis and together they went to the library portico and watched the fountain, or "jet d'eau," throw water sixty to seventy feet into the air. The sight of water playing in a fountain at the foot of Capitol Hill, drawn from Great Falls more than eighteen miles away, was wonderfully gratifying to both the engineer and his patron. Meigs considered the fountain and the water jet the most beautiful sight in Washington and proudly wrote: "It signifies so much good, so much safety, health and purity, that I cannot tire of looking at it. . ."[54] He wrote his father in Philadelphia about his latest accomplishment:

> I wish you could see my jet d'eau in the Capitol Park. I look upon it with constant pleasure for it seems to spring rejoicing in the air & proclaiming its arrival for the free use of the sick & well, rich & poor, gentle & simple, old & young for generation after generation which will have come to rise up & call me blessed.[55]

On the morning of January 4, 1859, Walter hurriedly wrote his wife with news about the arrival of Potomac water to the city and a report on the number of callers he had on New Year's day, a social custom that he thought "don't suit these times." (Among other annoyances, a motley and inebriated band of strangers turned away from Walter's door when they discovered he was not serving food or drink.) Much of his letter was about the upcoming ceremony in the Capitol accompanying the Senate's historic move from the old chamber to its new room:

> Every thing is ready for the Senate and I see Meigs about as busy as a nailer—he has not been here before since my return; but there is no doubt that he will flourish today—I am going to the old hall at 12, and I think I will brave it out—The Senate will be opened by prayer; the committee on arrangements will then make their report, and the Vice Prest. will deliver an address. They will then move in procession to the new chamber, take their seats, and the

South Corridor in Front of the Senate Chamber
ca. 1860

*C*orridors were painted in a polychromatic color scheme to emphasize the elaborate decoration. French zinc was a favorite substitute for white lead paint because it did not smudge as readily under gas lighting conditions.

chaplain will again pray, after which they will proceed to business.

At half past one o'clock Walter was back in his office and was able to write a postscript giving an eye-witness account of the ceremony:

The ceremony is over, and a most beautiful and appropriate one it was—not one word said that was objectionable—I accompanied the senators to their new room, and the entrance was very imposing—every seat in the galleries was filled—they were one vast mass of humanity—scores of senators congratulated me—some who I did not know.[56]

Senate Chamber
1867

\mathcal{L}ined with Corinthian pilasters grouped in pairs, the lower walls of the Senate chamber were rich creations in cast iron and plaster. A niche framed the presiding officer's chair with the reporters' gallery above. Senators' desks and chairs were reused from the old chamber.

Meigs was impressed by Vice President John C. Breckinridge of Kentucky, who made "the most eloquent oration I ever heard. . . . His tribute to the memory of Calhoun, Webster, and Clay was beautiful and his condemnation of the man who would strike his sacrilegious hand at our Union was terrible and sublime."[57] Upon entering the new chamber Meigs noticed that the galleries were filled to capacity and the air was pure. The temperature was maintained at seventy degrees—give or take a degree—all day.

Benjamin B. French attended the historic ceremony and recalled being in the gallery overlooking the new room as the "potent, grave and reverend seignors" entered for the first time, led by the sergeant at arms and the vice president. From that vantage point he formed his first judgment of the new room, which, while not wholly favorable, was decidedly more positive than his low opinion of the new House chamber. Comparing it with the beautiful old Senate chamber, however, he thought the new one was like a cellar ventilated by a furnace blower.[58]

For those unable to come to Washington to see the new Senate chamber, the press carried descriptions that were far more complimentary than those following the opening of the hall of the House more than a year earlier. *The New York Herald,* for instance, told its readers:

The general aspect of the new hall is light and graceful. In shape and dimension it is similar to the new Hall of Representatives, but to the eye appears more finely proportioned. The style and character of the decorations are nearly the same in both Houses, except that in the Senate the tone of color is more subdued. The area of the floor is 80 feet by 48 feet, and of the roof 113 by 80 feet, the difference being occupied by a continuous gallery around four sides of the apartment capable of seating 1,200 persons. The inner roof or ceiling, of iron, is flat, with deep panels, twenty-one of which are fitted with ground glass, having in the center of each pane a colored medallion representing the printing press, steam engine, cornucopia, and other symbols of progress and plenty. The light is supplied wholly through this window in the roof. The gas apparatus is placed above the ceiling. The ceiling is thirty-five feet from the floor, but presents an appearance of greater altitude. It is encrusted with floral and other embellishments in high relief, and all of iron. The floor of the chamber is covered with 1,700 yards of tapestry carpeting, having a large pattern of flowers on a purple ground.[59]

Meigs' annual report for 1858 was mainly about the hall of the House, which had been in use for a year. He touted its astonishingly successful acoustical properties, which promoted perfect hearing and speaking to every corner. Meigs published a letter from Speaker James L. Orr of South Carolina testifying to the comfort of the new chamber and the parliamentary order fostered by its acoustics, heating, ventilation, and lighting. Meigs also claimed that the hall promoted the good health of members and contributed to their ability to better conduct the nation's business. More bills were passed and more hours were spent in session than during any other period in history. Despite the workload, no member of the House had died during the long and laborious session.[60]

Reporting on the new dome, Meigs stated that forty-two and a half feet of ironwork was in place, including the skeleton of the drum's first story. Standing on the cantilever brackets were the thirty-six columns of the peristyle. The decorative skin that would cover the dome's lower frame was under way at the foundry in New York operated by Janes, Beebe & Company. He wished he were able to report greater progress on the dome and blamed the delay on Walter. In his annual message Meigs wrote:

> I should be pleased to be able to report a greater progress in this work, but the want of cordial co-operation on the part of the architect associated with me has much interfered with the studies and drawings of the work. As it appears to me, he has much mistaken his authority and his duty; and, as it was a matter which could be settled only by the department, I have awaited its decision.[61]

It was unusual to censure a public official such as Walter in a public document such as the secretary of war's annual report, but it gave Meigs the opportunity to record for posterity his troubles with the architect and perhaps was seen as a way to nudge the War Department into action. Meigs' report also showed that he spent $1.13 million over the course of six months and a few weeks later would be completely out of funds. These facts left Walter to wonder "if the money lasted but 7 months under the retarding influences which he says I have exerted, how long would it have lasted if it had not been retarded?"[62]

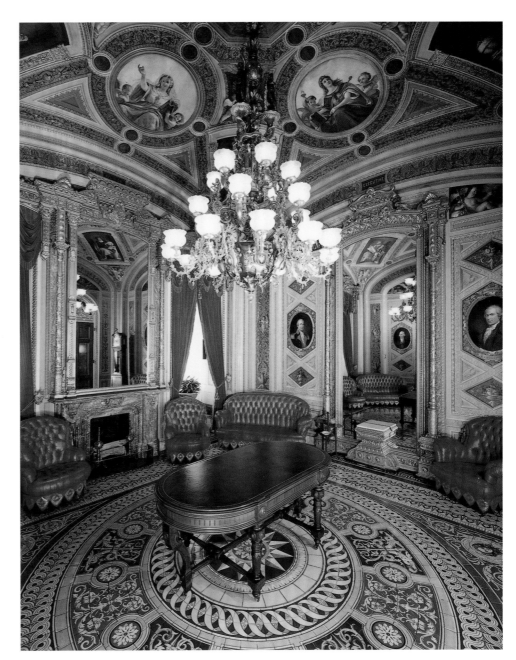

The President's Room

*I*n 1859 Brumidi began decorating the President's Room with allegorical and historical figures on the ceiling while the walls were painted with portraits of George Washington and members of the first cabinet. The overall composition was derived from the ceiling of the Stanza della Segnatura at the Vatican. Hanging in the center of the room is an elaborate eighteen-arm bronze chandelier with allegorical statuettes mingled with figures of Washington and Franklin. It was made by Cornelius & Baker in 1864 and cost $900. All other gas burning chandeliers were banished from the Capitol following the explosion in 1898, but this one survived by being electrified. (1996 photograph.)

DOME REVISIONS

\mathcal{D}uring the height of his battles with Meigs, little new work was being demanded of Walter, who had the time and leisure to make revisions to old designs. On Saturday, February 12, 1859, he entered a note in his diary saying that on that day he "completed sketches of new design of Dome—changed the

exterior proportions above Peristyle."[63] The revisions were necessary to accommodate the statue of Freedom, then on its way to Washington.

After Crawford's death, his widow made arrangements to ship the model of Freedom to Washington. It was a jinxed voyage, marred by leaking vessels, inadequate repairs, bad weather, and navigational miscalculations. The model left Leghorn in the spring of 1858 on a ship that soon foundered in the Mediterranean but was able to coast into Gibraltar, where repairs were made. Setting out again, the ship foundered in the Atlantic, taking on water, and much of the cargo was heaved overboard to lighten the load; it was sheer luck that the six cases containing the statue were spared a burial at sea. Arriving in Bermuda, the ship was condemned, and alternate transportation had to be arranged. By the end of December part of the statue had reached New York, but part remained in Bermuda. The statue did not arrive in Washington until the summer of 1859, some months after Walter completed the revisions necessary to accommodate it.

When Walter's original dome design was drawn, the crowning statue was intended to stand about sixteen and a half feet tall, but Crawford's third design for Freedom stood, or so he reported, eighteen feet, nine inches. By the time it was finished, however, the statue had grown to nineteen and a half feet. Its conical pedestal had a bottom diameter of fourteen feet, eight and a quarter inches. Unless adjustments were made, the statue and its pedestal would not fit on top the new dome. Chief among the necessary alterations was the proportion and shape of the cupola. Walter lowered the height of the cupola seventeen feet, thus changing its profile from ellipsoidal to circular. This increased the diameter of the platform on top of the cupola by about five feet. The tholus' diameter grew by

Revised Dome Design
by Thomas U. Walter, 1859

\mathcal{T}o accommodate the statue of Freedom, Walter adjusted the dimensions and proportions of the upper parts of the dome. The revisions were illustrated in this elevation, which is among Walter's finest drawings.

three and a half feet to eighteen feet, three inches. The changes brought the overall height of the dome (as measured from the ground) down from 300 feet to 287½ feet. At the same time the consoles of the attic were redesigned, made broader and enriched with beading, scrolls, and floral ornaments. Windows between the consoles were replaced with panels. While lower than the earlier design, Walter's final dome design was bold and rich, suffering not at all from its reduced height.

Revisions inside were more dramatic. There, Walter designed a wholly new inner dome better scaled for the rotunda. Through the eye of this inner dome a large painting would be seen, a grand and dramatic conclusion to the room's interior design. Walter had admired a similar scheme at the Panthéon in Paris during his trip to Europe in 1838, and he was now determined to crown the rotunda with a heroic painting. It would be the largest fresco in the building, unrivaled by anything American art had ever witnessed before. It is not known if Walter discussed the project with Brumidi at the time the painting was first conceived, but such a conversation was unlikely considering the artist's close relationship with the supervising engineer. Walter's revisions were made without Meigs' knowledge and drawn in the one place he refused to go—the architect's office in the Capitol. The engineer probably never saw the beautiful elevation and the accompanying section, which are among the greatest architectural renderings produced in nineteenth-century America. The drawings were finished in February 1859 but not shown to the supervising engineer until Meigs' successor took over later that year.

At the end of February 1859, Walter submitted vouchers for the pay of the draftsmen who assisted him drawing the revised dome design. He signed the vouchers with his name under the title "Architect of the New Dome." If the men had worked on drawings for the Post Office extension or the Capitol extension, the architect's title would have been changed accordingly. But Meigs took exception to Walter calling himself "Architect of the New Dome" and refused to honor the vouchers. He returned them with a command to change the title. He said he did not know that any such title had been conferred on Walter and he thought

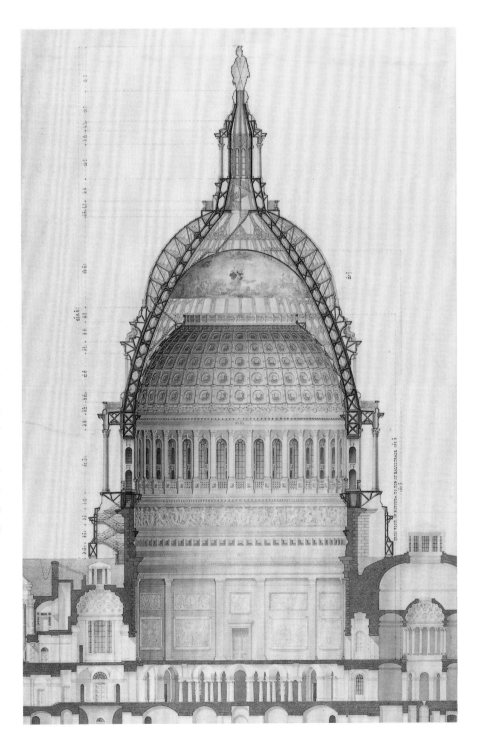

Section through Dome of U. S. Capitol
by Thomas U. Walter, 1859

*I*nspired by the Panthéon in Paris, Walter's 1859 interior revisions introduced a monumental painting suspended over the oculus of a new inner dome.

it was inconsistent with his own authority. Although titles do generally mean a great deal to military men, Meigs was engaged in pure harassment, trying to make life so miserable that Walter would go away.[64]

The chief clerk in Meigs' office looked out his window above the Adams Express office and saw Walter's carriage driving "like mad" up Pennsylvania Avenue soon after he received Meigs' letter.[65] The architect was off to the War Department with the latest evidence of Meigs' tyranny. Before going to see Floyd, Walter replied to Meigs in a long letter containing a simple question: "If I am not the architect of the New Dome I would like to know who is."[66] He later wrote the secretary about the way he signed the vouchers and then described Meigs' "quibble" with it. Walter said the engineer was motivated by a desire to prevent the young men from receiving their wages, and he asked the secretary to interpose on their behalf.[67] On March 19, the secretary of war ordered Meigs to pay Walter's men. Instead of obeying the order right away, however, the engineer demanded to see the document appointing Walter architect of the new dome. Walter responded with a lecture about the nature of a commission in "civil architecture." Back and forth it went, long letters from the engineer attacking Walter on numerous points, accusing him of tricks and duplicity. Walter accused the engineer of trying to rob his professional reputation in order to magnify his own "aggrandizement."[68]

The problems at the Capitol festered under the lame administration of President Buchanan. The secretary of war's health became a problem in the spring of 1859, making it impossible for either Meigs or Walter to see Floyd to discuss matters that might have eased the terrible situation. On April 27 Walter informed Rice that the secretary was weak and "broken down."[69] He was suffering from a vague nervous condition that was aggravated by exciting talk. "As the Capitol & Meigs always excites him," Walter wrote, "he avoids all reference to them if he can with propriety do so." The architect thought that only a rest for a few months far from Washington would restore Floyd's health.

The secretary of war was, however, well enough to order Meigs back to the marble quarries in Massachusetts to see about getting column shafts. If prospects remained unfavorable, he was to return by way of John F. Connolly's quarry in Texas, Maryland (near Baltimore), which was said to be capable of fulfilling an order for monolithic shafts. On April 28 Meigs was in Lee and found the quarry in worse shape than he expected. He did not believe it could even supply the shafts in two pieces and thought the vast amount of marble needed for the cornices and architraves would prohibit anything else—especially column shafts—from being extracted without years of effort and boundless good luck. On May 5, Meigs was in Maryland, where he found a couple of blocks large enough for monoliths and thought the rest could be had with ease.[70] Unfortunately, Connolly's stone cost more than Italian marble and was inferior to both Italian and Massachusetts marbles. Upon returning home, he wrote a report to the War Department and was instructed to declare that portion of Rice & Baird's contract dealing with column shafts null and void. A supplemental contract would be drawn directly between the government and Connolly. But before anything was done, the president stepped in and cautioned against violating Rice & Baird's contract. Buchanan did not wish to antagonize John Rice, whose brother was the editor of *The Pennsylvanian,* a powerful Democratic mouthpiece in his home state.

Meigs was then ordered to visit every quarry offering marble for the columns, and on May 21, 1859, he embarked on an extensive journey covering 1,000 miles in twelve days. Another inspection trip began on June 10 and lasted nine days. In all, Meigs visited seventeen quarries and found seven that could furnish monolithic shafts. He considered all of them too expensive and inferior. None was as good as the Massachusetts marble nor was any as cheap as Italian marble. On June 29, he recommended that Rice & Heebner be permitted to supply monoliths from any source and that they be allowed six months to make arrangements with some other quarry. Thus Rice's contract would remain intact, but another marble would be used for the shafts. Floyd immediately approved Meigs' recommendation. When Walter heard of it, he wrote Rice—in *"profound confidence"*—to suggest that unless specifically prohibited from doing so, his firm should import Italian marble.[71] If Buchanan and Floyd maintained their objection to foreign marble, Walter thought a congressional

Coil for Senate Chamber

by Thomas U. Walter and Montgomery C. Meigs
1858

*H*ot-water pipes warmed the air that ventilated the extension.

SIDE VIEW.

SCALE of FEET.

COIL FOR SENATE CHAMBER.

U.S. CAP: EXT.

№ 1724.

M. C. Meigs
Capt. of Engineers
in charge Feb. 2th 1858

FRONT VIEW.

resolution could relieve them of responsibility for the decision. The problem was not with American marble but getting the shafts in one piece. Walter personally did not like monolithic shafts and preferred to use six or eight pieces so as to produce the same effect as the rest of the building. To give his position authority from antiquity, Walter claimed that building up columns with drums "was the practice when Grecian art was at its zenith, while monolithic shafts marked the decline of art—there is no exception in ancient architecture to this rule." He was in the minority, however: "I have made these arguments over and over again, but nobody cares a fig for them—monoliths they want and they will have them." Apparently the old idea of using granite had resurfaced, with proponents claiming that the darker stone would give a *"fine contrast"* to the white marble walls. To avoid the horror of placing granite shafts on a marble building, Walter advised Rice to strike a deal with Meigs as soon as possible.

On doctor's orders, the secretary of war spent much of the summer of 1859 convalescing at home, or "taking the waters" at White Sulfur Springs in

SCALE of FEET.

Fan for Committee Rooms

by Thomas U. Walter and Montgomery C. Meigs, 1857

*A*lthough the drawing was made in Walter's drafting room, the fan design was dictated by Meigs' consulting engineer, Robert Briggs. Made of wood and powered by steam, fans such as this forced air over hot water coils and then into ducts that snaked throughout the wings.

**Steam Engine
and Fan**

ca. 1911

One of the last operating steam-powered fans is shown here just before it was decommissioned.

what later became West Virginia. His absence left things fairly quiet on Capitol Hill. Building funds were low and the only work of major consequence at the Capitol was done in the marble yard. Even that work stopped when the sawmill was destroyed by fire in mid-August. No work could proceed on the dome without the drawings, which Walter would not surrender and Meigs would not retrieve. The captain considered the architect and his men to be in a state of rebellion and awaited the department's action to correct the situation.

During the summer the last of the bronze railings from Philadelphia were being put up on the members' private stairs the south wing. In late August the commissioner of public buildings agreed to keep the old hall of the House closed

while workmen unpacked the statue of Freedom and put it together. The arrival of Crawford's statue would normally have excited the engineer, but his enthusiasm was on the wane. Meigs confided in his journal that he felt discouraged by his diminished authority, his lack of respect for the War Department, and the department's lack of faith in him. Without support or sufficient authority, he felt "less interest in it, and I can not drive it while I am taken up with the correspondence and imputation of the War Department, which ought to support me; in fact, is trying to defeat me and embarrass me all the time."[72]

THE LAST STRAW

*A*mong the many problems Meigs had with the War Department during this period, heating the Post Office extension was one of the most contentious and, as it turned out, the last episode in an extensive battle of wills. For a year and a half, Meigs tried to convince the department that Nason & Dodge of New York was the most qualified firm to undertake the heating work, but Floyd saw the opportunity to enrich Democratic friends and overruled the engineer. At first Floyd wanted the contract given to Charles Robinson, a dentist from Virginia, who had arranged to sell the contract to Henry F. Thomas & Company of Baltimore. By the summer of 1859, Robinson had disappeared from the scene, but the Baltimore firm remained Floyd's choice for the work. Month after month Meigs and Floyd argued until the secretary finally ordered the engineer to enter into a contract with Thomas & Company. Meigs refused on the grounds that he was legally bound to advertise the contract for sixty days. He also had ample evidence that the firm was not qualified and would probably subcontract with other firms after skimming a hefty profit for themselves. Another version of the story was told by the architect:

> Meigs boasted to the Secy. of his great skill and claimed the invention of the heating of the Capitol as his in toto; the Secy. concluded that so much good brains ought not to be lost, and therefore ordered him to contract with Thomas & Co., instead of his Capitol men Nason & Co.

so as to give him a chance to impart his wisdom to another firm.[73]

Walter observed the contest between Meigs and Floyd from a safe distance. He was sure that Meigs wanted Nason & Dodge to get the contract because they would do all the work and give him all the credit.[74] He was also convinced that Meigs was incapable of designing the heating system but would never think of asking him for help. Meigs complained that he could not study the problem without the plans, which were locked up in Walter's office. He accused the architect of retarding the work, and Walter feared another order to surrender the drawings. The department ultimately gave Meigs no such authority but ordered him to design the heating and ventilation system using Walter's plans, letting Thomas & Company make all the necessary boilers, pipes, and engines. In a letter to Meigs written on September 8, 1859, Walter indicated his intention to cooperate and offered to forward any drawings Meigs might specify.

Meigs again railed over the fact that Walter controlled the drawings and that he was placed in a position of having to ask for documents that belonged to his office. He could not ask for specific drawings since he had not seen them in years, nor did he have a record of those made more recently. Thus, it was impossible to specify which drawings to send.[75]

In communications with the War Department, Meigs kept up his vigorous protest regarding the drawings. Meanwhile, instead of contracting with Thomas & Company as instructed, he wrote machine shops and foundries asking them to submit bids for various parts of the work. Meigs then forwarded the information to the War Department, which had already issued instructions and was now highly annoyed to find its orders ignored again.

During Floyd's illnesses and frequent absences from the office, his chief clerk, William R. Drinkard, served as the acting secretary of war. Drinkard wrote Meigs telling him to contract with Thomas & Company without further delay. In the same letter he ordered Meigs to pay an outstanding invoice for granite used on the Post Office. Matthew Emory, the granite contractor from Richmond, was unhappy with Meigs and applied pressure on the War Department for satisfaction. Meigs replied in a long letter saying he was unable to pay for granite because he did not know how much was called for in the architectural drawings. Walter—his rebellious and disobedient assistant—would not hand them over, and the War Department alone was responsible for the continuation of the unresolved problem.[76]

Drinkard returned Meigs' letter with a reiteration of the department's previous orders regarding the rights of the engineer to examine drawings in the architect's office, along with an order to pay Emory's bill. The acting secretary claimed that he was well aware of the facts of both cases and knew Floyd's intentions in both regards.

Considering the tone of many letters that had passed between the War Department and the engineer's office, Drinkard's latest note was perfectly polite. Yet, for some unexplainable reason Meigs took offense, haughtily replying that he did not need a clerk to explain written orders to him: "I am as capable of understanding a written order of the Secretary of War, as the chief clerk or the acting secretary . . . my official rights cannot be explained away by the knowledge Mr. Drinkard may have of the desires or purposes of the Secretary."

After so many months doing battle with the War Department, Meigs had lost his temper. Despite the justice that he thought his cause represented, his intemperate words smacked of insubordination. Upon returning to the office after an extensive absence, Floyd was furious at the tone of Meigs' retort and wrote:

> The conduct of Captain Meigs, in thus interpolating the records in his possession with a paper manifesting such flagrant insubordination, and containing language both disrespectful and insulting to his superiors, is reprehensible in the highest degree. The spirit that dictated it is manifest throughout this correspondence, and shows a continuous insubordination that deserves the strongest censure.[77]

The captain's ill-considered and impolite letter to the acting secretary was the last straw in the battle of wills waged in the War Department. Floyd was too tired to argue with Meigs anymore and no longer cared if Jefferson Davis stayed mad forever. On October 29, 1859, Floyd sent for Captain William B. Franklin of the Topographical Engineers, whom he intended to name as Meigs' replacement. Franklin listened while the secretary described the state of affairs and said that either he or Meigs would have to go. The next day

Senate Reception Room

ca. 1910

*F*or the most elaborate room in the extension, Captain Meigs drew upon the talents of a variety of artists and manufacturers to carry out his ambitious decorating scheme. The ornamental plaster work was overseen by a Frenchman, the scagliola and frescoes were by Italians, the encaustic tile floor came from England, and the bronze chandeliers were made in Philadelphia. It was here that Meigs bid farewell to his workmen after the secretary of war reassigned him in November 1859.

Franklin went to see Meigs to recount his interview with Floyd, who always felt "thwarted" by the engineer.[78] Later that day Meigs heard a rumor that an order had been issued relieving him of his command at the Capitol: the rumor was true.

On November 2, 1859, Meigs received notice of the secretary's action through the mail. He asked the principal workmen to gather in the Senate reception room—the Capitol's most elaborately decorated space—where he introduced Franklin and said goodbye. He wrote a short letter of farewell that was read by one of the foremen. "They seem to feel regret at the parting," Meigs

recalled that evening, "Many of these strong men looked upon me with moistened eyes; and for myself, I could not trust my voice to speak or to read what I had written."[79] John C. Harkness replied for the workmen, concluding: "To whatever field of labor you may hereafter be assigned, be assured, dear sir, you will bear with you the unanimous esteem of these my collaborators whom I represent; and for your present and future welfare they will continue to cherish the most ardent wishes."[80] Despite their goodbyes, however, the workmen and the Capitol had not seen the last of Montgomery C. Meigs.

Walter greeted the news of Meigs' departure with little more than a sigh of relief. He was glad the episode was finally over and looked forward to moving ahead. Meigs' personality, his awkward position as a military man in charge of civilian projects, his handling of the interior decorations, and his driving ambition made harmonious relations unlikely. Yet history would remember Meigs' high aspirations for the Capitol, his administrative prowess, his amazing energy, and his unshakable honesty in the face of the most corrupt administration yet seen in American history. Also remembered was an unfortunate legacy of windowless chambers, the subject of endless complaint and spirited condemnation by countless congressmen and senators until the 1920s, when air-conditioning cooled them down.

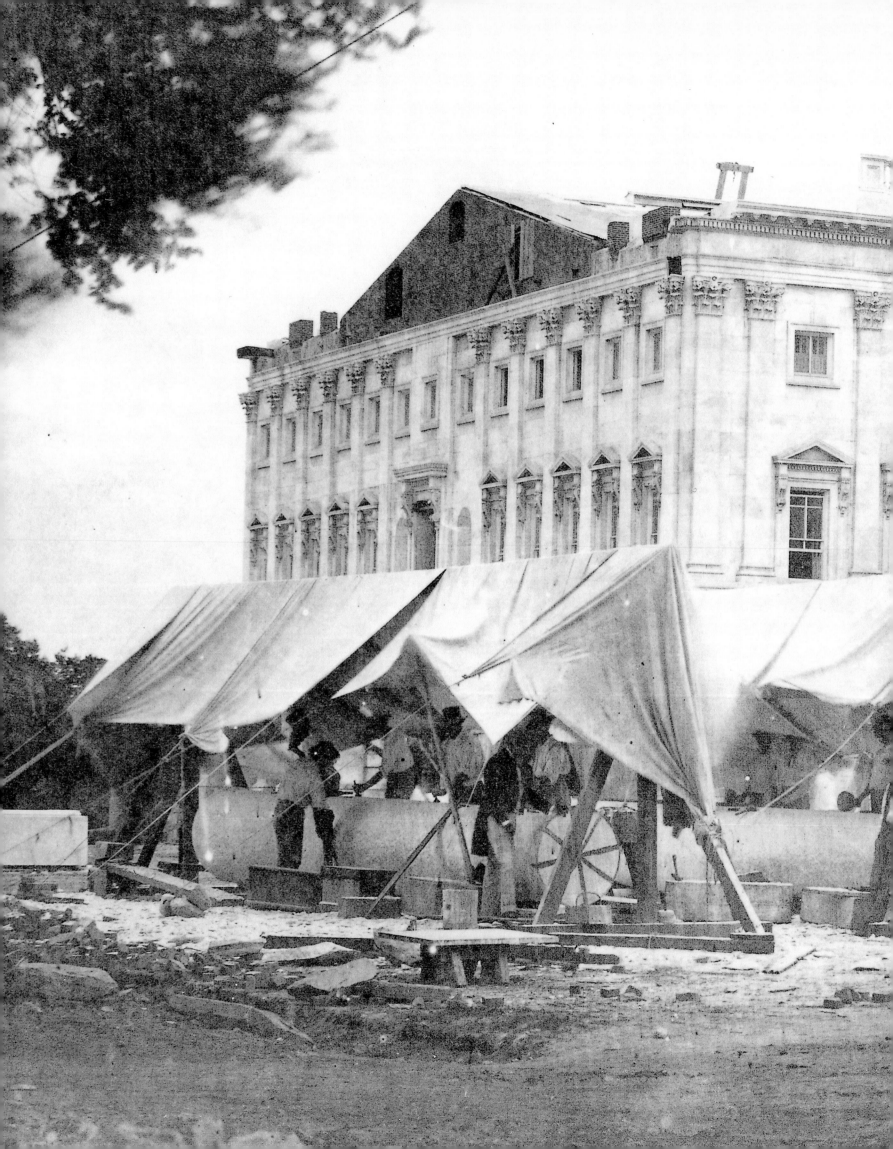

CALM AND CALAMITY

ith Captain Meigs out of the picture, Walter's professional life returned to normal. He was not acquainted with William B. Franklin but believed their relationship could only be an improvement over the past. Work on the dome could now resume and the extension could proceed under agreeable circumstances. Yet, just as peace in the office was restored, ominous clouds of war were getting thicker. Hotheads on both sides of the slavery issue fired the rhetoric to the boiling point and prospects for the nation's future were looking ever more bleak. Just as the Capitol extension office entered an amicable period, belligerents north and south were careening headlong into a fratricidal bloodbath.

Captain Franklin of the Corps of Topographical Engineers came to Washington in the fall of 1857 to serve as the army secretary of the Lighthouse Board, a bureau of the Treasury Department. Franklin was on the board for a year and a half before going to Illinois to investigate a damaged bridge over the Mississippi River.[1] He returned to Washington just as the troubles between Meigs and the secretary of war reached the breaking point. On October 31, 1859, Floyd asked Secretary of the Treasury Howell Cobb to relieve Franklin so he could take Meigs' job. Franklin regretted the circumstances that brought him to the Capitol, believ-

ing that the secretary of war had treated Meigs badly. Like most people in Washington, he was well aware of Floyd's glaring faults, his lack of integrity, and unscrupulous political practices, and Franklin feared that his own reputation would become tainted by a close association with him. Yet the appointment brought welcome prestige to his career and his corps. "The change is pleasant in one respect," Franklin wrote, "that it shows to the other Corps that they are not the only people in the Army who can do things, and that their clay is not entirely superior to that of which other men are made."[2] For his part Meigs was concerned about Franklin's untested political instincts and worried that he was unaware of the many dangers surrounding the job.[3] Yet Franklin was not a total stranger to the ways of the capital city. When he was ten years old, his father had been elected clerk of the House of Representatives, serving five years until his death in 1838. As an adult, Franklin and his wife had lived among the city's military and social elite for more than two years before he was placed in charge of the Capitol extension and new dome.

On November 3, 1859, Walter met Franklin for the first time and spent several hours discussing business with him. After the meeting, Walter wrote a hasty note to Rice giving word of his initial impression of the new supervising engineer:

> I find him as far as I can now judge, every thing that could be desired; he is kind, affable, gentlemanly, liberal in his views, and determined

Marble Cutters (Detail)
1860

not to interfere with any body's rights or immunities. Our interview was cordial, and perfectly agreeable and satisfactory in every particular. —What a contrast with the scamp that preceded him![4]

The first topic of discussion was the unresolved matter of column shafts. They agreed to prepare a statement asking Congress to allow monoliths of Italian marble or to let the shafts be made of four or five pieces of American marble. Work on the dome—work that had been stalled for a year and a half—was the second topic. The change of command liberated a tall stack of drawings from Walter's office, where they had piled up during the conflict. Under Meigs' regime photographic copies of each drawing would have been sent to the usual foundries to solicit bids. But with so many drawings calling for so many castings, bidding each one separately would entail a great deal of work and waste more time. Either Walter, Franklin, Floyd, or (more likely) Charles Fowler suggested that the entire project be placed under a single contract to expedite matters. Fowler's firm, the Janes, Fowler, Kirtland Company of New York (successor to Janes, Beebe & Company), was prepared to cast, deliver, and install all remaining iron for the dome at a fixed price. Still in Washington and still adept at stirring up trouble, Meigs got wind of the scheme and claimed that it was illegal to award such a contract without competition. Annoyed, Walter hoped the army would ship his adversary to a faraway post and leave him in peace. Grumbling to Rice, Walter wrote: "Meigs is still about poisoning everybody he can. I wish they would send him to Pekin [sic] to teach the celestials how to make forts."[5]

A month after Franklin assumed his post at the Capitol, the first session of the 36th Congress began. Over the preceding summer and fall, the nation's attention had been focused on two exciting events. Stephen Douglas returned to the Senate following a closely watched election in Illinois, where he was challenged by a former one-term congressman named Abraham Lincoln. The election was decided on the issue of the treatment and expansion of slavery in the territories and brought Lincoln into the national spotlight. Another exciting development occurred just three days before Congress met: the fanatical abolitionist John Brown was executed for his ill-fated raid on the government arsenal at Harper's Ferry. The raid was part of a plan to instigate a massive slave revolt. Lieutenant Colonel Robert E. Lee led a detachment of marines to capture Brown, whom some considered a madman best committed to an insane asylum. His death by hanging produced another martyr for the abolitionist cause.

Members of the House gathered in their vast new chamber on December 5, 1859, to begin what turned out to be a protracted process of electing a Speaker. The desks and chairs had been removed from the room and curving benches installed in their place. The alteration was ordered at the close of the previous session as an experiment to help those who found it difficult to hear. The problem was not acoustics, but rather the sheer size of the chamber, which put great distances between members. Contracting the seating by eliminating the desks and chairs was considered a practical way to bring individuals closer together so they could hear each other. Seated on the new benches, members began to vote for a Speaker soon after the session opened. It took forty-four votes, cast over a two-month period, finally to elect William Pennington of New Jersey, who was serving his first and only term in the House of Representatives. With no congressional record on slavery, or any other issue, to make people angry, Pennington's main qualification was a lack of enemies.

Walter watched from the sidelines as the Senate appointed members to the Committee on Public Buildings and Grounds. Two of his personal friends, Daniel Clark of New Hampshire and James Doolittle of Wisconsin, were named to the committee, as was Anthony Kennedy of Maryland. Jesse D. Bright of Indiana was appointed chairman. Walter felt that the committee would be in favor of using Italian marble for the exterior columns, reasoning that his friends would be loyal to him, their friend from Maryland would be loyal to them, and the chairman "will do anything [Jefferson] Davis wants and Davis is crazy for Italian."[6] But regardless of the committee's disposition towards authorizing Italian marble, the secretary of war was still very much opposed to the idea. Only American marble would do, and it would be particularly attractive if it could be bought from a southern Democrat.

Despite Walter's preference for Italian marble, the firm of Rice, Baird & Heebner was never allowed to submit a sample of foreign stone for consideration. Instead, the company submitted six

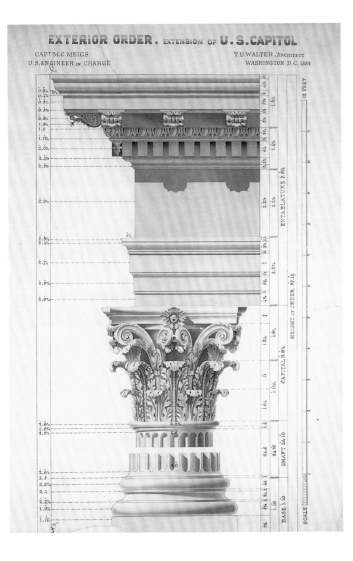

EXTERIOR ORDER. EXTENSION OF U.S. CAPITOL

CAPT.M.C.MEIGS
U.S.ENGINEER IN CHARGE

T.U.WALTER,ARCHITECT
WASHINGTON,D.C.1854

Exterior Order
by Thomas U. Walter, 1854

*T*ypical of Walter's fine draftsmanship, this drawing illustrates the elements, proportion, and dimensions of the Capitol's exterior Corinthian order. Unlike those on the old building, the extension's column shafts were fluted.

specimens of American marble for the Capitol's outside columns. Four were from Vermont (Rutland, Danby, and two from Dorset Mountain), and one each was from Baltimore County, Maryland and Dover, New York. Franklin tested the samples and reported that none was strong enough nor did any of the quarries have enough stone to fill the order.

Another marble merchant, John F. Connolly, wrote the secretary of war about the loss he suffered when the president stepped in and put a stop to his contract. Six months had passed since Floyd ordered Meigs to purchase the column shafts from Connolly (at $1,550 per block), which had led him to build a spur from his quarry near Baltimore to the Northern Central railroad. He undertook the investment based on his belief that the government was ready to buy his marble. Contrary to Walter's steadfast preference for Italian marble

shafts, the secretary of war now ordered Franklin to take the necessary steps to purchase 100 blocks of Maryland marble from Connolly. A few days later Franklin responded in a letter spelling out his objections to the order. The letter was brief and polite, but by questioning the legality of the department's action the captain was bound to remind his superiors of Meigs and his meticulous ways. Franklin doubted the legality of the order because Rice & Baird's contract had not been annulled, there was no money (yet) to pay for the marble, and there was some ambiguity regarding Connolly's price. Franklin was also under the impression that if Rice & Baird forfeited that part of their contract dealing with columns, the remainder of their contract would be voided as well. The supply of Lee marble would come to a halt and another marble would be used to finish the outside of the extension.

Floyd was not happy with Franklin's letter. He wished the supervising engineer had spoken up earlier and in person, without resorting to a formal letter of protest. "Such a procedure would have been more in harmony with the cordial relàtions heretofore subsisting between us," Floyd wrote, "and in more strict conformity to the peculiar rights and duties which are prescribed by our official positions." Each of Franklin's points was addressed in a tone and manner that conveyed the secretary's displeasure. As to the illegality of the order, Floyd was quick to pull rank: "I do not deign to wound your feelings when I remind you that it is scarcely your duty to decide upon the legality of my orders. . . . The Attorney General is my legal adviser, and it is to him that I look when I am involved in legal doubts." Discrepancies in the prices offered by Connolly were dismissed as "too small to be made an impediment to the accomplishment of so desirable an object."

Nothing Franklin had written altered Floyd's decision to buy marble from Connolly. When made

aware of the matter, President Buchanan agreed that the secretary's order was probably illegal but he was too weak to act. He simply let well enough alone.[7] In one last protest, the firm of Rice, Baird & Heebner wrote the secretary to complain that the proposed deal violated its contract. Among other injustices, the partners pointed out that their offer of $1,400 per shaft was a lower bid than Connolly's offer by $150 apiece. Floyd dismissed the protest, citing the firm's failure to deliver the shafts as the reason for which the government was forced to look elsewhere. Considering the "procrastination and delay," he thought that Rice, Baird & Heebner was being let off the hook in a most lenient fashion. On March 20, 1860, Floyd issued an order to purchase 100 monolithic shafts for $1,550 each. Four days later, the House Committee on Expenditures in the War Department declared Floyd's action illegal because it placed an order with a contractor before there was money in the treasury to pay for it. Floyd's order was also found to be in violation of the government's contract with Rice, Baird & Heebner. The committee reasoned that to buy Connolly's marble through Rice's firm would save the government $15,000. It upheld each of Captain Franklin's objections, yet Floyd was not forced to take corrective measures for nearly three months. In the Civil Appropriation Bill of 1861, approved on June 25, 1860, the War Department was formally directed to purchase Connolly's marble through Rice, Baird & Heebner. In a last-minute move Congress foiled Floyd's efforts to sidestep the marble contractor and enrich a person who was undoubtedly a political supporter.

Even before Congress passed its directive, Rice, Baird & Heebner had delivered the first four blocks of Connolly's marble to the Capitol. There were eight more blocks at the quarry ready to be

Marble Delivery

1860

*O*ne of the first column shafts from Connolly's quarry arrived at the Capitol on June 15, 1860. It came to Washington by railroad and was pulled on carriages from the station to the Capitol by a team of horses.

Marble Cutters

1860

*S*trong-armed masons transformed rough blocks of Maryland marble into perfectly shaped and fluted column shafts, working under canvas tents that protected them from sun and rain.

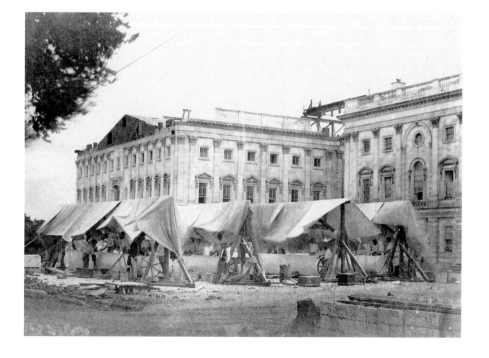

put on railroad cars and transported to Washington. The appearance of the marble greatly annoyed Walter, who did not think it fit for such a grand building.[8] Provost & Winter's workmen dressed the stones in tents put up to protect them from the sun. (But the tents did not protect pedestrians from the danger of flying spalls propelled by the hammers and chisels wielded by strong-armed masons.[9]) It took about 114 working days to boast, cut, turn, and smooth each shaft. About the same amount of time was necessary to flute it, and seventy-eight days were needed for rubbing and polishing. It cost $728 to transform each rough block into a perfectly shaped and fluted shaft, while an additional $242 was allowed the contractor for setting it in place and for profit.[10] Thus, from the quarry to the Capitol, each column shaft cost $2,370 installed.

DOME CONTRACT

*W*hile Floyd's handling of the marble business was unethical, it illustrated the War Department's freewheeling approach to its business affairs and the administration's willingness to use contracts to satisfy political ends. A contract with Janes, Fowler & Kirtland to complete the dome also had legal questions, but it resulted in enormous savings of time and money.

The contract to finish the dome came about in an unusual manner. On December 1, 1859, Captain Franklin wrote Janes, Fowler, Kirtland & Company asking for a bid on the dome's skin.[11] A similar letter was sent to J. M. Reed, president of the Architectural Iron Works in New York. His letters also asked about prices for pieces of the framework delivered and ready to install. These were Franklin's first communications with foundries and the first orders in fourteen months for the dome's ironwork.

The day after they received Franklin's letter, Janes, Fowler & Kirtland offered to cast and deliver the skin of the outer dome for four and a half cents per pound and to install it for one and a half cents per pound. The trusses would cost three cents a pound if all the staging and hoisting apparatus were supplied by the government. Having answered Franklin's questions, the firm unexpectedly proposed to execute all remaining work—both casting and installing—for seven cents a pound saying:

> We have examined the plans for the dome, and we find the design of what remains to be done above the work now being put up, is so dependent, the one part on the other, that it forms a whole that cannot well be divided; and the frame-work and the skin bear such relations to each other as to make it important that both should be made in the same shop; our experience in what we have already done, proves to us the advantage to government as well to the mechanics, of having all the work done at the same establishment; we therefore propose to execute all that remains to be done to the dome, including the putting up of the entire work, exclusive only of staging and hoisting, as before expressed, *for seven cents per pound,* (7¢).[12]

Franklin forwarded the voluntary proposal to the secretary of war, who replied that, since the offer relieved the government of considerable work and responsibility, accepting it would be "true economy." Unfortunately, the department did not have the authority to accept the offer because there was not enough money appropriated to finish the dome. But if the company understood the situation and was agreeable, Franklin was authorized to buy all remaining ironwork for the dome from Janes, Fowler, Kirtland & Company for seven cents a pound.[13]

As soon as Floyd accepted the offer without opening the work to competition, he came under pressure to reverse the decision. Through Senator Davis, Meigs stirred up the matter in Congress, saying that Janes, Fowler, Kirtland & Company actually offered to finish the work for six cents but somehow got a penny more through Floyd's shenanigans.[14] Walter advised the ironworkers to include scaffolds and hoisting in their bid to help calm the growing storm. This was done and, despite Meigs' best efforts, congressional grumbling died down. After small matters were resolved during the next few weeks, the agreement was approved on February 15, 1860.

The dome had risen to 129 feet above the ground when Janes, Fowler, Kirtland & Company took responsibility for erecting the rest. Walter welcomed the deal and had worked diligently behind the scenes on its behalf. Yet, soon after the contract was signed, he found the contractor's own

diligence to be noticeably lacking and was obliged to plead that more men be put on the job:

> I sincerely wish you would *greatly* increase your force on the Dome—you are suffering in public estimation by the slowness with which the work goes on, and I shall find it impossible to stem the storm of public opinion for you much longer if stronger demonstrations are not speedily made—you will observe that the slowness of your progress was one of the subjects of the Senate resolutions, and if you don't hurry up matters very quick you may look for further action—they are quieted for present, and I think all trouble over in reference to the Dome, if you let people see you are in earnest . . . [15]

With the dome rising slowly outside, the art commission assembled in the Capitol to write its report. It had been formed on May 15, 1859, when President Buchanan appointed Henry K. Brown (a sculptor), James R. Lambdin (a portrait painter), and John F. Kensett (a landscape painter) as its members. In June, the three artists met in Washington to organize, inspect the public buildings in the city, interview Meigs and Walter, and begin formulating recommendations for the future decoration of the Capitol. The commission issued its one and only report on George Washington's birthday, February 22, 1860. After a predictable preface about the importance of the Capitol and its art, the commission wrote that, except for the works by Crawford and Rogers, the money spent on decoration had been "misapplied." American history was the foremost subject worthy of the Capitol, they maintained, yet little history could be found among the decorations. They were unimpressed by the replication of European art in the Capitol and asserted that when foreign artists attempted American subjects the results were far from satisfactory:

> We are shown in the Capitol a room in the style of the 'Loggia of Raphael;' another in that of Pompeii; a third after the manner of the Baths of Titus; and even in the rooms where American subjects have been attempted, they are so foreign in treatment, so overlaid and subordinated by symbols and impertinent ornaments that we hardly recognize them.

Having casually dismissed five years of work by Brumidi and other artists, the commission proceeded to map out future decorations. The rotunda was the point of departure. The 300-foot long frieze intended for sculpture was ripe for didactic material such as "Freedom, civil and religious." In the chambers, the subject of the art should be legislative history. Busts of the first two vice presidents should be commissioned for the Senate chamber, with James Madison and Fisher Ames honored in the House with busts or statues. "It is the opinion of the commission," they wrote, "that far greater sobriety should be given these halls in their general effect to render them less distracting to the eye." While perfectly appropriate to military uniforms and banners, the gaudy colors were too diverting for the House and Senate chambers and should be replaced.

Paintings in the Supreme Court should reflect judicial history, significant discoveries and inventions should be depicted on canvasses hung in the corridors leading from the rotunda to the chambers, and lobbies should be decorated with paintings showing scenes of pioneer life. Passages that were not well lighted should be decorated with simple flat colors. Stucco ornamentation should be avoided because of "constant mutilation." (In any event, its use was "cheap and showy.") Affixing bronze ornaments to doors was cited as another instance of misguided taste: viewed from afar, the metal appeared as so many "unintelligible dark spots incapable of light and shade in themselves." If ornamentation was required, the commission suggested that it should be carved from the same wood used in the door's construction.

Most of Meigs' decorative program was laid waste in the devastating appraisal by the art commission. Only sculptures by Crawford and Rogers were spared the blanket condemnation. Their works were praised as entirely suited to the purposes for which they were designed, and they had the distinct advantage of being by American artists. The commissioners hoped that Crawford's plaster models, which Meigs had sent to West Point, would become the nucleus of a national school of art. After digressing briefly to touch on the importance of landscape improvements and redesigning the national coinage, the commission ended its report with a list of works of art to carry out its recommendations: eight paintings, eight statues, and two colossal busts, with a total cost of $169,000.

The first and only art commission appointed to recommend how the Capitol should be decorated had little effect. Despite the high moral and patriotic tone of its message, the report failed to convince Congress that more or different decorations

were needed. In hindsight, it appears that most of the commission's appeals to the country's history—a summons to honor her past—plainly ignored current conditions. As the cancer of slavery ate away at the nation, the art commission perhaps saw patriotic decorations as one way to rekindle a sense of loyalty, a way to calm passions and restore national pride.

A MORE CHEERFUL SENATE CHAMBER

One of the recommendations made by the art commission was to fill the niches in the Senate retiring room (modern day S–215) with $20,000 worth of statuary. Designed for the exclusive use of senators wishing privacy and relaxation, the retiring room was one of the most elegantly finished spaces in the Capitol. Its walls were lined with Tennessee marble, tall mirrors were positioned opposite windows to maximize light, and white marble Corinthian columns supported a deeply paneled and carved marble ceiling. Except for the tile floor, the room was composed entirely of marble. Indeed, it was then (as now) more commonly referred to as the "marble room." Next door was an elaborately painted chamber set aside for the use of the president during his infrequent visits to the Capitol (modern day S–216). These rooms ranked high in the roster of the extension's great interiors, yet both were nearly lost in a scheme to relocate the Senate chamber. On March 19, 1860, Senator John P. Hale of New Hampshire offered a resolution inquiring into the cost of moving the chamber to the outside walls in order to provide the room with windows.

Walter thought the reason some senators wanted windows was merely for "cheerfulness," a chance to admire a view and catch a breath of fresh air.[16] Senator Davis sprang to his feet to object to the resolution because it asked Walter rather than Captain Franklin for a report and it also sidestepped the Senate Committee on Public Buildings. Never wanting to give the architect credit for anything, Davis said that the engineer was surely "a better constructor than the architect."[17] Hale replied that he did not care if protocol directed the inquiry to the superintendent or the architect,

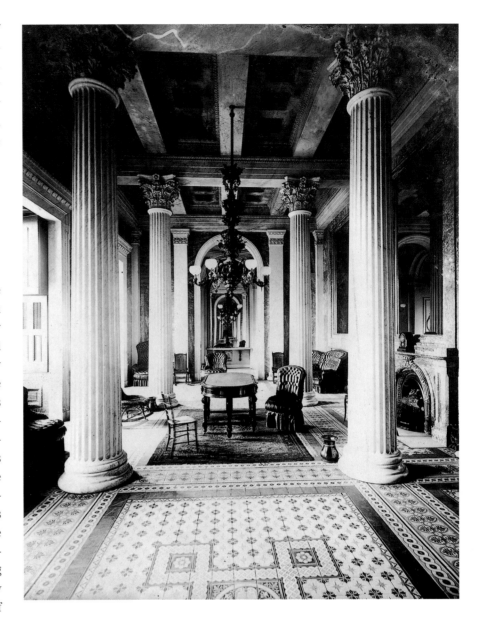

Senators' Retiring Room
ca. 1890

An eclectic collection of tufted furniture, supplemented by a few wooden rocking chairs and a spittoon, was used to furnish one of the grandest rooms in America.

but he wanted plans and cost estimates in hand before the question was referred to the Committee on Public Buildings.

Franklin responded to the inquiry on April 9, 1860.[18] Relocating the chamber to the north wall would cause the demolition of the marble room, the president's room, and the vice president's office. It would also require reconstruction of half

of the north wing's interior structure from the basement to the roof. If the interior ironwork were reused, the cost of that plan would be $165,000. Alternatively, rebuilding the Senate chamber in the northwest corner of the wing would cost $200,000 but offered the advantages of having windows on two sides of the room and saving the marble room. The president's room would be sacrificed in either scheme. Franklin estimated that it would require two years to rebuild the Senate chamber upon either plan.

On the afternoon of June 11, 1860, near the end of the first session of the 36th Congress, the Senate discussed several matters relating to the art commission, alterations in the old Capitol, and the possibility of relocating its chamber. Robert Toombs of Georgia started the discussion by offering an amendment to repeal all laws creating an art commission. Senator Davis thought that if the commission were to be abolished, perhaps it was time to abolish the architect's position as well. Toombs did not understand the correlation, which Davis then explained: "The drawings are already made, and as there is no appropriation for the building, of course there is no use for him."[19] While the senator from Mississippi was being spiteful, Walter's friends were quick to defend the architect and his posi-

tion. Daniel Clark of New Hampshire argued that if the architect's job were abolished the extension would never be completed. Davis' reply rehashed his rather skewed view of Walter's professional duties and accomplishments:

> . . . after the appointment of the late superintendent, Captain Meigs, the architect, became, in fact, a draughtsman. He made plans under Captain Meigs, who was both the constructor and architect in fact, though he never took the name. The drawings have now been completed, and as the present architect failed utterly as a constructor, as was shown by the report of the committee, when he was in charge of construction, I do not see what duties he can have to perform, except to draw his salary. I look upon it, therefore, as a useless expense. The plans are complete. Construction is what remains to be done, not designs.[20]

Clark had no desire to fight the battle between Walter and Meigs on the floor of the Senate. He simply wanted the extension finished and considered Walter the best person to see the work to its end. If he were dismissed, the job would be left to Franklin, whom he called "a comparative stranger." According to Davis, that argument called for Meigs' reinstatement. Alfred Iverson of Georgia supported Davis, saying there was no further need for architectural services and the government would do well to save the expense of Walter's salary. "He came here poor," Iverson mistakenly said of the architect, "and now he is rich." James Doolittle of Wisconsin declared that the whole question revolved around Davis' support for Meigs and Floyd's support for Walter. It was an old "misunderstanding," one that should not be discussed when an appropriation bill was under consideration. He called for a vote on Davis' amendment, which was soundly defeated. By a comfortable margin, Walter had sustained yet another assault from the powerful Mississippi senator.

The Senate returned to the question of abolishing the art commission. Meigs' friend, James Pearce of Maryland, gave a blistering appraisal of the commission's labors on behalf of American art. He thought that its members had little to show for a year's work when they wrote their "little report," and he was alarmed at their suggestion to spend nearly $170,000 on new decorations. There was no call for additional ornamentation at that time and Pearce did not know what the commission would do in the future. He had heard a rumor that the

Design for Removing Senate Chamber From the Centre of the Wing to the North and West Fronts Per Senate Resolution of March 19, 1860

by Thomas U. Walter
1860

*T*he Senate chamber was only a year old when the first attempt was made to relocate it in order to provide the room with windows. Of the several plans made by the architect, this was the one preferred by those who supported the move. The Senate rejected the scheme on June 11, 1860.

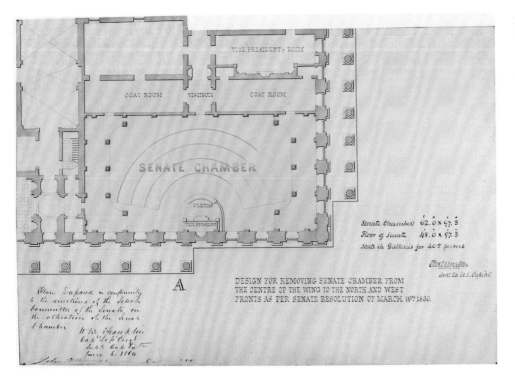

members of the commission wanted a salary of $3,000 apiece, desired an office with a messenger, and had given other signs of wanting a permanent place in government. For his part, Pearce desired to see an end to any claim the commission might place upon the federal purse or public taste. Toombs' amendment to abolish the commission was readily agreed to.

In the next order of business, Senator Jesse D. Bright of Indiana, chairman of the Committee on Public Buildings and Grounds, offered an amendment to appropriate $45,000 to convert the old Senate chamber for the Supreme Court's use, to convert the old courtroom on the first floor into a law library, and to refit other rooms in the old north wing for the Court's benefit. John Hale of New Hampshire questioned the wisdom of proceeding while the matter of rebuilding the Senate chamber was still undecided. If that work were authorized, the Senate would need a place to meet and their old room seemed perfect. He wished to see the matter postponed until the other question was decided. He then introduced legislation to remove the chamber to the northwest corner of the wing and to provide $200,000 for the work. In a spirited rejoinder, Senator Davis defended the room's position in the center of the wing:

> The great object has been to separate the Senate Chamber from exterior noise, and relieve the deliberations of the body from any confusion which might be outside the Capitol. All the heating and ventilation have been directed towards the present location of the Chamber. To remove it now into a wing, a room which cannot be made exactly suited to the purpose, which never can be brought to compare favorably at all with the one in which we are now sitting, seems to me an idiosyncracy on the part of the Senator from New Hampshire . . . [21]

With biting sarcasm, Davis continued his defense of the chamber by inviting Senator Hale to leave the room any time he wished to gaze out a window. The Senate would miss his counsel, but if the matter were so important, then he should by all means leave and find a window. In Davis' opinion there was no reason to abandon the present chamber, a room that "must attract the admiration of every one who sees it, and which, in its acoustic effects, is as perfect as any room of its size I ever saw." [22]

Senator Hale claimed to have been unable to hear anything Davis had said. But he remarked that praise for the appearance of the chamber was an exercise in personal taste that could not be debated. Its arrangement, however, was another matter. He considered the heating and ventilation so bad and so unnatural that he doubted many new senators would survive their six-year term in the room. The Senate chamber, he declared, was an utter failure. His committee had seen Walter's original plan for the north wing with the chamber located in the northwest corner and noted with pleasure its similarity to the proposed alteration. Repositioning the chamber would result in a far superior room with windows and a smaller gallery. More than 1,000 people could be accommodated in the present gallery, which presented too great a distraction. The proposed alteration would reduce the seating capacity to 400, a more manageable number. It would also bring daylight and fresh air directly into the room.[23] When Hale's motion was put to a vote, however, only nine senators supported the relocation. While soundly defeated, the window issue would be revisited from time to time over the next sixty-five years.

The discussion next turned to refitting the former Senate chamber for the Supreme Court. Anthony Kennedy of Maryland, Trusten Polk of Missouri, and Robert Johnson of Arkansas spoke against the matter as too expensive. "I am in favor of fitting up these rooms in [a] very handsome style," Kennedy said, "but, for the life of me, I do not see how it will take $45,000 to do it." [24] George Pugh of Ohio decried the Supreme Court's present location in the "cellar" and hoped the Senate would agree to the proposed improvement. James Mason of Virginia thought the only reason to move the Supreme Court was to give the old Senate chamber a new use. He declared: "I think we are somewhat in the condition known to many of us who have had the misfortune to build a new house. The difficulty is to know what to do with the old one." [25] James Bayard of Delaware disagreed. He stated it had always been understood that the Supreme Court would take over the old Senate chamber and that the old courtroom would be refitted as a law library. Inadequate space for books caused inconvenience in the old library (modern day S–146 and 146–A), and the growing

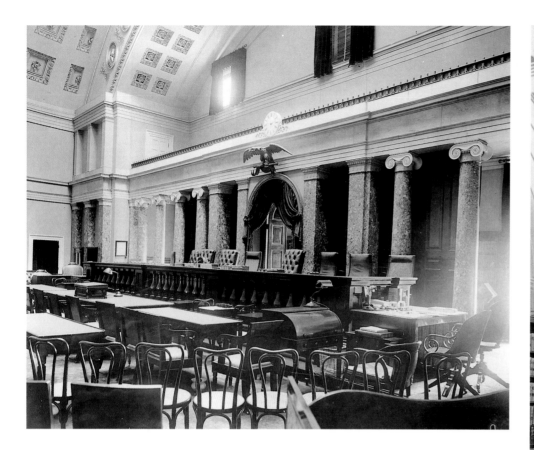

Supreme Court Chamber

ca. 1900

*M*inor modifications made in 1860 transformed the former Senate chamber into a courtroom. A level floor replaced the terraced platform formerly occupied by senators' desks; the justices' bench was placed where the vice president's rostrum had once stood. The semicircular visitor gallery was also removed.

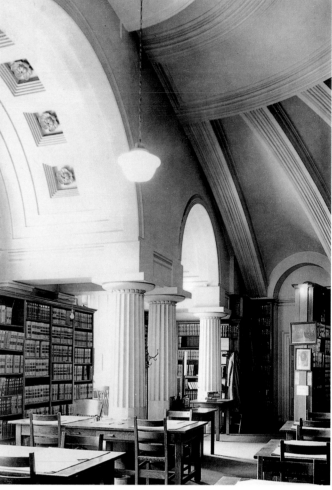

Law Library

ca. 1900

*I*n 1860 the Supreme Court's library moved into the former courtroom, where it stayed for the next seventy-five years.

collection needed better accommodations. Stephen Mallory of Florida was against the measure simply because he hoped the Senate would return to its old room. He also thought the money requested was more than enough to build the Supreme Court its own building.

The cost of converting rooms in the old north wing for the Supreme Court was the principal objection most senators had to the plan. Other figures were substituted for the original $45,000, ranging from $5,000 to $25,000. One senator thought the conversions would require more structural modifications than anyone suspected and would result in a more expensive project than anyone realized. Robert Johnson thought that it was not fair to vote so much money for the Supreme

Court when senators were unwilling to vote funds for their own comfort.[26]

After almost two hours of discussion and votes on various matters—abolishing the art commission, sustaining Walter, refusing to relocate the Senate chamber—a vote was finally taken on Bright's amendment to convert the old Senate chamber into a courtroom. The amount of money available for the project, including the transformation of the old courtroom into a law library, was reduced to $25,000 to help make the appropriation palatable to reticent senators. By a vote of twenty-two to seventeen, the legislation finally passed.

The House of Representatives went along with the Senate's actions. When it debated the appropriation for 1861, a few members worried that some of the money might be used to further the decorations and wondered about the future role of the art commission. There seemed to be little support for the continuation of the commission, as no new art was envisioned for the foreseeable future. But the issue gave members an opportunity to express their opinions about the decorations around them, which inspired the usual oratorical flourishes. With eloquence and imagination, Morrison Harris of Maryland took aim at the work of foreign artists in the Capitol:

> . . . the whole building appears to have been delivered over to the gross and flashy conceits of second-rate German or Italian fresco painters, who have covered the walls of the corridors and committee-rooms with inappropriate designs of flowers and fruits, Venuses, bacchantes, flying dragons with heads of chicken cocks, and curious combinations neither human, divine, mythological, nor allegorical.[27]

When the votes were counted, the House agreed to abolish the commission and to limit the appropriation to the work necessary to finish the wings: no funds could be expended on paintings or sculpture. On June 9, 1860, $300,000 was given for the extension, an unexpectedly large sum considering the state of the treasury.

THE UNION UNHINGED

With the political climate more blustery than ever, the first session of the 36th Congress ended on June 25, 1860. By then the presidential campaign was well under way and the nation resounded with the sounds of marching bands, parades, and red-hot oratory. Democrats met in Charleston to nominate a candidate, but delegates split over the issue of federal protection of slavery in the territories. Supporters of the proposition walked out after the 57th ballot. The convention reconvened in Baltimore, where Stephen Douglas was nominated. National Democrats representing the hardliners who walked out in Charleston reconvened in Baltimore as well, naming Vice President John C. Breckinridge as their candidate for the nation's highest office. Mean-

while, the Constitutional Union party, a loose confederation of old Whigs and remnants of the Know-Nothing party, named John Bell of Tennessee as its candidate. All would face stiff opposition from the united Republican party and its candidate, Abraham Lincoln of Illinois. He captured the party's nod on the third ballot at its convention held in Chicago in May.

When funds became available on July 1, work resumed on the extension. During the previous seven months little was done due to the lack of money. A few men were employed at the sawmill getting marble paving ready for the porticoes, but no work was done on the wings except some routine painting and gilding. Once work resumed, it again concentrated on the porticoes, and the boasting, cutting, turning, fluting, and polishing of column shafts. By the first week in November 1860, sixteen shafts had been delivered and Franklin reported that their appearance was better than anticipated.[28]

From time to time, Franklin and Walter took carriage rides out Bladensburg Road to visit Clark

Plan, Section, and Details of Ceiling of Western Staircase, North Wing
by Thomas U. Walter, 1858

Janes, Fowler, Kirtland & Company received the contract for the ceilings over the four public stairs in August 1860.

Mills at his foundry near the Maryland state line. Mills was a sculptor of considerable renown whose spirited statue of Andrew Jackson across from the President's House was the first equestrian statue cast in the United States. Teaching himself by trial and error, Mills cast the work himself in 1849–1852. Now he was busy casting Crawford's statue of Freedom for the top of the Capitol's new dome.

As was the case with most other projects connected with the Capitol during this period, selecting the person to cast the statue was a political decision. Crawford had wanted to send the model to the Royal Bavarian Foundry in Munich, where he expected the casting would be superior to that available elsewhere—especially in America. A cargo of bronze would also be safer to ship across the Atlantic than a cargo of plaster. Earlier, Meigs had wanted to melt down old bronze cannons to cast the statue, making it a tribute to military men and their accomplishments. In 1857, he told Senator Pearce: "I wish to make this great work, not only an object of national pride as a work of art, but also a memorial of battles won on sea and land in the struggle which gained and since maintained our independence." [29] Both Walter and Franklin wanted James T. Ames of Chicopee, Massachusetts, to do the job. Ames had extensive experience casting statues for sculptors and cannons for the War Department. Clark Mills, however, made quite an impression on his own behalf by calling on the secretary of war arm-in-arm with the entire congressional delegation from his home state, South Carolina. When Walter learned of the extraordinary visit, he went immediately to see Floyd to persuade him that Ames was better qualified. Knowing that the administration always looked to appease southern politicians, Walter informed Ames of the situation and advised him to counter that influence if he could:

> outside pressure (from members of Congress from the south) was so great as to make it a very embarrassing question with him [Floyd], and much as he desired to gratify Capt. F[ranklin] and myself in the matter he was afraid that he would have to "*give in*". . . . We have done all we could but our influence is only professional and that, you know, makes but little show in politics. . . . Can't you make some movement through [the Secretary of the Navy] Mr. Toucey—he is from your region, and a word from him to the Secy. of War would be potent.[30]

The doubts apparent in Walter's letter were borne out when the secretary of war ordered Franklin to draw up a contract with Clark Mills. On April 8, 1860, Mills proposed to do the work for $25,000, asking for a $10,000 cash advance. Thinking the cost too high, Franklin appealed to the secretary for permission to open the job for bids, but Floyd would not budge. South Carolina's senators and representatives were too powerful to be toyed with. Franklin was, however, allowed to negotiate with Mills, and they struck a deal whereby the government would rent Mills' foundry and pay him $400 a month for his professional services. The government would supply all materials. Despite Meigs' hope, the bronze was made from Lake Superior copper and tin bought in New York rather than obtained from melted cannons. For every pound of copper used, one ounce of tin and one half ounce of zinc were added to produce bronze. It cost about $20,000 to cast the statue and haul it to the Capitol.

When Franklin finished his 1860 annual report on November 6, there was little to recount beyond a description of masons working on the column shafts and other tasks relating to the porticoes. He reported that the benches had been removed from the House chamber and the desks and chairs restored. While the report was rather uninteresting, that particular day was not. The first exterior column was set in place on the east side of the House connecting corridor, and Franklin, a lifelong Democrat, cast his presidential vote for Abraham Lincoln. Earlier that year he said that the corruption in the Buchanan administration had turned him away from the Democratic party and he was "leaning towards the rail splitter."[31]

While the majority of voters leaned away from the "rail splitter," Lincoln won the election by a wide margin in the electoral college. As soon as this result was known, the sectional time bomb that had been ticking for decades finally exploded. Although Lincoln was not an abolitionist, he wanted slavery contained. Southern extremists saw his election as the perfect time to break away from the north and its dominating power, which threatened their "peculiar institution." The legislature of South Carolina remained in session during the election, and when it learned of Lincoln's victory it called a convention to determine the state's

course. Even before the convention met, South Carolina's senators began to withdraw from Congress. On November 10, 1860, Senator James Chestnut withdrew, followed by James H. Hammond the next day. When South Carolina seceded on December 20, her six representatives in the House withdrew immediately. In January, the states of Mississippi, Alabama, Florida, Louisiana, and Georgia followed suit. On a single day—January 21, 1861—five southern senators, including Jefferson Davis, withdrew from Congress. (While many politicians were leaving Washington, the lone representative from the new state of Kansas took his seat in the House on January 20.) The following month Texas joined the secession movement and the Confederate States of America was formed in Montgomery, Alabama. Jefferson Davis was named its provisional president.

Benjamin B. French, an ardent supporter of the north, noted in his journal that one of the column shafts being wrought on the Capitol grounds split on the day that South Carolina left the Union. He suspected that the accident was actually a terrible omen. Walter, too, was taken by the coincidence, telling Rice that the huge stone "went for *Secession*." He thought everything in the nation was headed for secession except his colleague Edward Clark, who had recently gotten married: "our old friend Clark, . . . he goes in for Union."[32]

Although Buchanan deemed secession illegal, he also thought the president lacked the constitutional authority necessary to force states back into the Union. One of the few concrete actions he took was a reorganization of the cabinet. Secessionists were rooted out and sent packing. The first to go was John B. Floyd, whose sympathies with the secession movement had never been well disguised. He left Washington on December 29, but not before sending arms and ammunition south, where he hoped they would eventually fall into rebel hands.

During the first week in February, Walter watched the city fill with troops, some of whom were quartered across from his home on F Street, NW. He awakened with "drums beating to arms" in the morning and endured the sound of the bugle throughout the day. If Virginia seceded, he was prepared to depart the next day. "I shall leave here as soon as they begin to burn gunpowder," he told one of his adult children, "I don't like the smell of it."[33] He owned a fine lot in the quiet Germantown

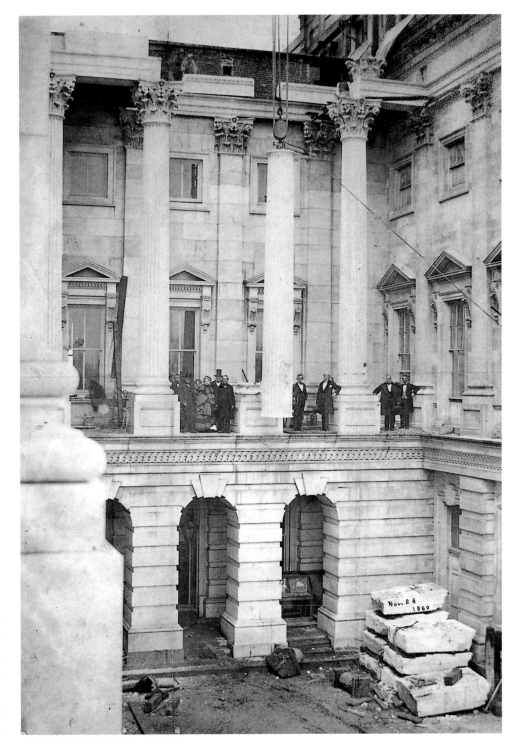

Column Shaft Installation
1860

*A*mong those observing the scene were Senator Jefferson Davis and Thomas U. Walter (with hand on hip). These unlikely companions watched as the fourth and final shaft was positioned on the east side of the House connecting corridor. The photograph was taken a few weeks before Davis left the Senate when Mississippi withdrew from the Union.

section of Philadelphia and was in the process of building a house there. But Walter was not sure he would live peacefully among "black republicans who have brought these horrid evils upon us." Perhaps he would wait out the war in Europe, but whatever course he took, the future looked grim—his financial prospects were bleak. He explained the situation to a close friend:

> We have come to the conclusion today that the country is to be torn asunder, that war and fighting are to be the fashion for the next decade, and that we shall lose at least $50,000 in this district alone, and all for an abstraction—a mere phantom in the brain of northern fanatics—a thing that don't concern them, and never did—they have, however, made it concern me to some purpose; my wrath against northern aggression is quite up to the boiling point.
>
> I want to get away from this place; I hate politicians of *every* stripe with a perfect hatred, and would like to get out of the din of their degrading strife, but I very much fear that while we live in this country we are destined to live in the midst of its tumults and its broils wherever we may go.[34]

MEIGS' RETURN

After Floyd's departure, the War Department was run by the postmaster general, Joseph Holt of Kentucky. Being prone to reverse Floyd's decisions, Holt recalled Meigs to Washington and again gave him charge of the aqueduct.[35] Since October 1860, Meigs had been detailed to Fort Jefferson on the Dry Tortugas in Florida, where he had been banished by the former secretary of war. By February 25, 1861, he was back at the aqueduct and trying to recapture his place at the Capitol. That day Meigs wrote Franklin a remarkable letter, telling his friend and fellow army officer that God had sent him back to Washington so he could install the statue of Freedom on top of the new dome:

> I have always held a firm conviction that, with or without effort on my part, if God spared my life, I should place the Statue of American Freedom upon the Dome of the Capitol; and, having a firm faith in the justice of God, and in his providence, which overrules all things great and small, for good, I believe that I shall yet do this.

> *'Finis coronat opus'*
> To this end I invite your cooperation.[36]

Franklin was not particularly sympathetic to Meigs' candid letter. Despite the former headaches with Floyd, he was enjoying working at the Capitol and thought the experience would prepare him for a future career in civilian life. He neither understood why Meigs wanted to return to the Capitol, when the Washington Aqueduct gave him so much to do, nor did he want to give up his own occupation merely to be placed "on the shelf."[37]

Amid the confusion marking the close of Buchanan's administration, Secretary Holt replaced Franklin with Meigs at the head of the Capitol extension and new dome projects. He took charge on February 27, 1861, arriving at the office the next day. Quite unexpectedly, Walter paid him a courtesy call; he was greeted with growls and sneers. A description of the unpleasant encounter was written by Walter the following day:

> Under the best advice I called on Meigs yesterday at 12¼ P.M. just 15 minutes after he ascended the throne (Franklin was present). Bowing to M. as I entered the room I said *'good morning Capt. Meigs, I have called to pay my respects to you on your reassuming the charge of the works with which I am connected.'* He looked daggers at me, and gave a grunt, gnashing his teeth and turned his head away from me. Not the least discomfited, as soon as I had finished my address to him, I turned to Capt. Franklin and pleasantly said *'and to you Capt. F. I have come to bid good bye.'* Thus ended the first act. I am not sorry I did it, tough job as it was.[38]

Meigs soon wrote Walter a letter dismissing him from the position of architect of the Capitol extension. He declared that Walter's continuation in office would not promote the public interest and he therefore had "the honor to inform you that your services are dispensed with from this date."[39] Meigs' letter was written on March 2, 1861, just two days before Abraham Lincoln took office. Prudently, Walter waited a couple of days before making his reply. On March 5, he wrote to remind Meigs that his appointment was presidential and that he therefore was under no obligation to leave office at the presumptuous order of a mere army captain:

> I take occasion, very respectfully to say that my connection with the public works, which were placed in your charge during the past weeks, depends upon the will of the President of the

United States, and is in no way at your disposal as your letter assumes. . . . As your letter has no bearing whatever upon my official relations to Government, I decline to recognize the authority it affects.[40]

Upon receiving this statement, Meigs asked the commissioner of public buildings to post a guard at Walter's office door to prevent him from removing public property. Commissioner John B. Blake obliged and Walter took the opportunity to visit Philadelphia and Germantown while the administration sorted the matter out. While in Pennsylvania he attended to some personal business regarding his new house and conferred with friends to plot his next move. Returning to Washington, the architect regretted that the works were interrupted by the change in command and noted that the mood among the workmen was uncertain. In a letter to Charles Fowler, who had a question about the dome, Walter wrote:

> I can't give you any information about the Dome as I have no access to Meigs, and all the clerks, receivers, messengers, &c &c are frightened out of their gizzards—Meigs don't come here and I don't suppose he will, until he gets me off (provided that he can do that thing) he stays at home and writes and fusses; he is afraid to see me, for fear I will speak to him as I did the other day viz, politely; that kind of salutation of mine almost killed him; I don't think he would survive another scene of the kind; he turned the color of the '*ashes of rose*,' let down his two ports upon me, and screwed his mouth as though he had just had a bite of indian turnip—poor fellow, let him alone and he will soon do the business himself.[41]

At the architect's urging, John Rice and Pennsylvania's state treasurer, Henry D. Moore, came to Washington to have a word with their mutual friend and political ally from the Keystone State, Simon Cameron, who was Lincoln's secretary of war designate. "I have my friends all ready to jump on the Secy. of war as soon as he enters on his duties," Walter informed Fowler.[42] Unlike former disputes, this one was settled quickly. Three days after his Senate confirmation, Cameron issued an order prohibiting Meigs from interfering further with the architect. The order was issued on March 14, 1861, and, among other things, illustrated a welcome decisiveness on the part of the new administration.

Meigs was furious that his order was overturned. He reacted with a long, labored letter to Cameron that attempted to establish his "official

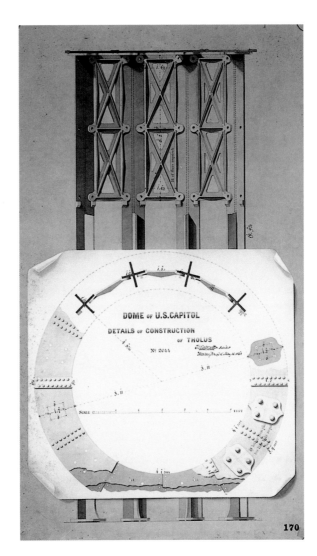

170

Details of Construction of Tholus

by Thomas U. Walter 1861

Walter drew a plan of the tholus's structural elements on what appeared as a sheet of paper laying on top of another drawing showing the same subject in elevation. Indulging in artistic exercises such as tromp l'oeil helped the architect through the tough times when Captain Meigs returned to the Capitol and attempted to fire him.

authority and very sufficient reasons for putting an end to Mr. Walter's connection with the public works under my charge."[43] He pointed out that Walter's appointment was authorized in an appropriation bill passed in 1850 and argued that the appointment expired when the first appropriation ran out. He quoted the law transferring the works to the War Department, placing supervision and control of the extension in his hands. Despite the complete and absolute power he held over Walter, Meigs claimed that he at first found it useful to keep the architect in office and that he had been treated with benevolence. Page after page the letter described Walter's insubordination and intrigues, his lack of gratitude, and his attempt to "blacken my character and to rob me of reputation and position." But the remarkable thing about Meigs' letter was the number of times he quoted documents supporting his positions that were writ-

ten by the nation's premier *persona non grata*, Jefferson Davis. Considering Davis' recent ascension to the presidency of the Confederate States of America, Meigs reliance on the former secretary's authority and opinion was a stunning tactical error. He delivered the letter personally to the secretary of war, who was in no mood to read about such things. Cameron abruptly dismissed Meigs, who left with his long letter unread.[44] At the end of the episode the only person removed was the watchman outside Walter's office door.

A week after Meigs' first letter to Cameron, he wrote a second one questioning the legality of the government's dome contract with Janes, Fowler, Kirtland & Company. He recited the chronology of events leading up to the contract,

Union Troops at the Capitol

1861

Library of Congress

𝒜t the beginning of the Civil War, the U. S. Army occupied the Capitol as a hospital and bakery, while as many as 4,000 troops were quartered in every available room and corner.

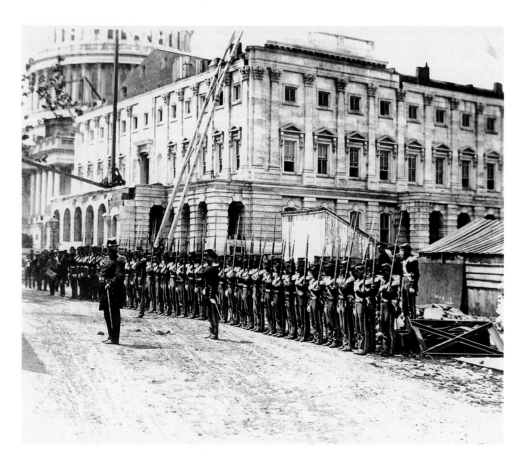

claiming it was illegally signed without the benefit of competition. He also claimed that the firm offered to furnish and install the ironwork for six cents but received seven cents per pound. In the first contention Meigs was correct but in the second he was not. Considering the irregularities marring the agreement, Meigs doubted that any contract existed between the two parties, and administering the government's end of the agreement, therefore, made him uncomfortable.[45] He was also convinced that the price paid the contractor was too high. He admitted that if the work was advertised it was entirely possible that it would be contracted at an even higher price—but at least the contract would be legal.

Walter thought that Meigs was out to ruin his good friend Charles Fowler and to throw doubt on Captain Franklin's reputation. At the heart of the issue, however, were the legality of the dome contract and the business practices of the previous administration. Before the War Department could answer Meigs' letter, President Lincoln dispatched him to the Gulf of Mexico to resupply federal troops at Fort Pickens in Pensacola. (A similar expedition was headed to Fort Sumter in Charleston.) Meigs placed his brother-in-law, Captain John N. Macomb of the Army Corps of Topographical Engineers, temporarily in charge of the extension office during his absence. Meigs left on April 3 and was gone a month. Having completed his mission successfully, he returned to a city gripped by panic and fear. After thirty hours of bombardment, Fort Sumter had fallen to southern guns on April 13, 1861. The dreaded War Between the States had begun. Virginia joined the confederacy on April 17; North Carolina and Tennessee soon followed.

The day after the surrender of Fort Sumter, President Lincoln issued a call for 75,000 troops to serve in the army for three months. Many came to the federal city and occupied the public buildings and grounds as barracks and camps: troops quartered in the architect's office made it impossible to work. At the War Department Walter encountered men who expected "hot times" but felt that work on the public buildings would continue. "No body's hurt and nothing's the matter, hence no interference with the public works is necessary," he was

told. The next day he sent war news to his son, who had written his father asking for money:

> We are here in the midst of war. We expect every moment the clash of arms around us—business is at an end. Every hole and corner of Washington is filled with soldiers; guns are planted along the Potomac to meet Virginia when she comes; Harper's ferry was taken this morning & blown up. My office is at this moment while I write filled with soldiers.—The Capitol itself is turned into a barracks; there will be 30,000 troops here by tomorrow night. This is no time for money arrangements—property is valueless—business is dead.[46]

By April 20, Walter had decided to pack his family and move to the safety of Germantown. While his residence was still under construction, he rented a house and gave instructions to the landlord for fixing the front porch, building a fence, and "rat-ifying" the cellar.[47] Although it took three days, he was able to move his wife, three daughters, and young son to Germantown during the last week in April and return to Washington by the first of May. His trip back to the federal city was "unpleasant and tedious."[48] Rumor that the way to Washington was clear turned out to be untrue. Railroads, ships, and hotels were clogged with people fleeing their homes in Washington and Baltimore. His passage down the Chesapeake was stormy and the food at his Baltimore hotel was miserable. At seven o'clock in the morning he was at the train station, where he found cars crowded and ticket prices wildly inflated. Upon reaching Washington, he went to his residence where furniture and 150 boxes of household goods were ready to be sent north. He rode to Georgetown to arrange shipment by propeller ship, but due to the general exodus, the competition for space on ships leaving Washington was stiff. Gloomy and pessimistic, Walter wrote his wife:

> Washington is nothing but a military encampment. I am glad you are out of it—Every body who could get off has gone—half the houses are shut up. They say that it is the safest place in the country, but who cares for safety in such a place as this? —I believe it is safe, but it is demoralized and business is at an end, I think a perpetual end. This will never be any thing of a place again—so I fear.[49]

The day Fort Sumter fell the Capitol was commandeered by the military. The commissioner of public buildings "cheerfully" admitted troops into the building, but he wanted time to ensure the preservation of its contents.[50] In a few days, however, it was overrun with soldiers and supplies, resulting in the inevitable damage to the building's fabric and furnishings. It was difficult to navigate corridors filled to the ceilings with barrels of flour, pork, beef, and crackers.[51] Bakeries with gas-fired ovens were set up in basement rooms and under the terrace. Constructed under the supervision of Lieutenant T. J. Cate of the Sixth Massachusetts Infantry, the bakeries were capable of turning out 16,000 loaves of bread each day. Marble mantels were removed from the rooms and stored in the tomb long ago prepared for George Washington's remains. Soldiers passed bread through windows to be loaded onto wagons waiting in the courtyards. Smoke from the ovens wafted through the Library of Congress' windows, causing damage to books and works of art. The Senate chamber was "alive

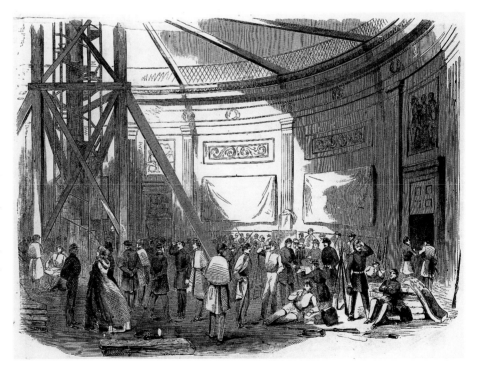

Troops in the Rotunda
Harper's Weekly, 1861

At the beginning of hostilities, the Eighth Massachusetts Regiment was bivouacked in the rotunda while dome construction continued overhead. The scaffold used to build the dome stood in the center of the room, while cloth covers protected the historical paintings.

with lice" brought in by filthy soldiers camping there.[52] But the worst conditions were caused by the woeful inadequacy of the sanitary facilities used by thousands of troops now living in the Capitol. While apologetic for bringing the subject up, Walter described the sordid conditions in a letter to his wife on May 3, 1861:

> Several thousands more troops arrived yesterday—the city swarms with them; they say there are 30,000 here—There are 4,000 in the Capitol, with all their provisions, ammunition and baggage, and the smell is awful.—The building is like one grand water closet—every hole and corner is defiled—one of the Capitol police says there are cart loads of ____ in the dark corners; Mr. Denham says in one of the water closets rooms where he made an attempt to step in, some 200 at least must have used the floor. . . . It is sad to see the defacement of the building every where. These are nasty things to talk to a lady about, but ladies ought to know what vile uses the most elegant things are devoted to in times of war.[53]

A YEAR'S INTERIM

*D*espite Walter's hopes to continue work during the war, Meigs issued an order stopping construction at half past three on May 15, 1861. Only a small band of clerks was retained to sort through documents, pay bills, and close the books. Walter gathered personal papers from his office and wrote Captain Macomb to say he was leaving immediately for Germantown. Two days later, the secretary of war wrote

Dome Construction 1861

*W*hen the Civil War began, construction of the dome had reached the top of the drum's second story. During the first year of the war, the iron contractor continued building the dome despite not being paid for its labor and materials.

Visible in the foreground are Union troops and the back of Crawford's statue of America, the central figure of *Progress of Civilization* destined for the Senate pediment.

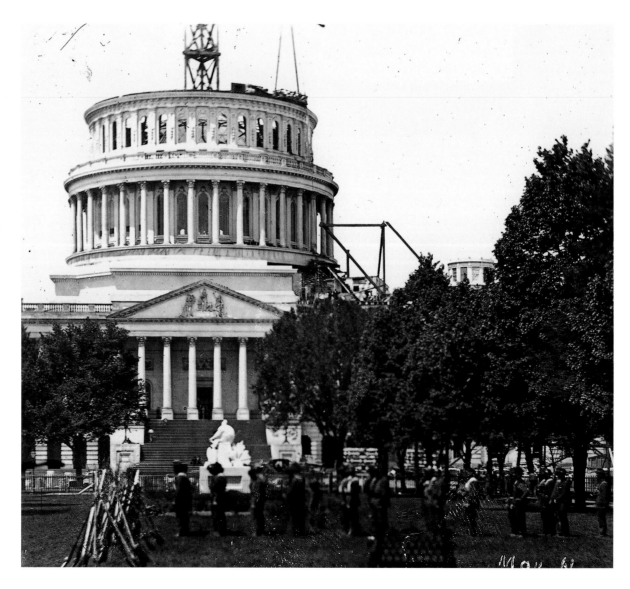

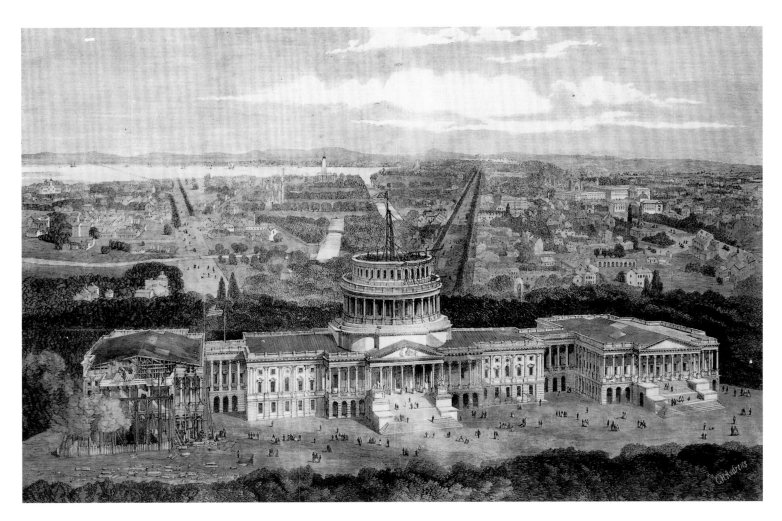

Bird's-eye View of the City of Washington with Capitol in Foreground
by George Henry Andrews, 1861

The *Illustrated London News* of May 25, 1861, published this wood engraving showing the Capitol at the commencement of the Civil War. Andrews indulged in artistic license by showing the Senate portico finished and the House portico under construction—a scene that lay four years in the future.

Janes, Fowler, Kirtland & Company, advising the firm not to expect payment for any further work on the dome until the country's financial outlook improved.[54] Thinking the matter over, Charles Fowler and his partners determined that there was no choice but to continue to hoist and bolt ironwork on the dome. They had 1.3 million pounds of iron stockpiled on site, and walking away from such valuable material would be irresponsible and costly. Instead, the firm decided to continue building the dome, trusting the government to pay when times were better. A small force was kept at work throughout the time Janes, Fowler, Kirtland's contract was suspended, so that "the sound of the hammer [was never] stopped on the national Capitol a single moment during all our civil troubles."[55] (Thus, contrary to a popular twentieth-century legend, President Lincoln was not responsible for the continuation of the dome during the war.)

Despite troubled times, Meigs revived the dormant art program by commissioning a painting for the western staircase in the House wing. He saw a study by Emanuel Leutze of a picture representing westward emigration, which the artist proposed to execute for $20,000. On May 23, 1861, he forwarded the proposal to the secretary of war with a recommendation that it be accepted. "It would be a pity to defer it," he wrote, "even amid the shock of arms."[56] Cameron immediately disapproved the suggestion, as the nation had only a month earlier embarked upon a war of uncertain duration and cost.

Meigs would not take no for an answer. Ten days after he was promoted to quartermaster general, he wrote the secretary another letter about the painting. He saw the project as one way the government could assure the nation of its confidence in the successful outcome of the conflict:

> The people do not intend to permit rebellious hands to deface the Capitol, & they probably would hail with joy such evidence of the determination & confidence of the Government. . . . I would be gratified, all other expenditures upon the building having been stopped, to see in this time of rebellion one artist at least employed in illustrating our Western Conquest.[57]

On July 2, 1861, two days before opening of the 37th Congress, the secretary of war relented and approved the plan to decorate the staircase with a monumental painting entitled *Westward the Course of Empire Takes its Way*. Leutze was given two years to complete the work. The New York *Evening Post* noticed the irony of proceeding with the Capitol's decoration during times of war and wrote sarcastically: "With due respect to the government and the artist, we think we have several stern realities to deal with just now, without dabbling in the allegorical."[58]

While Leutze visited Colorado to see Pike's Peak and other western landscapes to prepare his painting, other works of art were being removed from the Capitol for safekeeping. George P. A. Healy's portraits of John Tyler and James Buchanan were on display in the rotunda when war broke out and were in danger of being vandalized by angry mobs. Condemned as a traitor, Tyler was a member of the Provisional Congress of the Confederacy, and the commissioner of public buildings asked the Speaker's permission to remove his portrait—"the subject of so much vituperation"—to a storeroom.[59] The portrait of James Buchanan was placed in the commissioner's office "to protect it from threatened indignity."[60] As the painting was Healy's property, the artist was asked to make arrangements for its safety.

Walter was in Washington for the opening of Congress, hoping to interest politicians in the resumption of work. He also labored alone in the drafting room preparing designs for the time when workmen would return. (He found that he could accomplish much more when not distracted by assistants.) He daydreamed about the works being returned to the Interior Department and having a clerk take care of disbursements while he would act as the general superintendent. This would "undo what Jeff Davis did and put things back to their original status," he said.[61] But the politicians could talk only of war, and Walter got nowhere with them or his vision of the future management of the works. Returning to Philadelphia at the end of July, he told Alexander Provost that "members of Congress, without an exception, were averse to making any move in any way that did not bear directly on '*crushing out the rebellion*.'"[62]

Throughout the summer and fall of 1861, Walter visited or wrote people whom he thought could help restart the works. While he missed his salary, he missed his occupation more. (The government later reimbursed the wages he lost that year.) He returned to Washington while Congress was in session, went to Harrisburg to see Henry Moore, and traveled to New York to confer with Charles Fowler. He was not able to generate much enthusiasm for his cause. One of his few allies in the matter was Benjamin B. French, whom Lincoln had reinstated as commissioner of public buildings. French called Congress' attention to the war's effects on the Capitol, the damage caused by the troops and bakeries, and the boost to morale that would be felt if the works were continued. He was not persuaded that saving a little money was worth the symbolic cost of keeping the works shut down: "When it is considered that less than one-fourth of a single day's expenditure in carrying on the war would complete the Capitol, can it be that Congress will suffer it to remain an unfinished monument of exultation for the enemies of the Union?"[63]

When construction resumed, it was important to Walter that work not continue under the War Department. It may have seemed obvious that the War Department had too much responsibility at that particular moment, but Meigs—for one—did not want the department to relinquish control. Walter knew that a fight lay ahead but had faith that most people would see eye-to-eye with his position. In a letter to Fowler, he spelled out four compelling reasons to transfer the works from the War Department to the Department of the Interior:

> 1st. The War Department is not the place for civil works; they are just the things that the Home Department was originated to take care

of; they were put into that Department by the Whig administration of Mr. Fillmore—just the place they ought to be, and there they would have remained, and been completed long ago, had it not been for that atrocious wretch, Jeff Davis; it was he who removed them, and it would be exceedingly graceful for an administration kindred to Mr. Fillmore's to put them back again.—2nd. The War Department expresses itself . . . as desirous to get rid of them.—3rd. The Interior Department is desirous to have them; —and 4th. Such a transfer is a virtual resumption of the Public works, and the moral effect of such a resumption would be equal in Europe to half a dozen victories.[64]

In the Senate, the matter of resuming work on the Capitol extension under the secretary of the interior was taken up on March 5, 1862. As chairman of the Committee on Public Buildings, Solomon Foot of Vermont spoke at length in its favor. Foot made it clear that the proposed transfer was not a reflection of the War Department's honesty or capacity, but a simple acknowledgment that it had more pressing duties. He praised the new secretary of war, Edwin Stanton of Ohio, who had replaced Simon Cameron some months earlier. Stanton was a man of "distinguished ability, of high integrity, of uncommon business capacity, and of devoted loyalty," but "has not an hour of time to give to the direction of this work."[65] General Meigs was also a "gentleman of a very high order of talent, of great energy, and of remarkable executive ability," but he, too, had no time to dabble in the Capitol works: "His hands are full of other matters," Foot rightly declared.

Foot noted that the Department of the Interior had not quite enough to do, while the War Department had too much work. It was vital to continue construction because the wings were suffering from water filtering into areas that should have been protected by porticoes. It would cost more in the future to repair the damaged plaster, ornaments, and paint than to resume work at the present time. Enough money remained from unexpended appropriations to fund the work, and none of the money would be used to buy needless things like works of art. "We are only asking so much as is absolutely necessary to protect this magnificent and costly structure from further and from lasting injury in consequence of its present exposed condition."[66]

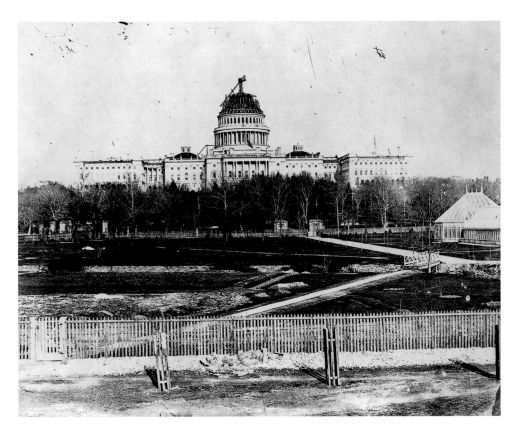

Dome Construction
1862

*S*low but steady progress was made on the dome's cupola during the first full year of the Civil War. To the right is the Botanic Garden's Gothic greenhouse located at the eastern end of the Mall.

Senator William Pitt Fessenden of Maine, chairman of the Committee on Finance and a Meigs ally, opposed Foot's proposal. Despite assurances to the contrary, he took the measure as a rebuke of General Meigs' management as well as a waste of money during wartime. He wanted the Capitol to "stand as it is, comparatively, until better days."[67] And he was decidedly opposed to the idea that the work might go on under an "eminent architect," a quarrelsome man whom he thought would "spend this money when we have no money to spare." He continued his defense of Meigs at Walter's inevitable expense:

> General Meigs has not asked to be relieved at all. He has adopted his policy. The whole thing is now in charge of men whom he left here sufficient to take care of what has been done. If he said that he had no time to attend to it, if he wanted to be relieved from the superintendence of the work, if the War Department asked to be relieved from it, it would be a different affair; but they ask no such thing. It is a movement outside of them, and the movement comes in connection with this gentleman, who has been so desirous from the beginning to control this work, and who has a quarrel with the War Department from the beginning to end, and been turned out once or twice; I mean

Mr. Walter, the architect. This seems to be a good chance for him to get control of the work again. I am opposed to that.[68]

In response, Senator Foot widened the debate to include a discussion on the whole subject of military control of civilian construction projects. It was a subject that had been aired many times before, but this time Jefferson Davis' role in the matter was sharply ridiculed. The high cost of the extension, the change in the floor plans that brought the chambers into the center of each wing, and the painted decorations were all condemned as *"the military plans, the Jefferson Davis plans."*[69] While all the old arguments against military control had been heard before, the evocation of Davis' name was a useful new tool that Foot wielded to advantage.

With only three votes against it, the joint resolution to resume work under the Interior Department passed the Senate easily. It was then taken up by the House on April 14, 1862. Robert McKnight of Pittsburgh thought that anyone who wished to keep the works in the War Department was only interested in keeping the quartermaster general happy. "It would seem that this is to be kept as a nest egg for General Meigs after this war is over," he noted suspiciously. McKnight supported resumption in order to protect the expensive materials that were stored on the Capitol grounds:

> The capitals and columns ready to be put up are every day mutilated by strangers and soldiers who visit the city. They knock off cornices and put them into their pockets to carry away with them as memorials of their trip to Washington. I think that all these capitals ought to be put up. Let us at least pass this resolution and protect this building, which has cost us so much, from the inclemencies of the weather.[70]

The chairman of the Committee on Public Buildings, Charles Russell Train of Massachusetts, acknowledged that opponents of the resolution saw it "as a blow at General Meigs," with whom he had no quarrel. Yet he could not understand why the superintendent had not taken measures to protect the extension or to allow the contractors to continue with the dome. (They were proceeding on their own, but without compensation.) To delay the completion of the Capitol until the close of the war, as General Meigs wanted, would mean that the works would be "rotted down, and that

new ones [would] have to be constructed at an expense of thousands of dollars."[71] Train was asked about projects other than the Capitol and dome under Meigs' control, and he replied:

> He has control of the water works and the extension of the Post Office building. Now the water works will tumble in before this war is over, and then we will have to begin again unless the work is transferred from the hands of General Meigs to those of somebody who can attend to it. He has a laudable ambition to distinguish himself by the completion of all these works. It would be a nice little entertainment for the decline of his life. But in the mean time are we to suffer loss because he will not allow Mr. Walter, who has far more judgment and capacity than General Meigs, to complete the dome?[72]

After Train declared his committee unanimously in favor of the resolution, it passed the House of Representatives with only six members voting against it.[73] President Lincoln approved the legislation on April 16, 1862, and the secretary of the interior immediately put Walter back in charge. For Meigs the transfer of authority was surely a disappointment, but it also allowed him to devote his full energy to the critical role of quartermaster general. For Walter it was a welcome vote of confidence after a nine-year association that had degenerated from goodwill to discord.

BACK IN THE OFFICE

Caleb Smith of Indiana, the secretary of the interior, was given a tour of the Capitol by Walter soon after the works were placed under his department. They went all over the building, from top to bottom, and the secretary seemed surprised and pleased with his new responsibility.[74] After the tour, Walter began work on a report to the department describing the condition of the Capitol extension and giving an estimate of the cost of finishing it, exclusive of ornamental and decorative designs.[75] A constant stream of visitors (most of whom wanted work) interrupted his writing. Walter found visits from sculptor Horatio Stone, who came armed with a portfolio of "absurd designs," particularly annoying.[76] Knowing that the report would be scrutinized by everyone in town, he wanted to make it

as good as possible; indeed, he told his wife that it would be the most important document he ever wrote.[77] But this burden notwithstanding, he was immensely thankful to be back at work. Edward Clark was back in the office as a superintendent, Thomas C. Magruder took Zephaniah Denham's place as chief clerk, and Benjamin B. French was made disbursing officer while retaining the job of commissioner of public buildings. "I feel very thankful," Walter wrote his wife, "for the providential turn our things have taken."

Walter finished his report on May 8, 1862, and immediately sent it to the printer. He stated that the only work remaining to be done on the interior of the extension was to lay the marble tiling in the principal vestibule of the north wing. Trimmings for some openings could not be installed until the bronze doors were received. Eleven columns had been raised on the outside (all on connecting corridors), leaving eighty-nine to be erected. Twenty-one of these were on hand. Outstanding liabilities for works of art included Leutze's painting and the cost of casting three

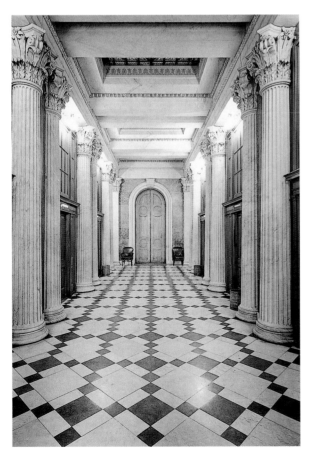

Plan and Sections of Vestibule of North Wing
by Thomas U. Walter, 1859

*T*he passage leading from the east portico to the Senate chamber was one of the most elaborate interiors in the Capitol extension. Marble columns with corn leaves, tobacco leaves, and magnolia flowers blended into the Corinthian capitals were especially elegant and appropriate features. Wall niches were intended to hold busts of worthy citizens. The pattern of the black and white marble floor was simplified when it was installed during the Civil War

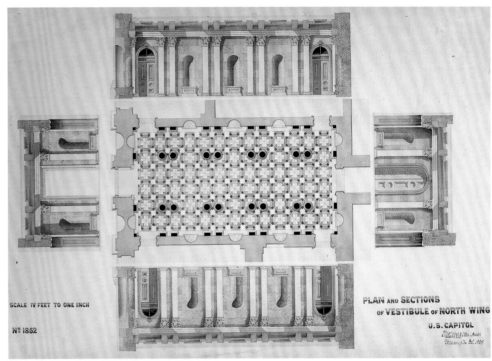

Senate Vestibule

*D*espite modern elevators occupying the side aisles, Walter's colonnaded vestibule remains a grand space. Directly ahead are the original maple doors at the entrance to the Senate chamber. A similar but smaller vestibule was provided in the House wing. (1977 photograph.)

Ceiling of Senate Vestibule

*M*arble columns and beams support the ceiling with its decorative glass panels. Deeply carved egg-and-dart moldings outline the ceiling panels. (1977 photograph.)

bronze doors. He reported that there was a balance of more than $345,000 in the treasury in favor of the extension and estimated that another $600,000 would be needed to finish the wings. More than $138,000 was available for the dome, and that was enough for a year's work.

Once work resumed, it concentrated on the porticoes. Five columns were necessary to complete the connecting corridor colonnades, and

Senate Portico Construction
1862

*S*ecretary of the Interior Caleb Smith was among the dignitaries who gathered on November 28, 1862, to observe the second column shaft being put into place.

these were the first things attended to. As a favor to Senator Foot, the main portico of the Senate wing came next. Walter hoped to have it completed before Congress returned in December, but as the building season wore on it became clear that such hopes were unrealistic. Blocks of marble cut on compound curves to form the groin vaults over the carriageway were beautifully executed and installed without incident, but trouble with other parts of the marble work threatened delay. In October, several column shafts, bases, and capitals sat on the ground waiting for pedestals. The pedestals were not huge pieces of marble—just four and a half feet square and three feet tall—but the quarry found it difficult to supply them. Walter wrote Rice saying that it was a sin to leave the columns lying in the mud merely for the want of pedestals.[78]

The slow progress on this one portico led the secretary of the interior to wonder about the wisdom of building all six porticoes called for in Walter's design. He suggested that the two side and two west porticoes be abandoned, an idea Walter called "horrible." The secretary was also thinking about ordering shafts made up of pieces of Lee marble to supplement Connolly's monoliths. Connolly's column shafts were not only slow in arriving but some were blemished by deposits of pyrites that weakened the stone and marred its looks. Such stones had always been condemned in the past, but now Walter was more forgiving. He made a careful examination of each block to determine the probable danger of the deposits staining the marble or decomposing. If the danger seemed slight, he was inclined to approve the suspect stone in order to avoid delay.[79] Despite this liberal policy Walter was able to install only two of the twenty-two columns on the Senate portico by the end of November, just before the opening of Congress.

Understandably, war conditions made it difficult to proceed peacefully on the works. In late August the second battle of Bull Run sent Union troops scurrying in retreat to Washington as the Confederate Army made advances toward the capital only 35 miles away. On August 29, 1862, Walter told Provost that rumors were flying that Chain Bridge had been blown up and that "rebels are all around us."[80] Three days later the wounded were being brought to the Capitol, where more than 1,000 beds were set up in the rotunda, in

the old hall of the House, and in the corridors. On September 2, the assistant adjutant general ordered all employees at the Capitol to organize into an armed company for the defense of Washington. Following the battle of Antietam on September 17, 1862,—the bloodiest day of the entire war—more sick and dying men were transported to Washington. This latest wave of war wounded made working in the building intolerable. The "filth and stench and live stock in the Capitol" compelled Walter to remove his office to one of the shops.[81] He soon had a cheap frame office building constructed in the east garden, where he and his staff worked in relative peace and quiet.

With wagons thundering by, the wounded going in, and bodies coming out, there was scarcely a place in the Capitol or on the grounds that could be considered peaceful. French was particularly annoyed by the livestock that roamed Washington, damaging public property. To the superintendent of the metropolitan police he asked that steps be taken against

> the hog, goat, and geese nuisance now suffered to triumph over all law . . . hogs can not be kept out of the Capitol enclosure and have done much damage to the newly painted iron lying in front of the Capitol ready for the new dome—so much that it is necessary to renew

the painting where it has been rubbed off or discolored by the hogs, at more expense than all the hogs are worth.[82]

French had good reason to worry about animals rubbing off or "discoloring" the painted ironwork. Shortly before the commissioner lodged his complaint, Walter estimated that it would take ten men 600 days to paint the remaining ironwork using 50,000 pounds of white lead, oil, and drying. Before being hoisted each piece of iron was painted inside and out—including the edges—with pure white lead ground in oil. Once in place, the joints were puttied and the iron was painted again. Walter intended to have the entire structure painted inside and out with two more coats after the dome was finished.[83] James Galway was awarded the contract to paint the ironwork. His bid of fifteen cents per pound of paint (which

View of Washington City, D. C.
by Edward Sache, 1862

*T*his romanticized view of the federal city showed both the Capitol and the Washington Monument finished. At the time this picture was drawn, the upper parts of the dome were not yet completed; they were in fact never intended to be any color other than white.

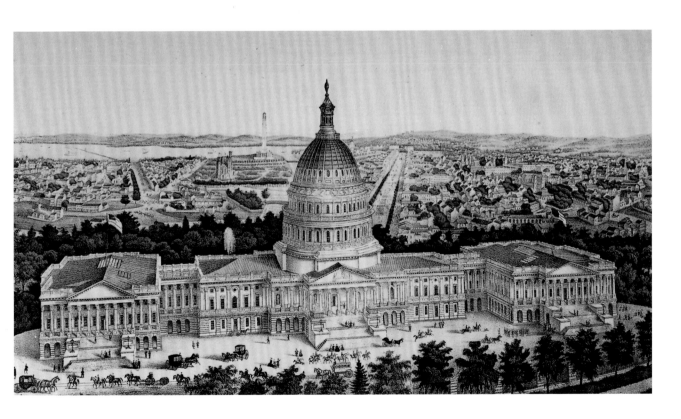

included brushes, pots, and supervision as well as $1.75 per day wage for painters) was accepted over several other offers.[84]

French was anxious to ready the Capitol for the opening of the third session of the 37th Congress on December 1, 1862. The building had suffered considerably while occupied by the army as its bakery, barrack, and hospital, and it would take time and money to repair the damage. For this purpose he had been able to secure an appropriation of $8,000 at the end of the previous session, but the army would not vacate the building until ordered out by the president. French went to see Lincoln about removing the bakery and asked to be shielded from congressional censure if the army was still using the Capitol when Congress reconvened.[85] By the middle of October the soldiers were gone but the rooms once used as bakeries were in ruins. All the mantels were missing and no one could say what happened to them. Chandeliers had also been torn out and scattered in fragments over the rooms and corridors. For whatever good it would do, French scolded the secretary of war about the army's "strip & waste" policy.[86] French had the rooms restored, hoping that the "Capitol may hereafter be left to its legitimate uses, and not be defaced and disfigured by military occupation."[87]

When Congress returned, it faced, among more important military matters, two funding requests from the Department of the Interior for work on the Capitol. Half a million dollars was requested for the extension and $200,000 for the dome. The requests were greeted with little opposition, although Rowland E. Trowbridge, a representative from Michigan, spoke against giving money while the war was still going on. He thought that Meigs had the right idea when he shut things down, and he could see no reason to spend money on anything but "the crushing out of this wicked rebellion, and the preservation and restoration of their government."[88] Others thought work should continue but wished to scale back funding. Congress decided that $150,000 was all that the nation could afford for the extension. Walter noted that with money left over from previous appropriations the sum available for 1863 would be about all that could be used considering the scarcity of workmen. The money for the dome was given without complaint or discussion. Both appropriations passed on March 3, 1863.

Walter's plan for the 1863 building season sought to accomplish two high-profile objects: finishing the eastern porticoes and mounting the statue of Freedom on top of the dome. He wanted to finish the platforms, carriage ways, and steps; hoist and set thirty columns; and complete the entablatures and pediments before Congress returned. He also wanted to position the statue as part of the Fourth of July ceremonies and finish the outside of the dome by the first of December. His expectations, however, proved unrealistic.

On May 28, 1862, the secretary of the interior and his wife accompanied the commissioner and the architect on a ride to Clark Mills' foundry to inspect the statue of Freedom. According to French, the figure was magnificent and the workmanship was "exceedingly well done."[89] Secretary Smith accepted the work and provisions were made to remove it to the eastern garden in front of the Capitol, where it would stand until the dome was ready to receive it. Mills instructed Capitol workmen about the assembly details so that no mistake would be made when their turn came to disassemble the statue's five sections and reassemble them on top of the dome.

While a work of art in bronze would crown the outer dome, a painted work of art would crown the inner dome. The painting (covering 4,664 square feet) was conceived when Walter revised the dome design in 1859. It would appear to hover over the eye of the inner dome and would be illuminated by sunlight reflected off huge mirrors. The painting would be lighted differently in morning and afternoon, in winter and summer. Light and shadow would be in constant movement depending on the weather and the season. By night, hundreds of gas jets would illuminate the work evenly. A great painting seen unexpectedly through the eye of the inner dome was a breathtaking way to finish off the interior of the new dome. Only Brumidi could do the job.

On August 18, 1862, Walter wrote Brumidi asking him to furnish a design for the painting and to name his fee. After making some preliminary studies, the artist replied with a description of a final design: an apotheosis (elevation to divine status) of George Washington ringed by six groups representing War, Science, Marine, Commerce, Manufacturing, and Agriculture. The composition was an imaginative combination of historical and

allegorical figures, of classical mythology and contemporary technology, of great men and noble ideas. It had to be painted, as Brumidi said, in "the most decided character possible" so that it would appear intelligible from 180 feet away.[90] Because the fresco was to be painted on a concave surface, the perspective of the composition also had to be carefully worked out.

Brumidi asked for $50,000 to prepare the full-sized cartoons and to execute his design. The architect agreed that there was "no picture in the world that will at all compare with this in magnitude, and in difficulty of execution," but thought that wartime conditions would not justify such expenditure. Walter asked that the price be lowered and that the artist consider "some sacrifice to accomplish so great an achievement."[91] In other words, Walter suggested that whatever might be lost financially would be recouped in greater celebrity. Brumidi immediately reduced his price to $40,000, hoping it would meet with the architect's views of economy.[92] Walter recommended that the government accept the offer and pointed out: "The design is probably the grandest, and the most imposing that has ever been executed in the world. . . . The grandeur of this picture, the great distance at which it will be seen, and the peculiarity of its light will render it intensely imposing."[93]

Walter gave Brumidi word of official approval on March 11, 1863, soon after Congress passed the dome appropriation for the year. In a few weeks, the artist began working on the cartoons using a full-scale model of the canopy built by the Capitol's carpenters. By the first week in May, however, a new secretary of the interior, John P. Usher of Indiana, questioned the legality of contracting with Brumidi when there was a prohibition against artistic decorations. Walter was obliged to send the new secretary copies of all correspondence relating to Brumidi and his painting for the dome's canopy. He argued that the painting was an inseparable part of the dome's design and not merely a decoration. Nevertheless, the secretary suspended Brumidi's contract for the *Apotheosis of Washington* until July. Growing weary of government ways, Walter told his wife:

> The secy. has made an attack on us about Brumidi's contract, and I have sent to the Dept. all the correspondence. I suppose he will try to upset it. Well let him do it; —if he does I shall resign. I am heartily tired of this small business; I dare not blow my nose without "*an order from the Department.*" The said secy. has never been on the works in his life, and yet he assumes to manage even the smallest details of it. This is another source of excitement and annoyance, but I must fight it through.[94]

In another instance of meddling for no apparent reason, Usher removed chief clerk Thomas Magruder from the Capitol extension office and replaced him with Clement West, one of Walter's former apprentices. The change was unannounced and Walter felt sorry for his former clerk, but he was happy to have West again in the office. The secretary then removed B. B. French as the disbursing agent and gave that responsibility to West. French's position as the commissioner of public buildings, however, remained unchanged. The secretary also dismissed Edward Clark, but later reversed himself at Walter's request.

By the end of April 1863, Walter was compelled to face the fact that the statue of Freedom was not going to be put up on the Fourth of July. He told Fowler: "our 4th of July frolic is *no go*."[95] Fowler's man in Washington, John Cuddy, told Walter that it would be impossible to begin the tholus until all the heavy ornaments were installed on the cupola. Installing three ornaments a day, it would take about forty days to complete that part of the work. Even if the weather remained fine, the tholus could not be begun until the first of August at the earliest.

As July 4th approached, Walter decided to take a few weeks off to visit his new home in Germantown and proceed to Atlantic City for a cool respite by the sea. It was just as well he did not have to supervise placement of the statue of Freedom, as the heat of a Washington summer and the headaches of his office made the prospect of a few days of mental and physical rest most welcome.[96] While in Germantown, he was pleased to learn from the secretary of the interior that Brumidi's contract had been reconfirmed, but the best news came from Vicksburg and Gettysburg. When he heard of the decisive Union victories in those places, Walter took them as signs of the war's imminent conclusion. "The war news," he wrote, "is truly encouraging—The rebellion is on its last legs, and I doubt not that before Congress meets again, the Union will be virtually restored."[97]

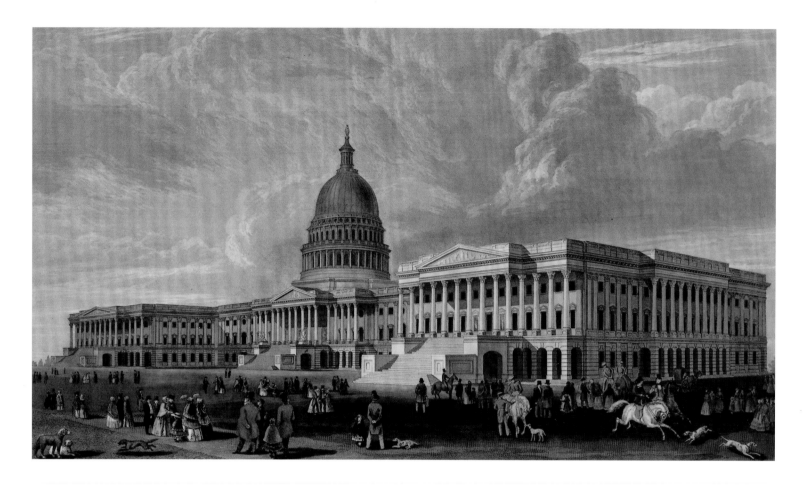

N. E. View of the United States Capitol, Washington, D. C.
by Henry Sartain, 1863

Published during the darkest days of the Civil War, this view of the Capitol anticipated completion of the great building and the restoration of peace. The artist showed well-dressed citizens strolling amid a few tranquil soldiers.

Back at his desk after a vacation that had turned out hot, rainy, and not particularly restful, Walter noted that the last ornament for the exterior of the dome was put into place on August 22 and the first piece of the tholus was bolted on two days later. He expected that the structural skeleton of the tholus would take about three weeks to install, but a shortage of manpower—a common complaint in wartime—threatened delay. And even when workmen could be found, it was difficult to keep them working so high above the ground. Strong riggers were as susceptible as anyone else to acrophobia or vertigo, and many simply refused to go up so high. Some found courage in strong drink, including a rigger borrowed from the Navy

Yard who regularly got drunk on the job; the Capitol's own head machinist, Charles F. Thomas, drank his share with the Navy Yard man. Walter wondered why accidents were not more common and hoped to find sober riggers in Baltimore.

PUTTING ON THE "TRIMMINGS"

While Walter worried about the drinking habits of his workmen, he learned that the Columbus doors by Randolph Rogers had arrived in New York from the Royal Bavarian Foundry in Munich. The doors would soon be sent to Washington for installation between the old hall of the House of Representatives and the connecting corridor leading to the new House chamber. Although Walter had been opposed to many of Meigs' decorating schemes, he was pleased at the prospects of installing this work in the Capitol. "This door will

attract more attention," he wrote his wife, "than any work of art ever seen in this country."[98] The doors were sent in six sections and Walter thought that only James T. Ames could be trusted to put the whole assembly back together. Ames was duly engaged and part of the rotunda was fenced off for a workshop, where he and an assistant assembled the doors, finishing the installation on December 1, 1863. Walter told his Philadelphia lawyer that the doors alone were worth a trip to Washington. The barrister was also invited to inspect Crawford's statuary in the Senate pediment, which had just been put into place, as well as the reclining figures of Justice and History positioned over the principal door to the north wing. The "trimmings," as Walter called the statuary, were being put up rapidly.[99]

By the end of November work on the tholus had progressed to the point when it was time to prepare *Freedom* for its ascent to the top of the dome. Workmen disassembled the five sections and "pickled" them in acid washes to produce a bronze patina. "We are going on finely with the pickling of Mrs. Freedom," Walter wrote Rice, "she looks as bright as a new copper cent."[100]

On a rainy Tuesday, November 24, 1863, the first section of the statue was set into place. The second section followed the next day. Three days later, the third section was placed during increasingly stormy weather. Attempts to hoist the fourth section were made on Monday, November 30, but failed due to a strong northwest wind and freezing temperatures. The next day workmen were successful in placing the fourth section of *Freedom* on top of the dome.

Walter set noon on December 2, 1863, as the time and day when the fifth and final section of the statue would be bolted into place. A celebration seemed in order. The commissioner of public buildings suggested a day of speeches and drinking, but Walter wanted something more solemn and dignified. In consultation with the War Department, he determined to have a battery of artillery at the Capitol fire a salute of thirty-five rounds (one for each state) as soon as the head was put into place. A response from the forts around Washington would follow.[101] The War Department was prepared "to burn as much saltpeter on the occasion as we may desire."[102] At the appointed hour,

Columbus Doors

by Randolph Rogers

*C*ommissioned in 1855, the bronze doors were installed in the House connecting corridor in 1863. (They were relocated to the east portico in 1871.) Nine panels depict events in the Columbus' life, sixteen statuettes portray historical personages, and four figures represent the continents. (1991 photograph.)

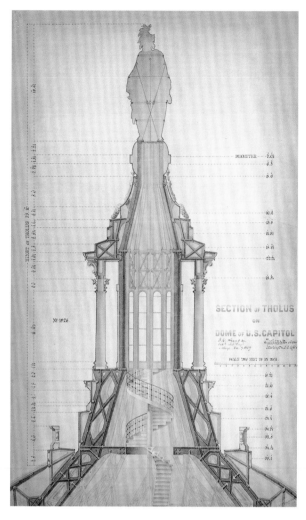

Elevation (left) and Section (right) of the Tholus

by Thomas U. Walter
1859

*R*evisions made in 1859 enlarged the diameter of the tholus to accommodate the statue of Freedom.

the head and shoulders of Crawford's allegorical statue of Freedom began its journey to the top of the Capitol dome. At quarter past noon it was set into place by Charles F. Thomas, who unfurled an American flag over its head as soon as the deed was done. He and his men were given orders not to wave their hats or attempt to make a speech. (Walter had earlier discovered a printed version of a long speech Thomas planned to give and put a stop to it.) He wanted "the head put on as a matter of every day work."[103]

The symbolic nature of *Freedom*'s placement on top of the dome, coming as it did amidst civil war, was not lost on those who witnessed the ceremony. Writing for the *New York Tribune* one correspondent (who did not realize that the statue faces east, toward Maryland) wrote:

> During more than two years of our struggle, while the national cause seemed weak, she has patiently waited and watched below: now that

victory crowns our advances and the conspirators are being hedged in and vanquished everywhere, and the bonds are being freed, she comes forward, the cynosure of thousands of eyes, her face turned rebukingly toward Virginia and her hand outstretched as if in guaranty of National Unity and Personal Freedom.[104]

Walter was more interested in the effect of the statue as seen from the ground. He was generally satisfied, warmly praising Crawford's taste and talent, but condemned the headdress with uncharacteristic severity:

> Mr. Crawford has made a success of it, except so far as it relates to the buzzard on the head. I would like to cut this excrescence off, but have no authority. The proportions, and the entire bearing of the figure are faultless. I did not like it so well on the ground but Mr. Crawford knew what he was about.[105]

The headdress worn by *Freedom* has always been its most controversial feature. Walter was

almost granted permission to remove it on February 28, 1863, when Robert McKnight of Pennsylvania introduced a resolution in the House to dispense with the "nondescript ornament." The resolution, however, was ruled out of order.[106] The architect's dislike of the headdress was long lived; describing it five and a half years after the statue's installation, he wrote:

> It is an eagle so disposed as to constitute a cap, without being a cap—a helmet without being a helmet. The beak looks towards the front, and the plumage ruffles over the top in such a way as to render it impossible to form any idea of its design from the distance at which it is viewed.[107]

Reactions to the artistic merit of the statue now positioned on top of the dome were varied, but everyone agreed that the celebration itself was a success. Walter was relieved that the event had gone off so well. The day before had been cold and windy and the possibility of an accident had preyed on his mind: the eyes of the nation were on him, and any blunder would ruin him in an instant. So it was with considerable relief and satisfaction that Walter described the event to his wife as one both stirring and uneventful:

> I have succeeded in putting on the head of the statue without accident. Her ladyship looks placid and beautiful—much better than I expected. There was an immense crowd to witness the operation, and everything was done with propriety and dignity. I have had thousands of congratulations on this great event, and a general regret was expressed that you were prevented from witnessing this triumph.[108]

While cannons continued to make the ground tremble, Walter went back to his office to finish out the day at work. Nearby, Benjamin B. French was sulking in his own office, suffering a wound to his pride inflicted by those officials who neglected to invite him to the ceremony. "Being Commissioner of Public Buildings, and, by law, charged with the care of all the Public Buildings," French wrote bitterly in his journal that evening,

> I thought that those having the control of putting up the statue, under John P. Usher, the present Secretary of the Interior, would have done me the trifling honor of notifying me, *officially,* when it was to be done, and have requested my presence on the occasion, but it was not done, and I remained in my office. Freedom now stands on the Dome of the Capi-

tol of the United States—may she stand there forever not only in form, but in *spirit.*[109]

Five days after the statue was put into position, the first session of the 38th Congress began. Although construction debris was seen everywhere, the dome and the extension were beginning to look complete. The north wing still lacked its side and western porticoes, but the magnificent eastern portico with its massive flight of marble steps, stately Corinthian columns, rich entablature, and pediment displaying Crawford's *Progress of Civilization* was complete at long last. Its counterpart on the south wing was under way with most of the steps in place, but none of the columns had been hoisted. Overall, the extension was looking quite finished and handsome while the dome added mightily to the Capitol's impression of grandeur.

Capitol, Looking Southwest
1863

*S*oon after *Freedom* was mounted on top of the dome, the scaffold was removed to reveal the sculpture's silhouette. At the same time the east portico of the Senate wing was nearing completion.

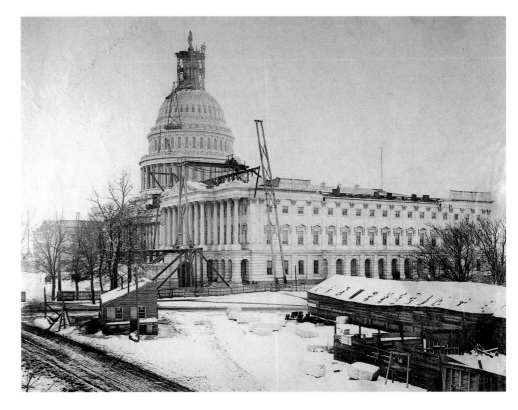

Walter described the condition of the works in his annual report dated November 1, 1863, which the secretary of the interior submitted to Congress a month later. Much of the report dealt with problems at the Lee quarry and the difficulties in transporting stone to Washington. Everything inside the two wings was finished but there was some damage to plaster and paint caused by faulty gutters. To stop the leaks Walter proposed to line the iron gutters with wood logs and cover them with copper. Problems with the corrugated copper roof were also worrisome, but temporary fixes had to be substituted for permanent solutions because of the war. An account was given of all the marble, granite, brick, and cement consumed in building the extension since 1851. Walter also recounted the history of the statuary bought for the Capitol, noting what had been delivered and what was still expected. He did not like where the Columbus doors had been installed and preferred to relocate them to the Capitol's "front door" —the door leading from the central portico into the rotunda. But that had the disadvantage of exposing the doors to outside weather conditions, which might damage some of their fine details. Then, quite matter-of-factly, Walter stated that the Columbus doors should eventually be removed to an inner vestibule in a new east front extension:

> The eastern portico of the old building will certainly be taken down at no very distant day, and the front be extended eastward, at least to the front line of the wings, so as to complete the architectural group, and at the same time, afford additional accommodations to the legislative department of the government.[110]

Thus, before the extension and dome were even complete Walter was calling for another addition to the Capitol—this one to cover the central portion of the east front. Embarrassed by cracked sandstone clotted with thick layers of paint, Walter wanted to bury the old walls under a sparkling marble addition that would stand a fair comparison with the elegance and sophistication of the new wings. By bringing Bulfinch's portico out from its position under the dome's skirt, he could also remove the visual impression that the dome was not stable. Adding committee rooms and offices, while always welcome, was to him a secondary consideration. Walter repeated the east front extension recommendation in his 1864 annual report, just as his successors would do in their own reports over the next ninety years.

"TERRIBLE PROCRASTINATION"

The more the extension and dome appeared finished, the more Congress seemed anxious to be through with the construction business. The din of working men and machines had greeted Congress for more than a dozen years, and there were some who were mightily tired of the commotion. "Congress expects a finish all around before they leave," Walter informed John Rice emphatically, "and a finish *must* be made."[111] Senator Foot kept up his regular inspection tours, making sure all that could be done to finish up was being done. Progress on the east portico of the south wing was particularly slow due to troubles at the quarry. The dome also showed little progress, because of the scarcity of workmen in New York and Washington. Walter pleaded with the ironworkers to find more men to put on the job, both to demonstrate a go-ahead zeal and to spare him from annoying criticisms. At the end of January 1864 he asked Charles Fowler:

> What has become of you? . . . We are getting along with the work outside very slowly, partly on account of bad weather, partly on account of the going out of the boiler of the engine, and partly on account of your force being too limited for so grand a work. I had hoped to have Brumidi at work on the canopy before this, but we have as yet no show for it whatever. If it is in your power to push on this work, I would take it as a particular favor if you would do it.[112]

A few weeks later, Walter again pleaded with Fowler to speed the exterior work. Inside, the old wooden ceiling and tripod that Meigs had built in the rotunda at the beginning of the project were finally removed. A new platform built on wood trusses spanned the rotunda, held by the dome's ribs; it was to be used by Brumidi whenever he was allowed to begin painting the *Apotheosis of Washington*. The artist was ready to start and grew impatient for the canopy to be installed. The delay left him without an income and he wanted a cash advance. Walter tried to placate him, while at the same time finding it difficult to escape rebukes

from disgruntled legislators every time it happened to rain. Because the tholus was unfinished, rainwater flooded the rotunda, bringing "down upon our heads the condensed ire of both houses of Congress."[113] To push the work, at least 100 more men were needed. "The idea of driving on this enormous work with 5 or 6 men," Walter wrote in desperation, "seems more like . . . sending a corporal guard to defeat Lee and capture Richmond."[114]

Pleading did little good, however, and Walter was helpless to control the pace of progress towards what he had come to regard as the light at the end of a very long tunnel. His irritation grew on two levels. Professionally, the dome was the only work that offered a challenge, and its completion would free him to retire. Personally, he was anxious to quit the capital city, which he routinely called "wretched," and return to Germantown to live among family and friends. But month after month, his simple goals were frustrated by the "terrible procrastination" of the iron workers whose employment he had done so much to secure.

The first session of the 38th Congress finished work on July 4, 1864. Two days before the gavel fell, President Lincoln approved a $300,000 appropriation for the extension, which reserved $1,500 to fund a special Committee on Ventilation. Once again, some members were unhappy with their windowless chambers and wanted improvements made to the air they were obliged to breathe. Some considered the air unhealthful while others thought it just smelled bad. James Brooks, a representative from New York City, compared it unfavorably to the air found in some of the nation's worst urban slums:

> Why, sir, our tenement houses in New York, some of them fifty, sixty, or one hundred feet under ground, some of them ten or twelve stories high, are better supplied with air; their tenants enjoy better ventilation than we who live within these gorgeous rooms, in this magnificent Capitol, amid this gold, surrounded by these pictures, reposing upon these luxurious seats. Sir, I would rather sit upon a broken bench under some leafy tree in the open air in some wild woods than to submit to the miserable confinement within this Hall.[115]

While the complaints were nothing new, there was a new agitator roaming the halls of Congress, an architect claiming to have originated the plans of the two wings and therefore to be the only one who knew how to ventilate them properly. Charles Frederick Anderson had returned to Washington to press his claim against the government for unpaid architectural services. In his own mind, the fact that the extension housed centrally located chambers—a feature of his failed entry in the Senate competition of 1850—was reason to believe that he deserved credit and compensation for the extension as built. While they agreed on very little, both Meigs and Walter thought Anderson was mentally deranged. Anderson had shown his designs to Meigs (it is unclear when that meeting took place) but there is no evidence that they influenced the engineer when he ordered changes to the floor plans. Anderson's claim as the architect of the extension was dismissed by Meigs as "rascality or craziness."[116] Among Walter's kinder epithets were "atrocious scamp" and an "intolerable pest."[117] Yet there were some gullible men in Congress who, taken in by Anderson's bluster and self promotion, wanted to use the $1,500 ventilation money to commission him to solve the problem of stale and smelly air. They also supported Anderson's claim that $7,500 was due him for designs that were executed by others. When Walter condemned Anderson's claim as utterly preposterous, Anderson sued him for libel and demanded $50,000 in damages. (The suit went to court after Walter's retirement, dragged on through months of legal proceedings, and ended abruptly upon Anderson's death in July 1867.)

NATIONAL STATUARY HALL

*O*n July 2, 1864, Congress passed a bill written by Justin Morrill of Vermont aimed at preserving the old hall of the House, a room that, except for some plaster models on display and peddlers selling goods, had stood empty for more than six years. The bill reserved $15,000 from the extension appropriation to convert the old House chamber into a "National Statuary Hall."[118] It was an early instance of what modern preservationists call "adaptive reuse."

The fate of the old hall had been under discussion for some time. Before the extension was

begun, there were plans to eventually convert the room into a library or an art gallery. The latter idea was usually deemed impractical due to the lack of wall space. In an early study for the Capitol extension Walter eliminated the old hall altogether, designing two floors of committee rooms in its place. Now, however, the new hall was in use and the fate of the old one was no longer just an academic issue. In some people, the room invoked a sentimental feeling, a reverence for the past that was fairly unusual for Americans of the period. The grand colonnade that had given Latrobe such heartache was universally admired, as were the beautifully painted ceiling and elegant sculpture. Yet it was not the architecture that motivated Morrill; rather, it was the memory of the people who once sat in the chamber that made it a sacred place. One of Morrill's colleagues, Robert Schenck of Ohio, spoke of the old hall with affection and eloquently contrasted its glorious past with its degraded present:

> I never pass through the old hall of the House of Representatives without feeling myself reproached by the spirits that haunt that place. I look around to see where the venerable John Quincy Adams trembled in his seat and voted and I see a huckster woman selling ginger bread. I look to see where Calhoun sat—for there was a time when we might speak with reverence even of him—I look to see where he sat and where Clay sat and I find a woman selling oranges and root beer. I look around the floor where these men stood and uttered their patriotic sentiments in the day when patriotic sentiments were heard with reverence everywhere and by every man and I see a floor rotting and trembling under my tread.[119]

As it stood, the room was "draped in cobwebs and carpeted with dust, tobacco, and apple pomace."[120] A newspaper in Morrill's home state described the old hall as a "barn-like store room for invalid furniture, where a brisk business is carried on in pies and lemonade for the crowds who throng the Capitol. These peddlers should be driven from the temple of state, whose walls once echoed the accents of Clay and Benton . . . Webster or Douglas."[121]

Morrill planned to preserve the historic chamber's dignity by giving the hall a new function. It would be set aside for the display of commemorative statues of worthy persons whom the states might wish to honor in the nation's Capitol. There would be no restriction on whom the states might select except that the person depicted would have to be deceased. The statues could be either bronze or marble. Morrill was quite certain that the room would soon house a splendid collection of statuary brought to the Capitol at no cost to the federal government and hoped that the legislation would stimulate the art of sculpture in America.[122]

To prepare the old hall for its new use, the terraced wooden floor would be removed and a level marble floor built in its place. There seemed to be plenty of scrap Italian and Massachusetts white marble in Rice, Baird & Heebner's stone yard, so only black accent tiles would have to be purchased. In addition, the legislation directed that a pair of high railings be built through the center of the room to create a clear passage from the rotunda to the south wing while offering protection to the statuary.

Converting the old House chamber into National Statuary Hall was undertaken by the commissioner of public buildings, B. B. French. He, in turn, relied on Walter to design and supervise construction. The architect originally estimated that the new floor would cost $24,000, but the Senate reduced the figure to $15,000 to economize and Walter feared the lower amount would be insufficient. Aggravating the situation were troubles with the workmen. Just before he ordered a surplus block of white Italian marble sawed into floor tiles, Provost & Winter's men went on strike for higher wages. The stone workers demanded an increase of a dollar a day over their current wage of three dollars, but Walter thought they really just wanted an excuse to quit and leave town before the next army draft. Not only was the new floor for Statuary Hall delayed, but work on the east portico of the House wing was adversely affected as well. Rather than risk a forfeiture of their contract, Provost & Winter yielded to the workmen's demands. To a friend, Walter explained the effects of inflation, paper money, and the war on the workmen:

> I have great difficulty in carrying on the Public works on account of the want of hands and the increases of wages—the contractors made their bargains with the Govt. in *gold times,* but they are compelled to take their pay in *legal tenders,* which makes the present exorbitant prices very hard on them, and causes "strikes" and interruptions that greatly retard the work.[123]

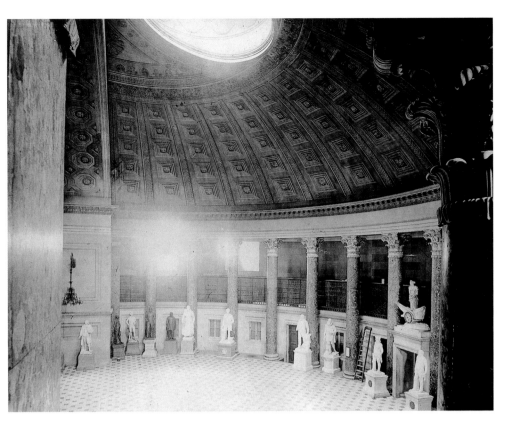

Statuary Hall
ca. 1890

*S*tatues donated by the states were not the only things occupying Statuary Hall in the late nineteenth century. An overflow of books from the Library of Congress was shelved on the former visitor's gallery. The smooth wooden ceiling was painted to imitate a three-dimensional dome with coffers.

On October 4, 1864, Walter hired Henry Parry of New York to dress and lay the white octagonal tiles for the floor for seventy-five cents apiece. The 2,268 black tiles ordered from James Baird began arriving from Philadelphia on October 19. Walter's design for a seven-foot-high bronzed iron railing was manufactured by Janes, Fowler, Kirtland & Company.

During the summer and fall of 1864 the Union Army scored a series of victories that lifted northern spirits considerably. In August, Admiral David G. Farragut captured Mobile Bay. Atlanta fell to General William T. Sherman on the first of September. The breadbasket of the Confederacy, the Shenandoah Valley of Virginia, was in Union hands by October. Petersburg was under siege and Richmond was next. The Lincoln administration had earlier looked upon the approaching 1864 election with dread but now enjoyed a commanding lead. With each victory, opposition from Radical Republicans melted away, and Lincoln won reelection by a comfortable 55 percent in November. Andrew Johnson of Tennessee, the only southern senator to remain loyal to the Union, was elected vice president.

On December 5, 1864, the second session of the 38th Congress began. The special Committee on Ventilation set up earlier that summer was still at work. It conducted experiments with the assistance of Joseph Henry of the Smithsonian Institution and Dr. Charles M. Witherill, a chemist and physicist. Robert Briggs, who had played a leading role in the original design of the heating and ventilation system, was asked to assist. At first, Walter wanted Briggs to install water jets in the ventilation shafts to increase the air's humidity but worried about the odors they would create. He then hit upon the idea of putting "evaporating reservoirs" in the ducts to purify the air by steam, an experiment that he hoped would appease the grumbling members of Congress until more "philosophical conclusions" could be scientifically drawn.[124]

In his yearly accounting to Congress, Walter told of the arrival of the plaster model for one of Crawford's sets of doors. The doors depicted events in the life of George Washington, along with Revolutionary War scenes. Sent from Italy by Crawford's widow, the doors arrived in New York in four boxes. The cargo was forwarded to Chicopee, where James T. Ames had been hired to

Capitol with the Proposed East Front Extension

by Thomas U. Walter
1865

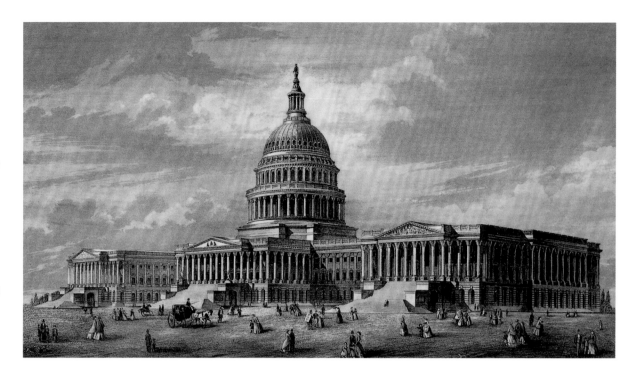

Walter's initial proposal for an east front extension would have brought the central portico out the same distance as the wings. A marble veneer would have replaced the old sandstone in order that the entire elevation might be faced with the same material. The wisdom of Walter's proposal was debated intermittently for nine decades.

After he left office in 1865, Walter's drawing of the east front extension remained at the Capitol. This image is an 1866 engraving of a photograph taken of the (now lost) original rendering.

Plan of the Capitol with Additions to the East and West Fronts

by Thomas U. Walter, 1865

The proposed east front extension included a room for the Court of Claims and a lobby in front of the rotunda door. Suggested improvements to the west front included several new rooms for the Library of Congress as well as three new porticoes.

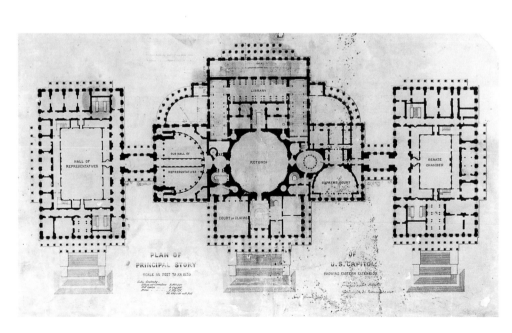

cast the plaster models in bronze. He also reported that the doors were unsurpassed works of art and bore "the marks of Mr. Crawford's superior genius." [125] He was glad that Ames was given the commission to cast the doors because it would result in a thoroughly American masterpiece.

AT WIT'S END

During the early days of 1865 Walter worked on a perspective drawing showing the design for his proposed east front extension, though most politicians felt it would be years before the country would be prepared to fund such an improvement. Although that project stood little chance of approval, the time was right to fund an extension to the Library of Congress. An appropriation of $160,000 was given on March 2, 1865, to triple the space for the library. When Walter designed the iron library in 1852, its eventual expansion into adjacent committee rooms was planned as well. Once these rooms were vacated, they could be dismantled and rebuilt into tall, airy spaces surrounded by iron galleries similar to those in the central library. While the general outline of the library extension had been worked out years earlier, following passage of the

appropriation Walter prepared the working drawings at the request of the Joint Committee on the Library. On March 14, he submitted the plans to the secretary of the interior for approval. Soon Usher asked Walter to contact Janes & Kirtland (Charles Fowler had recently left the company) to see if the firm would build the library extension at the same prices it had received in 1852. Not surprisingly, it answered in the negative.

Following the secretary's next set of instructions, Walter prepared specifications and had photographic copies made of the architectural drawings. These were sent to seven foundries capable of doing the work. One set of bidding documents went to Janes & Kirtland and another set went to Charles Fowler. Walter worried about Fowler's access to the machinery, tools, and furnaces necessary for the work, but Fowler had made arrangements with his former partners and Walter trusted him to do a good job if his bid were accepted. Hayward & Bartlett of Baltimore and the Architectural Ironworks of New York were also among the better-known firms asked to submit bids. The bidding was not advertised because of the risk of having to accept somebody who would "botch" the job.[126] Invited bids were to be opened at noon on April 26, 1865.

While Walter waited for the library bids to arrive, the city was overjoyed at the fall of the Confederate capital and the ending of the bloodiest war in American history. News of the capture of Richmond reached Washington on April 3, 1865, and the administration ordered the public buildings illuminated the following evening. B. B. French had just enough time to prepare an unusual display at the Capitol:

> I had the 23rd verse of the 118th Psalm printed on cloth, in enormous letters, as a transparency, and stretched on a frame the entire length of the top of the western portico, over the Library of Congress-viz., "This is the Lord's doing; it is marvelous in our eyes." It was lighted with gas and made a very brilliant display, and was a marked feature, as it could be read far up the Avenue.[127]

At the conclusion of the final military engagement of the war, Robert E. Lee surrendered to Ulysses S. Grant at Appomattox on April 9. Jefferson Davis escaped capture and was on his way to Georgia, where federal troops caught up with him on May 10. Slavery was in its final days, but there remained plenty of questions about the future of former slaves. Looming ahead was a long period of national healing. As is always the case, the human price of war was terrible. Over half a million Union soldiers were dead or wounded. The number of Confederate casualties was unknown. Just as the north celebrated the war's end, however, the world was shocked by the murder of the president. On Good Friday, April 14, 1865, Lincoln was shot while watching a comedy at Ford's Theater in Washington. He died in a rooming house across the street the next morning. Horrified and dismayed, Walter was convinced that the calamity was without parallel in world history.[128] This Sunday school teacher found it particularly appalling that the murder occurred in a theater, which he likened to a bawdy house.

Lincoln's assassination sank the city into a blur of confusion and grief. His body lay in state in the White House's east room, where the funeral was held on April 19. It was then taken to the rotunda of the Capitol. Thousands of people silently passed the coffin as it rested on a catafalque draped in

Capitol, Looking Northeast
1865

*T*aken while the nation mourned the death of President Lincoln, this photograph shows flags at half staff and black bunting on the columns.

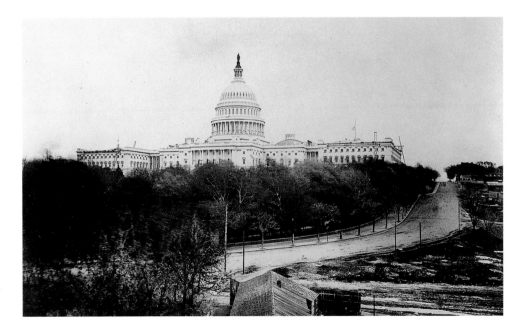

black cloth hastily sewn by the wife of the commissioner of public buildings. The tripod scaffold having recently been removed, the only sign of construction was the platform over the eye on the inner dome, where Brumidi normally worked on his painting.

Walter attended neither the funeral at the Executive Mansion nor the lying in state in the rotunda. Cynical and depressed, he was strangely peeved that the tragic events interrupted work at the Capitol. Uncertainties about the makeup of Andrew Johnson's cabinet also worried him. Before the assassination, John P. Usher had announced his intention to retire as secretary of the interior effective May 15, and Lincoln had nominated James Harlan of Iowa to take his place. Considering that Harlan and the new president were political enemies, it was unclear whether the appointment would stand.

In the meantime, Walter received four bids for the library extension. (Three of the seven foundries contacted had declined to participate.) The bids were forwarded to Usher for direction. Fowler's bid of $169,900 was the lowest and, after consultation with Senator Jacob Collamer of Vermont, the chairman of the Joint Committee on the Library, it was accepted. The bid was slightly more than the appropriation, but Collamer thought the difference too trifling to delay the project. Walter informed Fowler of the decision on May 1, 1865.

Fowler sent a crew of workmen to Washington on May 8 to begin demolition of the old floors, walls, arches, and vaults. The work filled the Capitol with thousands of bricks, piles of rubbish, and choking clouds of plaster dust. Having been detained in Germantown by an injury to his young son's leg, Walter was unable to be at the Capitol for the first few days of the work. He returned on May 15 and first went to inspect Brumidi's progress; he found that the center group showing Washington flanked by Fame and Liberty was finished, and the artist was about to begin the group representing Science. Leaving the dome, Walter went to pay his respects to Secretary Harlan on his first day in office, later describing him as "sweet as sugar."[129] Harlan wanted to meet with both Walter and French sometime soon to discuss the Capitol, a prospect that did not please the architect. He had recently heard that the com-missioner was stirring up trouble by questioning Walter's contracting practices.

After only a few days in office, Secretary Harlan dismissed the heads of the Bureau of Indian affairs, the Census Bureau, and the commissioner of patents. He fired any clerk over sixty and replaced them with younger men. Walt Whitman, who was working as a clerk in the department, was fired because Harlan considered *Leaves of Grass* immoral (a sentiment widely held at the time).[130] To prepare for his housecleaning at the Capitol, Harlan asked French to report on the state of affairs there. Without explaining the circumstances, the commissioner told the new secretary that the contract for the library extension was a violation of the law requiring advertised bids. He also complained that the library project rightly belonged in his office and not with the architect of the Capitol extension. Harlan agreed and issued a hasty and ill-conceived order canceling Fowler's contract and bringing the library project to a sudden standstill. He also transferred all public works in Washington to French's office. The unexpected action removed Walter from his position as head of the Capitol extension and the new dome, as well as the library extension project. Harlan issued the order on May 25 and Walter resigned the next day, effective June 1, 1865.

Walter had discussed resigning for some time but never said exactly when he expected to make the move. Usually he mentioned the completion of the dome as the most appropriate time to leave. He advised his daughters not to expect to spend another Christmas in Washington and told his friends and associates to expect his resignation at any time. Yet, when he finally acted upon the long-standing threat, there was a sense that he had acted on impulse, hoping that the mere mention of resignation would force the secretary to reverse his obnoxious order. Walter's letter of resignation called attention to the fact that while serving as architect of the Capitol extension he designed many other structures for the government, including the new dome, the Post Office extension, and the Patent Office extension, for which he had not been paid. (In 1899, twelve years after his death, Walter's daughters received $14,000 for their father's extra services.) He advised the administration that the works at the Capitol were so far

advanced that the services of an architect were not required. Edward Clark, who intended to succeed Walter, asked that this section of the resignation letter be expunged but was ignored—for some time, Walter had thought Clark a bit too eager to fill his shoes.

What few possessions Walter had with him in his rented room were packed up and sent to Germantown. In the office he gathered personal papers and drafting equipment for the trip home. He believed that architectural drawings belong to the architect and began packing more than 2,000 to take with him. August Schoenborn stood helplessly watching fourteen years of government work being boxed up for shipment to a private residence in Pennsylvania. He tried to persuade Clark to say something in protest, but found that he did not care to cause a fuss. They would manage without drawings.

At the close of business on May 31, 1865, Walter wrote French a letter, transferring all the books, papers, and furniture in his possession as the "late architect of the U. S. Capitol extension & c."[131] The next day he left Washington just before noon and by supper time was reunited with his family in Germantown. Thus concluded one of the most productive and thankless chapters in the life of a great American architect. During his fourteen years in Washington, Walter transformed an idiosyncratic building into an inspiring monument, one ranking high on the world's roster of architectural achievements. Bearing down on him had been five presidents, five secretaries of the interior, five secretaries of war, two supervising army engineers, and countless committee chairmen, senators, and representatives. Some of these associations had been cordial and productive, yet too many were not. His career in Washington was not free of questionable exploits, particularly during the Floyd years, yet for the most part he had conducted himself honorably and well. Through it all the extension steadily breathed new life into the old building, renewing its spirit with every stone laid. Without doubt, the magnificent dome was the singular transforming element. Its commanding presence over the city changed the perception of the nation's capital forever. Impressed at the sight of the great white dome, Europeans no longer sneered and Americans gained a welcome sense of national pride. The image of the Capitol and its new dome was etched in the memories of countless soldiers as they marched through Washington to face an uncertain future. Few people, however, were interested in thanking the man who was mainly responsible for the architectural triumph that now crowned Capitol Hill. For all the works of magnificence that sprang from his mind, for all the headaches he endured, and for the lasting legacy of honor to his country, Walter left the city without so much as a handshake or a word of farewell at the train station.

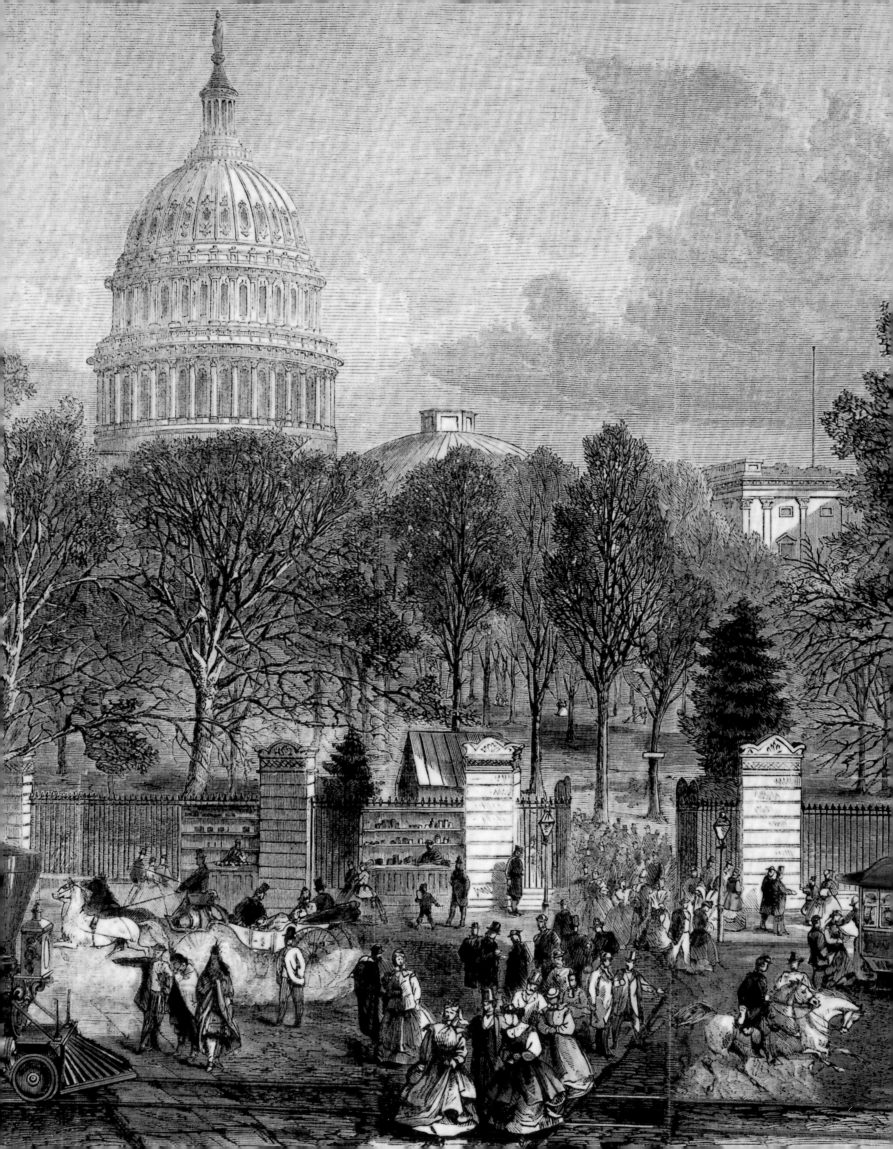

THE CLARK YEARS, 1865–1902

When Walter left Washington, neither the extension nor the dome was complete. A temporary wooden floor closed the eye of the inner dome, blocking views to Brumidi's half-finished *Apotheosis of Washington.* Only one of the porticoes was finished on the outside, but the interiors of the wings were complete. Sheds and shops that littered the grounds were being torn down one by one as they ceased being useful. There was now talk of enlarging and landscaping the grounds, giving them professional attention after their years as a disheveled construction site.

Walter's departure caused some commotion in the office. On June 1, 1865, the commissioner of public buildings appointed his son, B. B. French, Jr., architect of the Capitol extension and wrote Secretary Harlan to inform him of the fact. In a few days the secretary overturned French's act, reminding him that the office was filled by a presidential appointment. French immediately put his son to work as a clerk in the architect's office, bestowing the impressive title of "supervising engineer" upon him.

Within a week of leaving Washington, Walter was notified that the president had accepted his resignation. Throughout the summer of 1865, however, he thought there would be a change of heart in the administration and awaited a recall. His legal troubles with Anderson and curiosity about the library extension brought him back regularly to Washington. At the commissioner's urging, the secretary of interior ordered the library project advertised for bids, attracting a variety of builders and entrepreneurs. Samuel Strong, the superintendent of the Capitol extension forced out of office in 1852, reappeared as a contractor, as did Charles B. Cluskey, a local architect. Charles Fowler and his former partners, Adrian Janes and Charles Kirtland, also resubmitted bids. The lowest offer, however, was received from the Architectural Iron Works of New York City, which was awarded the contract on June 29, 1865. Under French's supervision work resumed on the library project the following day. Walter soon heard that the ironworkers regretted bidding so low ($146,000) and were looking for ways to annul their contract. He shuddered at the prospect of construction shortcuts and inferior workmanship that would reflect poorly on him as the architect. But now he was only a sideline observer, viewing the situation from a distance. Walter wrote to the assistant secretary of the interior about the troubled project:

> I would not have the responsibility of that work upon me in its present relations and conditions for any consideration the Dept. could suggest. If the Secy. had talked 10 minutes with me on the subject before he put the ball in motion, I

Scene at the Pennsylvania Avenue Entrance to the Capitol at Washington on the Daily Adjournment of Congress **(Detail)**

by F. Dielman, *Harper's Weekly,* April 28, 1866

think he would have saved himself some trouble—The accounts I have of the anxieties of the contractors are *heart rendering*.[1]

Out of office more than a month, Walter remained hopeful that the administration would reconsider his resignation, but the chances were fading fast. Soon after his resignation became official, the secretary of the interior tapped Edward Clark to fill the position temporarily until President Johnson named a successor. When Walter learned

Portrait of Edward Clark

by Constantino Brumidi

ca. 1865

*A*s a student in Walter's office, Clark (1822–1902) moved from Philadelphia to Washington in 1851 to continue his apprenticeship. He worked at various jobs, first for his master and later for Captain Meigs as superintendent of the Patent Office extension.

Clark's fifty-one-year service in the architect's office—thirty-seven as its head—were productive yet unspectacular. He was more comfortable attending to administrative details than solving design challenges, which were left to hired consultants. This management style perfectly suited the times and foreshadowed the way the office would be operated in the twentieth century.

of the arrangement he thought that Clark would refuse a permanent appointment if the office remained under the commissioner. "The Secy. will not find any Architect to accept the office," he wrote naively, "while under the degrading conditions which drove me away."[2] Walter's high-minded convictions notwithstanding, Clark was hard at work behind the scenes hoping to transform his temporary job into a permanent appointment. Easygoing, practical, and likable, Clark was adept at keeping peace, making friends, and landing jobs. On the strength of his experience and popularity, the president appointed him architect of the Capitol extension on August 30, 1865.

During the 1865 building season, Clark completed the east portico in front of the House wing; he raised the first column on the north portico at the end of August. For the next year's work, he requested and received an appropriation of $175,000 to continue the porticoes. To expedite matters, Clark abandoned monolithic shafts in favor of using two stones. In April 1866, however, the chairman of the House Committee on Public Buildings wrote the secretary of interior objecting to the shortcut. He wanted to substitute eight new monolithic shafts for the two-piece shafts already in place. The cost would be small and the dignity of the porticoes would be restored.[3] Inside, work progressed slowly on the library extension. By mid-October, demolition was complete and the roofs were under way. (The north room was occupied in the fall of 1866, while its counterpart south of the main reading room was finished at the beginning of 1867.) The new marble floor in Statuary Hall was also completed during the year, and the room stood ready to receive commemorative statues from the states.

While on one of his visits to Washington in November 1865, Walter climbed up on the scaffold where Brumidi worked on *The Apotheosis of Washington*. He was disappointed not to find Brumidi but later wrote him: "I like the picture very much; you have greatly improved it both in figures and tone—I think it will be perfect when seen from below."[4] Although the painting was finished by the time of Walter's unexpected visit, the artist declined to have the scaffold removed until workmen finished installing the gas lights that would illuminate the picture at night: he knew that he might need to make some adjustments after seeing the work

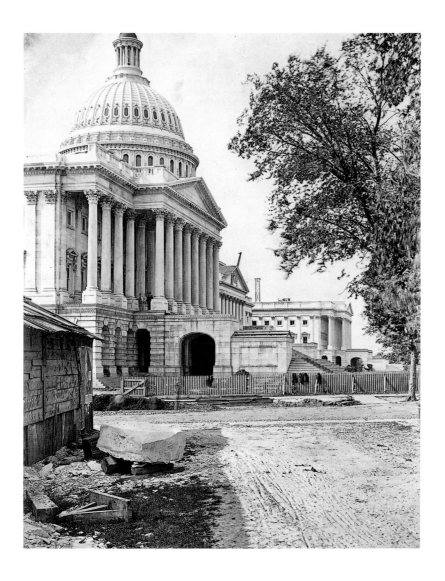

Detail of Portico Stonework

\mathcal{T}he ceilings of the porticoes were marble with egg-and-dart moldings outlining the deep coffers. Also seen in this closeup view are the familiar elements of the Corinthian order—the capital with its distinctive acanthus leaves and volutes, and the modillions and dentils belonging to the cornice. (1974 photograph.)

View of the Capitol from the Southeast

ca. 1865

\mathcal{T}he east portico of the House wing was completed during the summer of 1865.

Portico Construction

1865

\mathcal{T}he first column on the north portico was raised on August 31, 1865. Four additional shafts—two rough and two finished—appear in the foreground.

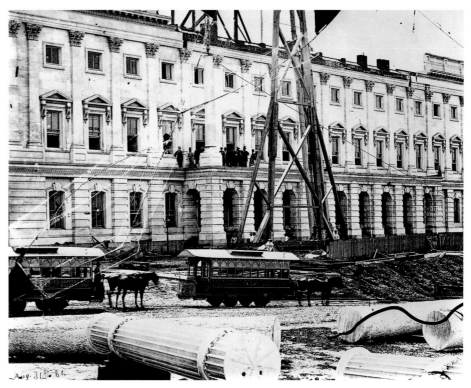

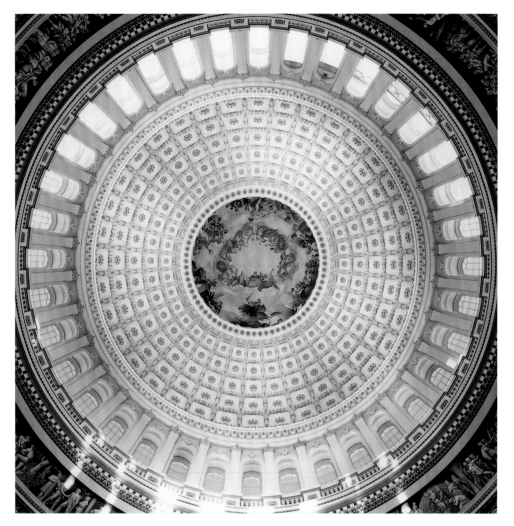

Construction of the dome was completed in January 1866 when the scaffold was removed below the 4,664-square-foot painting, *The Apotheosis of George Washington*. The gigantic figures appear life-size when seen from the floor 180 feet away. (1990 photograph.)

artificially lit. He also wanted time to retouch the *giornate* (the joints between each day's application of plaster and paint) but was obliged to postpone that job. Five hundred dollars was retained from his fee to cover the cost of repairing the *giornate*, but he was never given the chance to do the work. The scaffold was removed in January 1866, using old sails borrowed from the Navy Yard to catch the dirt that would fall to the rotunda floor.[5] After more than a decade of hard work by a legion of laborers, riggers, carpenters, machinists, foremen, pattern makers, foundry workers, painters, glaziers, engineers, draftsmen, artists, and an architect—the great iron dome was finished.

B. B. French, Jr., sent Walter a photograph of the completed painting a few weeks after the scaffold came down. The retired architect was impressed with the photography as well as the painting, which he declared "a decided success." In his opinion the United States government had made quite a bargain with this particular work of art. For creating its counterpart at the Panthéon in Paris, Antoine Jean Gros had been paid 100,000 francs and made a baron, while Brumidi's fresco was one-third larger, ten feet higher, and was a "far better painting."[6]

ENLARGING THE GROUNDS

In his annual report for 1865, the commissioner of public buildings called attention to the necessity of enlarging and enclosing the Capitol grounds. The recommendation was nothing new; French himself had called for improving the grounds while commissioner during the Pierce administration eleven years earlier.

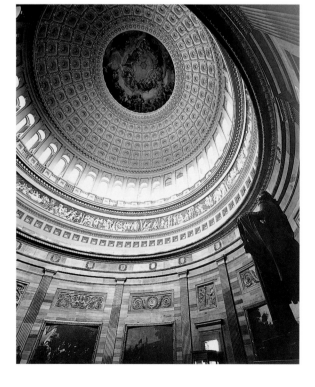

The Rotunda

The iron inner dome stands on sandstone walls erected in the early 1820s. (1958 photograph.)

The two new wings came within a few feet of A Street north and A Street south, and construction activities had long since caused sections of the old iron fence to be removed. French suggested closing a short stretch of north A Street and the equivalent stretch of south A Street in order to give the grounds additional area. Under French's proposal, the land around the Capitol would have assumed the shape of a "T," growing from thirty-one to forty-one acres. The most attractive aspect of the proposal was that it did not require the government to acquire private property. Closing the streets simply united parcels of publicly owned land, with a minimal financial outlay.

On the last day of the Pierce administration, the Senate debated the idea of closing both A Streets and extending the grounds north and south to both B Streets, a proposal that required the acquisition of two privately owned city squares. Some senators wanted to see the grounds extended even further—all the way to C Streets north and south and west to Third Street. An enlargement of that scale, in some minds, better reflected the importance of the building, but it would also require the purchase of fifteen squares of land and entail considerable expenditure. The more modest of the two schemes was favored by James Bayard of Delaware, chairman of the Senate Committee on Public Buildings, while the more ambitious enlargement was supported by Stephen Douglas of Illinois and William P. Fessenden of Maine. Fessenden was convinced that the grounds would eventually extend to C Streets north and south and argued that it would be more economical to proceed right away rather than wait until rising land values prohibited such acquisitions. In his address to the Senate, Fessenden said:

> Now, sir, that we shall be obliged to go to a larger extent on each side of the Capitol, and take in some portion of those grounds is very manifest. In the first place, to a person walking up in this direction, when he arrives at the bottom of the grounds the Capitol can not be seen. It makes no show, or a very small portion of it does so. It does not present the appearance that a building that has cost so much ought to do. Considering for one single moment what the feeling of this country is—that if we are not we are to be the greatest nation on the face of this earth, it would seem very singular to allow the building up of this city to go on, and to be contracted in grounds as we are at present, or must be if what the committee proposes be

adopted, and leave it to the future to clear the buildings surrounding the Capitol at a very much greater cost than would be necessary at the present time.[7]

Against the advice of the Committee on Public Buildings, the Senate agreed on March 3, 1857, to enlarge the grounds to the extensive boundaries advocated by Douglas and Fessenden. Due to cost, however, the measure was defeated in the House.

Year after year, the commissioner or the architect called on Congress to make a decision regarding the Capitol grounds. As different plans were discussed, some land owners in the neighborhood were reluctant to make improvements while others were busily making improvements that would increase the eventual acquisition cost to the government. Uncertainty made it difficult to rent property with long-term leases. In 1860, the district attorney for the District of Columbia was asked to determine the fair cash value of real estate located within the two squares bordering the Capitol grounds along A Streets north and south. On February 13, 1861, Robert Ould reported that it would require about $500,000 to enlarge the grounds by closing the streets and annexing the two privately owned squares. The grounds would then encompass fifty-eight acres.

The Civil War prevented Congress from making the appropriation necessary to carry out any of the enlargement schemes. In his 1865 annual report, Edward Clark recommended the adoption of the enlargement proposed earlier by B. B. French so that the terracing of the west grounds could begin. In 1866, Senator Lyman Trumbull of Illinois resurrected Robert Ould's estimate for enlarging the grounds to fifty-eight acres and advocated that the government acquire the land using the appraised values enumerated in 1861. He also proposed landscape improvements. Trumbull noted that the elevation of the ground at First Street east was eight feet higher than the base of the Capitol's center steps, a condition that gave the building a "very low appearance." Removing the high ground in front would improve not only appearances but drainage as well.

After the war the House and Senate Committees on Public Buildings and Grounds annually reported bills authorizing the enlargement of the grounds, and each year objections in the House of Representatives thwarted the legislation. Support

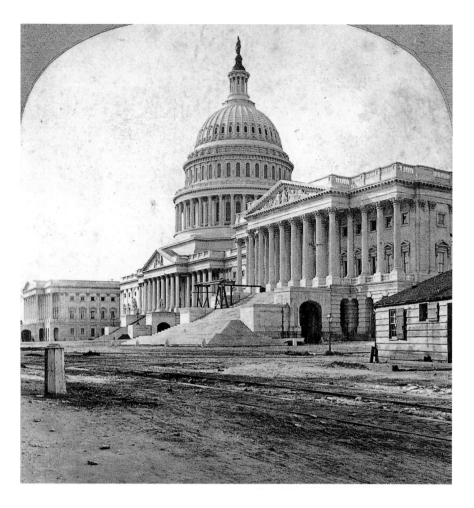

View of the Capitol, Looking Southwest

ca. 1867

\mathscr{A}fter sixteen years, the Capitol extension was completed in 1867. At the time this photograph was taken several small items, such as the stone caps for the cheek blocks of the Senate portico, remained to be installed.

Scene at the Pennsylvania Avenue Entrance to the Capitol at Washington on the Daily Adjournment of Congress

by F. Dielman, *Harper's Weekly*, April 28, 1866

\mathscr{S}ouvenir vendors wait hopefully as sightseers leave the grounds following an afternoon watching Congress in session.

in the Senate was far greater, but hardly unanimous. Some objected to the expenditure as contrary to the principles of economy, and some objected to any improvement in Washington that would keep the seat of government from moving westward. In 1866, for instance, Senator Jacob Howard of Michigan claimed not to see the necessity of expending money to enlarge the grounds when vast tracts of free land awaited in the Mississippi River valley. In 1870, James Harlan, the former secretary of the interior who had returned to the Senate, presented a petition from the Iowa legislature objecting to any and all appropriations for improvements in the District of Columbia, as the removal of government to the center of the nation was "only a question of time."[8] Even if the government stayed in Washington, Harlan insisted, the expense of enlarging the Capitol grounds was "merely a luxury and nothing else. There is no public necessity for making this expenditure at the present time, except to enhance the pleasure of pleasure seekers, those who may desire to recline in the shade of the groves located or to be located on these grounds."[9]

Regardless of their size, the grounds required upkeep. In 1867, $20,000 was given to the architect of the Capitol extension for grading, removing work sheds, and improving the grounds and streets around the Capitol. Under the terms of this otherwise minor piece of legislation the architect was put in charge of improvements that in years past would have been the domain of the commissioner of public buildings. The grounds of the Capitol had been under the supervision of the commissioner or a board of commissioners since George Washington appointed the first board in 1791. On March 4, 1867, Radical Republicans in Congress abolished the office of commissioner as a way of punishing Benjamin Brown French for his steadfast loyalty to President Andrew Johnson. Robert Schenck of Ohio ridiculed French on the floor of the House and had the clerk read a poem the commissioner wrote praising the 17th president, which gave members a hearty "jollification."[10] The humiliating jeer was aimed more at the scorned president, rather than at the author of the innocuous rhyme, but it indicated the political consequence of supporting Johnson.

After the office of commissioner was abolished, its duties were transferred to the chief engineer of the army, General A. A. Humphreys, who, in turn, appointed General Nathaniel Michler engineer in charge of public buildings and grounds. While the change may have been prompted by French's politics, it also addressed the problem that the vast duties of the office had become too much for one man to handle. The army, it was thought, could surely take better care of so much valuable public property in the capital city.

On March 14, 1867, French surrendered books, ledgers, accounts, and other property held by the commissioner of public buildings and accompanied General Michler to see the secretary of the interior. Michler remained in charge of the Capitol for a couple of weeks: on March 30 Congress placed the maintenance of the Capitol building and grounds in the hands of Edward Clark, who was just about to finish work on the extension. Thus, the architect replaced the commissioner as the official with a permanent place in the government with oversight of the Capitol as his principal responsibility. To reflect the expanded jurisdiction of the office, the word "extension" was dropped from Clark's title, who was thereafter called the "architect of the Capitol."

Congress granted the architect of the Capitol a small sum to grade the streets and regulate the grounds around the building. Part of the funds was used to remove work sheds and other obsolete nuisances. In 1868, Clark again urged Congress to decide on a plan for enlarging the grounds. He now recommended extending the grounds to C Streets north and south to ultimately unite them with the Mall and the grounds around the President's House. He envisioned carriage drives connecting these parks through a system of roads, bridges, and underpasses that would carry pleasure vehicles without intersecting with street traffic. "These drives could be so arranged," Clark wrote, "that carriages could run almost from the Capitol to the President's mansion without touching a paved road."[11] A similar circulation system, separating those enjoying the park from the traffic merely passing through, had been successfully incorporated into the design of New York's Central Park and may have inspired Clark's proposal.

Year after year Justin Morrill, now in the Senate and chairman of the Committee on Public Buildings and Grounds, introduced legislation to acquire two squares of land to extend the Capitol grounds to B Street north (modern day Constitution Avenue) and B Street south (modern day Independence Avenue). While not as ambitious or grand as some had hoped, it was the most realistic proposal considering the opposition that had been encountered every year in the House of Representatives. On March 5, 1872, the junior senator from Vermont was hopeful that his efforts on behalf of the Capitol grounds would prove successful:

> I desire to say to the Senate that this is the same proposition that has passed time and again, year after year, for the addition of two squares of ground on the east side of the Capitol. It seems that the Senate has been unanimously in the opinion that it was good economy to take these two squares, for years, and I should not propose the amendment again only that I understand there is a prospect that the other House will now assent to the proposition.[12]

Morrill's amendment easily passed the Senate. A few days later the House of Representatives took up the matter amid a long and rambling debate. Norton P. Chipman, a delegate from the District of Columbia, praised the beauty and grandeur of the Capitol that so aptly reflected the strength and magnificence of the nation. But as soon as the eyes focused on the grounds, he claimed, it became "a standing reproach and disgrace to the whole people of this country."[13] The vastly enlarged and newly domed Capitol seemed to demand a suitable landscape setting to correspond with the building's grandeur. It was not dignified, he argued, to have private property so close to the Capitol, property that housed noisy restaurants and bawdy saloons. Delay posed hardships to his constituents on Capitol Hill, who did not know how or whether to proceed with improvements to their property. Only those who wished to see the capital city relocated to the west, people Chipman characterized as "unpatriotic" and "mischievous," would deny the wisdom of acquiring the two squares to enlarge the grounds. "Let us, then," Chipman concluded:

> no longer while we point with pride to this great building, and exhibit to our friends and visitors its beauties and the glory of its architecture; let us no longer be obliged, as we conduct them from this splendid monument to American

Justin S. Morrill

ca. 1870

Library of Congress

During his forty-three years in Washington representing Vermont in Congress, Morrill (1810–1898) exercised considerable influence over public buildings in the capital city. As a congressman, he introduced legislation to convert the old House chamber into National Statuary Hall. This action saved the historic room by giving it a new function and thwarted those who wished to see it rebuilt into offices. As senator, he spearheaded the successful effort to enlarge the Capitol grounds and was instrumental in securing the landscaping services of Frederick Law Olmsted. He supported the idea of moving the Library of Congress out of the Capitol and into a separate facility. He also wished to provide the Supreme Court with a new building, but that proposition failed to win support during his lifetime. In addition to his effect on Capitol Hill, Morrill was instrumental in securing legislation to finish the Washington Monument.

taste, to apologize for the shabby, mean, and disgraceful condition of its surroundings.[14]

Horace Maynard of Tennessee agreed, saying it was not right to allow the Capitol to be surrounded by such ordinary buildings and unkept grounds. But James Garfield of Ohio, chairman of the House Appropriations Committee (and future president of the United States) disagreed. He thought the grounds were large enough and did not wish to expend public money to purchase any more. Others pointed to the spectacle of war widows and orphans begging for their "little pensions," while Congress turned its back on them to spend money foolishly on land acquisitions. Robert B. Roosevelt of New York City thought the treasury could satisfy the claims of all widows and still have enough money for the Capitol grounds. To the great amusement of the House, he claimed with mock alarm that "widows had entire control of the appropriations of this House" and felt that signs should be posted in committee rooms warning of the danger of approaching widows.[15] Others noted the irony of Congress buying land from individuals when it routinely gave land away to rich corporations. Examples of this practice included the train stations built on the Mall without cost to the railroad companies, which reaped huge profits from congressional largess.

After hours of debate, with exhaustive arguments and bewildering digressions, the House failed to reach an agreement that day on Morrill's plan to enlarge the Capitol grounds. But a month later on April 12, 1872, following another long and grueling afternoon of tedious speeches, the House finally—and narrowly—passed an amended version of the bill. On May 8, 1872, President Ulysses S. Grant signed legislation authorizing the secretary of the interior to purchase private property in the two squares at prices not exceeding the 1861 appraised values. The sum of $400,000 was appropriated, and the secretary was further directed to auction salvaged building materials and apply the receipts to the project. After two decades of discussion, the Capitol grounds were about to receive some professional attention.

FREDERICK LAW OLMSTED

A year after Congress authorized the enlargement of the grounds, Senator Morrill secured an appropriation of $125,000 for grading, paving, and improving the landscape around the Capitol. Soon after the money became available in March 1873, the senator wrote landscape architect Frederick Law Olmsted asking that he develop a new plan for the grounds. "I hope you may feel sufficient interest in this rather national object," Morrill wrote bluntly, "not to have it botched." [16] Olmsted was pleased with the offer, but an eye ailment prevented him from attending to the project immediately. Due to Olmsted's preeminence in his field, Morrill was willing to wait. Clark was relieved at the prospect of Olmsted taking responsibility for landscaping the grounds. "Not having any practice or pretensions to skill as landscape gardener," he reported to Congress, "I earnestly recommend that a first-class artist in this line may be employed to plan, plant, and lay out the grounds." [17] This signaled a fundamental change in the way architectural and other design services were provided to Congress. While taking care of day-to-day matters, the architect of the Capitol would now also supervise the work of consultants hired to perform large design tasks. It also began a century-long practice of hiring consulting architects and other designers without competition of any sort.

In the year after Morrill wrote his letter, Olmsted made several trips to Washington to investigate the problems he was about to face. Morrill wanted his thoughts regarding the possibilities for improving the Capitol grounds, as well as any additional advice regarding the landscape situation in Washington. Olmsted set forth an analysis of existing conditions at the Capitol in a letter written on January 26, 1874. Among his keenest concerns was the way in which trees affected views to the Capitol from various directions:

> Under present conditions there is no position where the eye of the observer can hold it all in a fair perspective, none from which its proportions are not either concealed or seen in effect a little distorted. The best points of view are on the Northwest and the Northeast—but from these it appears crowding over the edge of a hill and having no proper standing room.

Frederick Law Olmsted

Photograph by Barlett F. Henny, ca. 1895

Courtesy of the National Park Service
Frederick Law Olmsted National Historic Site

*A*fter careers in farming and journalism, Olmsted (1822–1903) became interested in landscape architecture while visiting England. There he discovered the urban park and came to appreciate its role in the health and happiness of city dwellers. Back in America, Olmsted formed a partnership with an English-born architect, Calvert Vaux. In 1858 Olmsted and Vaux were commissioned to execute their plan of Central Park in New York City, which launched Olmsted on a lifelong career as a landscape architect. City parks in Brooklyn, Buffalo, Detroit, and Boston were among his notable public commissions, which built upon the success of Central Park. He also designed numerous college campuses, city squares, and suburban developments. His work at the Capitol confirmed his position at the top of the profession. Olmsted's landscape plan for George W. Vanderbilt's "Biltmore" estate in North Carolina was perhaps his most significant private commission. One of Olmsted's most important and lasting legacies was the scenic conservation of Niagara Falls and the Yosemite Valley.

The face of the hill is broken by two formal terraces which are relatively thin and weak, by no means sustaining in forms and proportion the grandeur of the superimposed mass.

These disadvantages of the Capitol are mainly due to the single fact that the base lines of the wings were not adapted to the ground they stand upon but were laid down with relation to those of the original much smaller central structure, and that the trees now growing about it were planted with no thought of the present building but only with regard to the old one. A

considerable number of those on the East have also been introduced subsequently to the original planting and apparently without reference to the purposes then had in view.

It is chiefly by these trees that the design of the architect is on that side obscured. On the west a few of the permanent trees were probably planted with consideration only for the effect they would have while young and small; others, unquestionably, with the expectation that they would be thinned out. Had this been done at the proper time the Capitol would be seen to much better advantage than it is now and the general effect of the trees would be much more umbrageous as well as more harmonious with its architecture.[18]

The creation of a more sophisticated landscape for the Capitol was Olmsted's principal mandate. But he also looked forward to making improvements to all the open ground from the Capitol to Lafayette Square north of the President's House. As Clark had suggested earlier, the public lands of the Botanic Garden, the Mall, and the President's Parade Ground (today called the "Ellipse") could be developed under a uniform plan that would impose a degree of harmony amid the disparate parks. As things stood, individual government buildings were surrounded by their own landscapes, which differed in style and effect. The result, Olmsted claimed, was "broken, confused and unsatisfactory." From a citywide perspective, marble, granite, and brick public buildings were sprinkled among cheaper commercial and residential buildings, producing a bewildering effect. "In short," Olmsted scolded, "the Capital of the Union manifests nothing so much as disunity." (A charge of "disunity" was very serious at that time.) A coordinating landscape and better planning would do much to correct the impression of helter-skelter. His recommendations were farsighted, but they would go unheeded until his son helped revive them early in the next century.

On March 27, 1874, Olmsted stated the terms under which he would begin work. He requested an initial fee of $1,500 for a general design, in addition to traveling expenses. The next day Senator Morrill wrote Olmsted (with the concurrence of James H. Platt, chairman of the House Committee on Public Building and Grounds) to accept the proposal. Morrill soon steered legislation through the Senate authorizing employment of a topographical engineer to survey the grounds and pinpoint every

View of the Capitol, Looking Southeast
1874

*C*losing A Streets north and south and buying two city squares enlarged the grounds immediately around the Capitol to its present size of fifty-eight acres. This view was taken after the streets were closed but before Olmsted's landscape improvements were begun.

tree, walk, drive, curb, bench and lamppost on the site. An appropriation of $3,000 paid the engineering cost as well as Olmsted's initial fee. Taking notice of the movement toward landscape improvements, *Harper's Weekly* reported in its "Home and Foreign Gossip" column of March 7, 1874: "Discussions are going on in Congress in regards to plans for improving and beautifying the grounds surrounding the Capitol in Washington. . . . Great bodies, it is said, move slowly, and when there are several great bodies in charge of a matter, they often do not move at all."[19]

By June 1874 Olmsted had fully digested the special problems presented by the Capitol landscape, and he offered his general solution in a single drawing that would guide the project over the next two decades. From the west the Capitol would be approached by pedestrians using two shaded walks following the lines of Pennsylvania and Maryland Avenues. Gone was the central walk, which was overgrown with trees that blocked a particularly fine view. Secondary curving walks took longer but easier paths up the hill and offered changing prospects of the building and grounds. One of the boldest features of the general plan was the suggestion for a marble terrace to replace the grass berm, which Olmsted thought too puny to uphold visually the stupendous structure above. A new terrace would serve as mighty pedestal for the Capitol and its soaring dome.

As in the past, the principal carriage entrances to the east plaza were from the north and south. A new entrance was created from First Street east. Flanking it were two expansive lawns planted with trees shading the walkways but not blocking views. Much of the open lawn area had once been the site of bars, boarding houses, and other private property. Throughout the plan, Olmsted imposed symmetrical order without geometric formality. Curving walks were used in preference to straight ones, contributing to the sense of informality. Much of what later landscape architects would call the "hardscape" —fences, walks, lamps, and such—shows oriental, classical, and Romanesque influences. The planting conformed to Olmsted's idea of managed scenery. The framing of views was an important aesthetic consideration: on a pragmatic level, Olmsted had also to reconcile the convergence of fifteen streets and avenues. The grounds were to be planted not as an arboretum, but as a park-like setting that

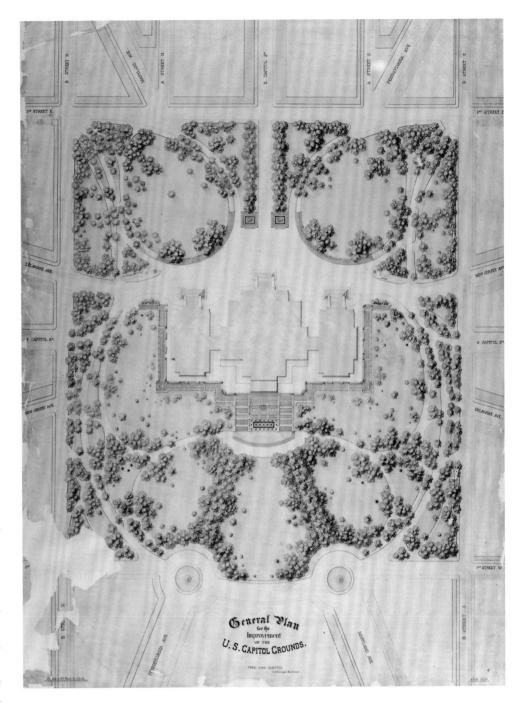

General Plan for the Improvement of the U. S. Capitol Grounds
by Frederick Law Olmsted, 1874

*O*lmsted presented his overall scheme for landscape improvements in a single drawing, shown here with east at the top. The outline of the Capitol indicated a large east front extension and a more modest addition to the west front, where the Library of Congress was located. The size and shape of these unauthorized additions were presumably provided by the architect of the Capitol.

The most ambitious aspect of Olmsted's proposal was a new marble terrace adjacent to the Capitol's north, south, and west sides. A pair of grand staircases were reached from walks following the lines of Pennsylvania and Maryland Avenues.

Designs for a Fountain (top) and an Entrance Pier (bottom)

by Thomas Wisedell and Frederick Law Olmsted, ca. 1875

These designs drew upon classical, Romanesque, and oriental traditions.

would focus attention on the Capitol. Olmsted carefully and properly kept the landscape as an accessory to the architectural features of the Capitol.

On June 23, 1874, Congress approved Olmsted's plan and put him on an annual salary of $2,000 to provide general supervision. Along with the approval came an appropriation of $200,000 to be expended under the direction of the architect of the Capitol. Clark had begun leveling the grounds, filling in, and smoothing the earth before Olmsted's plan was approved, but much remained to be done. In July, Olmsted reported to Senator Morrill that about 400 trees would have to be removed, grading had been contracted at the very reasonable rate of thirty cents per cubic yard, and the search was on for some of the more important ingredients needed for the work ahead, such as "soil, peat, dung, and trees." [20] During the first season, 2,500 cubic yards of earth were moved each day. Olmsted was busily designing features and fixtures, such as the low walls bordering the walks and roads and the various lamps needed for lighting the grounds at night. One of his first designs was for the large planters on the east plaza. Each red granite container was to be filled with laurel or other evergreen shrubs in the winter and with callas or papyrus in the summer. Above was an oval bronze vase with a fountain spraying water to create a "constant rainbow

illumination." [21] At night, the rainbow effect continued under gas lights.

Supervising daily operations was John A. Partridge, whom Olmsted appointed engineer in charge on August 15, 1874. He was described as having "New England training" and being "accustomed to hard work and to nice work, a methodical, deliberate, prudent man, precise and exacting." [22] Two years later he was succeeded by F. H. Cobb, who remained on the work until its conclusion. For architectural assistance, Olmsted hired Thomas Wisedell, a native of England who came to America in 1868. He had been an assistant to Olmsted's former partner, Calvert Vaux, and had worked with Olmsted on previous commissions, including Prospect Park in Brooklyn. After Wisedell's death in 1884, architectural services were provided by C. Howard Walker of Boston.

Labor problems plagued the work from the beginning. In mid-August 1874, the first contractor walked off the job, and Clark was obliged to look elsewhere for workers to continue the backbreaking task of grading the grounds. After advertising, he received fourteen bids ranging from fourteen to thirty-five cents per cubic yard. The four lowest bids were accepted. Soon the grounds were visited by a "mob" of laborers demanding an increase in wages of 50 percent. Olmsted looked upon the agitators and saw "25 second class field hands and as many boys and girls . . . a few smarter looking and roguish men." It was hardly a threatening scene: some of the discontented workers napped while others sang hymns. [23] These so-called rowdies were met by the Capitol police, who arrested the ringleaders and confiscated their weapons. Impressed, the architect testified: "I must say that our Police, which I have always regarded as purely 'ornamental,' proved themselves efficient and 'plucky.'" [24]

Despite labor problems, progress was made in 1874 on grading and leveling the grounds east of the Capitol. More than 150,000 cubic yards of earth was removed and replaced by new enriched soil on the lawns. A layer of topsoil a foot deep was placed on a fertilized subsoil two and a half feet deep. New gas, sewer, and water pipes were also laid, and the foundations for walks and roads were prepared. The frame office Walter had built in 1862 was cut down the middle, and one half was carted off to a lot adjoining the grounds to be used as the

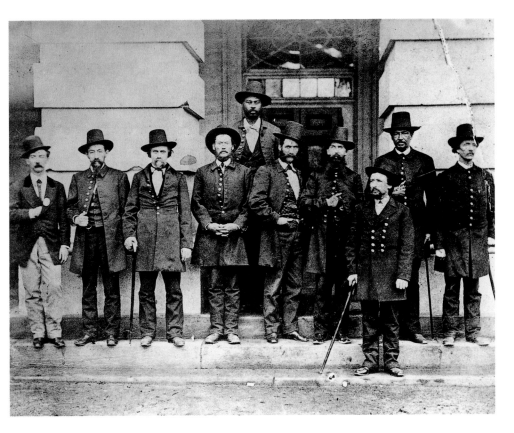

engineer's office. The other half served as Clark's office for a while.

TERRACE AND LIBRARY TANGLE

Improvements to the western grounds were delayed while Congress considered Olmsted's proposal to replace the Bulfinch terrace with a more substantial structure. The improvement would entail a large expense, which had not been previously anticipated, and there were those who could not appreciate the need for such a structure. Complicating the debate was the question of making further enlargements to the Library of Congress, which continually suffered space shortages. The enlargements of the library completed in 1867 were no match for the flood of books, pamphlets, sheet music, engravings, and other materials sent to Washington under the provisions of the Copyright Act of 1870, which required that two copies of any item protected by the law be deposited in the congressional library.

No one doubted the need to provide the library with more room, but there was plenty of disagreement on how that need should be met. Some wanted an addition built on the west front; others proposed removing the library from the Capitol altogether. The first group did not like the idea of a separate library building because of the distance it would place between them and their books. Where to relocate the library facility was another knotty question. Those in the opposing camp could see no end to the library's space needs and warned of the architectural catastrophe of making endless additions to the Capitol. There were merits on both sides of the question, and while the library issue was debated, Olmsted's west terrace would have to wait.

To help sell the idea of a new marble terrace, Olmsted's collaborator, Thomas Wisedell, drew two views of the Capitol's west front. Each rendering showed an addition to the central building fronted by a new portico capped by a broad pediment. Presumably designed in Clark's office, the addition was intended to accommodate a new library extension. The first view showed the old terrace scooped away in the center of the Capitol to make way for the new extension—a condition that intentionally

**The Capitol
with a Proposed
Library Extension**

by Thomas Wisedell
1875

\mathscr{O}lmsted hoped this
rendering would hasten
approval of his terrace
design. It showed the
Library of Congress
enlarged by an extension
that would require
demolition of the center
section of the earthen
terrace. The unsightly
results seemed to support
the need for a marble
terrace that could
accommodate the
library extension.

produced a ridiculous effect. By contrast, the second view showed a sturdy new stone terrace handsomely upholding the library extension. While the library extension was still a question open to debate, Olmsted cleverly used it to help justify his marble terrace.

In January 1875, Clark received a letter from General Montgomery C. Meigs that was critical of Wisedell's renderings. Although he no longer had any direct connection with the Capitol, the opinions of General Meigs still carried a great deal of weight around town. He had no objection to the new terrace, which he called "imposing and beautiful," but he did not like the idea of building an addition to the west center building. In Meigs' opinion, it would harm the appearance of the Capitol when viewed from an angle. The central projection would cut off views to the wings and actually decrease the apparent size of the building. He wrote:

> the proposed projection of the central portion of the building, while it will not afford permanent relief to the library, will darken two stories of rooms now not too well lighted, and it will, while costing a large sum, be an actual injury to the effect of the building from the most valuable and important points of view.[25]

Meigs wrote Olmsted a similar letter. Olmsted replied that he had labored under the impression that the library extension had been practically decided upon and that his terrace had been designed to accommodate it. In his judgment, the size of the west projection shown in the sketches was about as large as it should be. He thought an addition was acceptable, but agreed that it should be held back as far as possible.

Meigs also asked about the possibility that the terrace might block views to the Capitol, a subject dear to Olmsted's heart. Olmsted described in reply a temporary scaffold that he had built to approximate the height and width of the proposed terrace. The scaffold gave him and others (including Thomas U. Walter, whose name was not mentioned) the opportunity to study and judge the effect the terrace would have on views to the Capitol. To help keep the view open, Olmsted devised a two-level terrace with the first stage five feet lower than the part closer to the building. He concluded: "I think that there is no point of view in which an observer can be expected to place himself, (if my plan is adhered to) at which the Capitol will not appear more stately with the terrace than without."[26]

On March 3, 1875, Senator Morrill introduced legislation to appropriate $300,000 to begin the terrace. He acted as if there would be no opposition to the measure: he claimed that every senator who saw the design had approved it. The proposal had the unanimous support of his Committee on Public Buildings, and he had not met a Republican or a Democrat in either house of Congress or any architect who did not agree with making the

improvement. Aside from the grandeur and magnificence of the marble terrace, it would provide fifty-six windowless vaults for storing documents. Morrill maintained that this practical advantage was nevertheless incidental to the main purpose of the terrace, acting as a grand pedestal for the building perched on the brow of a hill.

Any hope of easy passage faded when Senator Allen Thurman of Ohio questioned his colleague from Vermont about vaults under the terrace. He doubted the wisdom of spending so much money "to make some damp vaults to stow away old documents to feed rats . . . of putting these old documents where the moth doth corrupt and where the rats do eat and thrive."[27] Morrill replied by describing conditions at the Treasury building, where the corridors were piled high with documents, and noting that the overflow of copyright books from the Library of Congress needed to be put somewhere. The terrace offered a perfect place to store such items. Thurman still thought it foolish to spend money "to make a cellar to keep old books in." William B. Allison of Ohio revived the subject of the library extension and advised the Senate not to make the terrace appropriation until "we have settled finally the question of improving the Capitol on the west front."[28]

The terrace legislation was tabled soon after Allison took his seat. Morrill waited more than two years to reintroduce it. On June 17, 1878, he submitted an amendment providing $50,000 to begin work, but he met strong opposition from James B. Beck, the junior senator from Kentucky. Beck ran down a list of expensive federal buildings then under construction, including a new building for the Bureau of Printing and Engraving and a massive new structure for the Navy, War, and State Departments. Every appropriation contained funds for new federal buildings across the country. Now came another request for construction funds "to tear up, under the pretense of improvement, the whole of the west front of the Capitol grounds, to adorn them with stairways, I suppose, which will cost before we get through over a million dollars, probably two." The senator then took an unusual swipe at Olmsted, whom he implied was self-aggrandizing, wasteful, and lacking in good taste:

> If we begin this work now we shall have to spend for five or six consecutive years two, three, or four hundred thousand annually to

Bartholdi Fountain
1876

One of the popular attractions at the Centennial Exposition in Philadelphia was an iron fountain designed by Frederick August Bartholdi. The base featured aquatic monsters and fishes while three caryatids upheld the wide, shallow basin. Lighted by gas lamps, the fountain made a lively display of fire and water at night.

On November 22, 1876, Bartholdi's friend Frederick Law Olmsted wrote Edward Clark to say that the fountain was for sale at a reasonable price and to urge him to find a place for it in Washington. He enclosed this drawing in his letter. Following Olmsted's suggestion, the government paid $6,000 for the fountain and set it up on the grounds of the Botanic Garden, where it remained until 1927 when the garden was taken off the Mall. It was re-erected in 1932 on its current site in Bartholdi Park, a display garden southwest of the Capitol maintained by the U. S. Botanic Garden.

Bartholdi's most famous work in America is the Statue of Liberty in New York harbor.

ornament according to the design of somebody who thinks it is going to make him immortal to have his name in the grand plan. We have now a couple of Dutch spittoons standing out on the east front of the Capitol, costing forty or fifty thousand dollars intended, I believe, for fountains. We now find it will require two or three hundred thousand dollars to furnish them with water and fix them up.[29]

Morrill was annoyed at Beck's sarcastic characterization of the landscape architect as well as his shortsighted vision of future improvements. He asked if it was not strange that Congress made liberal appropriations for buildings everywhere else in the United States, but when it came time to fund work at the Capitol some senators "begrudge every

Statue of John Marshall

by William Wetmore Story

*T*he seated figure of Marshall presided over the Capitol's lower west terrace from 1884 until 1981, when it was relocated to the Supreme Court building. Worn steps leading to the old terrace may also be seen in this ca. 1884 photograph.

little picayune amendment here and compel the completion of these grounds to be procrastinated year after year." Senator Daniel W. Voorhees of Indiana doubted that the improvements under way were any better than the old landscape that had been ripped out. He asked a fellow senator:

> if he really believes that this scraggy, ragged line of trees down here are as handsome today as those beautiful chestnuts which lined the walk when he and I first came here together young men in the other branch of Congress. If he answers in the affirmative, I despair of his lines of beauty, of his vision, of his appreciation.[30]

Morrill again spoke in favor of the appropriation, saying it would cost no more than funding a lighthouse on Lake Superior. The Capitol's outside stairs had been neglected for years and it was time to replace them with something better. Again, Beck opposed the measure, this time citing the unresolved issue regarding the library extension. To him it was folly to build the terrace when it might have to be torn down to make way for a new addition. "It seems to be the general plan all around this Capitol," Beck noted suspiciously, "to put up one year and tear away the next."[31] The Committee on Appropriations, he said, felt the terrace could wait until the library issue was resolved. Henry B. Anthony of Rhode Island supported Morrill's amendment on economic grounds: after noting the danger of the worn steps, he slyly reminded his colleagues that it cost $5,000 to bury a member of Congress. Despite that, and other more serious arguments, Morrill's drive to authorize the terrace failed again by a wide margin.

The two prime movers for a separate library building were Ainsworth Spofford, the librarian of Congress, and Timothy Howe of Wisconsin, the Senate's senior member on the Joint Committee on the Library. With their push, Congress authorized a design competition for a new library building and appointed a commission to select a plan. The commission and competition were authorized on March 3, 1873, and more than nine months later the Washington firm of Smithmeyer & Pelz was awarded $1,500 for its first-place design. (Thomas U. Walter, one of the twenty-seven competitors, was awarded $100 for his entry.) On June 23, 1874, the competition was reopened and $2,000 appropriated to acquire additional designs. In August 1874 Senator Howe asked Walter to prepare two designs for the

enlargement of the Capitol. One scheme showed an addition on the west front for the additional accommodation of the library, while an eastern extension addressed the problem of the dome's apparent want of support. The second design omitted the library extension and showed an addition only on the east side of the building. Walter was paid $1,000 for the drawings, a welcome sum as he waited in vain for a recall to Washington to improve his woefully diminished financial situation.

Despite years of discussion on the matter, the competing factions could not reach an agreement on the best way to accommodate the library's needs. In 1876, Howe's committee recommended a separate building at the foot of Capitol Hill where the Botanic Garden was located, but there were those who still could not accept the idea of the library leaving the Capitol. Congress appointed a committee to reconsider the subject in 1878. The majority of its members reported in favor of a new building located on Judiciary Square, several blocks northwest of the Capitol. A minority favored a location opposite the east plaza, but at least one important consensus had been reached: everyone agreed that the library should have its own building. At the same time, Ainsworth Spofford asked Thomas U. Walter to estimate the cost of enlarging the Capitol for the library and was told that about four million dollars would be needed. The librarian subsequently used Walter's estimate to justify funding a separate facility.

George F. Edmunds, the senior senator from Vermont, was among those who opposed the idea of moving the library out of the Capitol. During an extensive discussion on the matter, which took place on February 11, 1879, he presented four ways of enlarging the Capitol for the accommodation of the library. The most daring was a design prepared by Alfred B. Mullett, who had been supervising architect of the treasury from 1866 until 1874. His plan called for an addition to the east front containing a new chamber for the Supreme Court and a broad corridor in front of the rotunda running north and south to connect the House and Senate wings. The former Supreme Court chamber and adjacent rooms would be turned over to the Library of Congress and the rotunda would become the library's main reading room.[32] The suggestion found little support.

President Rutherford B. Hayes wrote in favor of a new building for the Library of Congress in his 1879 annual message. (President Chester Arthur would repeat the recommendation two years later.) In an address to the Senate delivered on March 31, 1879, Justin Morrill lent his support to the idea. *The American Architect and Building News,* the nation's leading architectural journal of the period, happily quoted the senator, who condemned the notion of enlarging the Capitol as "perhaps the greatest blunder now in process of incubation among civilized peoples."[33] With momentum building for a separate facility, another commission was appointed on June 8, 1880, to again examine the long-range needs for the library. Washington architects Edward Clark and John Smithmeyer and Boston architect Alexander Esty were named to the "Joint Select Committee on Additional Accommodations for the Library." Their report, issued on September 29, 1880, strongly and unequivocally recommended a new building to house the congressional library. They calculated that in a very few years the entire Capitol would be needed to shelve the library's holdings. As that was unthinkable, a new building was fully justified.

The report ended talk of extending the Capitol on the west front for the library. It did not, however, put an end to ideas for enlarging the building in other ways. In 1882, an architect from Texas submitted a photograph of a design that would raise the dome and insert two floors of stack space above the rotunda. The idea was seized upon by Senator Henry L. Dawes of Massachusetts and others who still wanted to keep the library in the Capitol. To kill the foolish scheme as quickly as possible, Spofford forwarded it to General Meigs for comment, which the engineer gave in his usual thorough and analytical style. After providing a detailed description and analysis of the materials used in the construction of the center building, such as handmade brick, sandstone, and lime mortar, Meigs concluded that no new weight could be safely supported. He was decidedly against the proposal on aesthetic grounds as well. "To raise the center, even if it were safe," he wrote, "would not improve its architecture. . . . Nowhere is to be found a great a building of such rich and graceful composition as the present Capitol of the United States."[34]

In September 1882, six months after Meigs reported on the dome-raising scheme, Smithmeyer was sent to Europe by the library committee to study national libraries there. In 1885, President Grover Cleveland joined his two predecessors in recommending a new library building in his first message to Congress. Finally, on April 15, 1886, Congress authorized the construction of a building to house its library on First Street east. One half million dollars was appropriated to begin construction, with another $585,000 allocated to acquire the site. (Unfortunately, the location of the library caused a block of Pennsylvania Avenue to be closed, thus obstructing views to the Capitol from the southeast.) In years to come, the Supreme Court and most congressional members and committees followed the library out of the Capitol into new buildings. The new library had become the first step towards the creation of a Capitol campus.

"FEARFUL BOTCHERY"

Although the new library building was not funded until 1886, it was widely viewed as a fait accompli when Smithmeyer was sent to Europe by Senator Howe's committee four years earlier. At that time, with the question all but settled, Justin Morrill next tried to direct the Senate's attention back to the stalled terrace project. In an appropriation approved on August 7, 1882, he was able to secure a small sum ($10,000) to construct the permanent approach to the terrace on its northeast corner. Most senators did not realize that the money was intended to begin the terrace—perhaps because Morrill never used the word "terrace," but spoke only of the "approach." Yet with that money the terrace made a modest and irreversible beginning in the fall of 1882.

During the next year's discussion on the landscape appropriation, some senators realized what Morrill had done to begin the terrace without stirring up debate. Senator Beck wished that the matter had been discussed openly instead of slipped by in a sneaky maneuver. On the strength of a single, half-finished approach the whole terrace would now have to be built, and he hoped for more forthright dealings in the future.[35] One of his allies,

Eugene Hale of Maine, offered an amendment requiring that the cost of future improvements to the Capitol grounds be estimated in detail and illustrated so that everyone would know exactly what was being voted upon. This suggestion was not a censure upon the landscape architect, but rather a simple measure to ensure that the misunderstanding of 1882 would not be repeated in the future. Hale's amendment was agreed to without objections. It was included in the bill appropriating $65,000 for the Capitol grounds, which President Chester Arthur approved on March 3, 1883.

To comply with Senator Hale's amendment, Olmsted divided the terrace and grand stairs into thirteen parts. He proposed building from the north and south approaches and working westward along the sides of the two wings. Once those sections were completed, the front of the terrace facing the Mall could be begun. The central section and two monumental stairs would be the last parts to be built.

On February 6, 1884, Morrill's Committee on Public Buildings and Grounds reported a bill making available all the funds necessary to finish the terrace. The chairman promoted the terrace as the appropriate base on which the Capitol should stand, more imposing and more handsome than the old dirt terraces. Again, he mentioned the storage rooms (now seventy-four in number), but he also stated that there would also be ten rooms suitable for committees. These rooms looked onto the courtyards between the terrace and the Capitol. Morrill's legislation passed the Senate but was curtailed in a conference with the House. On July 7, 1884, $60,000 was appropriated to construct one section of the terrace, a stretch along the north side of the Senate wing. The following year Morrill's powers of persuasion were greater: $200,000 was given for the terrace in 1885.

With construction of the terrace assured, Olmsted quietly resigned his commission in December 1884. He thought it would be best not to divide the supervision among the several parties, as before. Because the terrace was mostly a work of architecture, he felt it should be supervised by Clark's office. When Clark forwarded Olmsted's letter to congressional authorities, he recommended that the landscape architect be retained as an

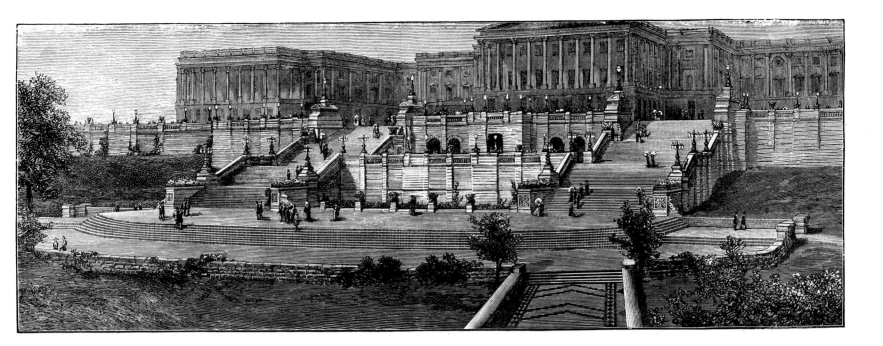

advisor with an annual stipend of $500.[36] The recommendation was accepted.

As the terrace seemed to be gaining in popularity with legislators, and its annual funding became easier to secure, a proposal suddenly appeared that would have altered the design and threatened untold harm to its effectiveness. When the appropriation for 1886 was being discussed, Senator Hale introduced an amendment to suspend work until a plan could be developed to provide more committee rooms in the terrace with windows looking westward toward the Mall. George G. Vest of Missouri immediately objected to the proposal because it would diminish the apparent strength of the terrace. He explained to his colleagues in the Senate that the idea of windows looking west had originated in their Committee on Appropriations and was opposed in the Committee on Public Buildings.

Aware that Olmsted would want to know what was going on with regard to his terrace, Clark wrote him an account of the window question. Apparently the architect of the Capitol did not think the idea was particularly bad, which surprised and alarmed Olmsted. Immediately writing Morrill, Olmsted urged him "to resist with all your might the proposition to open windows in the terrace wall."[37] He rushed to Washington on February 25, 1886, to persuade Congress not to order windows, concerned that "the fearful botchery" would destroy the impression of strength and solidity. In case his word was not enough, Olmsted brought with him a testimonial from Henry Hobson Richardson, a personal friend and America's greatest living architect, confirming the correctness of his position. To the chairman of the Appropriations Committee, Senator William B. Allison of Ohio, Olmsted explained his objections to windows by describing the importance of an unbroken terrace wall:

> There is nothing more necessary . . . in a building than that it should seem to stand firmly; that its base should seem to be immovable. There is a difficulty in making as strong an impression in this respect as it is desirable when an extraordinarily massive structure is placed, as in the case of the Capitol, hanging upon the brow of a hill.
>
> The object of the terrace was to more effectually overcome this difficulty. How was it to be accomplished?
>
> It was proposed to be accomplished by setting a strong wall into the face of the hill in front of the foundations of the building; that is to say, in front of its cellar wall. Such an outer wall, it was calculated, would have the effect upon the eye of a dam holding back whatever on its upper side looked liable to settle toward the down-hill side. Every dollar thus far spent on the terrace, and on the grounds in connection

The Proposed Terrace of the Capitol at Washington

by Hughson Hawley
1884 or 1885

*A*longside a detailed description of the terrace written by Olmsted, this drawing was published in *Harper's Weekly* on December 25, 1885. An addition to the Library of Congress was shown behind a new central portico. The addition was to be supported on Olmsted's marble terrace, illustrated here in its original form without windows between the two grand staircases.

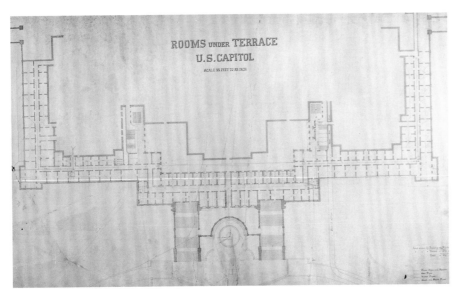

ROOMS UNDER TERRACE
U.S.CAPITOL

Rooms Under Terrace

ca. 1890

*I*n 1886 Olmsted rearranged the floor plan of the central portion of the terrace to provide committee rooms with western views. Six rooms were blessed with windows looking west while twenty rooms had windows looking onto courtyards.

This plan was probably drawn in Clark's drafting room and indicated the location of gas, water, steam, and drainage pipes. It also noted that the terraces covered an area of two and two-thirds acres compared to the three and a half acres covered by the Capitol.

with it, has been spent on the supposition that this calculation was soundly made. If it was soundly made, then it will appear that the opening of holes in this wall would leave the same effect as the opening of holes in a dam. It would make the building behind it look less secure in its foundations, less firmly based on the down-hill side.[38]

Soon after Olmsted learned of the window problem, he made a small revision to the plan hoping to satisfy the desire for committee rooms with westward views. The original design for the wall between the two monumental staircases called for a central feature (possibly a wall fountain), flanked by four arched openings leading into a crypt that was the vestibule for the rooms under the terrace. Massive piers had been designed for the crypt to support the library extension, but now that the library was moving out of the Capitol, they could be eliminated. In fact, the crypt itself could be eliminated and its space used for a central passage and six committee rooms lighted by western windows. This slight alteration increased the total number of committee rooms to twenty-eight and gratified those in the Senate who wanted some to have a Mall view. It was a simple, effective compromise that was adopted on June 24, 1886. Hale fought Olmsted to the end over the window issue, but was finally "completely whipped, horse, foot, and dragoons."[39] After the revision was accepted, Olmsted's collaborator in Boston, Howard Walker, designed the details of the area between the grand staircases. There he planned a series of Corinthian

pilasters and arched windows with a distinctive Romanesque flavor.

With the crisis defused, the terrace project entered a peaceful period unencumbered by criticism or discord. The appropriation for 1887 was $175,000, and it was followed by $330,000 the next year. By the close of the 1888 building season a total of $740,000 had been expended on the terrace, which by then stood almost complete. Over the next five years small appropriations were made to pay for such things as paving, bronze lamps and vases, railings, and finishing the interior. In 1889, part of the funds was given to provide a fountain between the grand stairs at ground level. It was a simple octagonal bowl upheld by squat granite columns designed in the fashionable Romanesque style.

Year by year, landscape improvements were carried out while the terrace was being built. Trees were ordered from France and England through agents in New York. Shrubs and undergrowth were planted for "variety, cheerfulness, and vivacity."[40] Olmsted preferred simple shrubs to large, "showy" flowers, which tended to capture and unduly hold the viewer's attention. Roads were paved with modern surfacing materials such as "Gray's patent macadam," vulcanized asphalt, bituminous concrete, Grahamite and Trinidad asphalt, and "Van Camp's patent pavement."[41] Subsoil drains, sewers, and water pipes were laid and scores of lamps—both ornamental and plain—were installed. Underground pipes fed gas to the fixtures while miles of wire were strung to light the lamps by electric sparks. In 1882, gas leaks were discovered to be killing certain shrubs and Clark promised to investigate lighting all of the grounds by electric lamps. (J. P. Hall of New York City was hired in 1897 to substitute 138 electric arc lamps for gas burners.) Footpaths were paved with a variety of materials, including concrete, Seneca and blue stone flagging, Belgian block, and artificial stone (a mixture of cement and sand). Blue stone was used for ordinary edging and black granite from Maine was used for the low coping walls at more prominent locations.

A brick summerhouse was built in 1879–1880 on the western grounds to provide a cool retreat where visitors might have a drink of water and rest a while. Sometimes called the "grotto" or "resting

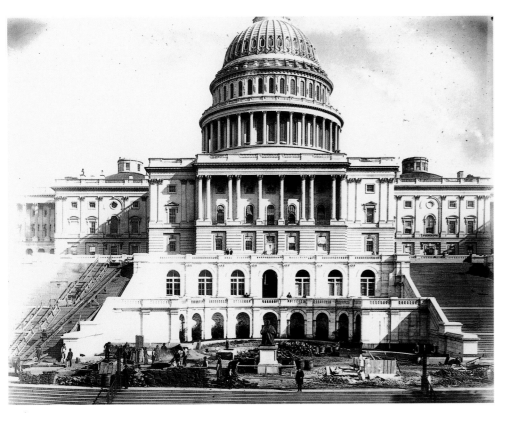

Terrace Construction

ca. 1888

*T*he space between the stairs was redesigned in 1886 to provide windows for a few committee rooms under the terrace. At the same time, an exedra with pilasters and niches was designed for the lower terrace.

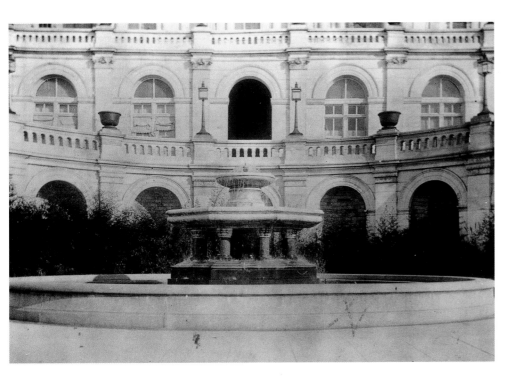

Exedra and Central Fountain

by Frederick Law Olmsted and C. Howard Walker
ca. 1892

*T*he octagonal fountain was designed in the Romanesque style popularized by Olmsted's friend Henry Hobson Richardson.

court," the structure was not part of Olmsted's 1874 plan but was a delicious afterthought that has long been admired for its picturesque character. Clark reported that it was designed to "combine both drinking fountain and a secluded cool retreat, while sufficiently public to prevent its being used for improper purposes."[42] More poetically, Olmsted said he designed the fountain to supply a continuous flow of water in several streams "with a view to musical murmurings and moistening the air."[43] He planted ivy around the summerhouse to merge it with its surroundings. Water diverted from the old

drinking fountain that Robert Mills had built at the base of the terrace in 1834 was piped into a rock-lined alcove off the summerhouse where delicate ivies were grown for display.

When the summerhouse was finished in 1880, it attracted a great deal of attention—some welcome, some not. Olmsted complained about the ineffective police protection the grounds were receiving. More than 3,000 plants had been stolen and more than 100 persons were observed climbing over the summerhouse on a single Sunday afternoon. Once discovered by recreating visitors, the building's red tile roof was damaged by people rocking back and forth or walking on it. Others beat down plants around the structure. Its popularity also attracted the attention of the press. Olmsted prepared a brief account intended to be carried in the local papers:

The Summerhouse

*P*erhaps Olmsted's finest architectural design for the Capitol grounds was the brick summerhouse. The intricate textures and patterns seen on its wall surfaces and around its various openings are a tribute to the bricklayer's craft. (1992 photograph.)

> When planting about the summer house is well grown the masonry is intended to be all mantled with ivy and the South wind drawing through is to bear at times a slight perfume suggestive of romantic foliage rather than the sweetness of flowers. The overflow of the fountain is designed to produce through an apparatus specially planned for the purpose a succession of sounds suggestive of melody but not a tune and not so loud as to be always distinguished above the tinkling and murmur of the water falling into the cavity below. A window looks into a rocky runlet not a grotto but suggestive of the coolness of a grotto and giv-

ing conditions favorable to the growth of plants proper to cool & moist situations.[44]

A water-powered musical apparatus, a set of chimes referred to as the "carillon," was indeed built in 1881 at Olmsted's request by Tiffany and Co. of New York. However, it apparently could not be made to function properly in the summerhouse and was placed in storage.

Whenever a massive undertaking such as landscaping the Capitol grounds was under way, there were always those in Congress who tired of being asked yearly for money to finish up. It was true in Latrobe and Bulfinch's day, it was true in Walter's day, and remained equally true in Olmsted and Clark's time. The dashing senator from New York, Roscoe Conkling, seemed to think the landscaping would go on forever and spoke up to protest. As early as 1878, he asked the chairman of the Committee on Public Buildings if the money about to be appropriated for the grounds would finish the project. He had grown tired of the disruption, dirt, noise, and traffic stirred up by the landscaping and hoped the end of work was in sight. Senator Dawes of Massachusetts, who was chairman at the time, urged patience:

> I will answer the Senator in the language of the Yankee who told me he was going to New York when it was finished; he did not propose to go there to see the city when it was unfinished. I think that it will be a good many years before the grounds will be finished. I think as the capital grows, as the nation grows, as these grounds about here change, as time's tooth wears away what is erected, there will constantly be expenditure in the line of the suggestion of the Senator from New York.[45]

Senator Morrill noted that "pyramidal evergreens" were being planted along parts of the terrace just completed. To his eye these pointed plants were suited more to a Gothic building, where pointed arches, crockets, and spires characterized that architectural style. Because the Capitol was classical, the senator felt that such plants should be avoided on the grounds. He also thought that evergreens covered over too much of the terrace, part of which was faced with beautiful Vermont marble.[46]

Some of the terrace committee rooms were occupied in 1891 and the rest were ready the following year. These were simply finished rooms with oak doors, oak paneled wainscoting, and flat

From the time of its completion, the terrace has been a favorite place to view the city of Washington. Shown here is one of the electric arc lamps that replaced gas lighting on the terrace in 1897.

ceilings made of iron plates. Steam radiators provided heat. The corridors were lighted from above by sidewalk lights; unfortunately, these lights leaked from the beginning. Water also seeped into the committee and storage rooms through plant cases that did not drain properly. Copper lining was installed to contain moisture, but the leaks continued. Indeed, from the time the terraces were completed, annoying and hard-to-find leaks played a continuous role in their history.

UPKEEP & UPDATE

Throughout much of the Clark years, the Capitol was maintained by the architect with an administrative staff of two clerks, one draftsman, and one messenger. Scores of laborers were hired seasonally and there were mechanics on the permanent payroll to take care of the machinery, plumbing, and electrical

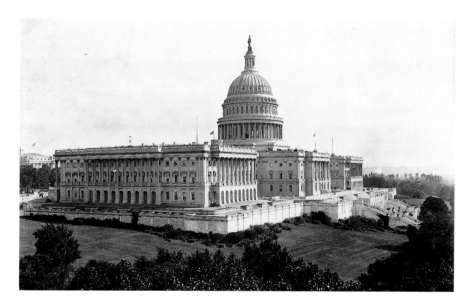

The Capitol

ca. 1905

Upon completion of the marble terrace, the Capitol no longer appeared as if it were about to slip off the edge of Jenkins Hill.

plant. A few blacksmiths, carpenters, and masons also served under the architect. Clark was responsible for the maintenance of a patchwork building served by a variety of mechanical systems that constantly needed repair or updating. Resourcefulness and American knowhow were routinely called upon to keep the Capitol's creature comforts on par with the latest technological developments. Such innovations as elevators and electric lighting were introduced during this period, while improvements kept the existing mechanical and sanitary plants up to date. Particularly welcome were the additional water closets and wash basins installed where conditions permitted. These and other plumbing modifications snaked pipes around, under, and through massive brick walls and vaults without structural consequences. Repairs to the center building routinely involved removing old wood materials and introducing fireproof substitutes. In 1870 steam heating replaced the coal burning stoves that had been used to warm the rotunda; gradually, it replaced all the furnaces in the center building.

Some members of the House became annoyed at the crowds of tourists who gathered around the *Columbus Doors* at the entrance to the corridor leading to their chamber. In 1870, John Farnsworth of Illinois complained about the great nuisance caused by "strangers" blocking the passage, making it difficult to get by. Some tourists admired the bronze doors so much that they could not resist breaking off pieces to take as souvenirs. Farnsworth wanted to remove the doors to the east entrance of the rotunda, where they could serve "outside duty."[47] His suggestion spurred a general discussion about enlarging all the doorways from the House to the Senate, which was accompanied by a few humorous remarks; Omar D. Conger of Michigan, for example, observed that the best way to get from the House to the Senate was through the state legislatures (which elected senators at the time). Fernando Wood of New York City objected more seriously to the change because he was tired of seeing the Capitol in a constant state of flux:

> I think if there is anything that illustrates the instability of the American character and of American institutions it is the style of architecture that had been adopted periodically with reference to this Capitol. Since the original

erection of the Capitol nearly every Congress, and certainly every Administration, has done something to change it. We have no fixed style of architecture; we have no plan; we have nothing stable; nothing is fixed beyond this periodical disposition of the American people to change, change, change. We no sooner establish one thing, however well and carefully matured, than those who succeed us in public life see some improvement to be made, and make a still further change. This is, however, I regret to say, the physical temperament of the American people.[48]

Those who opposed relocating the *Columbus Doors* noted that it would be necessary to cut away some of the stonework around the entrance to enlarge the opening. Fears that the dome's support might be compromised caused the proposal to be deferred while the architect studied the issue. Clark reported back to Farnsworth in a brief note on June 27, 1870, stating that there were no structural reasons to prevent the work from being done. Thus reassured, Congress ordered the doors rehung at the east central portico in 1871.

Clark's reports and letter books describe hundreds of small things done to the Capitol during his tenure to maintain and modernize the building. On the exterior, old sandstone walls and the iron dome were painted every four years, usually just before an inauguration. Annual painting and whitewashing projects undertaken by private contractors kept the interior fresh and clean. Constantino Brumidi, Emerich Carstens, George Strieby, Joseph Rakemann, G. W. Fosberg, and Charles E. Moberly, among other artists, labored at the ornamental painting and decorations that were extended little by little throughout the Capitol, especially in the Senate wing. Water and gas leaks forced repairmen to remove the Minton tile, which they usually relaid carefully but occasionally put down without regard to surrounding colors or patterns. Canvas window awnings were installed in 1878 to help control the sunlight streaming into the Library of Congress. Small upholstery jobs were carried out by boys at the local reform school, who also made the Capitol's brooms. Barrels of sawdust were purchased for cleaning the stone floors in the old center building. Lighting fixtures were routinely taken down to be repaired, gilded, or bronzed. A Turkish bath was set up in the basement of the Senate wing in 1878. In 1884, Clark paid fifty-four dollars for an enameled French bath

partition walls were removed to join two flanking rooms (modern day H–212 and H–214) with the central area, resulting in a single long space that became the members' retiring room. Removing the walls further facilitated an unencumbered flow of air both throughout the spacious suite and indirectly into the nearby House chamber.

Each attempt to purify the air in the House chamber was followed by a brief period of quiet before the old complaints were heard again—usually louder and more bitter than before. The board of advisors routinely investigated the complaints and always concluded that the air was healthy and the ventilation ample. Dr. Billings went to England to examine the ventilation system in the House of Commons and conferred there with officials in charge. The more data they gathered, the more the board believed that the ventilation system in the House was well devised and properly operated. A scientific analysis of the air, made in 1880 by Dr. Charles Smart of the U. S. Army, found the levels of carbonic impurities insignificant. Another investigation was conducted in 1884 by Dr. J. H. Kidder of the U. S. Navy. He collected sixty-five specimens of air and tested them for carbonic acid, ammonia, and other contaminants. He determined that no more impurities were present in the chamber's air than were usually found in any private home lighted by gas. Ten years later the process was repeated by Dr. J. J. Kinyoun of the Marine Hospital Service, whose conclusions were the same.

All evidence to the contrary, some members persisted in their complaint about foul air. In 1895, Joseph H. Walker of Massachusetts initiated an investigation into the architect's office by accusing Clark of standing in the way of change to the ventilating system. On the floor of the House he declared:

> We never can have any decently pure air in this Hall until we reverse the operation by which the air enters the Hall, taking it in at the top instead of at the bottom, and we will never get it done by the present Architect—never in this world . . .
>
> You will not get the Hall ventilated until you have an architect competent in those things, and who will not endeavor in every possible way to defeat every measure of this character brought before him. Until that is done you can not expect proper ventilation of this Hall,

because the present system of not ventilating this Hall is his pet child.[52]

The irate representative thought that no jail or prison in New England was as badly ventilated as the hall of the House. A storm of indignation would await a county commissioner in Massachusetts if his jail had such foul air as that found in the chamber. Defenders of the architect seized upon that claim and compared the air in the hall to that found in a number of school houses, town halls, and factories in the Bay State. The congressional air was scientifically proven to be as pure as that breathed by the school children of Massachusetts.

Unswayed by science, George Washington Shell of South Carolina, chairman of what had become a full Committee on Ventilation and Acoustics, echoed Walker's concerns in a speech delivered in the House on January 24, 1895. He was greatly alarmed by the unhealthful conditions caused by leaking gas pipes and bad ventilation. Every day he heard complaints about the air, but most distressing was the damage to the health of his fellow representatives. "We see Members carried away from here corpses after very short illnesses," Shell lamented, "and we have been led to suppose that this is occasioned largely by the unhealthy condition of the Hall itself."[53] He requested a small sum to finance yet another investigation into the chamber's atmospheric conditions as well as a study of the general sanitary conditions in the Capitol. His committee would also examine the architect's office to see if any change there would promote the health of the nation's legislators.

The results of the investigation were reported on March 2, 1895.[54] One source of stale or foul-smelling air was determined to be store rooms filled with decaying, musty, and filthy books, rubbish, and waste paper. Obviously, the committee concluded, if the air is vile it must be unhealthy. Also, the kitchen operated by the doorkeeper was too small, unclean, and inadequately ventilated. Impure air was pervasive, striking the nostrils well outside the cooking area. Smoking and chewing tobacco in the chamber were further nuisances affecting air quality: ashes and expectoration found their way into the floor registers, which, therefore, required more regular and thorough cleaning. The report also declared that smelly people who came to loaf in the gallery should be barred from entering the

chamber. Gas leaking from the lighting apparatus above the ceiling should also be fixed. Although still viewed with some suspicion, electric lighting was considered a good candidate to replace gas altogether. Having identified the sources of the foul air, Shell's committee concluded that the architect of the Capitol was not responsible for any of the noxious conditions; the causes were, in fact, under the control of the House's own officers.

The Senate also took a turn at improving its ventilation. In 1872, Senator Morrill asked his colleagues to approve a plan to extend the shaft used to bring air into the chamber. Under the existing arrangement, air from the courtyard between the Capitol and the terrace was brought into the ventilation system and was subject to sudden downdrafts that could suck chimney smoke into the air tunnels. Morrill reminded the Senate of one windy day when its chamber had filled with "gas and sulphurous smoke," a condition he called "very disagreeable."[55] Moving the air intake farther from the Capitol would help solve the problem.

Senator Lyman Trumbull thought the only solution to the ventilation problem was to rebuild the chamber on the outside walls so that it might have windows. Having served in the windowless chamber since its inauguration, Trumbull said the move was long overdue and especially urgent now that the grounds were being landscaped and the view improved. Roscoe Conkling joined in the protest against the windowless chamber. There was nothing new about the complaint, but Conkling gave it a fresh sting by rubbing salt into an old war wound:

> If Jefferson Davis had never engaged in rebellion against his country, I think he would be sufficiently guilty for being responsible, as I understand he is, for cooping up the Senate in this iron box covered with glass. As has been said, who ever heard of putting men or animals in a box inside a building, shut out on every hand from the outer air, then going to work by artificial means and contrivances to pump up and blow up atmosphere so that they shall not be like a rat in an exhausted receiver [i.e., in a vessel from which air had been emptied by a vacuum pump], dying from the want of something to breathe?[56]

William Sprague of Rhode Island agreed, but took the position that to spend any more funds on the chamber was to throw good money after bad:

> There is no use of appropriating money for a ventilation which is destructive to the health and energy of members; and it is passing strange to me that Senators will sit six, eight, and ten hours breathing diseased air, coming here fresh at the beginning of the session, and leaving impaired in health, and intellectually, and in almost every other way.[57]

Despite vocal and occasionally eloquent opposition, Morrill's modest proposal to improve the atmosphere in the chamber was adopted. Workmen soon began cutting a tunnel through the old earthen terrace, lining it with whitewashed brick, and connecting it to the air intake opening in the courtyard. Complaints were soon lodged against the location of the new air intake, however: the unmistakable odor of manure being spread on the grounds easily made its way into the Senate chamber, and animals were occasionally found taking up residence in the tunnel. Before the old terrace was removed and the Olmsted terrace begun, the Senate's ventilating tunnel was placed underground. In 1889 it was connected to a rustic stone tower designed by Olmsted. A similar tower had been built for the ventilation system for the House of Representatives ten years earlier. Both towers were recommended by Robert Briggs, the engineer who designed the original system under Captain Meigs in the 1850s. By raising the air intake well above the dust, smells, and creatures lurking at ground level, Briggs promised that the system would be supplied with the purest air available in Washington.[58]

CENTENNIAL

At first glance, the Capitol at the end of the nineteenth century gave the impression of a relatively new establishment. The impression was fostered by the landscape improvements that surrounded the building with young trees and by the new terrace, walks, walls, lamps, and fountains. For those who did not look closely, the Capitol defied its age. To many it appeared as though built at one time from a single design. While that impression was entirely at odds with its history, it was a credit to the talents of its architects and builders. What may have appeared as a relatively new building was actually a century old—its 100th anniversary was observed in an impressive ceremony held on September 18, 1893.

The idea for a centennial celebration originated at a meeting of the East Washington Citizens Association held on September 3, 1891. Officials of the city of Washington formed a general committee in the spring of 1893 to oversee preparations. Once the machinery was in place, Congress was consulted. On August 11, 1893, the House passed a resolution allowing members of Congress to participate in a ceremony marking the upcoming anniversary. The Senate agreed to the resolution in a few days. Passage was secured once it was made clear that the cost of the ceremony was to be borne entirely by private citizens. A joint committee of seven representatives and seven senators joined the citizens' group to prepare the Capitol for the event.

The steering committee appointed a score of subcommittees to take care of such duties as coordinating the musical program, or producing badges and souvenirs to raise money. A "rates committee" was appointed to pressure railroads to lower fares to Washington to stimulate attendance. The decorations committee installed grandstands, draped the Capitol with red, white, and blue bunting, and hung huge flags above the speaker's platform. Between the columns of the central portico, the committee arranged a series of gas lights in the form of an arcade. Flanking the grand stairs were large gilded signs honoring the first and present presidents, on one side "*1793— Washington*" and on the other "*1893—Cleveland.*" The commemoration of the cornerstone's anniversary was destined to be far more spectacular than the original event.

September 18, 1893, was declared a holiday in the city of Washington. The day's program began with a concert by the "centennial chimes" mounted on top of the roof of the Library of Congress, which stood unfinished opposite the Capitol. For an hour, the air was filled with melodies such as *Way Down Upon the Suwannee River, The Sweet By and By,* and Wagner's *Wedding March.* As a tribute to the states, thirteen bells were struck forty-four times at the end of the morning's concert. At one o'clock a second concert played from atop the library while a parade left the vicinity of the White House heading for the Capitol. More than 150,000 spectators lined Pennsylvania Avenue, where they watched as President Cleveland and the cabinet,

justices of the Supreme Court, miscellaneous Masons and Odd Fellows, the Society of the Cincinnati, a variety of other patriotic and fraternal organizations, and numerous military regiments and fire companies traveled approximately the same route taken by President Washington's procession in 1793. The parade reached the Capitol before two o'clock and was greeted by the Committee on Invitations. Soon senators and representatives marched out of the rotunda past the *Columbus Doors* and joined their guests on the portico. Positioned nearby were the Marine Band and a chorus of 1,500 voices. Crowds cheered again and again as the participants assembled.

The bishop of Maryland opened the ceremony with an invocation, followed by a warm introduction of the president. Cleveland spoke for a few minutes, recalling that the Capitol was "designed and planned by great and good men as a place where the principles of a free representative government should be developed in patriotic legislation for the benefit of free people."[59] His address was followed by an oration that lasted two hours. William Wirt Henry of Virginia, a descendant of the fiery patriot Patrick Henry, noted that the day's festivities were the last in a series of centennial celebrations commemorating the most important events of the American Revolution. Henry covered minutely the nation's early struggles and its progress during times of peace and war. He quoted statistics illustrating the progress of the nation, the number of states, population, exports, imports, and treasury receipts. A new and interesting fact showed the nation was blessed with 220,000 miles of telephone lines.

The Marine Band, under director Francesco Fanciulli, played *The Star-Spangled Banner* as Henry took his seat. Vice President Adlai Stevenson spoke on behalf of the Senate, followed by Charles Frederick Crisp, Speaker of the House; Henry Brown, an associate justice of the Supreme Court; and Myron Parker, a commissioner of the District of Columbia. The ceremony concluded with the singing of *America.* According to one account, "The volume of sound from voices of the thousands present was such as had never been heard before on any similar occasion."[60] That evening, another concert was given by the Marine Band and the centennial chorus. An actor recited

The Star-Spangled Banner while the vast multitude cheered wildly. Fanciulli's composition entitled *A Trip to Mars* ended the day's activities on a celestial note.

By any reckoning, the centennial celebration of the Capitol's cornerstone had been a spectacular success. A full account of the event was compiled by the committee's chairman, General Duncan S. Walker, and printed as a government document in 1896. Included in that work was a brief history of the Capitol written by Edward Clark. In two paragraphs he gave the dimensions of the old Capitol and the extension, the dates when the extension and the new terraces were begun and finished, and the total cost of the Capitol—$14,455,000. The remainder of the brief essay was an attempt to provide biographical material on the various architects employed on the building from its beginning.

Had Clark known more about the early history of the Capitol, he could have prevented the bronze plaque donated by the citizen's centennial committee from being mounted in the wrong location. On April 23, 1894, Senator Daniel Voorhees of Indiana introduced a joint resolution directing Clark to affix the plaque above the supposed location of the first cornerstone. The resolution passed the Senate without objection and was approved by the House the next day. Soon Clark had the centennial plaque mounted on the south face of the southeast corner of the old north wing. He reasoned that because the old Senate wing was the first part of the Capitol finished it would have therefore been the first—and only—section started in 1793. Clark failed to understand that the whole building was begun in 1793 and curtailed only after the financial conditions of the city soured. Had these facts been known, the tablet would have been installed on the southeast corner of the old south wing.

EXPLOSION

When the Capitol extension was under way in the 1850s, ample provisions were made to supply the vast quantities of gas needed to illuminate the building. Fortunately, it was not often that a night session of Congress coincided with an evening levee at the President's House: there was not enough gas in the city to fuel the chandeliers in the east room and the illuminating apparatus above the House and Senate chambers at the same time. Among the largest consumers of gas in the Capitol were the 1,083 jets lighting the rotunda. These were installed in 1865 by Samuel Gardnier, using his patented device that permitted multiple gas lights to be ignited simultaneously. An electrical current was sent to magnets that opened the gas supply to the fixtures. Another current was sent to heat wires placed just above the gas jets, and the hot wires lit the fixtures. Thus, by throwing a few remote switches, one person could open and light hundreds of gas lamps at the same time. Turning off the magnets closed the source of gas and extinguished the flames. Gardnier's apparatus was the first application of electricity in the Capitol.

In 1879, the voltaic batteries connected to Gardnier's lighting fixtures in the rotunda and House chamber were replaced with "dynamo-electric machines." The electrician in charge of the House wing, J. H. Rogers, conducted experiments to light the House chamber with electrodes, but the flickering light was distracting and disagreeable. Further experiments were conducted two years later with a "voltaic arc." Rogers was still not happy with the unsteady light, but he thought that electric lighting would eventually be less expensive, cooler, and safer than gas. In 1882, the American Electric Light Company experimented in the Capitol with incandescent lights, but did not achieve valuable results. Three years later the company installed lamps on the terrace, but the effect was unsatisfactory because the bright light attracted too many insects.

In the mid-1880s Clark thought the future of electric lighting at the Capitol would be limited to windowless cloakrooms, lobbies, and other places where artificial lighting was necessary at all hours. However, when the Edison Company for Isolated Lighting was permitted to install lights in the Senate cloakrooms and lobby in 1885, the experiment proved so successful that the Senate approved a measure to extend electric lighting throughout its wing. In 1888, the Sayer-Mann Electric Company of New York City installed 650 lights in the Senate wing. That year the same company was permitted to place 200 lights in the south wing, while the

House Committee on Public Building and Grounds considered the desirability of permanent electric lighting. By 1890 more than 1,150 lights (averaging sixteen candlepower) had been installed in the Capitol and on the terrace.

In 1890, the architect of the Capitol began to recommend that Congress make its own electricity. Electric companies had been leasing dynamos to the government and charging for the electricity consumed, which cost as much as $200 a month. As the lighting was extended throughout and around the building, operating costs grew accordingly. Clark wanted the authority and money to purchase equipment and operate a power plant himself. In 1895, Congress granted the request and the next year Clark purchased from the Westinghouse Electric and Manufacturing Company four engines and dynamos that could light 5,000 lamps. Soon, electric lighting was installed over the glass ceilings above the House and Senate chambers, replacing gas that was sometimes smelly and always dangerous. The gas apparatus caused problems in the winter when heat buildup shattered the skylights on the roof. The problem was solved when the gas was turned off and electric lights were installed in 1896.

While electricity was quickly overtaking gas in the illumination business, there was a lingering suspicion that it could not always be trusted. Flickering light and power outages hampered acceptance of the new technology, and the possibility of electrical shock frightened many a steadfast soul. (President Benjamin Harrison, a veteran of fierce military campaigns during the Civil War, refused to touch electrical switches, employing a White House electrician to operate them for him.) Hybrid chandeliers, outfitted with gas and electric lights, were common. If the weather was hot or the gas pressure was low, the electric lamps could be operated. For a while, both forms of illumination were used at the Capitol, but that peaceful coexistence ended abruptly on a Sunday afternoon in 1898.

Just after five o'clock on November 6, 1898, lieutenant Robert S. Akers of the Capitol police was in his office when a sudden and violent explosion knocked him out of his chair. He ran out of his office and into the ornamental air shaft (today called the "small Senate rotunda"), where he witnessed a scene of terrible destruction. The floor had been blown away and sections of Latrobe's

The Press Corps
ca. 1895

*A*t the end of the nineteenth century, members of the press covering the House of Representatives worked below a chandelier that burned both gas and electricity.

Aftermath of the Gas Explosion
1898

*T*he stone floor in the ornamental air shaft (today called the "small Senate rotunda") was blown away by the force of the gas explosion that rocked the Capitol on November 6, 1898.

tobacco columns and other pieces of stone had been hurled far and wide. All over the old north wing, windows and doors were blown out. The skylights above the Supreme Court chamber were damaged, as were the cupolas over the main stairway and the air shaft. In the cellar a fire raged with great intensity, burning fiercely from a broken gas meter. Nearby piles of discarded documents were on fire. Flames licked at the woodwork of the elevator shaft located near the entrance to the law library. The room used by the marshal of the Supreme Court (modern day S–229) was heavily damaged, its window blown out and its plaster and woodwork destroyed. Other offices suffered as well, but to a lesser degree. Some arches in the cellar supporting the floors were knocked down and stone and brick paving was thrown up or loosened everywhere.

Because the accident happened on a Sunday afternoon, no one was near the immediate scene, and, luckily, there were no injuries. The city's fire companies hastened to the Capitol when the alarm was sounded. They arrived as flames leaped from the east front windows, but these small fires were put out with relative ease. Firefighters discovered a broken gas meter in the cellar and began to pour water on the flames, but the fire was not easily extinguished. Clark's chief electrician bravely crawled through the maze of pillars and debris and managed to turn off the gas.[61] Firemen worked elsewhere trying to put out smaller fires before flames reached the roof—a tinderbox of dry wood.

Soon after the fires were extinguished, Elliott Woods, an assistant to the old and ailing Edward Clark, asked Glenn Brown and Charles Munroe to make a thorough examination of the north wing and report on the damage. Brown was a prominent local architect and Munroe was a professor of chemistry and an expert on explosives. While the two sleuths went over the north wing and interrogated witnesses, workers began clearing debris. Twenty tons of brick, mortar, and plaster were hauled from the building and dumped temporarily on the east plaza.

Speculation on the cause of the explosion included a theory that the Capitol was bombed by Spanish nationals seeking revenge for the nation's intervention in Cuba during the Spanish-American War. That brief conflict, begun soon after the battleship *Maine* was sunk in Havana harbor on February 15, 1898, was over by August. Although few lives were lost on either side (and most casualties resulted from malaria), Spain was forced to give up Cuba, and the United States gained control of Puerto Rico, Guam, and the Philippines.

No trace of a bomb could be found. Instead Brown and Munroe blamed a meter that had been leaking gas into the cellar. Heavier than air, coal gas built up from the floor until it reached a pendant lamp, which was left burning to assist attendants from the gas company in their weekly meter reading. The instant the accumulated gas ignited, it exploded with considerable force and sent fire balls flying throughout the old north wing. Brown and Munroe absolved Spain of any involvement and blamed the $50,000 damage on carelessness and faulty equipment.

Because Congress would return in a few weeks, Woods had little time to repair the damage. Temporary concrete floors were laid, and stone and woodwork were patched and replaced hurriedly. The Supreme Court, whose fall term was already under way, was relocated temporarily to the room of the Senate Committee on the District of Columbia (modern day S–211).

Two days after the explosion, a local newspaper carried a story under the eye-catching headline: "CAPITOL NOT FIRE–PROOF; Central Portion of the Building in Danger; GREAT DOME MIGHT FALL." The story noted that the roofs over the old north and south wings were framed with wood and speculated that if the fire had spread to these areas the resulting heat could have destabilized or possibly melted the iron dome. The article was illustrated with plans and a section view of the center part of the Capitol showing the extent of the wooden roof structure as well as the sundry attic areas crammed with books and papers. Editors quoted John Smithmeyer, the architect of the new Library of Congress building, who was also well acquainted with the structural conditions at the Capitol. He credited the promptness and efficiency of the fire departments for containing the fire and, thereby, saving the roofs and dome. If not for their efforts, the Capitol might have been left a ruin, its magnificent dome damaged if not entirely destroyed. The article further recalled a report on the safety of federal buildings that President Hayes

had commissioned following a disastrous fire at the Patent Office in 1877. Apparently, the hazardous conditions at the Capitol had been known for at least twenty years.[62]

A NEW CENTURY

*A*t the beginning of the twentieth century, the Capitol was beset by old and new problems. Roofs over the center section needed to be fireproofed, the ventilation system in the House chamber needed to be overhauled, and something needed to be done with the rooms vacated by the Library of Congress. Unlike the first two concerns, the fate of the old library space was a relatively new issue. Without the slightest hint of sentimental regret, during the spring and summer of 1897 the librarians and their books moved out of the Capitol and into the magnificent new building across the street. Left behind were three iron rooms that were once among the most celebrated specimens of metallic architecture in the world, now empty and without a purpose. Some legislators wanted to retain at least the central room as a reference library, but others wanted the three spaces gutted and rebuilt into committee rooms and offices.

While the future of the old library space was under discussion, interest in building an east front extension was revived and became associated with a proposal to spruce up the rotunda with marble columns, marble walls, and a new mosaic floor. Also, in 1900 the House of Representatives asked the architect's office to investigate the feasibility of building a fireproof structure that would be used for congressional offices; an underground tunnel would connect it to the Capitol. Each idea was proposed in the name of progress, efficiency, convenience, safety, or comfort. During few periods in the history of the Capitol were so many large projects simultaneously under consideration as when the new century began.

As the office of the architect of the Capitol geared up to take on an unprecedented round of improvements, the man who headed the small agency retired. By 1898, old age and failing health had taken their toll on Edward Clark, who turned

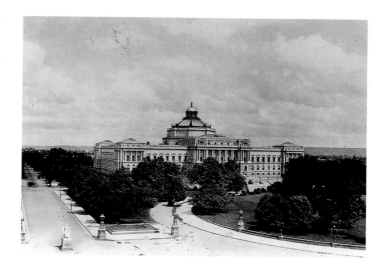

Library of Congress
ca. 1897

*T*he decision to relocate the Library of Congress into a separate facility was reached after years of discussion among politicians, architects, and the persistent librarian of Congress, Ainsworth Spofford. The building was designed by Washington architects Paul Pelz and John Smithmeyer, who took the Paris Opera House as their model. After construction was transferred to the Army Corps of Engineers in 1892, the work was directed by Edward Pearce Casey, who orchestrated a legion of artists and sculptors to decorate the inside and outside of the building. The results were astonishing. Immediately after it opened in 1897, the Library of Congress was widely considered to be the most beautiful, educational, and interesting building in Washington.

over the operation of the office to his assistant Elliott Woods. With congressional permission, Clark retained his title and salary and all official documents still carried his name, but he rarely came to the office or participated in its daily operation. The young, personable, and energetic Woods had joined the architect's office as a clerk in 1885, with the help of Vice President Thomas A. Hendricks. Although without a college education or formal architectural training, he soon proved himself a master of detail, a skillful administrator, and a trustworthy public servant.

On June 6, 1900, Congress authorized the architect of the Capitol to reconstruct the old library space into three floors. The attic level was

Demolition of the Iron Library
1900

It took just five weeks to disassemble the ironwork in Walter's library, which was then sold for scrap.

Plan of the Rooms Built in the Old Library of Congress Space
1900

The plan for the new rooms fitted into the former library space was straightforward. Elevators were tucked into courtyards while a staircase was built in the narrow passage leading to the west portico at the bottom of the plan. That stair was soon considered an encumbrance and removed within three years.

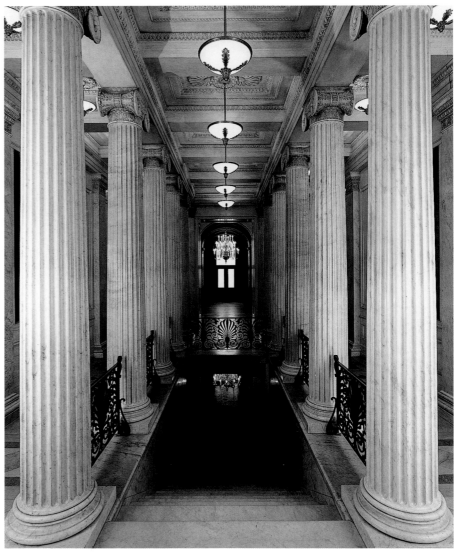

Lobby in the Old Library of Congress Space

The principal feature of the reconstructed library space was a grand lobby with columns, walls, and ceiling made of white Vermont marble. The Ionic details were inspired by the Erectheion order found in the old Senate chamber. (1964 photograph.)

to be fitted as a reference library, while the rooms on the second and third floors would be divided equally between the House and Senate and used for such purposes as those bodies might choose. Demonstrating extraordinary confidence in Woods' integrity and ability, the legislation did not limit or specify the funds available for the project, appropriating "such sum as is necessary" to carry out the work. It was an unprecedented appropriation.[63]

Woods repaid the compliment by finishing the reconstruction in just six months. Demolition work began on June 11, 1900, and was completed in five weeks. The old ironwork was sold at an auction, recouping most of the demolition cost. Black and white marble flooring was carefully taken up and relaid in the corridor directly below. Once the

rooms were stripped bare, unforseen structural defects blamed on the 1851 fire and natural settling prompted Woods to take down and rebuild more partitions than he had anticipated. Working two eight-hour shifts a day, masons labored from August 10 to October 15 building new brick partitions, arches, and vaults. Construction and decorative details were approximate copies of the originals in the Capitol, as Woods reported, "with the paramount idea to preserve the sentiments and ideas of the old and historic central building."[64] (The details actually resemble those in the Walter extension.) The two courtyards were refaced with glazed brick, which was cleaner and reflected light better than red brick. As soon as conditions permitted, a special fast-drying plaster was applied over the masonry, and the molded ornaments were affixed soon thereafter. Henry Chick of Washington was hired to install the ornamental plaster, for which he was paid 5 percent above cost. Sixteen thousand square feet of tile was bought from the Mosaic Tile Company of Zanesville, Ohio. Time would not permit special patterns to be made. Hot and cold water was piped to a marble lavatory in each room. A forced-air heating and ventilation system was installed to supplement steam radiators. Each room was fitted with a working fireplace, and each fireplace had an Italian marble mantel designed "in keeping with the simple dignity of this building."[65] Electrical service was provided through steel conduits placed in the ventilating ducts. The new rooms and corridors were illuminated by 760 lights, and provisions were made for more. Pivot sash windows were used instead of double-hung sash or casements because they were easy to operate and allowed a greater flow of air. The windows were glazed with American plate glass.

When the rooms were finished, just before the opening of the second session of the 56th Congress on December 3, 1900, they were either empty or scantily furnished with left-over pieces. By May 1901, Woods' office had designed suitable furnishings that were then put out to bid for the House committee rooms. No two were furnished alike, but a typical room had a conference table, a variety of cane-bottom and upholstered chairs, one five-foot-wide roll-top desk, a couch, a combination bookcase and wardrobe, a clothes tree, and an umbrella stand.

In 1901, Congress appropriated $153,500 to remove the wooden roofs over the old north and south wings and the west-central building and rebuild them with fireproof materials. The new roofs covered 37,500 square feet and were constructed of steel and concrete covered with copper. For the sake of appearances, the profile of the domical roofs was lowered and the steep pitch gently eased. In order that the lanterns might remain at the same elevation, the new saucer domes were raised on low walls that could not be seen from the ground. These adjustments allowed a habitable attic level to be added to the north wing, but no similar addition could be built above Statuary Hall due to interior conditions.

While the outside work produced only a few subtle changes, the interior alterations to Statuary

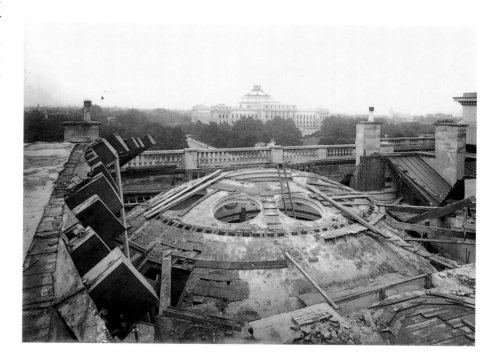

Removal of the Roof over the Old Senate Chamber 1901

Following the gas explosion of 1898, Congress authorized removal of the old wooden roofs over the north and south wings and construction of new roofs made of fireproof steel and copper. This view shows the roof over the north wing partially removed, exposing the dome over the old Senate chamber (then occupied by the Supreme Court).

*O*n September 10, 1901, a small crowd gathered to watch a steel truss being hoisted for the north wing's new fireproof roof.

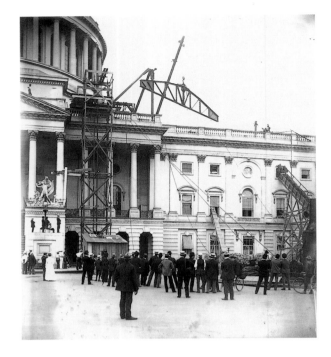

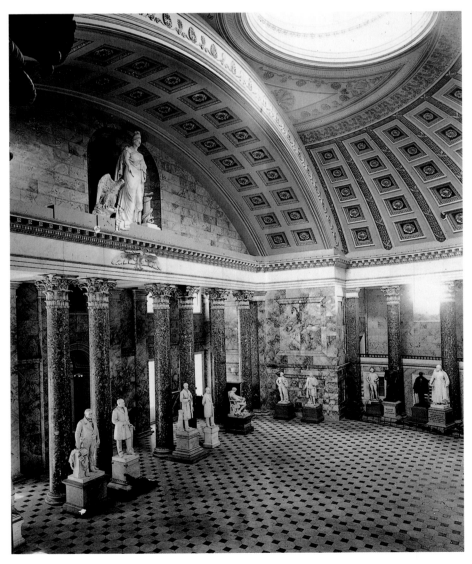

Hall were more noticeable. Gone was the smooth wooden ceiling painted by Pietro Bonanni in 1819. The ceiling promoted echoes when the room was used for legislative purposes and had been a prime reason the chamber was abandoned by the House of Representatives. James Monroe's order to construct it of wood, against the professional judgment of B. Henry Latrobe, contributed to sour relations with the president during the architect's last days in Washington. Removal of the wooden ceiling and its reconstruction in fireproof materials was a tardy vindication of Latrobe's good sense. The replacement was not masonry, as Latrobe would have used, but structural steel and ornamental plaster. Graduated coffers with rich moldings and flowers alternated between decorated ribs that radiated from the central lantern. The new ceiling unavoidably affected the room's acoustical properties, but Woods hoped that some of its curious echoes would remain to entertain tourists:

> One of the features of the Capitol building interesting to visitors was the combination of echoes in the old hall. While mysterious to the ordinary listener, they are readily explained by the laws of acoustics. It was a problem of some interest to preserve these characteristics which have been the pleasure of numerous visitors. To do this and be entirely successful would have required a smooth ceiling exactly as before. Preserving to within five-eighths of an inch variation the contour of the old hall ceiling, and by compromising on the depth to which the new panels might go, the echoes have been saved to a great extent, though somewhat diminished in strength.[66]

While the new ceiling was being put over Statuary Hall, a new floor was being built in the House Chamber. It was the room's third floor in its forty-four-year history and the latest attempt to improve the quality of the air pumped into the chamber. After the floor was removed, glazed tiles were laid and scoured weekly.[67] The new floor supplied air to the chamber through risers in the platform and

Statuary Hall

*T*his photograph was taken soon after a new fireproof ceiling was placed over Statuary Hall. Unlike its predecessor, this ceiling was designed with three-dimensional coffers and ornaments. (ca. 1902 photograph.)

grills under 400 new desks, each of which was fitted with an electric call button to summon pages. New furniture was also purchased for the cloakrooms and lobbies, and the chamber was repainted in a simpler style than the original Meigs-Brumidi scheme.

Work accomplished around the Capitol in 1900 and 1901 was impressive. Gone was the threat of fire from the old wooden roofs and ceilings that were dangerously close to the dome. Gone too was the iron library: built as a revolutionary response to a fire, it was now a victim of Congress' insatiable appetite for committee rooms and offices. Unfortunately, it was also an irreplaceable loss to the history of American architecture. Thomas U. Walter, the man who created that iron masterpiece, died in 1887 honored but penniless, bitter to the end about the government's failure to pay him for the design of the library, the Capitol dome, and a half-dozen other projects. Walter's poverty rendered him resentful at times about his former pupil Clark's successful career and comfortable life. Privately, he considered his successor ungrateful and unhelpful in times of need.

The annual report that Woods wrote for the year ending June 30, 1902, was the largest in the agency's history. For the first time, the report was extensively illustrated with photographs and drawings that helped explain the work accomplished over the course of the year. Thirty-seven drawings showed such things as the steelwork of the new ceiling over Statuary Hall and the framing plan for the floor in the House chamber. Sixty-eight photographs showed before and after conditions of the roofs and the design of a suggested improvement to the rotunda. Also included in the report were testimonials to the lives of Edward Clark and August Schoenborn, both of whom died in January 1902. Head draftsman since 1851, Schoenborn had, like Clark—begun his Washington years in Walter's drafting room. He was remembered for his "marked artistic and official fidelity" as well as his "even temperament apparently only satisfied by hard work."[68] Woods was particularly eloquent in the tribute he wrote Clark, his mentor and friend. After briefly sketching Clark's career, he wrote:

> I may be pardoned for the expression of my great personal love for him and his character. It is on the experience of seventeen years' service with him that I build my estimate of his

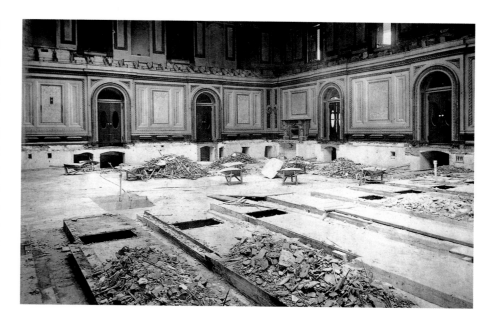

Rebuilding the Floor in the House Chamber
1901

*C*omplaints about the foul air in the House chamber usually resulted in reworking the duct work under the floor. This also provided an opportunity to reconfigure the platforms and risers to accommodate more desks and chairs for additional members.

character. No man was more modest than he. No man oftener lifted his hand to the worthy or more unobtrusively exercised his charitable instincts. Modest and unassuming, his whole life is worthy of emulation. . . .

Probably no man connected with the history of the Capitol building enjoyed more than he the confidence and respect of those whose official and personal life brought them in contact with him.[69]

Clark's death marked the end of a career known mainly through official documents. He left no personal papers to shed light on his intimate thoughts or record his observations on the world around him. His official life was nonetheless long and productive. He had little of Walter's genius for design, yet he was enthusiastic about working with those who did; his collaboration with Olmsted was one case in point. Clark was temperamentally equipped to transform the office from a design atelier to an administrative post, helping set the stage for the tremendous growth of the job during the twentieth century.

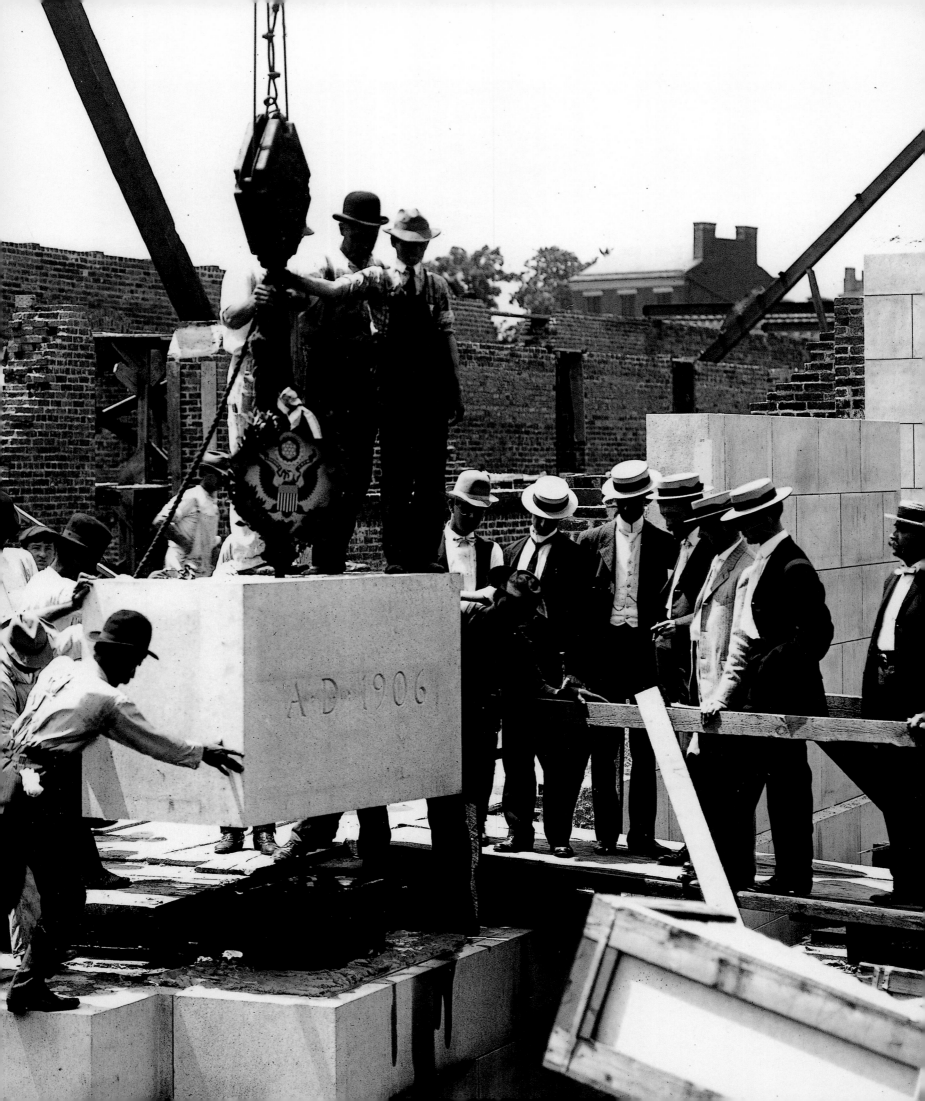

CIVIC IMPROVEMENTS

*T*he dawn of the twentieth century brought a new interest in the capital city and its place in American culture. Washington had been the seat of government for a century, variously nurtured or starved by the officials it served, but growing steadily until it boasted over a quarter million souls. Monumental buildings like the Capitol; the White House; the Navy, War, and State Building; and the Library of Congress were the pride of America. They represented a staggering investment that helped silence talk of relocating the capital. Proposals for additional government buildings were being made, particularly for sites along the Mall and on Capitol Hill. For some civic leaders the new century seemed a good time to study the city's history, examine its present situation, and explore its potential for improvement. Spurred by the so-called City Beautiful Movement, prophets of urban America hoped to reform and embellish urban areas, making them healthy by building extensive parklands and dignified by erecting beautiful buildings and monuments. Although the movement was rooted in the 1893 Columbian Exposition in Chicago, its national laboratory was Washington, with Capitol Hill becoming a large part of the noble experiment.

When the American Institute of Architects held its 1900 annual meeting in Washington, its members lobbied Congress for an official commission to examine the city's future development and architectural enhancement. They found a willing partner in Michigan Senator James McMillan, chairman of the Committee on the District of Columbia, who would sponsor legislation creating the Senate Park Commission in 1901. Members of this commission, some of the country's leading design professionals, would advise the government on the capital's future. The "McMillan Commission," as the Senate Park Commission was also known, was chaired by Daniel Burnham, a Chicago architect best remembered for the edict "Make no little plans; They have no magic to stir men's blood." Burnham and his colleagues—architect Charles McKim, landscape architect Frederick Law Olmsted, Jr., and sculptor Augustus Saint-Gaudens—proposed sweeping changes to Washington's monumental core. Aiming to reverse decades of neglect and thoughtless development, the commission sought to make the city a world-class capital, ornamented with handsome buildings, parks, plazas, and landscapes. Of prime importance was the Mall, which would be cleared of the unsightly train tracks and railroad stations that Congress had permitted to be built there, thinned of the forest that had grown thick over the years, and restored to the formal *tapis vert* that Pierre L'Enfant had intended. The commission proposed a phalanx of marble buildings for Capitol Hill to replace the stores, saloons, hotels,

Laying the Cornerstone of the Senate Office Building (Detail)
July 31, 1906

and houses overlooking the Capitol grounds. Such a classical enclave, designed with unity, harmony, and symmetry, would be a more worthy neighbor.

In January 1902 the Senate Park Commission issued its report. An exhibition of its work, consisting of scale models of the city showing before and after conditions, photographs, and renderings, was put on display at the new Corcoran Gallery of Art near the White House so that citizens could come to have a look at their future. Senator McMillan escorted President Theodore Roosevelt around the exhibit, viewing the large and impressive models from an elevated platform. The spirit of urban reform struck a chord with the progressive president, who expressed enthusiasm for the commission's work.

While the Senate Park Commission's exhibit was inside, black crepe shrouded the outside of the Corcoran Gallery in memory of Edward Clark, a faithful public trustee who had recently died. No sign of mourning was found at the Capitol, where he had worked since 1851, but Washington's premier art museum publicly grieved the city's loss. The office of architect of the Capitol was vacant for the first time in thirty-six years, and, the need to name a successor soon pitted leaders in Congress against those who guarded the prerogatives of the architectural profession.

During Clark's lengthy illness it had been assumed by many in Congress that his popular and hardworking assistant, Elliott Woods, would be elevated to the post in due time. In an institution that puts great stock in tradition and continuity, it seemed only right to promote Clark's assistant in the same way that Clark, who had been Walter's assistant, had been promoted in 1865. Over the previous four years Woods had been the de facto architect of the Capitol, and it was fitting to confer on him the title of office along with its responsibilities and salary (which had stood at $4,500 a year since 1851). But the fact that Woods was not an architect bothered leaders of the architectural profession. Especially disturbed was Glenn Brown, the secretary of the American Institute of Architects and author of the two-volume *History of the United States Capitol,* who had designs of his own on Clark's post. Chief among Brown's supporters was J. R. Proctor, the chairman of the Civil Service Commission and a friend of President Roosevelt.

He actively promoted Brown to succeed Clark in the architect's job.[1]

In a matter of hours after Clark's death, however, the political machinery in Congress geared up to steer Woods into the architect's office. Some thought that his chances could be spoiled only if he were found to be a Democrat. Telegrams from his home state of Indiana poured in with testaments to his loyalty to the GOP. Complicating the situation was Woods' father, who apparently had abandoned the party and caused some questions regarding his son's politics. Representative Jesse Overstreet of Indianapolis, where Woods grew up, received a telegram from a local politico that set the record straight: the father may have quit the Republican party, but "the boy stuck."[2] Another telegram supporting Woods was sent to Roosevelt by Senator Matt Quay, the political boss of Pennsylvania. Quay was the chairman of the Committee on the Organization, Conduct, and Expenditures in the Executive Department, a potent position that readily gave him entree to the president. William Hepburn of Iowa contacted fellow representatives, urging them to write Roosevelt in support of Woods' promotion. He was alarmed that a "society of architects" was attempting to interfere in the matter.

As telegrams and letters piled up on Roosevelt's desk, the American Institute of Architects quietly expressed concern at the possibility of a non architect becoming architect of the Capitol. Two of the institute's officers, President Charles McKim and Secretary Glenn Brown, were leading opponents of Woods' appointment. As a member of the Senate Park Commission, McKim understood that its future success required cooperation from key civic and government figures, and among these was the architect of the Capitol. In February 1902, Brown published an article entitled "The Twentieth Century Washington" in *House and Garden* magazine, informing the public about proposals to restore the federal city to the way Washington and L'Enfant had envisioned it.[3] Part of the focus of the McMillan Commission was the area around the Capitol, which was seen as a precinct devoted exclusively to classical government buildings and gardens. Other areas near the Capitol would be affected by the commission's proposals, and it would need a sympathetic partner in Clark's old job. McKim did not think Woods was such a person and supported Brown for the post. He was, after

all, the leading authority on the history of the Capitol, a man well acquainted with the intricacies of its construction history and details, as well as a respected architect. Few doubted that Roosevelt would listen to McKim, who within a few months would embark on a joint project to remodel and redecorate the White House. With McKim's support, and that of other influential men in Washington, Brown had reason to believe that the office of architect of the Capitol would be his for the asking.

On the other hand, Representative Joseph Cannon of Illinois, the powerful chairman of the House Committee on Appropriations and future Speaker, did not care a fig for McKim, nor did he have much use for the Senate Park Commission or the American Institute of Architects. He felt snubbed when Senator McMillan proceeded with the Park Commission without the consent or participation of the House of Representatives. In his view, these bodies were meddlesome, and he especially did not appreciate the American Institute of Architects telling Congress who should be appointed architect of the Capitol. Cannon went to see Roosevelt about the matter, fortified by a petition signed by forty members of Congress supporting Elliott Woods, and explained that, unless Woods was appointed to the post, the president's relations with the House and Senate would become unnecessarily strained. According to Cannon, it was the prerogative of Congress to say who should fill the position that was, in fact, their chief housekeeper.

Brown and McKim were no match for Joe Cannon and others in Congress who lined up behind their man. Roosevelt agreed to appoint Woods but wanted the job title changed. Cannon suggested calling the officer "superintendent" instead of "architect" if it would help quiet critics. This was easily done and on February 14, 1902, Congress enacted an appropriation bill that contained language to effect the change.[4] All the powers and authority of the architect's position were vested in a new "Superintendent of the Capitol Building and Grounds," whose office remained under the Department of the Interior. The office and the salary were exactly the same but the head of the agency would no longer be an architect. Five days later Roosevelt appointed Woods to the newly renamed post.

Looking back on the episode, Brown blamed his loss to Woods (whom he consistently referred

Joseph G. Cannon at the Speaker's Rostrum

ca. 1903

Library of Congress

A representative from Illinois, Cannon (1836–1926) was chairman of the Appropriations Committee for eight years before becoming Speaker of the House in 1903. He is remembered mainly for the tight control he exercised over legislative activities, but he also took a considerable interest in the Capitol and the accommodations of the House of Representatives. The first office building designed for the House, a building that bears his name today, was begun soon after he became Speaker. He unsuccessfully pushed for the east front extension as a means to ease crowded conditions in the Capitol. The American Institute of Architects came up against Cannon's power when it tried to influence the appointment of the next architect of the Capitol when the office became vacant in 1902. Cannon repelled the institute's initiatives and steered Elliott Woods into the office. He remained Woods' champion throughout their service on Capitol Hill.

Elliott Woods in His Laboratory

ca. 1910

*A*side from his regular duties as superintendent of the Capitol, Woods (1865–1923) enjoyed scientific experiments with wireless telegraphy and X-rays. His laboratory was located at the corner of Delaware Avenue and C Street, N. E.

to as "Wood" in his memoir), on Roosevelt's inexperience and lack of backbone. "This was early in Roosevelt's administration," Brown wrote almost thirty years later, "and he had no desire to antagonize Congress as he did in later years."[5] Brown remained a lifelong critic of Woods' performance at the Capitol, even after the superintendent was welcomed into the American Institute of Architects as a full-fledged member in 1921.

CONGRESSIONAL OFFICE BUILDINGS

*T*he census of 1900 increased the membership of the House of Representatives to 391, up an astonishing 148 seats in the half-century since the Capitol was last enlarged. Rearranging seats and buying smaller desks made it possible to accommodate members comfortably on the floor of the chamber, but elsewhere overcrowding was a problem. Committee rooms remained in short supply, and restaurants, barber shops, and bathing rooms were severely

taxed. About fifty-six members could have offices in the Capitol, and these were usually provided by virtue of a chairman's use of a committee room as his personal office.

Members of the House were envious of the Senate, which in 1891 acquired an office building in the form of a converted apartment building. The Maltby House, located at the corner of New Jersey Avenue and B Street north (modern day Constitution Avenue), was only three years old when the government purchased the property and remodeled the apartments into eighty-one offices and committee rooms. In 1893, the government purchased Benjamin Butler's ponderous stone mansion on B Street south (modern day Independence Avenue). It was too small for congressional offices and the Coast and Geodetic Survey moved in instead.

At that time, acting architect of the Capitol Elliott Woods, old August Schoenborn, and local contract architects were working on preliminary schemes for a House office building. Four squares of land south of the Capitol were considered as possible locations, and schematic designs were created to help develop preliminary cost estimates. No matter where the new office building was located, it was to be connected to the Capitol via an underground tunnel. The tunnel would carry pedestrian and truck traffic, as well as electrical conduits and steam pipes. A new power plant connected with the office building would be built to serve it, the Capitol, and the Library of Congress. Woods promised that members would be able to reach the floor of the House through the tunnel as quickly as from any committee room in the terrace.

Woods submitted plans and elevations showing six possible designs for an office building suited to city squares south of the Capitol. All were for three-story structures with an Ionic order standing on a rusticated ground floor. Their similarity and deference to the basic composition of the Capitol were obvious. Woods explained his initial ideas about the style and character of the proposed building in his annual report for 1902:

> In view of the proximity of the proposed new structure to the Capitol building, the construction should be carried out on classic lines. The idea had been carried out in the sketches. The exterior walls of the new building should be either of marble or granite, preferably the former. The interior would be constructed largely of steel and terra-cotta and other fireproof

materials. The court walls would be faced with
enamel brick conducive to cleanliness and good
lighting for the interior rooms.[6]

The smallest proposed version of a House office
building contained 285 offices and another ninety-
five rooms intended for folding rooms (where out-
going mail was handled), storage, or work shops.
Designs for larger buildings accommodated more
than 400 offices with 125 support rooms. Woods
estimated that it would cost about $2,500,000 to
construct the smaller building, while the larger
versions would cost about $4,300,000.

The Civil Appropriations Act of March 3, 1903,
authorized the creation of a commission to oversee
construction of a new office building for the House
of Representatives and provided $750,000 to begin
the project. Serving on the commission were Joe
Cannon of Illinois (elected Speaker later that year),
William Hepburn of Iowa, and James D. Richardson
of Tennessee. Woods was designated by law to
direct and supervise construction and to make all
the necessary contractual arrangements. The idea
of using a supervising commission to oversee con-
struction of the House office building was entirely
new and a welcome improvement over the old way
of doing business. Unlike the time when Latrobe or
Walter answered to the executive branch, enduring
attacks in Congress from members who felt help-
less and ignored, the commission of two Republi-
cans and one Democrat provided appropriate
project oversight within the House of Representa-
tives itself. The bipartisan commission also pro-
tected the work from the sort of politically
motivated scrutiny that had characterized past
projects. Woods' friendly relationship with the
Speaker was another propitious sign that the work
would proceed smoothly.

In one of its first actions, the commission
decided to build the new office building on a large
parcel bounded by First Street east, B Street south
(modern day Independence Avenue), New Jersey
Avenue, and C Street south. The site was conven-
ient and the ground was level and solid. A corner
of the property lay over the path of a proposed rail-
road tunnel carrying southbound trains from Wash-
ington's new Union Station, but that was not
considered an insurmountable problem. The secre-
tary of interior was asked to initiate condemnation
proceedings to obtain title to the square, the
assessed value of which was about $250,000. Demo-

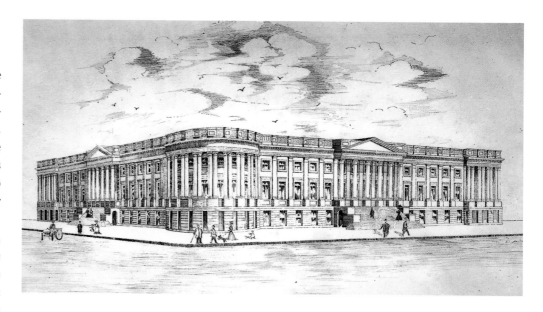

**House Office Building Design "C" by Elliott Woods
1902**

*T*his was one of six preliminary designs for an office building worked up by the
superintendent of the Capitol.

lition of existing structures (mainly nineteenth-
century commercial buildings overlooking the Capi-
tol and residential row houses facing side streets)
began on February 1, 1904, and excavation on the
site began that summer. Tracks were constructed
across the east plaza in front of the Capitol for
trains transporting dirt from the House office build-
ing site to the site of Union Station, which needed
fill material. (One of the first and finest accom-
plishments of the McMillan Commission, the city's
new railroad station permitted removal of the old
stations and tracks cluttering the Mall.)

After the site was selected, the commission
decided how the building would be designed. Can-
non seemed particularly averse to spending money
to hire an architect who would charge 5 or 6 per-
cent of the construction cost and add an unneces-
sary expense to the project. He thought that Woods
and his staff could do the work just as well and far
more cheaply: they had already worked up several
competent designs and there was no need to go
elsewhere for architectural assistance. But it was
Woods himself who understood the limitations of
his organization in the design field, realizing that

John M. Carrère and Thomas Hastings

ca. 1890

The American Institute of Architects Archives, Washington, D.C.

*T*he son of a Baltimore coffee merchant, Carrère (1858–1911) was born in Rio De Janeiro, studied in Switzerland, and graduated from the Ecole des Beaux Arts in 1882. Returning to America, he was a draftsman in the office of McKim, Mead & White before forming a partnership with Thomas Hastings (1860–1929), a native New Yorker who was also a graduate of the Ecole.

From the commencement of their work together, Carrère and Hastings attracted wealthy clients, enjoying widespread success and celebrity. Their first important patron was Henry Flagler, for whom they designed the Ponce DeLeon Hotel and the Flagler Memorial Presbyterian Church in St. Augustine, Florida, and "Whitehall," Flagler's Palm Beach estate. Great mansions were the firm's specialty—clients included Mrs. Richard Townsend of Washington, D. C.; Mrs. Richard Grambrill of Newport, Rhode Island; Murrary Guggenheim of Elberton, New Jersey; William K. Vanderbilt of Great Neck, New York; and Alfred I. duPont of Wilmington, Delaware.

Following a nationwide competition, the firm of Carrère & Hastings was commissioned to design the New York Public Library, which was completed in 1911. The Jefferson Hotel in Richmond, Virginia, the Agricultural Building at the Louisiana Purchase Exposition in St. Louis, and the National Amphitheater at Arlington Cemetery were other notable commissions. From 1904 to 1929, the firm provided most of the architectural services required by the United States Congress.

Both partners were active in the New York chapter of the American Institute of Architects and the Architecture League of New York. Carrère was a founder of the New York Art Commission, a director of the American Academy at Rome, and a member of the National Academy of Design. Hastings was awarded the Royal Institute of British Architects' Gold Medal and was made a Chevalier of the Legion of Honor by the French government.

the building would be scrutinized by the architectural profession—in particular, the AIA. He wanted the authority to hire a consulting architect.

Striking a middle course, the commission charged Woods with planning the new House office building, writing specifications, and overseeing construction. A drafting room would be operated under his direction and he would act as the general contractor. Consulting architects would be hired to ensure a first-rate design, but they would not be allowed to charge a percentage fee. Instead, the consultants would be given a flat fee of $10,000 per year. Finding a firm with the requisite prestige that would also accept the terms allowed by the commission could well have been a daunting task. Happily, however, it did not take Woods long to become acquainted with one of the nation's most fashionable firms. Partners John Carrère and Thomas Hastings were society architects, with elegant Beaux Arts tastes perfectly suited to the needs of their wealthy clients. The firm was held in high esteem by the AIA and would surely help Woods in any public relations problems that might arise in the future. (Charles McKim was Thomas Hastings's "best man" when he married in 1900.)

On April 8, 1904, Woods laid before the commission a letter from Thomas Hastings in which he agreed without a word of equivocation to four general stipulations: the working drawings would be produced in Washington under Woods' supervision; the fee was satisfactory; the general layout of the interior already devised by Woods was acceptable, but his firm would become responsible for its "correct" architectural effect; and a suitable exterior architectural effect would be devised. With considerable solemnity Hastings pledged to render Woods services with "full loyalty and confidence."[7] On April 11, 1904, the commission accepted Woods' recommendation to hire Carrère & Hastings as consulting architects, beginning a friendly and mutually beneficial association that lasted a quarter-century.

Woods set up a drafting room to produce detailed working drawings for the building, and he hired Oscar Wenderoth, an architect associated with Carrère & Hastings, to serve as head draftsman. (Wenderoth later served as supervising architect of the treasury, 1912–1915.) Owen Brainard, another of the architects' close associates, was retained as consulting engineer. Not only would Wenderoth work out the details of the new House office building; he and his men would also plan a new office building for the Senate. Four months earlier, the Senate had created its own commission to oversee construction of an office building for its use, a building mirroring its counterpart on the other side of the Capitol's east garden as proposed by the McMillan Commission. (As it turned out, the Maltby House had been built on unstable ground and was showing alarming signs of structural failure.) A new building for the Senate would complement the House office building, ensuring that neither body was better accommodated than the other. Miscellaneous projects relating to the office buildings, such as plans for the connecting tunnels and designs for furniture, were also addressed in Wenderoth's drafting room. Schemes for rebuilding the House chamber and other tasks were handled there as well.[8]

Of the partners, Thomas Hastings was considered the better designer, and John Carrère was the businessman who handled clients. For their work in Washington, however, Hastings took responsibility for the House office building and Carrère had charge of the Senate office building. The two buildings were nearly identical on the outside, designed as elegant yet deferential backdrops to the Capitol. Although dominant features such as domes or pediments were avoided, smaller details were plentiful and rich. Facing the Capitol grounds were colonnades almost 300 feet long with thirty-four paired Doric columns standing on a ground-story base. End pavilions featured large arched windows framed by columns. Pilasters continued the Doric order along secondary elevations, while the backs of both office buildings were originally left perfectly plain. A continuous balustrade masked a low roof. The design was inspired by the Gardes-Meubles on the Place de la Concord and the great colonnade at the Louvre in Paris.

The principal entrance to each office building was located at the corner closest to the Capitol. No hint was made on the outside to indicate that a rotunda fifty-seven feet in diameter lay just behind the entrance. It functioned as the main lobby and the introduction to the building's interior grandeur. Using Woods' plan for a grand circular vestibule, Carrère & Hastings designed a ring of eighteen Corinthian columns standing on an arcade and supporting a coffered dome. Opposite the entrance was placed a broad, split staircase leading to the most sumptuous room in the building—the caucus room. The procession into the building, through the rotunda, up the stairs, and into the caucus room, was both clear and compelling. While originally intended to be copies of Statuary Hall, the caucus rooms were redesigned as rectangular two-story spaces fifty-two feet wide and seventy-four feet long. The flat ceilings were divided into panels and decorated with a variety of molded plaster ornaments highlighted with gold leaf. In the House caucus room the walls were lined with Corinthian pilasters, while its counterpart in the Senate office building had freestanding Corinthian columns twenty-seven feet high in white Vermont marble. Tall arched windows looked onto interior courtyards lined with Indiana limestone. The House office building's court was fully enclosed from the beginning, but the one at the Senate office building remained a three-sided yard until 1931. The First Street addition, begun that year, enclosed the courtyard with a fourth side.

Committee on Military Affairs, House Office Building

ca. 1908

*M*ost committee rooms in the first House office building were functional and businesslike.

Member's Office

1907

*T*his photograph was taken after the interior of the House office building was finished but before it was occupied. The central table was manufactured by Gimbel Brothers of New York, the tufted "Turkish" chair was made by the Julius Lansburgh Company of Washington, while the remaining furnishings were ordered from John Wanamaker of Philadelphia.

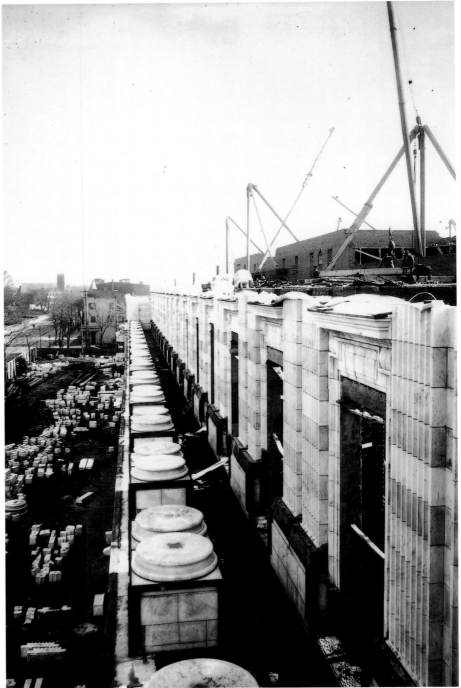

Construction of the House Office Building

1906

*T*he first House office building was designed by the New York firm of Carrère & Hastings using plans developed by Elliott Woods. The principal feature of the exterior was a colonnade 300 feet long with paired Doric columns, which are shown here with only their bases in place.

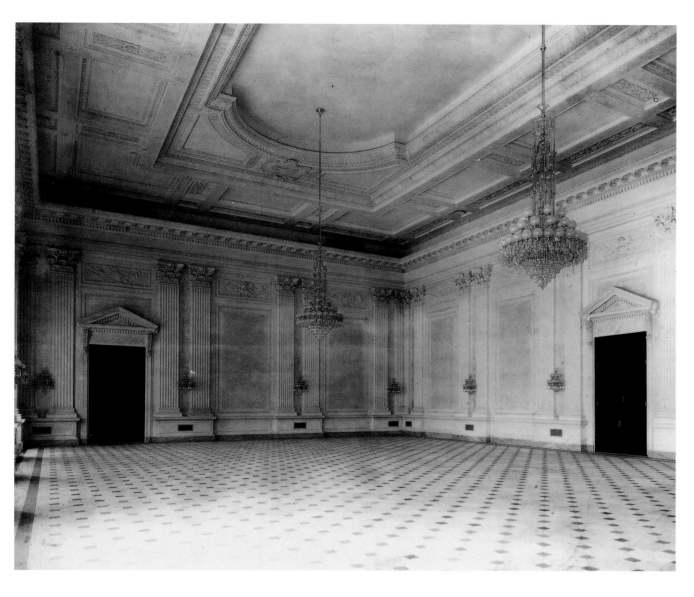

House Office Building Caucus Room

ca. 1908

A versatile chamber for hearings, meetings, and receptions, the caucus room was an elegant design with coupled Corinthian pilasters, a marble floor, and a richly ornamented plaster ceiling. It was similar in scale and spirit to the east room at the White House, which Charles McKim redesigned for Theodore Roosevelt in 1902.

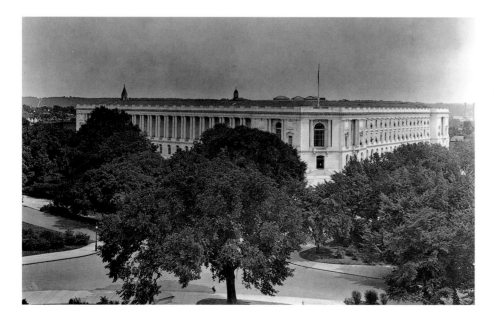

House Office Building

1908

*T*he design of the House office building acknowledged its accessory role in the architectural hierarchy of the Capitol complex.

On December 12, 1908, the House office building opened for business. For the first time in the nation's history each representative had an office, actually a modest room averaging fifteen and a half feet wide and twenty-three feet long. Modern in every respect, the offices were outfitted with telephones, lavatories (supplying hot, cold, and iced water), steam heat, and forced-air ventilation. In addition, fourteen rooms were available for committees. Ninety-eight suites and eight committee rooms were provided in the Senate office building, which opened on March 5, 1909. A Philadelphia paper took note of the beautiful new office buildings as they neared completion in Washington, observing in its headline that legislators were being "Good To Themselves":

> Each division of the nation's Legislature will have a stately edifice of its own and the combined cost of the two is placed at about five million dollars. In the building for the Representatives there will be a fine office for every member of the House. The Senators will each have a three-room suite, including a bathroom, in the edifice devoted to their use. All expenses for heat, light, maintenance, and attendants will be paid by the government. A special little subway road will transport the lawmakers free of charge between the Capitol and the splendid structures erected for their comfort and convenience.

> The laborer is worthy of his hire, no doubt; and he is likewise worthy of suitable housing while he is performing his work. Yet it is also to be remembered that Congress, besides providing for the creation of these semi-palatial "annexes," has voted to increase the salary of every Senator and Representative from $5,000 to $7,500—while at the same time by a little adroit legislative juggling, each of them is entitled to an extra fifteen hundred dollars yearly for clerk hire, which he may spend for that purpose, or put it in his pocket.[9]

While hardly biting, the article took a dim view of congressional luxury purchased with the people's pocketbook. Unlike publicity concerning the Capitol, stories about congressional office buildings seemed not so much about civic improvements as about personal extravagance on the part of elected officials. Nothing was ever too good for the Capitol, but everything was too good in the legislative office buildings. Despite the evidence of judicious economy and good urban design that usually governed

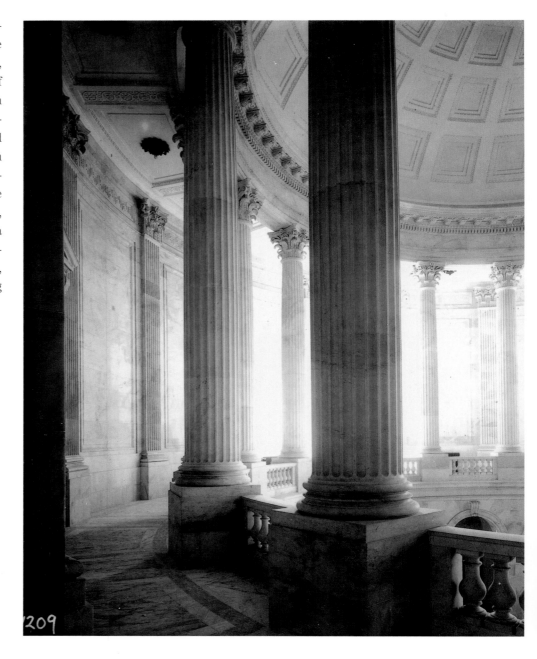

Rotunda, Senate Office Building
1909

*E*xcept for the plaster dome, the rotunda was made entirely of white marble.

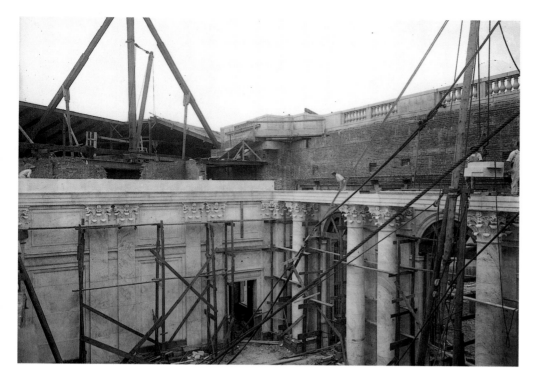

Senate Caucus Room Under Construction
1908

Although initially smaller, the Senate Office Building cost more than its counterpart built for the House of Representatives. One reason for the discrepancy was the use of more costly materials for the interior. Here workmen are setting a stone for the caucus room's entablature, which was marble like the room's columns, walls, and floor.

Committee Room, Senate Office Building
1909

Still missing its clock and sconces, this room was photographed just before the Senate office building opened. Leather-covered chairs and conference table, crystal chandeliers, and a marble mantle contribute to the impression of a corporate board room.

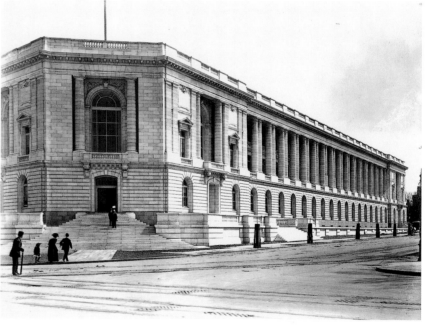

Senate Office Building
ca. 1909

While the design of the office buildings may have avoided architectural competition with the Capitol, it did not shy away from rich details. Particularly notable were the plaques carved with plumed helmets, eagles, banners, flags, trophies, and other symbols.

such projects, this pattern of thinking in the press persisted throughout the twentieth century.

THE BONUS

*D*espite occasional snide comments, the office buildings were hailed as great successes. At no time in the history of Capitol Hill had construction projects of such magnitude been bathed in such harmony. Woods was applauded for administrative tranquility and smooth operations, but the two commissions and the two consulting architects deserved a good deal of credit as well. The superintendent was congratulated for saving the government more than $100,000 that otherwise would have been paid to

architects charging a percentage fee. Instead, Woods drew only his salary and rendered the same service as a highly paid professional architect. On February 28, 1911, James A. Tawney of Minnesota, chairman of the House Committee on Appropriations, introduced legislation to pay Woods $7,500 for preparing the plans and specifications and superintending the construction of the House office building. Even considering this unprecedented gratuity, he argued, the government still got the best of the bargain:

> These buildings were constructed under the supervision of the Superintendent of the Capitol at an expense not only within the bare limit of cost, but considerably below the limit of cost. There would have been paid for architect's fees on the House Office Building on the basis of 5 per cent $158,000. As it was the supervisory and architectural work actually cost the Government the sum of $88,000, or only 2.7 per cent of the cost of the building. . . . Out of this a sum of $31,703.95 was paid for the services of the consulting architect [Carrère & Hastings], and a further sum of $11,000 for special engineering services, which ordinarily the client has to pay. The total net saving to the Government on architectural cost alone on this building has actually been $70,027.44.
>
> I have a similar statement with regard to the saving on the Senate Office Building. Now, the net saving to the Government on the entire construction has been $140,855.12[10]

James R. Mann of Illinois supported the extraordinary measure, asserting that the completion of construction without cost overruns was "largely owning to the common sense and to the constant care of Mr. Woods."[11] But William E. Cox of Indiana spoke against the appropriation, telling

Capitol Power Plant
1910

*A*uthorized in 1904, the power plant was built to supply electricity and heat to the new congressional office buildings, the Capitol, the Library of Congress, and other public buildings. This photograph shows the twin chimneys at their original height of 212 feet.

While electrical production ceased in 1951, the facility has been expanded five times to keep up with heating and cooling demands.

his colleagues that Woods was only doing his duty, and that it was unnecessary to give a bonus for mere competence and efficiency. He also objected to the House providing the superintendent with a bonus when the Senate might not follow suit. That would be unfair. Thetus Sims of Tennessee declared his intention to support the measure as a matter of sound policy. He complained that the House depended too often on the executive branch or on outside experts for advice and it was time to reward their own officers who performed so well. He said:

> I think this is something more than a mere personal compliment to Mr. Woods. I think we ought to rely on our own servants and use them as much as we can. Mr. Woods would have, the same as any other man, the pride of having his name connected with this great building, and would perhaps regard that as compensation enough, but I think it is absolutely niggardly on our part not to give him something. I think there is a higher consideration than any contract that can be made. Let us have more of this thing done hereafter, instead of employing experts outside of this House, who have no pride in the success of the economics that may have been attempted by this House.[12]

A final tribute to Woods drew applause from members of the House. Four days later the Senate considered additional compensation for the superintendent in the amount of $5,000, but the figure was soon raised to equal that granted by the House. Both appropriations were approved at the end of the 61st Congress. Along with funds to buy flags and fertilizers, Woods was granted $15,000 for his extraordinary services.

BROODING OVER THE CAPITOL

*N*ewspapers of the day carried stories describing Woods' energy and devotion to the Capitol. "Uncle Joe" Cannon was quoted in one article as saying: "I do not know how Elliott Woods could be overworked unless he was hitched double with a mule." The masthead of the story read: "Broods Over The U. S. Capitol Like A Mother Over Only Child: Elliott Woods Finds Joy in His Work, and Plenty of Work to Keep Him Joyful." Woods was given credit for wearing many hats while acting so nonchalantly that few people could guess that the man stayed so busy:

> Woods is extremely versatile, he is Uncle Sam's builder in the National Capital; he is a clever musician and composer; he is an all-round scientist, antedating the bureau of standards in many important tests; he is custodian of a unique art collection of very great value; he has cut down the death rate of Congress by original innovations for ventilation and sanitation—and withal he is extremely modest.

> He is managing director of a complete little city with a scientific laboratory, blacksmith shop, machine shop, carpenter and cabinet making shop, electric shop, painters and glaziers, tinners and roofers, stone masons, plumbers and gas fitters, jacks of all trades.[13]

Visitors to Woods' laboratory near the Senate office building sometimes found the superintendent playing the violin or working at an operatic composition. He also relaxed by conducting experiments with X-rays or exchanging telegraphic messages with ships at sea. Especially favored were ships carrying cargo destined for Capitol Hill, such as freighters bringing marble from Vermont, New York, or Georgia for the office buildings. According to one account, Woods was in the habit of warming his dinner in one of the boiler rooms in the Capitol alongside some of his employees. He also joined them in a kazoo band that occasionally annoyed policemen who were napping nearby. These harmless recreations were well deserved, as newspapers liked to report, because Woods was otherwise the "busiest man in Washington."

Around the Capitol, routine maintenance was varied as ever. Old gas chandeliers were replaced by new bronze electric fixtures with milk glass shades and downward-pointing light bulbs. At the end of January 1903, Woods despatched a cart to the White House to haul back crystal chandeliers and other furnishings purchased at Roosevelt's auction, which cleared out the "Victorian" accretions cluttering the residence. As part of his own housecleaning, Woods hired men, dogs, and ferrets to hunt and destroy rats in the Capitol. Releafing picture frames, relaying floor tiles, preparing a sign with the command "Pull The Chain" for a water closet, and buying new cherry toilet seats (at six dollars apiece) were other examples of small projects that kept Woods and his staff busy.

Two Designs for Architectural Improvements in the Rotunda

by August Schoenborn
ca. 1901

*T*o bring the rotunda up to twentieth-century standards of classical grandeur, the architect of the Capitol sought ideas for redecorating the room with marble columns, marble walls, and other artistic additions. None of the ideas were implemented.

Macnichol & Sons, a local painting firm, was hired year after year to keep the interior finishes fresh. Typical projects included painting the Senate document room in simple tints or treating the walls and ceiling in the Supreme Court chamber with an "asbestive coating." They were hired to remove paint from interior stonework, beginning with the lower walls of the rotunda in 1905. Outside, the Macnichol firm usually received the quadrennial contract to paint the dome, which required 4,200 gallons of paint and kept thirty-five men occupied for two months. Inside, decorative painting was introduced into areas that needed sprucing up. Complaints were occasionally made by those who compared the Capitol's haphazard decorations with the well-orchestrated and harmonious interiors at the Library of Congress. While the complaints were not particularly fair, they initiated a spate of improvements by various artists. One project was a redecoration of Statuary Hall and the lobbies around the House chamber. Joseph Rakemann, an artist who had worked under Brumidi, began decorating the walls of Statuary Hall in the summer of 1902, painting them to resemble huge blocks of marble. The ceiling was also painted in a variety of colors highlighted with gold leaf. Pleasant little scenes of Mount Vernon, Arlington House, and the Washington Monument were painted in the connecting corridor, near where the Columbus doors once hung. Another artist, Elmer Garnsey of New York, had charge of decorating the new offices and committee rooms in the old library space.

In the spring of 1905, Gutzon Borglum, a sculptor later famous for Mount Rushmore, was paid $250 for suggesting improvements to the rotunda. He proposed removing the eight history paintings, lining the walls with marble, erecting pairs of tall Ionic columns, re-trimming the doorways, and placing sculptural panels above them. A new marble frieze representing American society would replace the unfinished painted frieze. Borglum's suggestions would have transformed the rotunda into a room on par with the Beaux Arts interiors being built in great urban libraries, train stations, and state capitols at the beginning of the century. His scheme, however, went nowhere and the only significant work on the rotunda during this period was the "restoration" of the stone walls that removed layer after layer of paint and whitewash. The work was termed a restoration in spite of the fact that paint was an

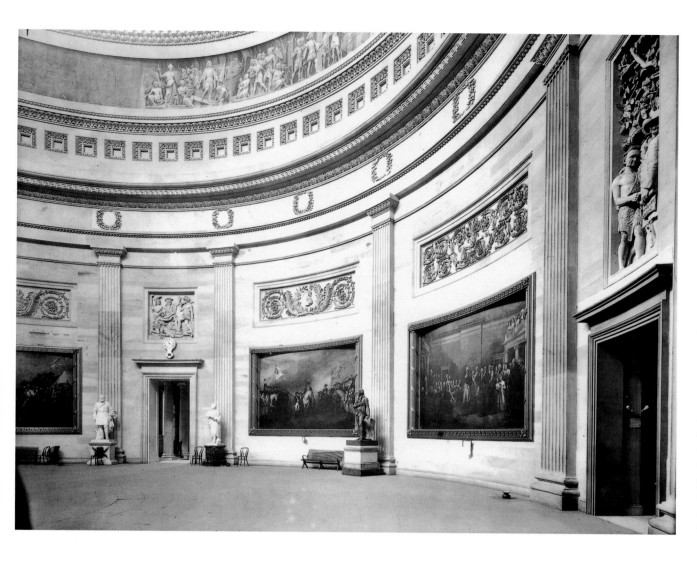

The Rotunda

ca. 1910

\mathcal{B}elieving that the walls of the rotunda were originally bare, the superintendent of the Capitol removed paint from the stonework, shown here soon after the "restoration" was completed.

original finish. Another contribution to the Capitol rotunda was made in 1907 when Woods installed a marble disk ten inches in diameter in the center of the floor. Despite proposals for major architectural embellishments, the little marble disk and the clean stone walls were the only modifications made to the rotunda during this period.

Woods' policy of stone "restoration" extended to the ornamental air shaft (called today the "small Senate rotunda"), where he removed the white paint from Latrobe's tobacco columns to reveal the brownish sandstone for the first time since the 1820s. The bare stone stood in stark contrast to the white plaster walls, creating an unexpected clash of colors and finishes, which the superintendent found disagreeable. In an effort to reconcile the different materials, Woods proposed replacing the plaster with an imitation stone to complement the "restored" stone columns. Unwilling to make such a drastic change without professional concurrence, he wrote to Carrère & Hastings:

> You will remember that we have been making some extensive restorations in the Capitol, whereby a large portion of the old sandstone work has been brought to light.

> . . . If it is the proper thing to do I would like to remove the plaster from the walls and give them a coat of stucco which would resemble the other stone and, in fact, be of such a character as practically become a stone. The vestibule would then appear to be entirely of stone.

> This method, you will understand, is not an attempt at imitation by painting, but it is an imitation by the use of actual building material.

> Will you kindly inform me if this is architecturally correct or whether or not such procedure might bring criticism? [14]

In a few days Woods had an answer. The firm declared that the proposal was "entirely reasonable and architecturally correct," citing precedents in Europe and America. It declared that the best and most current example of this type of treatment was found at the Pennsylvania railroad station in New York City, a monumental work by McKim, Mead & White. Travertine from Rome lined part of the walls, while the rest was "stucco cast to look exactly like real stone. There were structural reasons for not using stone throughout and reasons of architectural harmony for adopting the substitute."[15]

Thus assured by the highest authorities in New York, Woods instructed his assistant David Lynn to escort representatives from the Washington construction firm of Richardson & Burgess around the Capitol to look at painted plaster that might be replaced by imitation sandstone. Aside from the small Senate rotunda, they looked at heavily-traveled areas in the center building such as the passages on the ground floor, the crypt, and the vestibule in front of Statuary Hall (called today the "small House rotunda"). They proposed to do the work for cost plus 15 percent, an offer that was accepted on August 22, 1910. Soon, Richardson & Burgess began removing old plaster and installing the imitation sandstone that has proven to be a durable (and impossible to precisely replicate) surface material.

"COMPLETING" THE CAPITOL

In the early days of Woods' term, the east front extension joined the list of civic improvements planned for Capitol Hill. The idea had received little notice since Walter first proposed it in 1863, although most of Edward Clark's annual reports contained a line or two describing the advantages such an addition would have. Congressional nonchalance in the Gilded Age was superseded in the early twentieth century by an attitude more hospitable to ambitious civic improvements that would tout America's growing wealth, power, and self-confidence. Congress appropriated $1,500 in 1902 to give Woods the funds to prepare plans and estimates for an extension to the east front. In his report Woods submitted Walter's forty-year-old drawings and wrote that they would guide the project:

> Walter has left as a heritage the plans which I now present you for consideration. He had left us a picture of his conception of the completed Capitol. What greater tribute to his remarkable genius could be paid than to say that, if completed in accordance with his plans, the Capitol will gain a splendid addition, and yet, as one views it from the view point supposed in the perspective, it is still the Capitol.
>
> It would seem sacrilege to offer any other plan for consideration than the Walter plan. We may be safely guided by the thought, the effort, and the production of this great man's genius.[16]

Woods estimated the east front extension would cost $2,300,000. Joe Cannon took the matter before the House on February 10, 1903, and spoke in favor of the addition. He solemnly declared that, despite its grandeur and magnificence, the Capitol was an unfinished building. The additions built in the 1850s and 1860s were just the beginning of a more extensive program of enlargements. Using a familiar argument, Cannon cited the growth of the nation, the number of states, the population, and the number of representatives in Congress as justifications for a bigger Capitol:

> I am not an old man—I fancy I am not, but it is within my recollection as a boy, after I had begun taking some notice of public affairs as they were referred to in the few newspapers that we had back in 1850, as a lad of 14, reading that Congress had authorized the extension of the Capitol building; then year after year progress was reported on the dome, this wing, the other wing, and finally as I recollect, there was substantial completion—not full completion—along in the early sixties . . .

> But by the time the extension was determined upon we had 23,000,000 of people in the United States, 30 states—a population of 23,191,876 to be exact. The membership in the House, including delegates, was 173. Each Representative represented 134,000 people. There were 36 committees of the House. The minimum membership of any committee was 3 and the maximum 9. The number of States represented in Congress was 31. In 1900 the population was 76,000,000 plus. The membership of the next House, the Fifty-eighth Congress, will be 389, as against 173 a half century ago. Each representative will represent 190,000 people. There are now 45 committees of the present House,

as against 31 of the House a half century ago. The minimum membership of the committee is 5 and the maximum 17, as against 9 of a half century ago.[17]

Cannon cited the architectural reason for the extension and invited his colleagues to look up at the skirt of the dome and see for themselves how it appeared to hover in thin air over the east portico. He was neither particularly careful about the facts of the case, nor especially honest in manipulating the details of the building's history, but he made the east front extension sound like the logical next step in the Capitol's development:

> The central extension would be 55 feet beyond the wall line of the present wing. Now, gentlemen will notice that the western extension has lately been put into committee rooms for the House and Senate. That was completed according to the original design. The corresponding extension on the east was never built. If gentlemen want to verify—if it needs any verification—if you will go out and look at the Dome on the east side, looking at the main wall of the building, you will see that the Dome extends 9 or 10 feet beyond the main wall to the east . . .
>
> Now, I submit that the time has come, not only for an office building for the House, but for the completion of this Capitol.[18]

Cannon's last remark drew loud applause. He was also applauded when he spoke of the happy condition of the treasury, which permitted the extension to be funded with ease. Yet John H. Stephens of Texas challenged the contention that the east extension was simply a continuation of an ongoing (but stalled) project. In his view, the extension was an entirely new building and, therefore, required committee hearings and authorizing legislation. Despite Cannon's best efforts, the House took a cautious view of the question. On March 3, 1903, $7,000 was appropriated for study models of the Capitol showing the architectural effect of the proposed addition.

Before the models were begun, Woods and Cannon thought it would be wise to employ Carrère & Hastings to help with the extension design. Apparently, Woods no longer felt that the Walter design was the only one to consider. On April 28, 1904, Congress established a six-man commission comprising three senators and three representatives for the "extension and completion" of the Capitol. Among its duties, the commission would study and report on the idea of refacing the west elevation of the old Capitol with marble, replacing the west terrace steps with marble, and providing sculpture for the House pediment. Within two days of its creation, the commission hired Carrère & Hastings to assist in its multifaceted mission.

On December 27, 1904, Carrère & Hastings finished its report, which presented two schemes for the extension. The first envisioned a modest extension twelve feet deep, just enough to place a masonry wall under the skirt of the dome. This would provide the appearance of support that the dome seemed to require, but it would add little usable space on the interior: only two new rooms and several storage alcoves would be gained. The second scheme called for an extension thirty-two and a half feet deep, adding eighteen new rooms per floor as well as a corridor connecting the House and Senate wings. Both plans called for widening the new central portico by the addition of two columns, which would create a broader pediment. Thus, the central portico would become the dominant one, befitting its importance. Although its origins are unclear, Carrère & Hastings also presented a "Supplementary Report" showing the structural changes to the rotunda and surrounding areas necessary to replicate the dome in marble.

In stating the opinions of the firm, Carrère & Hastings declared a decided preference for the first extension scheme. It changed the Capitol the least, and it solved the architectural problem just as well as the larger addition. They recommended preserving the forecourt and condemned the idea of bringing the central portico in line with the porticoes of the two wings. That alignment would obscure the view of the wings when seen from an oblique angle. This admonition was not a rebuke to Walter, whom they thought had been obliged in his day to provide an extension with as many rooms as possible. Now that office buildings were under way, the need for additional rooms in the Capitol was not as urgent.

On other matters, Carrère & Hastings recommended that the west front be refaced with marble, exactly reproducing every detail of the historic facade. There was no pressing architectural problem to solve on that side of the building, but the deteriorated sandstone walls—with some of its

carved details held together by paint—was an embarrassing sight. Olmsted's stairs were also worn, and the firm recommended replacing the bluestone steps with marble. Finally, they estimated $55,000 would be needed to commission a sculptural group for the long-vacant House pediment. In all, Carrère & Hastings described $1,333,000 worth of improvements, but the pediment sculpture was the only item approved.

In the days of Captain Meigs, several sculptors wanted the commission to fill the House pediment with something equivalent to Crawford's *Progress of Civilization.* In the Pierce and Buchanan administrations Henry Kirke Brown, Erastus Dow Palmer, and a few other artists presented designs that were not accepted for various reasons. In 1869 Clark Mills' son Theophilus came close to landing a commission for a group of sixteen figures representing the emancipation of slaves. His extravagant fee ($130,000), however, doomed the project. In 1879 Launt Thompson of New York proposed a sentimental group illustrative of "Peace and Plenty," but his plan went nowhere as well. By the dawn of the twentieth century Gutzon Borlum and Charles Neihaus were working on designs that they hoped would persuade Congress to fill the empty pediment. The time was finally propitious for such civic improvements, after decades of what has been termed "official disinterest."[19]

Borglum produced a composition entitled *The Building of a Nation,* while Neihaus' group was called simply *The Law.* Unfortunately, each artist estimated that his works would cost about $110,000, or twice what Carrère & Hastings suggested. These prices did nothing to smooth the way for congressional approval, and the project stalled for a while. In 1908, Representative Samuel McCall of Massachusetts nudged it along by asking Woods how much money should be included for the House pediment in a bill he planned to introduce. The superintendent replied that $55,000 was needed for statuary and about $20,000 was needed for contingencies. McCall's legislation was approved on April 16, 1908, and the pediment appeared destined to be completed at last.

As soon as the money became available, Woods contacted Neihaus about doing the pediment for the sum stipulated in McCall's bill. The sculptor agreed, but the final decision was left up to members of yet another commission, this one made up of members of the Joint Committee on the Library (including McCall), the Speaker, and the superintendent. The commission returned to Carrère & Hastings for advice and the firm recommended four eminent artists, including John Quincy Adams Ward, who replied that at age seventy-eight he was simply too old to consider doing it: he recommending Paul Wayland Bartlett instead.[20] Bartlett had collaborated with Ward on the pediment for the New York Stock Exchange, a work fairly equivalent to the House pediment. A second endorsement was given by National Sculpture Society. On May 26, 1908, Bartlett was given the contract subject to the approval of the commission. Without lifting a finger on his own behalf, Bartlett bested some of America's most prominent artists, some of whom had spent large parts of their careers vying for the job.

While in Paris during the summer of 1908 Bartlett received photographs of the House pediment annotated with its dimensions. He modeled small clay maquettes for a work called *The Apotheosis of Democracy* that would be further refined and developed as his ideas matured over the course of the project. Two central figures representing *Peace Protecting Genius* stood between a group entitled *The Power of Labor: Agriculture* and another called *The Power of Labor: Industry.* Bartlett finished the first two sketches in September 1908, and upon returning to America he showed them to Woods, Cannon, McCall, and other members of the pediment commission. They approved the concept and basic design on February 16, 1909.

By the terms of his contract, Bartlett had three years to finish the sculpture, yet it would actually take more than seven years to complete and install. Curiosity about the project was strong, both in France and America. Periodicals, such as *Scribner's Magazine,* carried illustrated articles that gave the public a look at the great work destined for the Capitol. As time wore on, Bartlett was twice able to extend the deadline with Woods' blessing. The superintendent advised the Speaker that it was better to suffer delay rather than hurry the work and suffer an inferior product. Most of the figures were sculpted in France and, one by one, shipped to New York, where Italian-born

carvers replicated the models in Georgia marble. The finished products were sent to Bartlett's Washington studio, near Union Station. There the city's elite, including Mrs. Woodrow Wilson, came to have a close look. In the summer of 1916 *The Apotheosis of Democracy* was finally completed and installed in the pediment that had stood empty since 1865. The magnificent work was unveiled during a ceremony held on August 2.

RETHINKING THE HOUSE CHAMBER AGAIN

The day before Bartlett's composition was approved by the pediment committee, Samuel McCall reported on another matter related to improvements for the House of Representatives. As the result of a resolution passed on May 12, 1908, the Committee on the Library investigated the acoustics, ventilation, and general accommodations of the House chamber. This latest study had a long pedigree that could be traced to the time when representatives first complained in 1857 about the "artificial" air they were obliged to breathe. This time, however, McCall looked into other matters as well. His committee was asked to consult with architects about a complete reconstruction of the room to place it in direct contact with the south wall and thereby take advantage of the windows there. Reducing the size of the room so as to make speaking and hearing easier, was another topic of consideration. Woods was directed to report to the Speaker about the issues before the committee. As usual, he turned immediately to Carrère & Hastings for help.

Unveiling of
The Apotheosis of Democracy
1916

Paul Bartlett was commissioned in 1908 to create sculpture for the House pediment, which had stood empty for forty-three years.

Peace Protecting Genius
by Paul Bartlett
ca. 1908

These figures in *The Apotheosis of Democracy* were the focal point of Bartlett's composition. Represented as a winged youth holding the lamp of knowledge, the figure of Genius is protected by a resolute figure of Peace crowned by a laurel wreath.

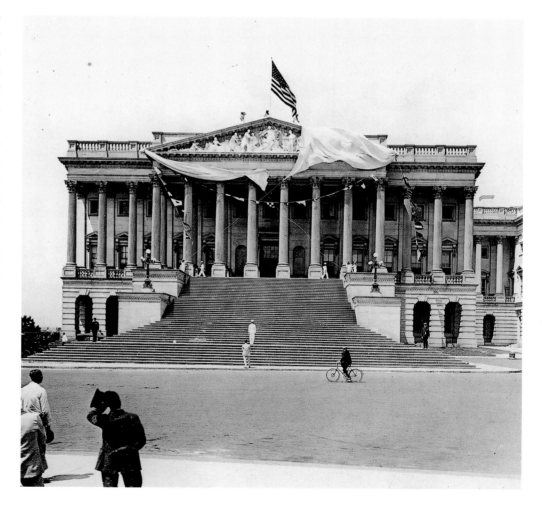

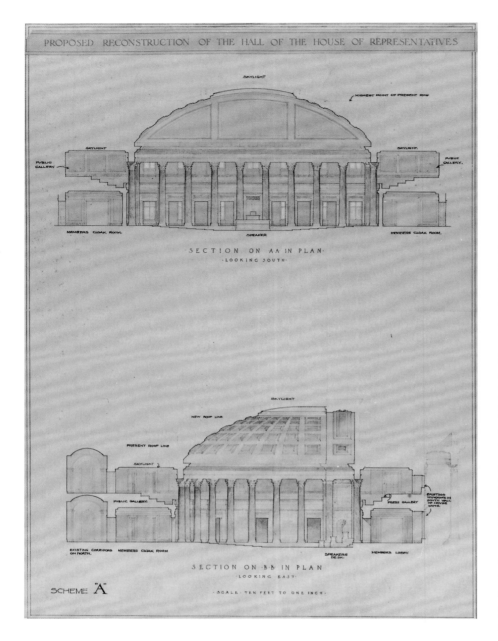

PROPOSED RECONSTRUCTION OF THE HALL OF THE HOUSE OF REPRESENTATIVES

SECTION ON AA IN PLAN·
·LOOKING SOUTH·

SECTION ON BB IN PLAN
·LOOKING EAST·

·SCALE·TEN·FEET·TO·ONE·INCH·

SCHEME "A"

Scheme "A" for Rebuilding the House Chamber
by Carrère & Hastings, 1908

*S*tatuary Hall was the model for this scheme to rebuild the House chamber.

There was nothing new about the complaints regarding the hall's ventilation, nor was the proposed solution novel. Removing the south wall would allow windows in the members' retiring room and the press gallery to light and ventilate the chamber. Carrère & Hastings developed at least five designs for rebuilding the chamber with

these windows as part of the scheme. One was a reproduction of Statuary Hall, a sentimental favorite of Woods and the consulting architects. Two other options would have created rectangular chambers somewhat smaller than the one in use. One retained the long axis parallel to the south wall; the other rotated the axis ninety degrees, placing the Speaker's chair in the center of the east wall. Although the latter design offered some structural advantages, it found no favor with Woods, who called it "faulty."

In each proposal, emphasis was placed on reducing the size of the floor and the gallery and increasing the size of the cloakrooms and the number of seats on the floor. The arrangements were developed using the superintendent's considerable experience with the existing room as well as Carrère & Hastings' experience designing auditoriums and theaters in New York. The firm also studied materials about the legislative halls of England, France, Germany, Austria, and other European nations collected by McCall. The foreign halls were found to be equally divided between rectangular and semicircular chambers, and all but the British Parliament (in which legislators faced each other on benches) arranged seats in concentric rows, like those already set up in the House and Senate chambers.

Reducing the size of the House chamber was a goal of this reconstruction project, and it was given close attention in the report that McCall communicated to the full House on February 15, 1909. He noted that there was "no critic of repute who has written about the House of Representatives who has not commented upon the inordinate dimensions of the chamber and its adverse effect upon debate and deliberation."[21] After citing a few examples, McCall quoted at length from *Congressional Government: A Study in American Politics*, Woodrow Wilson's classic look at congressional domination of American government published in 1885. It was written while Wilson pursued a doctorate in political science at John Hopkins University and contained insightful observations about the room in which the House conducted its business:

> There are, to begin with, physical and *architectural* reasons why businesslike debate of public affairs by the House of Representatives is out of the question. To those who visit the galleries of the representative Chamber during

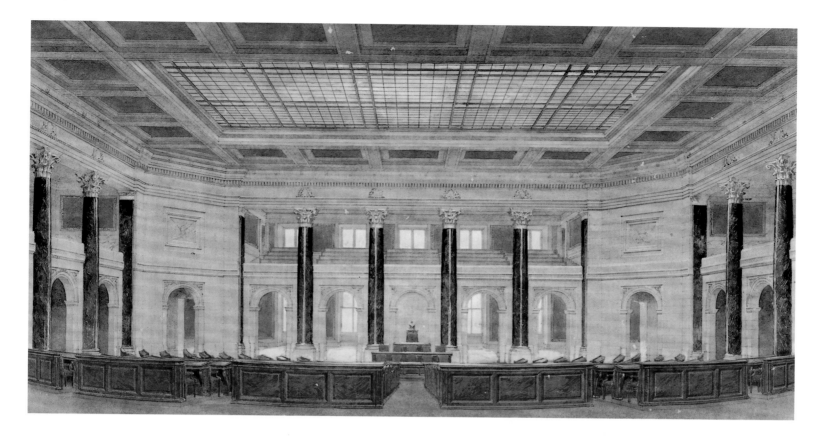

Scheme "B" for Rebuilding the House Chamber
by Carrère & Hastings, 1908

*R*emoving the press gallery and the members' retiring room would allow a reconstructed House chamber to have windows.

a session of the House these reasons are as obvious as they are astonishing.

It would be natural to expect that a body which meets ostensibly for consultation and deliberation should hold its sittings in a room small enough to admit of a easy interchange of views and a ready concert of action, where its members would be brought into close, sympathetic contact; and it is nothing less than astonishing to find it spread at large through the vast spaces of such a chamber as the Hall of the House of Representatives, where there are no close ranks of cooperating parties, but each Member has a roomy desk and an easy revolving chair; where broad aisles spread and stretch themselves; where ample, soft-carpeted areas lie about the spacious desks of the Speaker and clerk; where deep galleries reach back from the outer limits of the wide passages which lie beyond the "bar": an immense, capacious chamber, disposing its giant dimensions freely beneath the great level lacunar ceiling through whose glass panels the full light of day pours in. The most vivid impression the visitor gets in looking over that vast hall is the impression of space.

A speaker must have a voice like O'Connell's, the practical visitor is apt to think as he sits in the gallery, to fill even the silent spaces of that

room: how much more to overcome the disorderly noises that buzz and rattle through it when the Representatives are assembled—a voice clear, sonorous, dominant, like the voice of a clarion. One who speaks there with the voice and lungs of the ordinary mortal must content himself with the audience of those Members in his own immediate neighborhood, whose ears he rudely assails in vehement efforts to command the attention of those beyond them, and who, therefore, can not choose but hear him.[22]

McCall speculated that the magnitude of the hall had diminished the influence of the House of Representatives over the years. Why were the great orators in the history of the House—Henry Clay, Daniel Webster, and John Quincy Adams—associated with the old hall while no one serving in the new chamber could match former oratorical

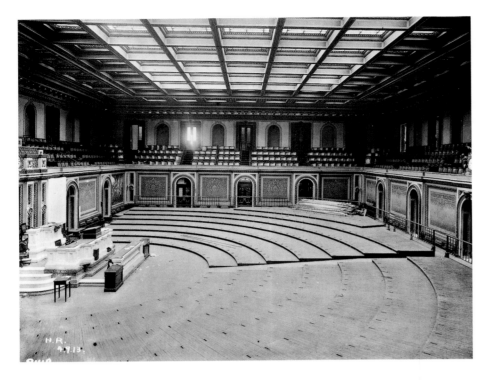

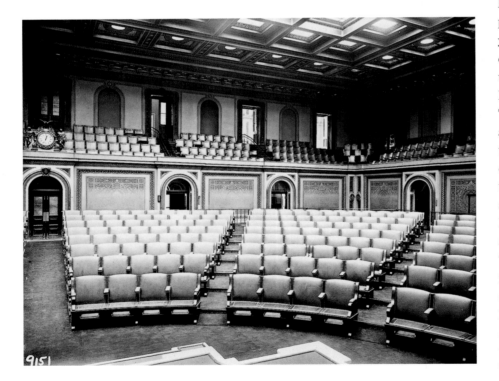

House Chamber with a New Floor (top) and New Seating (bottom) 1913

An increased membership following the census of 1910 caused 450 fixed seats to be installed in place of desks and chairs. The new arrangement permitted more space for aisles, thus making it easier and quieter to move about the room.

greatness or political influence? The fault, he concluded, was the size of the chamber rather than the quality of the nation's representatives.

McCall informed the House that the Library Committee had digested the information presented by the consulting architects and disapproved the superintendent's recommendation of scheme "A," the one based on the Statuary Hall prototype. He stated that it would appear ridiculous to have nearly identical chambers situated so close by—one filled with statues and the other with the people's representatives. In addition, the chance of encountering acoustical problems in the half-domed chamber should not be risked. His committee, therefore, recommended scheme "B," a plan promising great architectural improvement as well as a better room for debate. It reduced the floor area by 2,220 square feet and the gallery by more than 3,200 square feet. The size of the cloak rooms was increased by 3,700 square feet.

Despite the elegance of the new hall that McCall proposed, members of the House were not prepared to undertake such drastic action quite yet. Compelling arguments in favor of a smaller chamber were opposed by those who could not understand why it should be shrunk just when the House was about to gain forty-four new members. The idea to reconstruct the chamber was eventually doomed by the census of 1910, which increased the number of representatives to 435—a number destined not to change. Instead of being resized, the chamber was subjected to the latest in a long series of rearrangements. On January 10, 1913, the House voted $25,000 to buy new furniture to accommodate 450 seats on yet another new floor. The Francis H. Bacon company of Boston supplied roomy chairs and two large tables for the leadership. (Bacon, an old friend of Thomas Hastings, had also made much of the furniture for the House and Senate office buildings.) Gone forever were the individual desks that took up so much room, but the more spacious aisles made movement about the hall easier and less disruptive.

The latest increase in the membership of the House obliged the enlargement of its five-year-old office building as well. Forty-eight new rooms were built in the attic by cutting the roof beams and lifting a new roof into place while the building remained open and fully occupied. All the new

Stair Repair
1915

*A*fter ninety years of wear, the sandstone steps leading to the central portico were taken up in the summer of 1915 and replaced with granite. Workmen laid tar-soaked sheets as a waterproofing measure before installing the new treads.

The Grounds
ca. 1910

*S*ince 1867 the Capitol grounds have been under the care of the architect of the Capitol. Keeping the grass cut (top) and the trees healthy (bottom) are two important parts of the job.

rooms faced the interior courtyard, while the sloping roof that faced the streets provided space for a narrow corridor and dark, but handy, storage rooms under the eaves. Five elevators were extended to serve the new fifth floor, which was occupied in 1914.

WHAT'S IN A NAME?

*D*espite the nation's reluctance to enter into European conflicts, unprovoked attacks by German submarines against American shipping finally forced President Wilson to ask Congress for a declaration of war on April 2, 1917. Neutrality had not sustained peace, and the president promised that joining France, England, Russia, and other Allied Powers in the fight against the Central Powers would make the world "safe for democracy." Along with the troops and gas masks, the world war exported such treasured American images as the stars and stripes, Uncle Sam, and the Capitol's dome into the European theater, pressing America's message of determination, confidence, and moral uprightness. At home, the Capitol stood unfortified and open as always. As a boost to morale, flood lights were installed to illuminate the dome and its crowning statue. Lights were usually left on until midnight. The only defensive measure taken to secure the building during World War I was to hang new iron gates at the main entrances, which were closed and locked only at night.

The Capitol's calm appearance during the war helped keep spirits high without hinting at the deteriorating relations between the president and Congress that took place inside. With the end of the war came a retreat from world affairs that suited America's isolationist mood, and its attention returned to the heady business of making money. Wilsonian idealism was a burden most Americans happily traded for the "normalcy" of Warren G. Harding, as lighthearted a president as the nation had ever seen.

A spirit of peace and prosperity pervaded society in the happy-go-lucky days leading up to Harding's campaign and election. One small example of the national good mood occurred unexpectedly in early 1921, when Elliott Woods was elected an honorary member of the Washington chapter of the American Institute of Architects. The ill will that once existed between the Institute and the superintendent melted away as the architectural community of Washington recognized that Woods was responsible for some of the city's best new buildings. At the same time, Speaker Joe Cannon was afoot in the House of Representatives with a bill to restore the title of Woods' office to *architect* of the Capitol. On January 13, 1921, Cannon addressed the House about the superintendent's service on Capitol Hill and beyond:

> Mr. Woods is aging, but he is as competent today as he ever was. He is the best architect that I ever met. He had charge of the construction of the buildings here; he had charge of the Court of Claims building, which was overhauled by him; and he had charge of the courthouse down here. You are familiar with his work. He has done whatever he was called on to do without any increase of salary, so far as that is concerned, and he is not asking for it. He is not a very old man. I think he is between 50 and 60 years of age, but as he is getting along in years he would like to be called "architect."[23]

James R. Mann of Illinois remembered the days when Woods' office was called "architect of the Capitol" and considered the restoration of the title a worthwhile—although mostly sentimental—gesture. He understood that it meant a great deal to the superintendent, who had earned the title by virtue of his successful architectural projects. Mann also corrected a misapprehension held by a few members, who thought the measure would create a new position with new demands on the treasury. Mann made it clear that only the name of the office would be affected and no additional expense would be incurred. With its opponents thus assured, the measure was approved. Under the provisions of the Legislative Act signed on March 3, 1921, the office of "superintendent of the Capitol" was restored to its old title of "architect of the Capitol." Harding took the oath of office as the nation's 29th president the next day.

Woods was exceedingly gratified by the congressional action that restored the noble title of his office. He placed announcements in the local newspapers to inform businessmen of the change and was soon greeted with letters of congratulation. Typical of such correspondence was a letter from

James Tanner, a District court official and a fellow Hoosier who had known Woods since his youth:

> Speaking very seriously, I desire to say that I think that Congress, under the leadership of old Uncle Joe, has done a mighty just thing in adding the peacock feather they did to your tiara. You have repaired, embellished and glorified so much of our much abused city that it was your absolute due. I do not consider it a compliment to you, I consider it justice.[24]

No one was happier than Thomas Hastings. His association with Woods over almost twenty years had developed into a close friendship, and he wished to further Woods' standing by making him a full-fledged member of the American Institute of Architects. Hastings told his friend that he wanted to have the "real joy" of delivering full membership to him.[25] Woods, however, thought his status as an honorary member of the Washington chapter was not enough to promote him to full membership and advised Hastings to drop the matter. He was just as grateful for the mere proposal. Undeterred, Hastings placed Woods' name in nomination and asked Electus D. Litchfield and Henry Bacon, other prominent New York architects, to second it. Hastings told Woods that he was confident that the nomination would go through with flying colors. "Three cheers," Hastings wrote, "if anyone should be in the institute you should certainly be, and we will receive you with open arms."[26] On May 7, 1921, the secretary of the AIA informed Woods of his election. He was honored to join the professional association that once scorned him.

Unfortunately, Woods had only two years to enjoy the cherished title of architect of the Capitol. In the summer of 1923, while on vacation at Spring Lake, New Jersey, he died of heart failure at age 59. Vice President Calvin Coolidge and Speaker Frederick H. Gillett were among the honorary pall bearers at his funeral. Soon after the last rites were concluded, senators, representatives, and the employees of the office were busy writing President Harding about Woods' successor. The near unanimous choice was David Lynn, who had worked in the architect's office since 1901. (Glenn Brown wanted to be considered again but was advised not to meddle in the "family affairs" of Capitol Hill.) Lynn had begun as a laborer and worked his way through increasingly responsible jobs, such as foreman of cleaners,

watchman, and civil engineer, before becoming Woods' trusted assistant; indeed, his climb through the ranks paralleled Woods' own career under Edward Clark. He was from an old Maryland family, handsome and agreeable, and blessed with a knack for making friends in high places. Senior senators such as Furnifold M. Simmons of North Carolina, Oscar Underwood of Alabama, and Charles Culberson of Texas sent testimonials to the president regarding his suitability for the architect's job. Simmons wrote:

> Although I am a member of the Minority Party, I think that our personal relations will render my recommendation in the matter of filling the vacancy not unwelcome to you. When you were in the Senate you must have yourself met

Capitol Storeroom
ca. 1915

*B*y the early twentieth century, a room originally used as a restaurant (modern day SB–17) served as a storeroom stocked with such supplies as cakes of soap; bundles of rope, hose, and wire; bins of spare plumbing parts; and cans of French zinc. Seated at the desk is the superintendent's right-hand man, David Lynn (1873–1961), who would succeed Elliott Woods in 1923.

Mr. David Lynn. . . . I earnestly hope that you will decide to appoint Mr. Lynn. Mr. Lynn is a Civil engineer of long experience, a gentleman of the highest character, and he is personally very popular with all of us who have come in contact with him.[27]

Simmons' recommendation was echoed by numerous senators and congressmen who wrote from their homes while away from Washington's summer heat. Employees of the architect's office submitted a petition to the White House supporting Lynn. Congress was in recess when Woods' death occurred, and the president himself was about to embark on a trip west for recreation and to explain his administration's faltering policies. On August 2, 1923, while in San Francisco, Harding suddenly died of a stroke. Three weeks later and with little fanfare, President Coolidge appointed David Lynn architect of the Capitol.

The transition from Woods to Lynn was seamless. Newspaper articles about the new architect described Lynn as having grown up in the office, deserving the post by virtue of his intimate knowledge of the Capitol and the details of the job. He was usually referred to as the "fifth" architect of the Capitol, a numerical designation that Lynn himself probably created. The new architect was an amateur historian and genealogist who liked the idea that his office traced its roots to Washington's administration. While a part of the office was indeed an heir to the functions of the board of commissioners that Washington appointed in 1791, Lynn looked upon Dr. William Thornton as his professional forefather, citing him as the "first" architect of the Capitol. Lynn thought that Washington had appointed Thornton in 1793 to an office with the title of "architect of the Capitol," and no one questioned the matter. Similarly, Latrobe was designated the "second" architect, Bulfinch was the "third," and Walter was the "fourth." The actual evolution of the office was honorable and

Senate Barber Shop
ca. 1925

From 1860 to 1980, the Senate barber shop occupied a room in the old north wing (modern day S–145) first designated as a committee room in the Hallet-Thornton era floor plans. Following the fire of 1814, the room was occupied by the chief clerk of the Supreme Court.

Conveniences such as bathing rooms and barber shops were provided during a time when most legislators lodged in boarding houses or hotels, where such facilities were either crowded or nonexistent. Shaving mugs personalized with senators' names were stored in the cabinet near the entrance.

interesting, but it was also far too complicated to recite so easily. (Thornton never held an office with the title "architect of the Capitol," for example, and Latrobe and Bulfinch both worked under contract and did not occupy a government office as such.) While overly simplistic and fundamentally inaccurate, Lynn's view of his office helped bolster the pedigree of the position he now held.

Design for a New Senate Chamber
by Carrère & Hastings, 1924

*C*arrère & Hastings' proposal for the new Senate chamber included the Ionic order along the north wall and Doric columns supporting a semicircular gallery. Three tall arched windows would have provided the natural light and air that some felt were vital to good health. Air-conditioning and the stock market crash put an end to the project.

RETHINKING THE SENATE CHAMBER AGAIN

*O*n June 7, 1924, a busy day at the end of a long session of Congress, the Senate passed a resolution directing the architect of the Capitol to consult with reputable architects to improve the "living conditions of the Senate Chamber."[28] With a note of irony, Senator William Borah of Idaho asked if the measure would bring the Senate in "touch with the outside world," prompting Senator Royal S. Copeland of New York, from the Committee on Rules, to reply that it was a distinct possibility. The veiled reference to windows and a more comfortable chamber led the Senate to adopt the measure unanimously. It was the latest in a series of attempts to reconstruct the Senate chamber and to overcome Captain Meigs' legacy of a windowless room.

Instinctively, Lynn turned to Carrère & Hastings for assistance. Within five months the firm developed a design for rebuilding the chamber and adjacent rooms. To improve the space's acoustic qualities as well as its architectural treatment, Carrère & Hastings proposed to rebuild it in the form of a semicircle, covered by a low half dome. They cited Statuary Hall as the source of inspiration, saying that the new design "adhered strictly to the best traditions of the early part of the nineteenth century as evolved from the highest development of classical types."[29] Three two-story windows on the north wall would have provided an agreeable light, free from the direct glare of the sun. Little change to the outside appearance would have been noticed, but on the interior the marble room, president's room, vice-president's office, and press galleries would be sacrificed. Mechanical

ventilation would still be needed to augment the air introduced from the windows, but an investigation into the equipment and cost would wait until after the improvements were authorized. The cost of the new chamber was estimated at $450,000.

The design Carrère & Hastings proposed was a straightforward plan with a row of engaged Ionic columns placed along the north wall framing the windows and the central podium. Copied from the Ionic of the Erechtheion in Athens, the order was the same one that Latrobe used in the old Senate chamber. A lower ring of Doric columns carried the semicircular gallery opposite the windowed wall. For acoustical reasons the domed ceiling was kept low and deeply coffered. Walls were depicted as perfectly smooth blocks of marble or some other fine stone. The overall effect was masculine and stately, an elegant essay in the neoclassical revival style—expressed, in this instance, with Grecian orders. According to one account, Thomas Hastings considered Walter's "early Victorian" interior "too dreary and formidable for members of the Senate to maintain a cheerful frame of mind." The new design was more "cheerful" by virtue of its "early Colonial" inspiration.[30] Despite such haphazard use of architectural and historical terms (Grecian architecture is hardly "colonial," for instance),

the notion that the new design would rid the Senate chamber of its Victorian gloom by introducing architectural splendors from the early republic was a new twist in an old saga. Earlier complaints had been focused only on the lack of fresh air, but now the architectural style of the chamber was condemned as well.

Senator Copeland of New York was the principal proponent of relocating the chamber. A medical doctor by training, he was a former commissioner of public health, and president of the New York Board of Health, who had gained a national reputation through radio broadcasts and writings devoted to health issues. He now found himself greatly disturbed by the lack of fresh air in the Senate chamber. "I think it is a shame," he said sadly, "to see men in this chamber sicken and suffer as they do." [31] Finance Committee chairman Reed Smoot of Utah, who had served in the Senate since 1903, backed the move as well. He claimed that his health had been impaired by his long service in the windowless chamber and declared that the time had come to rebuild the room.

In 1927, while Copeland and Smoot worked for the adoption of Carrère & Hastings' plan, a commission of experts was formed to advise the architect of the Capitol about a new and wondrous improvement in the science of ventilation called "air conditioning." The commission's chairman was a professor of public health at Yale University, while other members of the eleven-person board included doctors, mechanical and sanitary engineers, and leading experts on ventilation. Hearings were held and the matter was fully discussed before going before the Committees on Appropriations. With relative ease, $323,000 was secured to install "dehumidifying air conditioning apparatus with automatically controlled ducts" in both the House and Senate chambers.

The Carrier Engineering Corporation won the bidding to air-condition the two chambers and adjacent cloak rooms. Air was introduced into the chambers through diffusers in the iron ceilings, which were supplied by ducts that snaked across the roofs and eventually descended to the equipment rooms under the terrace. One group of registers was placed directly over the floor area, and a separate ring of diffusers was placed over the galleries. By this means an "invisible partition" was created, allowing the temperature at the floor level to be unaffected by the number of persons in the galleries. [32] Two additional zones were installed, one each for the Republican and Democratic cloak rooms. Work was completed on the hall of the House by December 3, 1928, the opening of the second session of the 70th Congress, but it was deferred in the Senate while relocation of the chamber was being discussed.

During the first session of the 71st Congress the Senate chamber was fitted with an air-conditioning system. The equipment was operational by August 1929, bringing welcome relief to senators suffering through an unusual session that had begun on April 15. Calling its product "Manufactured Weather," the Carrier Corporation correctly predicted that its ventilation system would have a profound effect on the operations of Congress:

> Whether it be bitingly cold or raw or insufferably, enervatingly, prostratingly hot and humid *outside, inside* the historic walls of Congress it will always be comfortable, not only, but healthful, invigorating, inspiring.

> Manufactured Weather may, indeed, have a profound effect upon our governmental system! Congress may voluntarily remain in session throughout the summer,—in order that our Congressmen may be protected from the intolerable discomforts and dangers of the ordinary outdoor weather! [33]

Cooler air in the summer brought relief to be sure, but the major health benefit of "manufactured weather" was the control of humidity. The dry air used to heat the legislative chambers in winter was blamed for such ailments as grippe, influenza, bronchitis, and the common cold. Indoor air deficient in moisture was, according to the Carrier Corporation, "a menace to Health, ruinous to Comfort." [34] The benefits of air conditioning might not be as noticeable in winter, but its effects on health were welcome in all seasons.

The novelty of air conditioning promised to startle some senators unaccustomed to cool, dry air in summertime. Lynn had notices printed to assure them that there was nothing to worry about when experiencing an air-conditioned room for the first time. After explaining the mechanics of the new system he wrote:

> The sensation of chill experienced upon entering the Senate Chamber is due principally to the dryness of the air causing the evaporation

of the slight amount of moisture of the skin. After the completion of this evaporation the body will be perfectly comfortable, for the actual difference in temperature between the inside and outside air is very small. No fear may be felt by the occupants of the Senate Chamber from the conditions produced by this new system of ventilation and air conditioning.[35]

Once the chamber was air-conditioned Senators Copeland and Smoot dropped their crusade to relocate the room. The Senate chamber had joined the hall of the House to become one of the two most comfortable rooms in the Capitol. Despite its "gloomy Victorian" appearance, it felt wonderfully modern. A few months after the air conditioning was turned on, two unrelated factors conspired to doom the relocation project forever. The project's artistic director, Thomas Hastings, died of an appendicitis on October 22, 1929, two days before the great New York stock market crash—Black Thursday.

Air conditioning quickly became an indispensable part of life on Capitol Hill. In 1935, Congress appropriated $2.5 million to provide the rest of the Capitol and the office buildings with this new form of ventilation. The Carrier Corporation won the contract to air-condition the Capitol, while two of its competitors were hired for the office buildings. Central refrigeration equipment was installed at the Capitol power plant, whence chilled water was conducted to the various buildings through underground tunnels. At the Capitol, holes were cut in floors and walls to make way for metal duct work. Once again the massive structure proved capable of sustaining the loss of building materials (mainly brick) without any threat to its stability.

THE GROWING CAMPUS

lthough Senator Smoot eventually abandoned his efforts to have the Senate chamber rebuilt, he was instrumental in relocating the Supreme Court into its own building. In 1925, he proposed to spend fifty million dollars on new buildings in the federal city, and the chief justice of the United States, William Howard Taft, had a project in mind to help use part of the money. Taft took it upon himself to urge Congress to authorize a new home for the

Court, thus ending its "temporary" status as a guest of the Senate. For the past century and a quarter, the Court had borrowed space in the old north wing; it had been using the old Senate chamber for its proceedings since 1860. Whenever the Senate was provided with more space, the Supreme Court fell heir to a little more room as well. This was true when the old library space was converted into offices in 1900 and true again when the Senate office building opened in 1909. In both cases, although the Supreme Court gained a few rooms in the Capitol, there was still not enough space for each justice to have an office, and, as a result, most worked at home.

Chief Justice Taft argued that the present accommodations for the Court were woefully inadequate, certainly less convenient than what a lower court would find acceptable. Lawyers coming before the Court had no place to work, no table to use when making last-minute changes in their cases, no chair to sit on while reading a brief. They did not even have a place to put their coats and hats. While a mere symptom of a larger problem, this lack of basic accommodations for attorneys had an adverse effect on the Court. When Associate Justice Willis Van Devanter testified before a House committee considering a new building for the Supreme Court, he asserted that the lack of facilities for out-of-town attorneys accounted for some ill-prepared presentations, which, in turn, wasted the Court's time.

In December 1928, Congress responded to Taft's initiative by creating the United States Supreme Court Building Commission. The success of earlier commissions for the House and Senate office buildings had led the way for a new one, which would steer its project over the next seven years. Taft was designated chairman and was joined by Van Devanter, the chairmen and ranking members of the Committees on Public Buildings of the House and Senate, and the architect of the Capitol.

Like the commissions that came before it, this one produced magnificent results with virtually no acrimony. Deciding upon the architect, for instance, was an easy task. While Lynn would have undoubtedly recommended Carrère & Hastings for the job, the chief justice had already established a close relationship with Cass Gilbert of New York. Gilbert was another giant in the architectural

Portrait of Cass Gilbert

by Robert Aitken

ca. 1933

Collection of the Supreme
Court of the United States

*G*ilbert (1859–1934)
studied architecture at
the Massachusetts Insti-
tute of Technology and
spent his early career
working for McKim, Mead
& White. In 1895 he won
the competition for the
Minnesota State Capitol,
a project that earned him
a national reputation.
The Woolworth Building
in New York, one of his
most famous works, was
the tallest building in the
world when it was com-
pleted in 1913. Many of
Gilbert's buildings were
classical, including the
Treasury Annex (1918)
and the U. S. Chamber of
Commerce Building
(1924), both located in
Washington. His last
work, the U. S. Supreme
Court, was perhaps his
crowning achievement.

profession whom Taft had (when president) appointed to the Commission of Fine Arts in 1910. With Chief Justice Taft's encouragement, Gilbert began sketching designs for the Supreme Court in 1926.

As recommended earlier by the McMillan Commission, the site favored by the commission for the new Supreme Court building was on First Street east, directly across from the Capitol between Maryland Avenue and East Capitol Street. Two other locations were also mentioned, but neither was seriously considered. Judiciary Square, the Court's intended location on the L'Enfant plan, was already occupied by the massive brick Pension Building (now home of the National Building Museum). Another site near the Tidal basin was a possibility, but it was reserved for an unspecified monument by the McMillan Commission; the Jefferson Memorial was later built there. Gilbert did not like the site across from the Capitol because of its subordinate position and because Maryland Avenue, one of L'Enfant's diagonal streets, made it irregular. Nor did he like the idea of building next to the baronial Library of Congress. Gilbert proposed creating a new park for the Court about half a mile directly east of the Capitol, but that would have entailed the condemnation and destruction

of hundreds of post Civil War row houses—a time-consuming and expensive undertaking. Notwithstanding Gilbert's views, the site for the Supreme Court was not changed from the spot specified by the McMillan Commission.

Gilbert was formally commissioned to design the Supreme Court building in April 1929. Soon the architect and his assistants showed a preliminary design, along with an estimate of the cost of materials and labor for the complicated undertaking. Their work was approved by the commission, and, on May 25, 1929, the Speaker was informed that the new Supreme Court building would cost $9,740,000. The funds were appropriated on December 20, and demolition of the residential structures on the site was begun soon thereafter. On February 3, 1930, with the funding secure and the project well under way, the ailing chief justice retired from the Court and from the commission. The following day Gilbert wrote Taft an affectionate note that read in part:

> I have felt it to be a great honor to be selected
> by you as the architect of the new Supreme
> Court building and I have endeavored to make
> a design which shall be worthy of its great pur-
> pose and of your ideal. I shall always think of
> you as the real author of the project and the
> one to whose vision we shall owe a suitable
> housing for the Supreme Court of the United
> States. It will, in fact, be a monument to your
> honored name.[36]

The design of the Supreme Court building achieved a balance between classical grandeur and quiet dignity, appropriate for the nation's highest court. Unlike the Library of Congress building next door (a textbook example of the flamboyant Beaux Arts style), the Supreme Court was designed in a quieter, more reserved style now termed neoclassical revival. The building was a steel frame structure faced with white marble. The facade was about 300 feet wide with a central temple-like pavilion fronted by a monumental portico of sixteen Corinthian columns supporting an elaborate entablature. The commanding central section was flanked by lower wings in the Ionic order. Four spacious courts provided the interior with unexpected sources of light and air. The plan carefully and deliberately separated the justices' working areas from the public, ensuring privacy and quiet. Visitors approached the building by way of a long flight of marble steps leading to the portico and a grand rectangular vestibule

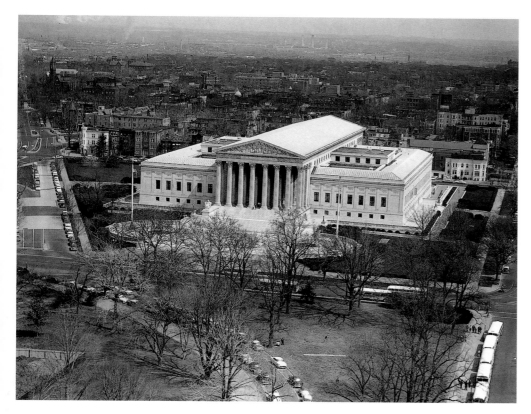

Supreme Court

*O*f the many architectural improvements made on Capitol Hill during the twentieth century, perhaps the most significant was the new building for the U. S. Supreme Court, which was finished in 1935. (1958 photograph.)

Supreme Court Law Library
ca. 1935

*T*he law library is one of America's great Georgian revival interiors.

(called the "Great Hall"), thirty feet high and lined with Doric columns. Straight ahead was the courtroom, a space about sixty-four feet square and lighted by side windows behind screens of Ionic columns. Although the court room could have been larger, Taft wanted to preserve much of the intimacy that he liked in the court room in the Capitol. Above the court was the law library, an elegant room paneled in oak with carvings of appropriate emblems and allegorical figures.

While the Supreme Court building was under way, a second office building was being planned for the House of Representatives. In 1925 Congress appropriated a modest sum ($2,500) to allow Lynn to work up plans and estimates for an addition to the existing House office building and another set of documents for an entirely new structure. He asked Carrère & Hastings to examine the possibility of enlarging the existing building, while a consortium of local architects known as the Allied Architects was hired by Lynn to develop preliminary designs for a new office building. The additional space gained by either scheme would allow each member to occupy two rooms and

Longworth House Office Building, Preliminary Lobby Design

by the Allied Architects ca. 1930

The second House office building was designed in the restrained neoclassical revival style.

Longworth House Office Building

ca. 1935

The central portico of the second House office building was inspired by one of the city's early landmarks—the Washington City Hall by George Hadfield (1820).

would provide more committee rooms, staff space, and support areas as well.

Carrère & Hastings responded with a plan to build a plain structure in the courtyard of the 1908 building. By lowering the ceiling heights in the new annex and tucking a few offices in the attic, the scheme could provide a total of 375 new rooms. The firm proposed to use steel frame construction and face it with limestone to match the finish of the existing court. It would be provided with the usual plumbing, electricity, heating, and elevators and would cost an estimated three million dollars.

During discussions with the Allied Architects, Lynn indicated that a new House office building should not be monumental, but rather be a serviceable, economical building, simple and dignified. Apparently, some in Congress considered their Carrère & Hastings building too regal and felt that a new structure should be less so. With that in mind, the architects developed two schemes. One included 266 office suites, a gymnasium, a swimming pool, a rooftop lounge, various storage rooms, and auxiliary offices and would cost a total of about six and a half million dollars. A second, more expensive scheme provided much the same facilities but also accommodated a few more offices and a 100-car garage. It was essentially two structures connected underground. Both schemes were designed without high ceilings or "pretentious" corridors, providing suites that reflected intensive study and thought. Each member's suite included a private office with built-in storage cabinets and a private entrance, a large general office that could accommodate two desks and a waiting area, a storage room, and a single lavatory.

The final design was an improvement over the first schemes proposed by the Allied Architects, but the general modesty of their early designs prevailed. The garage and gymnasium were dropped in favor of more offices and a large assembly room, which became home to the Committee on Ways and Means. Because of the building's position on a sloping site, its rusticated granite base varied in height: nearly invisible in front, it would stand a full story above ground in the rear. Above the base were five principal floors faced with marble. Ionic columns supporting a simple entablature were used for the building's five porticoes; the principal one, facing the Capitol, was topped by a pediment.

Two additional stories were partially hidden by a marble balustrade.

The issue of funding an additional office building for the House of Representatives was debated back and forth until March 4, 1929, when $8.4 million was appropriated for a new building. Without ceremony the cornerstone was laid on June 24, 1932, and the building was finished less than a year later. It was first occupied on April 20, 1933. Like its contemporaries, the Jefferson Memorial and National Gallery of Art, the second House office building was a fine example of the neoclassical revival style popular for public buildings in the second quarter of the twentieth century.

The third project that Lynn directed on the Capitol's growing campus was initiated a few days before the additional House office building appropriation was passed. On February 28, 1929, Congress allocated $10,000 for preliminary plans and estimates to complete the Senate office building by constructing an addition on First Street east. Other improvements, such as a new architectural treatment for the C Street elevation, were contemplated as well. Once the "back" of the building, the C Street side came to unforseen prominence when the Capitol grounds were extended to Union Station. The streets once lined with residences, hotels, and businesses were cleared and the land was turned into a park, creating a view from Union Station to the unadorned rear of the Senate office building. Acquisition of land through purchase and condemnation began in 1910, and the project continued over the next thirty years under a series of commissions. In all, eighteen city squares would be annexed into the Capitol grounds at a cost of more than ten million dollars. Informally, David Lynn asked Thomas Hastings for ideas about architectural and landscape improvements. A similar request was made to the architect of Union Station, Daniel Burnham, who proposed several schemes for a memorial to President Lincoln in the new park. William E. Parsons of Chicago, however, was retained in 1927 to develop a master plan for the area that included new walks, fountains, an underground garage, and other landscape improvements.

On July 18, 1929, Thomas Hastings was hired to draw preliminary designs for an addition to the First Street side of the Senate office building,

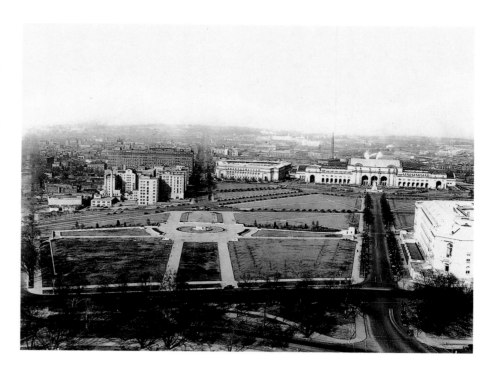

View of the Enlarged Grounds 1931

The land between Union Station and the Capitol was acquired by the government between 1910 and 1940 and developed into a park. An underground garage— the first on Capitol Hill— was provided beneath the new park.

Proposal for a Memorial to Abraham Lincoln

by Daniel Burnham, ca. 1910

The site for a memorial to the martyred president was a subject of controversy during the early twentieth century. Some influential politicians, including Joseph Cannon, wanted the memorial built on Capitol Hill, while others favored a site at the western end of the Mall. This sketch shows one of several designs that Daniel Burnham created for a Lincoln Memorial intended for the park about to be created between the Capitol and Union Station.

COMPLETION OF U. S. SENATE OFFICE BUILDING
C STREET COLONNADE AND FIRST STREET WING
SENATE OFFICE BUILDING COMMISSION HON. PHILLIPS LEE GOLDSBOROUGH—HON. WESLEY L. JONES – HON. CLAUDE A. SWANSON.

DAVID LYNN
ARCHITECT OF THE CAPITOL

WYETH AND SULLIVAN
CONSULTING ARCHITECTS

Completion of U. S. Senate Office Building
by Nathan Wyeth and Francis P. Sullivan, ca. 1930

Although the basic design was provided by Carrère & Hastings, two Washington architects were responsible for the working drawings of the First Street addition to the Senate Office Building. Part of the project included refacing the C Street elevation with columns and an entablature to present a fine face for those coming to the city from nearby Union Station.

improvements to the existing C Street elevation, and the landscape treatment of the courtyard. In the new addition, twenty-four three-room suites, two committee rooms, and the usual stairs, elevators, and rest rooms were provided. The C Street elevation was redesigned with pilasters (later changed to columns) and ornaments belonging to the Doric order. In November, a month after Hastings' death, Theodore I. Coe, representing the Carrère & Hastings firm, reported that the First Street addition would cost about $2,231,000, while other improvements intended to finish the Senate office building were estimated at an additional $883,000. Congress appropriated the funds to complete the building on February 20, 1931. With both principals of the Carrère & Hastings firm dead, Lynn hired two local architects, Nathan Wyeth and Francis P. Sullivan, to prepare working drawings. Wyeth was a veteran of Carrère & Hastings' Washington office and a future municipal architect of the Dis-

trict of Columbia. In September, the First Street wing was underway and the project was completed by the end of June 1933.

Despite the deepening economic depression that marked the last days of Herbert Hoover's administration, Lynn presided over an increasing inventory of construction projects. Many had been in the planning stages before the depression broke, but the timing of the unprecedented construction activity on Capitol Hill during the early 1930s was a welcome boon to thousands of workmen who otherwise faced unemployment. Major projects were undertaken at the western and eastern extremes of the Capitol grounds. Just before Franklin Roosevelt's inauguration on March 4, 1933, the new home for the Botanic Garden was finished. By relocating the garden, its old site cleared the vista to the Grant Memorial from the Mall, as directed by the McMillan Commission. On June 28, 1933, Lynn signed a contract with the Hechinger Engineering Corporation to clear a site east of the Library of Congress to prepare for the construction of an annex. Already under way was an addition to the back of the library, which was to contain the rare book collection and a reading room, a card catalogue room, a garage, a loading dock, extensive underground storage rooms, and shops.

While the sound and dust of construction activity were everywhere around it, the Capitol

U. S. Botanic Garden Conservatory

Chartered by Congress in 1820, the Botanic Garden is the oldest continually operating facility of its kind in the United States. Its first home was located behind the Patent Office and was constructed in 1842 to house a collection of exotic flora brought to Washington from the South Seas by a naval exploring expedition. When the Patent Office was enlarged in the 1850s, the collection was transferred to a new greenhouse built on the Mall at the foot of Capitol Hill.

At the turn of the century the McMillan Commission proposed to clear away extraneous buildings from the Mall to return it to an open park as envisioned by Pierre L'Enfant. Accordingly, a new conservatory for the Botanic Garden was designed by the Chicago firm of Bennett, Parsons & Frost and begun in the fall of 1931 on a site just south of the Mall. The facade is rusticated limestone with tall arched openings with keystones carved with images of Pan, Pomona, Triton, and Flora. This aerial view looking northwest shows the extensive greenhouses and tall palm court at the rear of the building. The framing of the greenhouses was the first structural use of aluminum alloy in a major American building. (1982 photograph.)

Bartholdi Park
ca. 1932

Construction of the new U. S. Botanic Garden included relocating the Bartholdi Fountain to its own park. Behind the fountain is a residential structure designed by the project architects, Bennett, Parsons & Frost of Chicago. It served briefly as the official residence of the garden's director but has been occupied by the garden's offices since 1934.

Adams Building of the Library of Congress

ca. 1938

*T*he Washington partnership of Pierson & Wilson was responsible for the design of the library's second building, now named for President John Adams after being known for years simply as "the Annex." A restrained and finely detailed art deco building, it features an exterior clad with Georgia marble. Its apparent bulk was reduced by holding the upper two floors back and projecting the end bays. Bronze entrance doors by Lee Lawrie depict persons important to the history of writing.

When the building opened in 1938, the Library's shelving capacity tripled to fifteen million volumes. A silent pneumatic system whisked books in leather pouches from the annex to the main reading room across the street in a breathtaking twenty-eight seconds.

Statuary Hall

Photograph by Underwood & Underwood, 1932

*B*y the early 1930s the arrangement of statues appeared haphazard and their weight threatened to overload the floor. In 1933 authorization was given to distribute the collection throughout the Capitol and display fewer pieces in Statuary Hall itself.

itself stood relatively unchanged during the 1930s. The first half of the decade saw only one notable interior project: on February 24, 1933, Congress authorized the architect of the Capitol to rearrange and relocate statues in the Statuary Hall collection. The collection had grown to sixty-eight pieces, overcrowding the former House chamber and threatening to overload the floor. Removing some statues to other parts of the Capitol allowed the remaining pieces to be shown to advantage and helped restore dignity to that historic room.

After the Supreme Court vacated the Capitol in June of 1935, a number of rooms in the old north wing were turned back to the Senate. The old law library on the first floor was kept as a reference library, while the Courtroom above (the old Senate chamber) was left virtually untouched. Other rooms, however, were remodeled and refitted for use by various Senate offices. Wood floors that had been laid over the original brick floors were removed and replaced with new concrete covered with rubber tile or white oak. Electrical wiring and plumbing were updated and the rooms were equipped with an air-conditioning system. Among the new tenants in the old Court space were the Senate sergeant at arms and the disbursing office.

REBUILDING THE CHAMBERS

On July 14, 1938, Lynn hired a structural engineer, Thomas W. Marshall, to inspect the roofs over the north and south wings. Lynn was worried about their safety, for they remained virtually as Captain Meigs had left them in the 1850s. By twentieth-century standards, Marshall concluded, they were "entirely obsolete." He described the roof structure and its general deficiencies succinctly:

> The roof trusses over both wings are made up of rolled-iron deck beams as top chord members, cast-iron web struts and wrought-iron eye bar bottom chords and web ties, all pin connected, a type of truss long since superseded by the all steel truss with riveted connections. The cast-iron struts and wrought-iron eye bars are of satisfactory sizes and are not over stressed. The top chord deck beams and the connecting pins are definitely deficient in size

and are greatly over stressed. The lateral bracing between trusses is light in weight, unsatisfactory in arrangement and detail, and generally deficient as compared with modern designs.[37]

Marshall recommended removing the old roofs and replacing them with structural steel and concrete. He estimated that the work would cost $585,000.

Marshall made his report in November 1938, and two months later Lynn requested funds to replace the roofs. Hearings were held, and engineers from the National Bureau of Standards, the Navy Yard, and the Treasury Department were called to verify Marshall's computations and conclusions. All agreed that the roofs were unsafe. Instead of granting Lynn's request, however, the House provided a small sum to hire two additional experts from private industry to reexamine the question. Senator Tom Connally of Texas and Representative Louis C. Rabaut of Michigan were appointed to oversee independent tests conducted by the head engineer from the American Institute of Steel Construction and another distinguished engineer in private practice from Baltimore. While the test results were being analyzed, Lynn, Connally, Rabaut, and the consulting engineers climbed up to the space over the chambers and had a firsthand look around. Again, all agreed that Marshall's conclusions were correct, except that perhaps the safety issue might be even more urgent than generally believed.

On June 27, 1940, Congress granted the funds needed to put new roofs over the wings. Marshall was retained as a consultant and Lynn began making the necessary arrangements to carry out the

Hall of Columns

Some of the statues from Statuary Hall were placed in the hall of columns, which proved perfectly suited for the purpose.

In the 1920s a new black and white marble floor was installed here and elsewhere in the House wing, replacing worn Minton tiles in heavily traveled corridors. Thomas Hastings provided the design for the new floors.
(1963 photograph.)

ambitious project. Before long, however, it became clear that strains on the steel industry would make it impossible to conduct the work while Europe was embroiled in war. Just five days before the roof appropriation passed, Paris fell to Nazi invaders. Norway and Denmark had been overrun in April, and they were followed by the Netherlands, Belgium, and Luxembourg in May. Although the United States was at peace with the belligerents, its future was interwoven with the fate of British resistance. In late 1940 and early 1941, the Roosevelt administration devised ways to assist Prime Minister Winston Churchill, with programs such as "Lend-lease," while staying clear of a declaration of war.

Recognizing that roof problems at the Capitol took a back seat to more pressing global matters, Lynn constructed temporary supports to allay fears about the ceilings crashing down around the heads of the nation's legislators. After the close of business on November 22, 1940, the House and Senate vacated their chambers until January 3, 1941. During this period, the Senate took up temporary quarters in its old chamber, while the House met in the Ways and Means Committee room in the new office building across the street. While the chambers were vacant, each ceiling was jacked up and its

weight was transferred to structural steel frames held on columns erected along the gallery walls. Due to wartime conditions, these temporary supports would remain in place until 1949.

During the interim, it occurred to some senators that the roof replacement might be a good opportunity to make other improvements in their chamber. Noise in the galleries was readily admitted to be the major source of annoyance, and although some senators mumbled and others were hard of hearing, the solution to the hearing problems was thought to lie in the realms of acoustics and architecture. Lighting and redecoration were other issues of interest. To investigate these matters, a subcommittee of the Senate Committee on Public Buildings and Grounds was authorized to hold hearings.

With Senator Charles O. Andrews of Florida presiding, the subcommittee held its broad, vague, and freewheeling hearings on October 24 and 27, 1941. David Lynn led the testimony with a description and history of the Senate chamber. He then introduced the idea of installing a new ceiling, one that had been devised in consultation with five distinguished engineers representing the sciences of acoustics, structure, lighting, electricity, and air conditioning. In addition to men of science, Lynn had consulted men of art—Francis P. Sullivan, an architect, and Ezra Winter, a painter. Sullivan had worked with the architect of the Capitol while the Senate office building was being enlarged and was now serving as the chairman of the Committee on the National Capital for the American Institute of Architects. He helped establish the Historic American Building Survey and became interested in the Capitol thirty years earlier through a friendship with Glenn Brown. Ezra Winter had devised the color schemes in the Supreme Court building and painted murals in the new Library of Congress annex.

Providing a new ceiling was thought to be a single solution to multiple problems. Instead of relying on a skylight, the room would be indirectly illuminated through cove lighting housed in an elliptical recess in the center of the ceiling. Artificial light would provide a dependable, even, and steady illumination, free from the distracting vagaries of outside weather and cloud conditions. Removing the hard metal and glass overhead would

Senate Chamber
ca. 1949

*F*rom 1940 until work on the new roof began nine years later, a steel frame supported the iron and glass ceiling over the Senate chamber. The support was necessary to prevent the dangerously weak ceiling from falling. A similar precaution was employed in the House chamber.

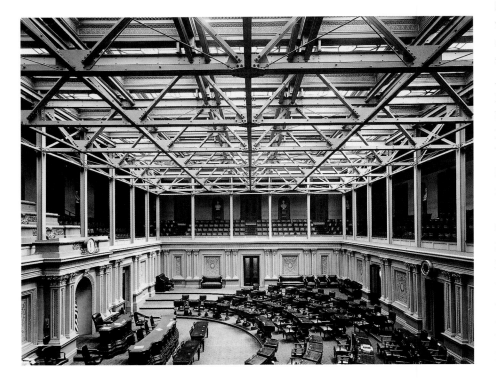

also improve acoustics. The new ceiling could be made with a special acoustical plaster border around a perforated steel center, which would permit air to fall gently and evenly into the chamber. Noise from the galleries could be muffled by new chairs with upholstered backs and seats that folded without unnerving squeaks. A new color scheme could be developed to tie the old and new work together and give the room a more up-to-date look.

No one seemed particularly interested in defending the architectural effect of the old ceiling or its place within the overall design of the historic chamber. Only Sullivan admitted to even a slight hesitation in recommending a new ceiling.[38] The style of the room, one of the high points in the rococo taste of mid-nineteenth-century decorative arts, was now indefensible to the many who preferred the sleek, modern look of steel and glass or the nostalgic look of Williamsburg and the colonial revival taste. In either case, Walter's interior was out of fashion, condemned as "Victorian," and therefore the very definition of bad taste in the 1930s and 1940s.

Andrews' subcommittee reported favorably on the new ceiling recommendation. The full committee adopted the measure in the early days of 1942, and the Senate included a request for funds necessary to pay for it in the Legislative Appropriations Bill for 1943. Citing wartime conditions, however, the House of Representatives struck it out. In the meantime, Lynn and his consultants continued to study the chambers, and in 1945, with the end of World War II in sight, they proposed a more sweeping remodeling scheme. Senator Andrews supported the expanded remodeling project, helping steer legislation through the Senate to authorize it. Prodded by Speaker Sam Rayburn of Texas, the House of Representatives suddenly joined the Senate in the pursuit of a more modern chamber. On July 6 and 10, 1945, the House Committee on Public Buildings and Grounds held hearings on the subject of installing a new ceiling over the hall of the House, as well as the idea of remodeling the rest of the room. On July 17, Congress passed legislation to enlarge the roof project to include new ceilings over the two chambers as well as new interior designs.

Francis P. Sullivan was retained as the associate architect for the venture. Senators and

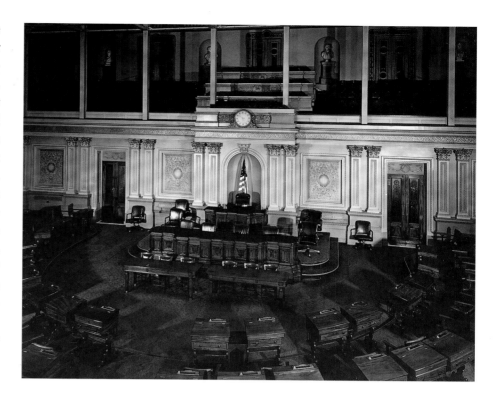

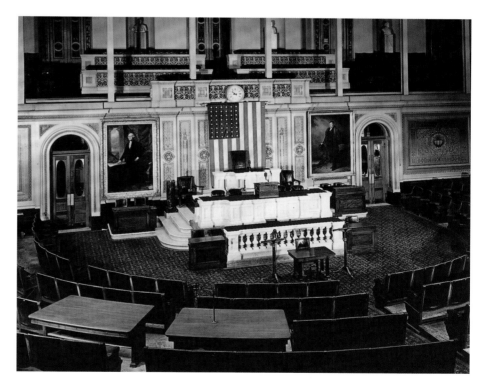

Senate Chamber (top) and House Chamber (bottom)
photographs by Theodor Horydczak, ca. 1949
Library of Congress

These are the only known color photographs of the chambers taken prior to their 1949–1950 remodeling.

representatives on the project committees wanted the new interiors reviewed by the Commission of Fine Arts, a permanent legacy of the McMillan Commission and the government's watchdog on design matters in the nation's capital. The commission, in turn, made arrangements for Paul Cret (one of its members) to serve as a consulting architect. A brilliant designer, Cret was noted particularly for his creative blend of modern and classical idioms; however, his death on September 8, 1945, forced the commission to look elsewhere for assistance. The commission recommended Cret's successor firm, Harbeson, Hough, Livingston & Larson of Philadelphia, for the job.

On February 22, 1946, the associate and consulting architects presented their plans for the Senate and House chambers to the Commission of Fine Arts, the architect of the Capitol, and the members of the House and Senate committees. In explaining their design motives in the new plans the architects stated that

> there seemed to be no point in preserving the existing character of the architecture of the two Chambers of the period of 1860. . . . There are in the Capitol two contrasting periods of architecture, that of the period of the Early Republic, and that of the period of 1860; to introduce a third and different period would be a mistake. Therefore it was agreed to return to the architecture of the Early Republic.[39]

The Commission of Fine Arts approved the designs unanimously. While no word of dissent has survived in the records, the commission's swift acceptance of the designs may have been a case of professional camaraderie rather than good judgment. Few connoisseurs today look upon the designs with satisfaction, nor has any student of Federal period architecture discovered either authenticity or wit among the details. The new chamber designs were pastiches of vaguely classical designs, pursued without conviction or vigor, sometimes without knowledge or even concern about the proper disposition or scale of classical ornament. Clearly the designers were uncomfortable with the genre, insufficiently acquainted with either the spirit or details of the architecture they sought to imitate. Yet, few architects of that generation could have done much better. It was a time when historicism was undervalued by the architectural profession, and its practitioners were discouraged from studying the past. Engineering concerns took top priority in the new House and Senate chambers.

The Commission of Fine Arts made a few suggestions to improve the designs. Its members thought that Brumidi's painting in the House chamber (*Cornwallis Sues for Cessation of Hostilities Under the Flag of Truce*) should be removed for its immediate preservation and eventual relocation. They recommended that a covering of fabric, rather than acoustical tiles, be installed to muffle sounds coming from the gallery.[40] For the Senate chamber, they suggested minor adjustments to simplify the ceiling's ornaments and to lengthen its central ellipse. Niches were eliminated from the upper walls of the House chamber and marble plaques substituted in their place. Sculptural embellishments and appropriate quotations were recommended for both chambers.

Work was expected to begin during the summer of 1947, but inflation in a construction industry still recovering from the effects of the war put project financing into jeopardy. Only one bid was received, and the company frankly admitted that its offer contained a large contingency to allow for fluctuations in the marketplace. The bid was rejected and Lynn recommended deferring the project for a year until conditions became more settled.

On October 28, 1948, ten years after Thomas Marshall first reported on the condition of the roofs, the Consolidated Engineering Company of Baltimore was contracted to rebuild the roofs and remodel the chambers. To minimize disruption, work was divided into two phases. In the first phase, which began in June 1949 and ended in December, the old roofs were removed and the new ones built, the new ceilings were installed, and the gallery level was remodeled. The lower parts of the chambers were remodeled in the second phase, which ran from July to December 1950.

As the work neared completion, the Washington press corps greeted the new chambers with unquestioning approval. One article claimed that the chambers now had a "theatrical splendor" and told its readers that the new "Technicolor" halls would be opened for inspection soon. No complaints of noise from the gallery were expected because of the new "non creaking seats" and because the floors had been covered with "sound-muffling linoleum." Rich, deep wood paneling

Senate Chamber
1998

The bravado of Walter's high "Victorian" chamber gave way to a vaguely "colonial" look that post–World War II designers found comfortable and reassuring.

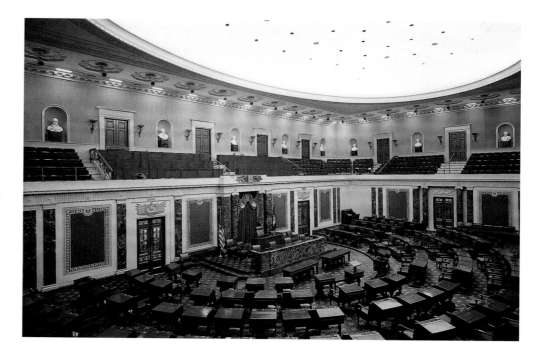

awaited members of the House, whereas the vice president's podium in the Senate was now Italian marble instead of the old walnut desk used formerly. The chambers were ready for the "persnickety" inspection of legislators "in the same critical manner as an aging actress tests her lighting." Those who had already seen the work told the architect of the Capitol that they liked the renovations, which would put the Congress on par with the Supreme Court and the White House.[41] Both chambers were finished on schedule and were ready for use on the first day of 1951.

At the other end of Pennsylvania Avenue the White House was in the midst of a complete interior reconstruction undertaken by the Truman administration. The old sandstone walls, built and restored by James Hoban, were propped up from within while a new steel and concrete structure was prepared for installation. Some of the interiors by McKim, Mead & White, installed in 1902 by Theodore Roosevelt, had been removed, reconditioned, and reinstalled. Other interior features were new, but very little (except the floor plan) remained from the early history of the house. As was the case with the House and Senate chambers, the President's House underwent its own transformation, incorporating a new structure wrapped within old walls. In this period, the urge to preserve the past was not as strong as the love of modern amenities, nor as motivating as a frightening report from a structural engineer. By mid-century, "progress" was more about originality and innovation than about the classicism and harmony that had been the goals of idealistic architects and planners fifty years earlier. Nevertheless, although its day had passed, the City Beautiful Movement had, in fact, transformed Capitol Hill into an especially pleasing enclave of classical grandeur, one of the more notable successes of that high-minded movement.

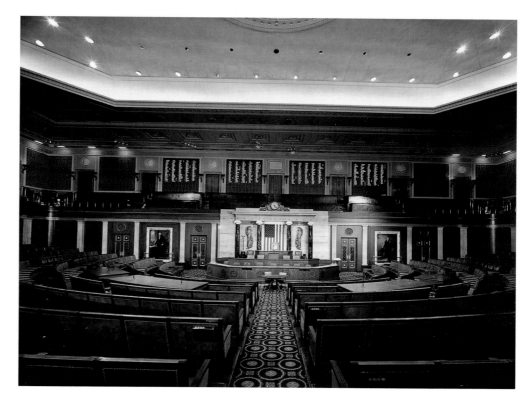

House Chamber
1995

With the colorful ceiling removed and other nineteenth-century decorations banished, the House chamber was redesigned in a so-called "Early Republic" style. Electronic voting was added in 1973 and television coverage began in 1979.

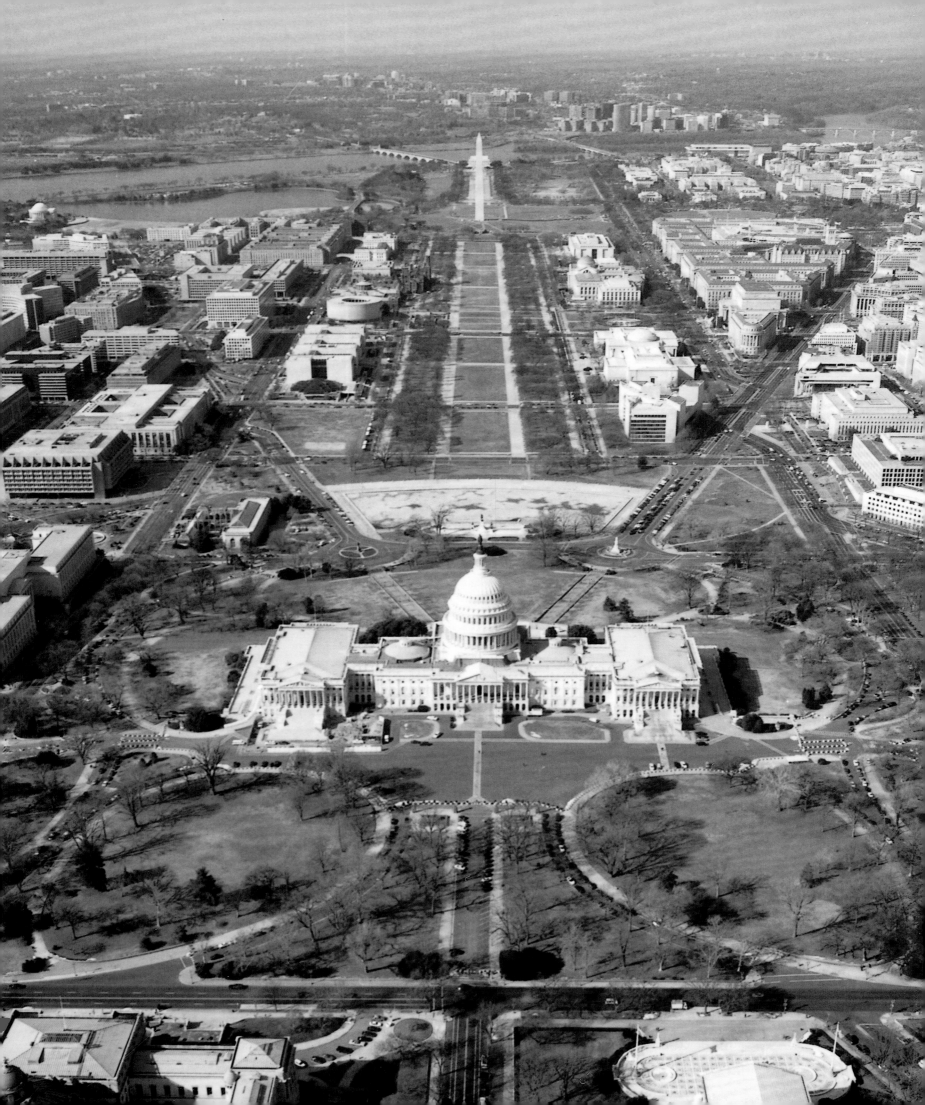

VIEWS OF HISTORY

At the close of World War II, the United States was a proud and confident nation. Yankee strength, knowhow, and vast natural resources defeated fierce enemies and overcame great hardships abroad. It was widely believed that problems at home—clearing slums or building modern highways—could be faced with the same determination and skill that crushed foreign tyranny and restored peace to the world. The country was not particularly hospitable to those who cherished the past—particularly those defending old buildings that otherwise stood in the way of "progress." Similarly, the intellectual struggle over architectural style and taste was waged by a small clique of tradition-minded preservationists against the more dynamic proponents of modern concrete, steel, and glass structures. Reminders of the old world and its velvet-tufted aristocracy were typically shunned, while the "international style" was the rage among the design intelligentsia. Not surprisingly, these multiple and overlapping conflicts in architecture, history, and taste had a significant influence on the continuing development of the Capitol and its surrounding campus following the second World War.

Aerial View of the Capitol, Looking West
1996

Upon the death of Franklin Roosevelt on April 12, 1945, Harry S Truman became president. He inherited a presidency that had been strengthened and expanded through Roosevelt's management of New Deal programs and the massive war effort. Powerful executive departments grew at a brisk rate under Roosevelt while the Congress limped along with an archaic and inefficient committee system manned by a small and largely nonprofessional staff. Following the war, the public generally viewed Congress as unhelpful to the president. Robert La Follette, a progressive Republican senator from Wisconsin, led a bipartisan effort to streamline and professionalize the committee system and, thereby, reassert Congress' role in government. By the provisions of the Legislative Reorganization Act of 1946, the number of standing committees was reduced from forty-eight to nineteen in the House and from thirty-three to fifteen in the Senate. However, expanding responsibility for a growing and more complex government and Congress' emerging oversight role called for a substantial increase in staff. The number of people working for congressional committees actually doubled in the decade following the adoption of the act. A new emphasis on the efficiency of the work of committees, aided by a new class of professional staff, resulted in a need for more hearing rooms and staff space in the Capitol and the legislative office buildings. Like the country it served,

Congress was experiencing a period of rapid post-war growth.

In 1948, the Senate Office Building Commission acquired half a city square immediately east of the 1909 office building. Dormant since the First Street wing was finished in 1933, the commission acted in response to the Senate's need for office space tailored to its new committee structure. The site was selected partly due to its convenient location and partly to rid the neighborhood of substandard housing. In announcing the plan to acquire the site, *The Washington Post* published a photograph of the neighborhood under the banner: "Senate Office to Replace This Slum."[1] Speaking for the commission, David Lynn asked the attorney general to condemn the properties, including 148 tiny dwelling units in "Schott's Alley," along with various rooming houses and residences collectively known as "Slum's Row." Congress appropriated $1.1 million to acquire and clear the site in preparation for the Senate's second office building. About 500 residents were left to find housing elsewhere.

With the demise of the trusty Carrère & Hastings firm, the commission was obliged to interview architects for the job of designing the new office building. Although matters of style were left to the

Original Design for the Second Senate Office Building
by Eggers & Higgins, 1948

*T*he entrance into the office building appeared to be located in the center of the main elevation, yet the doors were actually located around the corners. Despite this deception, the design of the Senate's second office building (now called the Dirksen Building) is a successful synthesis of classical and contemporary design.

design professionals, the commission expressed a desire for a building that would look at home among the classical structures on Capitol Hill, without necessarily replicating the expensive and (to some eyes) archaic detail of a full-blown classical design. A synthesis of modern and antique would do.

The facilities needed in the new physical structure were dictated by the Senate's new committee structure. The building was expected to house all fifteen standing committees, and their various subcommittees, with office suites for chairmen located nearby. Staff would be accommodated near the chairmen and the committee rooms. Most important, the committee rooms would be set up not with a central conference table but with a rostrum where senators would face witness tables and the public. That arrangement would be more conducive for holding informational and investigative hearings. A large auditorium equipped with radio, television, motion picture, recording, and broadcasting facilities was also needed, along with a cafeteria, a stationery room, a barber shop and beauty salon, a mail room, and underground parking.

On April 30, 1948, after interviewing five architectural establishments, the Senate Office Building Commission directed Lynn to hire the New York firm of Eggers & Higgins to prepare the preliminary plans and estimates for the new building. An initial fee of $14,500 was set aside for this phase of work. Otto Eggers and Daniel Paul Higgins had worked in the office of John Russell Pope, one of America's great classical architects, and carried on with his practice following the master's death in 1937. Pope's designs for the National Archives, the Jefferson Memorial, and the National Gallery of Art, built in the 1930s and 1940s, already adorned the federal city. Against the trends of the day, Eggers & Higgins continued to work in the classical idiom and were considered to be among the few firms able to blend a modern office building into the design context of Capitol Hill.

On June 8, 1948, only six weeks after the Eggers & Higgins firm was hired, the Senate Office Building Commission was shown a design for a seven-story "E"-shaped building with its principal elevation (about 450 feet long) on First Street backed by three rear wings. The building was a simple structure dominated by a central pavilion on First Street with square engaged columns capped by a plain entablature. (A pediment was

added later.) By its location and design the central pavilion seemed to indicate the main entrance to the building, but the promise was a sham. There was in fact no room to spare behind the portico for a grand entrance so side entrances on Constitution Avenue and C Street north were the main ways into the building. The suggestion of a colonnade was created by tall ribbons of glass and dark spandrel panels alternating between white marble piers. Cast into the panels were commemorations of American shipping, farming, manufacturing, mining, and lumbering. Unfurnished, the cost of the building and its underground connections and subway was first estimated at about twenty million dollars. The design was approved without debate and Lynn was instructed to meet with the legislative counsel of the Senate to draft the necessary authorization to build the second Senate office building, as well as to secure $850,000 to begin work. The legislation was approved on June 9, and two weeks later the money was granted. In two months, schematic designs had been developed and approved, and funding started—yet the hopes raised by this auspicious beginning soon turned sour.

Eggers & Higgins signed a contract with Lynn to provide architectural services for 5½ percent of construction cost. Final plans were approved on April 7, 1949, and construction documents were sent out for bids. Ten million dollars was requested to start work, but despite the support of Dennis Chavez of New Mexico, chairman of the Senate Office Building Commission, it was defeated at the hands of Senator Allen J. Ellender of Louisiana, chairman of the Legislative Appropriations Subcommittee. The project was sent back to the drawing board to trim costs. Lynn was directed to survey the Senate's existing facilities to see if a more economical solution to the space problem could be identified. The possibility of adding a new floor to the existing office building was investigated but rejected due to the cost of relocating air conditioning equipment in the attic. Space in the proposed east front extension of the Capitol was also found to be insufficient. Various studies were made that eliminated or lowered the three rear wings of the new building. When debate resumed in July 1950, senators in favor of the new office building declared that the project would have to wait until settlement of the Korean conflict that had begun in June. For the next four years, action on the second Senate office building was deferred.

A NEW ARCHITECT

With expansion plans in limbo, internal security investigations and spy scandals kept the political climate on Capitol Hill charged with paranoia and fear. In 1950, the suspected spy Alger Hiss was convicted of perjury, and the following year Ethel and Julius Rosenburg were convicted of passing atomic secrets to the Soviet Union. Also in 1950, Senator Joseph McCarthy of Wisconsin, claiming that hundreds of communists worked in the State Department, launched his investigations to root out traitors. McCarthy held his hearings in the elegant and versatile caucus room in the Senate office building under the hot lights brought in for television cameras. Building on hearsay and innuendo, McCarthy's fanatical investigations continued into the early days of Dwight Eisenhower's administration, ending only when the Senate could bear the charade no longer. In 1954, McCarthy was censured for bringing that body into "dishonor and disrepute."

As McCarthy stumbled into disgrace, David Lynn, one of Congress' most honest, trustworthy, and respected servants, retired from office. His resignation was written on August 5, 1954, and effective on September 30. His letter to Eisenhower, reviewing thirty-one years as architect of the Capitol, emphasized the buildings constructed and the vast sums of money expended under his supervision. At age eighty-one, he felt it was time to relinquish the post and retire from public service. Newspapers acknowledged Lynn's retirement with stories of his fidelity to the job, his longevity, and, most particularly, the changing face of Capitol Hill that took place during his long years in office.

A few days before Lynn resigned, the Speaker of the House, Joe Martin of Massachusetts, wrote Eisenhower recommending a replacement. Martin suggested an old friend who had served with him in the 74th Congress, a Republican from Delaware named J. George Stewart. The Speaker's petition was cosigned by all of the Republican hierarchy in

Congress, including the president pro tempore of the Senate, Styles Bridges of New Hampshire, and the Republican leader of the House, Charles Halleck of Indiana. Martin's efforts were quickly rewarded, precluding the American Institute of Architects or any other interested party from becoming involved in the process of recommending Lynn's replacement. On August 10, newspapers announced that Stewart would become the next architect of the Capitol. He was appointed on August 16, 1954, and, with Lynn looking on, took the oath in the Speaker's office on August 19, 1954. His service began on October 1.

Nearly twenty years earlier, as one of the victims of Roosevelt's landslide reelection victory of 1936, Stewart had been swept out of office after one term as Delaware's lone representative in the House. After his defeat, he returned to Wilmington to run the family's construction business and helped to build some of the area's great estates. After selling the business, Stewart returned to Washington to serve as the chief clerk of the Senate Committee on the District of Columbia, and he later worked as a civil engineer for the Justice Department and the Army Corps of Engineers. Gregarious and well liked, Stewart was equally comfortable in the company of Democrats and Republicans, and his status as a former congressman afforded him access and courtesies reserved for members. But because he had not come up through the ranks like Woods and Lynn, or been trained as an architect like Walter or Clark, Stewart's qualifications for the office soon came into question.

Stewart took the reins at the beginning of a period of great construction activity on the Hill. While plans were afoot to construct a third office building for the House of Representatives, and while the east front extension project simmered on the back burner as usual, the first project Stewart became involved with was the new Senate office building. (The armistice ending the Korean conflict had been signed in July 1953.) In July 1954, the Senate Office Building Commission issued a report urging Congress to fund the work, noting that every possible economy had been taken to assure a fine product at a reasonable cost. The center rear wing was eliminated to save money, as were a page school, a suite for the vice president, and thirty-five parking spaces. Twelve committees, instead of the previously planned fifteen, would be accommodated in the new building. A simple exercise room replaced plans for a gymnasium. On August 26, 1954, Congress appropriated six million dollars to begin construction. Groundbreaking ceremonies were held on January 26, 1955, and the cornerstone was laid on July 13, 1956. The building was finished in October 1958 at a final cost of $26.3 million.

THE EAST FRONT EXTENSION

*W*hile investigating ways to provide more and better-equipped hearing rooms, the Senate Office Building Commission looked again at the accommodation provided in the proposed east front extension. Only one committee room and twenty-six offices were on the drawing board in the Senate's half— not enough to solve the problem. The idea of building a new addition to the east front had been originated by Thomas U. Walter in 1863 as a means to correct the impression that the dome was not adequately supported. Since then others had come to see the project as a good way to add more rooms to the Capitol, while covering the flaking sandstone wall with a new marble facade.

People who disagreed with the proposal cited the history of the east front as reason enough to preserve it. Since Andrew Jackson's first inauguration in 1829, most presidential swearing in ceremonies had taken place on the central portico. Some inaugural speeches were considered defining moments in American history, including Abraham Lincoln's eloquent words of reconciliation near the close of the Civil War and Franklin Roosevelt's buoyant message of assurance during the depths of the Great Depression. The Capitol's central portico was revered as one of America's greatest historic places. The condition of the sandstone and the overhanging dome did not bother history-minded observers, who considered these quirks as harmless or even charming. They wanted the Capitol maintained just as it was, and they could become quite vocal in calls for its preservation.

By 1955, many members of the House and Senate were well acquainted with the reasons behind the proposal to extend the east front. Almost every year, the architect of the Capitol reviewed the conditions there, asking for the authority and money to build the addition. The dome that bore down on the east-central portico and the crumbling sandstone were two architectural reasons given year after year in support of the project. A quieter mention of additional rooms whetted the appetites of senior legislators who stood to gain a Capitol office if the project were authorized. The basis of discussion was usually Carrère & Hastings' scheme "B," devised in 1904, which would create an addition thirty-two and a half feet deep that approximated the existing facade but did not replicate it.

Joe Cannon almost succeeded in his attempt to authorize the extension in 1903. In 1935 and 1937 the Senate approved legislation, but the House disagreed. World War II and the Korean conflict deferred the project until the return of peace. During this period the architect of the Capitol made sure that the east front project was not forgotten. At the beginning of 1955, a new Democratic Congress was seated and a veteran Speaker returned to preside over the House. Sam Rayburn soon gave the east front project the push it needed to proceed. He agreed wholeheartedly with the arguments supporting the project and thought that too much time had been spent in discussion when it was clear something needed to be done soon. What Joe Cannon could not accomplish a half-century earlier, Sam Rayburn did within a few weeks after returning to the Speaker's chair in 1955.

In June 1955 Stewart gave the House Appropriations Committee an account of the proposed project, including arguments for and against. No one who disagreed with the project was invited to the hearings, and there was little interest within Rayburn's circle of friends for further discussion. After ninety-two years, every argument that could be made on either side of the issue had been made, again and again. With the help of the Senate Majority Leader, Lyndon B. Johnson of Texas (critics began calling the new addition the "Texas Front"), Rayburn secured an appropriation of five million dollars to "provide for the extension, reconstruction, and replacement of the Central Portion of the United States Capitol in substantial accordance with Scheme 'B'" by Carrère & Hastings.[2] A new

Speaker Sam Rayburn (wearing a hat) and J. George Stewart

The development of Capitol Hill was profoundly influenced by Rayburn (1882–1961). He singlehandedly revived the proposal to extend the Capitol's east front and spearheaded the creation of the third House office building, which would eventually bear his name. He worked to provide better parking, restaurants, and other creature comforts for visitors and representatives alike. Throughout, he found a loyal lieutenant in the person of George Stewart (1890–1970), the architect of the Capitol. (1960 photograph.)

commission was authorized to oversee the work, including the leadership of both houses of Congress and the architect of the Capitol. Rayburn was named chairman and Stewart was elected secretary. The public was neither invited to participate in the decision nor even informed that the extension was so close to authorization. To some, it seemed that Rayburn slipped the legislation through as quietly as possible—more than a few called it "sneaky."

On August 5, 1955, Stewart was authorized to spend $50,000 for preliminary engineering studies to determine site soil conditions and the condition of the Capitol's foundations. The first meeting of the Commission for the Extension of the Capitol was held on March 26, 1956, with only Vice President Richard Nixon absent. Stewart announced that the legislation under which the commission operated authorized the enlargement of the central building and, therefore, did not preclude other things such as an extension to the west

front, an underground garage, or a "security vault" (bomb shelter) under the west grounds. These facilities had not been openly discussed but were items on an informal "wish list" worked up by Rayburn and Stewart.

The work of the commission required the assistance of several architectural and engineering firms. Stewart brought with him the names and resumes of four associate architects, two associate engineers, and three advisory architects. Heading the list were Roscoe DeWitt and his partner Fred L. Hardison of Dallas, architects better known for their hospitals, office buildings, and banks in Texas. Alfred Poor and his partner Albert Swanke of New York City were recommended as associate architects. Jesse M. Shelton and Allen G. Stanford from

Atlanta were proposed as the associate engineers. To fill seats on an advisory board Stewart recommended Arthur Brown of San Francisco, John Harbeson of Philadelphia, and Henry Shepley of Boston. Only Harbeson had a prior association with the Capitol, having served in 1949–1950 as an associate architect on the project to rebuild the House and Senate chambers. With his partners, he was also engaged in developing a design for a third office building for the House of Representatives. DeWitt and Hardison had recently been retained to remodel the old House office building, while Poor and Swanke were preparing documents for a similar project for the new House office building. Shelton and Stanford were developing plans for a pair of underground garages to be located behind the House office buildings. The Texas architects had been associated with Rayburn, although the extent of their association is difficult to determine. Roscoe DeWitt, for instance, designed the Sam Rayburn Library in Bonham, Texas, without charge. All the architects were endorsed by the Commission of Fine Arts and according to Stewart were outstanding members of their professions. The commission unanimously approved the recommendations, launching the associate and advisory architects and engineers on an intensive study dealing with the Capitol's expansion possibilities.[3] Once confirmed, the architects from Dallas and New York City joined the engineers from Atlanta in a business venture known as DeWitt, Poor & Shelton.

The consulting architects proved to be an imaginative group. With Rayburn and Stewart's encouragement, they thought about enlarging the Capitol in ways never before (or since) contemplated. Ideas that were put forward included building three stories of underground offices beneath the Olmsted terraces, building sets of wings on the Walter extension in every available direction, adding to the center building both above and below ground, and building a bomb shelter with living and working space for 800 people. One proposal to improve the architectural effect of the Capitol suggested removing the east porticoes from Walter's wings to make way for additions. Thus, the central entrance would stand alone without flanking porticoes competing for attention.[4]

While the brainstorming sessions were going on behind closed doors, the American Institute of

Speaker Rayburn's Working Office

𝒮am Rayburn referred to his private office (modern day H–128) as the "Board of Education," for it was there that new House members learned their lessons about getting along and going along. On April 12, 1945, Vice President Harry Truman was visiting Rayburn in this room when a phone call from the White House asked him to come quickly. Truman had no idea that Franklin Roosevelt was dead and he was about to become the nation's 33rd president.

In 1857 the room was specially decorated for its original occupant, the House Committee on Territories. (1959 photograph.)

Architects became alarmed at the prospects of drastic alterations being made to the nation's most revered building. The Committee on the National Capitol was formed by members of the AIA along with other preservationists to oppose the east front project. It became a vocal critic of the Speaker, the architect of the Capitol, and the associate architects (who, awkwardly enough, were all members of the AIA). On June 12, 1956, Edmund R. Purves, the executive director of the AIA, appeared as a witness before the Senate Committee on Appropriations. He spoke against further funding for the extension, citing a report prepared by the Committee on the National Capitol, but he could not be specific because the report was confidential. Reluctantly, he confessed that he supported the plans to extend the Capitol, but because the AIA was opposed he was obliged to testify against it. This ambivalence so annoyed Senator Bridges of New Hampshire that he suggested Purves apologize to the committee and leave.[5] Meanwhile, the Dallas and Fort Worth chapters of the AIA refused to endorse the institute's position. The Dallas chapter's secretary transmitted a joint resolution to the Washington headquarters stating its belief that the project was in "trustworthy hands."[6]

On May 23, 1957, the associate architects issued a report with their recommendation regarding the enlargement of the Capitol. The architects took the position that the current generation had every right to add to the Capitol to meet the needs of Congress, as Walter's generation had done in the past. As long as the nation grew, it was only natural that the Capitol should grow along with it. Nothing was considered sacred, except that the Capitol should function efficiently. According to their calculations, the Capitol needed about 90,000 more square feet to accommodate an anticipated growth from 2,848 occupants (including visitors) per day to 3,174 occupants. It recommended spending $10.1 million on an east front extension and included an entirely new idea: rather than using the design developed by Carrère & Hastings in 1904, the original elevation was to be replicated exactly in marble. It was hoped that this "archaeological reproduction" would satisfy those who did not want the Capitol's appearance altered.

Continuing their extensive list of proposed improvements, the associate architects recommended a vast west front extension necessitating demolition and reconstruction of the Olmsted terraces at a cost of more than nineteen million dollars, a four-level parking garage for 1,800 cars costing almost forty-two million dollars, new pedestrian tunnels to the Library of Congress and Supreme Court estimated at $960,000, and four million dollars for new subway terminals for the Capitol and the legislative office buildings. On the bottom line, the architects totaled some seventy-five million dollars. This figure did not include cost of the bomb shelter, which was considered classified information.[7]

When he transmitted the architects' report to the commission, Stewart added a few items of his own. He wanted the Capitol's foundations underpinned, the dome repaired, the landscape improved, and the electrical service and lighting upgraded. Stewart estimated $110 million would be needed for all contemplated improvements. In addition, the advisory architects came up with their own recommendations, including restoration of the old Supreme Court chamber on the first floor and improvements to other "Shrine features." They wanted to ban automobiles from the east plaza and add dining facilities to the terrace to take advantage of the views.[8]

"DELIBERATE DESECRATION"

The full effect of the sweeping recommendations was not felt immediately. To some in Congress, Rayburn, Stewart, and the architects had overstepped their bounds and misinterpreted their legislative mandate. The American Institute of Architects began agitating for public hearings and the press started to question the matter as well. While Rayburn and the architect of the Capitol had encouraged their associates to "think big," they were now obliged to chart a more modest course to calm the protests. Rayburn took the view that the package of improvements should be treated as a long-range plan for the Capitol. Only the east front extension,

dome repair, lighting improvements, and new Senate subway terminal would be pursued for the time being. On January 22, 1958, Stewart gave the associate architects oral instructions to proceed with the working drawings for the extension based on the "archaeological reproduction" design concept.

Along with plans and specifications, the associate architects drafted rebuttals to the increasingly vigorous opposition heard from historical societies and patriotic groups. The troublemakers were, in the opinion of the architects, too sentimental and not sufficiently informed about the problems facing the Capitol. They thought that the cry of "desecration" was nothing more than a "catchy phrase" shouted by overexcited agitators. They wanted the commission to prepare a sound and irrefutable defense.[9] It would come in handy during the public hearing on the east front matter that was scheduled for February in response to legislation introduced by Senators Alexander Smith of New Jersey and Joseph Clark of Pennsylvania to revoke the project's authorization. The hearings were the first (and only) time the east front question was discussed before a congressional committee during this period.

The day before the hearings were held, *The New York Times*'s highly regarded architecture critic, Ada Louise Huxtable, wrote a scathing article condemning the east front extension. She called on people to wake up to America's architectural heritage, which she claimed was threatened by the proposed addition. The "deliberate desecration" was too high a price to pay for a few more committee rooms and a few more restaurants. Filling up the Capitol's forecourt with the new addition was also a grave aesthetic mistake. She criticized Stewart by noting that the architect of the Capitol was not an architect and condemned the secrecy shrouding the project. After questioning the motives of the various architects and politicians who supported the extension, Huxtable observed: "Since one of our fundamental freedoms seems to be freedom of taste (in the democratic tradition, the layman's is equal to the expert's) Congressmen are perhaps no less guilty than many of us in exercising unqualified expertise in matters of art."[10] On its editorial page, *The New York Times* joined the opposition with a strongly worded opinion. Under the banner "Capitol Folly," the paper wrote that "architectural vandals" plotting at the Capitol were nothing more than self-centered men bent on putting "the impress of their incompetence" on the most important building in the land. It did not begrudge Congress the space needed to do its work, noting that the Senate's second office building was almost finished and the third office building for the House was under way. But it argued that the historic east facade of the Capitol, "the product of Thornton, Latrobe, & Bulfinch ought to be left alone."[11]

On February 17, 1958, the Public Buildings Subcommittee of the Senate Public Works Committee held a full day of hearings on legislation to end the east front project. Senator Smith read a joint statement signed by three colleagues warning of the great mistake that was about to take place, a mistake "for which we are all responsible." He hoped the hearings would explore ways to relieve the space shortage without resorting to the "drastic alteration to the historic east front of the Capitol."[12]

George Stewart testified that the preservation of the old sandstone walls was not feasible. The legacy of Thornton, Latrobe, and Bulfinch was, in fact, encrusted beneath thirty-five layers of dirty paint that hid the evidence of their design skills. Falling stone was a danger to the public, and the necessary patching further eroded the authenticity of the facade. To answer the charge of "desecration," Stewart presented his own definition of the term:

> Decade after decade, century after century, down the vista of years beyond man's imaginative vision, the painting continues. Whereas there are now 35 coats of paint, a hundred years from now there would be 60, in another century 85—a staggering prospect. Already peeling and cracking, already obscuring the fine detail, there would only be a trace. Such a treatment of a fine old building can only be called desecration.[13]

A discussion followed about the Speaker's handling of the business of the commission, the lack of meetings, and the absence of open debate. It seemed that Rayburn ran the commission with an iron fist, not allowing other members to participate. A copy of a note written by Joe Martin was read into the record indicating that the minority leader of the House did not recall ever voting for the east front extension during commission meetings. Julian Berla from the AIA spoke at length about the need for Congress to create more working space,

suggesting that perhaps Stewart should give up his Capitol office. Berla also hinted at the possibility that the architect of the Capitol might be willfully neglecting maintenance of the outside walls in order to promote the extension project. Dr. Richard Howland, the president of the National Trust for Historic Preservation, sent a statement condemning the east front extension as an "ill-advised alteration . . . in the guise of necessary repairs." He understood that the Capitol was a working building but hoped that "present needs and the heritage of the past can be so reconciled that future generations will receive from us at least this small part of our legacy."

The president of the AIA diplomatically praised the architect of the Capitol as well as the associate architects, but condemned the legislation that led them astray. Another witness, Douglas Haskell, editor of *Architectural Forum*, noted that his magazine as well as *Look* opposed the extension. He thought the project cost was indefensible: it was a waste of money to tear one wall down to build another to gain a "thin sandwich of space." He did not believe the stories about falling stone posing a threat to the safety of the public or legislators:

> Mr. Chairman, to listen to gossip around the city of Washington, you would think that the present east front was showering everyone with meteors of falling stone. We have heard described some entirely fictitious stones weighing as much as 60 pounds which casually fell off as if a dog were shaking off water. Mr. Chairman, if this condition were indeed a fact, it would cast grave doubt on the competence and integrity and even the mother-wit of the Architect of the Capitol, who is charged with maintaining our public buildings and should long ago have prevented such stone shower baths by prudent patching.[14]

The docket was full of other people anxious to help put a stop to the east front project. Letters were introduced from the historical societies of Vermont and the District of Columbia, the state museum of Florida, the Society of Architectural Historians, and the American Veterans Committee. All agreed that the Capitol's east front was a historic treasure not to be meddled with after so many years as witness to the nation's history.

What no one who spoke that day noted was that a fundamental change was occurring in the perception of the nation's Capitol. Until quite

Condition of Exterior Sandstone
1958

*B*y the mid-twentieth century the Capitol's exterior sandstone was in places worn, cracked, and encrusted with paint. A particularly graphic example of deteriorated stonework is shown here.

recently, the building had been considered susceptible to improvement, capable of enlargement and modernization to keep pace with the needs of the legislative branch of government. Now voices were heard opposing change. For the first time in the history of the Capitol, the swell of a grass-roots preservation movement could be felt by those who ran the place. In years past, a handful of committee members discussed what course the Capitol should take, what should be done to make it better. Speeches were made in the House and Senate to debate the wisdom and cost of proposed changes, but the public's participation in the discussion had been largely reactive. Now, the public was trying to involve itself at an early stage of discussion, bringing a sense of history to the debate. With so much of the nation's past being swept away by highway construction and urban renewal, preservation of the Capitol's east front seemed a matter of great

importance. Historic preservation had become a growing force in the Capitol's destiny.

Sam Rayburn, however, was not deterred. He considered the project good for the Capitol, good for the House of Representatives, and good for the American people. Four days after the Senate hearings he convened the commission and told Stewart to proceed. Repairs to the dome, a new Senate subway terminal, and improvements to the electrical and lighting systems were also authorized. (For the time being no further plans would be pursued on the west front extension, bomb shelter, terrace reconstruction, underground garage, or landscape improvements.) Stewart was authorized to enter into contracts as soon as possible so that the extension would be finished before the next inaugural ceremony on January 20, 1961. Samples of Vermont Imperial Danby marble and White Georgia Golden Vein marble were presented by Stewart to the commission, which responded by leaving the decision up to him. The Georgia Marble Company later withdrew its Golden Vein sample because there was not enough available for the project and requested that Georgia Special White be considered instead.

Stewart asked the advisory architects for ideas about the disposition of materials to be removed from the Capitol to prepare for the new work. They replied that pieces of the columns, stairs, entablature, and balustrade coming off could be stored or, as Harbeson suggested, reconstructed into a national museum. What to do with the sculptural decorations was also open for discussion. The statuary groups on the two cheek blocks, *Discovery of America* by Luigi Persico and *Rescue* by Horatio Greenough, were, in the opinion of the advisory architects, not worth reusing. The Greenough group was considered particularly offensive to American Indians and was thought best consigned to a museum. With these sculptures out of the way, there would be an opportunity to commission new statuary groups as a show of more sophisticated contemporary taste. Other worn pieces of sculpture, such as the two figures of War and Peace by Persico and Antonio Capellano's *Fame and Peace Crowning Washington*, would be reproduced under the supervision of a trustworthy sculptor.

During the spring of 1958, arguments over the wisdom of going ahead with the project showed up again in the nation's newspapers. Although the committee hearing was over, the full Senate had not yet voted on the proposal to shelve the project. Writers pro and con kept the editorial pages filled with all the old arguments. A series of well-balanced articles by George Beveridge began to appear in *The Washington Star* on March 23, 1958, fairly presenting the justifications to extend or restore. The first was titled "East Front Architects Blast Foes As Unethical," followed by "Architects Differ Widely on East Front Extension—Views Range From Vandalism of Shrine to Improvement of Historic Values." Next came an article under the short rhetorical headline "Sense or Sentiment?" Editorially, *The Washington Star* eventually concluded that the east front project had been victimized by the "sinister accusations and half-truths of the whipped up 'Write Your Congressman campaign'" and should proceed immediately without "further dillydallying." [15]

On May 18, 1958, news of an important change of heart was reported in Washington's *Sunday Star*. The executive committee of the local AIA chapter had passed a resolution supporting the east front project. Members of the committee noted that the plans were "basically sound, esthetically pleasing, and in harmony with the design of the present Capitol." [16] Editorially, the *Sunday Star* thought that the reconsideration was wise and asked the architectural profession in general to take another look at the east front question. Too much passion and not enough hard facts had colored the debate, and it urged the profession to decide the matter "based on knowledge—not emotion." On June 13 *The Evening Star* reported that the Metropolitan (Washington) Chapter of the AIA voted to withdraw its opposition to the project. It was, according to the paper, a "knockdown, drag out session" lasting four hours. Richard Howland of the National Trust for Historic Preservation and one of the project architects, Albert Swanke, were among those who presented opposing arguments before the chapter that evening. [17]

On May 27, Rayburn went to the National Press Club to defend himself against charges being made regarding his handling of the project. Accusations that the Speaker thought he "owned" the Capitol, and that he was a dictator, were charges that surprised him. One by one Rayburn went down the list of problems with the east front: the thick paint obscuring carved details, falling stones that might

bop a president elect on the head as he stepped forward to be sworn in, cracks patched with cement, and the dome overhanging the portico. The materials could not be saved, but the design could be, if faithfully replicated in a durable material like marble. On another issue, Rayburn pleaded innocent to the charge of trying to pull a fast one. After all, he argued, generation after generation starting with Thomas U. Walter had advocated the project. He summed up changes made by Latrobe and additions made by Walter to illustrate the point that the Capitol had always been the subject of alteration and expansion.

The Speaker then took questions from the audience. A reporter wanted to know why so many architects had opposed the east front extension. Rayburn replied that of the thousands of members of the AIA, only a few had ever seen the Capitol up close; those who had, had approved the project. The recent action taken by the Washington chapter reversing its position proved the point. Would he consent for the House and Senate to vote on the issue again? Rayburn argued that Congress voted on the issue twice in the 1930s and again in 1955 and he did not see any use of "chewing over that old cud again." Questions continued and Rayburn cheerfully kept up his spirited defense. It was his first appearance before the Press Club in twenty-one years, a performance characterized as "lively" and "impassioned." No one doubted that Rayburn was determined to see the project through.[18]

The Washington Post was not swayed by the Speaker's performance and thought that he should let the question be voted on again. It did not believe that the east front was crumbling, or that Congress absolutely had to have more space in the Capitol. But even if those assertions were true, why did the Speaker and his "staunch ally"—the architect of the Capitol—oppose a fair and open hearing before Congress and let the facts speak for themselves? The paper concluded gravely: "We fear that Architect Rayburn made Parliamentarian Rayburn a trifle arrogant in dogmatically insisting that any reconsideration was out of order."[19]

In July 1958, the American Institute of Architects held its annual convention in Cleveland and considered a proposal to reaffirm its traditional stand against the east front extension. One of the leading critics, Julian Berla, addressed the assembly about the "hydra-headed issue that will not

stay dead." He blamed Stewart for not allowing the project to wither on the vine, and urged the institute to uphold its position in favor of retaining the old facade. His stand was supported by Ralph Walker of the New York chapter and Turpin Bannister, the dean of the University of Florida's school of architecture. One of the few voices raised against the current policy was that of Amos Emery of the Iowa chapter. He claimed that architects did not have the exclusive right to determine what was best for the Capitol and that the institute was just saving face by refusing to reconsider its position. He warned his fellow architects that "consistency is the hobgoblin of little minds, little statesmen, little creatures, and little men."[20]

The delegate from Iowa notwithstanding, the convention voted to reaffirm its opposition to the extension. In a few weeks, Fred Schwengel, a Republican representative from the Hawkeye State, gave a speech in the House condemning what he saw as the AIA's personal attacks on the Speaker. He demanded an apology for its "gross misunderstanding" of Rayburn's role in the extension and for calling him an "historic barbarian." As a member of Congress, Schwengel did not appreciate being called an "arrogant politician" just because he supported the Speaker, nor did he think the charges of "vandalism," "mutilation," and "destruction" were accurate or fair. He spoke of the honorable intentions of those involved in the project and again demanded that the AIA apologize to the Speaker.[21]

THE FOURTH CORNERSTONE

*T*he AIA never apologized and Rayburn never budged. On August 14, 1958, the full Senate rejected Senator Smith's bill to send the project back for further study. Advocates of historic preservation may have been shaken by this defeat, but they soon learned to be more vigilant. It was nearly impossible to derail Rayburn's plans once the first appropriation passed. The public debate aired many issues but ultimately could not alter the course of events. Yet interest in the preservation of historic buildings was growing deeper and broader every day, and

there would be ample opportunity to savor victory in the future.

At the end of August 1958, the decision was made to use Special Georgia White marble for the exterior of the extension, and Stewart accepted the offer of the Georgia Marble Company of Atlanta to furnish and deliver it for $2,873,650. In September, three local firms were asked to bid on the work to remove the east central portico and other features standing in the way of the new extension. John McBeath & Sons was awarded the contract on October 3, 1958, and directed

to have demolition completed by the first week in April. A sculptor's shed was built on the east grounds, where artisans working for the Vermont Marble Company repaired the weathered figures of *Fame and Peace Crowning George Washington*, the statues of War and Peace, and the three figures in the pediment comprising the *Genius of America*. When repairs were completed, carvers made reproductions from Vermont Imperial Danby marble. Repair and replication of exterior sculpture were supervised by Paul Manship of New York.

Portico Removal

1958

The monolithic column shafts, which were so difficult to quarry, transport, cut, and install in the 1820s, were removed with ease in the 1950s.

Portico Removal

1958

The head of America, the central figure in Luigi Persico's *Genius of America*, was one of the first things removed from the east portico during its demolition.

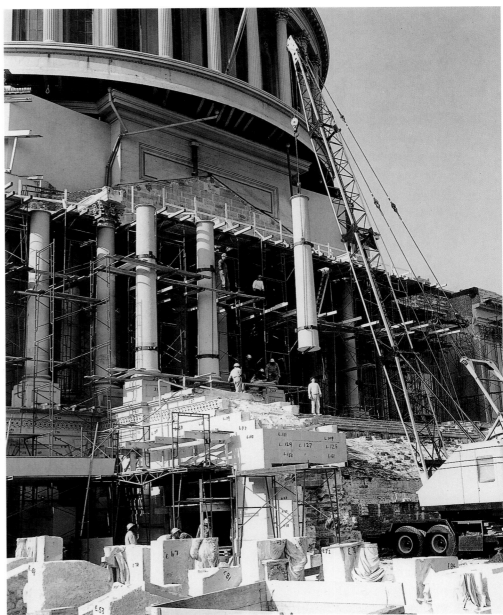

As the sandstone was removed, some was stored at a facility operated by the National Park Service, while other things such as the column shafts were stored at the Capitol Power Plant. Later, when the power plant was enlarged, the columns were transferred to a remote nursery operated by the U. S. Botanic Garden. Once demolition was complete, excavation was begun and workmen began installing new underpinning under the old foundations. On June 23, 1959, Stewart's office issued a press release announcing that the cornerstone of the east front extension would be laid by President

Portico Removal
1958

The lower half of a Corinthian capital was taken away while workmen disassembled another in the foreground.

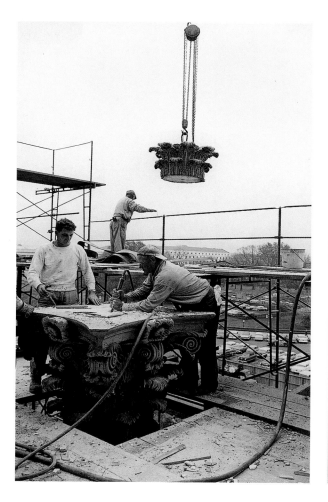

Eisenhower on the upcoming Fourth of July. A block of red granite was ordered in the form of a three-foot cube and bearing the inscription "A. D. 1959" on one face. The top of the stone was cut to receive a metal box for memorabilia. The cornerstone was quarried near Marble Falls, Texas, not far from Lyndon Johnson's ranch.

Construction of temporary stands and platforms began a week before the ceremony. There were none of the parades or barbecues that marked previous ceremonies, but Eisenhower, like Washington and Fillmore before him, came to the Capitol to personally lay the stone. An estimated 3,000 people were at the Capitol on July 4, 1959, to hear Rayburn introduce the president, who, in turn, made a short speech. Descending into a deep pit, Eisenhower spread cement on a foundation slab using the same trowel Washington wielded at the Capitol in 1793. As he leaned down to dip up the mortar, the president noted the small size of the tool and observed, "You can't get much mortar on this trowel!" A crane lowered the stone into place. With his hand on the cornerstone, Eisenhower tapped it lightly with the gavel that Washington had used in 1793. The president left as soon as the rites had been completed.

On July 17, 1959, the copper box containing memorabilia of the ceremony was removed from its niche in the cornerstone. It contained sealed messages from members of Congress, telephone books, a signed copy of the president's speech, and a

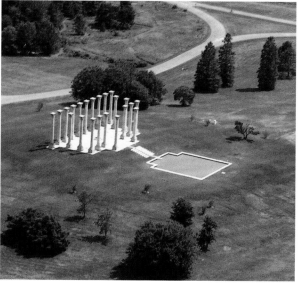

East Front Columns at the National Arboretum

Friends of the National Arboretum proposed reusing the columns from the east portico in a new setting at the arboretum located in northeast Washington. The noted landscape architect Russell Page provided the plan. After years of work and fund raising, permission was granted in 1984 to transfer custody of the columns to the Department of Agriculture. Four years later the columns were re-erected along a nearly square plan in front of a water stair and reflecting pool. (1991 photograph.)

*S*tripped of white
paint, the ironwork of the
dome was primed with a
rust inhibitor.

replica of the Bible on which Washington took his first presidential oath. A tape recording and a movie of the ceremony were added. The box was then treated by scientists at the National Bureau of Standards, who replaced the interior air with helium containing a small amount of moisture. The box was then hermetically sealed. (The same steps were followed to preserve the Declaration of Independence and the Constitution at the National Archives.) Weighing more than eighty-two pounds,

the box was returned to the cornerstone by Rayburn on September 3, 1959.

The Charles H. Tompkins Company was contracted to build the extension, a steel-frame structure with brick walls, reinforced concrete floors, and a facing of white marble. While construction was under way, the J. F. Fitzgerald Company of Boston repaired the dome. By the end of 1959, the exterior of the dome was surrounded by a scaffold with towers, ramps, and hoisting equipment.

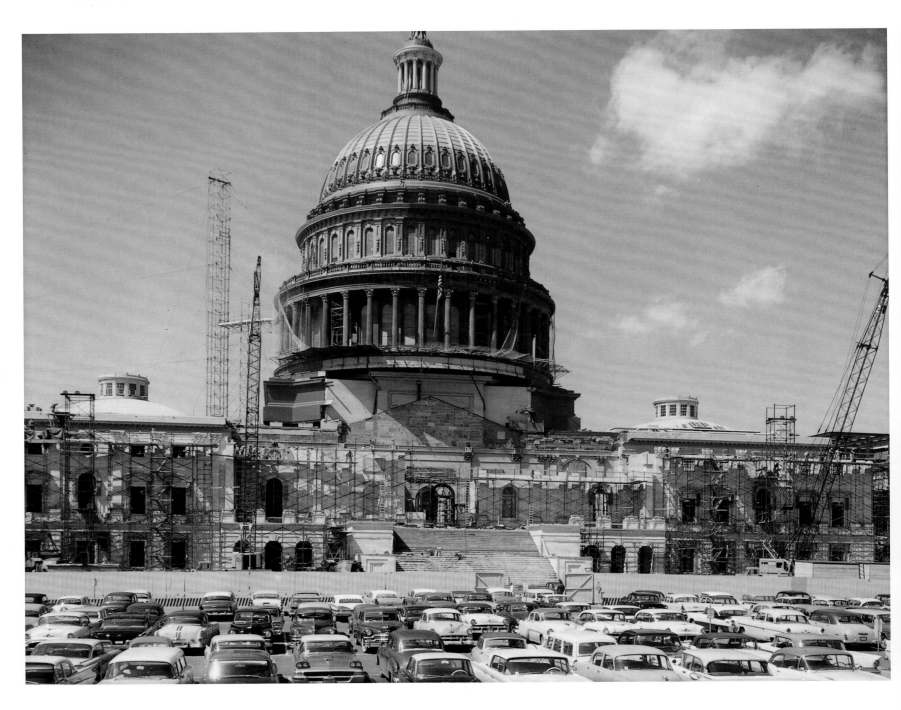

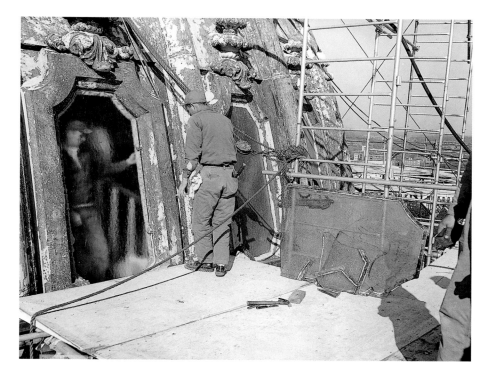

Dome Repair
1959

A few sheets of nineteenth-century hammered glass were replaced while repairs were made to the dome. Opaque glass diffused light and thus reduced glare and heat gain.

East Front Construction
1960

*T*he original walls gradually disappeared as the new addition grew higher.

Workmen wielding special pneumatic hammers removed paint from the iron, which was then sandblasted. Since bare iron rusts quickly, it had to be treated with a protective coating within five hours of paint removal.[22] Corroded and cracked metal was repaired or replaced where necessary, loose bolts were tightened, and missing bolts were replaced. New bronze window frames were installed in the tholus and the interior bracing in the statue of Freedom was reinforced. Repairs were made to the drainage system and flashing and the dome was completely inspected and repaired, using stainless steel wherever strength was required. Additional lightning protection was provided, along with a modern electronic bird control system. On the interior, Stewart hired a muralist, Allyn Cox of New York, to restore Brumidi's *Apotheosis of George Washington.* The methods used by Cox included scraping the fresco with nylon brushes, filling bare spots and overpainting with pigments ground in water. (The painting was subsequently treated by professional conservators in 1988.) The dome repair work was completed in the spring of 1960.[23]

On May 26, 1960, the first marble column shaft was installed on the new east central portico. It weighed about eighteen tons and was hoisted into place by a crane as Rayburn and Stewart proudly

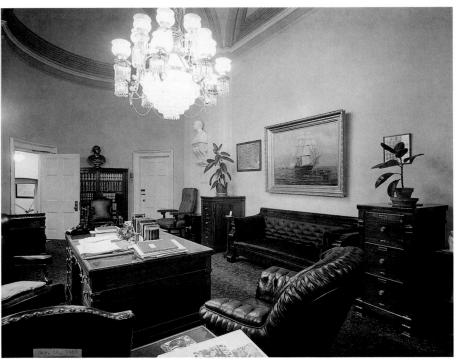

New Senate Reception Room
1962

*T*his photograph was taken before carpets were laid or paintings hung. The colonial revival paneling, pilasters, and entablature were fashioned from walnut by a Baltimore woodworking firm.

In 1976 the reception room was named in honor of Senator Mike Mansfield of Montana.

Office of the Clerk of the House of Representatives
1960

*B*efore work began on the interior phase of the east front project, a photographic survey was made of every room affected by the new addition. This office (modern-day H–235) was about to lose its view of the east plaza but otherwise would remain essentially as seen here. When this photograph was taken the office was occupied by Ralph Roberts, the clerk of the House. Today, it is part of the congresswomen's suite named in honor of Lindy Boggs of Louisiana.

Before the fire of 1814, the room was occupied by the Committee on Ways and Means. From 1819 until 1857 it was the Speaker's office. Here, on February 23, 1848, John Quincy Adams died on the sofa seen against the wall. The ex-president was serving his ninth term in the House of Representatives when he suffered a stroke at his desk in the nearby chamber. The bust of Adams by John Crookshanks King was acquired by Congress in 1849 and mounted on a marble bracket near the sofa.

looked on. Installing one column each working day, twentieth-century builders completed the colonnade in less than a month; the job had taken Charles Bulfinch, George Blagden, and their men more than two years in the 1820s. The last column hoisted was one of the eight Maryland marble columns taken down and reused from the House and Senate connecting corridors. It was reset on June 29, 1960.

As the exterior marble work was being finished, it was discovered that some marble blocks were

defective. Cracks were patched in an attempt to fool inspectors, who caught the imperfections only after the stones had been set. Once discovered at the end of August, the faulty stones were ordered replaced. Luckily no other problems arose to threaten the completion of the outside in time for the inaugural ceremony on January 20, 1961. On that bitterly cold, blustery day, forty-three-year-old John F. Kennedy stood on the new portico and took the oath of office. His inaugural address is usually ranked with the most eloquent in the nation's

East Front Lobby
1962

*A*lthough the outside of the east front extension was completed by January 1961, the interior was not ready until eighteen months later. Here, the new ground floor lobby appears as completed in July 1962. The column shafts were made of Colorado breccia while white Vermont marble was used for the capitals.

annals, and with it the patina of history began to accrue on the Capitol's new east front.

THE THIRD HOUSE OFFICE BUILDING

*I*n the spring of 1955, Speaker Sam Rayburn requested $25,000 to study the feasibility of building a third office building for the House of Representatives. When the legislation came before the House, Rayburn left the chair, took the floor, and offered an amendment to replace the modest planning funds with $2 million and any additional money "as may be

necessary" to begin construction of a new building. Republican Representative Clare E. Hoffman of Michigan objected to funding a project that had not yet been authorized pointing out that it was contrary to House rules. Yet, the chairman of the Appropriations Committee, Clarence Cannon of Missouri, quickly accepted the amendment in light of the urgent need for such a facility. After little debate, the House approved Rayburn's amendment on a voice vote. The legislation came less than four months after ground was broken for the second Senate office building, two months before the east front project was approved, and only two months after Sam Rayburn became Speaker and chairman of the House Office Building Commission. Other members of the commission, James Auchincloss of New Jersey and Carl Vinson of Georgia, supported the Speaker's plan to provide members with three-room suites and other rooms to accommodate the increasingly heavy load of committee business resulting from the Legislative Reorganization Act of 1946.

Building a large new office structure was but one component in a complex scheme to improve accommodations for the House outside the Capitol. Each of the two older office buildings would be remodeled to provide three-room suites and to improve the spaces occupied by committees and staff. A three-level garage was planned for the courtyard of the 1908 building, while a cafeteria was to be built in the courtyard of the 1933 structure. The site for the new building was created by closing a block of Delaware Avenue, S. W. and uniting the two squares immediately downhill from (i. e., west of) the second House office building. Adjacent blocks south of the site were acquired and cleared for park land, but the decision was soon made to build underground garages there as well. A transportation system, consisting of pedestrian tunnels connecting the new and old structures and an electric subway, was planned to link the new office building with the Capitol. Taken together, Rayburn's schemes for the House office buildings and other improvements far exceeded any project ever before seen on Capitol Hill.

The same architects who helped design the new House and Senate chambers, Harbeson, Hough, Livingston & Larson of Philadelphia, were retained by the House Office Building Commission

to design the new building. As noted earlier, Roscoe DeWitt and Fred Hardison of Dallas were hired for the remodeling of the 1908 building, while work in the other structure was planned by Albert Swanke and Albert Poor of New York City. Underground structures were the responsibility of Jesse Shelton and Alan G. Stanford, engineers from Atlanta in Congressman Vinson's home state. All of these firms were also involved in the east front project, which was undertaken at the same time as the new House office building.

Work began on the site of the new office building immediately after the land and title were clear. Soil samples and test borings were taken to help design the building's foundations. On May 8, 1958, McCloskey & Company of Philadelphia was awarded the contract (worth more than eight million dollars) for excavation and foundation work, while two months later the Bethlehem Steel Company was given a contract (worth almost seven million dollars) for the delivery and erection of the building's skeleton.[24]

As the highly visible site along Independence Avenue was excavated, the press became curious about the building destined to occupy the enormous hole. On August 13, 1959, the *New York Herald Tribune* ran a story about the new House office building under the banner "6-Block Hole in Ground Has Washington Guessing."[25] According to the article, plans for the new building were "top secret," a charge Stewart vigorously denied. He said the plans were under revision and would not be made public until they were finalized. The plans were, therefore, not "secret" but, rather, "unavailable." *The Washington Post* asked its readers if they had "Ever seen a $10 million hole?" and wrote that "no one knew what's going on." On the editorial page the *Post* complained about Stewart's "Edifice Complex":

> The plans for this new edifice are still sealed up in secret—even though $16 million has already been spent on digging the biggest hole in town for the foundation. The architect's office will concede that the four-story building will be made of white marble and shaped like an "H," but not much else. The plans, Mr. Stewart's office explains, are still not in a final form for release, although preliminary sketches have been on hand for a year. Will it be Gothic? Or Byzantine? Or an H-shaped copy of Stonehenge. We mere mortal taxpayers must just wait and see.[26]

Working closely with Rayburn and Stewart, the Harbeson firm labored at the building's design over a four-year period. Neither the Speaker nor the architect of the Capitol wanted to expose the design to public scrutiny until it was finalized. On October 16, 1959, Stewart unveiled the design and informed the press that his office would soon solicit bids from general contractors. From the elevation prepared by the associate architects, it was difficult to comprehend the scale of the new building. It would be 720 feet long and 450 feet wide, enclosing more than a million square feet (25 percent more than the Capitol), with another 1.2 million square feet for a garage capable of parking 1,600 cars. It contained 169 congressional suites, nine standing committee rooms, sixteen subcommittee rooms, fifty-one committee staff rooms, twenty-four passenger elevators, four freight elevators, stationery rooms, press and television facilities, a post office, work shops, storage rooms, a cafeteria with 750 seats, shipping and receiving docks, two gymnasia, and a swimming pool.

A typical office suite was fifty-four feet long, thirty-two feet wide, and divided into three rooms. The middle room housed the reception area and an office for the chief assistant. On one side was the member's private office with an adjacent toilet, closet, and file room with a burglarproof safe. The third room accommodated the general staff office and was lined with built-in file cabinets. Another storage room, coat closet, and toilet facility were nearby. Later, after the building was occupied in 1965, some representatives complained that the plan made it necessary for them to pass through the public waiting area in order to confer with staff. Without private access to the staff room, wrote the *Sunday Star*:

> a Congressman would have to sashay through a waiting room exposed to the pleading eyes, rapid tongues, and clutching hands of his constituents. To protect him, doors were cut from private offices to staff rooms, but, symbolically enough, you couldn't just cut a door. Built-in files had to be unbuilt and money had to be thrown to the winds in great handfuls to accomplish belatedly what the most chuckleheaded architect could have seen as necessary from the first.[27]

After advertising for bids, the general construction contract was awarded on March 19, 1960, to McCloskey & Company, the same Philadelphia

firm that built the foundations. The contract was in the amount of $50,793,000, a figure that helped make the new House office building the most expensive construction project yet undertaken on Capitol Hill. McCloskey & Company's success at landing lucrative government contracts raised eyebrows because the owner of the firm, Matthew H. McCloskey, was the treasurer of the Democratic National Committee and one of its major contributors. (During the Great Depression he invented the $100-a-plate fund-raising dinner. In 1962 President Kennedy named him the ambassador to Ireland.[28]) The press and politicians began complaining about the cost of the project, comparing it with the Pentagon or the new Pan Am building in New York City. Charges of extravagance and waste were hurled at the architect of the Capitol, who defended the large expenditures by noting the size and permanence of the structure and the costly materials used to build it.

During a brief ceremony held on December 14, 1961, an American flag was run up on the last steel column installed on the site. The "topping out" ceremony was conducted by Republican Representative James Auchincloss, who expressed his hope that the spirit of "Mr. Sam" would forever inhabit the building. Only a month earlier, Rayburn, to many Americans the very personification of the House of Representatives, had died of cancer. His intense interest in the building being built for the comfort and convenience of the House was well known and appreciated by the majority of his colleagues. Few members quarreled with him over matters concerning their accommodations, in either the east front extension or the new office building. "Mr. Sam" always had their best interests in mind and they loved him for it.

On May 21, 1962, the House voted to name its new office building after Rayburn. At the same time, the 1908 building was named for Joseph Cannon and the 1933 structure for Nicholas Longworth. Each man honored had served as Speaker at the time the building was authorized. Three days after the Rayburn Building was named, Speaker John McCormack and President Kennedy laid its cornerstone. They spread mortar on the half-ton marble block and, with the help of some professional masons, guided the cornerstone into place. During his remarks, the president recalled

that Rayburn was serving his 34th year in Congress when he, as a freshman representative from Massachusetts, came to Washington in 1947. Having now served at both ends of Pennsylvania Avenue, he appreciated the comity between the legislative and executive branches of government that Rayburn had always promoted.[29]

A QUESTION OF STYLE

When the architect of the Capitol released plans for the Rayburn Building in 1959, he described it as a "simplified classic design" that would fit in with its neighbors on Capitol Hill.[30] After seeing the rendering, the editors of *The Washington Post* were relieved to find that rumors of the building being "shaped like a wilted mushroom" were untrue. "Judging from the sketch now in public view," they continued:

> the third House office building looks just about like every other office building designed under Government auspices. This comes as something of an anticlimax after all the furtiveness of the past. For a while, the Capitol architect had us thinking that the House was really building a factory for H-bombs. . . . [31]

The *Post's* initial assessment of the building's architecture was high praise compared to the scorn heaped on it as construction neared completion. As its bulk became clearer and its sparse, eccentric details came into focus, critics began to use words like "hideous" or "monstrosity" when describing the Rayburn Building. One design critic claimed it could only be defended militarily. Its position on the slope of Capitol Hill, a site necessitating a towering podium in the form of a rock-faced wedge, caused others to speak chillingly of Valhalla, the Great Wall of China, or the great ziggurat of Babylon. Masses of cold, white marble, punctuated by long rows of square, unadorned windows, reminded at least one wag of ice cube trays. *The Washington Post* could not discern a single style and thought it might be a hybrid of "Middle Mussolini, Early Rameses, and Late Nieman Marcus."[32] Even thirty years after the building was finished, its detractors were as acerbic as ever. In 1993, a survey of Washington architecture included a scathing assessment of the building's

design. After describing the city's "most maligned public building," the author concluded:

> The difficulties of designing in a historical style whose time has passed by those untrained or ill-trained in the basic principles is manifested most obviously in the Rayburn Building by the lack of a comprehensive human scale, the most fundamental legacy of the classical system of architecture. . . . The end result is a bombastic architectural expression of raw, arrogant, and uncontrolled power that dominates through sheer size rather than coexisting amicably with its neighbors or enhancing the art of architecture by contributing a viable new interpretation of its building type or architectural style.[33]

Not everyone, however, condemned the building. Paul Manship wrote George Stewart a letter

Rayburn Building
1965

*T*he design of the Rayburn Building struggled to reconcile the practical needs of a modern office building to the architectural context of classical Capitol Hill—compliments from the architectural community have been few. Yet with fifty acres of floor space, views of the Capitol, and a subway, the Rayburn Building holds some of the most highly prized House offices.

Rayburn Building's Finishing Touches
1964

*A*ncient drinking horns called "rhythons" inspired the design of these unusual sculptural ornaments.

Committee Room in the Rayburn Building
1965

*F*ollowing reforms contained in the Legislative Reorganization Act of 1946, committee rooms were designed to allow members to face witnesses from a raised podium.

praising the design, which the architect of the Capitol found "reassuring." The sculptor wrote:

> May I say how much I enjoyed the architecture of the building which impressed me by its beautifully proportioned simplicity. It is modern in its adaptation of grand traditional forms and style. The fenestration, the great entrances with majestic columns and lofty ceilings add their impressive harmony to the whole; just but reticent detailing of ornament enhanced the architecture. The materials, marble and granite, are beautiful and fitting to this building in the great stately tradition. . . . [34]

But Manship's opinion of the building's architectural merit was not shared by many others, and condemning the building remains a favorite pastime among Washington's design critics.

Representatives and their staffs began occupying the Rayburn Building at the end of February 1965. With the remodeling of the Cannon and Longworth buildings and the land acquisitions, underground parking garages, tunnels, subway, furniture, and landscaping, the entire project had cost more than $135 million. Despite unfavorable reviews, the Rayburn Building is the most popular House office building among members, who covet its convenience, amenities, views, and space.

WEST FRONT

The Rayburn Building brewed a storm of controversy that was slow to pass. At the same time, another controversial project was to keep architects and politicians on Capitol Hill under intense scrutiny for two more decades. The latest idea was to build an addition to the Capitol's west front, a scheme hatched by the Rayburn team of architects and engineers soon after the east front extension was authorized in 1955. They considered the west front extension the logical next step in the building's inevitable development. For precedent, they cited plans by Thomas U. Walter and Edward Clark, both of whom had designed additions to the west front for the expansion of the Library of Congress. They also claimed that Olmsted anticipated an addition to the west front by providing courtyards between the terrace and the Capitol. The argument that a west front extension was not a new idea was accurate; however, the present proposal was entirely

unlike anything suggested before. It would have enclosed four and a half acres of space behind new marble walls, changed the composition of that side of the Capitol, and required the demolition and reconstruction of the terrace.

As with the east front project, the condition of the outside walls was a major factor behind the proposal to build a new marble addition. The Aquia Creek sandstone had not held up well, and ample evidence of structural failure was visible to the untrained eye. Particularly frightening was the sagging entablature above the central colonnade. A few keystones had dropped and there were cracks everywhere. In one farfetched additional observation, extension proponents claimed that the old building was somehow out of proportion with the dome. For those who admired the new east front, the obvious solution to the problems was a new marble facade on the west. To those who fought against the east front project, the solution was restoration and better maintenance. The battle lines were soon drawn over the last part of the old Capitol not covered by marble additions.

On December 30, 1963, Congress appropriated $125,000 to survey, study, and examine the structural condition of the west front. Stewart contracted with the engineering firm of Thompson

Taft Memorial and Carillon

The memorial to Robert Taft is a lean, modern design consisting of a rectangular bell tower 100 feet tall faced with Tennessee marble. Douglas Orr of Connecticut was the architect of the memorial, which is located in the park between the Capitol and Union Station near a site once proposed for the Lincoln Memorial. Wheeler Williams sculpted the bronze statue of the Ohio senator. (1961 photograph.)

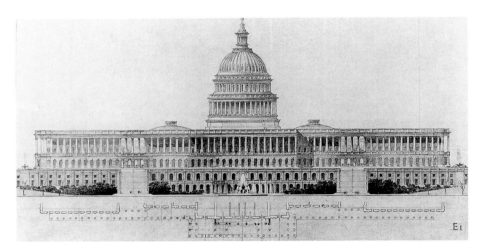

Study for the West Front Extension
by DeWitt, Poor & Shelton, 1963

One of the more drastic proposals for the west front envisioned an unbroken colonnade stretching from one end of the Capitol to the other. A massive reconstruction of the terrace included scores of new windows that would have diminished the impression of strength that Olmsted intended.

& Lichtner for the structural survey and with the J. F. Fitzgerald Construction Company for soil tests of the ground immediately adjacent to the west front as well as for drilling core samples in the old walls. Both firms were headquartered in Speaker John McCormick's home state, Massachusetts. In November 1964, the consulting engineers presented their findings in a five-volume report describing the alarming conditions of the west front. Not surprisingly, they wanted to brace the old walls behind a new addition, providing more room for offices and committees. A public hearing was held on the recommendations in June 1965, with McCormack presiding. The president of Thompson & Lichtner, Dr. Miles Clair, gave extensive testimony about the west front, its construction history (as he understood it), soil conditions, stone weathering, deterioration, and settlement. Representative Gerald Ford of Michigan (later president of the United States) asked about the "net result" of all these conditions and Clair predicted that the Capitol would begin to collapse within five years. Some areas, such as the portico, were in more immediate danger. He warned that stopgap measures would only delay a final solution. "You can keep compromising with this," Clair warned, "or you can face the problem."[35] George Stewart recommended that Congress appropriate funds to build an addition in order to buttress the old walls. Meanwhile, stout wooden braces were installed to keep the entablature from falling from the west central portico.

On October 31, 1965, $300,000 was appropriated to the architect of the Capitol to prepare preliminary plans and cost estimates for the extension of the west front. The veteran firm from the east front project—DeWitt, Poor & Shelton—was retained for this work. Within six months, three schemes were developed. All the plans called for a large addition, eighty feet deep, that would necessitate the demolition of the Olmsted terraces. Each scheme sought to "improve" the composition of the west side of the Capitol, an architectural pastiche that a handful of critics deemed "incorrect." Bulfinch's portico with its odd intercolumniation (2–2–1–1–2–2) baffled some observers, as did the lack of a pediment. Such architectural oddities would be "corrected" by a new front.

Before an appropriation was secured, however, history-minded preservationists began loud protests. In June 1966, the American Institute of Architects asked the Commission for the Extension of the Capitol to reconsider. The AIA offered to make an impartial examination of the structural conditions and recommend solutions to problems it uncovered. Building on the growing strength of the preservation movement, the AIA led the battle over the west front, hoping to atone for its losses in the war over the east front. Unlike the east front project, however, the west front had no champion with Rayburn's single-mindedness or clout, and opponents had sufficient warning to fend off an initial appropriation. At the same time, historic preservation became a national policy on October 15, 1966, when President Johnson signed the National Historic Preservation Act—legislation that helped prevent federal money from harming historic sites. Although it did not directly affect the Capitol, the act emboldened preservationists in their efforts to preserve the west front.

One of the leading opponents to the extension was Representative Samuel S. Stratton of New York. He published a call to the American people to save the west front in a widely read article in *Parade* magazine. Stratton claimed that the architect of the Capitol, the Speaker, and other members of the Commission for the Extension of the Capitol were about to accomplish something that British invaders had failed to do in 1814—destroy the Capitol. He described one of the plans for an addition eighty feet in front of the old north and south wings and forty-four feet in front of the central building. Thus, Stratton concluded, the pleasing composition of the Capitol's west front would become a "flat and undistinguished architectural blob." He also described what would happen to the Olmsted terraces:

> To add the restaurants, auditoriums, extra hideaway offices and special-access road for service deliveries and garbage removal that he deems necessary, Stewart further proposes a vast, seven-level expansion down under the back side of Capitol Hill. This means the grand terraces and marble staircases, added in 1874, are slated for extinction.[36]

Sixteen senators and twenty-five representatives had already formed a committee to defeat the project, and Stratton urged readers to write Speaker John McCormack and Vice President Hubert Humphrey: "You'll be surprised how effective your voice can be here in Washington."[37]

The AIA submitted its report on the west front's structural conditions on March 24, 1967. Officials of the institute presented alternatives to the extension before hearings of the House and Senate Legislative Appropriations Subcommittees. Such maneuvers and the escalating conflict in Vietnam prevented the project from being funded. Meanwhile, the forces against the extension grew stronger, persuading key members of Congress to examine alternatives that might be wiser and less expensive. In 1970, an appropriation of $2.75 million was given to the architect of the Capitol for a restoration feasibility study, and on May 25, 1970, a consulting engineering firm from New York, Praeger, Kavanaugh & Waterbury, was retained to undertake it. By the end of the year, the engineers reported that restoration was indeed feasible. They recommended strengthening the structure by injecting grout and epoxy into the foundations and walls and installing steel tie rods to strengthen the arches and vaults. All exterior stone work would be cleaned of paint and each block evaluated for stability and strength. Stone would be replaced only as needed. The entablature would be dismantled and rebuilt, using tensioning cables for strength. Following repairs, the exterior could be treated with a stone preservative and repainted. The engineers had no question that a restoration could return the west front to a stable, authentic, and attractive condition.

George Stewart, however, never learned of this recommendation: he had died the day before Praeger, Kavanaugh & Waterbury was hired. His health had been impaired for some months, and during his last days in a nursing home his office was operated by his assistant, Mario Campioli. Over his seventeen-year tenure Stewart had been hounded by critics, who loved to point out that he was not an architect. While the same was also true of his two predecessors, it made no difference to the critics. The real difference between Stewart and Lynn or Woods was not so much the persons as the times in which he and they worked. Stewart's alliance with Rayburn, for example, was different from Woods' relationship with Cannon: whereas Cannon championed and protected

Woods, Stewart used his office to protect the Speaker. Criticism that should have been aimed at Rayburn was routinely fired at Stewart, who gladly took the shot. Another factor was that too often the Speaker and architect kept their plans to themselves, not letting people know of their intentions and opening themselves to legitimate charges of secretiveness. Consequently, their relations with the architectural profession, the press, and the Capitol Hill community were hardly cordial. Following Stewart's death, plenty of ammunition remained in detractors' arsenals for the next architect, who inherited the hornet's nest hanging over the Capitol's west front.

A PROFESSIONAL ARCHITECT

When news of Stewart's death reached the White House, President Richard Nixon assigned his staff assistant (and future New York senator) Daniel Patrick Moynihan to the task of identifying a replacement. For the first time since the agency reached its present form in 1867, the initiative to fill the top position came not from Congress but from the president. The sentiment in both branches of government was that the next architect of the Capitol should be an architect, one with professional credentials to quiet the perpetual controversies that seemed to envelop the office. Nevertheless, rumors circulated around Washington that William Ayers, a ten term representative from Ohio who recently lost his reelection bid, was under consideration. Alarmed at the prospect of another politician in the architect's job, Congressman Andrew Jacobs of Indiana introduced a resolution providing that if the next architect of the Capitol were not an architect, then the next attending physician of Congress should not be a doctor.

Logically, Moynihan turned to the American Institute of Architects for advice. A roster of qualified candidates was duly prepared by the institute, and its own vice president, George M. White of Ohio, was at the top of the list. With a diverse and accomplished background, White seemed perfectly suited for a job with so many different demands and clients. He held two degrees in electrical engineering from the Massachusetts Institute of Technology, a degree in business administration from Harvard, and a law degree from Case Western Reserve University. He was a registered architect and engineer, a member of the bar, and a successful businessman. Ohio Senators William Saxbe and Robert Taft, Jr. lent their support, and Nixon appointed White on January 27, 1971.

When White took office, the controversy over the west front was hardly front-page news. The effort to "complete" the Capitol was stymied by the war in Vietnam. After two weeks on the job, White was obliged to deal with an explosion in the Capitol, the result of a bomb planted to protest America's military presence in Southeast Asia. Growing unrest in the streets and on college campuses reflected a nation uncertain of itself and unsure of its leaders. Antiwar marches and protests grew louder as a fumbled break-in at the Watergate began to undermine the Nixon administration. His subsequent resignation, the ascent of Gerald Ford, and the end of America's involvement in Vietnam started a healing process that helped restore faith at home.

During the early 1970s, the Senate refused to go along with the idea of enlarging the Capitol, which was advocated mainly by the leadership of House of Representatives. In 1973, the Senate Subcommittee on Legislative Appropriations blocked a request for funds to build the addition. Despite opposition in the Senate, the Commission for the Extension of the Capitol, chaired by Speaker Carl Albert of Oklahoma and, later, Thomas P. O'Neill of Massachusetts, remained committed to the project. While skeptical at first, the new architect of the Capitol became converted to the cause, which he felt promised the best chance to ensure the building's structural stability. But the size and scope of the proposed extension had to be trimmed to become architecturally and financially palatable. Under White's direction, the associate architects modified their design, scaling it back enough to preserve Olmsted's terraces. The revised design, varying from nineteen to sixty feet in depth, was also considerably less expensive than its predecessor.

After a four-year lull, the west front issue exploded upon the front pages of the nation's

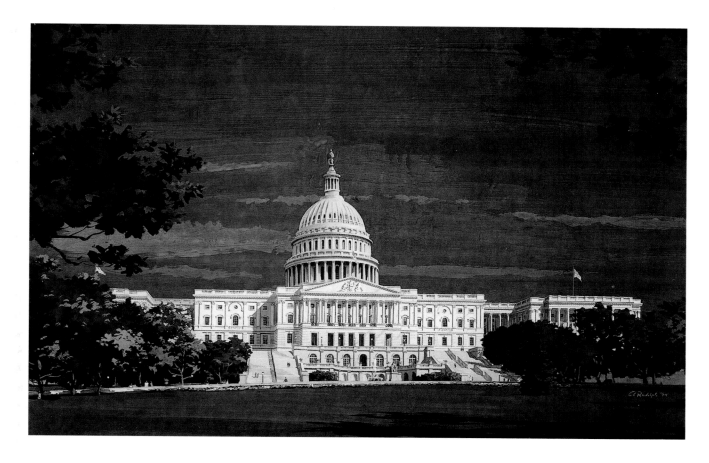

Revised Design for the West Front Extension
by DeWitt, Poor & Shelton, ca. 1973

To calm the storm of criticism gathering around the west front extension proposal, the architects scaled it back and left the terraces undisturbed. Congress rejected the extension scheme in favor of restoration in 1983.

newspapers in the spring of 1977. A change in the chairmanship of the Senate Legislative Appropriations Subcommittee gave hope to backers of the extension that the project would be funded. The new subcommittee head, Walter Huddleston of Kentucky, replaced Ernest Hollings of South Carolina, who had opposed the extension. On May 20, 1977, White presented the revised extension plan to Huddleston's subcommittee, telling the lawmakers that its estimated cost of fifty-five million dollars compared favorably with the estimated forty-five million dollars that would be needed for restoration. For a mere ten million dollars more, White argued, 135,000 square feet of office space could be added to the Capitol and the original walls would be protected behind the new addition.

Writing for *The Washington Post*, columnist George Will characterized the latest extension proposal as "Another Mindless Attack on the West Front." He claimed the extension would block views of the dome, flatten the elevation that so clearly expressed the bicameral legislative principle, and bury a "splendid achievement" of Ameri-

can architecture. Senator Ernest Hollings was praised for his sense of stewardship in having protected the Capitol from vandals. In a final thought, the author observed solemnly:

> Preservation is a civilizing task; it involves discerning and cherishing the most excellent work of previous generations and holding it in trust for subsequent generations. Preservation of the Capitol is a test of Congress's fitness for trusteeship, the most important measure of fitness to govern.[38]

The editorial board of *The Washington Post* strongly opposed the west front extension and claimed that upon learning that the congressional leadership approved the latest design, it had suffered a "sinking sensation." While agreeing that

the new design was an improvement over its "monstrous" predecessor, it considered restoration the only proper treatment for the ills plaguing the facade:

> The "Commission for the Extension of the Capitol" should restrain its lust for architectural disfigurement and get on with its *real* duty: the repair and restoration of the existing West Front, parts of which are now supported by unsightly heavy timbers. Three times in the past four years the Senate has voted to do just that, and the proposal has been shot down by the space-hungry House each time. The responsible action for congressional leaders would be to proceed with repairs that should have been done years ago—at a fraction of present costs.[39]

When the House Appropriations Committee voted fifty-five million dollars for the extension on June 29, 1977, *The Washington Star* wrote in disbelief:

> A reasonable piety toward the past is no more than a form of present self-respect. Considered in that light, the congressional itch to vandalize the West Front of the Capitol suggests a severe deficiency in our sense of national self worth—so far as that quality is refracted through the current crop of elected representatives. . . .
>
> The American Institute of Architects has valiantly opposed the congressional vandals. And the Capitol Hill poo-bahs who have pushed stubbornly ahead with the extension have disregarded even an engineering study commissioned by Congress itself that found restoration of the West Front to be feasible. The cost of the restoration would be more than expansion: to adduce that as a telling argument is to carry historical insensitivity to a canine level. The Capitol is a glorious monument and its preservation is not to be toted up merely in dollars.[40]

On the Fourth of July 1977, *The New York Times* weighed in with a stinging rebuke of the extension and its few but powerful supporters. On its editorial page, the *Times* demanded that the west front be restored. Scolding the powers in Washington, the editors wrote:

> Surely it is time to stop all the foolishness, once and for all, about extending the West Front of the Capitol. This dangerous Congressional boondoggle has now survived three times, and the idea doesn't improve with revival. . . . This is a proposal so unequivocally bad as economics, art history and planning, that one marvels at its apparent immortality.[41]

National news magazines wrote of the controversy as a classic struggle between the House and the Senate, between sentimental citizens and a handful of powerful politicians. *Newsweek*'s story was entitled "The Facade of Power," while *U. S. News and World Report* called its piece "Uproar over the West Front." Diagrams and floor plans gave readers a sense of the magnitude of the proposed addition and what it would do to the architecture of the Capitol. Neither article took sides, but the publicity did not help the proponents of the extension.

On July 20, 1977, a conference committee made up of members of the House and Senate Appropriations Committees agreed to postpone a decision on the west front until an estimate could be made of the cost of a restoration. Drawings and specifications for a restoration were needed in order that a fair comparison might be made. Money was an important issue, but the lawmakers also wanted to compare the time required for each project, the probable disruption to the workings of Congress, and other factors. Using an appropriation of $525,000, the architect of the Capitol hired Ammann & Whitney of New York City to prepare plans and cost estimates for a restoration. Their report was finished in March 1978.

For four years nothing was done with either proposal for the west front. In March 1983, the House Committee on Public Works and Transportation began another round of hearings that seemed no more auspicious than its predecessors until a section of lower west wall fell to the ground on April 27, 1983. Suddenly, the issue came to a head and there was no way to ignore the problems facing the Capitol's west front any longer. On May 18, the House Appropriations Committee approved more than seventy million dollars for an extension. Eight days later the Senate approved forty-eight million dollars for a restoration. By a wide margin (325 to 86), the full House disagreed with its committee's recommendation, deleting money for the extension, and substituting forty-nine million dollars for a restoration. On July 19, 1983, the House and Senate agreed in conference to fund the restoration with an appropriation of forty-nine million dollars. The legislation was approved by President Ronald Reagan on July 30, 1983.

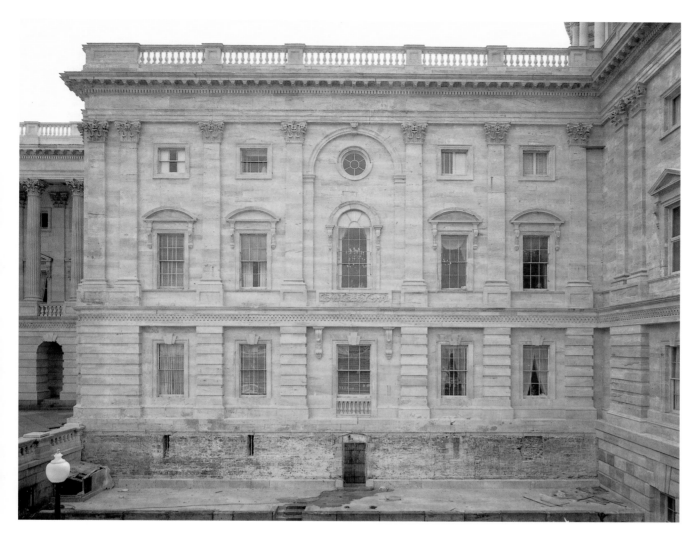

Restoration of the West Front
1984

*A*fter layers of paint were removed from the walls, each block of stone was categorized according to its condition. About 40 percent of the stone was replaced with Indiana limestone. Dating from the 1790s, the west wall of the old north wing is shown here.

Although it had taken more than twenty years, the most recent attempt at a west front extension was finally overpowered by the hue and cry of ordinary citizens, letter-writing architects, and noisy preservationists. For the first time since the British burned the building in 1814, forces outside of the Capitol altered the course of its future. To be sure, there were those in Congress who were instrumental in the effort to restore the west front, but the final outcome was determined by a powerful lobbying effort with roots reaching across America. It was a well-earned victory for those who valued the architectural legacy of the Capitol and were determined not to entomb the west elevation behind yet another marble addition. Arguments about space and money rang hollow against the names of Washington, Jefferson, Thornton, Latrobe, Bulfinch and Olmsted. At this point in the

West Front Restoration
1984

*W*hile the restoration was under way, the old sandstone walls were hidden behind a scaffold.

The West Front

The restoration returned the west front to a state of structural stability. (1997 photograph.)

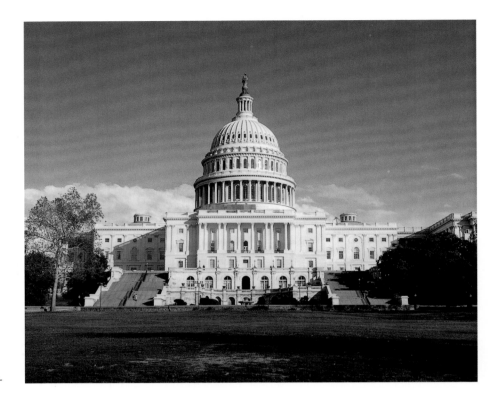

West Courtyard Prior to Infill

Frederick Law Olmsted intended to plant the courtyards between the Capitol and the terrace as winter gardens. His plans never materialized and the courtyards were generally used as work areas. (1991 photograph.)

Courtyard Infill

Construction of new offices and meeting rooms was completed within the west courtyards in 1993. The new structures were tied to the old walls by a continuous skylight. (1994 photograph.)

Capitol's evolution, American history became more precious than office space. And with that victory, historic preservation came of age in America.

By the first of February 1984, all the paint had been removed from the Aquia Creek sandstone on the west front. Bids were received from general contractors for the structural reinforcement and stone repair phase of the project, and on May 2 the Charles H. Tompkins Company was awarded the general restoration contract. Cement grout was injected into spaces within the foundations and behind the walls, and stainless steel rods were installed to strengthen the masonry arches and vaults. The portico was dismantled above the columns and rebuilt. Severely cracked or damaged sandstone was replaced with Indiana limestone, which was found to share many important physical characteristics with the original sandstone. Ultimately, about 40 percent of the old stone was replaced. The original cornice was replicated with the subtle variations of detail found in the old work. After a protective coating was applied to the new and old stone, the walls were repainted. The restoration was completed in November 1987, substantially under budget.

In 1986, the architect of the Capitol received permission to use funds remaining from the restoration to study the structural condition of the Olmsted terraces. Ammann & Whitney discovered weakness in parts of the terrace, as well as evidence of extensive failure in the waterproofing system. While repair documents were being prepared, a well-known Washington architect, Hugh Newell Jacobsen, was retained to design new structures to be located within the courtyards separating the terrace from the Capitol. The one-story structures (8,000 square feet each on the House and Senate sides) would provide additional meeting rooms and offices and extend Olmsted's terrace with new paving and additional plant cases. On March 7, 1991, the Charles H. Tompkins Company was awarded the construction contract (worth $11.3 million), and the terraces were closed to the public two months later. As work progressed, unforeseen structural problems were uncovered, making it necessary to commit an additional $2.8 million to the project. Work was finished on January 15, 1993, just five days before the inauguration of President William J. Clinton.

Inaugural Luncheon for President John F. Kennedy 1961

*F*rom the time the Supreme Court left in 1935 until its restoration in 1975, the old Senate chamber was a popular place for luncheons, cocktail parties, and meetings.

Old Senate Chamber 1970

CAPITOL SHRINES

*A*s the twin sagas of the east and west front extensions played out on Capitol Hill during the 1960s and 1970s, the fates of some of the Capitol's historic interiors were also under discussion. In the spring of 1960, Senator John Stennis of Mississippi spearheaded a movement to restore the old Senate and Supreme Court chambers as a tribute to the great men and deeds associated with those historic rooms. He was distressed to see the old Senate chamber playing host to endless rounds of luncheons, receptions, and cocktail parties. In his opinion, the room should be cherished as a shrine to American history, not degraded by the lingering odors of finger food, liquor, and cigars.

In an address delivered on May 10, 1960, Stennis lectured his colleagues about the scandalous

condition of the sacred room where their predecessors met from 1819 until 1859 and where the Supreme Court met from 1860 until 1935. He asked the architect of the Capitol to look into the cost of restoring the room as well as the chamber below, which had been home to the Supreme Court prior to 1860. The lower room, over which Chief Justices John Marshall and Roger Taney had once presided, had since been subdivided into four offices occupied by the Joint Committee on Atomic Energy. Latrobe's beautiful and bold vaulting was hidden by a suspended acoustical tile ceiling, while Franzoni's figure of Justice was buried behind sheets of protective plywood. But once the east front project was finished, the committee relocated to new quarters and the old chamber stood ready for restoration.

The idea of restoring the two chambers was not original to the junior senator from Mississippi. At the end of 1932, David Lynn had been approached by Frederic A. Delano, who expressed an interest in seeing the rooms preserved or restored to their early nineteenth-century appearances. A man of considerable influence, Delano was chairman of the National Capital Park and Planning Commission, president of the American Planning and Civic Association, and a favorite uncle of the president elect, Franklin Delano Roosevelt.[42] The idea of preserving the historic rooms had, in turn, been brought to Delano's attention by Mrs. John Lord O'Brian, the widow of a high-rank-

ing official in the Department of Justice. A conference was held in the offices of Attorney General Seth Richardson, with Lynn, Delano, Mrs. O'Brian, and a few others in attendance. There this ad hoc committee drafted a resolution calling for preserving the old Senate chamber and keeping it open to the public once vacated by the Court. On February 6, 1934, Majority Leader Joseph T. Robinson of Arkansas introduced the resolution in the Senate. David J. Lewis of Maryland introduced it in the House two weeks later. Soon the resolution was amended to include the old Supreme Court chamber on the first floor. It passed on May 28, 1934.

Although it had been in effect for more than twenty-five years, the resolution calling for the preservation of the two chambers was not strong enough to satisfy Senator Stennis. The old Senate chamber remained either locked or in use for parties or meetings. The press referred to it as the "Senate's Rumpus Room." Common offices still cluttered the old Supreme Court chamber, which was in no condition to be shown to the public. While the restoration was being studied, Stennis wanted the 1934 resolution toughened to prohibit the old

Supreme Court Chamber Prior to Restoration

1961

*S*andstone columns and acoustical tiles were odd architectural companions when the old chamber was occupied by a committee.

Supreme Court Chamber Prior to Restoration

1961

*W*hile it was occupied by the Joint Committee on Atomic Energy, the old Supreme Court chamber was divided into staff offices and a meeting room. A glimpse of Latrobe's magnificent ceiling and the Doric arcade may be seen in this view.

Senate chamber from being used for "any other purpose than a reminder of the Capitol's history."[43]

Using estimates supplied by Stewart's office, Senator Stennis introduced an amendment to the 1961 Legislative Appropriations Act providing $400,000 for the restoration of the old Senate chamber and the old Supreme Court chamber. The restoration would afford the American people an opportunity to appreciate two chambers that witnessed much of the nation's early history.[44]

The funds that Stennis inserted into the appropriations bill caught his counterparts in the House off guard. In conference, the House insisted that the money be removed until the matter could be fully digested. The Senate conferees, however, vowed to try again the following year.

Throughout September 1961, *The Washington Daily News* carried a series of articles and editorials highly sympathetic to Stennis' proposed restorations. In one article, which called the historic Senate chamber a "Cocktail Party Site," readers were told of a disturbing scene in the venerable room where a "young lady jiggled her martini—and it dribbled on the floor where Daniel Webster stood in his greatest debates."[45] A subsequent article noted that the parties held in this "stately night club" were so secretive that the sergeant at arms refused to reveal the "bookings."[46] According to one editorial, the use of the chamber for these purely social events was a "Misuse of a National Shrine."[47]

As time passed, the restorations were endorsed by Democratic leader Mike Mansfield of Montana and Carl Hayden of Arizona, chairman of the Committee on Appropriations. They held a news conference on April 1, 1962, announcing the Senate's intention to "kick out the cocktail parties" by restoring the chambers.[48] Still, more detailed cost figures and architectural information were needed before the project could proceed. Accordingly, on April 30, 1962, the architect of the Capitol asked for $37,500 to develop plans, specifications, and cost estimates for the restorations, but the funds were again removed by the House. Members of the House Appropriations Committee did not like the idea of restoring the old Senate chamber because they would lose a favorite place to hold their conferences with the Senate. The following year, however, they relented and planning funds were approved.

On March 6, 1964, Stewart hired DeWitt, Poor & Shelton to plan the restoration of the old Senate and old Supreme Court chambers. The firm was enjoying a string of successful engagements with the architect of the Capitol, including the east and west front extensions and a vast new building for the Library of Congress. With more than five million dollars in fees paid since 1955, there were charges of favoritism in the press. Aside from the near monopoly the firm had on Capitol Hill projects, it was also noted that Stewart's chief assistant, Mario Campioli, once worked for two of the firm's partners. To answer the charges, Stewart claimed that the DeWitt, Poor & Shelton firm was among the few in America practicing "traditional" architecture, a claim which the AIA later characterized as "hogwash."[49]

Section of the Old Senate Chamber and Old Supreme Court Chamber
by DeWitt, Poor & Shelton, 1965

*T*his rendering illustrates the relative position and height of the two rooms as well as an early suggestion for chandeliers in the Supreme Court chamber, which was later dropped for lack of documentation.

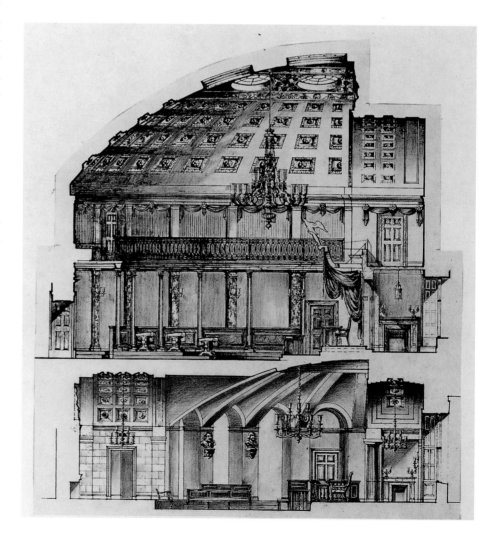

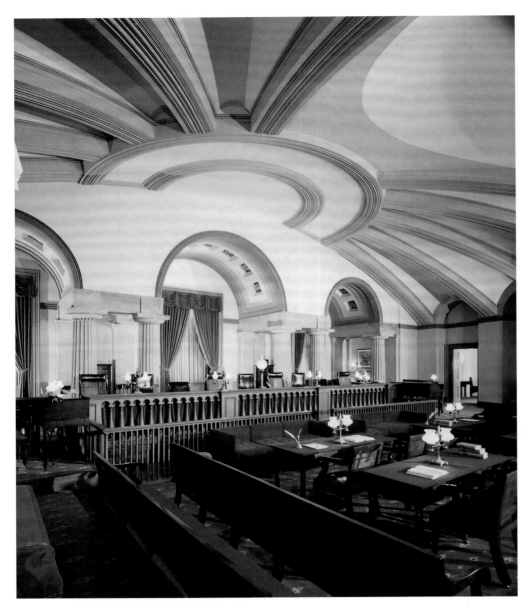

that the west front extension was a vastly more expensive endeavor.

During the impasse, the cost of the restoration tripled, from about $400,000 in 1961 to $1.2 million eight years later. Upon taking office in 1971, the new architect of the Capitol, George M. White, was asked to investigate the possibility of using the old Senate chamber and the old Supreme Court chamber as meeting rooms after the restorations were completed. Plans were drawn showing that such an arrangement was possible in the Court room, and this was used to help win Mahon's support. White was also asked about dividing the project into phases so one room might be used while work on the other was under way. Such an approach, White reported, would drive the project costs to one and a half million dollars, but this scheduling advantage was considered to be worth the money.

During this period the press, including the *Los Angles Times* and the *Chicago Tribune*, carried stories about the classic impasse between the House and Senate over the extension and restoration projects. In 1972, the deadlock finally ended when Mahon received a phone call from Lady Bird Johnson supporting the restoration. At the same time, Speaker Albert convinced him to drop his objection in exchange for a promise from Senator Mansfield to use his influence with William Proxmire to drop legislation designed to kill the west front project. The deal worked and funds for the restorations were provided in the Legislative Appropriations Act for 1973.[50] It seemed appropriate that the latest chapter in the history of the two chambers was decided by a legislative compromise nurtured by a gentle nudge from a well-respected former first lady.

To oversee these restorations and other matters relating to its history and patrimony, the Senate created a Commission on Art and Antiquities in 1968. The commission directed much of the research and hired many of the nationally known consultants used in the documentary phase of the project. Others in the architect of the Capitol's office conducted research as well. The commission was dissatisfied with the architects hired for the restoration because of their lack of experience in the field of historic preservation. White convinced the commission it would be unfair to hire a new firm to implement the designs of another. The

Supreme Court Chamber

*P*erhaps Latrobe's finest interior design was the Supreme Court chamber. The difficulties encountered in vaulting the one story space resulted in a dramatic ceiling structure that is unique in American architecture. (1996 photograph.)

Funding was held up year after year by the House of Representatives. George Mahon of Texas, the chairman of the House Appropriations Committee, was the principal stumbling block. He viewed the old Senate chamber as a perfectly good meeting room and wanted to delay the restoration until the west front project was finished, when more conference rooms would become available for his committee's use. Since the Senate was holding that project up, he felt the restoration should wait as well. One of his colleagues on the committee, Robert Casey of Texas, did not favor the Senate restoration, but felt it was wrong to tie the two projects together, especially considering

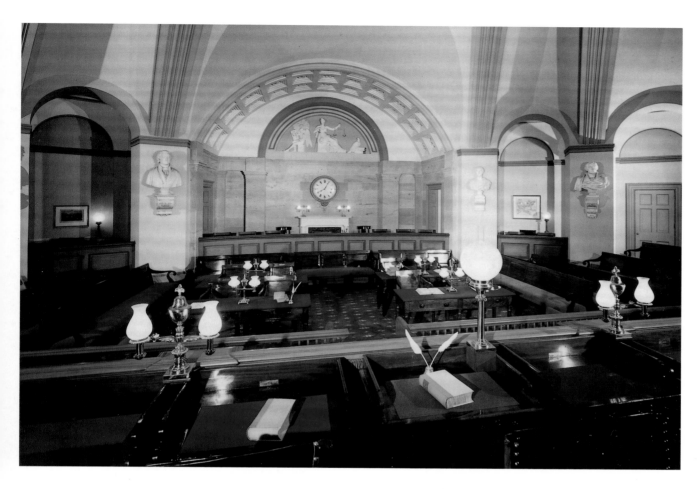

*C*arlo Franzoni's allegorical group representing Justice and Young America occupies the place of honor over the west fireplace. (1996 photograph.)

argument prevailed, and while DeWitt, Poor & Shelton remained project architects, the.Senate promised to scrutinize their work carefully.

The first phase of the restoration work, focusing on the old Supreme Court chamber, was finished in the spring of 1975. Partitions and the dropped ceiling were removed and the space was opened to its original configuration. Thinking that it was not an original treatment, restorers removed paint from the stone columns, leaving them bare. The room's three original fireplaces, two of which had been closed in 1936 and used as air-conditioning ducts, were reconstructed. New mantels were designed, drawing on the room's Doric order for inspiration. An 1854 guidebook gave restorers the chamber's general layout, showing that the justices originally sat with their backs toward the east windows. A portrait of John Marshall documented the color and design of a carpet used in the chamber and was the basis for the reproduction floor covering. Much of the original furniture, including desks, chairs,

benches, and tables, was returned to the room from private collections and from the Supreme Court itself. Simon Willard's wall clock, made in 1837, was returned to its original position below Franzoni's figure of Justice. Busts of the first four chief justices of the United States were placed on brackets affixed to the arcade.

The old Supreme Court chamber was dedicated and opened to the public on May 22, 1975. A year later the restored old Senate chamber was ready for public inspection. The work in that space had involved removing what little was remaining from the period when the Court used the chamber and building a new terraced floor covered with wall-to-wall carpet. Reproductions of the 1819 desks, chairs, and sofas originally made by the New York cabinetmaker Thomas Constantine were put into place. The visitor's gallery, designed by Charles Bulfinch in 1828 and removed by the commissioner of public buildings in 1860, was replicated using historic views as guides. Two pairs

*T*he Senate chamber
of 1816–1819 is one of
America's great neoclas-
sical interiors.
(1996 photograph.)

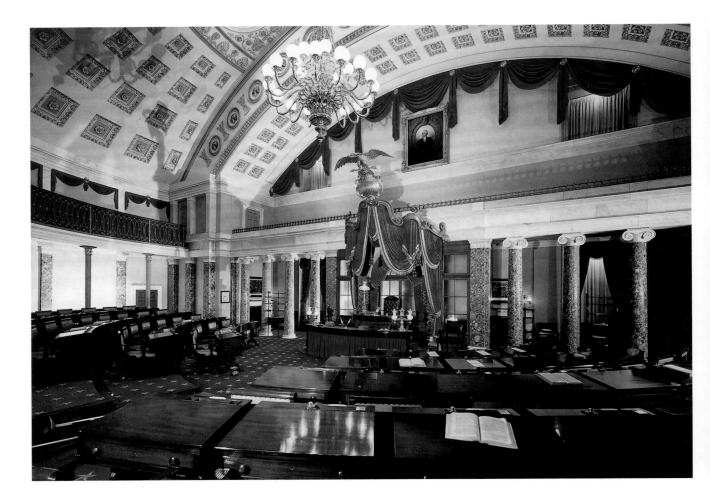

of mantels remained in the room, one of statuary marble designed by Giovanni Andrei and a much simpler one in verd antique and Potomac marbles. Although the second pair may have been in the chamber since 1819, they were not considered original and were replaced by two reproduction mantels matching the Andrei design. Reproduction iron stoves were placed in the niches flanking the principal entrance into the room. Also reproduced was a gilt chandelier with twenty-four oil-burning lamps, originally made by Cornelius & Baker of Philadelphia in 1837 and modified to burn gas in 1847. The canopy sheltering the president's chair reused the original gilt eagle and shield, while a reproduction crimson drapery was hung from a new mahogany valance. Rembrandt Peale's portrait of George Washington, purchased by the Senate in 1832 and removed from the chamber in 1859, was returned to its place of honor above the east gallery.

On June 16, 1976, the Senate convened in its restored chamber and was welcomed by Vice President Nelson A. Rockefeller, who presided over the dedication ceremony. In a short speech Rockefeller opened the room as a "new shrine of American liberty." Senator Mansfield was impressed with the splendor of the chamber and its furnishings and remarked that the modern Senate was not as beautifully accommodated as it had been in the past. He noted that the "Senate has lost some of its elegance over the past century and quarter. One might say that the peacock plumage has been plucked not only from the nest but from its occupants." But despite the different style of accommodation, Mansfield declared that

> what moved Senators yesterday still moves
> Senators today. . . . It is to remind us that the
> Senate's responsibilities go on, even though
> the faces and, yes, the rooms in which they
> gather fade into history. With the Nation, the
> Senate has come a long way and, still, there is
> a long, long way to go.[51]

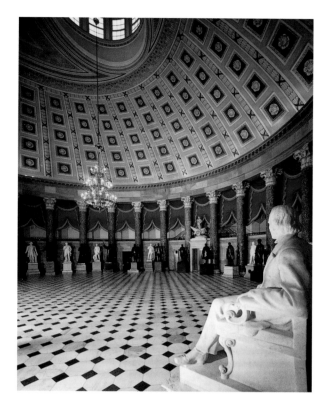

Statuary Hall was refurbished in 1976 with crimson draperies, a new paint scheme, and a reproduction of the original oil-burning chandelier. These improvements recalled the time when the room served as the hall of the House. (1988 photograph.)

THIRD SENATE OFFICE BUILDING

In 1972, the Senate's 1909 office building was named in honor of Senator Richard Brevard Russell of Georgia and the 1958 structure was named for Senator Everett McKinley Dirksen of Illinois. In the same year, the Senate Committee on Rules and Administration asked the architect of the Capitol to survey the space occupied by senators and their staff and report on their work environment. In the decade and a half since the Dirksen Building had opened, the number of persons working for the Senate had grown from 2,500 to 7,000. This growth resulted in overcrowded conditions, leading some resourceful staff to fashion offices in toilet rooms and improvise meeting rooms in passageways. It was discovered that the average Senate employee occupied a meager sixty-seven square feet of space, less than half of the minimum government standard of 150 square feet.

On October 31, 1972, Congress approved funds to enlarge the Dirksen Building with a rear addition as a means to ease overcrowding. It was first thought that the project would involve merely constructing a mirror image of the existing building, doubling its capacity and replicating its appearance. But as the requirements for the new building grew in the minds of those in charge, it became clear that an entirely new structure was called for, one that might be physically attached to the old building but would be separate in every other sense. (For instance, after it was decided to move fifty senators into the new building, it became clear that it would need to be significantly larger than the older structure.) The new building was to be a contemporary design with proportions sympathetic to surrounding classical buildings, but without any direct reference to classical detail. Its interior environment was to be sunny, cheerful, healthful, and flexible. Historic preservation and energy conservation were two new concerns that were also to be incorporated into the building's design. An important early nineteenth-century residential structure located on the corner of the site, the Sewell-Belmont House, was to be preserved rather than bulldozed as it most certainly would have been only a few years earlier.

Under the direction of the Senate Office Building Commission, White interviewed sixteen nationally known architects for the "Dirksen Extension," which was soon renamed the Philip A. Hart Senate Office Building after the much-admired senator from Michigan. The designers of the old building, successors to the firm of Eggers & Higgins, were among those eager to be considered for the project. On April 19, 1973, however, *The Washington Post* announced that John Carl Warnecke, a longtime friend of the Kennedy family, had been selected. The announcement assured readers that with Warnecke as architect, the new Senate office building "will bear no resemblance to the Kennedy Center," a gratuitous reference to the new and controversial performing arts center that now vied with the Rayburn Building as the structure Washingtonians most loved to hate. Warnecke, it

confided, "detests the white marble monument to JFK." It continued with praise for Warnecke's designs for the executive office buildings on Lafayette Park, opposite the White House, and mentioned his design of Kennedy's grave at Arlington National Cemetery. The president's widow had selected Warnecke for that important work, as well as for the Kennedy library at Harvard.[52] Now it seemed part of the Kennedy mystique was about to rub off on Capitol Hill.

The new building that emerged from Warneke's drafting room added more than a million square feet to the Senate's inventory of office and support space. Fifty senators would have suites, which would range in size from 4,000 to 6,000 square feet. A public hearing room would be equipped for the electronic and written press, while facilities for food service, parking, physical fitness, police, mail, and maintenance needs were also provided. The most novel aspect of the plan was its flexible offices. All the older office buildings provided offices in rooms strung along one side of a corridor, putting a considerable distance between staff members. For the new building, Warneke devised a totally new scheme. Each suite would occupy an envelope of space on two floors. The senator's personal office would have a ceiling height of sixteen feet, and staff areas with ceilings eight and a half feet high would be grouped around it. Within the staff space, partitions could be rearranged anywhere along a five-foot grid. Each office could be laid out with ease according to the management practices of an individual senator.

Rendering of the Philip Hart Senate Office Building

by John Carl Warneke
1975

The simplicity of the Hart Senate Office Building, its human scale, and its uncomplicated and regular fenestration helped to disguise its bulk—over a million square feet. It was the first building on Capitol Hill subjected to preliminary design review by neighborhood residents and professional critics.

After the preliminary plans were finished in the spring of 1974, the chairman of the Senate Public Works Committee, Jennings Randolph of West Virginia, made an unusual announcement. Through a press release, Randolph invited "Architects and others with experience in building design and urban planning" to discuss the exterior design of the proposed building:

'It is especially important that the City of Washington—and particularly Capitol Hill—be reflective of the best America has in planning, architecture, and construction,' Randolph said. 'Poor design occurs in many buildings after it is too late for correction.'[53]

Clearly, lessons had been learned from the perception of secrecy surrounding the design of the Rayburn Building, and there was no wish to repeat past mistakes. White sent letters to six nationally prominent architects, including I. M. Pei, Pietro Belluschi, and Hugh Stubbins, asking them to help evaluate Warnecke's design. A similar letter was sent to J. Carter Brown, director of the National Gallery of Art and chairman of the Commission of Fine Arts. The unprecedented public hearing on the design was held on June 5, 1974, with generally positive reviews coming from the design community. The architecture critic for *The Washington Post*, Wolf Von Eckardt, wrote:

The building as now designed is classic in the sense that it is a kinetic building. As you see it from one side, it is almost a solid wall, and then when you start walking, the columns open up, the spaces between the columns—in this case between the fins—become larger so that the building changes in appearance and becomes alive. I like that. I like it very much. The quality and, yes, even excellence in this building rests on the right proportions. They are pleasing, they are good. We can't ask for more.[54]

On August 8, 1974, the design for the Hart Building was approved by the Senate Office Building Commission and the Committee on Public Works. The first construction contract was awarded on May 20, 1975, with excavation beginning in December. Work proceeded in a total of six phases before the first occupant moved in during November 1982. Construction took place during a period of unprecedented inflation in which the national index of construction costs jumped 76 percent. With costs rising daily, interior work worth about twenty-four million dollars was deferred in

order to save money. Still, the building's final cost ran to more than $137 million, bringing down a storm of criticism from those who noted that the original estimate was around forty-seven million dollars. But the original estimate contemplated a much smaller building, and one built without inflation's debilitating effects. White pointed out that the cost per square foot (ninety-eight dollars) compared favorably with that in the better class of corporate buildings of the period.

The Senate's first nonclassical building opened in 1982 to mixed reviews. Some thought it was a refreshing change from the old-fashioned type of building—endless corridors lined with locked doors. Others missed the classical grandeur of the Russell Building, with its incomparable rotunda and caucus room. Yet few failed to appreciate the strides made in planning, circulation, and adaptability by the architects of the Hart Building. Those comparing it to the Rayburn Building viewed this newest congressional structure as a polite and modest addition to Capitol Hill. Critics comparing it to the East Wing of the National Gallery (a much different and smaller structure that coincidently cost about the same), found that the "architectural benefits to Washington are not comparable."[55] But the benefits to the architectural development of Capitol Hill were significant. The Hart Building reinvented and redefined the congressional office building: it provided a modern, workable environment promoting the efficiency, health, and happiness of its occupants and at the same time signaling a break from classicism as the official language of Capitol Hill architecture. It remains to be seen if the break is permanent.

PLANNING AHEAD

*I*n 1959, Senator Thomas C. Hennings, Jr., of Missouri introduced a joint resolution to create a commission to plan a memorial to James Madison, Father of the Constitution and fourth president of the United States. The commission would be empowered to accept gifts, hold hearings, organize contests, and otherwise oversee the development of a permanent memorial to Madison in the capital city. It would also be instructed to study the feasibility of reusing

the columns recently removed from the east front of the Capitol. (That idea was later dropped.) After the legislation was approved on April 8, 1960, the commission met to discuss what form the Madison Memorial might take. They soon hit upon the idea of incorporating the memorial into a new building for the Library of Congress, noting that Madison first proposed a library for use by the Continental Congress in 1783. They also noted that the library needed more space and that plans were already afoot to provide a second annex. It seemed especially appropriate to memorialize Madison in a library because his achievements seemed to lie in the area of intellectual pursuits.

The site for the Madison Memorial was the next topic for consideration. A square of land on Independence Avenue, near the Library of Congress and the Cannon House Office Building, had recently been acquired by the government and was being cleared of its residential and commercial structures. Because property owners had been given little warning about the government's intentions for their land, the architect of the Capitol was again accused of keeping plans secret. But to the memorial commission, the site seemed perfect.

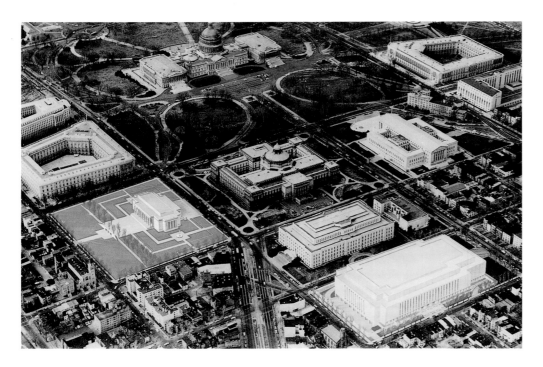

Capitol Hill with Proposed Buildings
1961

*T*his aerial view was overlaid with sketches showing two new buildings: a large annex for the Library of Congress and a smaller building for the James Madison Memorial. Eventually the two buildings were merged.

James Madison Memorial
by DeWitt, Poor & Shelton, 1961

*T*he original design for the Madison Memorial consisted of a stripped-down classical building containing a hall for a statue of the fourth president. It was to be surrounded by exhibit spaces, study carrels, a library, and offices. Archival space for presidential papers was planned for the space beneath the plaza.

Already at work on the design of the library's third building, DeWitt, Poor & Shelton quickly sketched a memorial building standing on a large plaza. For a time the architects considered using the Folger Shakespear Library or Madison's home, "Montpelier," for inspiration, but they settled instead on a plain rectangular structure that was devoid of ornament except for Corinthian porticoes on each of the four elevations. On July 20, 1961, the general design was approved by the commission.

The site for the new library annex was to be behind the library's existing annex (now called the John Adams Building), an area containing four blocks of residential structures and a church. Alarmed at the prospect of losing yet another significant piece of their Capitol Hill neighborhood, citizens gathered to condemn the proposed action as "extravagant vandalism," totally at odds with their efforts to restore the historic architecture of the area.[56] They also disapproved the design of the Madison Memorial itself, criticizing it for a lack of taste and imagination. These problems were resolved in October 1965, however, when Congress approved a proposal to merge the Madison Memorial building and the new library annex into a single building sited on vacant land already owned by the government. A memorial hall with a statue of Madison would occupy an alcove off the main entrance to the annex. Seventy-five million dollars was appropriated for planning and construction. Thus, the Library of Congress James Madison Memorial Building reconciled the objectives of the commission with the library's space requirements, while saving four blocks of historic Capitol Hill architecture from needless destruction.

After twelve years of planning, construction of the Madison Building began on May 1, 1971, soon after George White became architect of the Capitol. There were well-founded rumors that the House of Representatives was planning to take the building from the library to convert it into an office building for its own use. Such a move was not without reason, White thought, because the building's location on the south side of Independence Avenue seemed to indicate that it "belonged" to the House of Representatives rather than to the Library of Congress. The more White thought about the matter, however, and the more he learned about the way building sites were selected, the more it

**Rendering of the
James Madison Memorial Building
of the Library of Congress**

by DeWitt, Poor & Shelton, 1967

*M*easuring 500 feet wide and 400 feet deep,
the Madison Building is the largest library structure
in the world. (It encompasses 1.5 million square feet
of space.) The undecorated colonnades attempt to
echo classical columns while remaining faithful to
canons of modern design.

became apparent that there was no logic to the
way Capitol Hill had developed in the past. It
seemed to him as if a game of darts had been used
to select where buildings were placed on the map
of Capitol Hill. The haphazard approach would
doubtless continue unless logic, order, and reason
were imposed in a master plan, a blueprint to guide
future growth. Only two plans had ever been made
for Capitol Hill: L'Enfant's 1791 city plan locating
the Capitol alone on Jenkins Hill, and the McMillan
plan of 1902 showing the Capitol surrounded by
uniform classical buildings. Both plans were impor-
tant in the Capitol's history, but neither could help
guide its future.

To address the complicated issues surround-
ing the long-range development of Capitol Hill,
White secured an appropriation of $350,000 in
1975 to prepare the "Master Plan for Future Devel-
opment of the Capitol Grounds and Related Areas."
He assembled a team of professionals —represent-
ing the fields of architecture, landscape architec-
ture, ecology, civil engineering, urban and social
planning, economics, transportation, and historic
preservation—to assist him in developing not only
a comprehensive plan, but one of excellence and
stature. Promising that the planning process would
take place in full public view, White proposed a
thorough analysis of historic patterns, current
conditions, and a broad spectrum of future scenar-
ios. A plan for rational growth could improve the
relationship among existing buildings and provide
a coherent and perceptive vision for those to come.
The distinguished Philadelphia architectural and

planning firm of Wallace, McHarg, Roberts & Todd
was retained as the principal consultant.

Phase I of the Master Plan, a "plan for a plan,"
was published in August 1976. It traced the his-
tory of development of Capitol Hill, defining the
principal focus of the initial effort as the creation
of a framework for rational decision making.
Three major problems were identified and exam-
ined in detail: space needs, movement problems,
and visual disruption. The document also pre-
sented an extensive outline for the future study
of many aspects of Capitol Hill's natural and phys-
ical environment.

The planners looked at each of the major ten-
ants of Capitol Hill—the House and Senate, the
Library of Congress, and the Supreme Court—to
assess future space needs and offer logical places
for future expansion. Without encroaching on his-
torically sensitive residential neighborhoods, most
of the areas available for expansion lay north and
south of the Capitol core. Growth on the Senate
side was thought best targeted to the squares
immediately north of the Russell, Dirksen, and
Hart Buildings, thus preserving the open space
between the Capitol and Union Station. In the
opposite direction, development of the House side
was envisioned along the axis of South Capitol
Street, which had become a hodgepodge of nonde-
script commercial structures, highway and rail-
road bridges, and ramps that could benefit from
thoughtful development and beautification.

One of the plan's controversial recommenda-
tions was to relocate the Supreme Court to its own
precinct off the Hill. The planners thought the

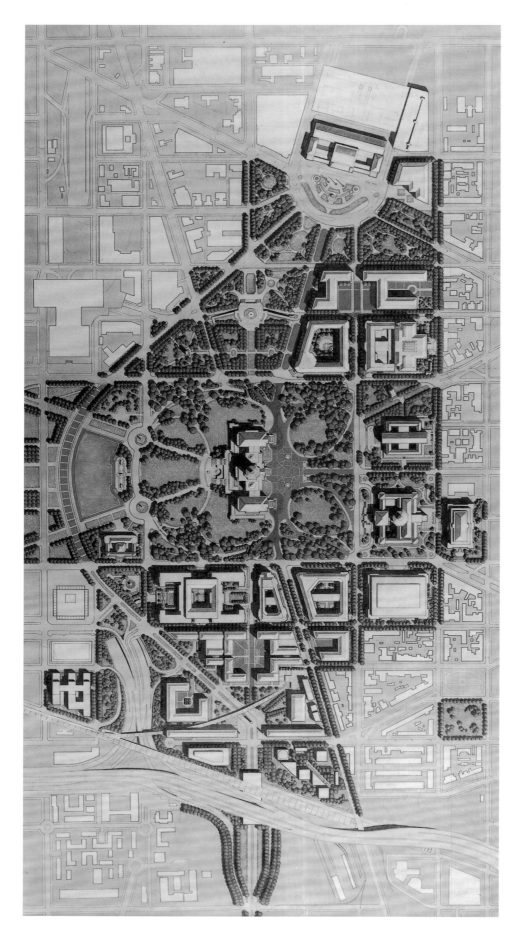

*T*his drawing illustrates several aspects of
the Master Plan, including suggested location of
future buildings.

Court's location was one of the few mistakes made
by the McMillan Commission and concluded that
this should be corrected. A "Judicial Campus,"
symbolically equivalent to the Capitol Hill campus
with its own monumental identity, should some
day be created for the Supreme Court. In the
meantime, growth of the Court could be accom-
modated on nearby sites. When the Court left
Capitol Hill, planners thought, its former home
could be adapted for special use by the Library
of Congress.

Facts about visitors' experiences were gath-
ered and analyzed. It was increasingly obvious that
the Capitol was more than a legislative center. It
was also a museum of American history and art,
attracting almost four million tourists a year. Visi-
tors had been coming since the building opened in
1800, but the numbers increased dramatically after
World War II. The inadequacy of existing restau-
rant facilities, restrooms, and parking was acknowl-
edged, and part of the solution seemed to lie with
a new visitor's center proposed for Union Station—
then a vast, deteriorating, and underutilized build-
ing. After parking their cars at the station, or so
the reasoning went, visitors could travel to points
throughout the Hill via a "people mover," using a
part of the tunnel built originally to carry south-
ward-bound train traffic. (These suggestions did
not anticipate the future restoration of Union Sta-
tion, or a later idea for an underground visitor cen-
ter attached directly to the Capitol.) Parking would
be prohibited on the plaza in front of the Capitol.
Since sites available for future parking lots seemed
limited, the planners recommended ways to
encourage the use of mass transit by staff and
tourists alike.

Future intrusion by Congress in the residen-
tial neighborhood of Capitol Hill was considered
unwise for historic preservation and urban design

reasons. The suggestion was made, however, to create a buffer zone between the monumental core of the Hill and the purely residential neighborhoods only a few blocks away. In the "Periphery and Historic District Transition Areas," the federal government would have jurisdiction over building facades, landscaping, fences, lamp posts, and other items of "street furniture." Area residents and the architect of the Capitol would jointly determine the best treatment of the architecture, while the government would provide uniform maintenance of sidewalks and outdoor lighting. Although the neighborhood might be domestic in design and scale, the standard of its maintenance would be worthy of its location so near the Capitol.

The Master Plan was transmitted to Congress in 1981. It was a heavily illustrated document brimming with facts, ideas, and proposals. Like the plans by L'Enfant and the McMillan Commission before it, the Master Plan did not suggest designs; rather, it designated specific sites for unspecified buildings. Its basic message was: "If a new building is needed in the future, build it here." In other areas of investigation, the Master Plan's message became entangled in the theory and rhetoric of design. Esoteric discussions focused on such issues as the "genius loci" of Capitol Hill, the "axial linkage" of buildings, and the "hierarchy of open space." Despite its occasionally stilted language, which few outside the design profession appreciated, the Master Plan's copious illustrations and free-ranging ideas continue to stimulate thought and discussion.

The first building sited in accordance with the Master Plan was the Thurgood Marshall Federal Judiciary Building, an administrative center for the federal court system. Its location, adjacent to Union Station, completed the "spacial enclosure" of Columbus Circle and was considered a long overdue complement to the city's train station and post office. In 1985, the architect of the Capitol was authorized to study the possibility of providing a facility for the courts, in consultation with the chief justice among others. White invited the country's leading architects and developers to submit proposals for the new building; they were to present ideas combining architectural solutions with creative financing options to "minimize or eliminate initial capital investment by the United States through the use of public-private partnerships or non governmental sources of financing."[57] The invitation was an innovative scheme to provide the judicial branch with a first-class building without resorting to the usual appropriation process. Financial and real-estate consultants were retained to advise the architect of the Capitol in matters relating to market analysis, cost evaluation, business deal structure, and implementation. Forty-three development firms were contacted, of which nineteen indicated an interest in the project. From this list, five developer-architect teams were asked to submit proposals. A jury unanimously selected the team of Edward Larrabee Barnes/John M. Y. Lee & Partners as the architects and Boston Properties as the developer. Chief Justice William H. Rehnquist approved the selection on January 13, 1989.

By the terms of the innovative financing package, the architect of the Capitol agreed to lease the site to the developer for thirty years. He also agreed to lease the finished building for thirty years, at which time it would revert to the government at no cost. Rents would be used to amortize the privately raised debt. Not since the 1790s, when the board of commissioners attempted to finance the Capitol and White House through the sale of city lots, had such unconventional financing been tried on a federal construction project. Unlike the commissioners' bungled efforts, however, this financing scheme proved entirely satisfactory.

Ground was broken for the Thurgood Marshall Federal Judiciary Building on April 4, 1990, and tenants began to occupy the finished building on October 1, 1992. It cost $101 million, providing more than 600,000 square feet of rentable space within its overall million-square-foot interior. Entrance is through a glass atrium planted with bamboo. The Massachusetts Avenue elevation was designed to recall the columns and arches that are conspicuous elements in Union Station, its neighbor to the west. Nowhere are classical moldings or carvings to be found, but the scale, rhythm, and sculptural qualities of the granite facade and its low dome (actually a mechanical penthouse) suggest a polite and deferential relationship with its grand neighbor.

Thurgood Marshall Federal Judiciary Building

A glass atrium occupies the space between two stone-clad wings and acts as the principal entrance into the building. (1996 photograph.)

Bicentennial Ceremony 1993

To honor the 200th anniversary of the Capitol's first cornerstone, a ceremonial cornerstone was laid during a program held on September 18, 1993. Among those participating in the event was the architect of the Capitol, George M. White (b. 1920).

THE CAPITOL BICENTENNIAL

*S*eptember 18, 1993, was the 200th anniversary of the day George Washington came to the heights of Jenkins Hill to lay the cornerstone of the Capitol. Under clouds and light rain, Masons from Federal Lodge No. 1, Potomac Lodge No. 5, and Alexandria-Washington Lodge No. 22 held a simple ceremony to commemorate the building's bicentennial. About 300 Masons from around the country also participated in the ceremony. There were none of the artillery salutes, parades, nor barbeques that marked the original event, nor were there such choral or carillon performances as marked the centennial celebration 100 years later. During the short program, contemporary Masons simply laid a ceremonial cornerstone. While the bicentennial was observed in historical exhibits, symposia, and publications, the small, soggy Masonic ceremony on the west front was the only event held on the actual anniversary. It served as prelude to a larger, more festive bicentennial celebration accompanying the return of the statue of Freedom to its place atop the dome.

The impetus for *Freedom*'s brief sojourn on the ground was a 1991 study by bronze conservation specialists hired by the architect of the Capitol to assess her condition. They found the surface extensively pitted and corroded. The joints between the statue's five sections had been caulked numerous times, leaving disfiguring lines that were visible from the ground. In addition, the cast-iron pedestal was cracked and rusted. Following an investigation addressing conservation and logistical issues, it was decided to remove the statue from the dome and place it on the east plaza while restoration was under way. This gave conservators easy access to the statue and afforded the public an opportunity to inspect the progress of the work. With *Freedom* secured in a harness and the bolts loosened, the statue was removed by a jet-powered Skycrane helicopter early on the morning of May 9, 1993.

Pressurized water was used to clean the surface corrosion and more than 700 bronze plugs were used to fill holes and pits. The metal was repatinated to "bronze green," the term used to

describe the statue's color when it was new. After coating the surface with a corrosion inhibitor, conservators applied lacquer and wax. During a festive and dramatic congressional celebration in honor of the Capitol's 200th anniversary, the statue was returned to its place on top of the dome on October 23, 1993. President Clinton was among those who greeted the return amid the roar of thousands of cheering voices.

The cost of the statue's restoration ($780,000) was paid for by the Capitol Preservation Commission, a congressional leadership group that raises money for projects relating to the stewardship of the Capitol and its contents. In 1994, the commission provided the architect of the Capitol with $2.55 million to develop plans and estimates for a new underground visitor center based on a 1991 conceptual study by the architectural firm RTKL Associates. The center would provide an educational introduction to the history and work of Congress and to the history, architecture, and art of the Capitol. Amenities such as food service and rest room facilities would be included. In addition, the underground location presented an opportunity to redesign the east plaza and remove parking, as had been recommended in the Master Plan. Security concerns and precautions could also be better handled in a new visitor center rather than in the Capitol itself. An underground loading dock would eliminate the need for trash trucks and other service vehicles to drive onto the plaza and mar the view. The center was authorized and funded in October 1998.

Planning for the Capitol Visitor Center was one of the last projects begun during White's tenure. Under the provisions of the Legislative Branch Appropriation Bill for 1990, Congress for the first time established a ten-year term for the architect and made the appointment subject to the advice and consent of the Senate. Under the new law, names of at least three potential appointees would be submitted to the president by a congressional panel comprising the chair and ranking member of each of the numerous committees with oversight of the architect's office. These were the first reforms to the way the architect's appointment was handled since the agency reached its modern form. Under the terms of the legislation, White retired from office on November 21, 1995, after nearly

Statue of Freedom

*V*isitors to the Capitol were able to watch the progress of the statue's restoration taking place within a fenced yard on the east plaza. (1993 photograph.)

twenty-five years of service. During his time as architect, White restored the office to a position of trust among the various communities it served. Professionalism and openness helped restore faith in an agency once known for secrecy and cronyism. The quality of architectural design was greatly improved and, for the first time, preservation and restoration became objectives in the care of Capitol Hill's historic buildings. And with the Master Plan, a sensible blueprint for growth was left for future generations to follow.

Upon White's retirement, the office was run by the assistant architect of the Capitol, William L. Ensign, until a successor was named. The AIA gave Congress a list of candidates it thought suitable for the job. Among others, the institute recommended Alan Hantman, who had been vice president of Facilities Planning and Architecture for the Rockefeller Center Management Corporation. President Clinton nominated Hantman to be architect of the Capitol on January 6, 1997, and the Senate confirmed the choice on January 30. He entered upon his duties on February 3, 1997.

EPILOGUE

When Dr. William Thornton came to the Capitol on November 22, 1800, to hear President John Adams welcome Congress to its permanent residence, his wife Maria was taken with the stately portraits of the king and queen of France hanging in the Senate chamber. Ever since that day, visitors have come to Washington to observe the operations of the House and Senate and to have a look around. Art, history, and politics permeate the building's every fiber, and coming to the Capitol is one of the best ways Americans can see and understand themselves, their country, and their government. Few buildings have been begun under less favorable circumstance, and fewer still enjoy greater architectural success than does the United States Capitol. Luck, grit, and determination played parts in the story, along with the brawn and brains of thousands of workers. A few key people played disproportionately significant roles. Two amateur architects, William Thornton and Thomas Jefferson, and two professionals, B. Henry Latrobe and Charles Bulfinch, shaped the Capitol during more than three decades of trial and error. Thomas U. Walter transformed their efforts into the powerful and majestic Capitol that today commands the world's respect. Countless senators and representatives wielded political influence over the Capitol's destiny, bringing to it all the wisdom and foolishness at their disposal. Two dozen state capitols, built after the Civil War, have been based upon the federal Capitol, making the genre a uniquely American contribution to world architecture. The Founding Fathers invented a new building type accommodating a new form of government. It was George Washington's vision that established the scale, extent, and style of the Capitol. His reputation fueled the project during his presidency and his memory continued to do so long after his death.

As the Capitol evolved, unforseen and unpredictable forces affected its course, influencing its development in ways Washington could never have imagined. In this regard, fire and fireproofing had a potent impact on the Capitol's history. The conflagration of 1814 still divides the Capitol into "pre-fire" and "post-fire" periods, while the fear of fire drove the idea to replace the wooden dome with one made of cast iron. Similarly, the development and growth of congressional committees affected the Capitol's history. There was only one standing (i.e., permanent) committee in the House and none in the Senate when the 1792 advertisement for the Capitol's design called for twelve rooms for committees and clerks. Latrobe's effort to build an "office story" for the House of Representatives; his 1816 plan to alter the north wing for the accommodation of the Senate's first permanent committees; Bulfinch's endeavor in 1818 to find space for committees, thereby saving the rotunda; and the replacement of Walter's revolutionary iron library with committee rooms in 1900 were major episodes in the Capitol's history driven by the demand for more meeting rooms. Reforms mandated in the Legislative Reorganization Act of 1946, and the dramatic staffing increase that followed, brought about new office buildings designed around the new, more modern and professional committee system. In addition to fireproofing and space problems, questions about acoustics, ventilation, and heating challenged

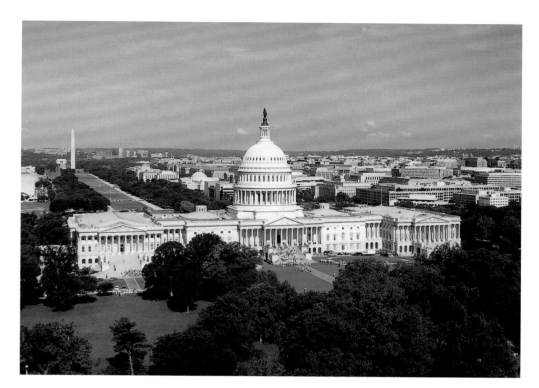

The East Front
1997

Floor Plans

*T*wo additions built after the second World War—the east front extension and the courtyard infill project—added 147,200 square feet of floor space to the Capitol, resulting in a total of 774,700 square feet.

succeeding generations and their resolutions left imprints on the Capitol's fabric. Throughout the years, each improvement built upon a general idea that the Capitol should be useful as well as beautiful.

What would Washington think if he were to return today and look upon the city he founded and the Capitol he began? He might not recognize them at first. The city has spilled out beyond the boundaries shown on L'Enfant's map, appearing much larger and more beautiful than any city he had known. Turning to the Capitol, he might look at the dome in wonderment, perhaps gazing in disbelief at the masses of marble, or marveling at its sheer size. Yet he would probably recognize the basic design that so pleased him. Doubtless, too, Washington would be gratified that the Capitol still houses the Congress in great style, magnificently presiding over the capital city on his beloved Potomac River.

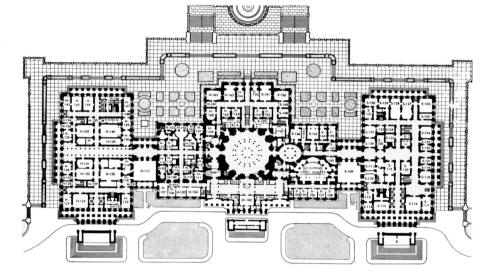

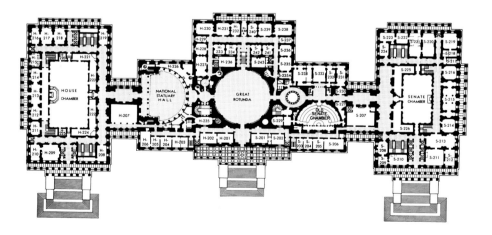

NOTES

CHAPTER ONE

1. Kenneth R. Bowling, *Creating the Federal City, 1774–1800: Potomac Fever* (Washington: The American Institute of Architects Press, 1988), p. 78.
2. Jefferson to Benjamin Harrison, November 11, 1783, Saul K. Padover, *Jefferson and the National Capital* (Washington: Government Printing Office, 1946), pp. 1–4.
3. Kenneth R. Bowling and Helen E. Veit, *The Diary of William Maclay and Other Notes on Senate Debates* (Baltimore: The Johns Hopkins University Press, 1988), p. 286.
4. Ibid., p. 321.
5. Ibid., p. 306.
6. Ibid., p. 301.
7. Jefferson's "Note on Residence Bill," Padover, *National Capital*, p. 12.
8. Jefferson to Edward Rutledge, July 4, 1790, ibid., p. 18.
9. John W. Reps, *Washington On View: The Nation's Capital Since 1790* (Chapel Hill: The University of North Carolina Press, 1991), p. 2.
10. Jefferson to the Commissioners, January 29, 1791, Padover, *National Capital*, p. 39.
11. *Weekly Ledger* (Georgetown), March 12, 1791, Reps, *Washington on View*, p. 1.
12. L'Enfant to Washington, June 22, 1791, ibid., p. 7.
13. Ibid.
14. Allan Greenberg, *George Washington Architect* (London: Andreas Papadakis Publisher, 1999), p. 112.
15. Marcus Whiffin, *The Public Buildings of Williamsburg* (Williamsburg, Virginia: Colonial Williamsburg, 1958), p. 35.
16. The thirty-five lots sold for $8,776 but netted only $2,000 in cash. C. M. Harris, "Washington's Gamble, L'Enfant's Dream: Politics, Design, and the Founding of the National Capital," *William and Mary Quarterly* 56 (July 1999), p. 546.
17. Richard D. Stephenson, *"A Plan Whol[l]y New" Pierre Charles L'Enfant's Plan of Washington* (Washington: Library of Congress, 1993), p. 33.
18. Andrew Ellicott to the Commissioners, February 23, 1792, Stevenson, *"A Plan Whol[l]y New,"* p. 38.
19. Commissioners to Washington, January 7, 1792, U. S. National Archives, Records of the Office of Public Buildings and Grounds, 1791–1867, Record Group 42.
20. Jefferson to L'Enfant, February 22, 1792, Padover, *National Capital*, p.93.
21. L'Enfant to Jefferson, February 26, 1792, ibid., p. 98.
22. Contrary to tradition, Daniel Carroll of Duddington was not the nephew of Commissioner Daniel Carroll of Rock Creek. Don Alexander Hawkins, telephone conversation with the author, January 26, 1999.
23. Washington to Jefferson, January 18, 1792, Padover, *National Capital*, p. 88.
24. Jefferson to L'Enfant, February 27, 1792, ibid., p. 100.
25. Andrew Ellicott to Jefferson, March 6, 1792, ibid., p. 131. The unflattering characterizations of L'Enfant were made by Ellicott.
26. Jefferson to the Commissioners, March 6, 1792, Padover, *National Capital*, pp. 103–106.
27. National Park Service, *Congress Hall* (Washington: Department of the Interior, 1990), p.14.
28. Louis Torres, "Federal Hall Revisited," *Journal of the Society of Architectural Historians* 29, pp. 327–338.
29. Jefferson to L'Enfant, April 10, 1791, Padover, *National Capital*, p. 59.
30. Jefferson to James Madison, September 20, 1785, Julian Boyd, ed., *The Papers of Thomas Jefferson*, 23 vols. to date. (Princeton: Princeton University Press, 1950–), vol. 8, pp. 534–535.
31. Susan Stein, *The Worlds of Thomas Jefferson at Monticello* (New York: Harry N. Abrams, 1993), p. 64.
32. Glenn Brown, "History of the United States Capitol," *The American Architect and Building News* 52, no. 106, p. 52.
33. Washington to David Stuart, July 9, 1792, Reps, *Washington on View*, p. 30.
34. Washington to the Commissioners, July 23, 1792, John C. Fitzpatrick, ed., *Writings of Washington* (Washington: Government Printing Office, 1939), vol. 32, p. 93.
35. For the chronology of Hallet's multiple designs for the Capitol, I have relied on Alexandra Cushing Howard's "Stephen Hallet and William Thornton at the U. S. Capitol, 1791–1797," Master's Thesis, University of Virginia, 1974.

36. Pamela Scott, "Stephen Hallet's Designs for the United States Capitol," *Winterthur Portfolio* 27 (Chicago: University of Chicago Press, 1992), p. 151.

37. Elinor Stearns and David N. Yerkes, *William Thornton: A Renaissance Man in the Federal City* (Washington: American Institute of Architects Foundation, 1976), p. 22.

38. Ibid., p. 24.

39. Washington to the Commissioners, January 31, 1793, Fitzpatrick, ed., *Writings of Washington,* vol. 32, p. 325.

40. Jefferson to Daniel Carroll, February 1, 1793, Padover, *National Capital,* p. 171.

41. Theodore Sizer, ed., *The Autobiography of John Trumbull* (New Haven: Yale University Press, 1953), p. 176.

42. C. M. Harris, ed., "Biographical Sketch of William Thornton, from 1759 to 1802," *Papers of William Thornton* (Charlottesville: University Press of Virginia, 1995), vol. 1, p. xlvi.

43. See Bates Lowery, "Architectural Imagery for a New Nation," *Building a National Image: Architectural Drawings for the American Democracy, 1789–1912* (Washington: National Building Museum, 1985).

44. Thornton to Jefferson, July 8, 1793, Howard, "Stephen Hallet and William Thornton," pp. 190–198.

45. Washington to Jefferson, June 30, 1793, Fitzpatrick, *Writings of Washington,* vol. 32, pp. 510–512.

46. Ibid., p. 512.

47. Jefferson to Washington, July 17, 1793, Padover, *National Capital,* pp. 184–186.

48. Jefferson to Latrobe, April 14, 1811, John C. Van Horne, ed., *The Correspondence and Miscellaneous Papers of Benjamin Henry Latrobe* (New Haven: Yale University Press, 1988), vol. 3, pp. 57–58.

49. Although Hoban did not use the title "surveyor of public buildings," Thomas Jefferson referred to him as such when the position was "revived" in 1803. Jefferson to Latrobe, March 6, 1803, ibid., vol. 1, p. 260.

50. David Stuart to the Commissioners, August 18, 1793, U. S. National Archives, Records of the Office of Public Buildings and Grounds, 1791–1867, Record Group 42, National Archives.

51. Commissioners' Proceedings, September 2, 1793, Record Group 42, National Archives.

52. Series 15, Journal Volume 2 (1791–1794), p. 64, Record Group 42, National Archives.

53. *The Columbian Mirror and Alexandria* (Virginia) *Gazette,* September 25, 1793.

54. Jefferson to Thomas Johnson, March 8, 1792, Padover, *National Capital,* pp. 111–112.

55. James and John Maitland, John Delahanty, and Robert Brown to the Commissioners, n.d., [ca. June 5, 1794], Record Group 42, National Archives.

56. Commissioners' Proceedings, June 22–28, 1794, Record Group 42, National Archives.

57. William Thornton, "To the Members of the House of Representatives of the United States," Printed letter, January 1, 1805, p. 2. Thornton Papers, Library of Congress.

58. Commissioners to Hallet, June 26, 1794, Record Group 42, National Archives.

59. Hallet to the Commissioners, June 28, 1794, Record Group 42, National Archives.

60. Hallet's courtyard plan is similar to the principal features in Jacques Gondoin's plan for the *Ecole de Chirurgie* (School of Surgery) in Paris, 1769–1775.

61. William C. diGiacomantonio, "All The President's Men: George Washington's Federal City Commissioners," *Washington History* 3, no. 1 (Spring/Summer 1991), p. 68.

62. Commissioners to Elisha Williams, September 19, 1794, Record Group 42, National Archives.

63. Commissioners' Proceedings, November 3, 1794, Record Group 42, National Archives.

64. Williamson to the Commissioners, December 19, 1794, Record Group 42, National Archives.

65. Commissioners' Proceedings, December 20, 1794, Record Group 42, National Archives.

66. Commissioners' Proceedings, December 19, 1794, Record Group 42, National Archives.

67. Commissioners' Proceedings, December 31, 1794, Record Group 42, National Archives.

68. "Expenses on the Capitol 1st of January 1795," Miscellaneous Papers in the District of Columbia, Letters and Papers, Manuscript Division, Library of Congress.

69. Commissioners to Washington, January 2, 1795, Record Group 42, National Archives.

70. Commissioners to Washington, January 29, 1795, Record Group 42, National Archives.

71. Washington to the Commissioners, March 3, 1793, U. S. Congress, House of Representatives, *Documentary History of the Construction and Development of the Capitol Building and Grounds,* 58th Congress, 2d Session, Report 646 (Washington: Government Printing Office, 1904), p. 24.

72. Commissioners to Trumbull, December 18, 1794, Record Group 42, National Archives.

73. William O'Neale to the Commissioners, March 5, 1795, Record Group 42, National Archives.

74. William O'Neale to the Commissioners, March 12, 1795, Record Group 42, National Archives.

75. Commissioners to James Ore, agent for William O'Neale, April 23, 1795, Record Group 42, National Archives.

76. Commissioners' Proceedings, June 17, 1795, Record Group 42, National Archives.

77. Commissioners to Edmond Randolph, June 26, 1795, Record Group 42, National Archives.

78. Cornelius McDermott Roe to the Commissioners, August 4, 1795, Record Group 42, National Archives.

79. John Mitchell to the Commissioners, August 4, 1795, Record Group 42, National Archives.

80. Hadfield to the Commissioners, ca. October 15, 1795, Record Group 42, National Archives.

81. Hadfield to the Commissioners, October 28, 1795, Record Group 42, National Archives.

82. Ibid.

83. Thornton to Washington, November 2, 1795, Thornton Papers, Library of Congress.

84. Hadfield to the Commissioners, November 19, 1795, Record Group 42, National Archives.

85. Commissioners' Memorial to Congress, January 8, 1796, *Doc. History,* p. 40.

86. Committee report communicated to the House of Representatives January 25, 1796, *Doc. History,* p. 41.

87. House proceedings of February 4, 1796, *Doc. History,* p. 46.

88. House proceedings of February 25, 1796, *Doc. History,* p. 59.

89. Ibid., p. 61.

90. Committee report communicated to the House of Representatives March 11, 1796, *Doc. History,* pp. 62–63.

91. Commissioners' letters received, August 19, 1796, Record Group 42, National Archives.

92. Commissioners to Washington, June 29, 1796, Record Group 42, National Archives.

93. Washington to the Commissioners, January 29, 1797, Record Group 42, National Archives.

94. Hadfield to the Commissioners, November 2, 1797, Record Group 42, National Archives. See also Thornton

to Timothy Pickering, June 23–25, 1798, Harris, ed., *Papers of William Thornton*, p. 456.

95. Thornton to the Commissioners, January 9, 1798, Thornton Papers, Library of Congress.

96. Thornton to the Commissioners, January 9, 1798, Record Group 42, National Archives.

97. Commissioners to Alexander White, March 13, 1798, Record Group 42, National Archives.

98. Commissioners to Hadfield, May 15, 1798, Record Group 42, National Archives.

99. Commissioners to Hadfield, May 18, 1798, Record Group 42, National Archives.

100. Commissioners to John Adams, June 25, 1798, Record Group 42, National Archives.

101. "Report of the Progress Made and the Work Done in the Building of the Capitol, From the 18th of November Last, to the 18th Instant (May 1798;) Also of the materials on Hand, Prepared and Unprepared," Communicated to the House of Representatives May 29, 1798, *Doc. History*, p. 84.

102. Ibid., pp. 84–85.

103. Commissioners to Littleton Dennis, November 7, 1798, Record Group 42, National Archives.

104. Commissioners to Archibald Campbell, December 5, 1798, Record Group 42, National Archives.

105. Commissioners to Grahame Haskins & Co., May 22, 1799, Record Group 42, National Archives.

106. Thornton to the Commissioners, April 17, 1799, Thornton Papers, Library of Congress.

107. Robert King to the Commissioners, August 1, 1799, Record Group 42, National Archives.

108. "Report of James Hoban, superintendent of the Capitol, of the progress of that building from the 18th of November 1798, to the 18th of May 1799," Communicated to the House of Representatives December 5, 1799, *Doc. History*, pp. 87–89.

109. "Act to make further provision for the removal and accommodation of the Government of the United States," approved April 24, 1800, *Doc. History*, pp. 90–91.

110. Jefferson to Thornton, April 23, 1800, Thornton Papers, Library of Congress.

111. Fourth annual address of President John Adams, Senate proceedings of November 22, 1800, *Doc. History*, pp. 91–92.

112. Charles Warren, "What Has Become of the Portraits of Louis XVI and Marie Antoinette, Belonging to Congress?" *The Massachusetts Historical Society*, October-November 1925, p. 68.

113. Latrobe to John Trumbull, January 13, 1817, in Charles E. Fairman, *Art and Artists of the Capitol of the United States of America* (Washington: Government Printing Office, 1927), p. 35.

114. U. S. Senate, *Inaugural Addresses of the Presidents of the United States*, 101st Congress, 1st session, 1989, S. Doc. 101–110 (Washington: Government Printing Office, 1989), p. 15.

115. Commissioners' Proceedings, June 10, 1801, Record Group 42, National Archives.

116. "Report of James Hoban, Superintendent of the Capitol, of the work done at that building from the 18th of May, 1801, to the 14th December, 1801," communicated to the House of Representatives December 21, 1801, *Doc. History*, p. 99.

117. William Parker Cutler and Julia Perkins Cutler, *Life, Journal, and Correspondence of Rev. Manasseh Cutler, LL. D.* (Cincinnati: R. Clarke & Co., 1888), p. 79.

118. Ibid., p. 93.

119. Albert Gallatin, January 15, 1802, *Doc. History*, p. 99.

120. "Message from the President," Senate Proceedings of January 11, 1802, *Doc. History*, p. 100.

CHAPTER TWO

1. Thomas Munroe to the President of the United States, December 20, 1802, communicated to Congress, January 25, 1803, *Doc. History*, p. 103.

2. House Proceedings of February 28, 1803, *Doc. History*, pp. 103–104.

3. Ibid., p. 104.

4. Jefferson to Latrobe, March 6, 1803, in Edward C. Van Horne, ed., *The Correspondence and Miscellaneous Papers of Benjamin Henry Latrobe* (New Haven: Yale University Press, 1984), vol. 1, pp. 260–261.

5. Ibid., p. 262.

6. Jeffery A. Cohen and Charles E. Brownell, *The Architectural Drawings of Benjamin Henry Latrobe* (New Haven: Yale University Press, 1994), vol. 2, pp. 338–343.

7. Van Horne, vol. 1, p. 263.

8. Hadfield to Jefferson, March 27, 1801, Padover, *National Capital*, pp. 200–201.

9. Latrobe to Jefferson, April 4, 1803, Van Horne, vol. 1, pp. 268–284.

10. Van Horne, vol. 1, p. 278.
 If Latrobe removed all the foundations, including that part which he called the "first offset," he also removed the cornerstone of the Capitol that was laid by President Washington on September 18, 1793.

11. Jefferson to Latrobe, April 23, 1803, Van Horne, vol. 1, p. 287.

12. Latrobe to Lenthall, May 5, 1803, Van Horne, vol. 1, p. 289.

13. Latrobe to Lenthall, May 6, 1803, Van Horne, vol. 1, pp. 290–292.

14. Dumas Malone, *Jefferson and His Time* (Boston: Little, Brown & Company, 1970), vol. 4, p. 93.

15. "Dr. Mitchell's Letters from Washington: 1801–1813," *Harper's New Monthly*, April 1879, p.747.

16. Latrobe to Lenthall, November 27, 1803, Van Horne, vol. 1, p. 381.

17. "Report of B. Henry Latrobe to the President of the United States, February 20, 1804, transmitted to Congress February 22, 1804," *Doc. History*, pp.104–106.

18. "To the Chairman of the Committee of the House of Representatives in Congress, to whom was referred the message of the President of the United States of the 22d of February 1804 transmitting a report of the Surveyor of public buildings of the 20th of February 1804, February, 28, 1803," *Doc. History*, pp. 107–110.

19. Latrobe to Jefferson, February 27, 1804, Van Horne, vol. 1, p. 437.

20. Jefferson to Latrobe, February 28, 1804, Van Horne, vol. 1, pp. 439–440.

21. Latrobe to Jefferson, February 28, 1804, Van Horne, vol. 1, p. 441.

22. Latrobe to Lenthall, March 8, 1804, Van Horne, vol. 1, p. 450.

23. Latrobe to Jefferson, February 28, 1804, Van Horne, vol. 1, p.441.

24. Van Horne, vol. 1, p. 464n.

25. Latrobe to Lenthall, March 28, 1804, Van Horne, vol. 1, p. 463.

26. "An Act concerning the Public Buildings at the City of Washington," approved March 27, 1804, *Doc. History*, p. 111.

27. Latrobe to Jefferson, March 29, 1804, Van Horne, vol. 1, pp. 466–473.

28. Jefferson to Latrobe, April 9, 1804, Van Horne, vol. 1, pp. 475–476.

29. Thornton to Latrobe, April 23, 1804, Van Horne, vol. 1, pp. 479–480.
30. Latrobe to Thornton, April 28, 1804, Van Horne, vol. 1, pp. 481–482.
31. Vol. 20, Thornton Papers.
32. Jefferson to Latrobe, October 5, 1804, Van Horne, vol. 1, pp. 548–550.
33. Latrobe to Jefferson, October 11, 1804, Van Horne, vol. 1, pp. 550–551.
34. Jefferson to Latrobe, November 12, 1804, Van Horne, vol. 1, p. 571.
35. Latrobe to Jefferson, November 17, 1804, Van Horne, vol. 1, pp. 571–572.
36. "Report on the Public Buildings," December 1, 1804, Van Horne, vol. 1, pp. 577–583. Also in *Doc. History*, pp. 111–114.
37. Latrobe to Philip R. Thompson, December 30, 1804, Van Horne, vol. 1, pp. 586–587.
38. "An Act making an appropriation for completing the south wing of the Capitol, at the City of Washington, and for other purposes," approved January 25, 1805, *Doc. History*, p. 115.
39. Latrobe to Mazzei, March 6, 1805, Van Horne, vol. 2, pp. 21–24.
40. Jefferson to Latrobe, February 28, 1804, Van Horne, vol. 1, p. 440.
41. Latrobe to Lenthall, March 3, 1806, Van Horne, vol. 2, p. 196.
42. Ibid., pp. 134–137.
43. Jefferson to Latrobe, September 8, 1805, Van Horne, vol. 2, p. 140.
44. Latrobe to Jefferson, September 13, 1805, Van Horne, vol. 2, p. 146.
45. Cohen and Brownell, vol. 2, p. 380.
46. Latrobe to Lenthall, November 6, 1805, Van Horne, vol. 2, pp. 158–160.
47. Latrobe to Lenthall, November 19, 1805, Van Horne, vol. 2, pp. 163–164.
48. "Report on the Public Buildings," December 22, 1805, Van Horne, vol. 2, pp. 168–174. See also *Doc. History*, pp. 115–118.
49. House proceedings of April 17, 1806, *Doc.History*, p. 118–119.
50. "An Act making a further appropriation towards completing the south wing of the Capitol, at the City of Washington," approved April 21, 1806, *Doc. History*, p. 119.
51. Mazzei to Latrobe, September 12, 1805, Van Horne, vol. 2, pp. 141–144.
52. Latrobe to Charles Willson Peale, April 18, 1806, Van Horne, vol. 2, p. 215.
53. Charles Willson Peale to Latrobe, April 21, 1806, Van Horne, vol. 2, p. 218.
54. Latrobe to Giuseppe Franzoni and Giovanni Andrei, April 26, 1806, Van Horne, vol. 2, pp. 219–222.
55. Latrobe to Mazzei, May 29, 1806, Van Horne, vol. 2, pp. 225–229.
56. Jefferson to Latrobe, July 1, 1806, Van Horne, vol. 2, p. 236.
57. Latrobe to Lenthall. July 3, 1806, Van Horne, vol. 2, p. 237.
58. Latrobe to Blagden, July 13, 1806, Van Horne, vol. 2, p. 246n.
59. Jefferson to Latrobe, July 17, 1806, Van Horne, vol. 2, p. 247.
60. Latrobe to Jefferson, August 15, 1806, Van Horne, vol. 2, pp. 262–265.
61. Latrobe to Jefferson, October 29, 1806, Van Horne, vol. 2, pp. 277–281.
62. Jefferson to Latrobe, October 31, 1806, Van Horne, vol. 2, pp. 282–283.
63. "The report of the Surveyor of the public buildings of the United States, at Washington," November 25, 1806, communicated to Congress on December 15, 1806, *Doc. History*, pp. 120–123.
64. Jefferson to the House of Representatives, December 15, 1806, *Doc. History*, pp. 119–120.
65. Latrobe to Jefferson, December 7, 1806, Van Horne, vol. 2, p. 321.
66. *A Private Letter to the Individual Members of Congress, On the Subject of The Public Buildings of the United States at Washington,* November 28, 1806, Van Horne, vol. 2, pp. 296– 316.
67. House Proceedings of December 15, 1806, *Doc. History*, p. 124.
68. House proceedings of February 13, 1807, *Doc. History*, pp. 126–129.
69. Latrobe to John J. Holland, December 30, 1806, Van Horne, vol. 2, pp. 344–345.
70. Latrobe to Charles Bulfinch, March 25, 1807, Van Horne, vol. 2, pp. 399–400.
71. Latrobe to John Cassin, July 22, 1808, Van Horne, vol. 2, p. 641.
72. Latrobe to Jefferson, September 11, 1808, Van Horne, vol. 2, p. 658.
73. Latrobe to Thomas Munroe, June 23, 1808, Van Horne, vol. 2, p. 636.
74. Latrobe to Jefferson, January 6, 1807, Van Horne, vol. 2, pp. 356–357.
75. Latrobe to Jefferson, April 14, 1807, Van Horne, vol. 2, pp. 408–409.
76. Jefferson to Latrobe, April 27, 1807, Van Horne, vol. 2, pp. 410–411.
77. Latrobe to Jefferson, May 21, 1807, Van Horne, vol.2, pp. 427–429.
78. Latrobe to Jefferson, August 13, 1807, Van Horne, vol. 2, pp. 463–465.
79. Jefferson to Latrobe, August 18, 1807, Van Horne, vol. 2, pp. 469–470.
80. Latrobe to Jefferson, August 21, 1807, Van Horne, vol. 2, pp. 472–474.
81. Charles Brownell, "Jefferson's Architectural Models," in Donald Kennon, ed., *A Republic for the Ages* (Charlottesville: University Press of Virginia, 1999), pp. 360–363.
82. Latrobe to Jefferson, September 1, 1807, Van Horne, vol. 2, pp. 475–476.
83. Latrobe to Robert Mills, September 20, 1807, Van Horne, vol. 2, pp. 486–487.
84. Latrobe to John Lenthall, October 18, 1807, Van Horne, vol. 2, pp. 488–489.
85. Van Horne, vol. 2, p. 505n.
86. Van Horne, vol. 2, p. 498n.
87. Ibid.
88. Latrobe to Lenthall, November 21, 1807, Van Horne, vol. 2, p. 497.
89. Latrobe to Christian Ignatius Latrobe, December 1, 1807, Van Horne, vol. 2, p. 508.
90. Latrobe to Joseph Clay, November 23, 1807, Van Horne, vol. 2, p. 505n.
91. Latrobe to the Editor of the *National Intelligencer,* November 30, 1807, Van Horne, vol. 2, pp. 499–505.
92. Latrobe to Orris Paine, August 26, 1816, in Carter 132/G1.
93. Latrobe to Lenthall, January 6, 1808, Van Horne, vol. 2, p. 515.
94. House proceedings of April 5, 1808, *Doc. History*, pp. 138–140.

95. Latrobe to Richard Stanford, April 8, 1808, Van Horne, vol. 2, pp. 584–589.

96. "Report of the committee to whom was recommitted the bill to make good a deficit in the appropriation of 1807, and to make a further appropriation for completing the south wing of the Capitol, and for other purposes," communicated to the House April 21, 1808, *Doc. History,* pp. 140–141.

97. House proceedings of April 23, 1808, *Doc. History,* p. 143.

98. Ibid., p. 144–145.

99. Jefferson to Latrobe, April 25, 1808, *Doc. History,* p. 145.

100. Jefferson to Latrobe, June 2, 1808, Van Horne, Vol. 2, pp. 631–633.

101. Latrobe to Jefferson, August 31, 1805, Van Horne, vol. 2, pp. 131–134.

102. Jefferson to Latrobe, September 8, 1805, Van Horne, vol. 2, pp. 139–140.

103. Latrobe to Jefferson, August 31, 1805, Van Horne, vol. 2, p. 133.

104. "Report on the Public Buildings," December 22, 1805, Van Horne, vol. 2, p. 169.

105. House proceedings of December 8 and 9, 1806, *Doc. History,* p. 119.

106. "The report of the Surveyor of Public Buildings of the United States, at Washington," November 25, 1806, communicated to Congress December 15, 1806, *Doc. History,* pp. 120–123.

107. House proceedings of February 13, 1807, *Doc. History,* pp. 127–128.

108. Latrobe to Jefferson, September 17, 1807, Van Horne, vol. 2, pp. 482–484.

109. "Report of the Surveyor of the Public Buildings of the United States at Washington," March 23, 1808, communicated to Congress March 25, 1808, *Doc. History,* pp. 134–135.

110. Thornton to the *National Intelligencer,* April 20, 1808 (Published April 26, 1808), Van Horne, vol. 2, pp. 600–605.

111. Latrobe to the *Washington Federalist,* April 28,1808 (Published April 30, 1808), Van Horne, vol. 2, pp. 607–609.

112. Thornton to the *Washington Federalist,* May 1, 1808 (Published May 7, 1808), Van Horne, vol. 2, pp. 614–617.

113. Latrobe to the *Washington Federalist,* May 9, 1808 (Published May 11, 1808), Van Horne, vol. 2, p. 619.

114. Latrobe to Jefferson, May 23, 1808, Van Horne, vol. 2, pp. 621–622.

115. Jefferson to Latrobe, April 26, 1808, Van Horne, vol. 2, p. 612.

116. Latrobe to the *National Intelligencer,* September 20, 1808 (Published September 23, 1808), Van Horne, vol. 2, pp. 662–664.

117. Latrobe to Jefferson, September 23, 1808, Van Horne, vol. 2, pp. 665–667.

118. Latrobe to the *Monitor,* September 19, 1808 (Published September 20, 1808), Van Horne, vol. 2, p. 661.

119. Latrobe to Jefferson, September 23, 1808, Van Horne, vol. 2, pp. 666–667.

120. "Report on the Public Buildings," November 18, 1808, Van Horne, vol. 2, pp. 670–675.

121. Ibid., p. 673.

122. *Doc. History,* pp. 149–152.

123. 93rd Congress, 1st Session, House Document No. 93–78 (Part 2), U. S. Department of Commerce, Bureau of the Census, *Bicentennial Edition, Historical Statistics of the United States, Colonial Times to 1970,* Federal Government Receipts—Administrative Budget: 1789 to 1939. (Washington: Government Printing Office, 1975), p. 1106.
 Customs duties remained the largest source of federal receipts until 1864.

124. Malone, vol. 5, p. 609.

125. "Report of the Committee appointed to confer with the Surveyor of Public Buildings relative to the accommodation of the Senate," February 18, 1809, *Doc. History,* pp. 153–154.

126. Latrobe to the Senate, June 12, 1809. *The Papers of Benjamin Henry Latrobe,* ed. Edward C. Carter (Clifton, N. J.: James T. White, 1976, microfiche), 198/E6.

127. Malone, vol. 5, p. 668.

128. Jefferson to Latrobe, July 12, 1812, in Carter 209/E10.

129. Report of B. Henry Latrobe on Public Buildings communicated to the Senate June 13, 1809, *Doc. History,* pp. 155–156.

130. "An Act making an appropriation to finish and furnish the Senate chamber, and for other purposes," approved June 28, 1809, *Doc. History,* pp. 156–157.

131. Latrobe to Jefferson, August 28, 1809, Van Horne, Vol. 2, pp. 749–751.

132. Latrobe to Madison, September 8, 1809, Van Horne, vol. 2, p. 764.

133. Ibid., pp. 765–766.

134. Senate proceedings of February 6, 1810, *Doc. History,* p. 161.

135. "Remarks on the Best Form of a Room for Hearing and Speaking," ca. 1803, Van Horne, vol. 1, p. 405.

136. Ibid., p. 406.

137. "Report of the Committee on the President's Message communicating a report of the Surveyor of the Public Buildings, accompanying a bill making further appropriations for completing the Capitol, and for other purposes," communicated to the House January 11, 1810, *Doc. History,* p. 160.

138. Report of the Surveyor of Public Buildings, January 3, 1811, communicated to the House January 15, 1811, *Doc. History,* pp. 162–163.

139. Latrobe to Thomas Law, November 10, 1816, Van Horne, vol. 3, p. 826.
 The intention that the caryatids would collectively represent "national prosperity" was stated in a letter to Samuel Lane dated April 29, 1817, in Carter 231/F3. In that letter, Latrobe mentioned eight figures, not six.

140. "The Report of the Surveyor of the Public Buildings of the United States," December 28, 1810, communicated to Congress January 15, 1811, *Doc. History,* pp. 163–164.

141. Ibid., pp. 169–170.

142. Latrobe to Jefferson, July 2, 1812, Van Horne, vol. 3, p. 328.

143. Van Horne, vol. 2, p. 668n.

144. Van Horne, vol. 3, p. 56n.

145. Jefferson to Latrobe, April 14, 1812, Van Horne, vol. 3, pp. 57–59.

146. Account of John Rea certified by B. Henry Latrobe, April 10, 1812, in Carter 208 C/5.

147. Latrobe to Robert Fulton, March 13, 1813, Van Horne, vol. 3, p. 430.

148. Ibid., pp. 430–431.

149. Latrobe to Walter Jones and John Law, ca. June 26, 1808, Van Horne, vol. 2, pp. 637–639.

150. Thornton Papers.

CHAPTER THREE

1. Anthony S. Pitch, *The Burning of Washington* (Annapolis: Naval Institute Press, 1998), p. 106.

2. Latrobe to Jefferson, July 12, 1815, Van Horne, vol. 3, p. 671.

3. Ibid.
4. Pitch, *Burning of Washington*, p. 138.
5. "Proclamation by the President," September 1, 1814, *Doc. History*, pp. 171–172.
6. "Report of the committee to inquire into the causes of the success of the enemy in his recent enterprise against this metropolis . . . ," communicated to the House November 29, 1814, *Doc. History*, p. 173.
7. Thomas Munroe to R. M. Johnson, "chairman of the committee to inquire into the causes of the success of the enemy . . . ," *Doc. History*, pp. 173–174.
8. House proceedings of October 20, 1814, *Doc. History*, pp. 174–176.
9. Senate proceedings of February 3, 1815, *Doc. History*, pp. 176–180.
10. House proceedings of February 7, 1815, *Doc. History*, p. 181.
11. House proceedings of February 8, 1815, *Doc. History*, pp. 181–184.
12. "An Act making appropriations for repairing and rebuilding the public buildings within the city of Washington," approved February 13, 1815, *Doc. History*, p. 185.
13. William Seale, *The President's House* (Washington: The White House Historical Association, 1986), vol. 1, p. 138.
14. Latrobe to Madison, February 25, 1815, Van Horne, vol. 3, pp. 630–631.
15. Talbot Hamlin, *Benjamin Henry Latrobe* (New York: Oxford University Press, 1955), pp. 435–436.
16. Commissioners to Latrobe, March 31, 1815, Van Horne, vol. 3, p. 635n.
17. Latrobe to Mary Elizabeth Latrobe, April 17, 1815, Van Horne, vol. 3, p. 644.
18. Ibid., pp. 644–645.
19. Commissioners to Latrobe, April 18, 1815, Record Group 42, National Archives.
20. Latrobe to the Commissioners of the Public Buildings, April 19, 1815, Van Horne, vol. 3, pp. 647–653.
21. Latrobe to the Commissioners of the Public Buildings, April 27, 1815, Van Horne, vol. 3, pp. 654–659.
22. Madison to the Commissioners, May 23, 1815, *Doc. History*, pp. 185–186.
23. Thornton to Jefferson, n.d., [ca. April 21, 1815], Van Horne, vol. 3, p. 674 n.
24. Latrobe to the Commissioners, May 2, 1815, Van Horne, vol. 3, pp. 660–663.
25. The Commissioners to Latrobe, June 19, 1815, Record Group 42, National Archives.
26. The Commissioners to Giovanni Andrei, August 8, 1815, Record Group 42, National Archives.
27. Latrobe to Van Ness, May 15, 1815, in Carter 216/A4.
28. Latrobe to the Commissioners, August 8, 1815, Van Horne, vol. 3, p 682.
29. Ibid., pp. 681–682.
30. Commissioners to Epaphroditus Champion, Timothy Perkin, and Samuel W. Warner, October 26, 1815, Record Group 42, National Archives.
31. Latrobe to the Commissioners, August 26, 1815, in Carter 218/A1.
32. Commissioners to Latrobe, August 28, 1815, in Carter 218/A14.
33. Latrobe to the Commissioners, August 26, 1815, in Carter 218/A1.
34. Commissioners to Latrobe, August 28, 1815, in Carter 218/A14.
35. Latrobe to Jefferson, July 12, 1815, Van Horne, vol. 3, p. 672.
36. Latrobe to Henry S. B. Latrobe, November 8, 1815, Van Horne, vol. 3, p. 701.
37. Latrobe to Charlotte Ann (Burney) Francis Broome, November 20, 1815, Van Horne, vol. 3, p. 712.
38. Latrobe to the Commissioners, February 21, 1816, Van Horne, vol. 3, pp. 732–735.
39. Latrobe to Rufus King, March 6, 1816, in Carter 221/C8.
40. Latrobe to Rufus King, March 27, 1816, Van Horne, vol. 3, pp. 744–746.
41. Robert C. Byrd, *The Senate, 1789–1989* (Washington: Government Printing Office, 1991), vol. 2, p. 217.
42. Latrobe to the Commissioners, April 12, 1816, in Carter 222/D7.
43. Commissioners to Latrobe, April 19, 1816, in Carter 222/E14.
44. Commissioners to Latrobe February 7, 1816, Record Group 42, National Archives.
45. Commissioners to Latrobe, February 26, 1816, Record Group 42, National Archives.
46. Commissioners to Latrobe, February 28, 1816, Record Group 42, National Archives.
47. Commissioners to Latrobe, March 6, 1816, Record Group 42, National Archives.
48. Latrobe to the Commissioners, March 26, 1816, in Carter 221/F1.
49. Ibid.
50. Commissioners to John McComb, April 4, 1816, Record Group 42, National Archives.
51. Latrobe to the Commissioners, April 10, 1816, in Carter 222/B11.
52. Latrobe to the Commissioners, April 10, 1816, in Carter 222/C12.
53. "Act making an appropriation for enclosing and improving the public square near the capitol; and to abolish the office of commissioners of the public buildings, and of superintendent, and for the appointment of one commissioner for the public buildings," approved April 29, 1816, *Doc. History*, p. 189.
54. Latrobe to Madison, April 24, 1816, Van Horne, vol. 3, pp. 765–767.
55. Latrobe to William Lee, August 13, 1816, Van Horne, vol. 3, p 799.
56. Latrobe to Henry S. B. Latrobe, May 1, 1816, Van Horne, vol. 3, pp. 768–770.
57. Ibid., p. 770n.
58. "Return of persons employed at the Capitol of the United States, independently of the Foremen of each Department, from Monday 27th May 1816 to Wednesday, May 19, 1816," Record Group 42, National Archives.
59. Van Horne, vol. 3, p. 802n.
60. Latrobe to Jacob Small, September 8, 1816, Van Horne, vol. 3, p. 810.
61. Lane to Latrobe, August 27, 1816, Van Horne, vol. 3, p. 807.
62. Latrobe to Jacob Small, September 8, 1816, Van Horne, vol. 3, p. 810.
63. Latrobe to Jefferson, November 5, 1816, Van Horne, vol. 3, pp. 822–823.
64. Latrobe to Lane, November 28, 1816, *Doc. History*, pp. 190–192.
65. "Disbursements made between the 30th of April 1816, and the 1st of January 1817, on account of the Capitol," January 22, 1817, *Doc. History*, p. 194.
66. Lane to Lewis Condict, February 1, 1817, *Doc. History*, p. 195.
67. "Estimate of the probable expense of finishing the north and south wings of the Capitol of the United States," February 12, 1817, *Doc. History*, p. 196.
68. "Report of the Committee," Van Horne, vol. 3, p. 861n.

69. "From the Memorial of B. Henry Latrobe, Surveyor of the Capitol," February 22, 1817, Communicated to the House Feb. 26, 1817, *Doc. History,* pp. 197–198.
70. Latrobe to Lane, February 27, 1817, Van Horne, vol. 3, p. 860.
71. Latrobe to Jacob Small, March 21, 1817, Van Horne, vol. 3, p. 869.
72. J. G. Swift and G. Bomford to Monroe, March 19, 1817, *Doc. History,* p. 221.
73. Latrobe to Monroe, April 2, 1817, Van Horne, vol. 3, pp. 876–877.
74. Blagden to Lane, March 14, 1817, Record Group 42, National Archives.
75. Lane to Latrobe, March 17, 1817, Record Group 42, National Archives.
76. Latrobe to Joseph Swift, April 7, 1817, in Carter 231/A13. Retaining the corner caryatids is documented in Latrobe's cross section (illustrated on page 109) of the north wing drawn about the time of his letter to General Swift.
77. Commissioner's Proceedings, April 10, 1817, Record Group 42, National Archives.
78. "Estimate of materials for the Dome and Roof of the South Wing of the Capitol," April 7, 1817, in Carter 231/A9.
79. Latrobe to Lane, April 30, 1817, in Carter 231/F9.
80. Latrobe to Lane, April 10, 1817, in Carter 231/C1.
81. Latrobe to John Hartnet, March 21, 1817, in Carter 135/G4.
82. Monroe to Lane, April 4, 1817, *Doc. History,* pp. 198–199.
83. Latrobe to Jefferson, August 12, 1817, Van Horne, vol. 3, p. 930.
84. *Niles' Weekly Register,* August 3, 1816.
85. Latrobe to Lane, January 15, 1817, Record Group 42, National Archives.
86. Lane to Thomas Towson, August 12, 1817, Record Group 42, National Archives.
87. Blagden to Lane, September 25, 1817, Record Group 42, National Archives.
88. Lane to Thomas Traquair, April 29, 1817, Record Group 42, National Archives.
89. Lane to Daniel Gantt, June 9, 1817, Record Group 42, National Archives.
90. John McComb to Lane, ca. June 10, 1817, Record Group 42, National Archives.
91. Latrobe to Lane, June 15, 1817, in Carter 232/D9.
92. Latrobe to Lane. May 21, 1817, in Carter 232/A1.
93. Latrobe to Lane, April 29, 1817, in Carter 231/F3.
94. Ibid.
95. Daniel Gantt to Lane, June 7, 1817, Record Group 42, National Archives.
96. John McComb to Lane, ca. June 10, 1817, Record Group 42, National Archives.
97. Lane to Messrs. Purviance, Nicholas, and Company, June 13, 1817, Record Group 42, National Archives.
98. William Lee to Charles Bulfinch, September 14, 1817, Ellen Susan Bulfinch, ed., *The Life and Letters of Charles Bulfinch* (Boston: Houghton Mifflin Co., 1896), p. 199.
99. Latrobe to John Trumbull, October 10, 1817, Van Horne, vol. 3, pp. 953–954.
100. Latrobe to Monroe, October 22, 1817, Van Horne, vol. 3, pp. 956–959.
101. John Mason, George Graham, and George Bomford to Lane, September 23, 1817, Record Group 42, National Archives. Lane to Latrobe, September 24, 1817 and September 25, 1817, Record Group 42, National Archives.

102. Shadrach Davis to Lane, October 27, 1817, Record Group 42, National Archives.
103. Van Horne, vol. 3, p. 964n.
104. Lane to Latrobe, October 31, 1817, Van Horne, vol. 3, p. 962–963.
105. Latrobe to John Trumbull, October 10, 1817, Van Horne, vol. 3, p. 951.
106. Latrobe to Robert Goodloe Harper, November, 24, 1817, Van Horne, vol. 3, pp. 969–970.
107. Hamlin, *Benjamin Henry Latrobe,* p. 477.
108. Latrobe to Monroe, November 20, 1817, Van Horne, vol. 3, pp. 968–969.
109. Latrobe to Robert Goodloe Harper, December 19, 1817, Van Horne, vol. 3, pp. 973–974.

CHAPTER FOUR

1. William Lee to Bulfinch, September 14, 1817, Ellen Bulfinch, ed., *Life and Letters,* p. 199.
2. Bulfinch to William Lee, September 27, 1817, *Life and Letters,* pp. 200–201.
3. William Lee to Bulfinch, October 1, 1817, *Life and Letters,* p. 203.
4. Bulfinch to William Lee, November 15, 1817, *Life and Letters,* p. 206.
5. Harrison Gray Otis to Bulfinch, December 2, 1817, *Life and Letters,* p. 207.
6. Samuel Lane to Nehemiah Freeman, December 3, 1817, *Life and Letters,* pp. 208–209.
7. Bulfinch to Hanna Bulfinch, February 7, 1817, *Life and Letters,* p. 198.
8. Charles A. Place, *Charles Bulfinch: Architect and Citizen* (New York: Da Capo Press, 1968), pp. 241–243.
9. Bulfinch to William Lee, September 27, 1817, *Life and Letters,* p. 202.
10. William Lee to Bulfinch, October 1, 1817, *Life and Letters,* p. 204.
11. Bulfinch to Hanna Bulfinch, March 16, 1818, *Life and Letters,* p. 224.
12. Bulfinch to Hanna Bulfinch, January 7, 1818, *Life and Letters,* p. 212.
13. Lane to Bulfinch, January 8, 1818, *Life and Letters,* p. 211.
14. Bulfinch to Hanna Bulfinch, January 7, 1818, *Life and Letters,* p. 213.
15. Lane to Monroe, February 10, 1818, *Doc. History,* pp. 200–202.
16. "Expenditures for rebuilding the public edifices," communicated to the House April 3, 1818, *Doc. History,* p. 204.
17. Lane to Henry St. George Tucker, January 24, 1818, *Doc. History,* p. 205.
18. "Report In Part Of The Committee Of Public Buildings," April 4, 1818, *Doc. History,* pp. 205–206.
 "Act making appropriations for the Public Buildings, and for furnishing the Capitol and President's house," approved April 20, 1818, *Doc. History,* p. 206.
19. Bulfinch to Lane, November 21, 1818, *Doc. History,* p. 208.
20. Lane to Blagden, May 25, 1818, Record Group 42, National Archives.
21. Lane to Blagden, May 30, 1818, Record Group 42, National Archives.
22. "Report of the state of the arch in the roof of the north wing," May 1, 1818, *Doc. History,* pp. 209–210.
23. *Memorial To Congress In Vindication Of His Professional Skill,* December 8, 1818, Van Horne, vol. 3, pp. 1010–1016.
24. Lane to David Daggett, July 20, 1818, Record Group 42, National Archives.

25. Lane to David Daggett, July 30, 1818, Record Group 42, National Archives.
26. David Daggett to Lane, August 5, 1818, Record Group 42, National Archives.
27. Thomas Traquair to Lane, April 17, 1817, Record Group 42, National Archives.
28. Andrei and Blagden to Lane, September 1, 1818, Record Group 42, National Archives.
29. William Seaton to Joseph Elgar, August 28, 1822, Record Group 42, National Archives.
30. William Stewart and Thomas Towson to Lane, July 21, 1818, Record Group 42, National Archives.
31. Lane to Joseph Bellinger, December 15, 1818, *Doc. History,* p. 211.
32. Bulfinch to Lane, December 12, 1818, *Doc. History,* pp. 211–212.
33. "An Act making appropriations for the public buildings, for the purchase of a lot of land, and for furnishing a supply of water for the use of certain public buildings," approved March 3, 1819, *Doc. History,* p. 213.
34. "Report of the Committee on the Public Buildings," January 7, 1819, *Doc. History,* pp. 210–211.
35. Lane to Samuel Smith, July 1, 1818, Record Group 42, National Archives.
36. Lane to Bulfinch, January 13, 1818, Record Group 42, National Archives.
37. Bulfinch to Hanna Bulfinch, January 7, 1818, *Life and Letters,* p. 215.
38. Thornton to Lane [Draft], April 13, 1820, Thornton Papers.
39. Sizer, *Autobiography of John Trumbull,* pp. 257–259.
40. *The National Intelligencer* (Washington), January 28, 1817.
41. Latrobe to Trumbull, January 22, 1817, Van Horne, vol. 3, p. 856.
42. Trumbull to Latrobe, September 25, 1817, Van Horne, vol. 3, pp. 942–943.
43. Latrobe to Trumbull, October 10, 1817, Van Horne, vol. 3, pp. 951–954.
44. Trumbull to Bulfinch, January 28, 1818, Sizer, *Autobiography of John Trumbull,* p. 263.
45. Place, *Architect and Citizen,* p. 248.
46. Irma B. Jaffe, *John Trumbull: Patriot-Artist of the American Revolution* (Boston: New York Graphic Society, 1975), pp. 251–256.
47. Trumbull to Bulfinch, July 25, 1818, Sizer, *Autobiography of John Trumbull,* p. 267.
48. *National Intelligencer* (Washington), August 27, 1818.
49. Bulfinch to Lane, November 21, 1818, *Doc. History,* p. 208.
50. "Estimate of Materials and Labor required on the Centre of the Capitol during the year 1819," *Doc. History,* pp. 212–213.
51. Lane to Thomas Cobb, January 5, 1820, *Doc. History,* pp. 223–224.
52. "Free Stone Quarries," Latrobe Journal Entry, August 24, 1806, in Carter 17/A8.
53. House Proceedings of January 24, 1820, *Doc. History,* p. 225.
54. "Act making appropriations to supply the deficiency in the appropriation heretofore made for the completion of the repairs of the north and south wings of the Capitol, for finishing the President's house, and for the erection of two new executive offices," approved February 10, 1820, *Doc. History,* p. 230.
55. "An Act making further appropriations for continuing the work upon the center building of the Capitol, and other public buildings," approved April 11, 1820, *Doc. History,* p. 233.
56. Thornton to Lane [Draft], April 13, 1820, Thornton Papers.
57. Bulfinch to Silas Wood, January 10, 1821, *Doc. History,* pp. 236–237.
58. "Report of the Committee on Public Buildings on the practicability of making such alterations in the Hall of the House of Representatives as will better adapt it to the purposes of a deliberative assembly &c.," January 19, 1821, *Doc. History,* p. 235.
59. "Report of the Committee on Public Buildings, with a bill making appropriations for the Public Buildings," January 30, 1821, *Doc. History,* p. 238.
60. *Life and Letters,* pp. 298–299.
61. Lane to William S. Blackledge, Chairman of the Committee of Public Buildings, February 5, 1822, *Doc. History,* p. 245.
62. "Report of the Committee on Public Buildings, accompanied with a bill fixing the compensation of the Commissioner of Public Buildings," April 8, 1822. Machine copy, AOC.
63. Bulfinch to John Quincy Adams, January 25, 1823, *Life and Letters,* pp. 245–246.
64. Monroe to William Wirt, January 31, 1823, *Life and Letters,* pp. 246–247.
65. William Wirt to Monroe, January 31, 1823, *Life and Letters,* p. 247.
66. Bulfinch to Elgar, December 6, 1823, *Doc. History,* p. 257.
67. Bulfinch to Elgar, September 8, 1823, Record Group 42, National Archives.
68. Brownell, "Jefferson's Architectural Models," p. 387.
69. Latrobe to Jefferson, December 7, 1806, Van Horne, vol. 2, p. 321.
70. Cohen and Brownell, vol. 2, p. 385.
71. Brownell, *Jefferson's Architectural Models,* p. 392n.
72. Elgar to J. H. Settle and Co., September 2, 1823, Record Group 42, National Archives.
73. Towson to Elgar, November 12, 1823, Record Group 42, National Archives.
74. Blagden to Elgar, April 21, 1824, Record Group 42, National Archives.
75. Elgar to Towson, May 1, 1824, Record Group 42, National Archives.
76. Elgar to Towson, September 16, 1824, Record Group 42, National Archives.
77. Bessie Roland James, *Anne Royall's U.S.A.* (New Brunswick: Rutgers University Press, 1972), p. 105.
78. "Accounts for Construction of the Central or Rotunda Section of the Capitol," typed transcript, AOC.
79. Ibid.
80. John Harris, Introduction to *A Treatise on the Decorative Part of Civil Architecture*, by Sir William Chambers (New York: Benjamin Blom, Inc., 1968), pp. 60–61.
81. Thornton to the Commissioners, January 9, 1798, Record Group 42, National Archives.
82. "The Stonecutters Celebration," *The Washington Gazette,* July 2, 1824.
83. "Celebration of the Fourth of July," *The Washington Gazette,* July 6, 1824.
84. "Report of the Committee on the Public Buildings, in relation to the operations on said buildings during the last year, and to their present state," February 13, 1824, *Doc. History,* p. 258.
85. "Report of the Committee on the Expenditures on the Public Buildings in the Year 1824," January 24, 1825, *Doc. History,* p. 267.
86. "Report of the Committee on the Expenditures on the Public Buildings," April 8, 1822, *Doc. History,* p. 248.

"Report of the Committee on the Expenditures on the Public Buildings," April 13, 1824, *Doc. History,* p. 261.

87. Ibid., pp. 261–264.
88. "Report of the Architect of the Capitol to the Commissioner of Public Buildings," December 8, 1824, *Doc. History,* p. 266.
89. "Report of the Architect of the Capitol," December 6, 1823, *Doc. History,* p. 257.
90. Hamlin, *Benjamin Henry Latrobe* p. 455.
91. Elgar to Bulfinch, August 16, 1824, Record Group 42, National Archives.
92. Bulfinch to Elgar, August 17, 1824, Record Group 42, National Archives.
93. William Thornton to "Sir," [Draft], July 11, 1825, Thornton Papers.
94. Bulfinch to Thomas Bulfinch, June 22, 1825, *Life and Letters,* p. 249.
95. Ibid.
96. William Dawson Johnston, *History of the Library of Congress* (New York: Kraus Reprint Co., 1967), vol. 1, pp. 132–134.
97. *The National Intelligencer* (Washington), January 1, 1825.
98. Hanna Bulfinch to her sons, December 25, 1825, *Life and Letters,* p. 250.
99. "Report of the Library Committee of the House, on the Subject of rendering the Library room fire-proof," February 6, 1826, *Doc. History,* pp. 270–271.
100. "Statement of various modes of building the external Offices, at the Capitol," Bulfinch to Stephen Van Rensselaer, Chairman of the Committee on Public Buildings, March 6, 1826, *Doc. History,* pp. 275–276.
101. House proceedings of February 6, 1826, *Doc. History,* p. 269.
102. "Act making appropriations for the public buildings in Washington, and for other purposes," approved May 22, 1826, *Doc. History,* p. 279.
103. Elgar to Bulfinch, June 4, 1826, Record Group 42, National Archives.
104. Elgar to the president, December 7, 1826, *Doc. History,* p. 279.
105. House proceedings of January 15, 1827, *Doc. History,* p. 280.
106. Ibid., p. 281.
107. House of Representatives, Report No. 75, 19th Congress, 2d Session, February 7, 1827; Bulfinch to Stephen Van Rensselaer, January 11, 1827, *Doc. History,* p. 284.
108. House proceedings of February 23, 1827, *Doc. History,* p. 289.
109. Ibid., p. 290.
110. Ibid., p. 291.
111. "Report of the proceedings on the Public Buildings, for the year 1817," *Doc. History,* pp. 294–296.
112. House of Representatives, Estimate for Work on the Capitol of the United States for 1828, 20th Congress, 1st Session, H. Doc. 180, *Doc. History,* pp. 296–297.
113. House proceedings of April 28, 1828, *Doc. History,* pp. 299–300.
114. Ibid., p. 300.
115. Senate proceedings of May 1, 1828, *Doc. History,* pp. 300–301.
116. "National Paintings," *Doc. History,* p. 301.
117. Elgar to Trumbull, December 11, 1828, Record Group 42, National Archives.
118. "Report of the Commissioner of Public Buildings," November 28, 1828, *Doc. History,* p. 301.
119. Miscellaneous Treasury Accounts, Record Group 412, National Archives; Commissioner of Public Buildings to James Martin, December 11, 1828, typed transcript, AOC.
120. House Report no. 69, 20th Congress, 2d Session, February 4, 1829, *Doc. History,* pp. 1038–1039.
121. *Nashville Republican & State Gazette,* March 24, 1829.
122. Bulfinch to Jackson, June 27, 1829, *Life and Letters,* pp. 262–263.
123. Jackson to Bulfinch, June 27, 1829, *Life and Letters,* pp. 263–264.
124. Place, *Architect and Citizen,* p. 273.
125. Bulfinch to Greenleaf Bulfinch, June 3, 1830, *Life and Letters,* p. 269.
126. George Hadfield, "Remarks on the Capitol," typed transcript, AOC.

CHAPTER FIVE
1. Robert Brown to Elgar, December 26, 1829, Record Group 42, National Archives.
2. Harris, ed., *Papers of William Thornton,* vol. 1, p. 522.
3. Thornton to Marshall, January 2, 1800, ibid., vol. 1, p. 527.
4. Ibid., vol. 1, p. 528.
5. House proceedings of February 16, 1832, *Doc. History,* p. 317.
6. Robert Mills to Leonard Jarvis, January 9, 1832, Pamela Scott, ed., *The Papers of Robert Mills, 1781–1855* (Wilmington, Del.: Scholarly Resources Microfilm, 1990).
7. Mills to the Committee on Public Buildings, ibid., ca. January 1832.
8. S. D. Wyeth, *The Rotunda and Dome of the U. S. Capitol* (Washington: Gibson Brothers, 1869), p. 202.
9. Ibid.
10. "Inventory of articles in the vault under the crypt of Capitol," April 14, 1849, Record Group 42, National Archives.
11. House proceedings of February 16, 1832, *Doc. History,* pp. 317–318.
12. Senate proceedings of June 25, 1832, *Doc. History,* pp. 318–319.
13. Benjamin Brown French Diary, December 1, 1841, French Papers, Manuscript Division, Library of Congress.
14. B. B. French to Henry F. French, December 3, 1841, ibid.
15. Bulfinch to Greenleaf Bulfinch, November 30, 1841, Bulfinch, ed., *Life and Letters,* p. 293.
16. Rembrandt Peale to Bushrod Washington, January 12, 1824, typed transcript, AOC.
17. *Poulson's American Daily Advertiser* (Philadelphia), March 27, 1824.
18. *Niles National Register* (Washington), September 16, 1837.
19. Fairman, *Art and Artists,* p. 65.
20. Ibid., p. 75.
21. Dr. John B. Ellis, *The Sights and Secrets of the National Capital* (Chicago: Jones, Junkin & Co., 1869), pp. 70–71.
22. House of Representatives, "Public Improvements in Washington," 22d Congress, 1st Session, H. Doc. 291, *Doc. History,* pp. 311–315.
23. Mills to G. C. Washington, January 13, 1832, *Doc. History,* pp. 316–317.
24. Robert Mills, *Guide to the Capitol of the United States* (Washington: n.p., 1834), p. 6.
25. Jonathan Smith to William Noland, December 17, 1834, *Doc. History,* pp. 330–331.
26. Robert Mills, *Guide to the National Executive Offices and the Capitol of the United States* (Washington: P. Forse, printer, 1842), p. 41n.

27. James M. Goode, *Capital Losses* (Washington: Smithsonian Institution Press, 1979), p. 303.

28. "Report of the Commissioner of Public Buildings," December 22, 1834, *Doc. History,* p. 327.

29. Wilhelmus Bogart Bryan, *A History of the National Capital* (New York: The Macmillian Company, 1916), vol. 2, p. 296. In Washington, gas was made from coal after 1852.

30. Mills to William Noland, April 5, 1840, Scott, ed., *Papers of Robert Mills.*

31. Donald B. Cole and John J. McDonough, eds., *Benjamin Brown French, Witness to the Young Republic, A Yankee's Journal, 1828–1870* (Hanover: University Press of New England, 1989), p. 108.

32. Henry N. Hooper & Company to the Committee on Public Buildings, *Doc. History,* pp. 337–338.

33. Mills to Asbury Dickens and Benjamin B. French, July 23, 1847, Scott, ed., *Papers of Robert Mills.*

34. House of Representatives, "Injury to the Capitol From the Introduction of Gas," 30th Congress, 1st Session, H. Ex. Doc. 61, AOC.

35. "Pay, for removing the mast & lantern above dome," National Archives Record Group 42, Ledgers, 1848, p. 240.

36. *National Daily Intelligencer* (Washington), December 3, 1838.

37. House of Representatives, "Hall of Representatives", 28th Congress, 1st Session, H. Rept. 516, p. 6, AOC.

38. House of Representatives, "National Edifices At Washington," 28th Congress, 2d Session, H. Rept. 185. AOC.

39. Mills to the House Committee on Public Buildings, April 8, 1846, Scott, ed., *Papers of Robert Mills.*

40. 31st Congress, 1st session, Senate Rep. Com. No. 145, May 28, 1850, p. 4, AOC.

41. Ibid., p. 2.

42. John M. Blum, et. al., *The National Experience* (New York: Harcourt, Brace & World, Inc., 1963), p. 282.

43. "Washington" to Millard Fillmore, ca. January 21, 1851, Papers of Millard Fillmore, Buffalo and Erie County Historical Society, microfilm.

CHAPTER SIX

1. Glenn Brown, *History of the United States Capitol* (Washington: Government Printing Office, 1900, 1902), vol. 2, p. 116.

2. "Washington" to Millard Fillmore, ca. January 26, 1851, Papers of Millard Fillmore.

3. James M. Goode, "Architecture and Politics: Thomas Ustick Walter and the Enlargement of the United States Capitol, 1850–1865," Ph. D. Dissertation, George Washington University, 1994, appendix E, p. 492.

4. Letters from competition architects are located in Folder 1, Box 13, Papers of Thomas U. Walter, The Athenaeum of Philadelphia.
 The letters were not included in the microfilm edition of Walter's papers prepared by the Smithsonian Institution, Archives of American Art.

5. Mills used a similar loggia scheme to connect a rear annex to the Rotunda at the University of Virginia in 1851.

6. Richard Upjohn to the Committee of the Senate on public buildings, November 27, 1850, Walter Papers.

7. Senate, Report of the Secretary of the Senate with a Statement of the Payments from the Contingent fund of the Senate for the year ending 30th November, 1851, 32nd Congress, 1st Session, S. Mis. Doc. 15.

8. Senate Rep. Com. No. 273, 31st Congress, 2d Session, February 8, 1851, *Doc. History,* p. 446.

9. Richard Stanton to the *Daily National Intelligencer,* March 7, 1851.

10. Charles F. Anderson to Fillmore, March 21, 1851, Fillmore Papers.

11. Goode, "Architecture and Politics," Appendix F, pp. 494–497.

12. *National Intelligencer* (Washington), July 7, 1851.

13. Stuart to Walter, July 29, 1851, *Doc. History,* p. 450.

14. Walter to Fillmore, September 13, 1851, *Doc. History,* pp. 450–451.

15. House proceedings of March 13, 1852, *Doc. History,* p. 484.

16. House proceedings of January 12, 1852, *Doc. History,* p. 460.

17. House proceedings of March 12, 1852, *Doc. History,* p. 469.

18. Ibid., p. 475.

19. Ibid., p. 471.

20. House proceedings of March 13, 1852, *Doc. History,* p. 488.

21. Ibid., p. 496.

22. Senate proceedings of March 15, 1852, *Doc. History,* p. 498.

23. Ibid., p. 500.

24. Senate proceedings of April 2, 1852, *Doc. History,* pp. 505–509.

25. Senate proceedings of April 9, 1852, *Doc. History,* pp. 533–534.

26. "Report of the Commission appointed by the Department of the Interior 'to test the several specimens of marble offered for the extension of the United States Capitol,'" November 3, 1851, *Doc. History,* pp. 554–558.

27. Horatio Greenough to Walter, December 12, 1851, Walter letter books, AOC.

28. William D. Johnston, *History of the Library of Congress* (Washington: Government Printing Office, 1904), vol. 1, p. 276.

29. Ibid., pp. 277–278.

30. Ibid., pp. 280–281.

31. Ibid., p. 292.

32. Walter to Stuart, December 28, 1852, ibid., pp. 293–294.

33. Susan Brizzolara Wojcik, "Thomas U. Walter and the United States Capitol: An Alliance of Architecture, Engineering, and Industry," Ph. D. Dissertation, University of Delaware, 1998, p. 106.

34. Walter to Stuart, December 1, 1852, Johnston, p. 293.

35. Ibid., p. 296.

36. Ibid., p. 297.

37. Walter to Stuart, December 28, 1852, ibid., p. 295.

38. Walter to Stuart, December 28, 1852, ibid., p. 294.

39. *New York Tribune,* May 18, 1853, ibid., pp. 297–298.

40. Walter to G. J. F. Bryant, August 11, 1855, Walter Papers.

41. Walter to Charles Fowler, September 3, 1853, Walter Papers.

42. Walter to Charles Fowler, August 10, 1853, Walter Papers.

43. Walter to Fillmore, July 24, 1852, AOC.

44. Senate, Select Committee on Abuses, Bribery or Fraud Report, 33rd Congress, Special Session, Rep. Com. no. 1.

45. Order of President Franklin Pierce, March 23, 1853, *Doc. History,* p. 585.

CHAPTER SEVEN

1. "Annual Report of the Superintendent of the Capitol Extension," 1853, AOC, *Doc. History,* p. 587. Meigs's appointment was dated March 29, 1853.

2. Mills to the President (Franklin Pierce), March 6, 1853, Scott, ed., *Papers of Robert Mills.*

3. Mills to Davis, September 12, 1853, ibid.

4. Annual Report of the Superintendent of the Capitol Extension, 1853, AOC, *Doc. History,* p. 587.

5. Ibid., p. 588.

6. Montgomery C. Meigs, "Notes on Acoustics and Ventilation, with reference to the new Halls of Congress," *The Civil Engineer and Architect's Journal* 27, no. 242 (May 1854), p. 162.

7. Ibid., p. 163.

8. Montgomery C. Meigs, "Journals, 1852–1872." (Unedited and unverified transcript of a work in progress sponsored by the United States Senate Historical Office). Manuscript Division, Library of Congress, Washington, June 9, 1853.
 He thought Mills' circular church housed "the worst room I have seen outside Washington."

9. "Annual Report of the Superintendent of the Capitol Extension," 1853, *Doc. History,* p. 588.

10. Walter to Anderson, August 10, 1853, Walter Papers.

11. Walter to John Rice, September 7, 1854, Walter Papers.

12. Walter to Meigs, September 21, 1853, Walter Papers.

13. Walter to Joseph Walter, November 11, 1853, Walter Papers.

14. Walter to Charles Fowler, February 25, 1854, Walter Papers.

15. Harriette Fanning Read, *The Crayon* (New York), September 1856.

16. Walter to Pringle Slight, June 7, 1854, Walter Papers.

17. Walter to Clements, June 28, 1854, Walter Papers.

18. Walter to Meigs, December 14, 1853, Walter Papers.

19. Senate proceedings of January 24, 1854, *Doc. History,* p. 595.

20. Ibid., pp. 598–599.

21. Ibid., pp. 604–605.

22. Ibid., p. 606.

23. Walter to Dr. Richard Gardiner, February 22, 1854, Walter Papers.

24. Walter to John Rice, June 20, 1854, Walter Papers.

25. House proceedings of June 14, 1854, *Doc. History,* pp. 609–616.

26. Ibid., p. 609.

27. Walter to Charles Fowler, July 20, 1854, Walter Papers.

28. "Report to the Building Committee of the Girard College for Orphans upon an Examination of Some of the Public Buildings of Europe made in Pursuance of their Resolutions of June 30, 1838. By Thomas U. Walter Archt. Philadelphia," Walter Papers.

29. Walter to Charles Fowler, September 9, 1854, Walter Papers.

30. Meigs Journal, December 11, 1854.

31. Meigs Journal, December 22, 1854.

32. Meigs Journal, February 26, 1855.

33. Meigs Journal, May 31, 1854.

34. Meigs Journal, December 26, 1854.

35. Meigs Journal, December 28, 1854.

36. Meigs Journal, December 29, 1854.

37. Meigs to John Pearce, December 23, 1854, AOC.

38. Meigs Journal, December 31, 1854.

39. Meigs Journal, January 9, 1855.

40. Meigs Journal, January 27, 1855.

41. Ibid.

42. House proceedings of February 22, 1855, *Doc. History,* p. 991.

43. Ibid., p. 992.

44. Meigs to Judah P. Benjamin, February 24, 1855, AOC.

45. Meigs to T. J. Pratt, February 24, 1855, AOC.

46. Meigs to William C. Dawson, February 24, 1855, AOC.

47. Meigs Journal, March 2, 1855.

48. "Death of an Architect," *The Union* (Washington), March 4, 1855.

49. Wojcik, "Thomas U. Walter and the United States Capitol," pp. 644–645.

50. Meigs Journal, March 13, 1855.

51. Meigs Journal, November 26, 1855.

52. Anonymous, "The Public Buildings of Washington," *The Crayon* (New York), May 1856, p. 151.

53. Senate, ["Letter from the Superintendent of the Capitol Extension . . . in relation to the Dome and Porticos of the Capitol," 36th Congress, 1st Session, S. Mis. Doc. 29, p. 9.

54. Meigs to A. G. Brown, April 15, 1856, AOC.

55. Meigs to J. H. Campbell, April 15, 1856, AOC.

56. Meigs Journal, July 19, 1854.

57. Meigs Journal, January 5, 1856.

58. Walter to John Rice, November 10, 1854, Walter Papers.

59. Walter to Charles Fowler, February 19, 1855, Walter Papers. Cotton may have been a feature in a preliminary design, but it does not appear in the final design.

60. Meigs to Minton and Company, September 14, 1854, AOC.

61. Meigs to Miller and Coates, September 23, 1854, AOC.

62. Pringle Slight to Meigs, February 18, 1858, AOC.

63. Meigs Journal, January 11, 1856.

64. Wojcik, "Thomas U. Walter and the United States Capitol," p. 56.

65. Meigs Journal, January 21, 1856.

66. Meigs Journal, August 9, 1854.

67. Pringle Slight to Meigs, February 15, 1855, AOC.

68. Benjamin Severson to Meigs, June 9, 1856, AOC.

69. E. Lyon to Meigs, December 3, 1855, AOC.

70. Samuel Champion to Meigs, June 10, 1856, AOC.

71. Meigs Journal, October 25, 1854.

72. Meigs Journal, August 22, 1854.

73. Walter to Joseph Henry, November 29, 1865, Walter Papers.

74. Meigs Journal, August 29, 1855.

75. "Specifications of Material to be provided and the labor to be performed in the construction of eight Boilers for heating and ventilating United States Capitol Extension," AOC.

76. Cole and McDonough, *Witness to the Young Republic,* p. 241.

77. Fairman, *Art and Artists,* p. 143.

78. Ibid.

79. Meigs Journal, April 20, 1854.

80. Meigs Journal, August 8, 1854.

81. Meigs Journal, November 12, 1856.

82. Meigs Journal, August 28, 1854.

83. Meigs to Jefferson Davis, November 18, 1854, AOC.

84. Meigs Journal, November 8, 1854.

85. Meigs Journal, November 18, 1854.

86. Meigs Journal, November 16, 1854.

87. Walter to J. B. Varnam, Jr., January 23, 1863, Walter Papers.

88. Meigs to Ernest Thomas, August 28, 1856, AOC.

89. Meigs to Zephaniah Denham, September 24, 1856, AOC.

90. Meigs Journal, November 21, 1854.

91. Meigs Journal, February 21, 1855.

92. Meigs Journal, January 10, 1855.

93. Meigs Journal, April 28, 1855.

94. Meigs Journal, February 7, 1854.

95. Meigs Journal, March 15, 1855.

96. Meigs Journal, December 24, 1855.

97. Thomas P. Somma, *The Apotheosis of Democracy, 1908–1916: The Pediment of the House Wing of the United States Capitol* (Newark: The University of Delaware Press, 1995), p. 23.

98. The *Albany Journal*, April 10, 1857, Fairman, *Art and Artists,* pp. 193–194.

99. Somma, *The Apotheosis of Democracy,* p. 35.
100. Fairman, *Art and Artists,* p. 197.
101. Thomas Crawford to Meigs, June 20, 1855, AOC.
102. Jefferson Davis to Meigs, January 15, 1856, AOC.
103. Thomas Crawford to Meigs, March 19, 1856, AOC.
104. House proceedings of May 26, 1856, *Doc. History,* p. 632.
105. House proceedings of May 26, 1865, *Doc. History,* pp. 633–641.
106. Meigs Journal, July 26, 1856.
107. Meigs Journal, July 2, 1856.
108. Walter to Amelia Walter, July 24, 1856, Walter Papers.
109. House of Representatives, "Message from the President of the United States, communicating a report in regard to the construction of the Capitol and Post Office Extension," 34th Congress, 1st Session, Ex. Doc. No. 138, *Doc. History,* p. 654.
110. Walter to Alexander Provost, August 9, 1856, Walter Papers.
111. Meigs Journal, August 14, 1856.
112. Meigs Journal, August 15, 1856.
113. Ibid.
114. Fairman, *Art and Artists,* p. 162.
115. Meigs Journal, September 29, 1856.
116. Meigs Journal, September 1 and 8, 1856.
117. Meigs Journal, September 12, 1856; Meigs to Joseph Henry, September 15, 1856, AOC.
118. Meigs Journal, September 15, 1856.
119. Annual Report of the Superintendent of the Capitol Extension, 1856, AOC, *Doc. History,* pp. 660–663.
120. Ibid., pp. 1006–1008.
121. Meigs Journal, December 15, 1856.
122. Meigs to Jefferson Davis, February 6, 1857, AOC.
123. Franklin Pierce to Meigs (copy), March 24, 1857, AOC.
124. Meigs Journal, March 24, 1857.

CHAPTER EIGHT
1. Meigs Journal, November 13, 1856.
2. Meigs to Brumidi, March 2/5, 1857, AOC.
3. *The Crayon* (New York), December 1856.
4. Senate proceedings of May 28, 1858, *Doc. History,* p. 677.
5. Ibid., p. 678.
6. Meigs to William Cullon, September 21, 1857, AOC.
7. Meigs Journal, June 22, 1857.
8. Meigs Journal, August 31, 1857.
9. Meigs Journal, November 11, 1857.
10. Walter to John Rice, October 12, 1857, Walter Papers.
11. Meigs Journal, November 4, 1854.
12. Walter to Boulton, December 9, 1857, Walter Papers.
13. Cole and McDonough, *Witness to the Young Republic,* p. 288.
14. Walter to Richard H. Stanton, December 8, 1857, Walter Papers.
15. *National Intelligencer* (Washington), December 7, 1857.
16. Meigs Journal, December 10, 1857.
17. Meigs Journal, December 18, 1857.
18. B. B. French to Henry French, December 17, 1857, French Papers.
19. John B. Floyd to Meigs, Draft, December 4, 1857, Walter Papers.
20. Meigs Journal, December 19, 1857.
21. Walter to John B. Floyd, December 21, 1857, AOC.
22. Meigs Journal, December 23, 1857.
23. Walter to John Rice, December 22, 1857, Walter Papers.
24. Meigs Journal, January 20, 1858.
25. Meigs Journal, January 21, 1858.
26. Meigs Journal, January 30, 1858.
27. Meigs Journal, February 10, 1858.
28. Walter to John Rice, February 10, 1858, Walter Papers.
29. Meigs Journal, February 17, 1858.
30. Walter to John Rice, April 19, 1858, Walter Papers.
31. Walter to Rev. Israel D. Ring, April 19, 1858, Walter Papers.
32. Meigs Journal, February 24, 1858.
33. House proceedings of May 19, 1858, *Doc. History,* p. 670.
34. Ibid., p. 671.
35. Ibid.
36. Ibid., p. 672.
37. Senate proceedings of May 28, 1858, *Doc. History,* p. 677.
38. Ibid., p. 679.
39. House proceedings of June 7, 1858, *Doc. History,* p. 691.
40. Ibid.
41. Ibid., p. 698.
42. Ibid., p. 701.
43. *National Intelligencer* (Washington), May 21, 1858.
44. Ibid., May 24, 1858.
45. Walter to Amanda Walter, May 22, 1858, Walter Papers.
46. Walter to John Rice, June 29, 1858, Walter Papers.
47. Walter to John Rice, July 24, 1858, Walter Papers.
48. Walter to Amanda Walter, August 7, 1858, Walter Papers.
49. Walter to John Rice, September 10, 1858, Walter Papers.
50. Walter to John Rice, October 22, 1858, Walter Papers.
51. Walter to Charles Fowler, October 5, 1858, Walter Papers.
52. Walter to John B. Floyd, November 1, 1858, Walter Papers.
53. Meigs Journal, December 23, 1858.
54. Meigs Journal, January 6, 1858.
55. Russell F. Weigley, *Quartermaster General of the Union Army* (New York: Columbia University Press, 1959), p. 88.
56. Walter to Amanda G. Walter, January 4, 1859, Walter Papers.
57. Meigs Journal, January 4, 1859.
58. Cole and McDonough, *Witness to the Young Republic,* p. 305.
59. *New York Herald,* January 5, 1859.
60. "Annual Report of the Superintendent of the Capitol Extension," 1858, AOC, *Doc. History,* p. 706.
61. Ibid., p. 1011.
62. Walter to John Rice, February 2, 1859, Walter Papers.
63. Walter Diary, February 12, 1859, Walter Papers.
64. Meigs to Walter, March 5, 1859, AOC.
65. Meigs Journal, March 14, 1859.
66. Walter to Meigs, March 15, 1859, Walter Papers.
67. Walter to John B. Floyd, March 16, 1859, Walter Papers.
68. Walter to Meigs, April 20, 1859, Walter Papers.
69. Walter to John Rice, April 27, 1859, Walter Papers.
70. Meigs Journal, May 5, 1859.
71. Walter to John Rice, June 28, 1859, Walter Papers.
72. Meigs Journal, September 14–15, 1859.
73. Walter to John Rice, September 7, 1859, Walter Papers.
74. Walter to John Rice, August 8, 1859, Walter Papers.
75. Meigs to Walter, September 19, 1859; "Senate, Message of the President of the United States Communicating Information Relative to the Heating and Ventilating of the Capitol Extension and Post Office Department." 36th Congress, 1st Session, S. Ex. Doc. 20, p. 183.
76. Meigs to William R. Drinkard, September 19, 1859, ibid., p. 179.
77. Ibid., p. 182.
78. Meigs Journal, October 31, 1859.
79. Meigs Journal, November 2, 1859.

80. *National Intelligencer* (Washington), November 3, 1859.

CHAPTER NINE
1. Mark Snell, "William B. Franklin," Ph. D. Dissertation (Draft), University of Missouri, 1997, p. 53.
2. Ibid., p. 59.
3. Meigs Journal, November 1, 1859.
4. Walter to John Rice, November 3, 1859, Walter Papers.
5. Walter to John Rice, November 30, 1859, Walter Papers.
6. Walter to John Rice, December 27, 1859, Walter Papers.
7. Franklin to W. F. Swift, March 17, 1860, Snell, "William B. Franklin," p. 65.
8. Walter to B. B. French, Jr., August 10, 1865, Record Group 48, National Archives.
9. B. B. French to Clement West, February 5, 1864, AOC.
10. John C. Harkness to Walter, September 29, 1862, AOC. For the higher cost of cutting, fluting, rubbing, and hoisting column shafts during the Civil War, see Walter to Alexander Provost, September 12, 1862, Walter Papers. In 1862, each shaft cost $1,085 to work and install.
11. Franklin to Janes, Fowler, Kirtland & Company, December 1, 1859; "Letter from the Superintendent of the Capitol Extension to the Chairman of the Committee on Public Buildings and Grounds, in Relation to the Dome and Porticoes of the Capitol," 36th Congress, 1st Session, S. Misc. Doc. 29, pp. 39–40.
12. Janes, Fowler, Kirtland & Company, to Franklin, December 2, 1859, ibid., p. 40.
13. John B. Floyd to Franklin, December 5, 1859, ibid., p. 43.
14. Walter to Charles Fowler, January 20, 1860, Walter Papers.
15. Walter to Janes, Fowler, Kirtland & Company, March 23, 1860, Walter Papers.
16. Walter to A. Harthill, March 29, 1860, Walter Papers.
17. Senate proceedings of March 19, 1860, *Doc. History,* p. 750.
18. Ibid., pp. 750–752.
19. Senate proceedings of June 11, 1860, *Doc. History,* p. 753.
20. Ibid., p. 753.
21. Ibid., p. 759.
22. Ibid.
23. Ibid., pp. 759–760.
24. Ibid., p. 762.
25. Ibid., p. 764.
26. Ibid., p. 766.
27. House proceedings of June 15, 1860, *Doc. History,* p. 771.
28. Annual Report of the Superintendent of the Capitol Extension, 1860, AOC, *Doc. History,* p. 781.
29. Meigs to James A. Pearce, February 12, 1857, AOC.
30. Walter to James T. Ames, February 7, 1860, Walter Papers.
31. Franklin to W. F. Swift, June 7, 1860, Snell, "William B. Franklin," p. 69.
32. Walter to John Rice, December 24, 1860, Walter Papers.
33. Walter to Helen Gardnier, February 4, 1861, Walter Papers.
34. Walter to George Anderson, February 4, 1861, Walter Papers.
35. Walter to Charles Fowler, March 1, 1861, Walter Papers.
36. Meigs to Franklin, February 25, 1861, AOC.
37. Franklin to Meigs, February 26, 1861, AOC.
38. Walter to Charles Fowler, March 1, 1861, Walter papers.
39. Meigs to Walter, March 2, 1861, AOC.
40. Walter to Meigs, March 5, 1861, AOC.
41. Walter to Charles Fowler, March 5, 1861, Walter Papers.
42. Walter to Charles Fowler, March 5, 1861, Walter Papers.
43. Meigs to Simon Cameron, March 16, 1861, AOC.
44. Walter to Henry D. Moore, March 20, 1861, Walter Papers.
45. Meigs to Simon Cameron, March 22, 1861, AOC.
46. Walter to Robert Walter, April 19, 1861, Walter Papers.
47. Walter to Olivia Walter, April 20, 1861, Walter Papers.
48. Walter to Amanda Walter, May 2, 1861, Walter Papers.
49. Ibid.
50. John Blake to Colonel Townsend, April 12, 1861, Record Group 42, National Archives.
51. Walter to Amanda Walter, May 6, 1861, Walter Papers.
52. Walter to Amanda Walter, May 8, 1861, Walter Papers.
53. Walter to Amanda Walter, May 3, 1861, Walter Papers.
54. *Congressional Globe,* July 17, 1866, p. 3870.
55. "Annual Report of the Architect of the Capitol Extension, 1862," AOC, *Doc. History,* p. 1022.
56. Meigs to Emanuel Leutze, May 23, 1861, AOC.
57. Meigs to Simon Cameron, June 20, 1861, AOC.
58. *The Evening Post* (New York), September 21, 1861.
59. William S. Wood to Galusha A. Grow, July 13, 1861, Record Group 42, National Archives.
60. William S. Wood to George P. A. Healy, July 20, 1861, Record Group 42, National Archives.
61. Walter to Alexander Provost, July 30, 1861, Walter Papers.
62. Ibid.
63. "Report of the Commissioner of Public Buildings," November 8, 1861, Record Group 42, National Archives.
64. Walter to Charles Fowler, March 17, 1862, Walter Papers.
65. Senate proceedings of March 5, 1862, *Doc. History,* p. 791.
66. Ibid., p. 792.
67. Ibid., p. 793.
68. Ibid., p. 794.
69. Senate proceedings of March 25, 1862, *Doc. History,* p. 799.
70. House proceedings of April 14, 1862, *Doc. History,* pp. 806–807.
71. Ibid., p. 807.
72. Ibid.
73. Walter to G. I. F. Bryant, May 17, 1862, Walter Papers.
74. Walter to Charles Fowler, May 1, 1862, Walter Papers.
75. *Doc. History,* pp. 809–811.
76. Walter to Amanda Walter, May 2, 1862, Walter Papers.
77. Walter to Amanda Walter, May 3, 1862, Walter Papers.
78. Walter to John Rice, October 3, 1862, Walter Papers.
79. Walter to John Rice, August 5, 1862, Walter Papers.
80. Walter to Alexander Provost, August 29, 1862, Walter Papers.
81. Walter to Alexander Provost, October 3, 1862, Walter Papers.
82. Benjamin B. French to William B. Webb, October 7, 1862, Record Group 42, National Archives.
83. Walter, "Specifications for Painting the Iron Work of the New Dome of the U. S. Capitol," May 29, 1862, Walter Papers.
84. Walter to John Rice, June 27, 1862, Walter Papers.
85. Benjamin B. French to Abraham Lincoln, September 24, 1862, Record Group 42, National Archives.
86. Benjamin B. French to Edwin Stanton, October 23, 1862, Record Group 42, National Archives.
87. "Report of the Commissioner of Public Buildings," October 29, 1862, *Doc. History,* p. 813.
88. House proceedings of February 28, 1863, *Doc. History,* p. 821.
89. Cole and McDonough, *Witness to the Young Republic,* p. 399.
90. Constantino Brumidi to Walter, September 8, 1862, AOC.

91. Walter to Constantino Brumidi, December 24, 1862, AOC.
92. Constantino Brumidi to Walter, December 27, 1862, AOC.
93. Walter to Benjamin B. French, December 29, 1862, AOC.
94. Walter to Amanda Walter, May 4, 1863, Walter Papers.
95. Walter to Charles Fowler, April 20, 1863, Walter Papers.
96. Walter to Clement West, July 10, 1863, Walter Papers.
97. Walter to Clement West, July 8, 1863, Walter Papers.
98. Walter to Amanda Walter, August 29, 1863, Walter Papers.
99. Walter to John Boulton, November 3, 1863, Walter Papers.
100. Walter to John Rice, November 19, 1863, Walter Papers.
101. Walter to Amanda Walter, November 30, 1863, Walter Papers.
102. Walter to Amanda Walter, December 1, 1863, Walter Papers.
103. Walter to Charles F. Thomas, December 2, 1863, AOC.
104. W. A. G., *New York Tribune,* December 10, 1863.
105. Walter to G. F. Bryant, February 17, 1864, Walter Papers.
106. House proceedings of February 28, 1863, *Doc. History,* p. 820.
107. Walter to R. Fenner, May 25, 1869, Walter Papers.
108. Walter to Amanda Walter, December 2, 1863, Walter Papers.
109. Cole and McDonough, *Witness to the Young Republic,* p. 439.
110. "Annual Report of the Architect of the Capitol Extension," 1863, AOC, Doc. History, p. 825.
111. Walter to John Rice, April 19, 1864, Walter Papers.
112. Walter to Charles Fowler, January 26, 1864, Walter Papers.
113. Walter to Charles Fowler, February 19, 1864, Walter Papers.
114. Walter to Charles Fowler, April 4, 1864, Walter Papers.
115. House proceedings of June 29, 1864, *Doc. History,* p. 836.
116. Meigs Journal, Clippings, frame C–1004, Meigs Papers, Manuscript Division, Library of Congress.
117. Walter to Clement West, October 19, 1864, and to Charles Fowler, December 10, 1864, Walter Papers.
118. Fairman, *Art and Artists,* p. 222.
119. Ibid., p. 224.
120. Ibid., p. 223.
121. William Belmont Parker, *The Life and Public Service of Justin Smith Morrill* (Boston and New York: Houghton Mifflin Company, 1924), p. 159.
122. Ibid.
123. Walter to Fenner, August 25, 1864, Walter Papers.
124. Walter to Robert Briggs, December 14, 1864, Walter Papers.
125. Walter to John P. Usher, October 1, 1864, Walter Papers.
126. Walter to Charles Fowler, March 27, 1865, Walter Papers.
127. Cole and McDonough, *Witness to the Young Republic,* pp. 468–469.
128. Walter to Amanda Walter, April 15, 1865, Walter Papers.
129. Walter to Amanda Walter, May 16, 1865, Walter Papers.
130. Goode, "Architecture and Politics," p. 301.
131. Walter to B. B. French, May 31, 1865, Walter Papers.

CHAPTER TEN
1. Walter to George Whiting, July 4, 1865, Walter Papers.
2. Walter to Alexander Provost, July 21, 1865, Walter Papers.
3. John Rice to James Harlan, April 6, 1866, Record Group 48, Entry 291, Box 2, National Archives.
4. Walter to Constantino Brumidi, November 21, 1865, Walter Papers.
5. Edward Clark to James Harlan, January 9, 1866, AOC.
6. Walter to B. B. French, February 17, 1866, Walter Papers.
7. Senate proceedings of March 3, 1857, *Doc. History,* pp. 1064–1065.
8. Senate proceedings of May 27, 1870, *Doc. History,* p. 1089.
9. Ibid., p. 1090.
10. Cole and McDonough, *Witness to the Young Republic,* p. 531.
11. "Annual Report of the Architect of the Capitol Extension," 1868, AOC.
12. Senate proceedings of March 5, 1872, *Doc. History,* p. 1107.
13. House proceedings of March 16, 1872, *Doc. History,* p. 1108.
14. Ibid., p. 1112.
15. House proceedings of April 11, 1872, *Doc. History,* p. 1125.
16. Justin Morrill to F. L. Olmsted, May 19, 1873, Olmsted Papers, Manuscript Division, Library of Congress, microfilm.
17. "Annual Report of the Architect of the Capitol," 1873, *Doc. History,* p. 1153.
18. F. L. Olmsted to Justin Morrill, January 26, 1874, Records of the U. S. Senate, Record Group 46, National Archives.
19. "Home and Foreign Gossip," *Harper's Weekly* (New York), March 7, 1874.
20. F. L. Olmsted to Justin Morrill, July 20, 1874, Morrill Papers, Manuscript Division, Library of Congress, microfilm.
21. F. L. Olmsted to Justin Morrill, August 4, 1874, ibid.
22. Olmsted to Justin Morrill, August 16, 1874, ibid.
23. Ibid.
24. Clark to Justin Morrill, August 22, 1874, ibid.
25. Meigs to "Dear Sir" (Edward Clark), January 8, 1875, AOC.
26. F. L. Olmsted to Meigs, January 15, 1875, Olmsted Papers.
27. Senate proceedings of March 3, 1875, *Doc. History,* p. 1202.
28. Ibid., p. 1203.
29. Senate proceedings of June 18, 1878, *Doc. History,* p. 1204.
30. Ibid., p. 1206.
31. Senate proceedings of June 9, 1880, *Doc. History,* p. 1208.
32. *Congressional Record,* February 11, 1879, p. 1193.
33. *The American Architect and Building News* (New York), April 19, 1879.
34. Senate, "Letter from Major General M. C. Meigs," 47th Congress, 1st Session, M. Doc. 65.
35. Senate proceedings of March 1, 1883, *Doc. History,* p. 1223.
36. Clark to William Malone, December 13, 1884, AOC.
37. F. L. Olmsted to Justin Morrill, February 18, 1886, AOC.
38. Senate proceedings of July 23, 1886, *Doc. History,* p. 1240.
39. Benjamin Durfee to Justin Morrill, July 25, 1886, Morrill Papers.
40. "Annual Report of the Architect of the Capitol," 1882, *Doc. History,* p. 1192.
41. "Annual Report of the Architect of the Capitol," 1877, *Doc. History,* p. 1171.
42. "Annual Report of the Architect of the Capitol," 1880, *Doc. History,* p. 1180.
43. F. L. Olmsted to F. H. Cobb, October 4, 1879, AOC.
44. F. L. Olmsted to F. H. Cobb, May 30, 1881, AOC.
45. Senate proceedings of February 27, 1878, *Doc. History,* p. 1174.

46. Justin Morrill to Clark, April 21, 1887, AOC.
47. House proceedings of June 27, 1870, *Doc. History,* p. 865.
48. Ibid., p. 868.
49. Ibid., p. 870.
50. House proceedings of February 18, 1873, *Doc. History,* p. 876.
51. Ibid., p. 879.
52. "Investigation of the Office of the Architect of the Capitol," n.d. [ca. March 1895] pp. 4–5, AOC.
53. House of Representatives, "Sanitary Condition of the Capitol Building, Etc.," 53d Congress, 3d Session, H. Rept. 1980, p. 1.
54. Ibid., pp. 1–22.
55. Senate proceedings of June 7, 1872, *Doc. History,* p. 872.
56. Ibid., p. 874.
57. Ibid., p. 875.
58. "Annual Report of the Architect of the Capitol," 1877, AOC.
59. Duncan S. Walker, *Celebration of the One Hundredth Anniversary of the Laying of the Corner Stone of the United States Capitol* (Washington: Government Printing Office, 1896), p. 47.
60. Ibid., p. 86.
61. *The Washington Post,* November 7, 1898.
62. *The Times* (Washington), November 8, 1898.
63. "Annual Report of the Architect of the Capitol," 1901, p. 3, AOC.
64. Ibid., p. 4.
65. Ibid., p. 8.
66. "Annual Report of the Superintendent of the United States Capitol Building and Grounds," 1902, p. 7, AOC.
67. Ibid., p. 5.
68. Ibid., p. 18.
69. Ibid., p. 17.

CHAPTER ELEVEN

1. Glenn Brown, *Memories: A Winning Crusade to Revive George Washington's Vision of a Capital City* (Washington: F. W. Roberts Co., 1931), p. 56.
2. Harry S. News to Jesse Overstreet, n. d. (ca. January 1902), AOC.
3. William B. Bushong, "Glenn Brown, the American Institute of Architects, and the Development of the Civic Core of Washington, D. C.," Ph. D. Dissertation, George Washington University, 1988, p. 137.
4. Public Law no. 9, 57th Congress, 1st session, February 14, 1902. (32 Stat., 20)
5. Brown, *Memories,* p. 56.
6. "Annual Report of the Superintendent of the Capitol Building and Grounds," 1902, p. 52, AOC.
7. Thomas Hastings to Elliott Woods, April 2, 1904; House of Representatives, *Report of the Commission to Direct and Supervise the Construction of the House Office Building,* 61st Congress, 3rd Session, H. Rept. 2291 (Washington: Government Printing Office, 1912), p. 136.
8. Oscar Wenderoth to Elliott Woods, December 15, 1910, AOC.
9. *The Evening Bulletin* (Philadelphia), August 31, 1907.
10. *Congressional Record,* February 28, 1911, p. 3731.
11. Ibid., p. 3732.
12. Ibid., p. 3733.
13. *The Sunday Star* (Washington), December 25, 1921.
14. Woods to Carrère & Hastings, August 15, 1910, AOC.
15. Carrère & Hastings to Woods, August 15, 1910, AOC.
16. House of Representatives, "Letter from the Superintendent of the Capitol Building and Grounds Transmitting a Report Relating to the Extension of the Capitol Building and Renovation of the Rotunda," 57th Congress, 1st Session, H. Doc. 583, *Doc. History,* p. 1273.
17. House proceedings of February 10, 1903, *Doc. History,* pp. 1275–1276.
18. Ibid., p. 1277.
19. Somma, *The Apotheosis of Democracy,* p. 41.
20. Ibid., p. 49.
21. Ibid., p. 3.
22. Ibid., p. 4.
23. *Congressional Record,* January 13, 1921, p. 1485.
24. James Tanner to Woods, January 26, 1921, AOC.
25. Thomas Hastings to Woods, March 11, 1921, AOC.
26. Thomas Hastings to Woods, March 18, 1921, AOC.
27. Furnifold M. Simmons to Warren G. Harding, June 4, 1923 (copy), AOC.
28. *Congressional Record,* June 7, 1924, p. 11142.
29. Senate, "Improvement of Senate Chamber," 68th Congress, 2d Session, S. Doc. 161, p. 1.
30. "Drafts New Scheme For Senate Chamber," *New York Times,* February 1, 1929.
31. *The Evening Star* (Washington), May 4, 1926.
32. "Annual Report of the Architect of the Capitol," 1929, p. 30.
33. Carrier Engineering Corporation, *The Weather Vein,* vol. 9, no. 3, ca. 1930, p. 30.
34. Ibid., p. 33.
35. "Installation of a New Ventilation and Air Conditioning System for the Senate Chamber," printed notice, ca. August 1929, AOC.
36. Fred J. Maroon and Suzy Maroon, *The Supreme Court of the United States* (New York: Thompson-Grant & Lickle, 1996), p. 31.
37. "Report of Thomas W. Marshall, Consulting Engineer, on Condition of the Roofs over the Senate and House Wings of the Capitol," November 29, 1938; Senate, "History of the United States Senate Roof and Chamber Improvements and Related Historical Data," 82d Congress, 1st Session, S. Doc. 20, p. 39.
38. Senate Committee on Public Buildings and Grounds, "Hearings on Acoustics, Redecoration, and Better Lighting System for the Senate Chamber," 77th Congress, 1st Session, 1941, pp.10–11.
39. "Report of the Commission of Fine Arts, 1944–1948," p. 21, AOC.
40. Ibid., p. 23.
41. Estelle Gaines, "New 'Technicolor' Halls Ready to Look at Next Week," *Times-Herald* (Washington), December 6, 1950.

CHAPTER TWELVE

1. *The Washington Post,* July 27, 1948.
2. Public Law 242, as amended by Public Law 406, 84th Congress, 1955.
3. "Minutes," Commission for the Extension of the Capitol, March 26, 1956, AOC.
4. "Minutes," Commission for the Extension of the Capitol, October 17, 1956, AOC.
5. "Proceedings," Legislative Branch Appropriations, 1957, June 12, 1956, Senate Subcommittee of the Committee on Appropriations, AOC.
6. Joint Resolution of the Dallas and Fort Worth Chapters, The American Institute of Architects, August 23, 1956, copy AOC.
7. "Report and Recommendation, Extension of the United States Capitol, May 23, 1957, Revised June 12, 1957, and July 12, 1957," AOC.
8. John F. Harbeson, Henry R. Shepley, and Gilmore D. Clark, "A Report to the Architect of the Capitol," August 19, 1957, AOC.

9. "Supplemental Report of the Associate Architects to the Honorable J. George Stewart, Architect of the Capitol on the Matter of the Extension of the Capitol Project," January 27, 1958, AOC.

10. Ada Louise Huxtable, "Capitol Remodeling Arouses Criticism," *The New York Times,* February 16, 1958.

11. "Capitol Folly," *The New York Times,* February 16, 1958.

12. Senate, Hearing before a Subcommittee of the Committee on Public Works, 85th Congress, 2d Session, 1958.

13. Ibid.

14. Ibid.

15. *Washington Evening Star,* March 27, 1958.

16. *Sunday Star* (Washington), May 18, 1958.

17. *Washington Evening Star,* June 13, 1958.

18. "Remarks By Speaker Sam Rayburn Before the National Press Club," typed transcript, May 27, 1958, AOC.

19. *The Washington Post,* May 28, 1958.

20. Typed Transcript of the Proceedings of the Opening of the Thursday Business Session, Convention of the American Institute of Architects, July 10, 1958, AOC.

21. *Congressional Record,* August 15, 1958, pp. 17870–17872. Draft of the speech titled "AIA Should Apologize to Speaker Sam Rayburn," prepared by the Library of Congress for Fred Schwengle at the request of the Architect of the Capitol, August 4, 1958, AOC.

22. "Painters Fight Rust and Starlings to Make Capitol Dome White Again," *Washington Evening Star,* January 28, 1960.

23. "Extension of the United States Capitol" (status report), December 1959, AOC.

24. J. George Stewart to James G. Fulton, June 24, 1960, *Congressional Record,* July 5, 1960, pp. A5806–A5808.

25. *New York Herald Tribune,* August 13, 1959.

26. *The Washington Post,* August 14, 1959.

27. "The Newest House Office Building: Why It Is So Widely Criticized," *The Washington Post,* December 29, 1963.

28. "Matthew McCloskey, 80, Dies; Builder Was Envoy to Ireland," *The New York Times,* April 27, 1973.

29. "Cornerstone of Rayburn Building Set," *The Washington Post,* May 25, 1962.

30. "Bids to Be Invited Soon On New House Building," *The Evening Star* (Washington), October 16, 1959.

31. "Lifting the Veil," *The Washington Post,* October 17, 1959.

32. "Door Prize," *The Washington Post,* June 10, 1963.

33. Pamela Scott and Antoinette J. Lee, *Buildings of the District of Columbia* (New York: Oxford University Press, 1993), pp. 136–137.

34. "Answers to Certain Questions in Article in January, 1965 Edition of *Reader's Digest,* by James E. Roper, titled 'Colossal New Palace on Capitol Hill,'" p. 4, typed

report by the Architect of the Capitol, February 2, 1965, AOC.

35. "Hearing before the Commission For Extension of the United States Capitol," June 24, 1965 (Washington: Government Printing Office, 1965), p. 11.

36. Samuel S. Stratton, "Should We Leave The Capitol Alone?" *Parade,* September 25, 1966.

37. Ibid.

38. George Will, "Another Mindless Attack on the West Front," *The Washington Post,* June 16, 1977.

39. "Back to the Mat on the West Front," *The Washington Post,* June 2, 1977.

40. "The West Front Vandals," *The Washington Star,* June 26, 1977.

41. "A Capitol Crime," *The New York Times,* July 4, 1977.

42. Frederick Gutheim, *Worthy of the Nation; The History of Planning for the National Capital* (Washington: Smithsonian Institution Press, 1977), p. 161.

43. "For Shrine or Recreation? Senate's Rumpus Room Stirs Debate Over Status," *The Washington Post,* May 7, 1960.

44. 86th Congress, 2d Session, 1961 Legislative Branch Appropriations Act, H. R. 12232.

45. Vance Trimble, "Historic Government Room, High Court Once, Now a Cocktail Party Site," *Washington Daily News,* September 19, 1961.

46. "Misuse of a National Shrine," *Washington Daily News,* September 21, 1961.

47. Ibid.

48. "Senate's Old Chamber to Become a New Shrine," *The Washington Post,* April 1, 1962.

49. "Architects See Capitol Job Favoritism," *The New York Times,* March 17, 1968.

50. Records of the United States Senate Commission on Art and Antiquities, Office of the Senate Curator.

51. "Ceremonies in the Old Senate Chamber," *Congressional Record,* June 16, 1976.

52. Maxine Cheshire, "Warnecke Design," *The Washington Post,* April 19, 1973.

53. *Congressional Record,* April 30, 1974, p. S 6594.

54. "Historical Digest: Philip A. Hart Senate Office Building," October 25, 1979, p. 5, AOC.

55. Scott and Lee, *Buildings of the District of Columbia,* p. 137.

56. "Minutes of the Committee of 100 of the Federal City" (Copy), Clinton M. Hester to Mario Campioli, November 19, 1964, AOC.

57. Architect of the Capitol, *The Design and Construction of the Thurgood Marshall Federal Judiciary Building: Final Report of the Architect of the Capitol to the Commission for the Judiciary Office Building* (Washington: Government Printing Office, 1994), p. 7.

BIBLIOGRAPHY

Adams, William Howard, ed. *The Eye of Thomas Jefferson*. Charlottesville: University Press of Virginia, 1981.

Aikman, Lonnelle. *We, the People: The Story of the United States Capitol*. Washington: U. S. Capitol Historical Society, 1991.

Alex, William. *Calvert Vaux: Architect & Planner*. New York: Ink, Inc., 1994.

Alexander, R. L. "The Grand Federal Edifice." *Documentary Editing* 9 (June 1987): 13–17.

Allen, William C. *"In The Greatest Solemn Dignity": The Capitol's Four Cornerstones*. Washington: Government Printing Office, 1995.

———. "'Seat of Broils, Confusion, and Squandered Thousands': Building the Capitol, 1790–1802." *The United States Capitol: Designing and Decorating a National Icon*. Athens: Ohio University Press, 2000.

———. *The Dome of the United States Capitol: An Architectural History*. Washington: Government Printing Office, 1992.

———. *The United States Capitol: A Brief Architectural History*. Washington: Government Printing Office, 1990.

Arnbeck, Bob. *Through a Fiery Trial: Building Washington 1790–1800*. Lanham, Md.: Madison Books, 1991.

Bacon, Donald, Roger H. Davidson, and Morton Keller, eds. *The Encyclopedia of the United States Congress*. New York: Simon & Schuster, 1995.

Beiswanger, William L. *Monticello in Measured Drawings*. Washington: Archetype Press, 1998.

Bennett, Wells. "Stephen Hallet and His Designs for the National Capitol, 1791–94." *The Journal of the American Institute of Architects* 4 (July, August, September, and October, 1916): 290–295, 324–330, 376–383, 411–418.

Beveridge, Charles E., and Paul Rocheleau. *Frederick Law Olmsted: Designing the American Landscape*. New York: Rizzoli, 1995.

Bickford, Charles Bangs, and Kenneth R. Bowling. *Birth of the Nation: The First Federal Congress 1789–1791*. Madison: Madison House, 1989.

Blake, Channing. "The Early Interiors of Carrère and Hastings." *The Magazine Antiques* 110 (1976): 344–351.

Blum, John M., et. al., eds. *The National Experience*. New York: Harcourt, Brace & World, Inc., 1963.

Bowling, Kenneth R. *Creating the Federal City, 1774–1800: Potomac Fever*. Washington: The American Institute of Architects Press, 1988.

Bowling, Kenneth R., and Helen E. Veit., eds. *The Diary of William Maclay and Other Notes On Senate Debates*. Baltimore: The Johns Hopkins University Press, 1988.

Bristow, Ian C. *Interior House-Painting Colours and Technology 1615–1840*. New Haven: Yale University Press, 1996.

Brown, Glenn. "Dr. William Thornton, Architect." *Architectural Record* 6 (1896): 53–70.

———. *History of the United States Capitol*. 2 vols. Washington: Government Printing Office, 1900, 1902.

———. *Memories: A Winning Crusade to Revive George Washington's Vision of a Capital City*. Washington: F. W. Roberts Co., 1931.

———. "The Making of a Plan for Washington City." *Records of the Columbia Historical Society* 6 (1903): 1–10.

———. "The United States Capitol in 1800." *Records of the Columbia Historical Society* 4 (1901): 128–134.

Brownell, Charles E. "Latrobe, His Craftsmen, and the Corinthian Order of the Hall of Representatives." In *The Craftsman in Early America*, edited by Ian M. G. Quimby. New York: W. W. Norton and Company, 1984.

Bryan, John M., ed. *Robert Mills, Architect*. Washington: The American Institute of Architects Press, 1989.

Bryan, Wilhelmus Bogart. *A History of the National Capital*. New York: The Macmillian Company, 1916.

Bulfinch, Ellen Susan. *The Life and Letters of Charles Bulfinch*. Boston: Houghton, Mifflin & Co., 1896.

Bushong, William B. "Glenn Brown, the American Institute of Architects, and the Development of the Civic Core of Washington, D. C." Doctoral Dissertation, George Washington University, 1988.

———. *Uncle Sam's Architects: Builders of the Capitol*. Washington: United States Capitol Historical Society, 1994.

Butler, Jeanne F. *Competition 1792: Designing a Nation's Capitol*. Washington: United States Capitol Historical Society, 1993.

Byrd, Robert C. *The Senate, 1789–1989*. 4 vols. Washington: Government Printing Office, 1988–1993.

Campioli, Mario. "An Historic Review and Current Proposals for the Nation's Capitol." *Journal of the American Institute of Architects.* January 1963: 49–52

Carrier Engineering Corporation. *The Weather Vein* 9, no. 3: 1–47.

Carrott, Richard C. *The Egyptian Revival: Its Sources, Monuments, and Meaning, 1808–1858*. Berkley: University of California Press, 1978.

Christman, Margaret. *The First Federal Congress 1789–1791.* Washington: Smithsonian Institution Press, 1989.

Cohen, Jeffery A. and Charles Brownell. *The Architectural Drawings of Benjamin Henry Latrobe*. New Haven: Yale University Press, 1994.

Cole, John Y. "Smithmeyer & Pelz: Embattled Architects of the Library of Congress." *The Quarterly Journal of the Library of Congress* 29 (October 1972): 282–307.

Congressional Globe. 46 vols. Washington. 1834–1873.

Congressional Quarterly. *Guide to the Congress of the United States: Origins, History and Procedure.* Washington: Congressional Quarterly Service, 1971..

Craig, Louis. *The Federal Presence: Architecture, Politics, and Symbols in the United States Government Building.* Cambridge: The MIT Press, 1978.

Craven, Wayne. *Sculpture in America*. New York: Thomas Y. Crowell Company, 1968.

Cutler, William Parker, and Julia Perkins Cutler. *Life, Journal, and Correspondence of Rev. Manasseh Cutler, LL. D.* Cincinnati: R. Clarke & Co., 1888.

di Giacomantonio, William C. "All The President's Men: George Washington's Federal City Commissioners." *Washington History* 3, (Spring / Summer 1991): 53–75.

Dole, Bob. *Historical Almanac of the United States Senate*. Washington: Government Printing Office, 1989.

Ellis, Dr. John B. *The Sights and Secrets of the National Capital*. Chicago: Jones, Junkin & Co., 1869.

Fairman, Charles E. *Art and Artist of the Capitol of the United States of America.* Washington: Government Printing Office, 1927.

Fillmore, Millard. Papers. Buffalo and Erie County Historical Society. Buffalo, New York.

Frary, I. T. *They Built The Capitol*. Richmond: Garrett and Massie, 1940.

French, Benjamin Brown. Papers, Manuscript Division. Library of Congress. Washington.

———. *Witness to the Young Republic, A Yankee's Journal, 1828–1870.* Edited by Donald B. Cole and John J. McDonough. Hanover: University Press of New England, 1989.

Fryd, Vivien Green. *Art and Empire: The Politics of Ethnicity in the U. S. Capitol, 1815–1860*. New Haven: Yale University Press, 1992.

Gale, Robert. *Thomas Crawford, American Sculptor*. Pittsburgh: University of Pittsburgh Press, 1964.

Gilchrist, Agnes Addison. *William Strickland: Architect and Engineer 1788–1854*. New York: Da Capo Press, 1969.

Goode, James M. "Architecture, Politics, and Conflict: Thomas Ustick Walter and the Enlargement of the United States Capitol, 1850–1865." Ph. D. Dissertation, George Washington University, 1994.

———. *Capital Losses*. Washington: Smithsonian Institution Press, 1979.

———. *The Outdoor Sculpture of Washington, D. C.* Washington: Smithsonian Institution Press, 1974.

Gray, David. *Thomas Hastings, Architect*. Boston: Houghton Mifflin Company, 1933.

Green, Constance. *Washington, Village and Capital* and *Washington, Capital City*, 2 vols. Princeton: Princeton University Press, 1962.

Greenberg, Allan. *George Washington Architect*. London: Andreas Papadakis Publisher, 1999.

Gutheim, Frederick. *Worthy of the Nation: The History of Planning for the National Capital*. Washington: Smithsonian Institution Press, 1977.

Hamlin, Talbot. *Benjamin Henry Latrobe*. New York: Oxford University Press, 1955.

———. *Greek Revival Architecture in America*. New York: Dover Publications, Inc., 1964.

Harris, C. M. "Washington's Gamble, L'Enfant's Dream: Politics, Design, and the Founding of the National Capital." *William and Mary Quarterly* 56 (July 1999): 527–563.

Hawkins, Don Alexander. "William Thornton's Lost Design of the United States Capitol." Unpublished manuscript, 1984.

Hazelton, George C. *The National Capitol: Its Architecture, Art, and History.* New York: J. F. Taylor & Company, 1914.

Hitchcock, Henry-Russell, and William Seale. *Temples of Democracy: The State Capitols of the U. S. A.* New York: Harcourt, Brace & Jovanovich, 1976.

Howard, Alexandra Cushing. "Stephen Hallet and William Thornton at the U. S. Capitol, 1791–1797." Master's Thesis, University of Virginia, 1974.

Hunsberger, George S. "The Architectural Career of George Hadfield." *Records of the Columbia Historical Society* 51–52 (1955): 46–67.

Hunt, Gilliard, ed. *The First Forty Years of Washington Society*. New York: Charles Scribner's Sons, 1906.

Hutson, James H. *To Make All Laws*. Washington: Library of Congress, 1989.

Jaffe, Irma B. *John Trumbull: Patriot-Artist of the American Revolution*. Boston: New York Graphic Society, 1975.

James, Bessie Roland. *Anne Royall's U. S. A.* New Brunswick: Rutgers University Press, 1972.

Jefferson, Thomas. *The Papers of Thomas Jefferson*. 23 volumes to date. Edited by Julian Boyd et. al. Princeton: Princeton University Press, 1950–.

Johnson, William Dawson. *History of the Library of Congress*. New York: Kraus Reprint Co., 1967.

Keim, DeB. Randolph. *Keim's Illustrated Hand-Book. Washington and its Environs: A Descriptive and Historical Hand-Book to the Capital of the United States of America.* Washington: "For The Compiler," 1874.

Kennon, Donald R., ed. *A Republic for the Ages: The United States Capitol and the Political Culture of the Early Republic*. Charlottesville: University Press of Virginia, 1999.

———, ed. *The United States Capitol: Designing and Decorating a National Icon*. Athens: Ohio University Press, 2000.

Kennon, Donald R., and Rebecca M. Rogers. *The Committee on Ways and Means: A Bicentennial History 1789–1989*. Washington: Government Printing Office, 1989.

Kerwood, John R. *The United States Capitol: An Annotated Bibliography*. Norman: University of Oklahoma Press, 1973.

Kimball, Fiske. *The Capitol of Virginia*. Richmond: Virginia State Library and Archives, 1989.

———. *Thomas Jefferson, Architect*. New York: Da Capo, 1968.

Latrobe, Benjamin Henry. *The Correspondence and Miscellaneous Papers of Benjamin Henry Latrobe*. Edited by John C. Van Horn. Published for the Maryland Historical Society. New Haven: Yale University Press, 1984.

———. *The Papers of Benjamin Henry Latrobe*. Edited by Edward C. Carter. Clifton, N. J. : James T. White, 1976. Microfiche.

Laverty, Bruce. *Girard College Architectural Collections*. Philadelphia: The Athenaeum of Philadelphia, 1994.

Lee, Antoinette J. *Architects to the Nation: The Rise and Decline of the Supervising Architect's Office*. New York: Oxford University Press, 2000.

Longstreth, Richard, ed. *The Mall in Washington, 1791–1991*. Washington: National Gallery of Art, 1991.

Lowery, Bates. *Building A National Image: Architectural Drawings for the American Democracy, 1789–1912*. Washington: The National Building Museum, 1985.

———. *The Architecture of Washington, D. C.* New York: Dunlap, 1978. Microfiche.

Maddox, Diane. *Historic Buildings of Washington, D. C.* Pittsburgh: Ober Park Associates, 1973.

Malone, Dumas. *Jefferson and His Time*. 6 vols. Boston: Little, Brown and Company, 1974.

Maroon, Fred J., and Suzy Maroon. *The Supreme Court of the United States*. New York: Thompson-Grant & Lickle, 1996.

———. *The United States Capitol*. New York: Stewart, Tabori & Chang, 1993.

Meigs, Montgomery C. Journals, 1852–1872. (Unedited and unverified transcript of a work in progress sponsored by the United States Senate Historical Office). Manuscript Division. Library of Congress. Washington.

Miller, Lillian B. *Patrons and Patriotism: The Encouragement of the Fine Arts in the United States, 1790–1860*. Chicago: University of Chicago Press, 1966.

Mills, Robert. *Guide to the Capitol of the United States*. Washington, 1834.

———. *Guide to the National Executive Offices and the Capitol of the United States*. Washington, 1842.

———. Papers. Edited by Pamela Scott. Wilmington, Del.: Scholarly Resources, 1990. Microfilm.

Morrill, Justin S. Papers. Manuscript Division, Library of Congress, Washington.

Morris, S. Brent. *Cornerstones of Freedom: A Masonic Tradition*. Washington: The Supreme Council, 33°, S. J., 1993.

Murdock, Myrtle Cheny. *Constantino Brumidi: Michelangelo of the United States Capitol*. Washington: Monumental Press, 1950.

Myers, Denys Peter. *Gas Lighting in America: A Guide for Historic Preservation*. Washington: U. S. Department of the Interior, 1978.

National Park Service. *Congress Hall*. Washington: Department of the Interior, 1990.

Nelson, Lee H. *White House Stone Carving: Builders and Restorers*. Washington: Government Printing Office, 1992.

Nichols, Frederick Doveton. *Thomas Jefferson's Architectural Drawings*. Boston: Massachusetts Historical Society; Charlottesville: Thomas Jefferson Memorial Foundation and University of Virginia Press, 1961.

Norton, Paul F. *Latrobe, Jefferson, and the National Capitol*. New York: Garland, 1977.

Olmsted, Frederick Law. Papers. Manuscript Division, Library of Congress, Washington.

Padover, Saul K., ed. *Thomas Jefferson and the National Capital*. Washington: Government Printing Office, 1946.

Parker, William Belmont. *The Life and Public Service of Justin Smith Morrill*. Boston and New York: Houghton Mifflin Company, 1924.

Peterson, Charles E., ed. *Building Early America*. Radnor, Pennsylvania: Chilton Book Company, 1976.

———. "Iron in Early American Roofs." *The Smithsonian Journal of History* 3 (1968): 41–76.

Piper, John E. "The Janes & Kirtland Iron Works." *The Bronx County Historical Society Journal* 11 (Fall 1974): 51–70.

Pitch, Anthony S. *The Burning of Washington: The British Invasion of 1814*. Annapolis: Naval Institute Press, 1998.

Place, Charles A. *Charles Bulfinch: Architect and Citizen*. New York: Da Capo Press, 1968.

Poore, Ben Perley. *Perley's Reminiscences of Sixty Years in the National Metropolis*. Philadelphia: Hubbard Brothers, 1886.

Radoff, Morris L. *The State House at Annapolis*. Annapolis: The Hall of Records Commission, 1972.

Reiff, Daniel D. *Washington Architecture, 1791–1861: Problems in Development*. Washington: U. S. Commission of Fine Arts, 1971.

Reps, John W. *Monumental Washington*. Princeton: Princeton University Press, 1967.

———. *Washington on View: The Nation's Capital Since 1790*. Chapel Hill: The University of North Carolina Press, 1991.

Ridout, Orlando. *Building the Octagon*. Washington: The American Institute of Architects Press, 1989.

Rogers, Millard F. *Randolph Rogers: American Sculptor in Rome*. Amherst: The University of Massachusetts Press, 1971.

Roper, Laura Wood. *FLO: A Biography of Frederick Law Olmsted*. Baltimore: The Johns Hopkins University Press, 1973.

Scott, Gary. "The Quarries at Aquia and Seneca." *Journal of the White House Historical Association* (1998): 32–37.

Scott, Pamela. "Stephen Hallet's Design for the United States Capitol." *Winterthur Portfolio* 27 (1992): 145–170.

———. *Temple of Liberty: Building the Capitol for a New Nation*. New York: Oxford University Press, 1995.

Scott, Pamela, and Antoinette J. Lee. *Buildings of the District of Columbia*. New York: Oxford University Press, 1993.

Seale, William. *The President's House*. Washington: The White House Historical Society, 1986.

———. "The Stonemasons Who Built the White House." *Journal of the White House Historical Association* (1998): 16–31.

———. *The White House: The History of an American Idea*. Washington: The American Institute of Architects Press, 1992.

Sizer, Theodore, ed. *The Autobiography of John Trumbull.* New Haven: Yale University Press, 1953.

Solit, Karen D. *History of the United States Botanic Garden 1816–1991.* Washington: Government Printing Office, 1993.

Somma, Thomas P. *The Apotheosis of Democracy, 1908–1916: The Pediment for the House Wing of the United States Capitol.* Newark: University of Delaware Press, 1995.

Snell, Mark. "William B. Franklin." Ph. D. dissertation [draft], University of Missouri, 1997.

Stapleton, Darwin H. *The Engineering Drawings of Benjamin Henry Latrobe.* New Haven: Yale University Press, 1980.

Stearns, Elinor, and David N. Yerkes. *William Thornton: A Renaissance Man in the Federal City.* Washington: American Institute of Architects Foundation, 1976.

Stein, Susan. *The Worlds of Thomas Jefferson at Monticello.* New York: Harry N. Abrams, Inc., 1993.

Stephenson, Richard D. *"A Plan Whol[l]y New:" Pierre Charles L'Enfant's Plan of the City of Washington.* Washington: Library of Congress, 1993.

Stuart, James, and Nicholas Revett. *The Antiquities of Athens.* Volume the First: A New Edition. London: Priestley and Weale, 1825.

Thomas, Charles F. Papers. Manuscript Division, Library of Congress, Washington.

Thornton, William. Papers. Manuscript Division, Library of Congress, Washington.

———. *Papers of William Thornton: Volume One 1781–1802.* Edited by C. M. Harris. Charlottesville: University Press of Virginia, 1995.

Torres, Louis. "Federal Hall Revisited." *Journal of the Society of Architectural Historians* 29 (1970): 327–338.

Tucker, J. Hampton. "The Library of Congress: Thomas Ustick Walter's Masterpiece of Technology and Tradition," Masters Thesis, University of Virginia, 1992.

U. S. Congress. Architect of the Capitol. *Art in the United States Capitol,* Washington: Government Printing Office, 1978.

U. S. Congress. Architect of the Capitol. *The Design and Construction of the Thurgood Marshall Federal Judiciary Building: Final Report of the Architect of the Capitol to the Commission for the Judiciary Office Building.* S. Pub. 103-5. Washington: Government Printing Office, 1994.

U. S. Congress. Architect of the Capitol. *Enlarging of the Capitol Grounds: The Final Report of the Commission for Enlarging of the Capitol Grounds.* 76th Congress. 3d Session. Senate Document 251. Washington: Government Printing Office, 1943.

U. S. Congress. Architect of the Capitol. Records. Office of the Curator. Washington.

U. S. Congress. Architect of the Capitol. *Report to the Congress of the United States on the Master Plan for Future Development of the Capitol Grounds and Related Areas.* Washington: Government Printing Office, 1981.

U. S. Congress. Architect of the Capitol. *The Restoration of the West Central Front of the United States Capitol and Terrace Repairs and Restoration and Courtyard Infill.* Washington: Government Printing Office, 1998.

U. S. Congress. House of Representatives. *Documentary History of the Construction and Development of the Capitol Building and Grounds.* 58th Congress, 2d Session Report 646. Washington: Government Printing Office, 1904.

U. S. Congress. House of Representatives. *History of the United States House of Representatives.* 87th Congress, 1st Session. House Document 246. Washington: Government Printing Office, 1962.

U. S. Congress. House of Representatives. *Report of the Architect of the Capitol on the Reconstruction of the Roofs and Skylights Over the House Wing of the Capitol and Remodeling of the House Chamber.* 82d Congress, 2d Session. House Document no. 531. Washington: Government Printing Office, 1952.

U. S. Congress. House of Representatives. *Report of the Commission to Direct and Supervise the Construction of the House Office Building.* 61st Congress, 3d Session. House Report 2291. Washington: Government Printing Office, 1912.

U. S. Congress. Senate. *Acoustics, Redecoration, and Better Lighting System for the Senate Chamber: Hearings Before a Subcommittee of the Committee on Public Buildings and Grounds...Hearings...on S. Res. 150.* 77th Congress, 1st Session. Printed for the use of the Committee on Public Buildings and Grounds. Washington: Government Printing Office, 1941.

U. S. Congress. Senate. *Biographical Directory of the United States Congress 1774–1989.* Senate Document no. 100–34. 100th Congress, 2d session. Washington: Government Printing Office,1989.

U. S. Congress. Senate. *Enlarging the Capitol Grounds: The Final Report of the Commission for Enlarging the Capitol Grounds.* 76th Congress. 3d Session. Document no. 251. Washington: Government Printing Office, 1943.

U. S. Congress. Senate. *History of United States Senate Roof and Chamber Improvements and Related Historical Data.* 82d Congress, 1st Session. Document no. 20. Washington: Government Printing Office, 1951.

U. S. Congress. Senate. *Improvement of Senate Chamber.* 68th Congress, 2d Session. Document no. 161. Washington: Government Printing Office, 1924.

U. S. Congress. Senate. *Inaugural Addresses of the Presidents of the United States,* 101st Congress, 1st Session, S. Doc. 101–10. Washington: Government Printing Office, 1989.

U. S. Congress. Senate. *Message of the President of the United States Communicating Information Relative to the Heating and Ventilating of the Capitol Extension and Post Office Department.* Executive Document no. 20. 36th Congress, 1st Session. January 26, 1860.

U. S. Congress. Senate. Records of the Commission on Art and Antiquities. Office of the Senate Curator. Washington.

U. S. Congress. Senate. "Report of the Secretary of the Senate with a Statement of the Payments from the Contingent fund of the Senate for the year ending 30th November, 1851." Miscellaneous Document no. 15, 32d Congress, 1st Session, January 13, 1853.

U. S. Congress. Senate. *Report of the Senate Office Building Commission Relating to an Additional Office Building for the United States Senate.* 83d Congress, 2d Session. Document no. 143. Washington: Government Printing Office, 1954.

U. S. Congress. Senate. "Report, The Special Select Committee appointed by the Senate under the resolution of the 6th August, 1852." Committee Report no. 1, March 1, 1853.

U. S. Congress. Senate. *The Improvement of the Park System of the District of Columbia.* 57th Congress. 1st Session. Senate Report no. 166. Washington: Government Printing Office, 1902.

U. S. National Archives. Records of the Office of Public Buildings and Grounds, 1791–1867. Record Group 42.

U. S. National Archives. Records of the U. S. Senate. Record Group 46.

Van Brunt, Henry. *Architecture and Society: Selected Essays of Henry Van Brunt.* Edited by William A. Coles. Cambridge: The Belknap Press of Harvard University Press, 1969.

Walker, General Duncan S. *Celebration of the One Hundredth Anniversary of the Laying of the Corner Stone of the United States Capitol.* Washington: Government Printing Office, 1896.

Walter, Thomas U. "Genealogical Sketch and Investigation Relating to the Ancestry and Family Connections Embracing Biographical and Historical Notes and Records." 1871. Handwritten bound manuscript in private collection.

————. Papers. The Athenaeum of Philadelphia. Washington: Smithsonian Institution. Archives of American Art. 1987. Microfilm.

————. "The Dome of the U. S. Capitol." *Architectural Review and Builder's Journal,* December 1869.

Warren, Charles. "What Has Become of the Portraits of Louis XVI and Marie Antoinette, Belonging to Congress?" *The Massachusetts Historical Society* (October-November 1925): 45–85.

Washington, George. *Writings of Washington.* 39 vols. Edited by John C. Fitzpatrick. Washington: Government Printing Office, 1931–1944.

Ways, Harry C. *The Washington Aqueduct: 1852–1992.* N. p., N. d., ca. 1994.

Weeks, Christopher. *AIA Guide to the Architecture of Washington, D. C.* Baltimore: The Johns Hopkins University Press, 1994.

Weigley, Russell F. *Quartermaster General of the Union Army.* New York: Columbia University Press, 1959.

Whiffen, Marcus. *The Public Buildings of Williamsburg.* Williamsburg, Virginia: Colonial Williamsburg, 1958.

White, George M. *Under the Capitol Dome.* Washington: The American Institute of Architects Press, 1997.

Withey, Henry F., and Elsie Rathbone Withey. *Biographical Dictionary of American Architects (Deceased).* Los Angeles: New Age Publishing Co., 1956.

Withington, Charles F. *Building Stones of our Nation's Capital.* Washington: Government Printing Office, 1975.

Wojcik, Susan Brizzolara. "Thomas U. Walter and the United States Capitol: An Alliance of Architecture, Engineering, and Industry." Ph. D. Dissertation. University of Delaware, 1998.

Wolanin, Barbara. *Constantino Brumidi: Artist of the Capitol.* Washington: Government Printing Office, 1998.

Woods, Mary N. *From Craft to Profession: The Practice of Architecture in Nineteenth-Century America.* Berkeley: University of California Press, 1999.

Wyeth, S. D. *The Rotunda and Dome of the U. S. Capitol.* Washington: Gibson Brothers, 1869.

INDEX

casting of, 308, 322
conservation of, 458–459, **459**
headdress criticized, 326–327
installation and celebration, 325–327
patina, 325
prompts revision to dome design, 288–289
freestone, 25. *See also* sandstone
French, Benjamin Brown
Capitol illumination, 333
commissioner, 217
cornerstone ceremony, 200
disbursing officer, 319
House chamber, opinion of, 269, 271
removed from extension office, 323
resuming work during war, 316
sculpture installation, 245
secession, opinion of, 309
Senate chamber, opinion of, 286
Statuary Hall and, 330
support for Andrew Johnson, 342
French, Benjamin B., Jr., 337
fresco, technique described, 250, 252
Fromentin, Senator Eligius, 100
funds spent
account of (up to)1794, 28
account of (up to)1802, 47
account of 1815–1817, 114
account of 1815–1818, 129
account of 1817, 129
account of 1828, 164
furnace, hot air, 259
furniture, 130, **266**, *303*
desks and chairs
House chamber, 265–266, **266**, 298, 308, 396
Senate chamber, *286*, 499
House
Latrobe, 68
Walter, 265–266
Woods, 396
House committee rooms, 371
members' retiring room, *362*
Senate, 87
Supreme Court, 90

G
Gage, Warner & Whitney, tool supplier, 243
Gallatin, Albert, secretary of the treasury, 47
galleries, 266, 285, 396
Galt, Alexander, sculptor, 250
Galway, James, painter, 321
garages, 422, 423, 433, 434
Gardnier, Samuel, inventor, 366
Garfield, James A., 344, 361
Garnett, Congressman, Muscoe, 281
Garnsey, Elmer, artist, 388
gas
explosion, 366–368, **367**
leaks, 364
lighting, 178–180, 218, *285*
chandeliers, *275, 287, 294*
exterior fixtures, 356
House chamber, 265
sconces, **270**, *270*
pipes, 242
structural problems, 179
gate houses, 159, 161, 163, **164**
Genius of America, by Persico, 157, **158**, 162, *428*
George Washington Resigning his Commission, by Trumbull, 155
George Washington University, 153
Georgia Marble Company, 426, 428
Georgian architecture, *13, 19, 21*
Georgian revival, *405*
Gerry, Vice President Elbridge, 108

Gibson, J. & J. H., Philadelphia ornamental glass makers, 245, 263
Gilbert, Cass, New York architect, 403–405, **404**, *404*
gilding, in Library of Congress, 210
Gilman, Ephraim, gilder, 155
Gilmer, Congressman John A., 277
Gimbel Brothers, New York merchants, *382*
Girard College, **190**, *190*, 194, 209, 226
Givan, Alexander, architect/builder, *12*
glass
English, 69, 70
German, 66, 69
hammered, *431*
north wing, 38, 40, 41
plate, 244
gneiss, foundation stone, 202
Goldsborough, Congressman Charles, 100
Gothic style, 358
Grain Market, Paris. *See* Halle au Bled
granite
extension, 202, 219
exterior column shafts, 267, 291
grounds, 356
Post Office extension, 293
grape, as ornament, *238*, 265
Grecian architecture, Latrobe's taste for, 68
Greek revival, 226
Greenleaf, Morris, and Nicholson, real estate syndicate, 28
Greenough, Horatio, sculptor
endorses Lee marble, 205
statue of Washington, 171, 174–175, **175**
criticism, 174, 246
relocation, 189
Rescue, *158*, 245, 246
Greenwood, Congressman Alfred, 229
Gregg, Andrew, congressman and senator, 68, 86
Gros, Antoine Jean, French artist, 340
Grosvenor, Congressman Thomas P., 100
grotto. *See* summerhouse
grounds. *See* Capitol grounds
gutta-percha, 242
gutters
extension, 328
north wing, 38, 41, 53, 76
snow melting, 361

H
Hadfield, George, architect, 51, 72, *406*
background, 29
cabinet offices, 38
dismissed, 38
modifications proposed, 30–32, **31**
restoration cost estimate, 100
Senate chamber and, *43*
hail, damage from, 266
hair, for plaster, 40
Hale, Senator Eugene, 354, 355
Hale, Senator John P., 303, 305
Hall, J. P., 356
hall of columns, 240–241, **240**, 259, **411**
Hall of the People. *See* rotunda
Halle au Bled, 63, **63**, 64, 70
Jefferson's admiration for, 23, 56, 67
skylights, Latrobe's objections to, 63
Halleck, Congressman Charles, 420
Hallet, Etienne (Stephen), architect
background, 17
competition prize, 21
designs
courtyard, 26, 36, **39**
fancy piece, 17, 18, **19**
final competition, 21, **22**
employment, 23, 26
evaluation of Thornton's design, 22

foundations, *31*
Hamilton, Alexander, secretary of the treasury, 5, 45
Hamlin, Talbot, biographer, 154
Hammitt Desk Company, 266
Hantman, Alan M., architect of the Capitol, 460
Harbaugh, Leonard, carpenter, 38, 106, 122
Harbeson, Hough, Livingston & Lawson, Philadelphia architects, 414, 422, 433
Harbeson, John, Philadelphia architect, 422, 426
Hardison, Fred L., Dallas architect, 422, 434
Harkness, John C., sworn measurer, 219, 295
Harlan, James, secretary of the interior, 334, 337, 342
Harper's Ferry, Virginia (now West Virginia), 110
Harris, Congressnman Morrison, 307
Harrison, Peter, architect, *12*
Harry, Phillip, architect, 189, 192
Hart Senate Office Building, 451–453, **452, 453**
Hartnet, John, mason, 110, 111, 117, 129, 131
Haskell, Douglas, editor, 425
Hastings, Thomas, New York architect, 380, **380**, *380*, 381, 399, 403
Hayden, Senator Carl, 447
Haydock, stone cutter, 107
Hayes, Rutherford, 353
Hayward & Bartlett, Baltimore ironworkers, 333
health
air conditioning effects on, 402
Capitol effects on, 184–185, 287, 305
ventilation effects on, 329, 363, 364
Healy, George P. A., artist, 316
hearths, 41
heating and ventilating, 193, 245, **291**, *291*
former library space, 371
Post Office extension, 292–293
rotunda, 154
See also House chamber, in the extension; Senate chamber, Walter; ventilation
Hechinger Engineering Corporation, 408
Heebner, Charles, marble merchant, 277
Henderson, stone carver, 112
Hennings, Senator Thomas C., 453
Henry, Chick, Washington plasterer, 371
Henry, Joseph, secretary of the Smithsonian Institution, 194, 270, 331
acoustics committee, 219
marble commission, 204
reprimanded by Meigs, 258
ventilation committee, 362
Henry, William Wirt, orator, 365
Hepburn, Congressman William, 376, 379
Hibbard, Congressman Harry, 229
Higgins, Daniel Paul, New York architect, 418
Hill, Samuel, Boston engraver, 10
Hints on Public Architecture, 182
historic preservation, 425–426, 439, 441, 445, 451
Hoban, James, architect/builder, 122, 141
ignores bad workmanship, 27
Latrobe and, 65, 93
north wing construction, 38
"oven" and, 45
President's House
repairs, 101, 102
south portico, 153
Senate chamber and, *43*
surveyor of public buildings, 23
Hoffman, Congressman Clare E., 433
Holland, John Joseph, decorative painter, 69
Hollings, Senator Ernest, 441
Holt, Joseph, secretary of war, 310
Hoover, Andrew, lime merchant, 202
Hope, by Persico, 157, **158**
hospital, 27, 321

Houdon, Jean-Antoine, sculptor, 171
House chamber
 in Brick Capitol, 143
 in the extension
 acoustics, 270–271, 287
 artwork, 302
 carpentry, 267
 ceiling, 263, **264**
 cotton ornaments, 247
 temporary supports, 412
 clock, **272**
 color scheme, 302
 criticism, 271, 281
 doors, **265**, 265
 fly doors, 265, **266**
 floor replacements, 361, 372, **373**
 furniture, 265–266, 298, 308, 396, **396**
 gallery seats, 266
 heating and ventilating, 245, 271, 272
 air-conditioning, 402
 hospital, 321
 lighting, 265
 electric, 367
 plans, **198, 220**
 reconstruction, 411–415
 proposed, 381, 393–396
 relocation, 217–218
 sections, **199, 221**
 skylight, 263, *264*
 Speaker's rostrum, **268**
 television coverage, *415*
 voting, electronic, *415*
 in Library of Congress, 45, **61**
 in the "oven," 45–46, **46, 54**, 55, 60, 122
 in the south wing
 post-fire
 acoustics, 141–144
 alterations (1832), 180
 carpet, 180
 ceiling, 132, 210
 chandelier, 179
 colonnade, Thornton critique, 143
 columns, 103, 105, 110, 113, 114, 121, 129
 bases, 119
 capitals, 105
 design, 103–105
 dome, 115
 furnishings, 130
 lantern, 104
 marble, 132
 religious services in, 144
 sculpture, 120
 venders in, 329, 330
 windows, 180
 See also Statuary Hall
 pre-fire
 acoustics, 71, 72
 ceiling decoration, 69
 columns, 52, 58, **59**, 62, 64, 65, 66, 68,
 70, 72, 89
 colonnade, 57, **57, 102**
 description, 72
 destroyed, 98
 Hallet plan
 criticism, 52
 description, 55–56
 variations on, 52, 56
 raising of, 56
 press reviews, 71
 sculpture, 71, 72
House chamber vestibule (small House
 rotunda), **59, 73**, 74, 98, 390
House of Commons, Dublin, **55**
House of Commons, London, 225, 363
House Office Building Commission, 379, 433
House office buildings. *See* Cannon Building
 (1908), Longworth Building (1933),

Rayburn Building (1965)
House pediment, sculpture for, 391, 392–393
Houston, Sam, congressman and senator
 fights library fire, 158
 investigates extension office, 211–213
 criticizes sculpture, 280
Howard, Senator Jacob, 342
Howe, Senator Timothy, 352, 353
Howland, Dr. Richard, National Trust
 president, 425, 426
Huddleston, Senator Walter D., 441
Humphreys, General A. A., 343
Hunter, Senator Robert M. T., 184, 194, 207,
 209, 257
Huxtable, Ada Louise, critic, 424

I

Iardella, Francisco, sculptor, 112, 113, *113*
ice, 361
immigrants, prejudice against, 248
inaugurals, location of, 165
industrialization, 243, *243*
Inge, Henry, cabinetmaker and ironmonger, 75
Ingersoll, Congressman Charles, 101
Inman, Henry, artist, 176
insects, as ornament, 265
iron
 beams, *148*
 ceilings
 hall of columns, 240
 library, **208**, 209
 Speaker's office, *269*, **269**
 staircases, **307**
 columns, Senate gallery, 164
 dome. *See* dome, Walter
 fireproof construction, 207
 pipes, 176
 railings
 to protect artwork, 135, 162
 terrace, 162
 library, 159
 reinforcement, 130
 roof, south wing, 68
 window and door casings, 242
Isherwood, Robert, Washington merchant, 152
Iverson, Senator Alfred, 304
Izard, Senator Ralph, 4, 5

J

Jackson, Andrew, 156, 165, 166
Jackson, Congressman John G., 68
Jacobs, Congressman Andrew, 440
Jacobsen, Hugh Newell, Washington architect,
 445
jail, Alexandria, 166
James Madison Memorial, 453–454, **454**
James Madison Memorial Building. *See* Library
 of Congress, Madison Building
Janes, Beebe & Company (later Janes, Fowler,
 Kirtland & Co.), New York foundry
 iron dome
 contract, 298, 301
 skin, 287
 wartime construction, 315
 work force, 302
 ceilings, *307*
 Library of Congress, 209, 333
Janes, Adrian, foundry owner, 337
Jarvis, Congressman Leonard, 171
Jefferson, Thomas
 American taste and, 13–14, *50*
 antique architectural models and, 13, 17, 18
 Capitol plan, **14**
 competition, 13, 17, 19
 conference, 23
 corn cob capital, 88, 113
 Halle au Bled, 23, 56, 63, 67

Latrobe and, 61, 76, 87, 94
L'Enfant and, 8, 11
library, *110*, 132
Maison Carrée, *13*
"oven," 45
panel lights, 67, 70
President's House, design for, *15*
public speaking, 54
reputation, 70
Residence Act, 5, 6
retirement, 86
rotunda and, 134
Senate chamber
 arrangement of, 41
 raising of, 77
south wing
 approves changes, 58
 construction pace, 53
statues of
 by David d'Angers, **50**
 by Powers, 258
Virginia capitol, **12,** *12, 13*
Jenckes, Congressman Thomas A., 361
Jenkins Hill, 8, 11
jet d'eau, 285
Johnson, Andrew, 193, 334, 338
Johnson, Congressman James, 140
Johnson, Lady Bird, 448
Johnson, Lyndon B., 421
Johnson, Senator Robert W., 222, 223, 305, 306
Johnson, Thomas, commissioner of the federal
 city, 8, 13, 27
Johnston, Senator Josiah S., 157
Johnston, Senator Samuel, 5
Jones, John, guard, 206
Jones, Walter, Latrobe's lawyer, 94
Joyce, Mr., stone carver, 147
Judiciary Square, 89, 353, 404
Jupiter, Stator, temple of, 62, 152
Justice
 by Carlo Franzoni, 120, *449*
 by Persico, 157, **158**
Justice and History, figures by Crawford, 325

K

Kearney, John, plaster contractor, 40
Kennedy, Senator Anthony, 298, 305
Kennedy, John, 432, **445,** *445*
Kensett, John F., artist, 302
Kerr, Congressman Michael C., 361
Kidder, Dr. J. H., 363
Key, Francis Scott, lawyer, 94, 95
King, James, Washington architect, 189
King, John Crookshanks, sculptor, *432*
King, Senator Rufus, 5, 109, 110
Kinyoun, Dr. J. J., 363
Kirtland, Charles, New York foundry owner, 337
Know-Nothing party, 248
Kreps & Smith, New York gilders, 180

L

labor problems
 carpenters, 34
 grounds, 348
 masons, 30
 stone cutters, 130, 159–160
 stone workers strike, 330
laborers
 number working, 144
 wages, 129
 See also workmen
ladies retiring room, 267
Lafayette, Marquis de, portrait by Scheffer,
 176, *271*
Lafayette Square, landscape tied to Capitol, 346
La Follette, Senator Robert, 417
Lambdin, James R., artist, 302

marble
 exploration, 110
 extension, 218
 exterior window frames, 257
 first building in Washington faced with, 204
 floors
 from Library of Congress, *139*
 House corridors, *411*
 Statuary Hall, 330
 vestibule, 319, *319*
 verd antique, 131, 239
 See also column shafts, marble; marble
 quarries
Marble Falls, Texas, 429
marble quarries
 Baltimore, 119, 299
 imperfections, 320
 Colorado, *433*
 Connecticut, 131
 Georgia, *410,* 426, 428,
 Italy, 238, 239, 283, 290
 capitals, cost of, 132
 exterior column shafts, political support,
 298
 Maryland, 106, 205, 290
 Massachusetts, 204, 205, 290
 route to Washington, 219
 New York, 119, 131, 205, 299
 Philadelphia, 119, 132
 Potomac, 106, 110, 111, 117, 119
 Tennessee, 238, 239, *239*, 303, *438*
 Vermont, 239, 299, 358, 381, *370,* 426, 428,
 433
 Virginia, 106
marble room, 303, **303**, 401
Marie Antoinette, portrait of, 44
marine band, 365
marine barracks, Pensacola, 283
Marine Corps, *349*
 Capitol police and, *349*
 guarding stone cutters, 130
 library fire and, 206
marshal, Supreme Court, 368
Marshall, Congressman Humphrey, 279, 281
Marshall, John, congressman and chief justice,
 170
 bust by Powers, 258
 statue by Story, **352**
Marshall, Thomas W., structural engineer, 411
Marshall Building. *See* Thurgood Marshall
 Federal Judiciary Building
Martin, James, blacksmith,164
Martin, Congressman Joe, 419, 424
Marvin, Congressman Dudley, 163
Maryland donation, 28
Mason, J. L., engineer, 203
Mason, General John, 101
masons
 number working, 144
 recruitment, 25
 trouble with, 30
 See also stone cutters
Masons, 24, 199
Massachusetts, soldiers from, 313, **313**, *313*
Massachusetts statehouse, *126*, 145, *148*
Master Plan for Future Development of the
 Capitol Grounds, 455–456, **456**
Maynard, Congressman Horace, 344
Mazzei, Phillip, 62, 65
McArthur, James, Philadelphia architect, *190*
McBeath, & Sons, contractors, 428
McCall, Congressman Samuel, 392, 393–396
McCleland, Thomas, Virginia architect, 192
McCloskey, Matthew H., Philadelphia
 contractor, 435
McCloskey & Company, Philadelphia
 contractors, 434, 435

McComb, John, New York architect, 119, 120,
 126
McCormack, Speaker John, 435, 438
McFarlan, A. B., foreman of south wing
 plasterers, 250
McIntire, Samuel, craftsman/architect, 17, *17*
McIntosh, stone carver, 112
McKim, Charles, New York architect, 375, 376,
 377, 380
McKim, Mead & White, New York architects,
 380, 390, 415
McKnight, Congressman Robert, 318, 327
McMillan, Senator James, 375
McMillan Commission, 375, 376, 377, 379, 381,
 404, 408, *409*
McMullen, Congressman Fayette, 209
McNair, Congressman John, 203, 211
Meade, Simeon, carpenter, 75
Meehan, John S., librarian of Congress, 206,
 211, 222
Meigs, Louisa Rogers, 252, 270
Meigs, Montgomery C., engineer
 acoustics, 273
 Anderson and, 329
 appointed supervising engineer, 215
 art and artists
 encouragement of, 281
 search for sculptors, 245
 background, *217*
 books, ideas from, 247
 column shafts, monolithic, 290
 control, lost of, 317–318
 credit and recognition, 228, 247, 258, 267,
 272, 274, 275, 282–283
 as an architect, 272
 dome
 contract, 301, 312
 cost estimate, 227
 raising, 353
 unaware of revisions, 289
 See also dome, Walter
 farewell, 294–295
 Franklin and, 310
 glass industry, 244
 Olmsted terrace, 350
 photograph of, **217**
 plan revision, 219
 Post Office extension, 230
 quarry visits, 259, 283
 salary, 275
 snakes, 250
 stonework evaluation, 237–238
 Walter
 dismissal, 310–312
 drawings, 283
 relations with, 224, 228, 287
 titles, 289–290
 work routine, 237
 work stopped, 314
members' retiring room, **362**, 363, *395*
Mexican War, 181–182
Michler, General Nathaniel, 343
Milford, Connecticut, 131
military superintendence, 222, 223, 256, 257
Millard, Thomas, New York carver, 180
Miller, Senator Stephen, 174
Miller & Coates, New York tile importers and
 installers, 241
Mills, Clark, sculptor and bronze caster, 245,
 307–308, 322
Mills, Robert, Washington architect, 101, 169
 background, *188*
 Crutchett's lantern and, 179
 death, 230
 drinking fountain, 178, 358
 extension proposals, 182, 184, 189, **189**
 premium awarded, 192

Senate plan, 192–193, **192**, **193**
House chamber alterations, 180
marble building, Washington's first, 204
photograph of, **188**
Walter's job, desire for, 216–217
Washington, George
 statue of, 174
 tomb of, 171
water supply, 177
Mills, Theophilus, sculptor, 392
Miner, Congressman Charles, 160
Mitchell, Congressman James, 163
Mitchell, Congressman Samuel L., 49, 54
Moberly, Charles E., artist, 360
models
 Capitol as designed
 by Bulfinch, **147**
 by Latrobe, **92, 151**
 by Thornton, **37**
 center building, 135
 east front extension, 391
 extension and new dome, **235**
Monroe, James
 dome and, 145
 inaugural, 115
 New England tour, 127
 quarry trip, 117
 urges speed, 115, 121
Moore, Henry D., Pennsylvania treasurer, 311,
 316
morocco, as upholstery, 265, 266, *266*
Morrill, Justin, congressman and senator
 background, *344*
 criticizes planting, 358
 enlarging grounds, 343–344
 library building, 353
 Olmsted and, 346
 photograph of, **344**
 Statuary Hall, 329–330
 terrace
 funding, 350–352, 354
 windows, 355
Morris, Senator Robert, *6*
Morse, Samuel F. B., artist/inventor, 176
Mosaic Tile Company, 371
Moyamensing Prison, Philadelphia, 242
Moynihan, Daniel Patrick, presidential aide
 and senator, 440
Mullett, Alfred B., Washington architect, 353
Munroe, Professor Charles, explosives expert,
 368
Munroe, Thomas, superintendent of the city of
 Washington, 49, 76, 99, 112, 131
Murray & Hazlehurst, boiler manufacturers,
 245

N
Nason & Dodge, heating and ventilating
 contractors, 245, 272, 292, 293
National Arboretum, *429*
National Bureau of Standards, 430
National Historic Preservation Act, 439
National Park Service, 429
National Press Club, 426–427
naval hospital, Norfolk, 166
Navy Yard, 151, 180
 dry dock, 50–51
 marble tests, 205
 sails from, 340
Neihaus, Charles, sculptor, 392
Nelson's Column, model of scaffold, 233
neoclassical revival, 401, 404, *406*, 407
neoclassicism, *12*, 19, *21*, 51, *126*
New York, as potential capital, 5
New York Times, 424, 442
Newsham & Company, Baltimore foundry, *274*
Newsweek, 442